TRANSFORMING THE CHURCH INTERIOR IN RENAISSANCE FLORENCE

Before the late sixteenth century, the churches of Florence were internally divided by monumental screens that separated the laity in the nave from the clergy in the choir precinct. Enabling both separation and mediation, these screens were impressive artistic structures that controlled social interactions, facilitated liturgical performances, and variably framed or obscured religious ritual and imagery. In the 1560s and 1570s, screens were routinely destroyed in a period of religious reforms, irreversibly transforming the function, meaning, and spatial dynamics of the church interior. In this volume, Joanne Allen explores the widespread presence of screens and their role in Florentine social and religious life prior to the Counter-Reformation. She presents unpublished documentation and new reconstructions of screens and the choir precincts that they delimited. Elucidating issues such as gender, patronage, and class, her study makes these vanished structures comprehensible and deepens our understanding of the impact of religious reform on church architecture.

Joanne Allen studied at the University of Warwick and the Courtauld Institute of Art, and completed postdoctoral research in Rome, Florence, and Venice. She teaches at American University, where she won a teaching award, and her research has been supported by the Renaissance Society of America and the Italian Art Society. She is a choral singer and artist.

TRANSFORMING THE CHURCH INTERIOR IN RENAISSANCE FLORENCE

SCREENS AND CHOIR SPACES FROM THE MIDDLE AGES TO TRIDENTINE REFORM

JOANNE ALLEN

American University

CAMBRIDGE
UNIVERSITY PRESS

CAMBRIDGE
UNIVERSITY PRESS

University Printing House, Cambridge CB2 8BS, United Kingdom

One Liberty Plaza, 20th Floor, New York, NY 10006, USA

477 Williamstown Road, Port Melbourne, VIC 3207, Australia

314–321, 3rd Floor, Plot 3, Splendor Forum, Jasola District Centre, New Delhi – 110025, India

103 Penang Road, #05–06/07, Visioncrest Commercial, Singapore 238467

Cambridge University Press is part of the University of Cambridge.

It furthers the University's mission by disseminating knowledge in the pursuit of education, learning, and research at the highest international levels of excellence.

www.cambridge.org
Information on this title: www.cambridge.org/9781108833592
DOI: 10.1017/9781108985659

© Cambridge University Press 2022

First published 2022

Printed in the United Kingdom by TJ Books Limited, Padstow, Cornwall

A catalogue record for this publication is available from the British Library.

ISBN 978-1-108-83359-2 Hardback

To my parents, Lesley and Ray

CONTENTS

FIGURES

ACKNOWLEDGMENTS

THIS PROJECT HAD ITS GENESIS in a short-term fellowship at the Nederlands Interuniversitair Kunsthistorisch Instituut (NIKI) in Florence in Spring 2012. The NIKI was my summer base for archival research in Florence for the following five summer vacations, and I thank the staff there, especially Michael W. Kwakkelstein, Gert Jan van der Sman, and Ilaria Masi, for their support and encouragement. Further financial support, for research travel, image rights, and publication costs, was provided by the Mellon faculty fund at American University (AU), an Italian Art Society Research and Publication Grant, and the Renaissance Society of America-Samuel H. Kress Publication Subvention for Art Historians. I am particularly grateful to the AU College of Arts and Sciences for awarding me a Book Incubator Grant, which gave me the opportunity of soliciting several peer reviews before publication.

I am grateful to the staff at the various libraries and archives who have assisted me with this research, in particular those at the Archivio di Stato di Firenze, the Medici Archive Project, the Archivio Arcivescovile di Firenze, the Biblioteca Nazionale Centrale di Firenze, American University Library, the Library of Congress, and the National Gallery of Art Library.

Many friends and colleagues have shared their specialist knowledge with me, brought important material to my attention, assisted with translations, and offered practical assistance for which I am most grateful. With apologies for any omissions, these include Jon Allen, Jordan Amirkhani, Maurizio Arfaioli, Alessio

Assonitis, Grazia Badino, Sheila Barker, Melissa Becher, Juliet Bellow, Giacomo Benedetti, Sarah Bercusson, Mattia Biffis, Erin Black, Rebecca Bossi, Louise Bourdua, Doug Brine, Ann Brooks, Kim Butler, Mehreen Chida-Razvi, Roberto Cobianchi, Thomas Dalla Costa, Carla D'Arista, Paul Davies, Maria DePrano, Douglas Dow, Nicholas Eckstein, Theresa Flanigan, Mary Garrard, Lucas Giles, Linda Goodwin, Gianmario Guidarelli, Erik Gustafson, Joseph Hammond, Grace Harpster, Sarah Hines, Alison Holdsworth, Megan Holmes, Andy Holtin, Deborah Howard, Tiffany Hunt, Sandro La Barbera, Stuart Lingo, Alison Luchs, Tycho Maas, Irene Mariani, Matko Marušić, Fabio Massaccesi, Rod McElveen, Sara Miglietti, Paola Modesti, Chemi Montes, Haude Morvan, Zuleika Murat, John Nadas, Alana O'Brien, April Oettinger, Ashley Offill, Laura Overpelt, Andrea Pearson, Ying-chen Peng, Beth Petitjean, Emily Price, Gaia Ravalli, Esther Rodriguez Camara, Alexander Röstel, Sam Sadow, Jaylynn Saure, Patricia Simons, Jennifer Sliwka, Elizabeth von Buhr, Justine Walden, Saundra Weddle, Matthew Woodworth, and Michela Young.

I owe a great debt of gratitude to Caroline Bruzelius, Joanna Cannon, Donal Cooper, Sally Cornelison, Alexandra Dodson, Antonia Fondaras, Julian Gardner, Christa Gardner von Teuffel, Erin Giffin, Michael Gromotka, Marcia Hall, and Sharon Strocchia, each of whom has read this study in its entirety or one of its chapters. I offer my affectionate thanks for their careful reading, critical comments, advice, and encouragement. Without their generosity my mistakes would have been many. Those that remain are, of course, all mine.

NOTE TO THE READER

I N ARCHIVAL TRANSCRIPTIONS, abbreviations have been expanded, and where relevant, words have been separated and punctuation and diacritics added. Incomprehensible or uncertain words are followed by (?). If text was added above, it is indicated thus: ^text^.

The Florentine year began on 25 March. In the text, dates have been modernized, but in archival transcriptions and notes, dates remain according to the Florentine calendar and are indicated by (stil. Flor).

For definitions of terms, please consult the Glossary at the end of the book.

ARCHIVE ABBREVIATIONS

ASF Archivio di Stato di Firenze
BML Biblioteca Medicea Laurenziana
BNCF Biblioteca Nazionale Centrale di Firenze
CRS Corporazioni Religiose Soppresse dal Governo Francese (a section within ASF)

INTRODUCTION

THIS BOOK EXAMINES a major transformation of the Florentine church interior that fundamentally impacted the artistic, practical, and liturgical life of the church. The painting in Figure 1 presents an evocative view – albeit imagined and idealized – of a fifteenth-century church. Traversing the nave, an immense monumental screen incorporates chapels decorated with gilded altarpieces and brocaded altar frontals. Laymen socialize and perambulate through the screen's central opening, beyond which friars congregate in the high altar area. During the course of the late Renaissance, these subdivided spatial arrangements were gradually transformed into open, unified interiors such as that portrayed in Figure 2, which itself was then further embellished in the baroque era and restored in modern times. Lacking a screen, this uninterrupted space – equipped with uniform side altarpiece frames, a pulpit and organ – focuses attention on a large Eucharistic tabernacle on the high altar, behind which friars conducted their liturgy completely hidden from view.

As agents of both segregation and mediation, screens (known as *tramezzi* in Italian) were important liminal structures that in essence divided the laity in the nave from the clergy in the choir. However, in a widespread phenomenon that gained momentum in the later sixteenth century, tramezzi were destroyed and original arrangements of choir stalls in the nave were transferred to so-called retrochoirs: sites behind the high altar either in the high chapel or in a dedicated extended space. This "revolution in church planning and liturgical practice" has marginalized the contemporary significance and cultural value of tramezzi, which are sometimes entirely overlooked by historians of Italian religious art.[1]

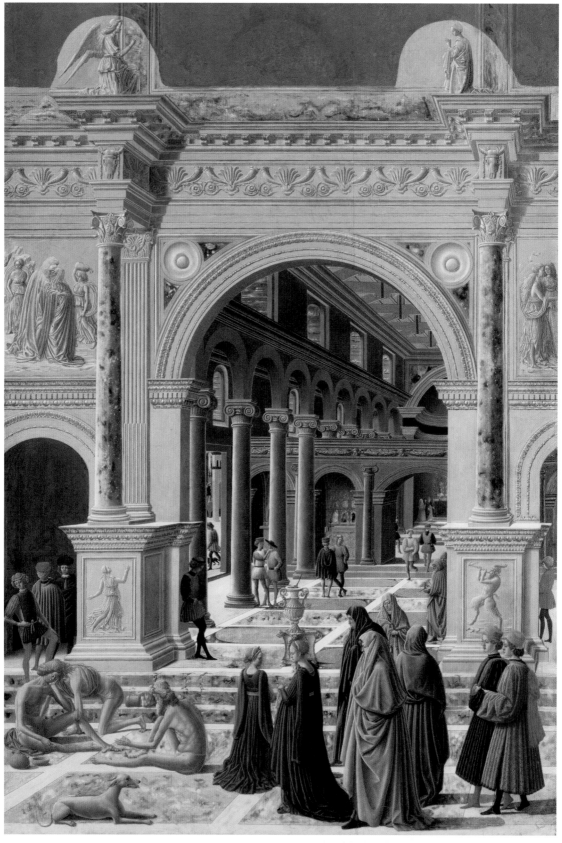

Figure 1 Fra Carnevale (Bartolomeo di Giovanni Corradini), *Presentation of the Virgin in the Temple (?)*, c. 1467. Oil and tempera on panel, 146.4 × 96.5 cm. Museum of Fine Arts Boston. Charles Potter Kling Fund 37.108. Photograph ©2022 Museum of Fine Arts, Boston

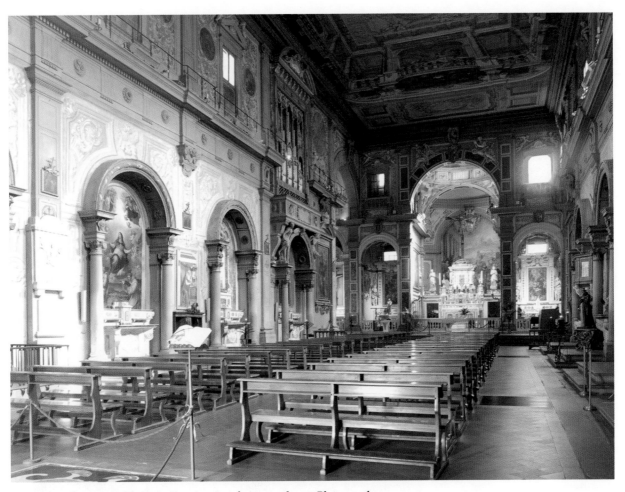

Figure 2 Ognissanti, Florence. Interior view facing northeast. Photo: author

Marcia Hall's groundbreaking studies of Santa Croce and Santa Maria Novella in the 1970s definitively proved the existence of large-scale tramezzi in Florentine churches and detailed their destruction within the climate of the Counter-Reformation. By restoring screens as essential components of the church interior, Hall instigated an entire field of enquiry into Italian art and architecture. While subsequent studies have revealed evidence for tramezzi in individual Italian churches, this book has two broader aims: to establish the original arrangements and functions of nave choirs and tramezzi, and to explore motivations for their later elimination, overall providing a significant reappraisal of how Italian Renaissance art and architecture were originally experienced, both before and after the renovations.

Current scholarship suggests that Florence was the only Italian city to witness the systematic removal of screens and nave choirs – many more than previously thought – within a short interval between the 1560s and 1570s. These alterations often formed part of broader artistic schemes involving the whitewashing of earlier fresco decoration and construction of new uniform altarpiece frames and high altar Eucharistic tabernacles. The churches that experienced such transformations include the Franciscan church of Santa Croce; the Dominican Santa Maria Novella;

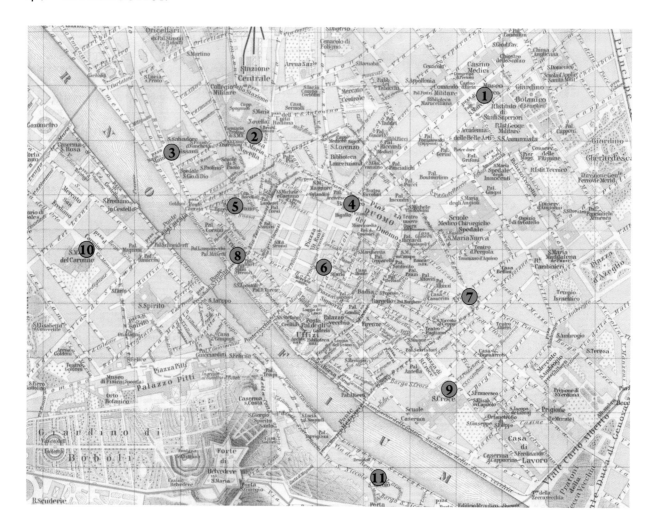

1	San Marco	7	San Pier Maggiore
2	Santa Maria Novella	8	Santa Trinita
3	Ognissanti	9	Santa Croce
4	San Giovanni	10	Santa Maria del Carmine
5	San Pancrazio	11	San Niccolò Oltrarno
6	Orsanmichele		

Figure 3 Map of Florence indicating churches altered between c. 1560 and 1577. Map image: The British Library

the Observant Dominican San Marco; the Carmelite Santa Maria del Carmine; Ognissanti (initially Humiliati, then Observant Franciscan from 1561); the Vallombrosan monks' churches of Santa Trinita and San Pancrazio; San Pier Maggiore, a Benedictine nunnery with parish duties; San Niccolò Oltrarno, a collegiate church with parish duties; the civic oratory of Orsanmichele; and the Baptistery of San Giovanni (Figure 3). Other fifteenth-century churches in Florence, like San Lorenzo, had already been constructed without the presence of monumental interior screens. Following an introductory chapter focused on the function and developments of screens, two linked chapters are devoted to a broad overview of sacred space in

Florentine churches. Five case studies – on the mendicant, male and female monastic, and civic contexts – demonstrate the almost ubiquitous presence of screens and nave choir precincts. Presenting unpublished archival documentation and new architectural reconstructions, each case elucidates wider issues that include gender segregation, patronage, function, and access.

The transformation of the church interior remains a thorny issue in Italian art history. What motivated these renovations and who instigated them? How profound was the impact of religious reform on the articulation of sacred space? How did the removal of nave choirs and tramezzi fundamentally change the experience of the church interior?

Although the destruction of tramezzi and the shift to retrochoirs had been gaining momentum outside the city from the mid-fifteenth century, and medieval examples existed in neighboring Umbria, in Florence both the chronological intensity of the transformations and the strong political motivations of the actors involved appear to be unique.[2] These alterations were enacted toward the conclusion of the reign of Duke Cosimo I de' Medici, who centralized political power and cultural patronage in an unprecedented manner in both Florence itself and the greatly enlarged Tuscan state. As this study will show, primary sources demonstrate that Duke Cosimo and his court artist and architect Giorgio Vasari were personally involved in many of the new schemes. Cardinal Carlo Borromeo, whose later writings on sacred architecture were widely disseminated and in many ways shaped perceptions of the 'reformed' church interior, may have encouraged Duke Cosimo to pursue the renovations so vigorously. The church renovations allowed the duke to pursue multiple objectives, which included promoting Catholic reform, reviving early Christian and Quattrocento Medici spaces, and demonstrating widespread artistic patronage throughout the

city. In the years leading up to his official abdication, Duke Cosimo also invited Archbishop Antonio Altoviti to return from political exile, which appears to have intensified this architectural and liturgical revolution. More broadly, historians have related the Florentine episode to shifting architectural and pictorial aesthetic taste, economic considerations, religious motivations related to the Council of Trent, local and state politics, and changes in social mores. In individual cases, flood damage, decline in monastic populations, exchanges of religious communities, and institutional reform were also instrumental. A complex intersection of motivating factors – including practical, aesthetic, and religious concerns – and a range of figures, including the duke, lay patrons, and ecclesiastical leaders, contributed to the single largest transformation of Florence's architectural landscape since the early Renaissance.

Chronologically, the Florentine alterations neatly postdate the conclusion of the widely influential Council of Trent in 1563. The council pursued two main objectives: to reaffirm church teaching, especially concerning the doctrines refuted by the Protestants; and to establish pastoral reform, in particular to enhance the roles of bishops and parish priests.[3] Beyond the twenty-five decrees issued between 1545 and 1563, the council had many wider consequences, such as an increase in papal and episcopal power, the development of the sensuous in the arts, and an emphasis on the Catholic Church's differences with the newly instituted branches of Protestantism.[4] As other historians have noted, Trent did not legislate on ecclesiastical architecture or furnishings directly or make any direct injunctions concerning the placement of choirs.[5] However, several decrees – especially those that emphasized the importance of the Eucharistic sacrament, encouraged preaching, and castigated against secular or disrespectful acts in churches – sanctioned a shift in the function, atmosphere,

and meaning of the church interior. In a period of both Catholic reform, characterized by an emphasis on lay engagement and clerical betterment, and Catholic renewal, characterized by intensified sacramental devotion, the church renovations were an economical way of expressing these institutional objectives in architectural form.

THE EUROPEAN ARCHITECTURAL CONTEXT

Almost exclusively treated as a Catholic – and specifically Italian – phenomenon, these church renovations have rarely been viewed in the broader European context.[6] In fact, across Europe in the later sixteenth century, churches experienced radical alterations in both the Protestant and Catholic spheres. In some cases, similar architectural outcomes across religious denominations – such as the removal or adaptation of screens or whitewashing of walls – expressed fundamentally differing concepts of the role of the church interior.[7]

In the Lutheran tradition, while many existing Catholic spaces were cleared of screens, some chancel screens were replaced by galleries for grand musical performances in Germany (Figure 4).[8] On the other hand, many were maintained in Denmark, and in the Norwegian and Swedish contexts were employed as devices to create restricted spaces that expressed social standing.[9] In the Low Countries, Calvinist iconoclasts ransacked churches in the major ecclesiastical centers of Flanders and Brabant in 1566, precisely paralleling the Florentine period of alterations.[10] Religious images and altars were

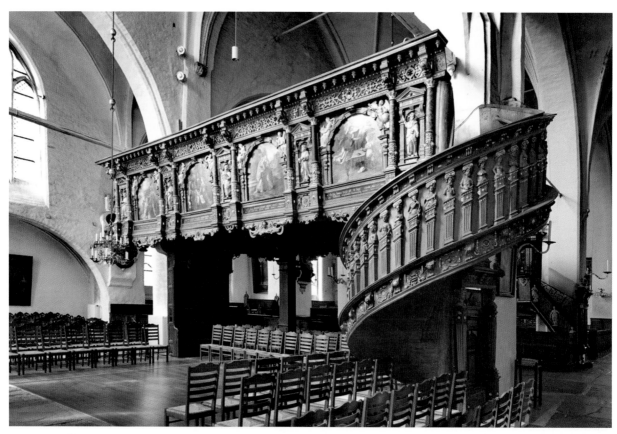

Figure 4 Ägidienkirche, Lübeck, Germany. Musician's gallery in the nave, view facing southwest. Photo: Bodo Kubrak

Figure 5 St. Peter's Church, Leiden, The Netherlands. Screen viewed from the nave, facing east. Photo: Harm Joris ten Napel

destroyed but many screens not only survived but were actively saved and repurposed as important elements in Calvinist religious practice.[11] Sculpted rood groups (depictions of the crucified Christ) present on those screens were often replaced by panels listing the Ten Commandments (Figure 5).[12]

In sixteenth-century England, after widespread removals under Henry VIII and Edward VI, roods were erected or reerected under the Catholic Mary I.[13] During the Elizabethan return to Protestantism, religious authorities endorsed the removal of roods but the preservation of screens. In 1560, roods were removed from many London churches and the following year orders issued either directly from the Crown or from Archbishop of Canterbury Matthew Parker gave further clarification regarding the alteration or "transposynge" of roodlofts and the installation

of "some convenient crest" (the Royal Arms).[14] The removal of screens themselves was not proposed at that point, but further Orders of 1571 stated that "all roodlofts are to be altered."[15] The Anglican animosity, therefore, was directed toward the "popish" roods themselves rather than the physical barriers, which reinforced a desired sense of hierarchy and authority in the church interior, and became important sites of lay identity.[16]

In early modern Spain, neither a development toward retrochoirs nor a definitive acceptance of nave choirs can be observed.[17] Moreover, Spanish cathedrals frequently had distinctive spatial arrangements in which the laity already occupied a privileged position directly in front of the high altar where they were more visually engaged with the liturgy.[18] While unrealized designs for Valladolid and Salamanca Cathedrals placed

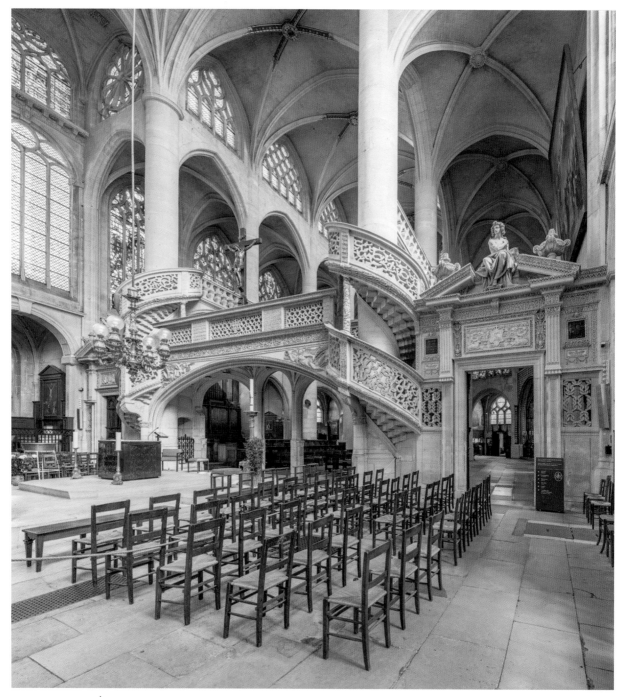

Figure 6 Saint-Étienne-du-Mont, Paris. Screen viewed from the nave, facing east. Photo: David Iliff

stalls in retrochoirs,[19] sometimes Spanish choir precincts were moved from the high altar area into the central nave, while the laity would remain in the area in front of the high altar.[20] Meanwhile, mendicant and monastic choirs were frequently moved to raised balconies above the church entrance doors.[21]

In France, various adaptations to the church interior took place gradually over a longer time span. Often screens (known as jubés in the

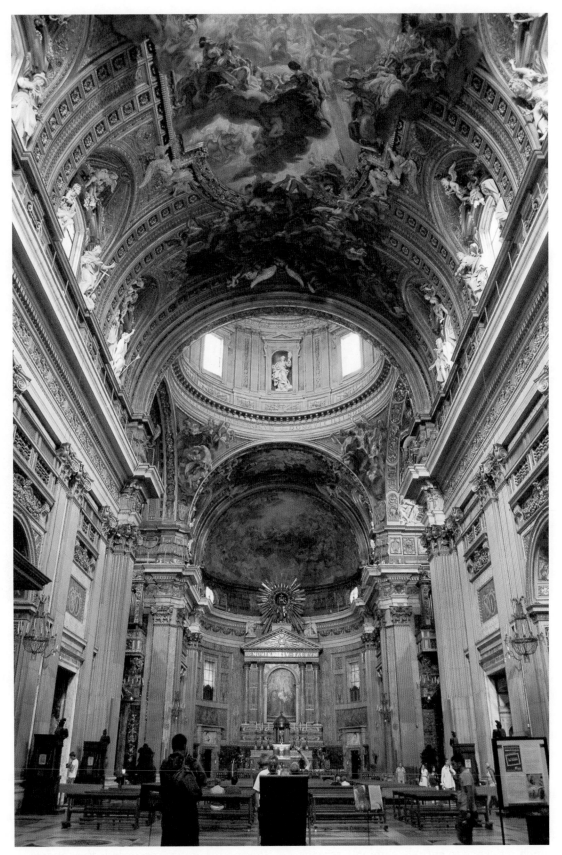

Figure 7 Il Gesù, Rome. Interior view facing east. Photo: author

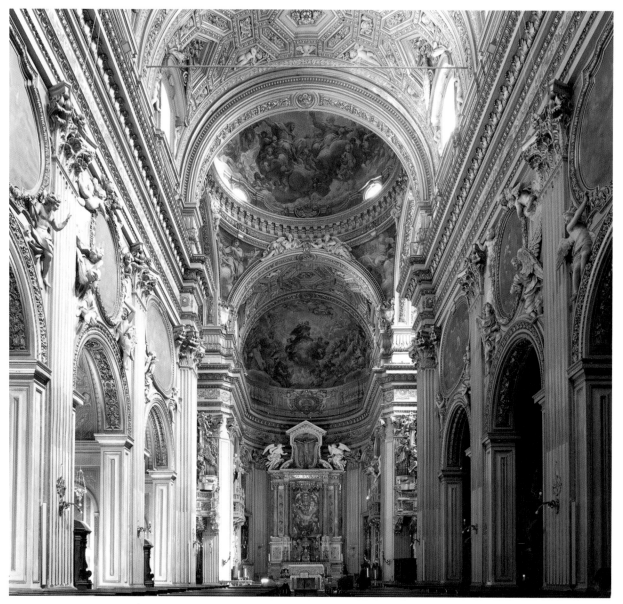

Figure 8 Chiesa Nuova (Santa Maria in Vallicella), Rome. Interior view facing north. Photo: author

French context) were demolished or refashioned, or more rarely nave altars were erected in front of screens, which were consequently relegated to architectural curiosities.[22] In the sixteenth and seventeenth centuries, jubés were constructed with more open forms such as porticos or triumphal arches, seen, for example, in Saint-Étienne-du-Mont in Paris (Figure 6).[23] The lay liturgical historian Jean-Baptiste Thiers displayed the French reticence to entirely eliminate screens

in his influential 1688 *Dissertations ecclésiastiques*, in which he emphasized the continuous historical presence of screening devices, labelling their demolition a rejection of ancient church tradition, authority, and liturgical practice.[24]

Across the Italian peninsula, countless churches were transformed, and new buildings were equipped with retrochoirs during the latter decades of the sixteenth century. Writing in 1588, Pompeo Ugonio recorded the effects of the

Figure 9 San Francesco della Vigna, Venice. Interior view facing east. Photo: Didier Descouens

widespread dismantling of nave precincts in Rome, for example, commenting that in Santa Sabina, Sixtus V "removed that obstruction, which cut the church in two parts, which has made the church ample and spacious."[25] Scholars have frequently described the construction of the mother church of the new Jesuit order – Il Gesù in Rome – as an important stylistic stage in the development of the open, unified church interior (Figure 7). First conceptualized by the order's founder, St. Ignatius of Loyola, in 1549 but only built between 1568 and 1584, the church comprises a light-filled, barrel-vaulted single nave, flat-ended transept arms, a crossing, and presbytery.[26] However, since Jesuit liturgical practice did not require a choir precinct (Ignatius's *Constitutiones* specified that Jesuits "will not regularly hold choir for the canonical hours or sing Masses and offices"),[27] the absence of a nave choir in the Gesù partly derives from

this functional peculiarity.[28] Likewise, since Filippo Neri's Oratorians also did not practice daily liturgical office in choir, the Chiesa Nuova lacked a precinct, but was instead equipped with two "*coretti*": raised balconies to either side of the high altar, completed in 1598–99 (Figure 8).[29]

In sixteenth-century Venice, new churches, such as the Observant Franciscan church of San Francesco della Vigna, were designed with the facility of retrochoirs (Figure 9).[30] Palladio's Il Redentore (1577–92), built using state funds as a votive offering following a great plague, accommodated three main audiences: the laity in the nave, the Venetian doge and his entourage in the chancel, and the Capuchin friars in the retrochoir.[31] Similarly, in the Benedictine San Giorgio Maggiore (1565–90s), Palladio included a retrochoir elevated on four steps from the presbytery, separated by a columnar screen and a walkway between a corridor and sacristy (Figure 10).[32]

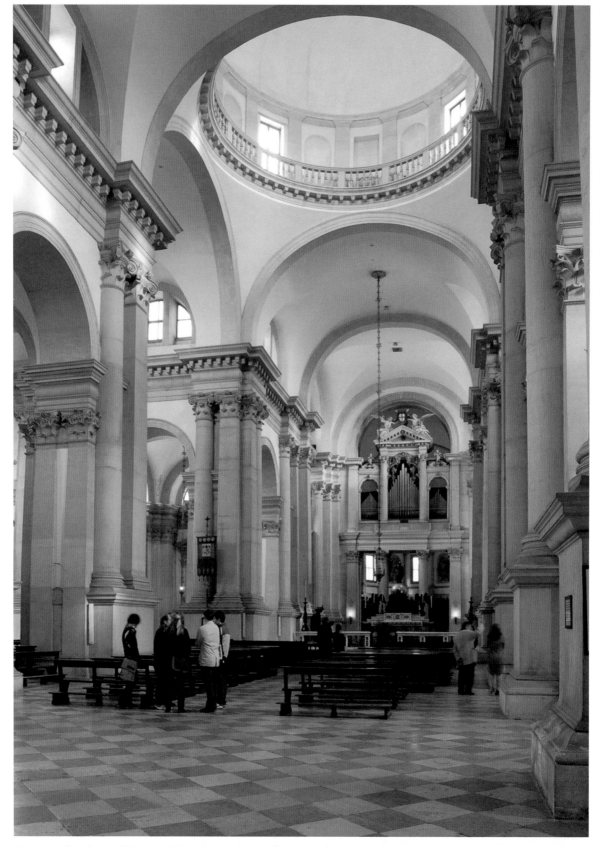

Figure 10 San Giorgio Maggiore, Venice. Interior view facing southeast. Photo: author

In Naples, numerous churches experienced transformations in the later sixteenth century.[33] For example, the Dominican Prior Ambrogio Salvi as early as 1551 instituted the transferal of the choir of San Pietro Martire, which according to his biographer was designed to "increase in the people devotion of the most holy Sacrament," located in a tabernacle on the high altar.[34] Similarly, in 1563, friars in the Franciscan church of San Lorenzo Maggiore transferred the choir so that the church would become "enlarged," and "empty and clear" so that the friars and laity could worship in more comfort.[35]

In the later sixteenth century, therefore, churches in both the Protestant and Catholic traditions experienced various spatial alterations, the motivations for which are still widely debated. While shifts in the demarcations of space and their accompanying hierarchical overtones can be interpreted as inherently power-driven and fundamentally related to societal ideology, this can be overstated, as this synopsis has demonstrated. In a venue as complex as the church interior, it is important to recognize the inherent flexibility of space, the dynamic multiplicity of both social relations and spatial contexts, and the extended time periods in which changes could occur.[36] In the contested arena of the Florentine church interior, which will be examined in more detail in the subsequent chapters, religious communities, lay patrons, and civic leaders variously controlled, adapted, and shaped these constantly evolving sacred spaces.

NOTES

1 James S. Ackerman, "Observations on Renaissance Church Planning in Venice and Florence, 1470–1570," in *Florence and Venice: Comparisons and Relations*, ed. Sergio Bertelli, Nicolai Rubinstein, and Craig Hugh Smyth (Florence, 1980), p. 294.

2 This impression may be informed by the relative lack of research being conducted on other urban centers.

3 On the Council of Trent, see James Waterworth, *The Canons and Decrees of the Sacred and Oecumenical Council of Trent* (London, 1848); Robert Bireley, "Redefining Catholicism: Trent and Beyond," in *The Cambridge History of Christianity: Reform and Expansion 1500–1660*, ed. R. Po-Chia Hsia (Cambridge, 2007), pp. 145–61; John W. O'Malley, *Trent: What Happened at the Council* (Cambridge, MA and London, 2013); John W. O'Malley, *The Council of Trent: Myths, Misunderstandings, and Unintended Consequences* [*Il Concilio di Trento: miti, incomprensioni e conseguenze involontarie: 12 marzo 2013*] (Rome, 2013). On bishops, see, for example, Jennifer Mara DeSilva, ed., *Episcopal Reform and Politics in Early Modern Europe* (Kirksville, MO, 2012).

4 O'Malley, *The Council of Trent*, p. 18. For the impact on the arts, see Marcia B. Hall and Tracy E. Cooper, eds., *The Sensuous in the Counter Reformation Church* (New York, 2013).

5 Marcia B. Hall, *Renovation and Counter-Reformation: Vasari and Duke Cosimo in Sta Maria Novella and Sta Croce, 1565–1577* (Oxford and New York, 1979), p. 15; Giovanni Lorenzoni and Giovanna Valenzano, "Pontile, jubé, tramezzo: alcune riflessioni sul tramezzo di Santa Corona a Vicenza," in *Immagine e ideologia: Studi in onore di Arturo Carlo Quintavalle*, ed. Arturo Calzona, Roberto Campari, and Massimo Mussin (Milan, 2007), p. 316; Michael G. Gromotka, "Transformation Campaigns of Church Interiors and Their Impact on the Function and Form of Renaissance Altarpieces: The Example of S. Pietro in Perugia and Pietro Perugino's 'Ascension of Christ'," *Marburger Jahrbuch für Kunstwissenschaft* 42 (2015), p. 79. See also Beverly Louise Brown, "Choir and Altar Placement: A Quattrocento Dilemma," *Machiavelli Studies* 5 (1996), p. 151.

6 Both Ważbiński and Conforti noted that the international entourage that accompanied the wedding celebrations of Francesco de' Medici and Giovanna d'Austria would have been struck by the similarity of the empty church interiors to those favored by the Protestant churches of Northern Europe. Zygmunt Ważbiński, *L'Accademia medicea del disegno a Firenze nel Cinquecento: idea e istituzione*, Accademia Toscana di Scienze e Lettere "La Colombaria" (Florence, 1987), p. 359. Claudia Conforti, *Vasari architetto* (Milan, 1993), p. 209.

7 Andrew Spicer, "Sites of the Eucharist," in *A Companion to the Eucharist in the Reformation*, ed. Lee Palmer Wandel (Leiden and Boston, 2014), especially pp. 331, 358. See also Joseph Leo Koerner, *The Reformation of the Image* (Chicago, 2004), pp. 402–21; Sarah Hamilton and Andrew Spicer, eds., *Defining the Holy: Sacred Space in Medieval and Early Modern Europe* (London, 2016).

8 Matthias Range, "The Material Presence of Music in Church: The Hanseatic City of Lübeck," in *Lutheran Churches in Early Modern Europe*, ed. Andrew Spicer (Farnham, 2012), pp. 216–17.

9 Birgitte Bøggild Johannsen and Hugo Johannsen, "Reforming the Confessional Space: Early Lutheran Churches in Denmark, c. 1536–1660," in *Lutheran Churches in Early Modern Europe*, ed. Andrew Spicer (Farnham, 2012), pp. 269, 271. For Denmark, also see Martin Jürgensen, "Between New Ideals and Conservatism: The Early Lutheran Church Interior in Sixteenth-Century Denmark," *Church History* 86, no. 4 (2017), pp. 1041–80; Øystein Ekroll, "State Church and Church State: Churches and Their Interiors in Post-Reformation Norway, 1537–1705," in *Lutheran Churches in Early Modern Europe*, ed. Andrew Spicer (Farnham, 2012), p. 283; Riitta Laitinen, "Church Furnishings and Rituals in a Swedish Provincial Cathedral from 1527 to c. 1660," in *Lutheran Churches in Early Modern Europe*, ed. Andrew Spicer (Farnham, 2012), pp. 327–28.

10 Jeremy Dupertuis Bangs, *Church Art and Architecture in the Low Countries before 1566* (Kirksville, MO, 1997), pp. 1–12.

11 Ibid., pp. 44–67, 189. Justin E. A. Kroesen, "Accommodating Calvinism: The Appropriation of Medieval Church Interiors for Protestant Worship in the Netherlands after the Reformation," in *Protestant Church Architecture in Early Modern Europe: Fundamentals and New Research Approaches* [*Protestantischer Kirchenbau der Frühen Neuzeit in Europa: Grundlagen und neue Forschungskonzepte*], ed. Jan Harasimowicz (Regensburg, 2015), pp. 86–98; Justin E. A. Kroesen, "The Preserving Power of Calvinism: Pre-Reformation Chancel Screens in the Netherlands," in *The Art and Science of the Church Screen in Medieval Europe: Making, Meaning, Preserving*, ed. Spike Bucklow, Richard Marks, and Lucy Wrapson (Woodbridge, 2017), pp. 214–19.

12 Kroesen, "Accommodating Calvinism," pp. 86, 90.

13 Frederick Bligh Bond and Bede Camm, *Roodscreens and Roodlofts* (London, 1909), p. 103; Elizabeth Aston, "Cross and Crucifix in the English Reformation," in *Macht und Ohnmacht der Bilder: reformatorischer Bildersturm im Kontext der europäischen Geschichte*, ed. Peter Blickle et al. (Munich, 2002), pp. 253–59. For extensive iconoclasm in Scotland, see David McRoberts, "Material Destruction Caused by the Scottish Reformation," in *Essays on the Scottish Reformation 1513–1625*, ed. David McRoberts (Glasgow, 1962), especially pp. 430, 452.

14 James Parker, *Did Queen Elizabeth Take "Other Order" in the "Advertisements" of 1566? A Letter to Lord Selborne, in Reply to His Lordship's Criticisms on the "Introduction to the Revisions of the Book of Common Prayer"* (Oxford and London, 1879), p. 157; Bond and Camm, *Roodscreens and Roodlofts*, p. 105; Nigel Yates, *Liturgical Space: Christian Worship and Church Buildings in Western Europe 1500–2000* (Aldershot and Burlington, VT, 2008), p. 22.

15 Bond and Camm, *Roodscreens and Roodlofts*, p. 105.

16 David Griffith, "Texts and Detexting on Late Medieval English Church Screens," in *The Art and Science of the Church Screen in Medieval Europe: Making, Meaning, Preserving*, ed. Spike Bucklow, Richard Marks, and Lucy Wrapson (Woodbridge, 2017), p. 76; Aston, "Cross and Crucifix," p. 272. For the so-called "1848 rood screen controversy," see Augustus Pugin, *A Treatise on Chancel Screens and Rood Lofts, Their Antiquity, Use, and Symbolic Signification* (London, 1851).

17 Alfonso Rodríguez G. de Ceballos, "Liturgia y configuración del espacio en la arquitectura española y portuguesa a raíz del Concilio de Trento" (Universidad Autónoma de Madrid, 1991), p. 48; María Dolores Teijeira Pablos, "'Aziendo presbiterio mui capaz'. El 'modo español' y el traslado de coros góticos en la España moderna," in *Choir Stalls in Architecture and Architecture in Choir Stalls*, ed. Fernando Villaseñor Sebastián et al. (Newcastle upon Tyne, 2015), p. 12; Pablo J. Pomar, "La ubicación del coro en las iglesias de España. San Pío V, Felipe II y el breve *Ad hoc nos Deus unxit*," in *Choir Stalls in Architecture and Architecture in Choir Stalls*, ed. Fernando Villaseñor Sebastián et al. (Newcastle upon Tyne, 2015), pp. 91, 96. For Portugal, see Rodríguez G. de Ceballos, "Liturgia y configuración del espacio," pp. 51–52.

18 For the discussion of Spain, Portugal, and France, I am indebted to the research assistance of Esther Rodriguez Camara. In Spanish cathedrals, large choir precincts occupying multiple bays in the central nave were frequently enclosed toward the west by a screen known as a "trascoro," which became a distinct area used for specific liturgical functions. Trascoros can be seen in the cathedrals of Avila, Leon, Toledo, Seville, and Granada. John Allyne Gade, *Cathedrals of Spain* (Boston and New York, 1911), pp. 83, 99, 112, 148–50, 216, 252, 257. For Toledo, see also Tom Nickson, "Reframing the Bible: Genesis and Exodus on Toledo Cathedral's Fourteenth-Century Choir Screen," *Gesta* 50, no. 1 (2011), pp. 71–89. Iron screens ("rejas") also often enclosed the choir to the east, which was sometimes connected via an enclosed corridor ("*via sacra*") to the high altar, leaving the crossing area between these hierarchical zones for use by the laity. Alicia Alonso, Rafael Suárez, and Juan J. Sendra, "The Acoustics of the Choir in Spanish Cathedrals," *Acoustics* 1 (2018), pp. 38–39. For the "*via sacra*," see Rodríguez G. de Ceballos, "Liturgia y configuración del espacio," p. 45.

19 Rodríguez G. de Ceballos, "Liturgia y configuración del espacio," pp. 46, 48.

20 See, for example, Cuenca Cathedral. Ibid., p. 47. Teijeira Pablos, "'Aziendo presbiterio mui capaz'," pp. 16–17.

21 The Carthusian order maintained their prominent nave choirs. Rodríguez G. de Ceballos, "Liturgia y configuración del espacio," p. 48.

22 Bernard Chédozeau, *Choeur clos, choeur ouvert: De l'église medievale a l'eglise tridentine (France, XVII–XVIII siècle)* (Paris, 1998), p. 77.

23 Ibid., p. 67.

24 Jean-Baptiste Thiers, *Dissertations ecclésiastiques* (Paris, 1688). For an explanation in English of Thiers's polemic,

see Christabel Jane Powell, "The Liturgical Vision of Augustus Welby Northmore Pugin" (PhD thesis, University of Durham, 2002), pp. 346–47.

25 "Egli levato quello imgombramento, che mozzava la chiesa in due parti, l'ha restituita ampia et spaziosa" (fol. 10v). Ugonio described choir seating in the apses of Santa Sabina, Santa Maria Maggiore, San Martino, San Marcello, San Crisogono, and Santa Prassede. Pompeo Ugonio, *Historia delle stationi di Roma che si celebrano la Quadragesima* (Rome, 1588), fols 10v–11r, 68v, 255r, 280v, 282r, 299r. De Benedictis noted that almost all of the medieval schola cantorum precincts had vanished by 1590. Elaine De Benedictis, "The 'Schola Cantorum' in Rome during the High Middle Ages" (PhD thesis, Bryn Mawr College, 1983), p. 114. See also Milton Joseph Lewine, "The Roman Church Interior, 1527–1580" (PhD thesis, Columbia University, 1960), p. 72.

26 Giovanni Sale, *Pauperismo architettonico e architettura gesuitica: dalla chiesa ad aula al Gesù di Roma* (Milan, 2001), pp. 55–62, 88–95; Aurelio Dionisi, *Il Gesù di Roma: breve storia e illustrazione della prima chiesa eretta dalla Compagnia di Gesù* (Rome, 1982), p. 20; James S. Ackerman, "The Gesù in the Light of Contemporary Church Design," in *Baroque Art: The Jesuit Contribution*, ed. Rudolf Wittkower and Irma B. Jaffe (New York, 1972), pp. 15–28.

27 *The Constitutions of the Society of Jesus and Their Complementary Norms, A Complete English Translation of the Official Latin Texts* (St. Louis, 1996), p. 258 (part VI, chapter 3, paragraph 586).

28 However, in 1568 Pope Pius V ordered the Jesuits to perform a modified Divine Office in a practice that only lasted five years. William V. Bangert, *A History of the Society of Jesus*, 2nd ed. (St. Louis, 1986), pp. 51–52.

29 Francesco Antonio Agnelli, *The Excellences of the Congregation of the Oratory of St Philip Neri*, trans. Frederick Ignatius Antrobus (London, 1881), p. 14. For the 'coretti', see Costanza Barbieri, Sofia Barchiesi, and Daniele Ferrara, *Santa Maria in Vallicella: Chiesa Nuova* (Rome, 1995), pp. 30, 52, 177, note 229.

30 Howard related the new architectural forms to mendicant reform. Deborah Howard, *Jacopo Sansovino: Architecture and Patronage in Renaissance Venice* (New Haven, CT and London, 1975), p. 67. See also Paola Modesti, "I cori nelle chiese veneziane e la visita apostolica del 1581. Il 'barco' di Santa Maria della Carità," *Arte Veneta* 59 (2002), pp. 39–65.

31 For Il Redentore, see Tracy E. Cooper, *Palladio's Venice: Architecture and Society in a Renaissance Republic* (New Haven, CT, 2005), pp. 229–57; Deborah Howard and Laura Moretti, *Sound and Space in Renaissance Venice: Architecture, Music, Acoustics* (New Haven, CT and London, 2009), pp. 117–27; Deborah Howard, "Venice between East and West: Marc'Antonio Barbaro and Palladio's Church of the Redentore," *Journal of the Society of Architectural Historians* 62, no. 3 (2003), pp. 306–25.

32 Palladio began work on the Cassinese church of San Giorgio Maggiore in 1565, but the perimeter of the church including a retrochoir was laid out in 1575; the fabric of the retrochoir was built in 1583–89, and carved walnut choir stalls installed in the 1590s. Cooper, *Palladio's Venice*, pp. 111–21. See also Andrea Guerra, "Croce della Salvezza. I benedettini e il progetto di Palladio per San Giorgio Maggiore a Venezia," in *Lo spazio e il culto: relazioni tra edificio ecclesiale e uso liturgico dal XV al XVI secolo*, ed. Jörg Stabenow, (Venice, 2006), pp. 353–83. For the older church, which featured a choir in the center of the nave, see Massimo Bisson, "San Giorgio Maggiore a Venezia: la chiesa tardo-medievale e il coro del 1550," *AFAT: Arte in Friuli Arte a Trieste* 33 (2014), pp. 11–38.

33 They included San Domenico Maggiore in 1562; San Giorgio Maggiore between 1560 and 1574; Santa Maria Maggiore by 1580; San Giovanni Maggiore in 1585, and Santa Restituta in 1591. Stefano D'Ovidio, "La trasformazione dello spazio liturgico nelle chiese medievali di Napoli durante il XVI secolo: alcuni casi di studio," in *Re-thinking, Re-making, Re-living Christian Origins*, ed. Serena Romano et al. (Rome, 2018), pp. 93–119.

34 "augumentare ne' popoli la devozione di quel santissimo Sagramento." Ibid., p. 98.

35 The chapter deliberations stated that changes would "ampliare et magnificare" the church, which would become "vacuum et expeditum" and "a lode e gloria di Dio onnipotente e a maggior comodo, tanto dei frati nella celebrazione degli uffizi liturgici, quanto dei molti fedeli di Cristo che in quella chiesa accorrono per ascoltare gli uffici divini, affinché vi si trattengano con maggior comodità." Ibid., p. 100.

36 For the dynamic simultaneity of social relations in space, see Doreen Massey, *Space, Place, and Gender* (Minneapolis, 1994), p. 3. For the relationship between architecture and time in the Italian Renaissance, see Marvin Trachtenberg, *Building-in-Time: From Giotto to Alberti and Modern Oblivion* (New Haven, CT and London, 2010).

Chapter 1

ACCESSING THE ITALIAN CHURCH INTERIOR

T HE MEDIEVAL CHURCH INTERIOR provides the setting for many surprising events in Boccaccio's *Decameron* (c. 1350), a compendium of one hundred short stories told by a group of friends who escaped plague-ridden Florence. In one tale, a young man pretends to be paralyzed to get a closer look at some saint's relics, while in another, a jealous husband dresses up as a priest to hear his wife's scandalous confession. A rather more quotidian incident in the frame story of the book also takes place in church:

> In the venerable church of Santa Maria Novella, one Tuesday morning when there was practically no one else about, seven young ladies, all dressed in the dark clothing which the times demanded, had just heard the Divine Office. . . . Having come together, not by prior arrangement, but simply by chance, in one corner of the church, they sat down in a rough circle, sighed a few times, left off saying their paternosters, and began to discuss the state of things. . . . While this discussion was taking place, three men came into the church . . . trying to find their loved ones, all three of whom happened to be among the seven ladies I have mentioned.[1]

Boccaccio's evocative description shows that churches in the medieval and early modern periods were not just sites for liturgical practice and contemplative devotion. Laywomen could enter the church, hear the Divine Office, stay a while after it was concluded, and even converse with laymen. As one of the few sites where all members of society (lay and religious, men and women) could interact, churches were dynamic spaces of movement and social interaction,

where sights and sounds – the spoken word, liturgical chant, or bawdy misbehavior – played a significant part. As a venue for covert assignations, legal meetings, and even social entertainment, the church interior was at the center of social and religious life.[2]

The articulation of this sacred space – its divisions, restrictions, and hierarchies – shaped participation in the liturgy, affected the viewing of religious art, and impacted social encounters. But how were these spaces originally arranged and who had access to them? Who determined their layouts and instigated alterations? How were art, architecture, and furnishings used in the context of liturgical space?

This chapter will analyze the function, development, and material components of some of the most important aspects of the Italian church interior – nave choir precincts and screens – and will interrogate the accessibility of those spaces for the clergy, laymen, and laywomen. Reconstructing the material, spatial, and functional dimensions of the church interior is vital to understand how and why these spaces were transformed so dramatically, particularly in late sixteenth-century Florence.

CHOIR PRECINCTS AND SCREENS

Although multiple diverse arrangements existed, the medieval church was frequently divided, to a greater or lesser extent, into three main zones: the high altar area or presbytery reserved for priests; the choir, a restricted area of permanent seating for members of the officiating religious community (monks, friars, canons, etc.); and the remaining space in the nave, which was variably accessible to laymen and laywomen.[3] Between these last two zones, an architectural screen, either integral or separated from the choir precinct, served to define this spatial layout.

Choir Precincts

Before later alterations, choir stalls in the churches of Renaissance Italy were customarily located in the upper nave (the nave bays closest to the high altar) and disposed in a U-shaped formation with an entrance toward the main portal of the church (see Figures 11 and 12).[4] The precise location for such precincts, which were often physically distinct from the monumental screen, was frequently determined at the outset of the church's construction, and signaled by changes in floor elevation or differing nave pier design.[5] Larger windows, proximity to side doors, and high stone vaulting could also indicate the location of a choir precinct with its accompanying screen.[6]

The internal arrangement of the choir precinct itself articulated the hierarchical strata of the religious community and regulated movement in and out of the area. A door or double doors provided an entrance to the precinct from the nave, and entrance stalls, reserved for the most senior members of the religious community, were situated to either side of this opening, frequently differentiated through distinctive iconography, technique, or architectural structure. Choir stalls were ergonomically designed for the two positions of standing and sitting, enabling the occupant to rest their arms in both attitudes. Their high stall-backs and canopies protected their occupants from drafts and aided with acoustics. Italian stalls generally lacked misericords, the projecting brackets on the undersides of the hinged seats that allowed occupants to rest during long services while giving the impression they were standing.[7] In the center of the choir, a large communal lectern – which facilitated group singing from large musical manuscripts – often incorporated a cupboard for the storage of manuscripts (Figure 13). Mendicant choirs featured a conventual altar for the use of the friars, although evidence for these

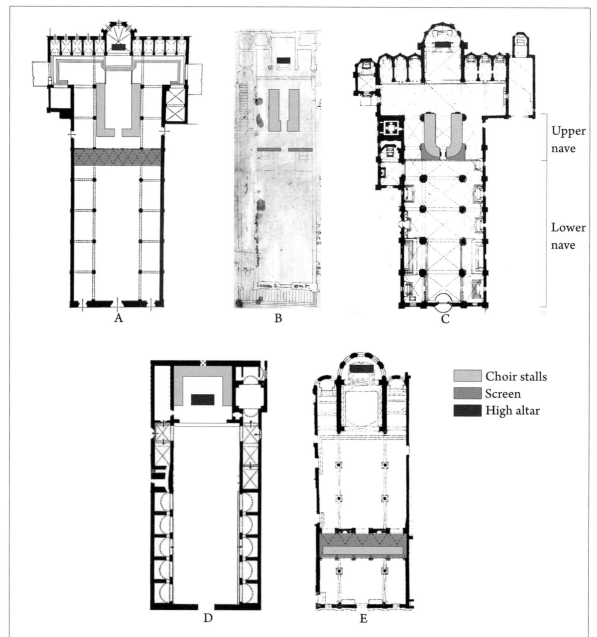

A Santa Croce, Florence: vaulted tramezzo; nave choir precinct. Modified after reconstruction by Hall

B San Francesco, Arezzo: wall tramezzo, attached screen chapels; nave choir precinct. Adapted from archival drawing.

C Santa Maria Gloriosa dei Frari, Venice. Nave choir precinct; integral marble screen. Extant arrangement.

D San Salvatore al Monte, Florence: retrochoir. Extant arrangement.

E San Michele in Isola, Venice: barco (stalls are above ground level on barco). Extant arrangement.

Figure 11 Diagram indicating common spatial arrangements in Italian churches. Image: author

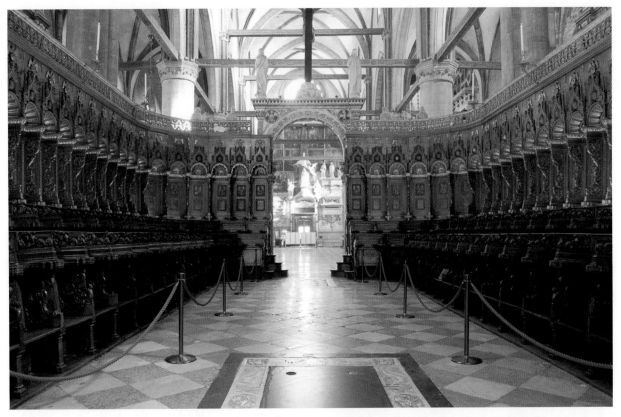

Figure 12 Marco Cozzi and workshop, *Choir stalls*, 1468, Santa Maria Gloriosa dei Frari, Venice. Interior view facing northeast. Photo: author

is often lacking (see Chapter 3 for the friars' altar in Santa Maria del Carmine).[8]

Italian choir stalls, particularly from northern Italy, are among the most complex and elaborate micro-architectural wooden ensembles to have survived from the late medieval and Renaissance periods. In the absence of physical or textual evidence, early medieval choir seating cannot be described with certainty, but simple wooden benches were likely used. In the Trecento, Gothic tracery and carving dominated choir stall production, and in the following century, the popularity of intarsia panels intensified alongside the continued presence of the micro-architectural Gothic style. The technique of intarsia, also known as marquetry or wood inlay, involved transferring cartoon drawings onto pieces of matrix wood, usually walnut, sections of which were then excavated to receive shaped

tesserae of different-colored woods from dozens of available varieties.[9] In the fifteenth century, inlaid panels drew upon a broad iconographical spectrum including geometrical decoration, cityscapes and landscapes, figures of saints or personifications, and open cupboards containing liturgical, scientific, or mathematical objects and musical instruments. The earliest extant intarsia panels portraying illusionistic, perspectival images of liturgical cupboards were produced between 1436 and 1445 for the Sacrestia delle Messe in Florence Cathedral, which used this new technique of inlaid wood to create effects of light and space.[10] In the sixteenth century, following the development of a virtuoso and painterly intarsia technique, relief carving returned to prominence. In Florence, despite the documented presence of numerous intarsia workshops, few complete Renaissance choir

Figure 13 Lectern, Santa Maria in Organo, Verona. Photo: author

ensembles survive, but some examples exist in San Miniato al Monte, Vallombrosa Abbey (stalls from San Pancrazio), and Santa Maria Novella.[11]

As expensive, highly prized objects that generally cost significantly more than painted altarpieces, choir stalls could be funded by the religious community as a whole, an individual ecclesiastical patron, or sometimes a lay patron or civic body.[12] In Florence, we will see lay patronage in Santa Trinita and San Lorenzo, civic corporate patronage in San Pancrazio, and communal religious patronage in many contexts, including San Pier Maggiore and Santissima Annunziata. In written contracts, craftsmen were often instructed to imitate features of an existing choir, which might be in a church of a different religious order or in a neighboring city.[13]

Choir stall precincts functioned as a dignified and regimented setting for the communal performance of liturgy, in particular the Divine Office. Liturgical guidelines specified the proper behavior to observe while occupying the choir precinct during worship. In the Benedictine context, hierarchy among the monks was expressed by the designated order of seating in the choir, but any transgressions would result in them not being allowed to occupy their regular stall.[14] The Franciscan Ordinal explained that the psalter was sung antiphonally (in which verses were sung alternately by the two sides of the choir), and friars were permitted to "stand and sit alternately."[15] When singing chants in this way – "one choir against another" – the friars were required to face the opposite side of the choir, demonstrating the functional value of the two opposing ranges.[16] Similarly, Dominicans were obliged to stand only while singing, since their Constitution reads, "at the first psalm let one choir sit [and] at the second stand and similarly let the other choir sit."[17] From an acoustical perspective, sung plainchant would have sounded most resonant and comprehensible to the occupants of the nave choir precinct itself (rather than those in the nave), which acted almost as a "church-within-a-church."[18]

Although the choir precinct was intended to function as a solemn space, this was not always the case. The Dominican ceremonial listed misdemeanors to be avoided in the choir, which included singing or reading badly, gazing around, or laughing.[19] The Dominican choir precinct was also the setting for communal discipline. Following Compline, friars would solemnly process in the nave singing the antiphon *Salve Regina*, bowing their heads while passing under the crucifix on the screen, and either within the choir or before the cross, their bare backs would be scourged in memory of St. Dominic's nightly self-discipline.[20]

Screens

Separating choir precincts from the lower nave, monumental screens dominated the interiors of medieval churches across Europe. In English, the term *rood screen* derived from the rood, an image of the Crucifixion in painted or sculpted form elevated above the screen. The French *jubé* and German *Lettner*, meanwhile, derive from the function of screens as the platform for the reading of scripture, while in Spanish the *trascoro* implies liturgical movement.[21] Ambiguity surrounding the form and function of church screens in Italy, meanwhile, has contributed to a lexicographical inconsistency surrounding their description. Primary sources from across Italy frequently used the generic term *coro* or *choro*, which could define the screen, the wooden seating, or the entire choir area. More specific terms referenced either the screen's location in the center of the church (*intermedium, tramezzo*) or its architectural form, which could be reminiscent of a bridge (*ponte, pontile*), corridor (*corridore*), wall (*muro, murricciolo*), door (*ostium*), or platform (*palco, pulpitum, podium*).[22] Given this wide variety, and the difficulties of precise interpretation, I will use the simple terms *tramezzo* or *screen*.

Church screens have ancient origins. While sporadic evidence shows that enclosed seating areas existed in front of the altar in churches in early Christian Syria, Spain, and North Africa,[23] the early Christian so-called *schola cantorum*, a site for the sung recitation of Divine Office, represented a decisive development.[24] In the *schola cantorum*, two rows of seats were arranged perpendicularly in front of the altar, forming a rectangular precinct surrounded by low walls with an entrance in the direction of the nave.[25] Elaine De Benedictis showed that later twelfth- and thirteenth-century Roman *schola cantorum* were more monumental, taller, and wider in disposition,

and incorporated both an ambo and a pulpit (Figure 14).[26]

In medieval Italy, some early screens relied on Byzantine prototypes. In the Abbey of Montecassino, the influence of Byzantine iconostases (chancel screens decorated with painted icons) could be observed in an eleventh-century choir screen that supported pendant icons, including a bronze beam manufactured in Constantinople.[27] Torcello Cathedral boasts an extant eleventh-century marble screen composed of a parapet of carved rectangular panels with a processional opening in the center, and six columns that support a wooden architrave, a structure associated with the colonnaded wall enclosures (templon) common in Byzantine churches (Figure 15).[28] A Byzantine-inspired structure was built in Venice as late as the fourteenth century. Completed by Jacobello and Pierpaolo dalle Masegne in 1395, the screen in the ducal chapel of San Marco was among the first to incorporate freestanding figures atop an architrave and an inscription recording the name of the doge, the artists, and the procurators who acted as patrons (Figure 16).[29]

In twelfth- and thirteenth-century Romanesque churches, distinctive structures that combined screens and raised presbyteries elevated above a change in floor level associated with a hall crypt were known as *pontili*, and can be seen in Modena Cathedral (Figure 17) and San Miniato in Florence (Figure 18).[30] Across Europe, many forms of monumental Gothic screens proliferated in churches of all types after c. 1200, and, as Jacqueline Jung suggests, they were perhaps heavily influenced by the Fourth Lateran Council of 1215, which sought to integrate the laity more fully into the life of the church and to intensify the Eucharistic cult via its affirmation of the dogma of transubstantiation.[31] The earliest monumental vaulted tramezzi in Italy also date from this early period. The oldest monumental Italian tramezzo to have survived is in the Cistercian Abbey

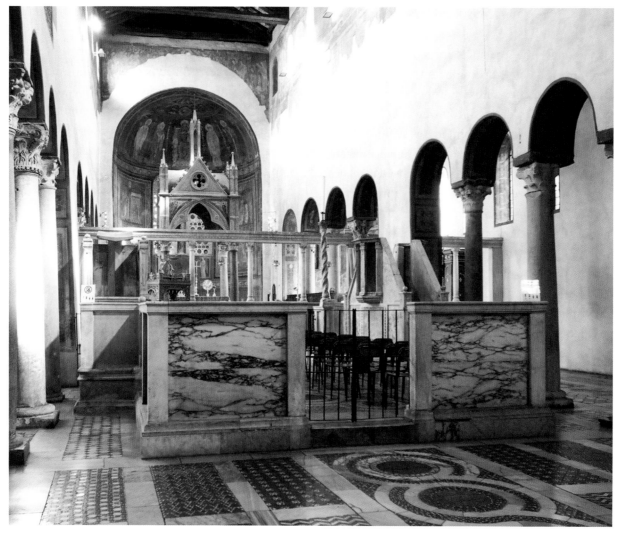

Figure 14 Santa Maria in Cosmedin, Rome. View of the twelfth-century *schola cantorum* (reconstructed in the nineteenth century) in the nave facing southeast. Photo: author

church of Vezzolano, to the east of Turin, dated by an inscription on its facade to 1189 (Figure 19).[32] Derived from French exempla, the five Gothic arches of the masonry screen enclose a shallow vaulted space extending the entire width of the nave with room for two altars beneath, while above, sculpted reliefs depict Old Testament patriarchs, the four Evangelists, and the life of the Virgin Mary. Liturgical furnishings in the Benedictine church of Sant'Andrea in Flumine at Ponzano Romano in northern Lazio reveal how medieval screens could be integrated into much older settings (Figure 20). Donal Cooper showed that a mid-

twelfth-century *schola cantorum* in the nave was reduced in size to accommodate the surviving triple-arched vaulted screen, dated c. 1300.[33] This must have been similar to an earlier, possibly eleventh-century, tramezzo in the Abbey of Pomposa, the three vaults of which were memorialized on a sixteenth-century schematic ground plan.[34]

Some screens took the form of simple transverse walls constructed in brick or wood. In the regular canons' church of San Vittore in the outskirts of Bologna, a high brick screen, variously dated to the twelfth or thirteenth centuries and pierced with a central door and

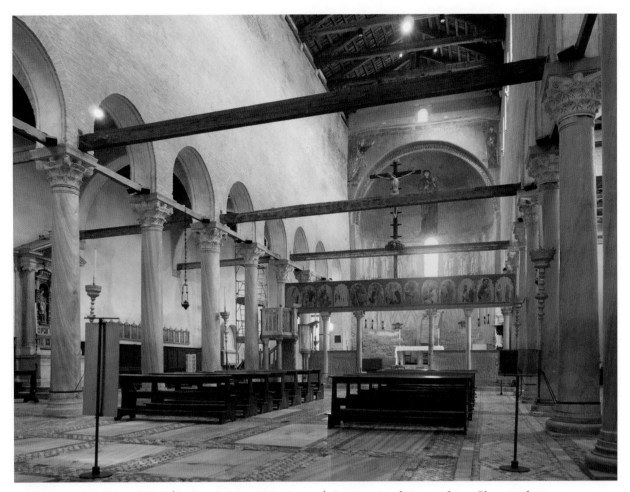

Figure 15 Torcello Cathedral (Basilica di Santa Maria Assunta). Interior view facing southeast. Photo: author

an open colonnade of round arches and colon-
ettes, dominates the diminutive single-aisle nave
(Figure 21).[35] The canons' and nuns' church of
Santa Maria del Gradaro in Mantua, built in the
late thirteenth century, was equipped with a
simple tramezzo wall that crossed the three-
aisled nave at the point where cylindrical piers
in the lower nave became cruciform piers in the
canons' choir.[36] Remarkably, the lower sections
of this tramezzo survived a mid-twentieth-cen-
tury restoration and are currently used to store
hymnals (Figure 22). The fictive white textile
hangings preserved on these fragments suggest
that the screen's upper sections might have fea-
tured figural iconography that perhaps indicates a
more widespread decorative practice.

While sporadic evidence for screens from the
eleventh to the thirteenth centuries places them
mainly in the monastic and collegiate contexts,
particularly in northern Italy, the rapid develop-
ment of the mendicant orders demanded screen
production on a new scale.[37] In 1249, the General
Chapter of the Dominican Order specified that
local priors should construct screens ("inter-
media") so that friars could not see or be seen
by the laity as they entered or left the choir.[38]
Interrupting the expansive spaces of the large
churches of the major Italian cities, mendicant
screens could be complex vaulted structures
comprising attached chapels, painted decoration,
tombs, pulpits, and platforms. The only surviving
medieval example is from the extreme north of

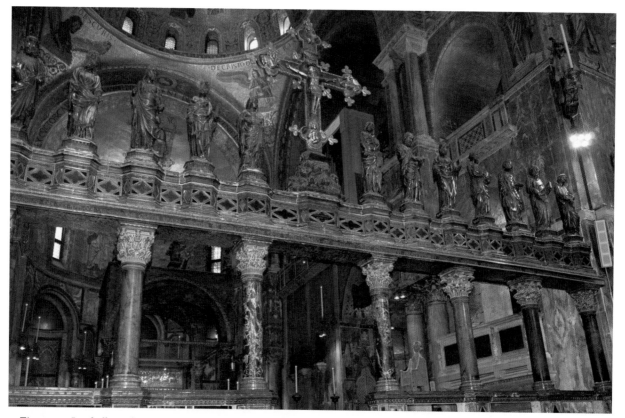

Figure 16 Jacobello and Pierpaolo dalle Masegne, *Screen*, San Marco, Venice, 1395. Interior view facing east. Photo: author

the country, in Bolzano. Dating to c. 1330, the tramezzo in San Domenico is a deep monumental structure comprising five arches and four chapels with fragmentary painted remains (Figure 23).[39] Meanwhile, in smaller mendicant churches, simple wall-like structures divided the nave, as seen in a mid-fourteenth-century parchment plan for San Francesco in Arezzo, which could represent a standard format (Figure 24).[40]

The present state of research only provides limited information about the screens that once occupied Italian churches.[41] Nonetheless, scholars including Joanna Cannon, Donal Cooper, Andrea De Marchi, Tiziana Franco, Michael Gromotka, Monica Merotto Ghedini, Giovanna Valenzano, and others, have reconstructed numerous lost tramezzi, especially in churches of the mendicant orders, in Tuscany, Umbria, Emilia Romagna, Lombardy, and the Veneto.

In Tuscany, besides Florence, screens have so far been noted in Pisa,[42] Pistoia,[43] Fiesole,[44] and Arezzo.[45] In Umbria, screens existed in Perugia[46] and in the Lower Church of San Francesco in Assisi.[47] In Emilia Romagna, tramezzi have been identified in Piacenza, Rimini, and in several mendicant churches in Bologna.[48] Notably, in the Augustinian church of San Giacomo Maggiore in Bologna, the so-called *corridore* from the first half of the fourteenth century had five bays, chapels, and an upper walkway that could be traversed.[49] In Lombardy, tramezzi were known to have been constructed in mendicant churches in Milan, Pavia, Brescia, and Mantua.[50] Particularly early for a Dominican church, the 1239 tramezzo in Sant'Eustorgio in Milan featured chapels and a pulpit, and was sited at a change in architectural pier design.[51] In the Veneto, tramezzi existed in Bassano,[52] Treviso,[53] Verona,[54] Vicenza,[55] Padua,[56] and

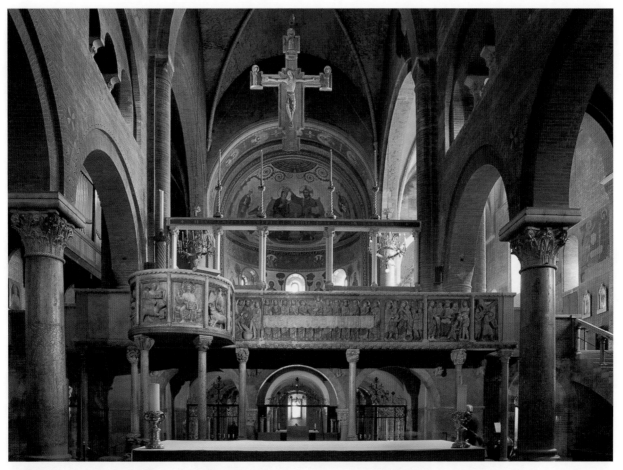

Figure 17 Modena Cathedral. Interior view toward southeast, showing *pontile* after twentieth-century reconstruction. Photo: author

Venice.[57] Detailed reconstructions have been proposed for monumental fourteenth-century tramezzi that featured multiple bays and chapels in the Dominican churches of Sant'Anastasia in Verona,[58] Santi Giovanni e Paolo in Venice,[59] and Sant'Agostino in Padua.[60] Screens were also constructed in the Veneto in the fifteenth century, including at the Santo in Padua, and Santo Stefano, San Francesco della Vigna, the Frari, and Santa Maria dei Servi in Venice, where a late fifteenth-century three-arched marble screen had two chapels embellished with bronze reliefs by Andrea Riccio.[61] Beyond these regions, tramezzi have also been noted, inter alia, in Rome, Genoa, Savona, and Udine.[62] Reflecting a general dearth of modern art-historical scholarship on southern Italy, little is known about church

screens in this area except for those in the city of Naples.[63]

The best preserved mendicant screen exists at Santa Maria Gloriosa dei Frari in Venice, completed by the workshop of Pietro Lombardo and dated by an inscription along its facade to 1475 (Figure 25).[64] In part inspired by the colonnaded screen in San Marco in Venice, the Frari structure physically adjoins the three sides of the choir precinct in the central nave, where a rise in floor level, a common indicator of choir location, reinforced the transition to a more elevated spiritual zone. Hall interpreted such fifteenth-century integrations of rood screens and choir enclosures in the central nave as compromises between the desire for segregating social groups and the contemporary taste for

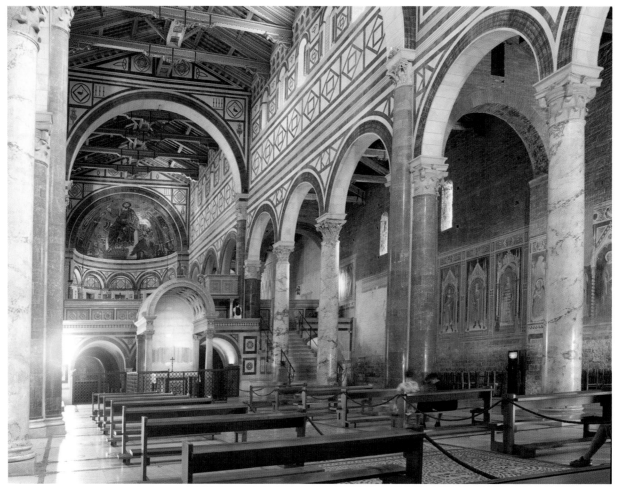

Figure 18 San Miniato al Monte, Florence. Interior view facing southeast. Photo: author

open, uninterrupted spaces.[65] This partially gilded marble ensemble comprises half-length portraits of Old Testament prophets, images of the Doctors of the Church and the patron Giacomo Morosini, two integrated pulpits, an architrave inscription, freestanding statues of apostles and Franciscan saints, and a triumphal arch entrance surmounted by a crucifix – sometimes attributed to Verrocchio – and two statues of Mary and John the Evangelist (Figure 26).[66] The elaborate and highly worked Frari screen demonstrates how tramezzi could act as significant components of the church interior in terms of materiality, iconography, spatial dynamics, and framing.

Also in the Veneto, the *barco* or *coro pensile* housed choir stalls atop a vaulted, raised balcony supported by columns at the nave floor level attached to the counter-facade or in the center of the nave. While sharing some formal similarities with tramezzi, *barchi* did not segregate social groups in the nave, but instead elevated the choir stalls, removing them completely from lay access (see plan on Figure 11). Surviving examples exist in San Michele in Isola (Figure 27), San Rocco in Vicenza, and several nuns' churches, and were also known to have existed in churches administered by the male communities of Santa Maria della Carità and Santa Lucia, both in Venice.[67] Another discrete genre of tramezzi with many

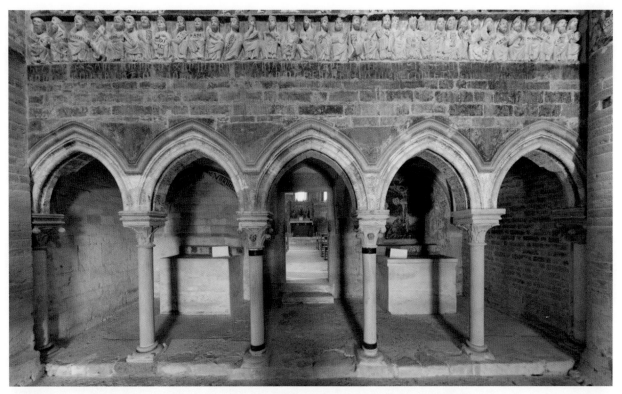

Figure 19 Vezzolano Abbey. View of the screen in the nave facing northeast. Photo: Elio Pallard

Figure 20 Sant'Andrea in Flumine, Ponzano Romano. View of the screen in the nave facing northeast. Photo: Michael G. Gromotka

Figure 21 San Vittore, Bologna. View of the screen in the nave facing east following renovation in 1941 and installation of detached frescoes in 2000. Photo: author

Figure 22 Santa Maria del Gradaro, Mantua. Interior view of the nave facing east showing remains of the brick screen. Photo: author

surviving exempla emerged in Franciscan Observant churches in Lombardy in the late fifteenth century (Figure 28).[68] These screens extend to the full height of the nave and are covered in frescoes that depict the Passion of Christ in multiple scenes. The high quality of these useful preaching aids may have been a factor in their survival.[69]

Besides the mendicant context, monumental screens also divided the interiors of cathedrals, and collegiate and parish churches.[70] Despite the differing liturgical needs of secular clergy, it appears that sacred space in the parish church was segregated, although more research on functionality and screen typology is needed.[71] Franco demonstrated that restrained tramezzi – often low walls of brick or wood – existed in parish churches

and rural *pieve*, debating whether such dividing structures separated laymen from laywomen, or laity from religious.[72] In Venice, Paola Modesti showed that parish churches, the majority of which were collegiate, could either have a raised *coro pensile* or a nave choir precinct in front of the high altar, sometimes enclosed by a screen.[73] Showing the ubiquity of screens in the parish context, in Book XI of his Treatise on Architecture, fifteenth-century architect Filarete described a screen in the middle of a hypothetical parish church:

I divide the middle of the church with columns across its width as with a portico. I make five arches so that one will lead to the high altar and the other two on each side will lead to two altars. Above it

Figure 23 San Domenico, Bolzano. View of the screen in the nave facing south. Photo: Buchhändler

there will be, so to speak, a passage and here there will be a pulpit for chanting the gospel.[74]

My own examination will demonstrate that Florentine parish churches, most notably the collegiate San Niccolò Oltrarno, were indeed subdivided by screens, and even the civic oratory of Orsanmichele was partitioned by an ironwork structure.

On occasion, the physical remains of screens were transferred elsewhere in the church interior, providing tantalizing glimpses of their rich materiality. In San Pietro in Perugia, Vallombrosa Abbey, and perhaps also in Santa Chiara in Naples, stone screens were mounted onto the counter-facade of the church where their scale perfectly fit the dimensions of the central nave.[75] In San Francesco della Vigna in

Figure 24 Fra Giovanni da Pistoia (?), *Project for, or Plan of, San Francesco in Arezzo*, mid-fourteenth century. Pen and ink on parchment. Archivio Capitolare, Arezzo (Carte di varie provenienza, N.873). Photo: Archivio Capitolare, Arezzo

Venice, marble relief sculptures dating to the 1490s and depicting prophets and narrative scenes from the life of Christ, now in the Badoer-Giustiniani Chapel in the church, probably formed part of a nave screen or a *barco* (Figure 29).[76] Few Italian choir enclosures provide such a rich inventory of surviving figural and relief sculpture as that of the Santo in Padua, which Sarah Blake McHam has interpreted in the light of fifteenth-century debates over the Immaculate Conception.[77]

Because of limited physical evidence, developing a definitive chronology of screen development and matching typologies with regions or religious affiliations is both challenging and potentially limiting. Even the reconstructions of the two most well-known mendicant screens, in Santa Maria Novella and Santa Croce, are the subjects of continuing scholarly debate (see Chapter 3). A major persistent challenge is determining the precise ground plans of screens, and whether they were physically separated from the choir precinct or were attached to the stalls as in the Frari in Venice. In several Florentine cases, it has been difficult to determine solely from archival sources (which often employ the vague term *coro* or *choro*) whether a screen existed, whether it traversed the entire width of the nave, and whether it was independent or essentially a revetment to the stalls. That being said, the emerging overall picture is one of variety and diversity. As significant components of material culture, tramezzi could variously incorporate architectural, sculptural, and pictorial features, which created dynamic visual and spatial interactions within the broader setting of the Italian church interior.

THE FUNCTIONS OF SCREENS

In essence, tramezzi were used to create quiet, warm, and sheltered choir areas for

Figure 25 Titian, *Assunta*, 1516–18, oil on wood, 690 × 360 cm, Santa Maria Gloriosa dei Frari, Venice. View through marble screen (1475) from center of third nave bay. Photo: author

Figure 26 *Crucifix*, c. 1475, choir screen, Santa Maria Gloriosa dei Frari, Venice. Photo: author

communities of monks, friars, or priests to perform and attend religious rituals away from the distracting influence of the laity. Indeed, the earliest recorded testimony relating to their function stated that screens were designed to impede the reciprocal vision of both the clergy and the laity.[78] The separation of laity away from the clergy, and especially from the high altar, was designed to serve the spiritual benefit of the religious more than that of the laity themselves.[79] As Jung and others have noted, choir enclosures restricted access to reserved, hierarchically more elevated spaces, thereby obscuring and potentially further mystifying the liturgical acts performed by the clergy.[80] Visual signifiers could reinforce the separation of social groups in the nave.[81] Old Testament and Passion iconography on tramezzi reflected the themes of transition, passage, and new life, embodied by the symbolic movement through the screen toward the high altar. For

Figure 27 San Michele in Isola, Venice. View of *barco* facing southeast. Photo: author

example, images of Dominican friars on or near the lost screen of Sant'Eustorgio in Milan accompanied the movement from lay to conventual space, emphasizing the kinetic shift between communities and audiences.[82] In the mendicant and monastic contexts, access to conventual spaces like cloisters, sacristies, and chapter houses was frequently located on the friar's side of the tramezzo, which allowed friars or monks to move between these spaces out of the view of the laity.

Almost granting the laity their own church in the lower nave (sometimes described as the *ecclesia laicorum*),[83] the screen approximated a separate interior facade. Indeed, the eighteenth-century chronicler Settimanni included in his Florentine chronicle a sixteenth-century source

that described screens as sites "where many devoted people would withdraw to pray," showing their central role in the lives of the laity.[84] Saints' shrines, which were specially targeted toward lay devotion, were frequently sited on the lay side of the screen. For example, the successive resting places of St. Dominic in Bologna were on the lay side of the tramezzi, as was the shrine of St. Peter Martyr in Milan.[85] In the Lower Church of San Francesco in Assisi, a marble tramezzo was dismantled after only half a century of use in order to facilitate pilgrims' access to the tomb of St. Francis.[86] In the Dominican church of Santa Corona in Vicenza, the tramezzo itself may have been the location of the shrine of the Blessed Bartolomeo da

Figure 28 Santa Maria delle Grazie, Varallo. View of screen facing west. Photo: Mattana

Breganze.[87] Other notable Florentine shrines, however, such as those for St. Antoninus in San Marco and the Blessed Andrea Corsini in the Carmine (two venerated bishops interred in mendicant spaces), were situated beyond nave tramezzi, but were still accessible to laywomen, showing the flexibility of screens in dividing social groups.[88]

Screens provided physical means to facilitate liturgical processions and performances, and their upper platforms often incorporated stairs, walkways, and stages for religious drama. The walkway at the top of the screen was used for the public reading of scripture, and crucially, was the only site in the church interior where both congregations – lay and religious – could be addressed at the same time. Indeed, Pope Martin V gave his papal benediction from the top of the Santa Maria Novella screen, where he could address as many faithful believers as

Figure 29 Prophet reliefs, 1490s, marble. San Francesco della Vigna, Venice, Badoer-Giustiniani Chapel. Photo: author

possible.[89] The Bolognese term sometimes used for screens, *corridore*, implies a connecting route, and screens certainly provided additional access throughout the upper reaches of the building, sometimes acting literally as a "bridge" (*ponte*) across the church. Traces of graffiti on the spandrels of the main nave arcade of Pomposa Abbey, which could only have been written by those accessing the upper level of the lost tramezzo, indicate the frequent use of these high walkways.[90] Chapter 4 will show how the screen in Santa Maria del Carmine in Florence was connected to spaces in the nave roof, enabling the lay confraternity of Sant'Agnese to set up the staging for religious drama events, known as the *sacre rappresentazioni*, an important function of screens in Florence in particular.

As Jung has demonstrated for northern Europe, screens could orchestrate complex visual effects through framing, concealing, and unveiling sacred mysteries and images.[91] Doors and apertures in the screen could provide the laity with "telescopic" views of the elevation of the Host, a ritual of intense sacramental efficacy accompanied by other sensory indications such as the ringing of bells. Codified by theologians in the twelfth and thirteenth centuries, this ritual was given added weight following the confirmation of the doctrine of transubstantiation at the Fourth Lateran Council.[92] The doors or gates, some of which survive and some of which are known from mentions in archival sources (see Chapter 4), added a crucial kinetic and versatile element to the static masonry of the screen.[93]

Figure 30 Marble panels on north wall of high chapel, San Giovanni in Bragora, Venice. Photo: author

Showing the potential benefits of the controlled viewpoints created by screens, the surviving arched choir entrance in the Frari in Venice was reconceived as a frame for Titian's *Assunta* high altarpiece when it was installed over forty years later.[94] As one approaches the altar from the main portal of the church, the painting is framed by the marble arch of the screen, but from the middle of the third nave bay, in correspondence with the side door, the entablature of the screen aligns with a cornice on the altarpiece frame, implying an ideal viewing position (Figure 25).[95] Scattered evidence suggests that in other contexts screens had crucial roles in the visual frameworks of the

church interior. For example, Peter Humfrey has shown that the marble choir screen and altarpiece frame visually complemented Cima's *Baptism of Christ* in San Giovanni in Bragora in Venice. There the surviving pink and blue tinged marble panels of the parapet-style screen echoed the color scheme of the high altarpiece (Figure 30).[96]

Screens and their accompanying nave choirs, therefore, were devices which performed a variety of practical, metaphorical, and visual functions in the church interior.[97] While ostensibly designed to segregate social groups, they performed more subtle and even contradictory functions. Moreover, in her studies on northern

European choir screens, Jung argued for a reinterpretation of screens as sites of interaction, permeable thresholds, and bridges between distinct spatial zones.[98] In the Florentine case studies, we shall witness numerous examples that attest to this fluid approach to the divisions of sacred space.

Screen Accoutrements

The most fundamental object associated with the screen was the rood itself: an image of the Crucifixion in painted or sculpted form.[99] Durandus of Mende, the thirteenth-century French bishop and liturgist, noted that frequently "a triumphal cross is placed in the middle of the church to denote that we love our Redeemer from the depth of our heart."[100] In Florence, the fifteenth-century Archbishop Antoninus commanded that a crucifix should be set up in the center of the church "so that almost all may see it," and be inspired to contemplate and imitate Christ, who also stood "in medio": in the midst of humanity.[101] Robert Gaston noted that these images of the crucified Christ on or around screens were of such a monumental scale because they were intended to be seen from afar.[102] Bruzelius called these crucifixes "a transactional medium" that forged for the laity a powerful connection along the central axis of the church leading toward the site of the Eucharist.[103] The suspended crucifix could also act as an allegory of the real presence of Christ in the transubstantiated Host, an object that was restricted and controlled but viewed by the faithful during the elevation in so-called "ocular communion."[104]

Carved or painted crucifixes could be mounted on the screen itself (Figure 26), which often required the use of chains and wooden frameworks to achieve a forward tilt, as witnessed by the Assisi *Crib at Greccio* fresco. As we shall see in Chapter 5, the Del Tasso woodworkers

were instructed to make "above the aforesaid arch [of the choir screen] a crucifix of wood" in San Pancrazio in Florence in the 1490s.[105] Alternatively, roods could be erected on large horizontal wooden beams, located "in medio ecclesie" (in the middle of the church), in the apse, or in both locations, which scholars have argued were often accompanied by two flanking panel paintings.[106] In this case they could be suspended high above the nave via chains and ropes that attached to iron rings on the ceiling.[107] Depicting this type of arrangement, the Assisi fresco of the *Verification of the Stigmata* (Figure 31) paralleled an actual beam in the nave of the Upper Church that supported Giunta Pisano's *Cross for Brother Elias* (1236).[108] Crucifix images could be illuminated by oil lamps, and covered or draped by textiles (see the carved crucifix framed by a white cloth in the background of Butteri's fresco of the *Recognition of the Relics of San Giovanni Gualberto* in the Abbey of San Michele Arcangelo in Passignano, Figure 32).[109] In terms of documented altar dedications to the rood, however, whereas in the northern European context screen chapels dedicated to the Holy Cross were specifically designated for distribution of communion to the laity, it is unclear whether this practice was observed in Florence and Italy more generally.[110]

The perceived spiritual power of the crucifix image was demonstrated by numerous miracles and hagiographic topoi. Donal Cooper noted that monumental crosses were attributed with the ability to enact numerous types of miracles, including speaking, moving, and causing viewers to spontaneously heal, or have ecstasies.[111] Famously, while praying before the crucifix in San Damiano in Assisi, St. Francis heard the divine injunction to repair the Church, which was falling into ruin. In Florence, a crucifix suspended via chains in the middle of the church ("mezo della chiesa") of San Miniato al Monte

Figure 31 *Verification of the Stigmata*, c. 1290–96, fresco, 270 × 230 cm, Upper Church, Basilica di San Francesco, Assisi. Photo: © Photographic Archives of the Sacred Convent of the Basilica of St. Francis in Assisi, Italy

tapped the Vallombrosan founder San Giovanni Gualberto on the head, which prompted him to request entry into the monastic community.[112] In another miraculous conversion narrative, the Piovano Arlotto recounted that when a lay converso was kneeling before the crucifix in an observant monastic church in Florence, the chains of the crucifix snapped, injuring the young

man's head, lower back, and arm.[113] The area in front of the screen particularly benefited from its proximity to the sacrally potent crucifix.[114] Thus, screens became coveted burial sites, for both lay and religious, with tombs proliferating both on and around the screen. For example, Hall used the recorded location of numerous floor tombs to reconstruct the Santa Maria Novella *ponte*, and

Figure 32 Giovanni Maria Butteri, *Recognition of the Relics of San Giovanni Gualberto*, detail, 1580–81, fresco on west wall of northeast transept, Abbey of San Michele Arcangelo, Passignano. Photo: Sailko/Francesco Bini

in San Marco in Florence, the communal tomb of the friars was sited before the entrance to the choir.[115]

Pulpits for reading or preaching could sometimes form part of the permanent architectural structure of the screen.[116] The Gospel was ritually recited from the left side of the screen when facing the high altar ("in cornu evangelii") and the Epistle, a reading of lesser liturgical importance, from the right ("in cornu epistolae"). Double pulpits fulfilling these functions are preserved as part of the extant marble screen in the Frari in Venice.[117] As we shall see, the commissioning of pulpits shortly after the dismantling of certain screens strongly suggests that they were originally equipped with pulpit facilities. Organs, which were frequently commissioned in pairs, were also generally located near the choir, either on a side wall or wall of a choir precinct, between nave piers at the height of choir stalls, on a choir

precinct perimeter wall, or on the tramezzo.[118] This placement facilitated the main function of organs at least up to the late sixteenth century, which was to alternate lines of musical chant with singers in choir.[119]

Chapels and altars, frequently constructed on the facade, reverse, or upper reaches of Italian tramezzi, created visually prominent sites of religious devotion now entirely lost. Situated in close proximity to the efficacious prayers of the religious community, the area around the choir was a privileged space for lay patrons.[120] Indeed, the vast majority of screen altars in Florence were sponsored by the laity and dedicated to a wide range of saints and angels, but as we shall see, in individual cases, it has been difficult to determine the relative control of laity and clergy on the selection of specific tituli.[121] In some cases, such as in the Carmine, Santa Maria Novella, and San Marco, the dedication of screen chapels to new mendicant saints publicly promoted these cults and situated them in a more established devotional context.

Screens and Paintings

Tramezzi significantly affected the viewing, framing, and display of painted imagery in the church interior. Screens could be densely packed with panel paintings or altarpieces, restrict sightlines toward important images beyond the screen, condition the arrangement of nave mural paintings, or guide attention toward wall paintings throughout the church, creating distinct and directed viewing experiences for both the laity and clergy.[122]

Integrated altarpiece schemes show that tramezzi could function within broader spatial frameworks, the screen itself acting as an iconographical sign of transition (Donal Cooper's "coordinated iconographical displays").[123] Now completely lost or decontextualized in art

museums, the altarpieces, furnishings, and iron-work grilles that once adorned these altars were conspicuous statements of material culture. For example, Perugino's screen altarpieces depicting the *Agony in the Garden* and the *Pietà* for the Jesuati church of San Giusto in Florence, together with a sculpted Crucifixion scene by Benedetto da Maiano above the screen door, would have formed a powerfully didactic Passion narrative.[124] In Santa Maria degli Angeli in La Verna, a surviving tramezzo dated to the late 1480s supports two glazed terracotta altarpieces depicting the *Nativity* and the *Sepulcher of Christ*, while the high altarpiece beyond portrays the *Madonna della Cintola*, all works attributed to various members of the Della Robbia workshop, which form a unified program in terms of style, material, and patronage.[125] Ligozzi's 1612 image of the interior of the church, albeit debatable in terms of its accuracy, depicts the tramezzo with the Della Robbia altarpieces and a carved crucifix supported on a horizontal architrave above the central opening, and a further grated screen in the lower nave (Figure 33).[126] In 1537–39, Vasari produced two tramezzo paintings and a high altarpiece for the Camaldoli hermitage in Casentino that were iconographically linked, and in 1540, two small tramezzo altarpieces for the Olivetan abbey of Santa Maria di Barbiano in Valdelsa.[127] Famously, the frescoes by Ghirlandaio and Botticelli on the Ognissanti tramezzo in Florence (Figures 83 and 84) – although not altarpieces *per se* – also formed part of an iconographically and stylistically consistent program (see Chapter 3).[128]

Recent scholarship has suggested that images could also have been housed on top of nave screens and beams, perhaps suspended via chains from roof trusses above. Taking the *Verification of the Stigmata* fresco at Assisi as a literal point of reference and utilizing archival sources, Bram Kempers, Irene Hueck, Andrea De Marchi, and Donal Cooper have variously argued that large

Figure 33 Jacopo Ligozzi, *Descrizione del Sacro Monte della Vernia*, 1612, plate 7. Photo: National Gallery of Art Library, Washington, DC, David K. E. Bruce Fund

gabled panel paintings were exhibited on screens and beams in churches in Florence, Pistoia, and Pisa.[129] For example, scholars have proposed that Duccio's *Rucellai Madonna* for Santa Maria Novella (Figure 92, see Chapter 3) and Giotto's Louvre *Stigmatization of St. Francis* for San Francesco in Pisa were displayed in this way. Now in the Uffizi, a small panel painting depicting the Pietà by Giottino, a follower of Giotto, was described by Vasari in both editions of *Le Vite* as located in San Remigio "placed in the tramezzo of said church on the right hand side."[130] In the Gothic church of San Remigio, Maria Bandini has investigated traces of medieval frescoes and masonry damage to suggest that an

architectural tramezzo was attached to the nave piers between the second and third bay, further arguing that two panels were displayed above the tramezzo wall: an Annunciation by Jacopo di Cione in the left bay, and the Pietà originally above the central opening but later moved to a position on the right, where a chapel of the Pietà was recorded in the Pastoral Visitation of 1575.[131]

These investigations prompt a reevaluation of the potential role of such images in the context of lay devotion and show how screens contributed to the overall artistic program of the church interior. In other sites, however, where tramezzi incorporated functional platforms such as the Florentine Carmine, a tilted painting would have surely interfered with *sacra rappresentazione* performances, and the pragmatic erection of gabled panels of such immense size is certainly questionable. While convincing in some cases, more research is needed in this area to ascertain widespread practices.

SPACE AND ACCESSIBILITY

Laity and Clergy

Although the choir has traditionally been viewed as an exclusively clerical zone, with the screen acting as a definitive barrier between lay and religious groups, contemporary scholars have encouraged a more nuanced reading of sacred space. Jung highlighted the potential inclusivity of architectural screens; and Cannon and others have suggested that screens did not exclude laypeople from accessing chapels in areas beyond the screen.[132] Perhaps we should interpret church screens as twentieth-century philosopher Henri Lefebvre characterized all types of visible boundaries, as structures that "give rise for their part to an *appearance* of separation between spaces where in fact what exists is an ambiguous continuity" (italics mine).[133] As Donal Cooper

elucidates, scholars are coming to a consensus that "[t]iming is key. Each church had its own liturgical rhythm and access must have varied accordingly."[134]

Although the Decretals of Gregory IX in 1234 stated that it was *not* a mortal sin for laity to stand among the clergy, especially where it was not contrary to custom, in his gloss written in 1263, Bernardo da Parma clarified that the laity should not stand near to the altar or in choir while Divine Office was being celebrated.[135] Similarly, a thirteenth-century Padua Cathedral ceremonial specified that lay people were not permitted to "stand or sit in the choir of canons during the Divine Office," suggesting that they could potentially enter the area on other occasions.[136] In a ceremonial from Novara Cathedral, canons were ordered not to talk in choir "and especially with laymen," indicating that laymen must have been present in the choir at certain times.[137] In early Renaissance Florence, Archbishop Antoninus reiterated this distinction, stating that the laity should not loiter with the clergy in choir.[138] The practice of periodically restricting lay access to the choir, then, seems to have been focused on ensuring that the liturgy performed by the religious community was undisturbed.

The laity frequently financed the construction of nave choir stalls, screens, screen chapels, and tombs, raising questions about the relationship between patronage, ownership, and access. For example, in Florence the early fifteenth-century choir stalls in Santa Trinita were sponsored by two local lay families whose chapels were adjacent to the choir precinct (see Chapter 5), while in Santa Croce the Alberti family claimed official ownership of the choir floor space (see Chapter 3). Payment records for repairs undertaken to the choir stalls of San Lorenzo indicate that single stalls might have been donated and even used by individual laymen. Heraldry on the *spalliere*, or stall-backs, were explicitly mentioned, and were possibly used to indicate seating

positions: for example, "the stall-back of Sassetti"; "the stall-back of messer Girolamo Giugni"; and "four coats of arms on the stall-backs of the Arte della Lana," which demonstrated that one of the most powerful trade guilds in Florence also engaged in this act of sponsorship.[139] Moreover, in San Pier Maggiore, the presence of a men's choir ("coro degli uomini") suggests a crucial role for the laity in this joint nuns' and parish church (see Chapter 6). The Venetian diarist Marin Sanudo's report of a funeral in 1515 shows that official dignitaries could also sit in mendicant choirs. He described a grand procession from San Marco to the Augustinian church of Santo Stefano, where the coffin was placed under a baldachin, and the Doge took his place "as was the custom . . . in the choir."[140]

Gender Divisions

Whether laywomen had access to areas beyond the screen has been widely debated among scholars. Certainly, the binary separation of the genders has long represented a fundamental way of dividing all genres of social space.[141] Deriving from ancient Jewish and early Christian practices, gender segregation in the Catholic church was intended to preserve the holiness of sacred space by keeping social categories distinct, shielding the Sacrament from the potentially dangerous impurity of women, and protecting men from the discomfort of having lustful thoughts.[142] Durandus identified two spatial arrangements of gendered divides: in one, "the men remain in the southern part, the women in the northern or northeast part in order to show that the stronger saints ought to stand against the greater temptations of this world," while in the other "the men are in the front part [i.e., eastward] and the women in the inner part since man is the head of the woman."[143] Examples of both spatial configurations were utilized in Renaissance Florence.

Screens were sometimes specifically characterized as gender dividers.[144] For example, the early fourteenth-century priestly mystic and cartographer Opicinus de Canistris noted that in Pavia, all the churches both large and small were equipped with a central screen, "which separated women from men," so that the women could not see the altar except through certain openings designed for that purpose.[145] For parish churches, Franco compiled numerous documents that described the function of tramezzi as dividing laymen from laywomen.[146] Evidence shows that mendicant churches were also subject to gender divisions. A 1382 sepoltuario described a dividing wall in Sant'Agostino in Siena that designated two spatial zones known as the upper church ("chiesa di sopra"), and the church of the women ("chiesa dala parte dele donne").[147] In Florence, a testator in 1386 requested burial by the central door of the tramezzo in Santa Croce, "which divides the place of the men from the place of the women"; Hall therefore concluded that the screen performed a specific function in dividing the genders.[148] A chronicle from the Dominican church of Santa Maria Novella, meanwhile, described the elegant black and white marble screen or ponte as a structure that "separated the men from the women, while they stood during holy office."[149]

Certainly, screens promoted a rigorous sense of hierarchy in the church interior, with women facing the toughest scrutiny. Bacci noted that in a vision, the Pisan female mystic Beata Gherardesca felt herself transported to the choir of the abbey church of San Savino, where she lived in an adjacent cell, exclaiming in terror, "Oh, how big an insult would the monks throw at me if they came and found me here!"[150] In Dominican churches, women were not permitted to enter the choir area except for the feast day of a consecration of a church and Good Friday.[151] In extreme cases, women were even fined for entering the choir during Divine Office. In Siena, an early fourteenth-century update to the

city constitution specified that women should not enter the choir or be around any altar in any church in the city during services, or face the substantial fine of twenty soldi.[152] Similarly, a 1414 statute for the medieval collegiate church of San Cristofano in Barga, a town north of Lucca, stated that women who ventured beyond the *cancelli* (gates or grates of the screen) were subject to a five soldi fine for each transgression.[153] Perhaps reflecting such stringent regulations, the *Miracle of the Crib at Greccio* fresco in the Upper Church at Assisi shows a group of women congregated at the entrance to the friars' choir, while laymen accompanied the joyously singing friars within.

Longitudinal gender separation, which placed women on the left and men on the right when facing the high altar, was also practiced in the churches of Florence. From the beginnings of Western philosophical thought, the right or dexterous side has been more favored than the left or sinister side. In Christian scripture, the "right hand of God" was reserved for the blessed, shown by the position of the Elect in the Last Judgment, the good thief in Crucifixion images, and the male patron in altarpieces.[154] In the church interior, somewhat surprisingly, when longitudinal divisions were in effect, laywomen stood on the less-favored left side, which ironically situated them at God's liturgical right hand. Elizabeth Aston noted that the standard position of the Virgin Mary to the visual left of Christ in the rood scene would have corresponded to the place of female worshippers directly beneath.[155] In east-facing churches, the left side of the nave is coincidentally also the north side, which holds distinctly negative connotations.[156] In San Francesco in Bologna, documentation designating the north aisle as "chorus dominarum" ("choir of women") suggested to Hall the possibility that women could have entered the tramezzo side gates in the north aisle where they would have remained hidden from the view of both friars and laymen, who stood in the central nave and south aisle.[157]

Evidence shows that in Renaissance Florence, the north or left side of the nave might have been associated with female worshippers. Indeed, Natalie Tomas discovered that in 1476, the Duomo Works Committee purchased "a curtain of coarse cloth in order to enclose the women at the sermon and to separate them from the men."[158] A woodcut depicting the Dominican friar Savonarola preaching in the Duomo shows women longitudinally separated to the left of men via a temporary textile hanging similar to the one specified in the archival source (Figure 34). In fact, the Dominican Constitutions were particularly strict about friars looking at women,[159] but in the Franciscan context gender segregation was also observed at times of preaching, as shown in images of San Bernardino da Siena preaching outdoors. However, as Adrian Randolph noted, these do not show a consistent positioning of the genders (the Piazza del Campo image, Figure 35, shows women on the left, but the Piazza San Francesco image shows women on the right).[160] Longitudinal segregation even persisted at a later date. In San Lorenzo, a temporary wooden barrier four *braccia* high was erected down the center of the nave (which at that time lacked a screen) to segregate men and women during the annual display of an illustrious relic collection atop Michelangelo's tribune gallery on the counter-facade, constructed in 1532.[161] Chapels and tombs on or near screens could also express longitudinal gender division. In the pre-Brunelleschi Augustinian church of Santo Spirito, the Frescobaldi family had two tombs in the church: one for males at the foot of the high altar, and one for females "next to or near the door in the middle of said church outside and near the choir."[162] This tomb was associated with a Frescobaldi chapel dedicated to San Giovanni

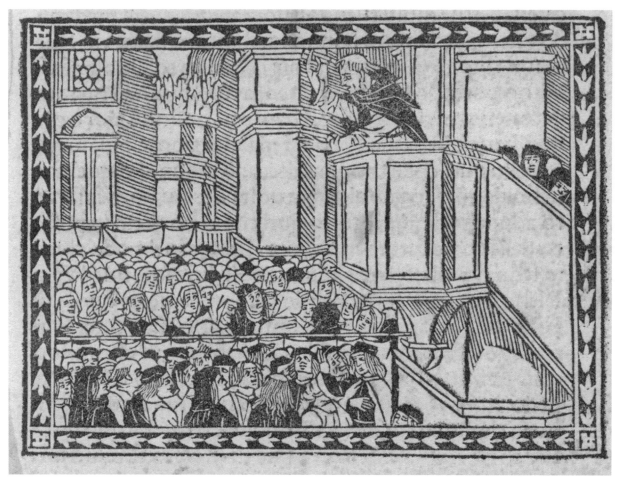

Figure 34 Woodcut from Girolamo Savonarola, *Compendio di revelatione*, Florence, Pacini, 23 April 1496. Photo: Harvard University, Houghton Library, Inc. 6316.10 (A)

delle Donne, which was near the screen on the left side of the nave.[163] Illustrating practices of longitudinal gender separation in the church interior, an evangeliary illumination produced in 1523–25 by Benedetto Bordon for the Reformed Benedictine Cassinese Congregation church of Santa Giustina in Padua depicts laywomen approaching a statue of the royal virgin martyr Giustina, located to the left of the screen, while laymen congregate on the opposite side of the nave (Figure 36).[164]

However, it seems that at various times, laywomen circulated throughout the church, in sites of devotion beyond the screen and even in the choir itself.[165] Scholars including Hall have cast doubt upon whether screens definitively

barred women from areas beyond the screen, Guirescu Heller stating that it seems unlikely that female patrons of transept chapels – such as Andrea Acciauoli in Santa Maria Novella – never saw the elaborate tombs and expensive decoration they themselves commissioned.[166] Donal Cooper has shown that from at least the fourteenth century, choir precincts in Tuscan churches had been used as sites for the signing of notarial acts, which were also witnessed by women.[167] Machelt Israëls discovered an example of a married couple making a declaration of debt in the choir of San Francesco in Chiusi in 1445, noting that the presence of appropriate, ordered seating in the choir was perfectly suited to these legal activities.[168] Other spaces beyond the

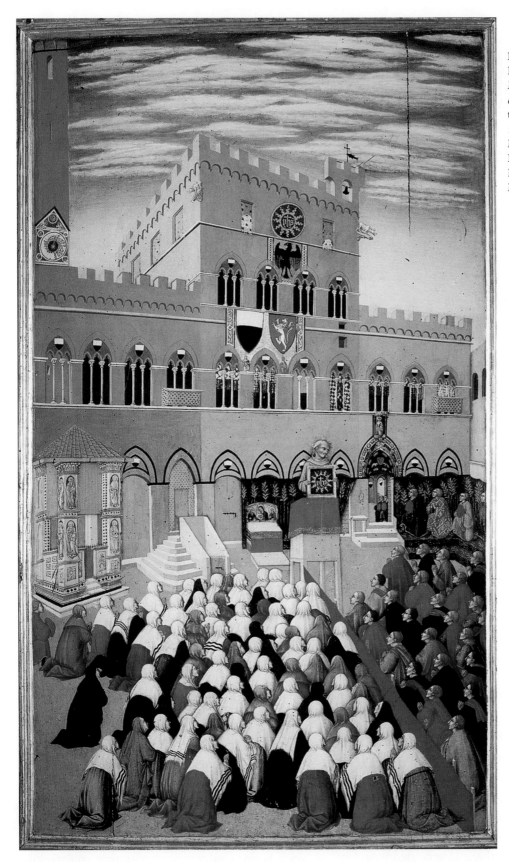

Figure 35 Sano di Pietro, *St. Bernardino Preaching in Piazza del Campo*, 1445, tempera on panel, 162 × 102 cm, Museo dell'Opera del Duomo, Siena. Photo: Opera della Metropolitana, Siena

Figure 36 Benedetto Bordon, *Evangeliary for Santa Giustina in Padua*, 1523–25. Dublin, Chester Beatty Library, CBL W 107, fol.18r. Photo: © The Trustees of the Chester Beatty Library, Dublin

screen, such as sacristies equipped with wooden seating, were similarly documented as multifunctional spaces variously accessible to the laity, often used for business transactions between clergy and laity.[169] Laywomen are also documented attending confraternity meetings and venerating shrines in areas beyond the tramezzo, further complicating these intertwined issues of gender and sacred space.

IMAGES OF THE DIVIDED CHURCH INTERIOR

Surviving screens, archival records, and archaeological data can only provide a limited understanding of the Italian tramezzo's aesthetic appeal and practical function. Images of screens in contemporary painting, meanwhile, can potentially provide invaluable insights into

the form, construction, and use of these structures. However, while feasibly grounded in the reality of a specific church's appearance, some images depict idealized screens that closely mirror the Renaissance architectural elements of the churches that house them: an impossibility in most contexts. The screens depicted in such images likely functioned less as records of individual buildings than as pictorial devices that served to convey specific ideas.[170] Providing tantalizing views of the church interior, medieval and Renaissance artists incorporated screens into images to underline the solemnity of a religious scene, to emphasize clerical authority and lay devotion, and to reinforce metaphorical themes of transition. Including screens in images conveyed the ambiance of a solemn liturgical space and provided the perfect backdrop for the depiction of sacred mysteries. For example, choir stalls and a simple wooden arched screen appear in Sassetta's image of a miracle that might have indeed taken place in choir, in which the Blessed Ranieri prophesized the damnation of an avaricious friar whose behavior did not befit his place in the religious community. In *The Damnation of the Soul of the Miser of Citerna*, a predella panel from the reverse side of the St. Francis altarpiece from San Francesco in Borgo Sansepolcro of 1437–44, Franciscan friars look on from the institutional space of their choir precinct, a representation of their community, as the expelled friar retreats through the church door on the left (Figure 37).[171]

The most frequently cited image of the medieval Italian church interior is the fresco dated c. 1290–95 depicting the *Miracle of the Crib at Greccio* in the Upper Church in Assisi, variously attributed to Giotto or one of his followers (Figure 38).[172] In this miracle, St. Francis beheld the Christ child in the first live nativity scene he had created in a cave in Greccio. Despite Bonaventure's report placing the miracle outdoors, the fresco depicts the choir precinct beyond a marble tramezzo equipped with a staircase leading to a pulpit surrounded by candlesticks, evidently a fictive location.[173] A panel-painted crucifix attached to a wooden framework tilts

forward via chains above the central entrance, where a group of laywomen, excluded from the choir, behold only a restricted view of the unfolding miracle.[174] Within the choir area, singing friars surround the lectern and priests gather at an altar sheltered by a magnificent ciborium, while a group of laymen witness St. Francis gently lifting the babe out of the crib.

Art historians have often used this fresco to demonstrate the functions of tramezzi, particularly in segregating the genders, but its literal accuracy has also been challenged. Janet Robson argued that while the presence of the generic tramezzo could situate the miracle in any late thirteenth-century Franciscan church (although certainly not Greccio itself), it was meant to illustrate the Lower Church of San Francesco, which featured a monumental marble tramezzo until the late thirteenth century.[175] Since this space did not house an altar ciborium, Robson claimed that this symbolic addition referenced Roman sites of papal liturgy such as San Paolo Fuori le Mura. Such allusions elevated the status of the mendicant friar Francis to that of an apostolic martyr and visually reinforced the "axis of power" between Rome and Assisi created by the patron, the first Franciscan pope, Nicholas IV.[176] Situating St Francis (lavishly dressed in ecclesiastical vestments) within the hierarchical space of the choir, enclosed by a tramezzo which rigorously divided social groups, only serves to enhance this status. Therefore, while it is tempting to interpret the image as an illustration of contemporary space, and it may well reflect architectural features significant to that practice, it is important to note that the fresco held communicative value for a specific audience within a defined historical and spatial context.

An image by Fra Carnevale (Bartolomeo di Giovanni Corradini), known as the *Presentation of the Virgin in the Temple (?)*, dated c. 1467 and preserved in the Museum of Fine Arts in Boston, depicts the most architecturally detailed screen in Italian Renaissance art (Figure 1). Formerly perhaps displayed in the hospital oratory of Santa Maria della Bella in Urbino, this panel shows a group of women

Figure 37 Sassetta (Stefano di Giovanni), *The Damnation of the Soul of the Miser of Citerna*, 1437–44, tempera on wood, 45.3 × 58.7 cm. Musée du Louvre, Paris, R.F. 1988–89. Photo: Erich Lessing/Art Resource, NY

at the entrance to a church (including the young woman in blue thought to represent the Virgin Mary), while laymen and clerics perambulate the church interior. A monumental, vaulted screen traverses the entirety of the nave, intersecting the space between two nave piers. This heavy and deep structure, raised on two steps, is pierced by a wide opening at its center through which the high altar can be seen, and two arched chapel recesses to the left where altars support gilded Gothic altarpieces. The screen's dark gray *pietra serena* stone, Ionic pilasters, and round arches harmonize with the macro-architecture of the church itself, while a carved frieze of putto heads, swags, and ribbons completes the ensemble. Matteo Ceriana showed that Fra Carnevale's architectural sources for the scene combine late Antique and early Christian

Roman precedents (Pantheon; Santa Sabina; Arch of Septimus Severus) with the contemporary style of Michelozzo and Alberti (Library of San Marco; Tempio Malatestiano).[177] Given these historical sources, it is tempting to interpret the building with its prominent screen as a deliberately antiquated setting that emphasizes the passing from the Old to the New Testament. From a symbolic perspective the functional association of screens with sites of passage reinforced the theme of transition in the Virgin Mary's acceptance into a new life in the Temple.

In the Dominican context, a panel depicting *St. Vincent Ferrer Baptizing Two Converts* by Angelo and Bartolomeo degli Erri, c. 1460–80, now in the Kunsthistorisches Museum in Vienna, originally formed part of the high altarpiece in

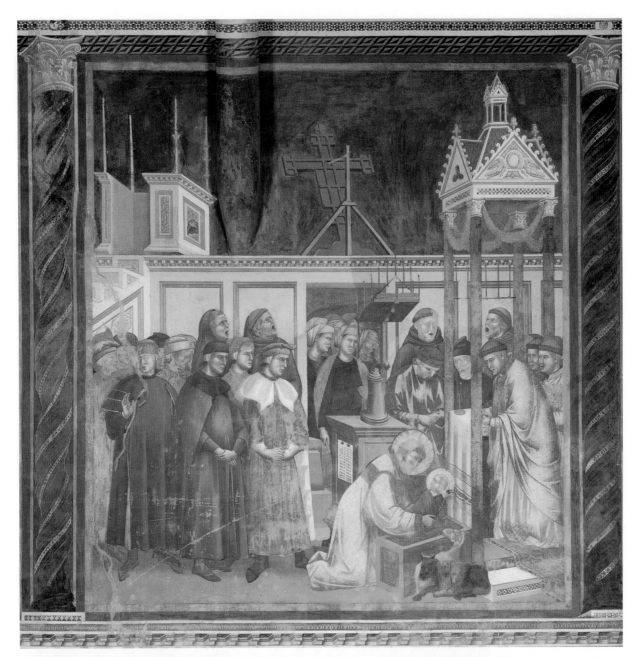

Figure 38 *Miracle of the Crib at Greccio*, c. 1290–96, fresco, 270 × 230 cm, Upper Church, Basilica di San Francesco, Assisi. Photo: © Photographic Archives of the Sacred Convent of the Basilica of St. Francis in Assisi, Italy

San Domenico in Modena (Figure 39).[178] The Erri workshop depicted a three-arched vaulted structure constructed from a pale-orange stone edged with pink stone around the arches and four roundels on its facade, which contain bust-length portrayals of Dominican saints.[179] Simple cross-vaults beneath the screen are whitewashed and reinforced with iron tie-beams. Atop the screen, above a white stone cornice, a sculpted and polychromed crucifix with SS. Mary and John the Evangelist crowns the structure. With its round arches, Corinthian-style columns, tie-beams, and use of colored stones and poly-chromed sculpture, this screen was clearly depicted to match the surrounding church, which features many of the same architectural elements. On a raised dais, a married couple is baptized in the lay section of the Dominican church. The

Figure 39 Angelo and Bartolomeo degli Erri, *St. Vincent Ferrer Baptizing Two Converts*, c. 1460–80, tempera on wood, 61 × 34 cm. Vienna, Kunsthistorisches Museum, Gemäldegalerie, 6698. Photo: KHM-Museumsverband

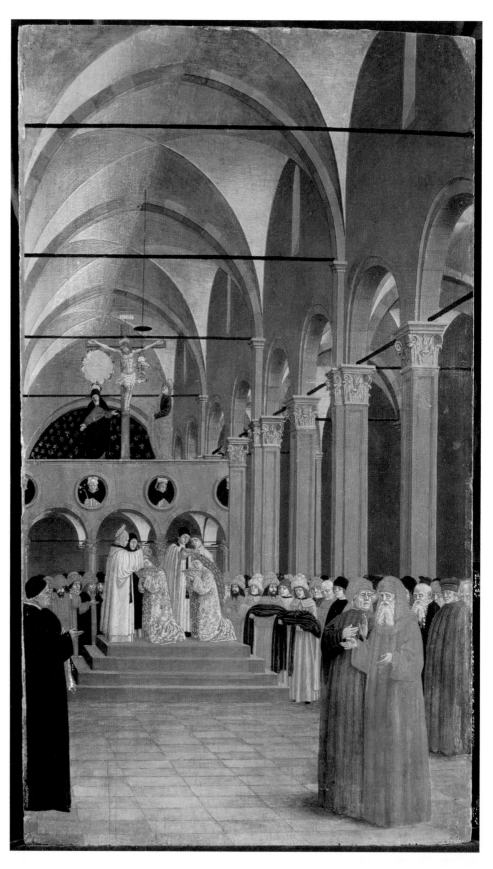

Figure 40 Vittore Carpaccio, *Apparition of the Crucified of Mount Ararat in Sant'Antonio di Castello*, tempera on canvas, 121 × 174 cm. c. 1512–15. Gallerie dell'Accademia, Venice, cat. 91. Photo: © Gallerie dell'Accademia di Venezia, Archivio fotografico, Ministero dei beni e delle attività culturali e del turismo

presence of a screen traversing the nave reinforces their societal position as unbaptized laity whose religious status would not afford them entry to the sacred area of the choir beyond. From a metaphorical standpoint, therefore, the theme of conversion as a rite of passage is echoed by the presence of a screen, with its symbolic associations of transition and hierarchy.

Vittore Carpaccio's *Apparition of the Crucified of Mount Ararat in Sant'Antonio di Castello*, c. 1512–15, now displayed in the Gallerie dell'Accademia in Venice (Figure 40) depicts Prior Ottobon of the Antonite Hospitaller's church praying that his community be spared from plague. Carpaccio portrayed the prior's vision, in which the ten thousand martyrs of Mount Ararat, bearing crowns and crosses and

led by St. Peter, entered his church in solemn procession amid sounds of hymn-singing, while the voice of St. Anthony assured the prior not to fear the pestilence.[180] Following the vision, the prior petitioned his nephew Ettore to construct a marble votive altar and an altarpiece depicting the martyrdom, which was also completed by Carpaccio and was included in the painting of *The Vision* (in a white marble frame to the left of center).[181] On the left of the interior view, a wooden structure, either a screen or Venetian *barco*, with micro-architectural carved detailing supported by white stone columns crosses the entire width of the nave. Underneath its heavy structure, densely packed with suspended wax ex-votos (reminding us that screens were sites of significant religious devotion), some of the

martyrs wander through its central opening while the prior kneels at one of the chapels enclosed by low marble balustrades. Carpaccio's screen, while evoking the recognizable setting of the miracle and thus verifying its objective truth, might indeed represent an actual construction.[182] A wooden screen with four attached chapels was probably sited within the fourth bay of the now-destroyed three-aisled medieval church.[183]

Conclusion

In early modern society, church interiors were complex sites of interaction and display. Screens or tramezzi with their accompanying nave choir precincts, long since removed from their prominent locations, created a distinct sacred topography that limited visibility and access while providing unique opportunities for religious performance and lay devotion. As agents of segregation, tramezzi created private areas for religious communities to observe the liturgy or in some cases divided laymen from laywomen. However, levels of physical access to areas beyond the screen for the laity, and laywomen in particular, was fluid. Beyond social and gendered separation, the functions of nave screens included restricting the reciprocal vision of clergy and laity, facilitating processions and other movement throughout the church, providing walkways and stages, and contriving complex visual effects through the framing and concealing of images and furnishings. Few nave choirs with accompanying screens survive in Italy, but extant examples show great variety and high quality as objects of material culture. Physically prominent structures in the nave, screens variously supported crucifixes, pulpits, organs, chapels, tombs, and paintings. Despite the constraints of survival and interpretation, reviving the memory of these lost structures can provide tantalizing insights into the materiality, temporality, and meaning of sacred space in the Italian church interior.

NOTES

1 Giovanni Boccaccio, *Decameron*, trans. J. G. Nichols (New York, 2009), pp. 14, 17.

2 Robert Gaston, "Sacred Place and Liturgical Space: Florence's Renaissance Churches," in *Renaissance Florence: A Social History*, ed. Roger J. Crum and John T. Paoletti (Cambridge, 2006), p. 338; Richard C. Trexler, *Public Life in Renaissance Florence* (Ithaca, NY and London, 1980), p. 54.

3 Michele Bacci, *Lo spazio dell'anima: Vita di una chiesa medievale* (Rome, 2005), p. 79; Paolo Piva, "Lo 'spazio liturgico': architettura, arredo, iconografia (secoli IV–XII)," in *L'Arte medievale nel contesto: 300–1300: funzioni, iconografia, tecniche*, ed. Paolo Piva (Milan, 2015), p. 151. Sible De Blaauw pointed out that the lay space was normally just the leftover, negative space created by the other enclosures for the clergy. Sible De Blaauw, "Origins and Early Development of the Choir," in *La place du choeur: architecture et liturgie du Moyen Âge aux Temps modernes: actes du colloque de l'EPHE, Institut national d'histoire de l'art, les 10 et 11 décembre 2007*, ed. Sabine Frommel, Laurent Lecomte, and Raphaël Tassin (Paris and Rome, 2012), p. 28.

4 The following section draws heavily from my PhD thesis: Joanne Allen, "Choir Stalls in Venice and Northern Italy: Furniture, Ritual and Space in the Renaissance Church Interior" (PhD thesis, University of Warwick, 2010).

5 Marcia B. Hall, "The Ponte in S. Maria Novella: The Problem of the Rood Screen in Italy," *Journal of the Warburg and Courtauld Institutes* 37 (1974), p. 173. More elaborate nave piers indicated the choir area in Santi Giovanni e Paolo in Venice and San Giovanni a Canale in Piacenza. Monica Merotto Ghedini, "Il tramezzo nella chiesa dei Santi Giovanni e Paolo a Venezia," in *De lapidibus sententiae: Scritti di storia dell'arte per Giovanni Lorenzoni*, ed. Tiziana Franco and Giovanna Valenzano (Padua, 2002), pp. 257–62; Giovanna Valenzano, "La suddivisione dello spazio nelle chiese mendicanti: sulle tracce dei tramezzi delle Venezie," in *Arredi liturgici e architettura*, ed. Arturo Carlo Quintavalle (Milan, 2007), p. 99; Tiziana Franco, "'Item in piscibus pro magistris qui aptaverunt pontem': note sul tramezzo dei Santi Giovanni e Paolo a Venezie," in *Sotto la superficie visibile: Scritti in onore di Franco Bernabei*, ed. Marta Nezzo and Giuliana Tomasella (Treviso, 2013), p. 164; Caroline Bruzelius, *Preaching, Building, and Burying: Friars and the Medieval City* (New Haven, CT and London, 2014), p. 57.

6 Joanna Cannon, *Religious Poverty, Visual Riches: Art in the Dominican Churches of Central Italy in the Thirteenth and Fourteenth Centuries* (New Haven, CT, 2013), p. 38. The Dominican Constitutions of 1300 dictated that vaulting could only cover the choir and sacristy, although in this case the term "chorum" could refer to the eastern part of the church. Ibid., p. 19. Bruzelius noted that once screens had been removed, later restorations sometimes completed the stone vaulting over the lay section of the nave. Bruzelius, *Preaching, Building, and Burying*, p. 57.

7 By contrast, Carthusian stalls in Italy generally incorporated misericords, since in this stricter and more uniform order, liturgical guidelines specified their use. Joanne Allen, "Carthusian Choir Stalls and the Misericord in Italy," *The Antiquaries Journal* 92 (2012), pp. 307–30.

8 For conventual altars in Dominican convents, see Cannon, *Religious Poverty*, p. 109.

9 Antoine M. Wilmering, *The Gubbio Studiolo and Its Conservation. Volume 2: Italian Renaissance Intarsia and the Conservation of the Gubbio Studiolo* (New York, 1999), p. 84.

10 Margaret Haines, *The "Sacrestia delle Messe" of the Florentine Cathedral* (Florence, 1983).

11 Benedetto Dei noted that in the 1470s there were eighty-four intarsia workshops in the city. Alessandro Cecchi, "Maestri d'intaglio e tarsia," in *Arti fiorentine: La grande storia dell'Artigianato. Il Quattrocento*, ed. Franco Franceschi and Gloria Fossi (Florence, 1999), p. 215.

12 For example, Cima da Conegliano's high altarpiece depicting *The Baptism of Christ* for San Giovanni in Bragora in Venice cost 137 ducats in 1492, compared to the 490 ducats spent on the San Zaccaria choir stalls, also in Venice. Michelle O'Malley, *The Business of Art: Contracts and the Commissioning Process in Renaissance Italy* (New Haven, CT and London, 2005), pp. 54–55, 262; Joanne Allen, "The San Zaccaria Choir in Context," in *La chiesa e il monastero di San Zaccaria, Chiese di Venezia: nuove prospettive di ricerca*, ed. Bernard Aikema, Massimo Mancini, and Paola Modesti (Venice, 2016), p. 165.

13 Of the twenty-five northern Italian choir contracts I analyzed from the late fourteenth to early sixteenth centuries, sixteen had imitation or *modo et forma* clauses. Allen, "Choir Stalls," pp. 78–81.

14 Benno Linderbauer, ed., *S. Benedicti Regula Monasteriorum* (Bonn, 1928), pp. 52–53, 67.

15 Stephen Joseph Peter van Dijk, *Sources of the Modern Roman Liturgy* (Leiden, 1963), pp. 338–39.

16 Ibid., p. 347.

17 "Deinde ad primum psalmum sedeat minus [*rectius:* unus] chorus et ad secundum similiter stet et sedeat alter chorus, et sic alternent usque ad 'Laudate Dominum de celis'." Georgina Rosalie Galbraith, *The Constitution of the Dominican Order 1216–1360* (Manchester, 1925), p. 207.

18 Howard and Moretti, *Sound and Space*, p. 87.

19 Galbraith, *The Constitution*, p. 218.

20 This tradition was first developed in Bologna in the 1220s or 1230s. William R. Bonniwell, *A History of the Dominican Liturgy 1215–1945*, 2nd ed. (New York, 1945), pp. 161–64; Cannon, *Religious Poverty*, pp. 26–28, 53.

21 For the *jubé*, see Henri Leclercq, "Jubé," in *Dictionnaire d'Archéologie Chrétienne et de Liturgie*, ed. Fernand Cabrol and Henri Leclercq (Paris, 1927). Erika Doberer categorized various types of Lettner, including the Kryptenlettner, Kanzellettner, Schrankenlettner, and Hallenlettner, in Erika Doberer, "Der Lettner," *Mitteilungen der Gesellschaft für vergleichende Kunstforschung in Wien* 9, no. 2 (1956), pp. 117–22.

22 Marcia B. Hall, "The Tramezzo in the Italian Renaissance, Revisited," in *Thresholds of the Sacred: Architectural, Art Historical, Liturgical, and Theological Perspectives on Religious Screens, East and West*, ed. Sharon E. J. Gerstel (Washington, DC, 2006), p. 216; Donal Cooper, "Recovering the Lost Rood Screens of Medieval and Renaissance Italy," in *The Art and Science of the Church Screen in Medieval Europe: Making, Meaning, Preserving*, ed. Spike Bucklow, Richard Marks, and Lucy Wrapson (Woodbridge, 2017), pp. 221–24; Cannon, *Religious Poverty*, p. 39.

23 Piva, "Lo 'spazio liturgico'," p. 152. De Blaauw identified three types of Early Christian choir arrangement: concentrated, spread, and bifocal, all of which had both static and dynamic elements. De Blaauw, "Origins and Early Development," pp. 28–30.

24 Piva, "Lo 'spazio liturgico'," pp. 152–53. De Blaauw noted that the term *schola cantorum* was not employed in contemporary documents to refer to a physical space. De Blaauw, "Origins and Early Development," p. 28. Piva argued that the Early Christian type developed into the medieval nave choir as a place of daily office through the mediation of Bishop Chrodegang von Metz, who spread the Roman typology north in the eighth century. Piva, "Lo 'spazio liturgico'," p. 153.

25 Sible De Blaauw, *Cultus et decor: liturgia e architettura nella Roma tardoantica e medievale: Basilica Salvatoris, Sanctae Mariae, Sancti Petri* (Vatican City, 1994), pp. 77–79.

26 De Benedictis, "The 'Schola Cantorum'," esp. pp. 112–16.

27 For a reconstruction of the screen at Montecassino, see Jennifer M. Sheppard, "The Eleventh-Century Choir-Screen at Monte Cassino: A Reconstruction," *Byzantine Studies* 9, no. 2 (1982), pp. 233–42. For the Byzantine context, see Sharon E. J. Gerstel, ed., *Thresholds of the Sacred: Architectural, Art Historical, Liturgical, and Theological Perspectives on Religious Screens, East and West* (Washington, DC, 2006).

28 The wooden architrave supported paintings of the Virgin and apostles attributed to Zanino di Pietro, erected in 1418–26. Paola Modesti, "Recinzioni con colonne nelle chiese veneziane: Tradizioni, revival, sopravvivenze," in *Lo spazio e il culto: relazioni tra edificio ecclesiale e uso liturgico dal XV al XVI secolo*, ed. Jörg Stabenow (Venice, 2006), pp. 191–92.

29 For the iconostasis of San Marco, see Wolfgang Wolters, *La scultura veneziana gotica (1300–1460)* (Venice, 1976), p. 223, cat. 146; Modesti, "Recinzioni con colonne," pp. 183–90.

30 For the early thirteenth-century sculpted *pontile* in Modena Cathedral (reconstructed in the twentieth century and replacing one from the early twelfth century whose panels are embedded into the church facade), see Dawn Cunningham, "One Pontile, Two Pontili: The Choir Screens of Modena Cathedral," *Renaissance Studies* 19, no. 5 (2005), pp. 673–85; Dawn Cunningham, "Sacrament and Sculpture: Liturgical Influences on the Choir Screen of Modena Cathedral," *Material Religion* 4, no. 1 (2008), pp. 32–53. For San Miniato, see Chapter 2.

31 See Jacqueline E. Jung, *The Gothic Screen: Space, Sculpture, and Community in the Cathedrals of France and Germany, ca. 1200–1400* (New York, 2013), p. 6.

32 Cooper, "Recovering the Lost Rood Screens," p. 227. For the tramezzo of Vezzolano, see Marziano Bernardi, *Tre abbazie del Piemonte* (Turin, 1962), pp. 70, 76, 96.

33 Cooper, "Recovering the Lost Rood Screens," pp. 227–29. See also Eugenio Russo, "Lo scomparso jubé della chiesa abbaziale di Pomposa," *Studi vari* 31–32, no. 7–43 (2006–07), pp. 24–25.

34 Russo showed that the screen was constructed above a pavement dated to the eleventh century. Ibid, p. 15.

35 Guido Zucchini dated the screen to the twelfth century. Guido Zucchini, *La chiesa e il chiostro di San Vittore presso Bologna* (Bologna, 1917), p. 18; Cooper, "Recovering the Lost Rood Screens," p. 229; Russo, "Lo scomparso jubé," pp. 22–23. Russo claimed that the screen was completed at the same time as the choir frescoes, c. 1240, and that the screen we see today is more authentic to the original after the removal of certain vaults and chapels added in either the fifteenth or eighteenth centuries.

36 Paolo Piva, "Dal setto murario allo jubé: il pòzo di Sant'Andrea a Mantova nel contesto di un processo evolutivo," in *Società, Cultura, Economia: Studi per Mario Vaini*, ed. Eugenio Camerlenghi et al. (Mantua, 2013), pp. 65–66; Roberta Piccinelli, Claudia Bonora Previdi, and Stefano Siliberti, eds., *Santa Maria del Gradaro tra storia e arte* (Mantua, 2004), pp. 21–22.

37 For the Italian rood screen in general, see among others Hall, "The Ponte in S. Maria Novella"; Marcia B. Hall, "The Tramezzo in Santa Croce, Florence, Reconstructed," *The Art Bulletin* 56, no. 3 (1974), pp. 325–41; Kornelia Imesch Oehry, *Die Kirchen der Franziskanerobservanten in der Lombardei, im Piemont und im Tessin und ihre "Lettnerwände"* (Essen, 1991), pp. 35–47; Bacci, *Lo spazio dell'anima*, pp. 79–83, 116–20; Hall, "The Tramezzo in the Italian Renaissance" pp. 214–32; Valenzano, "La suddivisione dello spazio," pp. 99–114; Andrea De Marchi, *La pala d'altare: dal paliotto al polittico gotico* (Florence, 2009), pp. 41–63; Bruzelius, *Preaching, Building, and Burying*, pp. 11, 24, 31, 57, 97; Marcia B. Hall, "Another Look at the Rood Screen in the Italian Renaissance," *Sacred Architecture Journal* 27 (2015), www.sacredarchitecture .org/articles/another_look_at_the_rood_screen_in_ the_italian_renaissance; Cooper, "Recovering the Lost Rood Screens" pp. 220–45; Caroline Bruzelius, "The Tramezzo of Sta. Chiara: Hypotheses and Proposals," in *Ingenita Curiositas: studi sull'Italia medievale per Giovanni Vitolo*, ed. Bruno Figliuolo, Rosalba Di Meglio, and Antonella Ambrosio (Battipaglia, 2018), pp. 952–55. For the mendicant orders, see also Caroline Bruzelius, "Introduction," in *Spaces for Friars and Nuns*, ed. Haude Morvan (forthcoming).

38 "Intermedia que sunt in ecclesiis nostris inter seculares et fratres sic disponantur ubique per priores quod fratres egredientes et ingredientes de choro non possint videri a

seculares vel videre eosdem." Cannon, *Religious Poverty*, pp. 25, 362, note 1.

39 Tiziana Franco, "Appunti sulla decorazione dei tramezzi nelle chiese mendicanti. La chiesa dei Domenicani a Bolzano e di Santa Anastasia a Verona," in *Arredi liturgici e architettura*, ed. Arturo Carlo Quintavalle (Milan, 2007), pp. 115–17; Cannon, *Religious Poverty*, pp. 29–32.

40 Donal Cooper, "In Medio Ecclesiae: Screens, Crucifixes and Shrines in the Franciscan Church Interior in Italy, c. 1230–c. 1400" (PhD thesis, University of London, 2000), pp. 47–49; Cooper, "Recovering the Lost Rood Screens," p. 232, fig. 10.5. However, Lucas Giles claimed that single-aisled mendicant churches most commonly featured screens comprising three Gothic cross-vaults. Lucas Giles, "Medieval Architecture and Technology: Using GPR to Reconstruct the Choir Screen at Santa Chiara in Naples," *Peregrinations: Journal of Medieval Art and Architecture* 6, no. 4 (2018), p. 147.

41 Gardner warned against generalizing the ubiquity of screens. Julian Gardner, "A Thirteenth-Century Franciscan Building Contract," in *Medioevo: le officine: atti del Convegno internazionale di studi, Parma, 22–27 settembre 2009*, ed. Arturo Carlo Quintavalle (Milan, 2010), p. 460.

42 For San Francesco di Pisa, see Donal Cooper, "Redefining the Altarpiece in Early Renaissance Italy: Giotto's Stigmatization of St Francis and Its Pisan context," *Art History* 36, no. 4 (2013), pp. 686–713.

43 For the Duomo di Pistoia, see Andrea De Marchi, "'Cum dictum opus sit magnum'. Il documento pistoiese del 1274 e l'allestimento trionfale dei tramezzi in Umbria e Toscana fra Due e Trecento," in *Medioevo: immagine e memoria*, ed. Arturo Carlo Quintavalle (Parma, 2009), pp. 603–21. Little is known about the tramezzo in San Francesco di Pistoia, except that it had attached chapels, which were demolished in 1512. See Giuseppina Carla Romby, "Trasformazioni, restauri, 'ornamenti' della chiesa di San Francesco a Pistoia dal'500 alla soppressione del 1808," in *S. Francesco: la chiesa e il convento in Pistoia*, ed. Lucia Gai and Alessandro Andreini (Ospedaletto, 1993), pp. 173–74; Alessandro Andreini, Cristina Cerrato, and Giuliano Feola, "I cicli costruttivi della chiesa e del convento di S. Francesco dal XIII al XV secolo: analisi storico-architettonica," in *S. Francesco: la chiesa e il convento in Pistoia*, ed. Lucia Gai and Alessandro Andreini (Ospedaletto, 1993), pp. 49, 60, 63.

44 For San Domenico in Fiesole, see Monica Merotto Ghedini, *La chiesa di Sant'Agostino in Padova* (Padua, 1995), pp. 61, 64 (figures V, 33).

45 For San Francesco in Arezzo, see Donal Cooper, "Access All Areas? Spatial Divides in the Mendicant Churches of Late Medieval Tuscany," in *Ritual and Space in the Middle Ages: Proceedings of the 2009 Harlaxton Symposium*, ed. Frances Andrews (Donington, 2011), pp. 93–96.

46 For San Pietro in Perugia, see Christa Gardner von Teuffel, "Perugino's Cassinese Ascension for San

Pietro at Perugia: The Artistic and Musical Setting of a High Altarpiece in Its Cassa," *Städel-Jahrbuch* 18 (2001), pp. 113–64; Gromotka, "Transformation Campaigns," pp. 79–125 and Michael G. Gromotka, *Die Geschichte der Kirchenausstattung von S. Pietro in Perugia: Ein Beitrag zur Kircheninnenraumforschung*, 3 vols. (Heidelberg, 2021). I am grateful to Michael Gromotka for sharing his book with me prior to publication. For San Francesco al Prato in Perugia, see Donal Cooper, "Raphael's Altar-Pieces in S. Francesco al Prato, Perugia: Patronage, Setting and Function," *The Burlington Magazine* 143, no. 1182 (2001), pp. 554–61.

47 A monumental marble tramezzo existed in the Lower Church in Assisi for only around fifty years: it was installed c. 1253 and removed c. 1300 to improve lay access to the tomb of St. Francis. Irene Hueck, "Der Lettner der Unterkirche von San Francesco in Assisi," *Mitteilungen des Kunsthistorischen Institutes in Florenz* 28, no. 2 (1984), pp. 173–202; Donal Cooper, "'In loco tutissimo et firmissimo': The Tomb of St. Francis in History, Legend and Art," in *Art of the Franciscan Order in Italy*, ed. William R. Cook (Leiden and Boston, 2005), pp. 24–28.

48 For the tramezzo in San Giovanni in Canale in Piacenza, see Valenzano, "La suddivisione dello spazio," pp. 99–101. For San Giovanni Evangelista in Rimini, see Carlo Valdameri, "Considerazioni sullo scomparso pontile di San Giovanni Evangelista in Rimini e sulla presenza a Rimini di Fra Carnevale," *Romagna Arte e Storia* 31, no. 91 (2011), pp. 5–24. For San Francesco in Bologna, see Cooper, "Recovering the Lost Rood Screens," p. 231. For San Domenico in Bologna, see Cannon, *Religious Poverty*, pp. 36–37.

49 Fabio Massaccesi, "Il 'corridore' della chiesa agostiniana di San Giacomo Maggiore a Bologna: prime ipotesi ricostruttive," *Zeitschrift für Kunstgeschichte* 77, no. 1 (2014), pp. 1–26, especially p. 21.

50 For San Francesco in Milan, San Francesco in Pavia, and San Francesco in Brescia, see Valenzano, "La suddivisione dello spazio," p. 101. For Mantua, see Piva, "Dal setto murario allo jubé," pp. 57–78.

51 Carla Travi, "Antichi tramezzi in Lombardia: il caso di Sant'Eustorgio," *Arte Lombarda, Nuova Serie* 158/159, no. 1–2 (2010), pp. 5–16, especially pp. 7–8.

52 For San Francesco in Bassano, see Valenzano, "La suddivisione dello spazio," p. 106.

53 Tramezzi existed in San Nicolò and San Francesco in Treviso. Ibid., pp. 102, 104.

54 De Marchi has argued that the tramezzo in San Fermo Maggiore in Verona reutilized the facade of the previous church building. Andrea De Marchi, "Due fregi misconosciuti e il problema del tramezzo in San Fermo Maggiore a Verona," in *Arredi liturgici e architettura*, ed. Arturo Carlo Quintavalle (Milan, 2007), pp. 138–39. For Sant'Anastasia in Verona, see Tiziana Franco, "Attorno al 'pontile che traversava la chiesa': spazio liturgico e scultura in Sant'Anastasia," in *La*

Basilica di Santa Anastasia a Verona: storia e restauro, ed. Paola Marini (Verona, 2011), pp. 32–49.

55 The churches of Sant'Agostino, San Lorenzo, and Santa Corona in Vicenza had fourteenth-century screens. Valenzano, "La suddivisione dello spazio," pp. 107–08.

56 San Francesco Grande, Santa Maria dei Carmini, the Eremitani, and the Santo had screens. Ibid., pp. 108–10.

57 Modesti, "I cori nelle chiese veneziane," pp. 39–65.

58 Franco, "Appunti sulla decorazione," pp. 118–26; Franco, "Attorno al 'pontile che traversava la chiesa'," pp. 32–49.

59 Merotto Ghedini, "Il tramezzo nella chiesa dei Santi Giovanni e Paolo a Venezia," pp. 257–62; Franco, "'Item in piscibus pro magistris qui aptaverunt pontem': note sul tramezzo dei Santi Giovanni e Paolo a Venezie," pp. 163–70. See also Julian Gardner, "Sant Antonino, Lorenzo Lotto and Dominican Historicism," in *Ars Naturam Adiuvans: Festschrift für Matthias Winner*, ed. Victoria von Flemming and Sebastian Schütze (Mainz, 1996), pp. 139, 145–46.

60 Merotto Ghedini, *La chiesa di Sant'Agostino in Padova*, pp. 59–64.

61 Eveline Baseggio Omiccioli, "Andrea Riccio's Reliefs for the Altar of the True Cross in Santa Maria dei Servi, Venice: A Political Statement within the Sacred Walls," *Explorations in Renaissance Culture* 38, no. 1–2 (2012), pp. 101–21.

62 For Santa Sabina in Rome, see Joan Barclay Lloyd, "Medieval Dominican Architecture at Santa Sabina in Rome, c. 1219–c. 1320," *Papers of the British School at Rome* 72 (2004), pp. 251–59; Cannon, *Religious Poverty*, p. 36; for San Pancrazio in Rome, see Hueck, "Der Lettner der Unterkirche," pp. 178–79. For Sant'Agostino in Genoa and San Francesco in Udine, see Valenzano, "La suddivisione dello spazio," pp. 101, 106. For San Giacomo in Savona, see Roberto Cobianchi, *Lo temperato uso delle cose: la committenza dell'osservanza francescana nell'Italia del Rinascimento* (Spoleto, 2013), p. 37; Amici di San Giacomo di Savona ODV, "Storia del San Giacomo di Savona," http://amicidelsangiacomo.org/ilsangiacomo/storiadel sangiacomo/.

63 For an overview of church transformations in Naples, see D'Ovidio, "La trasformazione dello spazio liturgico," pp. 93–119. For Santa Chiara in Naples, see Giles, "Medieval Architecture and Technology," pp. 123–60.

64 John McAndrew, *Venetian Architecture of the Early Renaissance* (Cambridge, MA and London, 1980), pp. 56–57; Wolfgang Wolters, *Architektur und Ornament. Venezianischer Bauschmuck der Renaissance* (Munich, 2000), p. 197. See also Julian Gardner, "San Zaccaria and Prophet Dedications in Venetian Churches," in *Der Unbestechliche Blick: Festschrift zu Ehren von Wolfgang Wolters*, ed. Martin Gaier, Bernd Nicolai, and Tristan Weddingen (Trier, 2005), pp. 37–38; Allen, "Choir Stalls," pp. 260–66; Allison Sherman, "'To God Alone the Honour and Glory': Further Notes on the Patronage of Pietro Lombardo's

Choir Screen in the Frari, Venice," *The Burlington Magazine* 156, no. 1340 (2014), pp. 723–28.

65 Hall, "The Ponte in S. Maria Novella," pp. 169–70.

66 Although Augusti proposed that Verrocchio could have carved the crucifix while in Venice in the late 1470s, a lack of documentary evidence hinders attempts at a secure attribution. Adriana Augusti, "Una proposta per Andrea Verrocchio," in *Studi per Pietro Zampetti*, ed. Ranieri Varese (Ancona, 1993), p. 212.

67 For San Michele in Isola, see Matteo Ceriana, "Gli spazi e l'ornamento della chiesa camaldolese di San Michele in Isola," in *San Michele in Isola: Isola della conoscenza: ottocento anni di storia e cultura camaldolesi nella laguna di Venezia. Mostra organizzata in occasione del millenario della Fondazione della congregazione camaldolese*, ed. Marcello Brusegan, Paolo Eleuteri, and Gianfranco Fiaccadori (Turin, 2012), pp. 100–01. For the Venetian *barco* in general, see Modesti, "I cori nelle chiese veneziane," especially p. 40.

68 For example, in San Bernardino a Ivrea, Santa Maria delle Grazie in Varallo, and San Bernardino a Caravaggio. Alessandro Nova, "I tramezzi in Lombardia fra XV e XVI secolo: scena della Passione e devozione francescana," in *Il Francescanesimo in Lombardia: storia e arte*, ed. Arnalda Dallaj (Milan, 1983), pp. 197–215; Imesch Oehry, *Die Kirchen der Franziskanerobservanten*.

69 Nova suggested the frescoes were instrumental in the survival of the screens. Nova, "I tramezzi in Lombardia," p. 197. See also Cobianchi, *Lo temperato uso*, p. 37.

70 Hall disagreed, stating that Italian screens were "found exclusively in monastic churches." Hall, "The Tramezzo in the Italian Renaissance," p. 216. For a different perspective, see Giovanni Lorenzoni and Giovanna Valenzano, *Il duomo di Modena e la basilica di San Zeno* (Verona, 2000), pp. 256, 262.

71 For example, see the Warwick Network for Parish Research: https://warwick.ac.uk/fac/cross_fac/myparish

72 Tiziana Franco, "Sul 'muricciolo' nella chiesa di Sant'Andrea di Sommacampagna 'per il quale restavan divisi gli uomini dalle donne'," *Hortus Artium Medievalium* 14 (2008), pp. 181–92. For another example of a *pieve* with a walled nave choir, see Paolo Piva, "La chiesa di San Fiorentino a Nuvolato (Mantova) e il problema dei 'cori murati' dell'XI secolo," in *Architettura dell'XI secolo nell'Italia del Nord: Storiografia e nuove ricerche. Pavia 8-9-10 aprile 2010 Convegno Internazionale*, ed. Anna Segagni Malacart and Luigi Carlo Schiavi (Pisa, 2013), pp. 91–97, 379–85.

73 Paola Modesti, "I cori nelle chiese parrocchiali veneziane fra Rinascimento e riforma tridentina," in *La place du chœur: architecture et liturgie du Moyen Âge aux Temps modernes: actes du colloque de l'EPHE, Institut national d'histoire de l'art, les 10 et 11 décembre 2007*, ed. Sabine Frommel, Laurent Lecomte, and Raphaël Tassin (Paris and Rome, 2012), pp. 141–53.

74 Filarete, *Filarete's Treatise on Architecture, Being the Treatise by Antonio di Piero Averlino, known as Filarete*, trans. John R. Spencer (New Haven, CT, 1965), vol. 1, p. 135.

75 In San Pietro in Perugia, the remains of a classical style carved choir screen created in 1534 survive attached to the counter-facade of the church, where they were moved in 1592. Gromotka, "Transformation Campaigns," p. 117, note 53. For Vallombrosa Abbey, see Chapter 5 on San Pancrazio. Giles suggested the possibility that remnants of the screen could have been utilized for the raised balcony at the counter facade of Santa Chiara in Naples, although more evidence is needed. Giles, "Medieval Architecture and Technology," pp. 145–47.

76 Anne Markham Schulz, *The Badoer-Giustiniani Chapel in San Francesco della Vigna, Venice* (Florence, 2003).

77 Sarah Blake McHam, "Visualizing the Immaculate Conception: Donatello, Francesco delle Rovere, and the High Altar and Choir Screen at the Church of the Santo in Padua," *Renaissance Quarterly* 69, no. 3 (2016), pp. 831–64.

78 In the 1060s, Milanese cleric Andrea di Strumi wrote: "Chorus namque alti circumdatione muri concluditur, in quo ostium ponitur; visio clericorum laicorumque ac mulierum, quae una erat et communis, dividitur." Piva, "Lo 'spazio liturgico'," p. 155.

79 At the end of the twelfth century, Parisian theologian Prévostin commented that "altius factum fuit peribulum ut nec clerus populum, nec populus clericos videret." Ibid., p. 156.

80 Jung, *The Gothic Screen*, pp. 17–18; Elizabeth Aston, "Segregation in Church," in *Women in the Church: Papers Read at the 1989 Summer Meeting and the 1990 Winter Meeting of the Ecclesiastical History Society*, ed. W. J. Sheils and Diana Wood (Cambridge, MA, 1990), p. 244. In his 1688 *Dissertations ecclésiastiques*, Jean-Baptiste Thiers argued that the obscuring properties of French jubés attracted greater respect for holy mysteries. Thiers, *Dissertations ecclésiastiques*, unpaginated.

81 For example, for the relationship between the screen and Michelangelo's ceiling frescoes in the Sistine Chapel, see Kerr Houston, "The Sistine Chapel Chancel Screen as Metaphor," *Source: Notes in the History of Art* 32, no. 3 (2013), pp. 21–27.

82 Travi, "Antichi tramezzi in Lombardia," p. 8. Similarly, images of Dominican friars also appear on the screen depicted in the degli Erri altarpiece panel.

83 For this phrase, see Cannon, *Religious Poverty*, pp. 25ff.

84 22 October 1565: "ove molte persone divote si ritiravano ad orare." ASF, Manoscritti 128 (Settimanni, *Diario fiorentino*, vol. III), fol. 334r, quoted in Agostino Lapini and Giuseppe Odoardo Corazzini, *Diario Fiorentino di Agostino Lapini: dal 252 al 1596, ora per la prima volta pubblicato* (Florence, 1900), p. 147n.

85 St. Dominic's shrine was originally in San Nicolò in Bologna. The church was later rebuilt and rededicated to San Domenico, which subsequently held the shrine. Cannon, *Religious Poverty*, pp. 36–37, 92, 100. See also Joanna Cannon, "Dominican Shrines and Urban Pilgrimage in Later Medieval Italy," in *Architecture and*

Pilgrimage, 1000–1500: Southern Europe and Beyond, ed. Paul Davies, Deborah Howard, and Wendy Pullan (Farnham, 2013), pp. 143–44. In another example, in Sant'Eustorgio in Milan, the tomb of St. Peter Martyr was located on the lay side of the screen. Cannon, *Religious Poverty*, pp. 43, 100; Travi, "Antichi tramezzi in Lombardia," p. 10, note 36.

86 Hueck, "Der Lettner der Unterkirche," p. 176; Cooper, "'In loco tutissimo et firmissimo'," p. 25.

87 Michele Tomasi, "Memoria dei vescovi e libertas Ecclesiae: il perduto monumento funerario del beato Bartolomeo da Breganze in Santa Corona a Vicenza," in *Medioevo: immagine e memoria. Atti del convegno internazionale di studi, Parma, 23–28 settembre 2008*, ed. Arturo Carlo Quintavalle (Milan, 2009), p. 437; Joanne Allen, "Giovanni Bellini's *Baptism of Christ* in Its Visual and Devotional Context: Transforming Sacred Space in Santa Corona in Vicenza," *Renaissance Studies* 27, no. 5 (2013), p. 683.

88 Cornelison likened these two figures and noted that laywomen in particular were allowed access to their shrines. Sally J. Cornelison, "Accessing the Holy: Words, Deeds, and the First Tomb of St. Antoninus in Renaissance Florence," in *Mendicant Cultures in the Medieval and Early Modern World: Word, Deed, and Image*, ed. Sally J. Cornelison, Nirit Ben-Aryeh Debby, and Peter F. Howard (Turnhout, 2016), especially p. 233.

89 Adrian Randolph, "Regarding Women in Sacred Space," in *Picturing Women in Renaissance and Baroque Italy*, ed. Geraldine A. Johnson and Sara F. Matthews Grieco (Cambridge, 1997), p. 32.

90 Russo, "Lo scomparso jubé," pp. 13–14.

91 Jacqueline E. Jung, "Seeing through Screens: The Gothic Choir Enclosure as Frame," in *Thresholds of the Sacred: Architectural, Art Historical, Liturgical, and Theological Perspectives on Religious Screens, East and West*, ed. Sharon E. J. Gerstel (Washington, DC, 2006), pp. 185–215.

92 Miri Rubin, *Corpus Christi: The Eucharist in Late Medieval Culture* (Cambridge, 1991), pp. 55–63; Massaccesi, "Il 'corridore'," p. 25. The 1249 Dominican general chapter specified that screens could be equipped with apertures which would allow the laity to view the Host at the mystical moment of the elevation. Cannon, *Religious Poverty*, p. 25.

93 For surviving choir doors, see Allen, "Choir Stalls," p. 104.

94 David Rosand, "Titian in the Frari," *The Art Bulletin* 53, no. 2 (1971), pp. 196–200.

95 Allen, "Choir Stalls," p. 267.

96 Peter Humfrey, "Cima da Conegliano, Sebastiano Mariani, and Alvise Vivarini at the East End of S. Giovanni in Bragora in Venice," *The Art Bulletin* 62, no. 3 (1980), p. 358. Whereas Humfrey characterized the screen as a low parapet, Modesti argued that it was a wall higher than eye level, with an arched opening surmounted by a wooden crucifix, the whole ensemble perhaps inspired by the Frari in Venice. Modesti, "I cori nelle chiese parrocchiali," pp. 145–47.

97 In the English context, Huitson characterized both cathedral pulpitums and parish rood lofts as multifunctional spaces that variously housed organs, clocks, lights, draperies, and stored miscellaneous items. Toby Huitson, *Stairway to Heaven: The Functions of Medieval Upper Spaces* (Oxford, 2014), pp. 71–72, 82, 87, 98, 151–52.

98 Jacqueline E. Jung, "Beyond the Barrier: The Unifying Role of the Choir Screen in Gothic Churches," *The Art Bulletin* 82, no. 4 (2000), pp. 622–57; Jung, *The Gothic Screen*; Jacqueline E. Jung, "Moving Pictures on the Gothic Choir Screen," in *The Art and Science of the Church Screen in Medieval Europe: Making, Meaning, Preserving*, ed. Spike Bucklow, Richard Marks, and Lucy Wrapson (Woodbridge, 2017), pp. 176–94.

99 The English term *rood* has the same linguistic derivation as the Old Dutch and Old Saxon terms *ruoda*, meaning *rod* or *pole*, and by extension the crossbar of the cross upon which Jesus was crucified. For the placement of crucifixes in the Italian church interior, see in particular Cooper, "In Medio Ecclesiae," pp. 124–45. On painted crucifixes, see also Joanna Cannon, "The Era of the Great Painted Crucifix: Giotto, Cimabue, Giunta Pisano, and Their Anonymous Contemporaries," *Renaissance Studies* 16, no. 4 (2002), pp. 571–81.

100 Timothy M. Thibodeau, *The Rationale Divinorum Officiorum of William Durand of Mende: A New Translation of the Prologue and Book One* (New York, 2010), p. 22.

101 Gaston, "Sacred Place and Liturgical Space," p. 338.

102 Ibid., p. 336.

103 Bruzelius, *Preaching, Building, and Burying*, p. 97.

104 Donal Cooper, "Projecting Presence: The Monumental Cross in the Italian Church Interior," in *Presence: The Inherence of the Prototype within Images and Other Objects*, ed. Robert Maniura and Rupert Shepherd (Aldershot, 2006), pp. 51–52.

105 For the Del Tasso family of woodworkers, see Gaetano Milanesi, *Sulla storia dell'arte toscana, scritta vari* (Soest, 1973), pp. 343–51; Francesco Traversi, "Per i Del Tasso: il crocifisso di San Pancrazio, da Firenze a Fossato e una nota su Benedetto da Maiano," *Prato storia e arte* 113 (2013), pp. 95–103. Paatz and Paatz mistakenly dated the woodwork to 1488. Walter Paatz and Elisabeth Valentiner Paatz, *Die Kirchen von Florenz, ein Kunstgeschichtliches Handbuch* (Frankfurt am Main, 1952), vol. 4, p. 573.

106 Cooper, "In Medio Ecclesiae," pp. 126–30, 132–41; De Marchi, "'Cum dictum opus sit magnum'," pp. 603–21; De Marchi, *La pala d'altare*, pp. 41–63; Cooper, "Redefining the Altarpiece," pp. 686–713.

107 See Chapter 6 for archival evidence relating to iron rings in San Pier Maggiore.

108 Stubs of the beam still exist in the side walls. The crucifix was supported by a base bracket and a chain attached to the nave vault. Donal Cooper and Janet Robson, *The Making of Assisi: The Pope, the Franciscans, and the Painting of the Basilica* (New Haven, CT, 2013), pp. 63–74.

109 De Marchi, *La pala d'altare*, p. 48.

110 Jung, *The Gothic Screen*, pp. 47, 63. Cannon surmised that the chapel dedicated to the Virgin Mary on Dominican screens served as a lay altar for the distribution of communion. Cannon, *Religious Poverty*, p. 75. Available evidence suggests that the only screen altar in Florence dedicated to the Holy Cross was in San Marco (see Chapter 3).

111 Cooper, "Projecting Presence," pp. 55–56.

112 *Codice Rustici: dimostrazione dell'andata o viaggio al Santo Sepolcro e al monte Sinai di Marco di Bartolomeo Rustici* (Florence, 2015), p. 129. The wooden carved crucifix was eventually translated from San Miniato to Santa Trinita on the order of Grand Duke Cosimo III in 1671 (see Chapter 5).

113 Bacci, *Lo spazio dell'anima*, p. 83; Arlotto Mainardi and Gianfranco Folena, *Motti e facezie del piovano Arlotto* (Milan and Naples, 1953), facezia 93.

114 Jung noted that the importance of the space in front of the screen is also manifested in northern European paintings; for example, Rogier van der Weyden's *Altarpiece of Seven Sacraments*, dated 1453–55. Jung, "Beyond the Barrier," pp. 629–30.

115 Hall, "The Ponte in S. Maria Novella," pp. 161–62. Bruzelius has shown the importance of lay burials in the expansion of large-scale mendicant churches more generally. Bruzelius, *Preaching, Building, and Burying*, especially p. 97. For the English context, see Richard Marks, "'To the Honour and Pleasure of Almighty God, and to the Comfort of the Parishioners': The Rood and Remembrance," in *Image, Memory and Devotion: Liber Amicorum Paul Crossley*, ed. Zoe Opačić and Achim Timmermann (Turnhout, 2011), p. 218. Sally J. Cornelison, "Relocating Fra Bartolomeo at San Marco," *Renaissance Studies* 23, no. 3 (2009), p. 316; Cornelison, "Accessing the Holy," p. 225. Antoninus was originally interred to the left of the choir entrance.

116 Bacci, *Lo spazio dell'anima*, p. 81. Nirit Ben-Aryeh Debby, *The Renaissance Pulpit: Art and Preaching in Tuscany, 1400–1550* (Turnhout, 2007), p. 55. For medieval pulpits and their origins, see Adriani Götz, "Der Mittelalterliche Predigtort und seine Ausgestaltung" (PhD thesis, Eberhard-Karls-Universität zu Tübingen, 1966).

117 Double pulpits, created in 1514, also existed on the screen in San Pietro in Perugia. Gromotka, *Die Geschichte der Kirchenausstattung*, vol. 1, p. 639.

118 Arnaldo Morelli, "'Sull'organo et in choro': Spazio architettonico e prassi musicale nelle chiese italiane durante il Rinascimento," in *Lo spazio e il culto: relazioni tra edificio ecclesiale e uso liturgico dal XV al XVI secolo*, ed. Jörg Stabenow (Venice, 2006), p. 213. Organs also existed on the screen in San Pietro in Perugia. Gromotka, *Die Geschichte der Kirchenausstattung*, vol. 1, p. 619.

119 Arnaldo Morelli, "Per ornamento e servicio: Organi e sistemazioni architettoniche nelle chiese toscane del Rinascimento," *I Tatti Studies in the Italian Renaissance* 7 (1997), p. 282.

120 Bruzelius, "The Tramezzo of Sta. Chiara," pp. 952–54. Cobianchi noted that altars attached to the tramezzo were "luoghi privilegiati." Cobianchi, *Lo temperato uso*, p. 28. Cannon called the site between the screen and the friars' choir in Santa Maria Novella "an additional, privileged lay zone." Cannon, *Religious Poverty*, p. 322.

121 For altars, altarpieces, and their tituli in general, see Julian Gardner, "Altars, Altarpieces and Art History: Legislation and Usage," in *Italian Altarpieces 1250–1550: Function and Design*, ed. Eve Borsook and Fiorella Superbi Gioffredi (Oxford, 1994), pp. 5–39.

122 Andrea De Marchi has analyzed the discontinuities in nave wall paintings to determine the locations of tramezzi. De Marchi, "Due fregi misconosciuti," pp. 129–42; Andrea De Marchi, "Il 'podiolus' e il 'pergolum' di Santa Caterina a Treviso: cronologia e funzione delle pitture murali in rapporto allo sviluppo della fabbrica architettonica," in *Medioevo: arte e storia*, ed. Arturo Carlo Quintavalle (Milan, 2008), pp. 385–407. Gromotka argued that it is vital to research the spatial transformations in a holistic way together with the artistic treatment of surfaces throughout the church interior. See Gromotka, "Transformation Campaigns," pp. 79–125.

123 Cooper, "Recovering the Lost Rood Screens," p. 239.

124 Giorgio Vasari, Rosanna Bettarini, and Paola Barocchi, *Le vite de' più eccellenti pittori scultori e architetti*, 8 vols. (Florence, 1966–87), vol. 3, p. 600. Gloria Fossi termed the arrangement of altarpieces and crucifix "a trilogy of the Passion." Gloria Fossi, *Uffizi: Art, History, Collections* (Florence and Hove, 2008), p. 310. Paatz and Paatz dated the two panels to 1495/97. Paatz and Paatz, *Kirchen von Florenz*, vol. 2, pp. 277–78.

125 The *Nativity* was donated by the Florentine Bartoli family and the *Sepulcher of Christ* was donated by the Florentine Rucellai family. They have been variously attributed to Andrea, Luca, Giovanni, or Francesco Della Robbia. Miller believed that Andrea was not involved in these altarpieces. Stephanie R. Miller, "Andrea della Robbia and His La Verna Altarpieces: Context and Interpretation" (PhD thesis, Indiana University, 2003), pp. 19, 143, note 116. See Tommaso Paloscia, Fabio Bernacchi, and Piero Bargellini, *Le Robbiane della Verna* (Sacro Monte della Verna, 1986), pp. 38, 42.

126 Miller noted that his engravings are renowned to contain inaccuracies. Miller, "Andrea della Robbia," p. 165, note 177. See Lino Moroni et al., *Descrizione del Sacro Monte della Vernia* (Florence, 1612), unpaginated. For Ligozzi's engravings of the monastery, see Lucilla Conigliello, *Le vedute del Sacro Monte della Verna: Jacopo Ligozzi pellegrino nei luoghi di Francesco* (Florence, 1999).

127 Vasari recorded these commissions in his Ricordanze 1527–73, fols. 8r–9r. Giorgio Vasari, *Ricordanze 1527–73* (Fondazione Memofonte, 2006), www.memofonte.it/autori/giorgio-vasari-1511-1574.html.

128 See also San Pietro in Perugia, where a pictorial scheme of the lives of SS Peter and Paul adorned the screen in the 1540s. Gromotka, *Die Geschichte der Kirchenausstattung*, vol. 1, pp. 640–41.

129 Bram Kempers, *Painting, Power and Patronage: The Rise of the Professional Artist in the Italian Renaissance*, trans. Beverley Jackson (London, 1994), pp. 44–53; Irene Hueck, "Le opere di Giotto per la chiesa di Ognissanti," in *La "Madonna di'Ognissanti" di Giotto restaurata* (Florence, 1992), pp. 37–49; De Marchi, *La pala d'altare*, especially pp. 43–54; De Marchi, "'Cum dictum opus sit magnum'," pp. 603–21; Cooper, "Redefining the Altarpiece," pp. 686–713.

130 "posta nel tramezzo di detta chiesa a man destra." Vasari et al., *Le vite*, vol. 2, part 1, p. 234. See also De Marchi, "'Cum dictum opus sit magnum'," p. 615; Maria Bandini, "Vestigia dell'antico tramezzo nella chiesa di San Remigio a Firenze," *Mitteilungen des Kunsthistorischen Institutes in Florenz* 54, no. 2 (2010–12), p. 221.

131 Bandini, "Vestigia dell'antico tramezzo," pp. 221–26.

132 Jung, "Beyond the Barrier"; Cannon, *Religious Poverty*, especially pp. 299–303.

133 Henri Lefebvre, *The Production of Space*, trans. Donald Nicholson-Smith (Malden, MA and Oxford, 1991), p. 87.

134 Cooper, "Recovering the Lost Rood Screens," p. 238.

135 Liber Tertius, Titulus I. De vita et honestate clericorum, Caput I: "Peccatum mortaliter non est, si inter clericos staret laicus, maximè ubi non est contraria consuetudo." *Commentaria Innocentii quarti pont. maximi super libros quinque decretalium* (Frankfurt, 1570), p. 348. "Gloss: Laici prope altare vel in choro dum officia celebrantur, stare non debent, sed causa orandi ire vel accedere possunt, hoc dicit. … Casus. Dicitur in hoc capitulo, quod laici non debent sedere in choro inter clericos, quando cantantur divina officia, sed in sancta sanctorum. Nota, quod laici inter clericos sedere non debent." *Corpus juris canonici emendatum et notis illustratum. Gregorii XIII. pont. max. iusslu. editum* (Rome, 1582), Part II: Decretales d. Gregorii papae IX, col. 991. References from Sonia Chiodo, "Uno sguardo indietro sul filo dalla memoria: la chiesa degli Umiliati nel età gotica," in *San Salvatore in Ognissanti: la chiesa e il convento*, ed. Riccardo Spinelli (Florence, 2018), p. 54.

136 "layci non debent stare vel sedere in choro clericorum ad divinum Officium." *Il "Liber Ordinarius" della chiesa padovana*, vol. 27, Fonti e ricerche di storia ecclesiastica padovana (Padua, 2002), p. 199.

137 "Item ut in choro omnes [the canons] a confabulationibus temperent et maxime laichorum." Cosimo Damiano Fonseca, "Vescovi, capitoli cattedrali e canoniche regolari," in *Vescovi e diocesi in Italia dal XIV alla metà del XVI secolo. Atti del VII convegno di storia della chiesa in Italia (Brescia, 21–25 settembre 1987)*, ed. Giuseppina de Sandre Gasparini (Rome, 1990), p. 112.

138 "Item habet immunitatem quod in choro non debent morari laici cum clericis." St. Antoninus of Florence, *Summa Theologica* (Nuremberg, 1486), Titulus 12, chapter 3. Gaston, "Sacred Place and Liturgical Space," p. 338.

139 "E a di 8 (agosto) a 1° figlio che reco le spallere del sassetto s. 14"; "A a di 13 a lorenzo di mser Giovanni peroni s. 4 per rappichare 4 armi alle spalliere dell'arte della lana che simissono incoro l. 4"; "E adi 18 [luglio 1488] s. quattro per fare rimendare la spalliera di ms girolamo giugni." Archivio di San Lorenzo 1931³, 1488, fol. 50v (not consulted by the present author). Riccardo Pacciani, "Cori, tramezzi, cortine, vele nello spazio interno di San Lorenzo," in *San Lorenzo: A Florentine Church*, ed. Robert W. Gaston and Louis Alexander Waldman (Florence, 2017), p. 326, note 70.

140 Sanudo described the funeral of Bartolomeo D'Aviano in November 1515 in Santo Stefano thus: "e posta le cassa in chiesa soto il baldachin, et reduto de more la Signoria in choro." Marino Sanudo, *I diarii di Marino Sanuto* (Bologna, 1969), vol. 21, column 276.

141 David Summers, *Real Spaces: World Art History and the Rise of Western Modernism* (London and New York, 2003), p. 24. General scholarship on gender, space, and architecture includes: Massey, *Space, Place, and Gender*; Iain Borden, Barbara Penner, and Jane Rendell, *Gender Space Architecture: An Interdisciplinary Introduction* (London, 1999).

142 Aston, "Segregation," p. 244.

143 Thibodeau, *Rationale Divinorum Officiorum*, p. 24. See also Randolph, "Regarding Women," p. 28.

144 Indeed, Hall noted that "[r]ecent research makes it clear that segregation of the sexes was an important part of the tramezzo's raison d'être." Hall, "Another Look at the Rood Screen." According to Vasari, Fra Bartolomeo's *St. Sebastian* panel painting was removed from the choir screen in San Marco in Florence because its lifelike nudity prompted laywomen awaiting confession to have sinful thoughts, emphasizing that screens were a site for female viewership. Both Cox-Rearick and Cornelison believed this story was fabricated. Janet Cox-Rearick, "Fra Bartolomeo's St. Mark Evangelist and St. Sebastian with an Angel," *Mitteilungen des Kunsthistorischen Institutes in Florenz* 18, no. 3 (1974), p. 340 (note 35), p. 350. Cornelison, "Relocating Fra Bartolomeo," note 35.

145 "Habent autem omnes tam magnae quam parvae ecclesiae in medio murum cancellorum quibus separantur a mulieribus viri totum solidum sine foraminibus vel fenestris, unde non possunt mulieres altare videre nisi per unum ostium in medio in parvis ecclesiis, in maioribus vero per tria ostia, quae cum necesse fuerit possunt claudi valvis, celebratis officiis." Opicinus De Canistris, *Liber de laudibus civitatis Ticinensis que dicitur Papia*, ed. Dino Ambaglio (Pavia, 2004), p. 44; Travi, "Antichi tramezzi in Lombardia," p. 5, note 5; Cooper, "Recovering the Lost Rood Screens," p. 235, note 59.

146 For example, in the *pieve* of Sant'Andrea di Sommacampagna, near Verona, an eighteenth-century text described "vi era un muricciolo, per il quale restavan divisi gli uomini dalle donne." Franco, "Sul 'muricciolo'," pp. 184–86. Zuleika Murat showed that the function of the tramezzo in the *pieve* of Santa Giustina in Monselice was to divide the interior space "in locum masculorum et feminarum," according to the Pastoral Visitation records of the bishop of Padua, Pietro Barozzi, in 1489. Zuleika Murat, "Il podium della pieve di Monselice nella

descrizione di Pietro Barozzi," *Musica e Figura* 1 (2011), pp. 87–117.

147 *Die Kirchen von Siena* (Munich, 1985–99), eds. Peter Anselm Riedl and Max Seidel, vol. 1, p. 162, cited by Hueck, "Le opere di Giotto," p. 41.

148 "1386 D. Franciscus Bruni fecit test. sepeliatur in tumulo suorum in Ecclesia Sce. Crucis fratrum minorum de Florentia iuxta portam que est propinqua choro et dividit locum hominum a loco mulierum." Hall, "The Tramezzo in Santa Croce," p. 339, note 47. Erik Gustafson, however, has suggested that the genders were divided longitudinally, at least during liturgical services, with the men on the south and the women on the north, where more chapels were dedicated to saints with female associations. Erik D. Gustafson, "Tradition and Renewal in the Thirteenth-Century Franciscan Architecture of Tuscany" (PhD thesis, Institute of Fine Arts, New York University, 2012), pp. 288–92.

149 In his chronicle of 1586, Fra Modesto Biliotti wrote: "quo mares secernerentur a foeminis dum sacris adstarent." "Venerabilis Coenobii: Sanctae Mariae Novellae de Florentia: Chronica," *Analecta Sacri Ordinis Fratrum Praedicatorum* 9 (1909), p. 200.

150 "O si venerint monachi, et invenerint me hic stantem, quantam inferent mihi injuriam?" *Acta Sanctorum Maii, Tomus VII* eds. Godefroid Henschen, Daniel Van Papenbroeck, François Baert, and Conrad Ianningus (Antwerp, 1688), p. 171 (Die XXIX, Caput III, section 32). Bacci, *Lo spazio dell'anima*, pp. 118–19. For women punished for crossing thresholds in twelfth-century Durham Cathedral in England, see Jane Tibbetts Schulenburg, "Gender, Celibacy, and Proscriptions of Sacred Space: Symbol and Practice," in *Medieval Purity and Piety: Essays on Medieval Clerical Celibacy and Religious Reform*, ed. Michael Frassetto (New York and London, 1998), pp. 358–60.

151 Cannon, *Religious Poverty*, p. 43.

152 Hayden B. J. Maginnis, "Lay Women and Altars in Trecento Siena," *Source: Notes in the History of Art* 28, no. 1 (2008), p. 6.

153 Ena Giurescu Heller, "Access to Salvation: The Place (and Space) of Women Patrons in Fourteenth-Century Florence," in *Women's Space: Patronage, Place and Gender in the Medieval Church*, ed. Virginia Chieffo Raguin and Sarah Stanbury (Albany, NY, 2005), pp. 176, 182, note 68. Cornelison, "Accessing the Holy," pp. 223–44, esp. 235, note 34. Giuseppe Richa, *Notizie istoriche delle chiese fiorentine, divise ne' suoi quartieri* (Florence, 1754–62), vol. 1, p. 72.

154 Corine Schleif, "Men on the Right – Women on the Left: (A)symmetrical Spaces and Gendered Places," in *Women's Space: Patronage, Place and Gender in the Medieval Church*, ed. Virginia Chieffo Raguin and Sarah Stanbury (Albany, NY, 2005), pp. 212–13.

155 Aston, "Segregation," pp. 271–74.

156 Schleif, "Men on the Right," pp. 229–30; Roberta Gilchrist, *Gender and Material Culture: The Archaeology of Religious Women* (London and New York, 1994), pp. 128–49.

157 Hall, "The Tramezzo in the Italian Renaissance," p. 221.

158 Florence, Archivio dell'Opera del Duomo, vii, i, 5 (Debitori e creditori, sommario ..., 1476), fol. 177, quoted in Natalie Tomas, "Did Women have a Space?," in *Renaissance Florence: A Social History*, ed. Roger J. Crum and John T. Paoletti (New York, 2006), p. 319. Archival reference not consulted by the present author.

159 See Theresa Flanigan, "Ocular Chastity: Optical Theory, Architectural Barriers and the Gaze in the Renaissance Church of San Marco in Florence," in *Beyond the Text: Franciscan Art and the Construction of Religion* (St. Bonaventure, NY, 2013), p. 47.

160 Randolph, "Regarding Women," p. 21; Catherine Lawless, "Representation, Religion, Gender and Space in Medieval Florence," in *Ritual and Space in the Middle Ages: Proceedings of the 2009 Harlaxton Symposium*, ed. Frances Andrews (Donington, 2011), pp. 240–41.

161 Interestingly, women stood on the left and men on the right as they were facing the counter-facade balcony. William Wallace, "Michelangelo's Project for a Reliquary Tribune in San Lorenzo," *Architectura* 17, no. 1 (1987), pp. 45–46. I am grateful to Sally Cornelison for bringing this material to my attention.

162 "situm iuxta et seu prope ianuam existentem in medio dicte ecclesie extra et prope chorum, et per quam itur in chorum dicte ecclesie." From a testament of Filippo di M. Castellano Frescobaldi in 1420, quoted in Mario Bori, "'L'Annunziazione' di Piero del Donzello in una cappella Frescobaldi nella chiesa di Santo Spirito," *Rivista d'Arte* 4 (1906), pp. 117–18, note 1.

163 Nerida Newbigin, *Feste d'Oltrarno: Plays in Churches in Fifteenth-Century Florence*, Istituto nazionale di studi sul Rinascimento Studi e Testi XXXVII (Florence, 1996), p. 163, note 27.

164 According to Lorenzoni and Valenzano, this miniature replicates the old church of Santa Giustina. Lorenzoni and Valenzano, *Il duomo di Modena*, p. 253 and image on p. 261, fig. 252. See also Massimo Bisson, "Controriforma e spazio liturgico: i cori della Basilica di Santa Giustina di Padova," *Atti dell'Istituto Veneto di Scienze, Lettere ed Arti* 172 (2013–14), p. 464. For Benedetto Bordon, see Lilian Armstrong, "Benedetto Bordon and the Illumination of Venetian Choirbooks around 1500: Patronage, Production, Competition," in *Wege zum illuminierten Buch: Herstellungsbedingungen für Buchmalerei in Mittelalter und früher Neuzeit*, ed. Christine Beier and Evelyn Theresia Kubina (Vienna, 2014), pp. 221–44.

165 Jung noted that the popular Augustinian preacher, Gottschalk Hollen, cited the proverbial phrase, "the worse the whore, the closer she stands to the choir." Jung, "Beyond the Barrier," p. 628.

166 Hall, "The Tramezzo in the Italian Renaissance," p. 221; Hall, "Another Look at the Rood Screen"; Giurescu Heller, "Access to Salvation," esp. p. 176; Randolph, "Regarding Women," p. 34. Gaston, "Sacred Place and Liturgical Space," p. 336. See also, Cannon, *Religious*

Poverty, pp. 43, 167; Cornelison, "Accessing the Holy," pp. 229–37. Schmid disagreed, arguing that women would have very seldom been allowed to visit chapels beyond the screen in Santa Maria Novella. Josef Schmid, *Et pro remedio animae et pro memoria: bürgerliche repraesentatio in der Cappella Tornabuoni in S. Maria Novella* (Munich, 2002), p. 158.

167 Cooper, "Access All Areas?," pp. 100–07. However, Burke noted that the evidence for women venturing beyond the tramezzo screen is "patchy and sometimes contradictory." Jill Burke, *Changing Patrons: Social Identity and the Visual Arts in Renaissance Florence* (University Park, PA, 2004), p. 120.

168 *Sassetta: The Borgo San Sepolcro Altarpiece*, ed. Machtelt Israëls (Florence and Leiden, 2009), vol. 1, p. 129.

169 Haines, *Sacrestia delle Messe*, p. 30.

170 In the northern European context, Jung argued that painters incorporated screens, doors, and windows in their religious works partly as a response to the "modes and habits of looking" viewers experienced in the church context. Jung, *The Gothic Screen*, p. 4.

171 According to Bacci, this panel shows in abbreviated terms a common wooden choir of late Middle Ages, situated between the body of the church and the presbytery complete with a lectern, simple stalls, and a screen pierced by a Gothic archway. Bacci, *Lo spazio dell'anima*, p. 118. See also Cobianchi, *Lo temperato uso*, p. 27. Machtelt Israëls noted that the church interior does not resemble San Francesco in Borgo Sansepolcro, which featured a retrochoir, but it could show a generic Franciscan church or indeed San Francesco at Citerna. Israëls, *Sassetta*, vol. 2, p. 429.

172 See Cooper and Robson, *The Making of Assisi*, pp. 177–80.

173 Janet Robson, "Assisi, Rome and the Miracle of the Crib at Greccio," in *Image, Memory and Devotion: Liber Amicorum Paul Crossley*, ed. Zoe Opačić and Achim Timmermann (Turnhout, 2011), p. 147.

174 Mulvaney argued that the women's obscured view paralleled the experience of reading religious meditations, which similarly deny visual access. Beth A. Mulvaney, "The Beholder as Witness: The Crib at Greccio from the Upper Church of San Francesco, Assisi and Franciscan Influence on Late Medieval Art in Italy," in *The Art of the Franciscan Order in Italy*, ed. William R. Cook (Leiden, 2005), pp. 184–85.

175 Robson, "Assisi, Rome," p. 149. The Lower Church tramezzo featured marble panels and Cosmati work, fragments from which are variously located throughout the Assisi complex. Hueck, "Der Lettner der Unterkirche," pp. 173–202; Cooper, "'In loco tutissimo et firmissimo'," pp. 26–27.

176 Robson, "Assisi, Rome," p. 155.

177 Matteo Ceriana, "Fra Carnevale and the Practice of Architecture," in *From Filippo Lippi to Piero della Francesca: Fra Carnevale and the Making of a Renaissance Master*, ed. Keith Christiansen (New York; Milan; New Haven, CT and London, 2005), pp. 119–22. Valdameri hypothesized that if the painting were dated c. 1475, Fra Carnevale's tramezzo could have been inspired by one recently constructed (after 1468) in San Giovanni Evangelista in Rimini, which also featured four attached altars. Valdameri, "Considerazioni sullo scomparso pontile," pp. 20–24.

178 Alberto Mario Chiodi, "Bartolomeo degli Erri e i politici domenicani," *Commentari* 2 (1951), pp. 17–25; Daniele Benati, *La bottega degli Erri e la pittura del Rinascimento a Modena* (Modena, 1988), pp. 69–75, 140. The degli Erri workshop also produced a high altarpiece and three further altarpieces for tramezzo altars in San Domenico, as described by Vasari: "la prima è all'altare maggiore di S. Domenico, e l'altre alle cappelle che sono nel tramezzo di quella chiesa." Vasari et al., *Le vite*, vol. 5, p. 420.

179 Cannon noted that roundels also feature on the Guebwiller screen in Alsace and in a description of the screen in Sant'Eustorgio in Milan. Cannon, *Religious Poverty*, p. 40.

180 Patricia Fortini Brown, *Venetian Narrative Painting in the Age of Carpaccio* (New Haven, CT, 1988), pp. 186–89.

181 Caterina Sandrelli, "Sant'Antonio di Castello: una chiesa scomparsa a Venezia," *Arte Documento* 9 (1996), pp. 162–63.

182 For the eye-witness style, see Brown, *Venetian Narrative Painting*.

183 Nathaniel Silver, "'Cum signo T quod potentiam vocant': The Art and Architecture of the Antonite Hospitallers in Trecento Venice," *Mitteilungen des Kunsthistorischen Institutes in Florenz* 58, no. 1 (2016), pp. 41–42; hypothetical plan based on a 1369 inventory on p. 45. The medieval screen was later replaced by a classical stone *barco* designed by Sebastiano da Lugano and still in the process of construction in 1534, known from a remarkable surviving drawing of an early conception, and an eighteenth-century architectural plan and elevation. For the stone *barco*, see Sandrelli, "Sant'Antonio di Castello," pp. 163–64; Antonio Foscari and Manfredo Tafuri, "Sebastiano da Lugano, i Grimani e Jacopo Sansovino. Artisti e committenti nella chiesa di Sant'Antonio di Castello," *Arte Veneta* 36 (1982), pp. 104–07.

Chapter 2

TRANSFORMING CHURCHES IN FIFTEENTH-CENTURY FLORENCE

T HE FLORENTINE CHURCH ALTERATIONS of the 1560s and 1570s, which disrupted the careful spatial arrangements analyzed in Chapter 1, represent just one significant episode in a checkered history of adapting, renovating, and reutilizing sacred space in Italy. With considerable variation across geographical regions, transformations that involved the removal of screens and the transferal of nave choir precincts to areas behind the high altar appear to have gained momentum in the late fifteenth century and early sixteenth century, becoming more normative toward the end of the sixteenth century. In Florence, fifteenth-century architects such as Brunelleschi created unified church interiors with innovative centralized choirs and retrochoirs that contrasted with the predominant nave choir and tramezzo model. These new spatially unified and stylistically consistent interiors provided important precedents for the major church renovations of the second half of the sixteenth century, which continued to change the face of the Florentine religious architectural landscape.

Although choir precincts were primarily destined for the exclusive use of the church community, this chapter will show how closely these spaces intertwined with the demands of lay patronage. The laity financed the construction of choir stalls and retrochoirs, and endowed chapels attached to the screen. Whether motivated by genuine piety or a desire to increase cultural capital, their involvement complicates our understanding of the dynamics of sacred space and challenges the restrictive interpretation of the church interior as a physical expression of religious and social hierarchy.

MEDIEVAL FLORENCE

In Florence, the only liturgical choir still surviving in close approximation to its medieval form is in the Romanesque basilica of San Miniato al Monte, which was administered by Benedictine monks until its transfer to the Olivetans in 1373 (Figure 18). In the eleventh-century church, the raised presbytery comprised the entire last bay of the nave, elevated some 3.4 m above the main level of the nave, with the crypt below. On the raised presbytery, a marble screen, 3 m high, encloses the monks' choir; its geometric and figural designs date it to between c. 1175 and 1207, while the pulpit on the right side is dated a few years later.[1] Despite alterations and damages after the Olivetans abandoned the basilica in 1553, the extant wooden choir stalls are still arranged in two rows in a U-shaped formation in the presbytery.[2] They were commissioned from Giovanni di Domenico da Gaiuole and Francesco

di Domenico detto Monciatto in 1466 (Figure 41).[3] The alternating intarsia panels on the stall-backs depict palm leaves to signify the martyrdom of San Miniato, and a design featuring a crown and olives, in reference to the Olivetans. The Arte di Calimala, the guild of cloth finishers and merchants in foreign cloth who were patrons of the basilica and likely financers of the precinct, included their coat of arms on two seats of larger dimensions in the corner of each range.[4]

Other local examples of this combination of raised choir, presbytery, and screen (*pontile*) included San Pier Scheraggio and the Badia a Settimo[5], and beyond Florence in Modena Cathedral and San Zeno in Verona.[6] Creating a hierarchical, elevated separation of clergy and laity echoed by accompanying imagery, this formation facilitated circulation through the crypt even while services were taking place above.

In the fourteenth and early fifteenth centuries, most churches in Florence featured prominently

Figure 41 Giovanni di Domenico da Gaiuole and Francesco di Domenico detto Monciatto, *Choir Stalls*, 1466, San Miniato al Monte, Florence. Photo: author

placed choirs in the nave accompanied by screens of varying scales and types that often housed chapels, tombs, and paintings. Nave choirs accompanied by vaulted architectural tramezzi were present in Santa Croce, Santa Maria Novella, Santa Maria del Carmine, and possibly Santissima Annunziata, and less imposing wall-like screens bisected the naves of San Niccolò Oltrarno and Ognissanti. Other churches featured nave choirs, but the presence and type of screen cannot be securely documented: these include Santa Maria del Fiore, Santo Spirito, San Pancrazio (see Chapter 5), San Pier Maggiore (see Chapter 6), Santi Simone e Giuda,[7] the Badia Fiorentina,[8] Santo Stefano,[9] San Remigio,[10] and Santa Trinita (see Chapter 5), and possibly also Sant'Egidio (church of the Santa Maria Nuova hospital),[11] San Lorenzo, San Paolino,[12] and Cestello.

QUATTROCENTO FLORENCE: CENTRALIZED CHOIRS

The centralized church design was an important goal of Renaissance architectural theorists. In the treatises of Alberti and Francesco di Giorgio Martini, and the sketchbooks of Leonardo da Vinci, round buildings were hailed as exemplifying perfection and harmony.[13] Giovanni Leoncini argued for the symbolic importance of centralized choirs placed directly beneath domes: the circular form echoed early Christian martyria and mausolea and the Anastasis rotunda of the Holy Sepulcher in Jerusalem, the traditional site of Christ's burial, and so by extension recalled the resurrection and the Eucharist. Moreover, he argued, the canopy motif of the dome itself alluded to holiness, and the combination of choir and high altar in a prominent location symbolized the beating heart of the church.[14] However, Roberto Pacciani noted that despite the high regard for centralized plans among Renaissance architectural theorists,

their unsuitability for the practical demands of the liturgy caused significant problems.[15] The prolonged and tortuous vicissitudes of the centralized plan for New St. Peter's in Rome exemplify this dilemma.[16] Two Brunelleschian projects in Florence, in Santa Maria del Fiore and Santo Spirito, incorporated compromise solutions that saw centralized choir precincts placed in the crossings of longitudinal church buildings.

Santa Maria del Fiore

In the small, Romanesque cathedral of Santa Reparata, the canons' choir was situated in a raised presbytery above a crypt.[17] The bishop and canons sat in the apse behind the high altar, from where they could view the reverse side of the double-sided Santa Reparata altarpiece, attributed to the workshop of Giotto, c. 1310–12.[18] The nave of the new Duomo, begun by Arnolfo di Cambio in 1296, was complete by 1378, and during the construction period the canons utilized a temporary choir in a separate building.[19] A wooden partition blocked off construction to the east, and in 1380 a choir precinct was erected in the nave with a screen of painted wood, which according to Louis Alexander Waldman occupied the fourth bay and possibly part of the third.[20]

Leoncini asserted that the scheme of placing the choir under the cupola in the new Duomo had been the intention since at least 1366, even if its realization in monumental form came much later.[21] The canons' choir remained in the nave for several decades, until September 1434 when Brunelleschi proposed a new octagonal choir precinct for the crossing. A report of 1435 by the committee designated to oversee construction of the choir reveals that three models had been presented – by Brunelleschi, Ghiberti, and Agnolo d'Arezzo (the latter just concerning the steps and platform) – but that all of them needed modifications.[22] In 1437, the *operai* ordered a full-scale wooden version of Brunelleschi's altered design to be installed in the crossing.[23] The

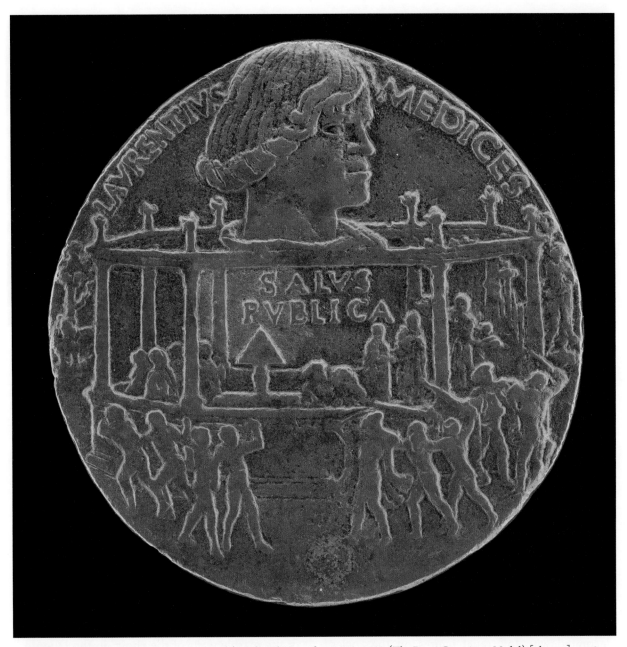

Figure 42 Bertoldo di Giovanni, *Lorenzo de' Medici, il Magnifico, 1449–1492 (The Pazzi Conspiracy Medal) [obverse]*, 1478. Bronze, 6.58 cm diameter. National Gallery of Art, Washington, DC, Samuel H. Kress Collection 1957.14.846.a. Photo: Courtesy National Gallery of Art, Washington, DC

famous Pazzi conspiracy medal of 1478 depicts the low parapet, colonnade, architrave, and candelabra of the surrounding enclosure, and the large choir lectern within (Figure 42).[24] Irving Lavin commented that Brunelleschi solved the "problem of the choir" by combining echoes from the Constantinian screen of Old St. Peter's in Rome with the octagonal enclosure of the Baptistery font in a choir and altar layout, which was at once centralized *and* longitudinal.[25] Following the addition of two arches and the crucifix by Benedetto and Giovanni da Maiano completed in 1510, further temporary modifications were made for Pope Leo X's 1515 *Entrata* – recorded in Monte di Giovanni's miniature – before the wooden choir was fully rebuilt in 1519–20.[26]

The ceremony in which Duke Cosimo received the Golden Fleece in 1545 finally

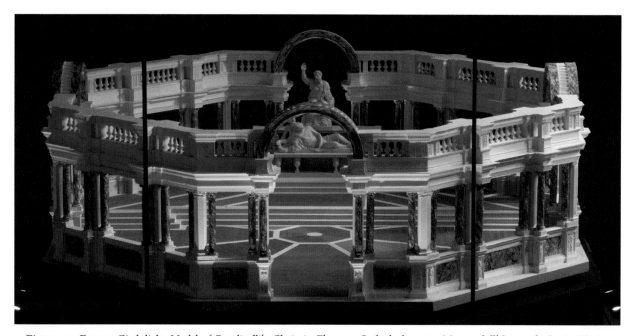

Figure 43 Franco Gizdulich, *Model of Bandinelli's Choir in Florence Cathedral*, 1987. Museo dell'Opera di Santa Maria del Fiore. Photo: Museo dell'Opera di Santa Maria del Fiore

demonstrated the unsuitability of the wooden choir, prompting him to commission from Bandinelli a new, image-laden, monumental marble choir (Figure 43).[27] The themes covered by the recently convened Council of Trent, including baptism, sin, and salvation, found visual expression in Bandinelli's religious iconography, although its nudity was criticized by a contemporary anonymous chronicler.[28] Labeled "retrospective" by Christine Smith, Bandinelli's choir reprised many formal aspects of Brunelleschi's version, but its architectural features became heavier and more ornamented.[29] The parapet, decorated with low relief figures on the socles and a series of Old Testament scenes, was surmounted by clusters of Ionic columns, which supported a substantial architrave and balustrade (Figure 44). Arched entrances appeared on all four sides, with marble figures of Adam and Eve on a parapet beneath the eastern arch, and the Dead Christ and God the Father on the altar within. The project was completed by Bandinelli's workshop in 1572, a notable revision occurring in 1569 when the white marble columns, arches, and architrave were exchanged for colored marbles including purple *breccia* following the

opening of new quarries at Stazzema and Seravezza from which it was sourced.[30] In the nineteenth century most of Bandinelli's structures were dispersed among various Florentine institutions, but the low perimeter walls of the precinct remain in place (Figure 45).

Critics have disagreed on how to analyze Bandinelli's unusual choir within the context of late sixteenth-century transformations of other Florentine churches. While contemporary cathedral canon Agostino Lapini approved of the removal of the nave choir in Santa Maria Novella, he praised "the beautiful and pleasant rotundity of the marble walls of the choir" in the Duomo.[31] In the later seventeenth century, Ferdinando Del Migliore commented that "it seems a great thing" that while nave choirs were eliminated from other churches, the Duomo choir, albeit not in the nave, was permitted to remain "where there was a great necessity to remove it" because it not only impeded circulation but detracted from the magnificence of the building.[32] He conceded, however, that since the Duomo choir was used for diverse ceremonies involving both ecclesiastical and temporal authorities, it should be a fitting and magnificent spectacle for the

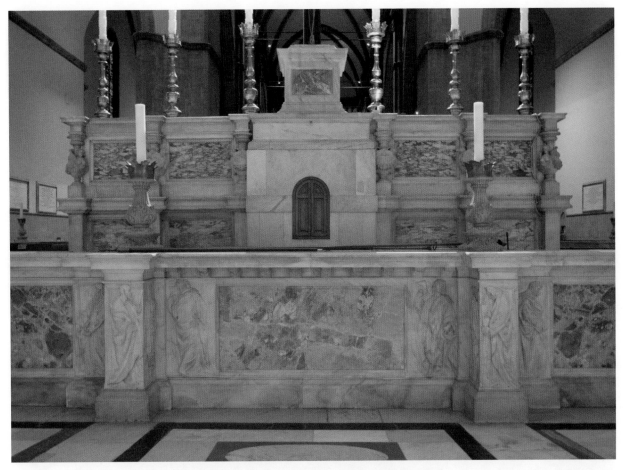

Figure 44 Wall of choir precinct, Santa Maria del Fiore, Florence. Photo: Pufui PcPifpef

populace. This unique function, together with its inception predating the Vasarian alterations in the Florentine mendicant churches by almost two decades, led Francesco Vossilla to conclude that the installation of Bandinelli's Duomo choir was not inconsistent with broader developments in Florentine church architecture.[33] Certainly, within the grand scale of the Duomo, Bandinelli's choir did not exhibit the same disruptive visual effect as the monumental mendicant tramezzi. Moreover, the location of the marble choir in the crossing meant that it did not inhibit movement and access throughout the cathedral.

Santo Spirito

As in the Florentine Duomo, Brunelleschi experimented with a centralized choir layout in the Augustinian church of Santo Spirito. The previous medieval church, in use by 1265, had featured a nave tramezzo. The anonymous author of *Motti e facezie del Piovano Arlotto*, dated between 1460 and 1484, described the old church of Santo Spirito as built "in the ancient manner, that is in the center of the church was a wall or rather a piece of wood going across, above which was an old and large crucifix tied to the wall with a chain or rather a rope."[34] A further confirmation is provided by Vincenzo Borghini, who listed in his *Discorsi* various Florentine churches that were internally subdivided by screens, including the old church of Santo Spirito.[35] Francesco Quinterio proposed that a screen appeared around half-way down the nave, which divided the laity from the friars in the choir, although Nerida Newbigin cautioned that this was not a large-scale tramezzo like those in other mendicant

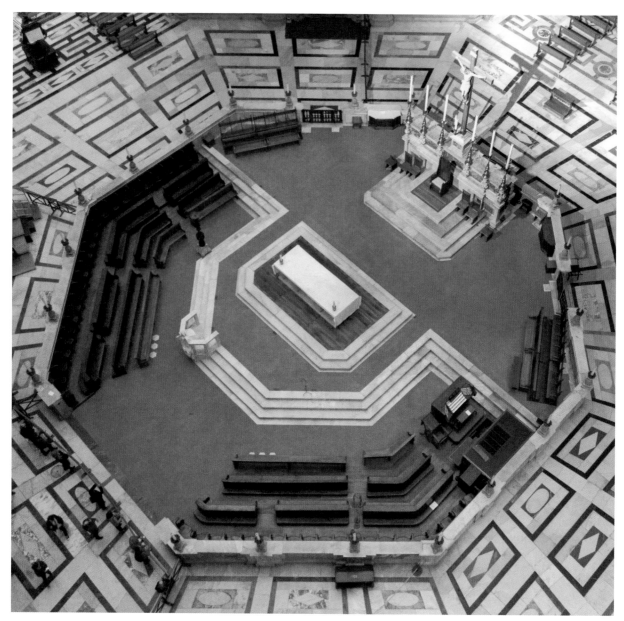

Figure 45 Choir precinct, Santa Maria del Fiore, Florence. Photo: Pufui PcPifpef

churches.[36] Tombs and chapels appeared near or attached to the screen. As mentioned in Chapter 1, the Frescobaldi, major patrons of Santo Spirito, had two tombs in the church: one for men at the foot of the high altar, and one for women associated with a Frescobaldi chapel dedicated to San Giovanni delle Donne, which was near the screen on the left side of the nave.[37]

Newbigin has shown that the staging for the Pentecost *sacra rappresentazione*, hosted by the Compagnia dello Spirito Santo delle Laude, detta del Piccione (the Company of the Holy Spirit of the Lauds, called the Pigeon) and first documented in 1416, was assembled on the screen.[38] A raised platform for the performance was supported by a wall above the altar of San Giovanni delle Donne and the wall of the choir screen itself. This area of the set was used for 'castello' where the apostles received the Holy Spirit, while heaven was suspended from the roof beams.

Brunelleschi's new church of Santo Spirito was still considered "recently begun" in 1444, and

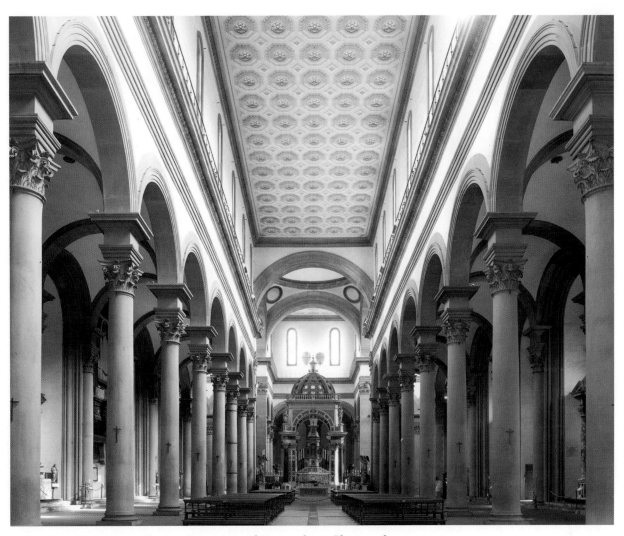

Figure 46 Santo Spirito, Florence. Interior view facing northeast. Photo: author

although building work was interrupted by the devastating fire of 1471, the church was completed in the early 1480s with the addition of Salvi d'Andrea's cupola (Figure 46). Generally interpreted as representing a close approximation to Brunelleschi's 'ideal' church, the building synthesizes the classic basilica and centralized ground plans.[39] Hall has shown that instead of a monumental rood screen, a choir precinct in the nave was enclosed by a low wall in an integrative ensemble that corresponds to other fifteenth-century examples (see Chapter 1).[40] A drawing of the interior of Santo Spirito (Uffizi 6746A, attributed to Giovanni Antonio Dosio, before 1574, Figure 47) depicts a wall enclosing the choir, where on an attached bench two seated

figures appear to be conversing, an intriguing anecdotal detail that further complicates the functions of screens from the lay perspective. Seemingly elevated above the wall, an upper cornice supports candelabra and two centralized archways at the front and back of the precinct along the central axis. Walter Paatz and Elisabeth Valentiner Paatz stated that this choir was probably designed by Salvi d'Andrea in c. 1481, noting that it was an interesting combination of a Gothic rectilinear choir precinct with a Renaissance-style placement under the crossing, the drawing further implying that in Santo Spirito the choir extended into the first nave bay.[41] A wooden crucifix, executed by the young Michelangelo in 1492–94, rested on the rear arch behind the high

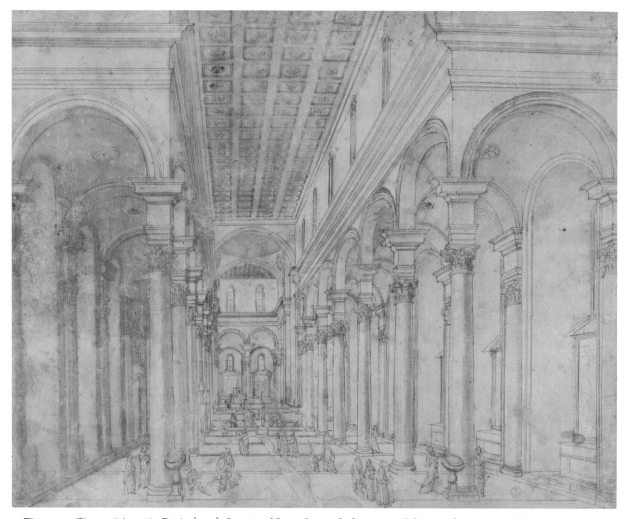

Figure 47 Giovanni Antonio Dosio (attr.), *Interior of Santo Spirito*, before 1574. Gabinetto dei Disegni e delle Stampe degli Uffizi, 6746 A. Photo: © Gabinetto fotografico, Gallerie degli Uffizi, Ministero per i beni e le attività culturali e per il turismo

altar,[42] while a pulpit was situated between two piers of the lower nave on the left side.

Fragments from the old Quattrocento stalls – including a frieze depicting motifs associated with the Corbinelli family, likely patrons of the original choir precinct – were purchased by the prior of San Domenico in Fiesole in 1611 after their removal from the church.[43] Analysis of these remaining pieces and the Uffizi drawing have allowed Margrit Lisner to propose that the overall height of the choir screen was roughly 3.5 m or almost six Florentine *braccia*. Perhaps betraying the influence of Giuliano da Sangallo in design and certainly reminiscent of the Duomo choir, the low parapet did not disrupt the visual axes of Brunelleschi's church, creating a hybrid

centralized choir formation. This nave choir was replaced by the present octagonal enclosure and high altar ciborium executed by Giovanni Battista Caccini and workshop in 1599–1608 (Figure 48).[44]

QUATTROCENTO FLORENCE: RETROCHOIRS

Retrochoirs are arrangements in which choir stalls were sited behind the high altar, either within the *cappella maggiore* or in dedicated extended spaces. While seemingly a modernizing element of the Renaissance, retrochoirs echo some early Christian dispositions: indeed, Durandus notes, "The word chorus comes from

Figure 48 Santo Spirito, Florence. View of the high altar facing northeast. Photo: author

'circular dance [*chorea*]' or 'crown [*corona*].' For in the past, clerics used to stand in a circle around the altar."[45] Retrochoirs held functional advantages for both religious communities and lay patrons. Communities of friars, monks, or canons were able to perform the liturgy in relative quiet and seclusion, and could gain access to these spaces directly from their conventual quarters, bypassing the need to interact with the laity. Lay patrons, on the other hand, if they had *jus patronatus* over the high chapel, experienced the spiritual benefits of proximity to the efficacious prayers of the church community, particularly if they erected tombs there, and would have enjoyed the coveted high status of symbolically domineering over other lay side chapels. Indeed, architect and theorist Francesco di Giorgio Martini advocated for the placement of the choir in the high chapel, placing symbolic emphasis on this site by likening it to the head of a man's body.[46]

Taking the original setting and function of double-sided painted altarpieces as a starting point, Donal Cooper discovered that a series of Franciscan churches in Umbria including San Francesco al Prato in Perugia (Figure 49) and San Francesco in Sansepolcro had retrochoir arrangements as early as the fourteenth century, albeit in combination with nave rood screens. He concluded that the apsidal choir arrangement in the Upper Church at Assisi – built to accommodate the requirements of the papal liturgy – could have acted as a prototype for Franciscan retrochoirs in Umbria.[47] Recently revisiting this material and acknowledging its complexity, Cooper presented further examples to suggest that Umbria represents "the most significant regional anomaly," where not only Franciscan churches but secular and monastic churches were sometimes equipped with retrochoirs, some as early as the mid-thirteenth century.[48] Indeed, the Benedictine church of San Pietro in Perugia likely had a retrochoir arrangement in c. 1330, which was unusually reversed in 1436, when the high altar was placed in the apex of the apse.[49] As more evidence is brought forward, Cooper cautioned that many questions still remain surrounding the liturgical function, degree of lay access, interpretation, and symbolism of these varied configurations of liturgical space.

Thus, while in the Middle Ages retrochoir arrangements were exceptions to standard practice for most religious settings, in the fifteenth century, church transformations are documented with more frequency. Multiple mendicant, monastic, and collegiate congregations instigated renovations for a variety of reasons, including the need for additional space for preaching or the viewing of relics, increased isolation and quiet for the clergy, and architectural aesthetics. For example, in 1451, the Consiglio Comunale of Brescia gave funds to San Francesco in Brescia (Figure 50) for the removal of the choir from the nave to an enlarged cappella maggiore, citing that the church was "too small and incapable for the people who devotedly visit it, especially in the practice and time of preaching," a later document adding an appeal to the "ornament and enlarging of the church."[50] Influential lay patrons and civic

A1: Pre-1530s high altar
A2: Post-1536 high altar
E1: Crypt tomb of Beato Egidio pre-1439
E2: Transept tomb of Beato Egidio post-1439
T: Likely location of hypothetical tramezzo screen
C: Location of conventual choir stalls

Figure 49 San Francesco al Prato, Perugia, proposed plan by Donal Cooper. With kind permission of Donal Cooper

political authorities were sometimes involved in the decisions and funding of renovations, providing a precedent to Duke Cosimo's encouragement and patronage of similar alterations in the churches of late sixteenth-century Florence. In what Pacciani has termed the "privatization of sacred space,"[51] lay patrons desirous of exclusive mausolea provided impetus for retrochoir projects at San Giobbe in Venice in the 1470s,[52] and as we shall see at San Lorenzo in Florence.

Newly built churches in the fifteenth century were frequently planned with choir stalls placed behind the high altar. In Bernardo Rossellino's Pienza Cathedral, carved wooden stalls in the apse for the bishop and canons, described by Pius II himself, bear the date 1462.[53] In Rome, the retrochoir of San Pietro in Montorio was probably constructed in the decade 1472–82,[54] and retrochoirs were created in the Augustinian churches of Sant'Agostino in 1483,[55] and Santa

Maria del Popolo in the 1470s, which was later extended by Bramante in c. 1508–10 when, under the direction of Pope Julius II, it became a mausoleum choir for two cardinals.[56] I have argued elsewhere that these Roman projects could have been influenced by Nicholas V's unfinished tribuna project at Old St. Peter's in Rome.[57]

Since fifteenth-century Italian retrochoirs have not yet been examined holistically, the gradual shift toward retrochoir rearrangements in both existing buildings and new constructions requires further investigation.[58] The picture that emerges is that of incremental change and the coexisting variety of arrangements across regions and religious contexts. For example, in the same span of time, nave choir enclosures were constructed and embellished in churches such as the Frari in Venice and San Pancrazio in Florence, while in other churches, nave screens were demolished, such as in San Giacomo Maggiore in Bologna in

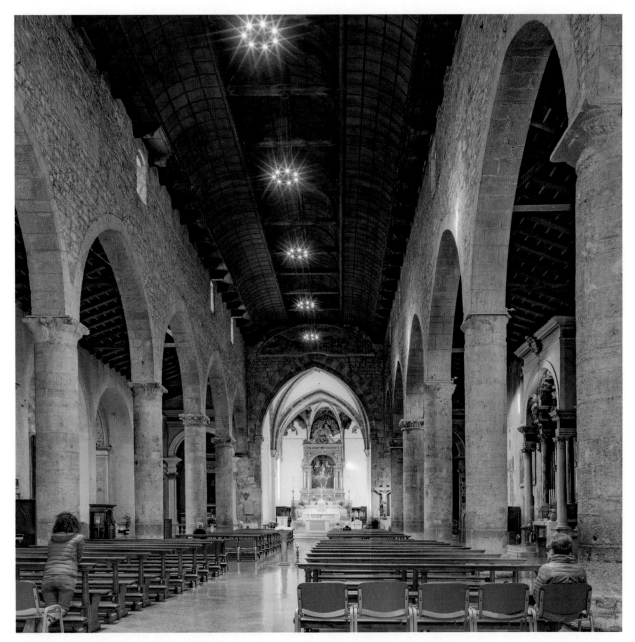

Figure 50 San Francesco, Brescia. Interior view facing south. Photo: Wolfgang Moroder

1483,[59] and San Giovanni in Canale in Piacenza, where the tramezzo was removed in 1492 because it was "formless and an obstruction to the church."[60] In other cases, nave choirs were removed to areas in the cappella maggiore but in front of the altar, such as in San Frediano in Lucca in 1426;[61] and the Dominican church of Santa Corona in Vicenza in c. 1482, where large crowds of laity wished to venerate a relic from

the crown of thorns.[62] In another solution, in 1480 the friars' nave choir in Santa Maria del Carmine in Naples was transferred to a raised gallery above the main entrance, for the "adornment" and "enlargement" of the church.[63] When it came to liturgical usage, religious communities variously demonstrated both substantial latitude and hesitancy toward new arrangements. For example, Cobianchi has shown that while a

retrochoir arrangement in San Francesco at Cotignola (near Faenza, founded in 1483) was sanctioned by the Observant Franciscan Vicar General and the Provincial Chapter, they decreed that this disposition should not be imitated by other churches without the express permission of the chapter.[64]

In Florence, lay patronage of high chapels that were furnished with choir stalls held a certain elite status. After Cosimo de' Medici il Vecchio was given the right to set up his heraldry and tomb in the high chapel of San Lorenzo in 1442, several similar spatial schemes were undertaken by prestigious Medici-supporting families.[65] The tribuna in Santissima Annunziata was eventually financed by Lodovico Gonzaga and supported by Lorenzo il Magnifico, who was elected as one of the church's *operai*. Castello Quaratesi, with Medici support, financed the new church of San Salvatore al Monte, which featured a choir in the high chapel. In 1485, Pandolfo Rucellai, a Medici supporter, provided funds for the choir in the high chapel of San Pancrazio (see Chapter 5). Designs previously attributed to Giuliano da Sangallo – long thought to be variants for Lorenzo de' Medici's Augustinian church of Santa Maria at Porta San Gallo (begun in 1488 and destroyed in the Siege of Florence in 1529) – show stalls around a rectangular space behind the high altar, although it is unclear whether this layout was adopted in any Florentine conventual church, and the identification with the Augustinian church is now disputed (Figure 51).[66] Giovanni Tornabuoni, director of the Roman branch of the Medici bank, was granted patronal rights over the walls and altar of the high chapel, excluding burial claims, of Santa Maria Novella in 1486, a privilege historically enjoyed by the Tornaquinci clan, of which the Tornabuoni were an offshoot.[67] Ghirlandaio completed an extensive mural cycle containing many family portraits, a double-sided high altarpiece, and designs for stained-glass

windows, and Baccio d'Agnolo constructed the wooden choir stalls (Figure 52).[68] It should be noted, however, that San Pancrazio and Santa Maria Novella maintained their prominent nave choirs, again indicating that multiple spatial arrangements could exist simultaneously.

Early retrochoir arrangements – especially those sponsored by the political elite of Florence surrounding the Medici family – anticipated the later city-wide sixteenth-century church renovations associated with Vasari and Duke Cosimo. In his sponsorship of similar schemes in the two mendicant projects, therefore, Duke Cosimo might well have appreciated the illusion of continuity with his fifteenth-century forebears, as he did in his other artistic and architectural projects.[69]

San Lorenzo

The parish church of San Lorenzo was one of the oldest foundations in Florence, reputedly first consecrated by St. Ambrose of Milan in 393 (Figure 53). Within the medieval church, Pacciani argued, there were likely at least two divisions in the nave between the main entrance and the high altar. An archival reference to a "men's choir" ("choro degli uomini") in 1440 with benches and presumably also a barrier shows that divisions in the nave might have segregated clergy and laity or laymen and laywomen.[70] A further reference to "reggi," meanwhile, a term often used for screen gates, suggests the presence of a tramezzo enclosing the clergy and utilized for liturgical purposes.[71]

While the canons' intention to replace the Romanesque fabric can be dated back to the late fourteenth century, Brunelleschi's construction of the Old Sacristy, which also served as a funerary chapel for Giovanni di Bicci de' Medici, began in 1422.[72] Due to a lack of primary documents and widespread reliance on Antonio di Ciaccheri Manetti's biography of Brunelleschi

Figure 51 Anonymous sixteenth-century architect, *Ground Plan of a Church*, sixteenth century, pen and ink. Gabinetto dei Disegni e delle Stampe degli Uffizi, 1573A. Photo: © Gabinetto fotografico, Gallerie degli Uffizi, Ministero per i beni e le attività culturali e per il turismo

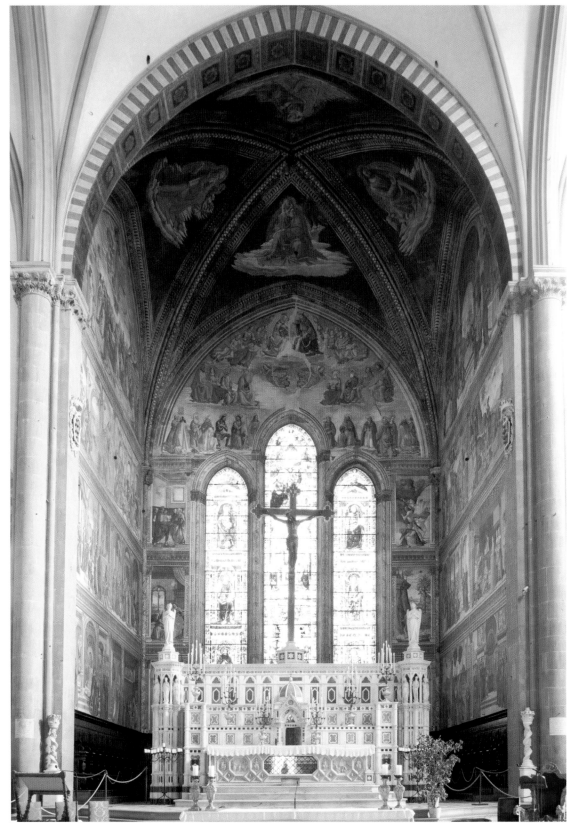

Figure 52 Santa Maria Novella, Florence. View of the high chapel (Tornabuoni Chapel) facing north, showing frescoes by Domenico Ghirlandaio (1485–90) and nineteenth-century high altar. Photo: author

Figure 53 San Lorenzo, Florence. Interior view facing west. Photo: John Nadas

written after his death in c. 1480, the new church of San Lorenzo is generally entirely attributed to Brunelleschi, although the nave was built much later and certainly after the architect's death.[73] Cosimo il Vecchio became the main patron of the church in 1442, crucially securing the right to place his tomb and heraldry in the high chapel and part of the new nave, although the *jus patronatus* over the high altar was retained by the chapter.[74] According to Manetti, Cosimo il Vecchio himself determined that the canons' choir should be placed in the cappella maggiore, which would have created the first retrochoir arrangement in Renaissance Florence.[75]

The physical shift toward a retrochoir disposition likely occurred well after Cosimo il

Vecchio's death in 1464, although the idea may have originated with him. Volker Herzner observed that the installation of Donatello's pulpit (1458–60) in the left nave aisle above the door to the cloister shows that the choir rearrangement was not considered at this point, given the likelihood that the choir and organ would have been in close proximity.[76] Pacciani concluded that the decision to relocate the choir was taken after Cosimo il Vecchio's death, noting that it was only after the installation of Verrocchio's floor tomb in the crossing in 1467 that the canons' stalls were placed behind the high altar (Figure 54).[77] Since the first explicit reference to the retrochoir emerged in Manetti's biography of Brunelleschi, written more than a

Figure 54 Andrea del Verrocchio, *Tomb of Cosimo de' Medici (il Vecchio)*, 1465–67, marble and bronze, 335 cm², San Lorenzo, Florence. Photo: Sailko/Francesco Bini

decade after Cosimo il Vecchio's death, Pacciani has recently pushed the dating even later to c. 1480 or a few years earlier.[78]

What were the motivations for such a decisive move? Howard Saalman has shown that the original location for the canons' seating in the crossing and part of the nave (the "cupola col coro") was superseded by Cosimo il Vecchio's desire for burial in the crossing, which necessitated a change in choir layout.[79] Janis Clearfield agreed that the San Lorenzo solution was largely intended to provide a hierarchically prominent and spiritually significant site for Cosimo il Vecchio's tomb, at a time when laymen were increasingly monopolizing sacred space in other contexts.[80] Christian-Adolf Isermeyer suggested that Cosimo il Vecchio might have been inspired to pursue this arrangement by the Greek delegation staying at Palazzo Medici for the Council of Florence in

1439.[81] Meanwhile, Herzner argued that it was Piero de' Medici who moved the choir, specifically to promote Cosimo il Vecchio's tomb as a symbol of Medici political dominance.[82]

Both Lavin and Clearfield argued that the early retrochoir coordinated with other aspects of San Lorenzo to specifically harken back to early Christian prototypes.[83] Indeed, according to the antiquarian writer Del Migliore, since its founding San Lorenzo had echoed aspects of early Christian architecture: "the Florentines ... permitted the construction of San Lorenzo outside the city, corresponding to the church built by Constantine outside the walls of Rome also to the honor of San Lorenzo [San Lorenzo fuori le Mura]."[84] Moreover, Cosimo il Vecchio himself purportedly discovered the original early Christian relics used in the legendary founding of San Lorenzo by St. Ambrose, and had them

consecrated within the new high altar in 1461.[85] With its flat coffered ceilings, low and wide proportions and classical vocabulary, San Lorenzo formed part of a broader early Christian artistic revival in mid-century Florence.[86] Lavin proposed that Cosimo il Vecchio's tomb ensemble consciously revived the *confessio* (a martyr's burial under the floor of Roman early Christian basilicas), and echoed the recent changes to the Lateran basilica. In c. 1425, the *basso coro* or *schola cantorum* in the Lateran basilica was demolished when Pope Martin V replaced the mosaic pavement and requested a floor burial in front of the high altar.[87] From a material perspective, the porphyry and bronze in Cosimo's floor tomb were replete with imperial associations. In a unique design, red and green porphyry inlaid disks are surrounded by bronze gratings, which allow a glimpse of the tomb itself, located in the supporting pier of the crypt below. As we shall see, the later city-wide sixteenth-century choir renovations were also to some extent influenced by early Christian prototypes, perhaps prompted by Duke Cosimo's visit to Rome in 1560.

San Lorenzo was also characterized by a striking liturgical peculiarity. The church is occidented (the high altar faces west instead of east), echoing early traditions in the basilicas of Rome.[88] The high altar in San Lorenzo, which lacked a high altarpiece, accommodated *versus populum* celebrations of the Eucharist, in which the priest faced the congregation, until the early seventeenth century.[89] With the retrochoir located behind a freestanding altar, the priest facing the people and a *confessio*-type tomb in front of the high altar, San Lorenzo presented a unique liturgical space within the sacred topography of Renaissance Florence. While Mass *versus populum* was a rare Catholic practice even up to the twentieth century, the concept of the freestanding high altar without an altarpiece would be revived in the later sixteenth century, this time in combination with the Eucharistic tabernacle.

As likely the earliest retrochoir disposition in Florence, San Lorenzo privileged Cosimo il Vecchio's tomb and created a secluded site for the canons during Mass. Given that the Brunelleschian nave was only built later in the fifteenth century, however, the possibility remains that San Lorenzo had both a retrochoir and tramezzo for a time. As we shall see, in his spatial alteration campaigns in 1560s Florence, Duke Cosimo – who commissioned Pontormo's controversial but now lost frescoes for the choir chapel of San Lorenzo (1546–57) – could have been inspired by his namesake's patronage of the new disposition in the Medici parish church.[90]

Santissima Annunziata

The mother church of the Order of Servants of Mary, known as the Servite Order, was founded in 1250 and enlarged in the second half of the thirteenth century (Figure 55), replacing the slightly earlier small oratory of Santa Maria di Cafaggio.[91] Situated to the immediate left of the main entrance and frequently surrounded by numerous wax ex-votos, a miracle-working fresco of the Annunciation (stylistically dated to the mid-fourteenth century but reputedly completed by angels in the mid-thirteenth) was the subject of one of the most popular Marian cults in Florence, inducing the church to acquire the popular nomenclature of Santissima Annunziata.[92] In 1288–89, the friars made numerous payments for choir stalls, which must have been sumptuously decorated with intarsia since no less than eighteen varieties of wood were used. Payments in 1289 to the "master for the masonry of the choir" ("maestro per muratura del coro") and 1319/20 "for the gate of the church" ("pro cancello ecclesie"), led Raffaele Taucci and Eugenio Casalini to posit the existence of a large stone tramezzo complete with a central door and arches.[93]

Information regarding this tramezzo is patchy. In a 1439 letter, Russian bishop Abraham of

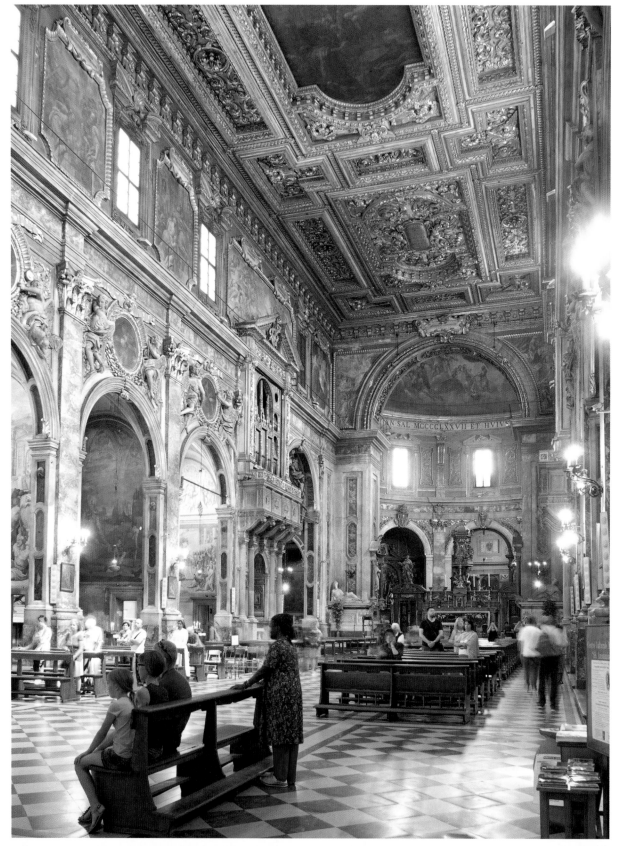

Figure 55 Santissima Annunziata, Florence. Interior view facing northeast. Photo: author

Suzdal, present in the city for the Council of Florence, described a church that hosted the Annunciation *sacra rappresentazione* (a religious performance of the Annunciation story, which took place on 25 March) thus: "[I]n the middle a stone rood screen runs from one side wall to the other on pillars 3 *sagenes* high and 1½ *sagenes* wide."[94] Long believed to refer to the Santissima Annunziata, scholars have used this description to determine that a monumental tramezzo divided the nave.[95] However, Newbigin deduced that the Russian bishop identified churches according to the plays they hosted rather than their official dedications.[96] This performance, although representing the Annunciation, in fact, took place in San Felice in Piazza, a church in the Oltrarno then belonging to Camaldolese nuns. Newbigin further commented that the Santissima Annunziata probably did have a screen, unfortunately undocumented in historical evidence.[97] Indeed, considering how closely the Servites were influenced by the Dominicans and Franciscans in all areas of their administration, this seems likely. Casalini further stated that "retro del coro" at Santissima Annunziata, probably under the tramezzo facing the laity, two altars or shrines were dedicated to St. Filippo Benizi (a thirteenth-century prior general of the Servites) and to an image of the Virgin Mary.[98] A pulpit, possibly near the nave choir attached to a pier, was also mentioned in fourteenth- and fifteenth-century archival sources.[99]

While it seems likely that a monumental tramezzo divided the nave of Santissima Annunziata, its removal from this position is equally ambiguous. According to a seventeenth-century history of the Order, Pope Eugenius IV advised the Servite friars to restore the church in 1443, in part because "the choir in the middle with arches inappropriately hindered the open space too much."[100] The following year, the foundation stone of the new tribuna was laid, and in 1449, a woodworker was paid to rearrange the choir stalls ("raconciare el choro"). Casalini interpreted this to mean they were repositioned in front of the high altar to either side, but Beverly Brown argued that the choir was reassembled in the old sacristy or the Villani Chapel for temporary use during the building of the tribuna.[101]

The tribuna – a large domed rotunda containing the friars' choir, high altar, and ambulatory with radiating chapels – was constructed between 1444 and 1476 under the sequential architectural directorship of Michelozzo di Bartolomeo, Manetti, and Alberti (Figures 56 and 57).[102] Disrupting the standard mendicant layout of the medieval period, this daring rearrangement has been linked to the installation of Observant friars at the convent around 1441, but was eventually financed by Lodovico Gonzaga, aided by Lorenzo il Magnifico, one of the church *operai*.[103] In a design derived from the full-scale wooden model for the octagonal choir in the Duomo, the tribuna both removed the choir from the laity in the nave *and* situated it in close proximity to surrounding lay chapels.[104] In its design and typology, the tribuna cleverly combined both the centralized plan and the retrochoir location. However, by disrupting established spatial hierarchies and functions, the tribuna represented a shift in choir location that proved controversial to contemporary Florentines and was never to be repeated.[105] Nevertheless, despite its unique approach, the elimination of the tramezzo and the creation of close proximity between choir and high altar established Santissima Annunziata as an unusual precedent for later sixteenth-century renovations, showing the diversity of options available for organizing sacred space.

San Salvatore e San Francesco al Monte

A site near San Miniato al Monte on the southern hill overlooking Florence was donated to the

Figure 56 G. Salvi (attr.), *Ground Plan of Santissima Annunziata*, between 1690 and 1702. Archivio di Stato di Firenze, CRS no. 119, vol. 1273, fol. 24. Photo: Courtesy of Ministero per i beni e le attività culturali e per il turismo/Archivio di Stato di Firenze

QUATTROCENTO FLORENCE: RETROCHOIRS ～ 83

Figure 57 Santissima Annunziata, Florence. Interior view of tribuna facing southeast, showing seventeenth-century choir enclosure. Photo: author

Observant Franciscans in 1418, and by 1435 a small church was complete (Figure 58).[106] Cosimo il Vecchio originally showed an interest in the community, but wanted it to relocate. The cause was instead taken up by Castello Quaratesi, a successful merchant and obedient Medici supporter, who dispersed substantial sums from 1457 on for the completion of a new church and convent on the same site.[107]

At the Provincial Chapter of the Observant Franciscans held in Poggibonsi in 1474, four friar-architects were appointed to maintain the conservative and restrained character of new church construction within the province. In the case of San Salvatore, they provided precise measurements for the new church, and advised that it should have a

simple wooden roof, and six small chapels, four along the nave walls and two against a tramezzo.[108]

Following the financial intervention of Lorenzo de' Medici, who was an *operaio* of the church, and that of his brother Giuliano, church construction proceeded in the 1480s. By 1500, the Arte di Calimala arms were erected on the entrance arch of the cappella maggiore, and the church was consecrated in 1504. The extant church differs substantially from the plan approved by the Provincial Chapter. It lacks a tramezzo, features two rows of nave side chapels interconnected via open archways in the chapel walls (a device also used in Santissima Annunziata), and crucially, includes a retrochoir disposition (see ground plan in Figure 11).[109] As we have seen, retrochoirs were

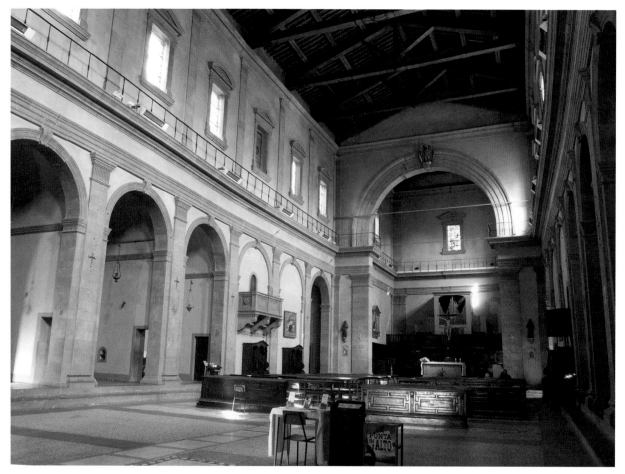

Figure 58 San Salvatore al Monte, Florence. Interior view facing southeast. Photo: author

not without precedent in central Italian Observant Franciscan churches, but more commonly, choir stalls were positioned in front of the high altar accompanied by a tramezzo.

In terms of architectural style, both Alexander Markschies and Pacciani interpreted San Salvatore as a symbolic clash between Observant asceticism and the civic magnificence pursued by wealthy patrons.[110] The surviving sixteenth-century stalls (with some nineteenth-century additions), surmounted by a now-illegible biblical inscription, are disposed along three sides of the cappella maggiore (Figure 59).[111] As we shall see, the friars of San Salvatore reprised their influential retrochoir arrangement to Ognissanti when they transferred there in the later sixteenth century.

Santa Maria Maddalena di Cestello

The Cistercian church of Cestello (now called Santa Maria Maddalena dei Pazzi following a swap with the Carmelite nuns from Santa Maria degli Angeli in Oltrarno, now San Frediano di Cestello) was renovated in the 1480s likely by Giuliano da Sangallo, in connection with the community's acceptance into the reformed Congregation of San Salvatore of Settimo (Figure 60).[112] While previously the church probably featured a choir in the nave, construction of a retrochoir behind the cappella maggiore took place in 1498 according to a seventeenth-century archival source.[113] The two architectural plans now in the Uffizi mentioned earlier in relation to the San Gallo convent have sometimes been

Figure 59 San Salvatore al Monte, Florence. Choir stalls in the high chapel. Photo: author

linked to Giuliano's design for Cestello (1573A, 1574A), although this is highly unlikely.[114] In 1503, two stained-glass windows for the retrochoir space were made by Ser Giovanni di Domenico "de vreti", confirming the completion of this extension. Depicting the Annunciation, they are now held by the National Gallery of Art in Washington, DC (Figure 61).[115] A Cistercian visitor to Cestello in Florence in 1505 recommended that curtains be provided to either side of the high altar "so that the monks in the choir may not be seen by laymen and disturbed," echoing calls for privacy seen in other contexts.[116] Alison Luchs notes that, unusually, a tramezzo was added to the church later, in 1524, but the phrasing of the source implies that this could

have been a dividing wall between the retrochoir and the cappella maggiore itself ("la serratura fra il coro et la cappella").[117] The present choir is a result of renovations enacted in 1669–85.

Conclusion

In the churches of medieval and early Renaissance Florence, choir location was neither static nor uniform. Some medieval layouts persisted, and churches newly constructed in the Quattrocento experimented with retrochoirs and centralized choirs beneath cupolas, types that echoed early Christian precedents. Church buildings of differing size and type, administered

Figure 60 Santa Maria Maddalena dei Pazzi, Florence (formerly named Cestello). Interior view facing southeast. Photo: Livioandronico 2013

Figure 61 Giovanni di Domenico, *Annunciation*, 1498/ 1503, stained glass, each panel: 199.4 × 78.8 cm. National Gallery of Art, Washington, DC, Widener Collection 1942.9.311/312. Photo: Courtesy National Gallery of Art, Washington, DC

by mendicant friars, cathedral canons, monks, or parish chaplains, were equipped with choir layouts that suited their liturgical needs and fulfilled the devotional and funerary demands of their lay patrons.

These ever-shifting spatial dynamics across the city's churches created an environment in which the church renovations of the 1560s and 1570s could flourish. Vasari and Duke Cosimo's large-scale plans for Santa Maria Novella and Santa Croce were not entirely innovative but rather created spaces that, to a Florentine audience, would have seemed familiar. As we have seen, several fifteenth-century churches featured a retrochoir behind the high altar. However, these transitional spaces often betrayed some level of compromise between openness and segregation: in some cases, tramezzi were maintained, while in others, low walls surrounded centralized choir precincts. While a diversity of spatial options

was available to patrons and architects in the fifteenth century, by the end of the sixteenth century, as we shall see in Chapter 3, almost all the city's churches would share an unobstructed, unified aesthetic.

NOTES

1 1175 is the date of a similar pulpit in Sant'Agata di Scarperia, and 1207 is inscribed on the pavement of the church. Francesco Gurrieri, "L'impianto architettonico origini e addizioni," in *La basilica di San Miniato al Monte a Firenze*, ed. Francesco Gurrieri, Luciano Berti, and Claudio Leonardi (Florence, 1988), p. 28.

2 Cecchi stated that there are thirty extant stalls, and that they were altered and damaged after Olivetans abandoned the basilica in 1553. Cecchi, "Maestri d'intaglio," pp. 228–30.

3 Frey's appendix on the Arte di Calimala provided the following note: "1466. Choro ò spalliere e seggioli del choro si danno a fare a Giovanni di Domenicho da Gaiuole e Francesco di Domenico, detto Monciatto, legnaiuoli, per Prezzo di lire 1200, con che condizioni, e in che modo deve stare." Giorgio Vasari and Karl Frey, *Le vite de' più eccellenti pittori, scultori ed architettori*, vol. 1 (Munich, 1911), p. 325.

4 Cecchi, "Maestri d'intaglio," pp. 228–30. See also Ferdinando Rossi, "Mosaici, intarsi e tarsie," in *La basilica di San Miniato al Monte a Firenze*, ed. Francesco Gurrieri, Luciano Berti, and Claudio Leonardi (Florence, 1988), p. 135.

5 For Romanesque churches in Florence, see Walter Horn, "Romanesque Churches in Florence: A Study in Their Chronology and Stylistic Development," *The Art Bulletin* 25, no. 2 (1943), pp. 112–31.

6 See Lorenzoni and Valenzano, *Il duomo di Modena*.

7 Richa, *Notizie istoriche*, vol. 1, p. 248; Paatz and Paatz, *Kirchen von Florenz*, vol. 5, p. 106.

8 Paatz and Paatz, *Kirchen von Florenz*, vol. 1, p. 273; Anne Leader, *The Badia of Florence: Art and Observance in a Renaissance Monastery* (Bloomington, IN, 2012), p. 36.

9 Paatz and Paatz, *Kirchen von Florenz*, vol. 5, p. 212.

10 Bandini, "Vestigia dell'antico tramezzo," pp. 211–29.

11 Vasari noted in the Life of Fra Angelico that "anco nel tramezzo di Santa Maria Nuova una tavola di sua mano" widely identified with a *Coronation of the Virgin* panel, now in the Uffizi. Vasari et al., *Le vite*, vol. 3, part 1, p. 272. Paatz and Paatz speculated whether the term *tramezzo* in this context indicated a choir enclosure at ground level or a nuns' balcony choir. Paatz and Paatz, *Kirchen von Florenz*, vol. 4, p. 5. Henderson pointed out that there is no sound evidence for the existence of a tramezzo at this date, and that a nuns' choir would only date to the sixteenth century. John Henderson, *The Renaissance Hospital: Healing the Body and Healing the Soul* (New Haven, CT and London, 2006), pp. 125, 384, note 56.

12 Paatz and Paatz, *Kirchen von Florenz*, vol. 4, p. 592. See also Alexander Röstel, "'Una Pieta chon molte figure': Sandro Botticelli's altarpiece for the Florentine church of S. Paolino," *The Burlington Magazine* 157, no. 1349 (2015), pp. 521–29.

13 Alberti, *De Re Aedificatoria*, Book VII, Chap. IV: "It is manifest that Nature delights principally in round Figures, since we find that most Things which are generated, made or directed by Nature, are round." Leon Battista Alberti, *Ten Books on Architecture*, ed. Joseph Rykwert, trans. Cosimo Bartoli and James Leoni (London, 1955), p. 138.

14 Giovanni Leoncini, "I 'cori centrali' di Santa Maria del Fiore e di altre chiese fiorentine: spazi liturgici e architettonici" in *La cattedrale e la città: saggi sul Duomo di Firenze: atti del convegno internazionale di studi (Firenze, 16–21 giugno 1997)*, ed. Timothy Verdon and Annalisa Innocenti (Florence, 2001), pp. 477–78, 491.

15 Riccardo Pacciani, "Liturgia e pianta centrale a Firenze nel Rinascimento. Percorsi d'incontro fra dissonanze, adeguamenti e innovazioni," in *La place du choeur: architecture et liturgie du Moyen Âge aux Temps modernes: actes du colloque de l'EPHE, Institut national d'histoire de l'art, les 10 et 11 décembre 2007*, ed. Sabine Frommel, Laurent Lecomte, and Raphaël Tassin (Paris and Rome, 2012), pp. 89–100.

16 For New St. Peter's, see, for example, Christof Thoenes, "Renaissance St. Peter's," in *St. Peter's in the Vatican*, ed. William Tronzo (Cambridge and New York, 2005), pp. 64–92.

17 The crypt was expanded to cover the side aisles in the thirteenth century. Franklin Toker, "Excavations below the Cathedral of Florence, 1965–1974," *Gesta* 14, no. 2 (1975), pp. 33 (fig. 17), 35 (fig. 20).

18 Julian Gardner, "Giotto in America (and Elsewhere)," in *Italian Panel Paintings of the Duecento and Trecento. Studies in the History of Art, vol. 61. National Gallery of Art, Washington, DC*, ed. Victor M. Schmidt (Washington, DC, 2002), pp. 164–66.

19 Louis Alexander Waldman, "Florence Cathedral in the Early Trecento: The Provisional High Altar and Choir of the Canonica," *Mitteilungen des Kunsthistorischen Institutes in Florenz* 40, no. 3 (1996), pp. 267–86.

20 Louis Alexander Waldman, "From the Middle Ages to the Counter-Reformation: The Choirs of S. Maria del Fiore," in *Sotto il cielo della cupola: il coro di Santa Maria del Fiore dal Rinascimento al 2000: progetti di Brunelleschi, Bandinelli, Botta, Brenner, Gabetti e Isola, Graves, Hollein, Isozaki, Nouvel, Rossi*, ed. Timothy Verdon (Milan, 1997), p. 38; For documents related to this construction, see Giovanni Poggi and Margaret Haines, *Il Duomo di Firenze: documenti sulla decorazione della chiesa e del campanile tratti dall'archivio dell'opera* (Florence, 1988), pp. 232–33, nos. 1161–67.

21 Leoncini, "I 'cori centrali'," pp. 475–76.

22 Waldman, "From the Middle Ages," pp. 40–41; Poggi and Haines, *Il Duomo di Firenze*, pp. 234–35, no. 1176.

23 Waldman, "From the Middle Ages," p. 50. Poggi and Haines, *Il Duomo di Firenze*, pp. 246–47, nos. 1227–32.

24 Bertoldo di Giovanni, *Lorenzo de' Medici, il Magnifico, 1449–1492 (The Pazzi Conspiracy Medal)* [obverse], 1478, bronze, diameter 6.6 cm. National Gallery of Art, Washington, DC, Samuel H. Kress Collection 1957.14.846.a.

25 The placing of the high altar in the eastern part of the choir enclosure reinforced the longitudinal aspect. Irving Lavin, "The Problem of the Choir of Florence Cathedral," in *La cattedrale e la città: saggi sul Duomo di Firenze: atti del convegno internazionale di studi (Firenze, 16–21 giugno 1997)*, eds. Timothy Verdon and Annalisa Innocenti (Florence, 2001), pp. 405–06.

26 Monte di Giovanni, *Leo X Celebrating Mass in the Choir*. Florence, Archivio dell'Opera di S. Maria del Fiore, Gradual R (no. 13), fol. 88, initial "T." Waldman, "From the Middle Ages," p. 48; Poggi and Haines, *Il Duomo di Firenze*, pp. 247–48, nos. 1234–37.

27 Waldman, "From the Middle Ages," p. 54. For Cosimo's acceptance of the Golden Fleece in 1545, see Lorenzo Cantini, *Vita di Cosimo de' Medici primo, Gran-Duca di Toscana* (Florence, 1805), pp. 179–80; Mary Weitzel Gibbons, "Cosimo's Cavallo: A Study in Imperial Imagery," in *The Cultural Politics of Duke Cosimo I de' Medici*, ed. Konrad Eisenbichler (Aldershot and Burlington, VT, 2001), p. 78.

28 Francesco Vossilla, "Baccio Bandinelli and Giovanni Bandini in the Choir of the Cathedral," in *Sotto il cielo della cupola: il coro di Santa Maria del Fiore dal Rinascimento al 2000: progetti di Brunelleschi, Bandinelli, Botta, Brenner, Gabetti e Isola, Graves, Hollein, Isozaki, Nouvel, Rossi*, ed. Timothy Verdon (Milan, 1997), pp. 71–75; Carlo Cresti, "Architettura della Controriforma a Firenze," in *Architetture di altari e spazio ecclesiale: episodi a Firenze, Prato e Ferrara*, ed. Carlo Cresti (Florence, 1995), p. 11.

29 Christine Smith, "The Bandinelli Choir," in *Retrospection: Baccio Bandinelli and the Choir of Florence Cathedral*, ed. Christine Smith (Cambridge, MA, 1997), pp. 55–68.

30 Ibid., p. 67; Waldman, "From the Middle Ages," p. 58. For Bandinelli's workshop, see Carlo Cinelli and Francesco Vossilla, "Baccio Bandinelli e Giovanni Bandini per il coro della Cattedrale. Note d'archivio," in *Atti del VII centenario del Duomo di Firenze* ed. Timothy Verdon (Florence, 2001), pp. 325–34. In two similar passages, Lapini wrote that the colored marbles were installed in both 1566 and 1569. Lapini and Corazzini, *Diario Fiorentino*, pp. 153, 164.

31 "la bella e vaga rotondità della muraglia di marmo del coro." Smith, "The Bandinelli Choir," p. 59.

32 "Pare una gran cosa, che il Gran Duca Cosimo I . . . nel darsi fuor di modo a riabbellire le Chiese con principal massima, consigliato dal purgatissimo ingegno di Michelagnolo, in levar loro i Cori del mezzo, come si vede che fece a S. Maria Novella, a Santa Croce, e al

Carmine; perchè, oltre all'impedir notabilmente il transito, apportavan anco gran pregiudizio alle fabbriche coangustiandolo la magnificenza, che è il maggior pregio lodevole che abbino in se gli edifizi; lo permettesse poi qui, dove era maggior necessita di levarlo, per far spiccare, e rendere agli occhi di tutti cospicua la spaziosità, e grandezza del Tempio." Ferdinando Leopoldo Del Migliore, *Firenze città nobilissima illustrata* (Florence, 1684), p. 40. See also Leoncini, "I 'cori centrali'," p. 488; Smith, "The Bandinelli Choir," p. 58; Vossilla, "Baccio Bandinelli," p. 69.

33 Vossilla, "Baccio Bandinelli," pp. 71–72. Bandinelli's *Adam and Eve* were replaced by Michelangelo's *Bandini Pietà* in 1722; the present high altar dates from 1973. Waldman, "From the Middle Ages," pp. 59–60.

34 "la quale badia era edificata allo antico modo, cioè nel mezzo della chiesa era uno muro o vero uno legno attraverso, in sul quale era uno antico e grande crocifisso legato al muro con una catena o vero corda." Mainardi and Folena, *Motti e facezie*, p. 146. For the dating of the source, see p. xv. Cobianchi, *Lo temperato uso*, p. 54, note 22.

35 "e tale era la chiesa vecchia di Santo Spirito, che arse." Vincenzo Borghini and Domenico Maria Manni, *Discorsi di monsignore D. Vincenzio Borghini: con annotazioni* (Florence, 1755), vol. 2, p. 432; Hall, "The Ponte in S. Maria Novella," p. 169.

36 Francesco Quinterio, "Un tempio per la Repubblica: la chiesa dei SS. Maria, Matteo e dello Spirito Santo in Firenze. Dal primo nucleo duecentesco al progetto brunelleschiano," *Saggi in Onore di Renato Bonelli, Quaderni dell'Istituto di Storia dell'Architettura* 15/20, no. 1990/92 (1992), p. 309.

37 Newbigin, *Feste d'Oltrarno*, p. 163, note 27.

38 Ibid., pp. 157ff.

39 For Brunelleschi's church, see Howard Saalman, *Filippo Brunelleschi: The Buildings* (University Park, PA, 1993), pp. 339–79; Arnaldo Bruschi, *Filippo Brunelleschi* (Milano, 2006), pp. 127–42.

40 Hall, "The Ponte in S. Maria Novella," p. 169. Antonia Fondaras also concluded that the friars' choir was enclosed by "a tramezzo, albeit, it seems, in the form of a simple extension of the wooden enclosure of the friars' choir." Antonia Fondaras, *Augustinian Art and Meditation in Renaissance Florence: The Choir Altarpieces of Santo Spirito 1480–1510* (Leiden, 2020), p. 65.

41 Paatz and Paatz, *Kirchen von Florenz*, vol. 5, p. 125. Margrit Lisner preferred the dating 1483–94. Margrit Lisner, "Andrea Sansovino und die Sakramentskapelle der Corbinelli mit Notizen zum alten Chor von Santo Spirito in Florenz," *Zeitschrift für Kunstgeschichte* 50, no. 2 (1987), p. 267.

42 Margrit Lisner, "The Crucifix from Santo Spirito and the Crucifixes of Taddeo Curradi," *The Burlington Magazine* 122, no. 933 (1980), p. 814.

43 Lisner, "Andrea Sansovino," pp. 267–74.

44 Paatz and Paatz, *Kirchen von Florenz*, vol. 5, pp. 140–41; Cristina Acidini Luchinat, "L'altar maggiore," in *La chiesa e il convento di Santo Spirito a Firenze*, ed. Cristina Acidini Luchinat and Elena Capretti (Florence, 1996), pp. 337–56.

45 Thibodeau, *Rationale Divinorum Officiorum*, p. 17.

46 Allen, "Choir Stalls," p. 183; Jörg Stabenow, "Introduzione," in *Lo spazio e il culto: relazioni tra edificio ecclesiale e uso liturgico dal XV al XVI secolo* (Venice, 2006), p. 13.

47 In papal liturgy the celebrant faced the congregation, making a high altarpiece an impediment. The papal throne in the center of the apse also had to be visible. Donal Cooper, "Franciscan Choir Enclosures and the Function of Double-Sided Altarpieces in Pre-Tridentine Umbria," *Journal of the Warburg and Courtauld Institutes* 64 (2001), pp. 32–39. For Sansepolcro, see Donal Cooper and James R. Banker, "The Church of San Francesco in Borgo San Sepolcro in the Late Middle Ages and Renaissance," in *Sassetta: The Borgo San Sepolcro Altarpiece*, ed. Machtelt Israëls (Florence and Leiden, 2009), pp. 53–105 (especially pp. 69–76), and doc. 4, p. 572.

48 Donal Cooper, "Revisiting the Umbrian Retro-Choir: Plurality and Choice in the Medieval Franciscan Church Interior," in *Spaces for Friars and Nuns*, ed. Haude Morvan (forthcoming).

49 Gardner von Teuffel, "Perugino's Cassinese Ascension," p. 125; Gromotka, "Transformation Campaigns," p. 85; Michael G. Gromotka, "Franciscan Choir Location as a Model in Umbrian Context: The Case of San Pietro in Perugia," in *Spaces for Friars and Nuns*, ed. Haude Morvan (forthcoming).

50 "forte nimis parvam et incapacem populi, qui devote illam [ecclesiam] visitat et maxime in exercitio et tempore preditationis," document dated 11 May 1451, in Archivio di Stato di Brescia, ASC, volume 495, fol. 211v. "pro ornamento et amplitudine ecclesie," document dated 7 July 1463. Archivio di Stato di Brescia, ASC, volume 500, 39v. Both documents partially transcribed in Valentino Volta and Rossana Prestini, *La chiesa e il convento di San Francesco d'Assisi in Brescia* (Brescia, 1994), p. 319, and Allen, "Choir Stalls," pp. 298–99.

51 Riccardo Pacciani, "Il coro conteso. Rituali civici, movimenti d'osservanza, privatizzazioni nell'area presbiterale di chiese fiorentine del Quattrocento," in *Lo spazio e il culto: relazioni tra edificio ecclesiale e uso liturgico dal XV al XVI secolo*, ed. Jörg Stabenow (Venice, 2006), pp. 127–51. Although De Blaauw cited the rebuilding of the tribuna of Santi Apostoli in Rome as an early example of a "mausoleum choir," Schelbert noted that the precise location of the friars' choir in the late fifteenth century is uncertain. Sible De Blaauw, "Private Tomb and Public Altar: The Origins of the Mausoleum Choir in Rome," in *Memory & Oblivion: Proceedings of the XXIXth International Congress of the History of Art, Held in Amsterdam, 1–7 September 1996*, ed. Adriaan Wessel Reinink and Jeroen Stumpel (Dordrecht, 1999), p. 479; Georg Schelbert, "SS. Apostoli a Roma: il coro-mausoleo rinascimentale e il triconco rinato," in *La place du choeur: architecture et liturgie du Moyen Âge aux Temps modernes: actes du colloque de l'EPHE, Institut national d'histoire de l'art, les 10 et 11 décembre 2007*, ed. Sabine Frommel, Laurent Lecomte, and Raphaël Tassin (Paris and Rome, 2012), p. 108.

52 Martin Gaier, "Il mausoleo nel presbiterio. Patronati laici e liturgie private nelle chiese veneziane," in *Lo spazio e il culto: relazioni tra edificio ecclesiale e uso liturgico dal XV al XVI secolo*, ed. Jörg Stabenow (Venice, 2006), pp. 153–80; Joanne Allen, "Innovation or Afterthought? Dating the San Giobbe Retrochoir," in *Art, Architecture and Identity in Venice and Its Territories 1450–1750*, ed. Nebahat Avcıoğlu and Emma Jones (Farnham, 2013), pp. 171–81.

53 "pars enim superior, tanquam coronatum caput, in aediculas quinque divisa … In aedicula quae media fuit episcopalem cathedram et canonicorum sedilia ex materia nobili, arte quam vocant tharsicam, sculpturis et imaginibus insignia composuerunt." *I Commentari* (Milan, 1984), vol. 2, p. 1762, book 9. See also Sible De Blaauw, "Innovazioni nello spazio di culto fra basso Medioevo e Cinquecento: La perdita dell'orientamento liturgico e la liberazione della navata," in *Lo spazio e il culto: relazioni tra edificio ecclesiale e uso liturgico dal XV al XVI secolo*, ed. Jörg Stabenow (Venice, 2006), p. 42.

54 Flavia Cantatore, *San Pietro in Montorio: la chiesa dei re cattolici a Roma* (Rome, 2007), p. 68.

55 De Blaauw, "Innovazioni nello spazio di culto," p. 47.

56 The cardinals were Ascanio Maria Sforza (d. 1505) and Girolamo Basso della Rovere (d. 1507). Christoph Luitpold Frommel, "La nuova cappella maggiore," in *Santa Maria del Popolo: storia e restauri*, ed. Ilaria Miarelli and Maria Richiello (Rome, 2009), pp. 383–410.

57 Joanne Allen, "Nicholas V's Tribuna for Old St. Peter's in Rome as a Model for the New Apsidal Choir at Padua Cathedral," *Journal of the Society of Architectural Historians* 72, no. 2 (2013), pp. 166–89.

58 The work of De Blaauw and Pacciani is instructive in this regard: De Blaauw, "Innovazioni nello spazio di culto," pp. 25–51; Pacciani, "Il coro conteso," pp. 127–51. See also, Brown, "Choir and Altar Placement," pp. 147–80; Paul Davies, "Architettura e culto a Venezia e nelle città di terraferma 1475–1490," in *Pietro Barozzi: un vescovo del Rinascimento*, ed. Andrea Nante, Carlo Cavalli, and Pierantonio Gios (Padua, 2012), pp. 193–203.

59 According to the historian Ghirardacci, on 24 July 1483, Giovanni II Bentivoglio: "parendo … il corridore che traversava la chiesa di San Iacomo, ove erano sotto gli altari di Santa Caterina e di San Pietro, troppo sconciamente occupasse il detto tempio, il fece rimuovere, et ridusse la chiesa ad un sol corpo, come ora si vede." Quoted in Massaccesi, "Il 'corridore'," p. 6.

60 Valenzano, "La suddivisione dello spazio," p. 99: "informe e di impedimento alla chiesa."

61 "il giorno 4 di maggio del 1426 fu disfatto il Coro che era in San Frediano in mezzo la chiesa, e le pietre di vari colori che vi erano, furono messe sopra li scalini avanti all'altare della Cappella maggiore." This is from a manuscript Ridolfi attributed to Canon Pera presso i marchesi Mansi. Michele Ridolfi, *Scritti d'arte e d'antichità*, ed. Enrico Ridolfi (Florence, 1879), p. 335; Romano Silva, *La Basilica di San Frediano in Lucca: urbanistica, architettura, arredo* (Lucca, 1985), pp. 5–26; De Blaauw, "Innovazioni nello spazio di culto," p. 46.

62 See Allen, "Giovanni Bellini's *Baptism of Christ*," pp. 681–704.

63 "Dicti domini provincialis prior [Johanne de Sinno] et fratres intendunt dictum corum amovere a medio ipsius ecclesie et construere supra portam magnam introitus eiusdem ecclesie pro decoru et ornatu ecclesie eiusdem ... unde ceperunt dictam capella [De Anna] exfabricare et diruere animo et intencione ipsam amovendi et ipsam ecclesiam ampliandi et ornandi." D'Ovidio, "La trasformazione dello spazio liturgico," p. 95, note 7.

64 Cobianchi, *Lo temperato uso*, pp. 26–27.

65 The banker and politician Cosimo de' Medici il Vecchio (1389–1464) was a distant relative of Duke Cosimo I de' Medici (1519–74).

66 Brown, "Choir and Altar Placement," pp. 171–75. The designs, in the Gabinetto dei Disegni e Stampe degli Uffizi, are now attributed to an anonymous sixteenth-century architect (1573A) and Antonio da Sangallo il Vecchio (1574A). Dario Donetti, Marzia Faietti, and Sabine Frommel, eds., *Giuliano da Sangallo: Disegni degli Uffizi* (Florence, 2017), pp. 66–70. See also F. W. Kent, "New Light on Lorenzo de' Medici's Convent at Porta San Gallo," *The Burlington Magazine* 124, no. 950 (1982), pp. 292–94.

67 The Sassetti and Ricci families also held historical claims to high chapel patronage. Patricia Simons, "Portraiture and Patronage in Quattrocento Florence with Special Reference to the Tornaquinci and Their Chapel in S. Maria Novella" (PhD thesis, University of Melbourne, 1985), pp. 190–212; Jean K. Cadogan, *Domenico Ghirlandaio: Artist and Artisan* (New Haven, CT and London, 2000), pp. 238–43, 266–68.

68 Maria DePrano, *Art Patronage, Family, and Gender in Renaissance Florence: The Tornabuoni* (Cambridge, 2018), pp. 126–30. For the double-sided high altarpiece, completed by Ghirlandaio's workshop after his death, see Takuma Ito, "Domenico Ghirlandaio's Santa Maria Novella Altarpiece: A Reconstruction," *Mitteilungen des Kunsthistorischen Institutes in Florenz* 56, no. 2 (2014), pp. 171–92.

69 Van Veen emphasized the sense of restoration and retrospection of these projects. Henk Th. van Veen, *Cosimo I de' Medici and His Self-Representation in Florentine Art and Culture*, trans. Andrew P. McCormick (Cambridge, 2006), pp. 117–21.

70 "Item adi xvii di debraio comprai due panche di faggio per lo choro delgliuomini costorono l. due s. otto."

71 Florence, Archivio di San Lorenzo (hereafter ASL), 1422², 1440, fol. 44v (not consulted by the present author). Pacciani, "Cori, tramezzi, cortine," pp. 321, 325, note 35. For the temporary wooden barrier that divided laymen and laywomen as they viewed the annual display of a precious relic collection, see Chapter 1.

71 "adi deto (8 agosto) per fare rimettere umpezzo dimarmo mancaua alle reggi sotto el pergamo per manifattura e spranghe e piombo grosso due s. XI"; ASL 1921¹, 1433, fol. 51r (not consulted by the present author). Ibid., pp. 321, 325, note 36. For the term "reggi," see note 130 of Chapter 5.

72 For the Old Sacristy, see Roger J. Crum, "Donatello's 'Ascension of St. John the Evangelist' and the Old Sacristy as Sepulchre," *Artibus et Historiae* 16, no. 32 (1995), pp. 141–61.

73 Riccardo Pacciani, "Testimonianze per l'edificazione della basilica di San Lorenzo a Firenze 1421–1442," *Prospettiva* 75–76 (1994), pp. 85–99. Trachtenberg argued strongly against the possible attribution to the prior of San Lorenzo, Matteo Dolfini. Marvin Trachtenberg, "Building and Writing S. Lorenzo in Florence: Architect, Biographer, Patron, and Prior," *The Art Bulletin* 97, no. 2 (2015), pp. 157–58. See also Gabriele Morolli, "Non solo Brunelleschi: San Lorenzo nel Quattrocento," in *Alla riscoperta delle chiese di Firenze. 5. San Lorenzo*, ed. Timothy Verdon (Florence, 2007), pp. 58–109.

74 Christa Gardner von Teuffel, "The Altarpieces of San Lorenzo: Memorializing the Martyr or Accommodating the Parishioners?," in *San Lorenzo: A Florentine Church*, ed. Robert W. Gaston and Louis Alexander Waldman (Florence, 2017), p. 217.

75 "The main chapel was built up [si tiro' su] in great part in another form than it has presently, because Cosimo had not yet thought of putting the canons' choir [coro del clero] into it. After he decided to do this, Filippo adapted its form to that which it now has." Manetti, quoted in Saalman, *Filippo Brunelleschi*, p. 162.

76 Volker Herzner, "Die Kanzeln Donatellos in San Lorenzo," *Münchner Jahrbuch der bildenden Kunst* 23 (1972), p. 119.

77 Pacciani, "Il coro conteso," pp. 142–43.

78 Pacciani, "Cori, tramezzi, cortine," p. 322.

79 Saalman, *Filippo Brunelleschi*, p. 164.

80 Janis Clearfield, "The Tomb of Cosimo de' Medici in San Lorenzo," *Rutgers Art Review* 2 (1981), pp. 24–30.

81 Christian-Adolf Isermeyer, "Il Vasari e il restauro delle chiese medievali," in *Studi vasariani: atti del Convegno internazionale per il IV. centenario della prima edizione delle "Vite" del Vasari* (Florence, 1952), p. 234.

82 Herzner, "Die Kanzeln Donatellos," pp. 120–21.

83 "The three salient features of San Lorenzo – the choir in the apse, the high altar *versus populum*, and the tomb at the foot of the altar – were thus interdependent innovations, all of which, like the paired pulpits, reflected Early Christian usage." Irving Lavin, "Donatello's Bronze Pulpits in San Lorenzo and the Early Christian

Revival," in *Past & Present: Essays on Historicism in Art from Donatello to Picasso* (Berkeley, CA, 1993), p. 6. See also Clearfield, "The Tomb of Cosimo," pp. 26–27.

84 "i Fiorentini ... ne permettessero l'edificazione fuori della Città, corrispondente a quella che il Magno Constantino edficò, ancor egli ad onor di S. Lorenzo, fuori delle Mura di Roma." Del Migliore, *Firenze città nobilissima illustrata*, p. 157.

85 Clearfield, "The Tomb of Cosimo," p. 27. Davies suggested that promoting lay accessibility to these relics might have motivated the retrochoir arrangement. Davies, "Architettura e culto," p. 197.

86 Linda A. Koch, "The Early Christian Revival at S. Miniato al Monte: The Cardinal of Portugal Chapel," *The Art Bulletin* 78, no. 3 (1996), pp. 527–55, especially p. 529.

87 Martin V's tomb slab arrived from Florence in 1445. De Blaauw, *Cultus et decor*, vol. 1, pp. 252–53; De Blaauw, "Private Tomb and Public Altar," p. 478; De Blaauw, "Innovazioni nello spazio di culto," p. 44. De Blaauw suggests this might have inspired a similar choir removal in Santa Maria Maggiore in c. 1460. Renovations in Santa Maria Maggiore were undertaken by Cardinal Guillaume d'Estouteville. De Blaauw, *Cultus et decor*, vol. 1, p. 365, 395.

88 Lavin, "Donatello's Bronze Pulpits," pp. 5–6.

89 For altarpieces in Brunelleschian spaces, see Victor M. Schmidt, "Filippo Brunelleschi e il problema della tavola d'altare," *Arte Cristiana* 80, no. 753 (1992), pp. 451–61; Lavin, "Donatello's Bronze Pulpits," p. 6 and for the absence of a high altarpiece in San Lorenzo, see Gardner von Teuffel, "The Altarpieces of San Lorenzo," p. 200. Swiss Protestant theologian Rudolf Hospinian, in his *De Templis* (1587), condemned the practice of facing the people in San Lorenzo in Florence, but he appears not to have realized that the church was occidented: "in ecclesia B. Laurentii apud Florentinos, sacerdos rem divinam faciens, ad occidentem spectat, atque populum prae oculis semper habet." Quoted in Francesco Repishti and Richard Schofield, *Architettura e controriforma: i dibattiti per la facciata del Duomo di Milano, 1582–1682* (Milan, 2004), pp. 184, 243, note 304.

90 This was signaled by Emanuela Ferretti, who commented that San Lorenzo provided a "fine precedent" for the 1560s alterations in Santa Croce and Santa Maria Novella. Emanuela Ferretti, "Sacred Space and Architecture in the Patronage of the First Grand Duke of Tuscany," in *San Lorenzo: A Florentine Church*, ed. Robert W. Gaston and Louis Alexander Waldman (Florence, 2017), p. 514. For the choir frescoes, see Alessandro Cecchi, "Pontormo e Bronzino nel coro di San Lorenzo," in *San Lorenzo: A Florentine Church*, ed. Robert W. Gaston and Louis Alexander Waldman, (Florence, 2017), pp. 525–32.

91 Paatz and Paatz, *Kirchen von Florenz*, vol. 1, p. 63. For the early church, see Paolo Bertoncini Sabatini, "I primi due secoli: dal 'tabernacolo di via' alla basilica tardo

gotica," in *La Basilica della Santissima Annunziata: dal duecento al cinquecento*, ed. Carlo Sisi (Florence, 2013), pp. 27–41.

92 Alana O'Brien, "San Filippo Benizi, 'Honour of the Servi and Florence': His Cycle and Cult at SS. Annunziata, c. 1475–1671" (PhD thesis, La Trobe University, 2001), pp. 90–94. I am grateful to Alana O'Brien for sharing her thoughts on various aspects of Santissima Annunziatas in personal communication dated 12 October and 21 November 2020.

93 Raffaele Taucci, "La chiesa e il convento della SS. Annunziata di Firenze e i loro ampliamenti fino alla metà del secolo XV," *Studi storici sull'Ordine dei Servi di Maria* 4 (1942), pp. 105–06. Eugenio M. Casalini, *Registro di entrata e uscita di Santa Maria di Cafaggio (REU), 1286–1290* (Florence, 1998), p. 27, note 21; Eugenio Casalini, *Michelozzo di Bartolommeo e l'Annunziata di Firenze* (Florence, 1995), p. 64.

94 Newbigin, *Feste d'Oltrarno*, p. 4.

95 Anna Biancalani suggested that the tramezzo divided the nave from the transept and was similar to the Carmine rood screen in form. Mario Fabbri, Elvira Garbero Zorzi, and Annamaria Petrioli Tofani, eds., *Il luogo teatrale a Firenze: Brunelleschi, Vasari, Buontalenti, Parigi, Firenze, Palazzo Medici Riccardi, Museo Mediceo, 31 maggio–31 ottobre 1975* (Milan, 1975), pp. 55–56. Again interpreting the Russian bishop's letter, Beverly Brown suggested that the rood screen crossed the nave near the third chapel from the main entrance. Beverly Louise Brown, "The Tribuna of SS. Annunziata in Florence" (PhD thesis, Northwestern University, 1978), p. 20. This interpretation was also followed by Riccardo Pacciani in Riccardo Pacciani, "'Signorili amplitudini ...' a Firenze. La cappella Rucellai alla Badia di S. Pancrazio e la rotonda della SS. Annunziata: architettura, patronati, rituali," in *Leon Battista Alberti architetture e committenti*, ed. Arturo Calzona et al. (Florence, 2009), pp. 164–65.

96 Newbigin, *Feste d'Oltrarno*, pp. 8–9.

97 Ibid., pp. 9–10.

98 Casalini cited two archival references from 1439: "una pancha sta drieto al choro da s. Philippo"; "per una lampada di retro al choro per quella Vergine Maria che si ruppe." Casalini, *Michelozzo di Bartolommeo*, pp. 67 and 63, note 29.

99 Taucci, "La chiesa e il convento", p. 106; Paola Ircani Menichini, *Vita quotidiana e storia della SS. Annunziata di Firenze nella prima metà del Quattrocento* (Florence, 2004), pp. 31, 119.

100 "... Chorum in medio cum arcubus aream nimis indecenter praepedire ..." Arcangelo Giani and Luigi Maria Garbi, *Annalium sacri Ordinis fratrum Servorum B. Mariae Virginis a suae institionis exordio centuriae quatuor* (Lucca, 1719), p. 460, quoted in Casalini, *Michelozzo di Bartolommeo*, p. 15, note 13. Giani's text was first printed in the early seventeenth century.

101 "Francesco di Bartolo legnaiuolo ... per raconciare el coro." Florence, Archivio del convento della SS. Annunziata di Firenze, Campione Nero 1442–1454,

fol. 68r (not consulted by the present author). Casalini also argued that in 1443 the stalls were likely moved to a temporary location behind the high altar. Casalini, *Michelozzo di Bartolommeo*, pp. 81, 137. Beverly Louise Brown, "The Patronage and Building History of the Tribuna of SS. Annunziata in Florence," *Mitteilungen des Kunsthistorischen Institutes in Florenz* 25 (1981), pp. 74, 138, note 37. O'Brien agreed with this assertion. O'Brien, "San Filippo Benizi," p. 85. Pellegrino Tonini, meanwhile, stated that the move to locate the stalls behind the high altar only took place following the completion of the tribuna in 1476. Pellegrino Tonini, *Il Santuario della Santissima Annunziata di Firenze* (Florence, 1876), p. 73.

102 Brown, "The Patronage and Building History," pp. 59–146.

103 Pacciani, "'Signorili amplitudini . . .' a Firenze," p. 164.

104 Brown, "The Patronage and Building History," p. 81.

105 Giovanni Aldobrandini, in a letter to Lodovico Gonzaga dated 2 February 1471, expressed concerns that the proximity of the choir to the chapels might disrupt liturgical activities. Brown, "The Tribuna," pp. 329–31 (Doc. 43).

106 For the early church, see Linda Pellecchia Najemy, "The First Observant Church of San Salvatore al Monte in Florence," *Mitteilungen des Kunsthistorischen Institutes in Florenz* 23, no. 3 (1979), pp. 273–96; Giampaolo Trotta, *San Salvatore al Monte: "Antiquæ elegantiæ" per un "acropolis" laurenziana* (Florence, 1997), p. 9. Pellecchia Najemy argued that the choir in the early church was an independent chapel next to the sacristy, to the right of the *cappellone*, a private family chapel of the Nerli.

107 Trotta, *San Salvatore al Monte*, pp. 10–12. Quaratesi's testament specified: "etiam quod corpus Ecclesiae predictae de novo et aliter construetur, intendens etiam illud perfici et fieri amore Dei." Ibid., p. 29, note 47.

108 "La chapella magiore si facia larga braccia tredicj et lunga braccia tredicj et facciasi involta. La chiesa si facci lungha da l'arco de detta chapella insino alla porta principale della chiesa braccia sessanta, et largha braccia venti et sia divisa in questo modo, cioè che lo spatio del choro per li frati sia lungo braccia venti, et dal choro insino alla porta principale de-dicta sia lo-spatio lungho braccia quaranta. Et facciasi detta chiesa con tecto simplice. Et di-sotto al-choro nella nave della chiesa si faccino sei chappellette con l'-altare, cioè due di-rieto al choro da ogne lato una et in essa nave della chiesa se ne facci da omni lato due siché in tutto siano di-sotto al choro sei altarj, come dicto di sopra." Ibid., pp. 12, 29, note 54. In his reconstruction of this projected church,

Alexander Markschies placed the friars' stalls in a U-shape around the high altar and a tramezzo separating this area from the single-aisled nave. Cobianchi, however, showed that this arrangement incorrectly interprets the document, which indicates that the tramezzo was closer to the main door. Alexander Markschies, *Gebaute Armut: San Salvatore e San Francesco al Monte in Florenz (1418–1504)* (Munich and Berlin, 2001), p. 77, fig. 13; Cobianchi, *Lo temperato uso*, p. 48, note 110.

109 Markschies, *Gebaute Armut*, p. 112.

110 Riccardo Pacciani, "Cosimo de' Medici, Lorenzo il Magnifico e la chiesa di San Salvatore al Monte a Firenze," *Prospettiva* 66 (1992), p. 31; Markschies, *Gebaute Armut*, p. 196.

111 For the stalls, see Licia Bertani, "Dallo spendore 'antiquo' dell'età di Cosimo il Vecchio e di Lorenzo il Magnifico al rigorismo della repubblica piagnona: capolavori artistici per le chiese di San Salvatore tra due stagioni dell'Umanesimo," in *San Salvatore al Monte: 'Antiquæ elegantiæ' per un 'acropolis' laurenziana*, ed. Giampaolo Trotta (Florence, 1997), p. 52.

112 Alison Luchs, *Cestello. A Cistercian Church of the Florentine Renaissance* (PhD thesis, The Johns Hopkins University, 1976), pp. 8ff. See also C. de Fabriczy, "Memorie sulla chiesa di S. Maria Maddalena de' Pazzi a Firenze e sulla Badia di S. Salvatore a Settimo," *L'Arte* 9 (1906), pp. 255–62.

113 The seventeenth-century Cistercian historian Ignazio Signorelli wrote: "1498. Quest'anno si fabbricò il Coro di Cestello con sfondare l'arco della facciata dell'Altare grande per farlo dietro a esso Altare; per la detta fabrica s'hebbero denari da molti, ma ispecie duc. 100 donò Ginevra Ubertini." de Fabriczy, "Memorie," p. 259; Luchs, *Cestello*, p. 28.

114 Markschies identified them as such; Luchs disagreed. Markschies, *Gebaute Armut*, p. 110, figs. 46, 47; Luchs, *Cestello*, p. 32.

115 A payment was made in 1503 "per 2 finestre fatte in choro." For the windows, see Alison Luchs, "Origins of the Widener Annunciation Windows," *Studies in the History of Art* 7 (1975), pp. 81–89; "The Angel of the Annunciation," www.nga.gov/collection/art-object-page .1472.html#provenance

116 "ne monachi in choro existentes a laicis videndo turbentur." ASF, Diplomatico, Cestello, 25 November 1505 (not consulted by the present author). Luchs, *Cestello*, pp. 29, 373, Doc. 16.

117 Ibid., pp. 30, 151, note 59.

Chapter 3

TRANSFORMING CHURCHES IN SIXTEENTH-CENTURY FLORENCE

I N THE 1560S, CHURCH ALTERATIONS gained momentum in Florence. Within a short span of time, renovations were enacted in San Niccolò Oltrarno, San Marco, Ognissanti, Santa Maria Novella, Santa Croce, Santa Maria del Carmine, Santa Trinita, San Pier Maggiore, Orsanmichele, San Pancrazio, and San Giovanni. Subsequent chapters will discuss several of these spaces at length, but this chapter will investigate the notable Florentine sites not covered by chapter case studies and situate their development in a broader Italian context. Despite the concentration of these renovations and the variable influence of Vasari and Duke Cosimo, this chapter will show that a wide variety of agents were involved. Multiple factors, including flood damage, administrative change, local reform, and politics, and increased emphasis on high altar tabernacles prompted alterations to liturgical space.

This chapter will also engage with the painted imagery, chapels, tombs, and liturgical furnishings that once adorned church screens in Florence. Although they have not always been definitively reconstructed, the presence of altarpieces, panel paintings, and wall paintings affirms the role of screens as loci of meaning within the church interior. These painted images of the saints, some of which were commissioned by confraternities or individual patrons, formed a now lost layer of visual focal points that mediated between the nave and the high altar. Before their elimination, nave choirs represented the heart of the church not only for the religious community but also for lay devotees; indeed, at times the memory of precincts and their chapels was preserved in inlaid flooring, revealing the importance they once held in articulating sacred space.

THE SIXTEENTH-CENTURY
ITALIAN CONTEXT C. 1500–1560

The isolated retrochoir arrangements of the fourteenth and fifteenth centuries, covered in Chapter 2, continued apace into the sixteenth century but often caused controversy. For example, in Siena Cathedral in 1506, the tyrannical leader Pandolfo Petrucci, who had taken full control of the Opera del Duomo, transferred the choir stalls that had been sited beneath the crossing dome to the new Dominican church of Santo Spirito, leaving the existing retrochoir for use by the cathedral canons. Petrucci also replaced Duccio's *Maestà* high altarpiece with Vecchietta's Eucharistic tabernacle.[1] Echoing fifteenth-century motivations, the clergy deliberations recorded that the scheme would be "to the greater ornament of said church and the

convenience of the clergy for divine [office]."[2] However, contemporary chronicler Sigismondo Tizio recorded that while Petrucci wished to make the cathedral "more spacious and ample," both the clergy and local citizens lamented such drastic changes.[3]

As we saw for the fifteenth century in Chapter 2, lay patrons could prompt alterations to liturgical space. At Ferrara Cathedral between 1498 and 1534, the cappella maggiore was rebuilt by architect Biagio Rossetti and financed by Duke Ercole I d'Este, to accommodate a staggeringly large choir of 150 stalls (Figure 62).[4] In the Franciscan Observant church of San Giovanni Battista in San Giovanni Valdarno in the Province of Arezzo, a now rebuilt retrochoir was financed by a layman in 1522.[5] Clerical concerns also prompted shifts in choir layout. Between 1502 and 1506, the choir of Reggio Emilia

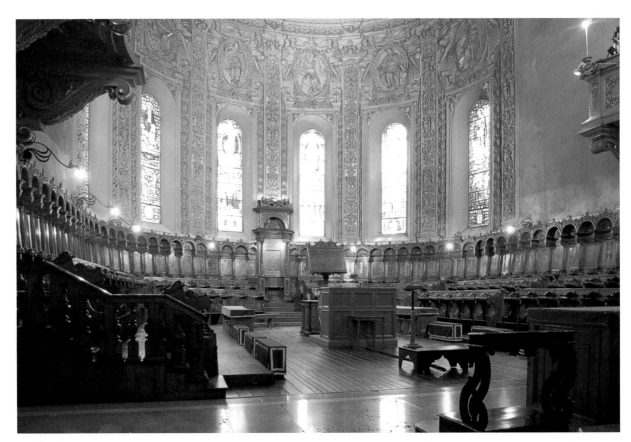

Figure 62 Ferrara Cathedral. Interior view of retrochoir facing southeast. Photo: author

Cathedral was placed behind the high altar due to an increase in clergy numbers and a need for more lay access to the church (Figure 63).[6] Choir stalls in Sant'Ambrogio in Milan were removed from their original position in the nave together with their marble frontage in 1507, only thirty-six years after their completion, so that "with a soul more quiet and more intent on God [the monks and canons] could do those things which relate to the singing of the Divine Office."[7] In the Dominican church of Santa Maria sopra Minerva in Rome, the transfer of the choir from the nave to behind the high altar in 1547 enabled the tombs of the two Medici popes Leo X and Clement VII to be more visually accessible to the laity in the nave.[8] In some cases, as in the fifteenth century, precise motivations for the institution of retrochoirs are unrecorded. Retrochoirs with new choir stalls were created at San Francesco in Cremona between 1508 and 1531,[9] and at San Giovanni in Monte in Bologna in 1517–18,[10] and a monumental tramezzo in Santa Caterina in Pisa that had several attached chapels and the facility to walk across the top was removed during the priorate of Fra Raphael Risalitus (1529–31).[11]

Anticipating the Tridentine period, Bishop of Verona Giovanni Matteo Giberti linked choir renovation to liturgical reform.[12] His numerous architectural interventions in Verona Cathedral, including the construction of new choir stalls around the apse and a new high altar that enabled the celebration of Mass *versus populum*, were centered around the glorification of the Eucharistic tabernacle, which Giberti in his *Constitutiones* (1542) commanded should be on every high altar.[13] In a pioneering and unique solution to the arrangement of sacred space, the so-called *tornacoro* comprised a semi-oval marble colonnade that enclosed the presbytery and retrochoir. Designed in the early 1530s, this construction utilized testamentary funds left by Ludovico di Canossa, Bishop of Bayeux, and is widely attributed to Michele Sanmicheli

(Figure 64).[14] Reprising the vocabulary of early Christian and early medieval screens, and Brunelleschi's choir enclosure in the Florence Duomo, the *tornacoro* echoed the curvilinear forms of the architectural apse and the tabernacle itself, and projected the presbytery further into the nave.[15] Although rarely repeated, this arrangement fulfilled Giberti's reform objectives in both enclosing the clergy away from the laity and framing the tabernacle in the spatial heart of the church, which the bishop's contemporary biographer, Pier Francesco Zini, described as the locus "where the body of our lord Jesus Christ is placed, just as the heart is held in the breast and the mind in the soul."[16]

Similarly, retrochoirs in churches belonging to the Reformed Benedictine Cassinese Congregation, known as *De Unitate* until the monastery of Montecassino joined in 1504, have been linked with the development of monastic reform.[17] In the fifteenth century, choirs were placed in the nave in front of the high altar, and in 1520, at a chapter held at Santa Giustina in Padua and presided over by the head of the order, Theophilus of Milan, the monks agreed "that the altar is placed in the head of the cappella maggiore according to the custom of our congregation,"[18] effectively indicating that the choir should be situated in front of the high altar.

Isermeyer noted that in the first few decades of the sixteenth century, Cassinese churches maintained this arrangement.[19] Then, in opposition to the 1520 decree, in 1543–45 stalls were placed around a semi-circular apse in the church of Montecassino according to a design made c. 1531 by Antonio da Sangallo the Younger. This drawing, for a Medici tomb, documents the existing rectilinear choir enclosure in the nave together with two proposed arrangements of stalls in the apse, leaving a visual testimony of the contested ideologies that surrounded this overall shift (Figure 65).[20] Aside from this transformation, and a similar one undertaken at San Benedetto al Polirone (1539–47), most Cassinese

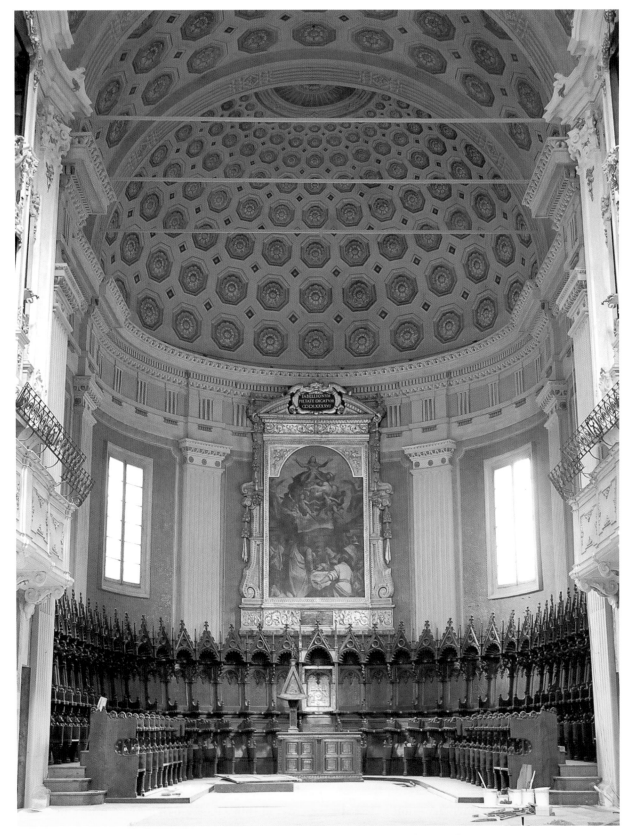

Figure 63 Reggio Emilia Cathedral. Interior view of retrochoir facing southeast. Photo: author

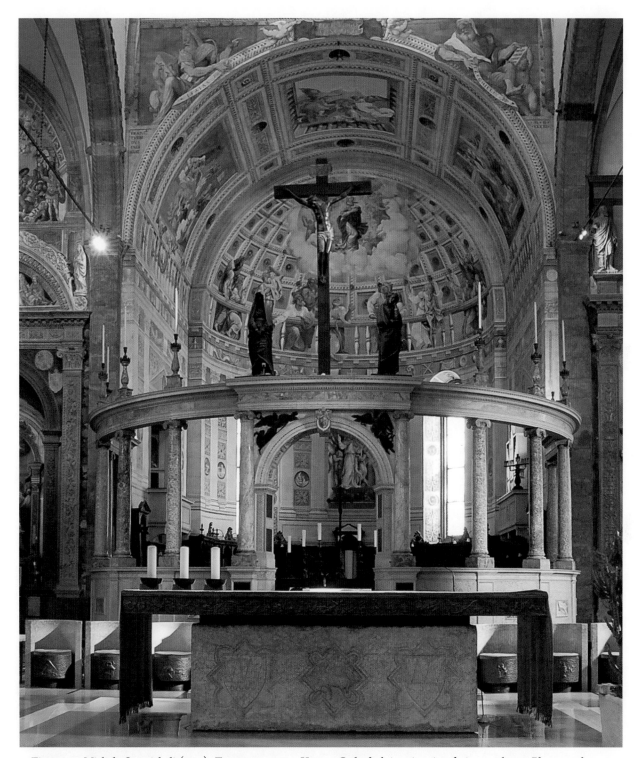

Figure 64 Michele Sanmicheli (attr.), *Tornacoro*, 1530s. Verona Cathedral, interior view facing northeast. Photo: author

churches would not be equipped with retrochoirs until at least the later sixteenth century, postdating the majority of the Florentine cases.[21] In the 1560s and 1570s, San Giorgio Maggiore in Venice and the Badia in Arezzo, perhaps influenced by changes to liturgical space witnessed outside the order, and the aesthetic choices of architects Palladio and Vasari respectively, were conceived

Figure 65 Antonio da Sangallo the Younger, *Montecassino: project for the church,* c. 1531. Gabinetto dei Disegni e delle Stampe degli Uffizi, 181 A. Photo: © Gabinetto fotografico, Gallerie degli Uffizi, Ministero per i beni e le attività culturali e per il turismo

with extensive retrochoirs.[22] At the mother church of the Congregation, Santa Giustina in Padua, and in the Badia Fiorentina, the monks' choir stalls were only removed to behind the high altar in the seventeenth century.[23]

Vasari in Arezzo

Giorgio Vasari's architectural interventions in his birthplace of Arezzo foreshadowed his mendicant projects in Florence by more than a decade, and began when Bishop Minerbetti, a Florentine, requested a renovation of Arezzo Cathedral.[24] In 1554, Vasari planned to move the choir stalls behind the high altar, stating,

> This [design] would make for the following effects: for one thing, the Sacrament would be isolated for everyone [to see] in the middle of the altar, and for another, the choir which today stands in front of the altar would be placed behind it, which would be good. And the Arca di San Donato would be saved, and the expense would not be great.[25]

Objections from the cathedral clergy and frequent absences of both bishop and architect, however, delayed the project, although the choir stalls were relocated the following year. It was only revived a decade later, following Vasari's work in Arezzo's Pieve.

The historical rival of the Duomo, the Arezzo Pieve, presents significant challenges of reconstruction due to a radical nineteenth-century restoration that sought to "restore" its pre-Vasarian medieval interior (Figure 66). Giovanni Freni has shown that the present-day raised presbytery above an extended crypt, in the manner of San Miniato al Monte, belongs to these nineteenth-century interventions. Instead, he argued, Vasari's writings show that he encountered the canons' wooden choir stalls in front of the high altar in

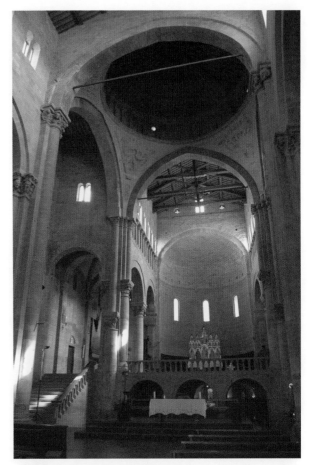

Figure 66 Santa Maria della Pieve, Arezzo, after nineteenth-century restorations. Interior view facing southeast. Photo: author

the nave behind a tramezzo. The high altar rested on a continuous floor level with the nave, and was adorned with Pietro Lorenzetti's polyptych high altarpiece.[26] Vasari initially sought to modernize his family chapel in the left nave aisle, but was subsequently ceded patronal rights to the high chapel, allowing him to pursue a more dramatic transformation of the church interior.[27] He transferred the polyptych to the nave, destroyed the tramezzo, and moved the nave choir stalls behind the high altar. The artist then installed a huge new double-sided high altar, which he designed with an integrated sacrament ciborium specifically for the setting (Figure 67). This construction was in a more frontal position than the previous high altar, and Vasari situated

Figure 67 Giorgio Vasari, Pieve high altar, 1560–64. Badia delle Sante Flora e Lucilla, Arezzo (removed from the Arezzo Pieve and reassembled here in the nineteenth century). Photo: author

relocation of the choir has provided more space for the church, commodity for the priests, and has conferred a sense of elegance for this work. The faithful seated in the rows between the columns free up the three aisles, and the entire body assembled in the church sees the raising of the Sacrament without rising from their seats. Previously, on account of the tramezzo and the impediment of the lectern, one had to twist and turn his head in order to see it.[30]

In this letter, Vasari explained that his project corrected many sensory and practical aspects of the church interior. Statements regarding the increased availability of space, better functionality for the clergy, and the more appealing interior aesthetics are conventional topoi that have been noted for earlier renovations (see Chapter 2). However, Vasari also added some new considerations that speak to broader motivations behind the church renovations: improved sightlines for the laity of the elevation of the Host and the enhanced soundscape. In their acoustical study of Venetian churches, Deborah Howard and Laura Moretti found that retrochoirs indeed altered the resonance and quality of sung music, in particular of plainchant, which could sound penetrating and rich when sung in these spaces.[31] The improved viewing of the elevation of the Host, meanwhile, reflects growing Eucharistic devotion in the Tridentine period also shown by the increased production and more prominent display of Eucharistic tabernacles (see Chapter 8 for a more extended discussion of these objects).

his family tomb behind in the center of the priests' choir.[28] He also erected new uniform side altarpiece tabernacles, enlarged the narrow medieval windows, and possibly whitewashed the walls and piers.[29] After Bishop Minerbetti consecrated Vasari's new high altar on 25 March 1564, Vasari wrote to Duke Cosimo extoling the virtues of his new scheme:

But the fact that I have removed the wooden choir [from the] front and placed it in the back, in the cappella maggiore, where the voices [in the choir] sound better, has improved [the Pieve] more than anything anyone else has done before. The

FLORENTINE RENOVATIONS
C. 1561–1564

While Vasari was involved in the reorganization of the Arezzo Pieve, it appears likely that the Florentine churches of San Niccolò Oltrarno, San Marco, and Ognissanti were also

being transformed, although none of these episodes can be securely dated.

San Niccolò Oltrarno

First documented in 1164 but likely in existence before this date, the parish church of San Niccolò Oltrarno was listed by Vincenzo Borghini as one of the twelve original "priorie" of the city (Figure 68).[32] The present Gothic church was built to replace the previous Romanesque structure in the first years of the fifteenth century.[33] Since its foundation, San Niccolò was placed under the protection of the Arte dei Mercatanti di Calimala, the merchants' guild, one of whose most prominent members – Bernardo di Castello Quaratesi – held patronage rights over the high chapel (A on Figure 69), furnishing it in 1425 with

a famous polyptych by Gentile da Fabriano.[34] In 1525, the church reacquired the title of "prioria" and the right to elect canons, privileges that Giuseppe Richa stated had been enjoyed by the institution at an earlier date.[35]

From the start of its existence, the Gothic church featured a tramezzo that bisected the nave. Excavations conducted following the 1966 Arno flood revealed the foundations of a wall that crossed the church at the approximate site of the present-day pulpit, roughly half-way down the nave (E on Figure 69).[36] Grazia Badino has analyzed thermographic traces of a Quattrocento window in the left nave, concluding that the tramezzo would not have surpassed the height of this blocked window, which was slightly lower than the extant altar tabernacles.[37] Beyond the tramezzo was the choir precinct (B on Figure 69). According to an inventory conducted in 1519, in

Figure 68 San Niccolò Oltrarno, Florence. Interior view facing north. Photo: author

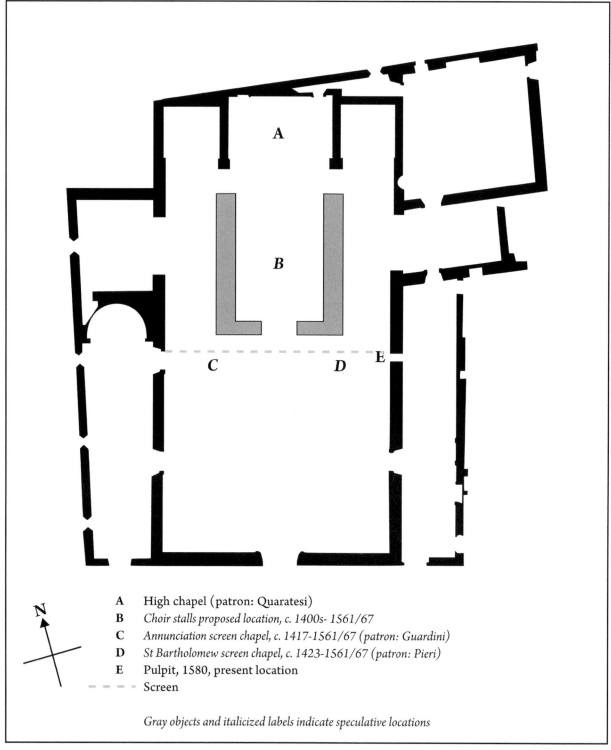

A High chapel (patron: Quaratesi)
B *Choir stalls proposed location, c. 1400s- 1561/67*
C *Annunciation screen chapel, c. 1417-1561/67 (patron: Guardini)*
D *St Bartholomew screen chapel, c. 1423-1561/67 (patron: Pieri)*
E Pulpit, 1580, present location
- - - - Screen

Gray objects and italicized labels indicate speculative locations

Figure 69 San Niccolò Oltrarno, Florence. Proposed plan of church before 1561/1567. Image: author.

the "choir where one sings," large settles (long benches with integrated chests beneath) to the left and right contained numerous antependia, revealing the multifunctionality of the choir furniture.[38] On the right were "the chests of the priests," while the chests on the left mainly held liturgical textiles decorated with family heraldry associated with the church's patrons.

In his *Memoria* dated 1579, Prior Leonardo Tanci, who provided an invaluable record (continued by his successors) of the state of the church in the sixteenth century, stated that the tramezzo featured two attached chapels each framed by two columns, while in the center of the screen a crucifix was supported by a disagreeable wooden beam ("travaccia").[39] In his testament of 1417, Michele Guardini left 600 florins for the establishment of a chapel dedicated to the Annunciation, which appeared on the left of the screen (C on Figure 69).[40] According to Stefano Rosselli, Guardini was a butcher who served as Florentine prior on two occasions, and "must have been a wealthy man" since he not only funded the library of Santa Croce, but patronized two chapels in San Niccolò and posthumously provided for repairs to the roof and exterior paving.[41] The right tramezzo chapel was dedicated to St. Bartholomew, the name-saint of its founder, the merchant Bartolomeo Pieri, who established the chapel in 1423 (D on Figure 69).[42] An inventory taken in 1427 listed liturgical cloths for the Guardini and Pieri altars, proving their existence at this date.[43] Moreover, Giovanna Damiani has shown that the original tramezzo also likely supported an organ, commissioned by Niccolò di Cione Quaratesi and located on a support above the Pieri screen chapel on the right side.[44]

According to Vasari, a tempera painting "by the hand of Masaccio" was in San Niccolò "nel tramezzo,"[45] now widely accepted to be *The Annunciation* by Masolino, dated c. 1423/1424 and currently housed in the National Gallery of Art in Washington, DC (Figure 70).[46] Serena Padovani and others have observed that the visual interest of the panel lies in its richly decorated and intricately conceived architectural setting, rendered using a rigid perspectival system that establishes a low vanishing point.[47] Indeed, the almost "di sotto in su" effect of the panel and its vertical format might immediately suggest that it may have been suspended atop the tramezzo

beam as scholars have argued for other Tuscan contexts.[48] However, Tanci confirmed that when the panel was reinstalled in the new Guardini Chapel in the sacristy, it was displayed "in the middle of two old columns that were on the tramezzo," likely reprising its earlier arrangement, thus reducing the possibility of an elevated position.[49] In addition to its curious architectural setting, the panel's fictive framing, rendered in imitation of *pietra serena* with trilobate leaves in the spandrels, was potentially designed to accord with carved details of the screen itself.[50]

The painted imagery associated with Pieri's chapel of St. Bartholomew is harder to establish with certainty, since in San Niccolò, two panels attributed to Bicci di Lorenzo depict the apostle saint.[51] The first, a heavily damaged polyptych from the early 1420s, depicts not only St. Bartholomew but St. Peter, a figure likely onomastically connected to the Pieri family.[52] A second possibility is Bicci di Lorenzo's 1430s single-panel altarpiece depicting the enthroned Madonna and Child between St. Francis, a bishop saint (possibly St. Louis of Toulouse), and SS Laurence, Lucy, Nicholas of Bari, and Bartholomew. This panel is not dissimilar to Masolino's *Annunciation* in structure and dimensions.[53] Moreover, if the image had been situated on the tramezzo, the twisting figure of St. Francis on the left would have displayed his chest wound to those entering the choir via the screen's central opening. Whichever altarpiece graced the Pieri Chapel, it is tantalizing to imagine the visual effect of the two tramezzo paintings framing through the screen's central opening a view of Gentile da Fabriano's coeval high altar polyptych.

At San Niccolò Oltrarno, the renovation of the church interior appears to have been initially guided by practical motivations. In 1557, a disastrous flood of the Arno badly affected the church, which is situated close to the southern bank of the river. Contemporary reports described how the large volume of water not only destroyed the Ponte Santa Trinita and two arches of the Ponte

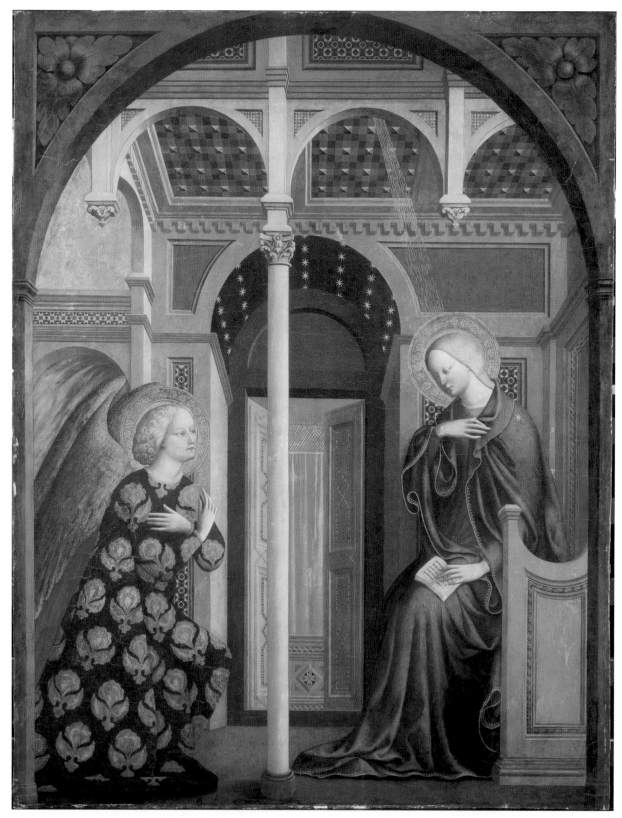

Figure 70 Masolino da Panicale, *The Annunciation*, c. 1423/1424, tempera (and possibly oil glazes) on panel, 148.8 × 115.1 cm. National Gallery of Art, Washington, DC, Andrew W. Mellon Collection 1937.1.16. Photo: Courtesy National Gallery of Art, Washington, DC

Figure 71 San Niccolò Oltrarno, Florence. Choir stalls in high chapel. Photo: author

alla Carraia, but also particularly afflicted the city's churches.[54] In his *Memoria*, Tanci mentioned the damage to the bridges and numerous churches (San Marco, Santissima Annunziata, San Lorenzo, Santa Felicita, San Felice, Santo Spirito, the Carmine), and especially to San Niccolò, where altarpieces were ruined and the prior lost a good portion of his personal library.[55] At San Niccolò, the height the floodwaters reached was commemorated in a plaque on the church facade; although this is now replaced by a modern copy, the original was recorded by Stefano Rosselli, who stated that it was installed at a height of around ten *braccia* from street level.[56] The potential for flood damage in San Niccolò reminds us of the materiality of choir precincts: these enclosures did not just fulfill a liturgical purpose but were physical structures susceptible to the ravages of time and natural disasters.

Tanci reported that a major restoration of the church began soon after the flood in 1561. In that year, he stated, the high altarpiece was removed from the altar and attached to the wall; a now lost Eucharistic tabernacle with figures in terracotta was fashioned "according to a design by Giorgio Vasari" at the expense of Bernardo Andrea and Pagolo Quaratesi; two rows of seats were removed from the tramezzo to the side walls of the cappella maggiore; and a wooden pulpit was removed with the intention of installing one or two replacements.[57] It is unclear whether the extant late fifteenth-century choir benches in the cappella maggiore, decorated with intarsia patterning, classical pilasters, and a now damaged intarsia frieze, are the ones originally sited in the nave (Figure 71).[58] Tanci's long explanation was supplemented in the margin of the manuscript with a note concerning the reuse of the tramezzo chapel columns, implying that this also occurred in 1561. Frustratingly, when describing the vicissitudes of the Guardini screen

chapel, Tanci left a blank space for the year this alteration occurred ("onde quando si levò il tramezzo l'anno ...").[59] While 1561 is a distinct possibility, scholars have tended to favor 1567, when the Pieri Scodellari altar (previously on the tramezzo) was translated to a newly restored *pietra serena* chapel.[60] Revealing a certain ambivalence about the drastic spatial changes in San Niccolò, an attempt was made to preserve the memory of the screen, which demonstrated its importance to the local lay community. In his Sepoltuario, Stefano Rosselli described "an inscription that you read in a marble inlay ('tassello') that is in the ground in the middle of the church almost even with the pulpit."[61] That inscription stated in poor Latin that the Scodellari altar – now on the side wall – was originally on the screen, reminding the viewer of its previously more prominent location.

Following the removal of the tramezzo in the 1560s, the introduction of new side altars and rectangular windows in the 1580s eliminated the medieval fresco decoration.[62] Eight large altar tabernacles – three along each nave wall and two on the counter-facade – have been attributed to the circle of Giovanni Antonio Dosio.[63] In 1589, Michele Poccianti particularly noted the "very beautiful altars done by many noble families."[64] The *pietra serena* pulpit, donated by the Pieri Scodellari family in 1580, also forms part of the unified aesthetic of the San Niccolò nave (Figure 72; E on Figure 69).[65]

Given the chronological uncertainty surrounding the elimination of the tramezzo, scholars do not agree on whether San Niccolò was an early case occasioned by flood damage, or a restoration that imitated the more high-profile churches of Santa Croce and Santa Maria Novella. Italo Moretti argued that while Tanci's restoration was initiated by flood damage, the influence of other sites such as Santa Croce was certainly an influential factor.[66] Anna Laghi concluded that San Niccolò's unified interior points to the involvement of Vasari, who

Figure 72 San Niccolò Oltrarno, Florence. *Pietra serena* pulpit on east nave wall. Photo: author

might have had an initial consultative role.[67] In either case, the status of San Niccolò as a parish church shows that tramezzi were not limited to the mendicant or monastic context but had significant relevance in a parish environment with strong local lay patronage.

San Marco

Initially founded for a congregation of Sylvestrine monks, the church of San Marco changed hands

Figure 73 San Marco, Florence. Interior facing northeast. Photo: author

in 1436 when, due to an intervention by Cosimo il Vecchio de' Medici, Pope Eugenius IV transferred the Sylvestrines to San Giorgio alla Costa and the Observant Dominicans from Fiesole to San Marco (Figure 73).[68] Cosimo il Vecchio and his brother Lorenzo naturally acquired patronage rights over the cappella maggiore at San Marco, and the subsequent architectural changes to the church and its adjacent convent have widely been attributed to Cosimo's favored architect, Michelozzo di Bartolomeo.[69] Constructed in c. 1437–41, Michelozzo's polygonal presbytery led to the friars' choir in front of the high altar. A plan by Giorgio Vasari the Younger toward the end of the sixteenth century probably indicates the fifteenth-century disposition of this area: the choir precinct enclosed by walls on three sides

and two chapels attached to the front of the choir screen facing the nave (Figure 74; B on Figure 75).[70] According to Vasari, a wooden crucifix by Baccio da Montelupo was suspended above the choir screen door.[71]

Sally Cornelison has shown that the screen enclosing the friars' choir was the original location of the tomb and first relic chapel of St. Antoninus, the Dominican archbishop of Florence who died in 1459 (Figure 75).[72] Situated on the left side of the screen, the brick floor tomb attracted numerous ex-votos and other offerings, later accompanied by an altar constructed following the canonization of the saint in 1523, which was further protected by a wooden enclosure built in 1553 (D on Figure 75).[73] Janet Cox-Rearick situated Fra

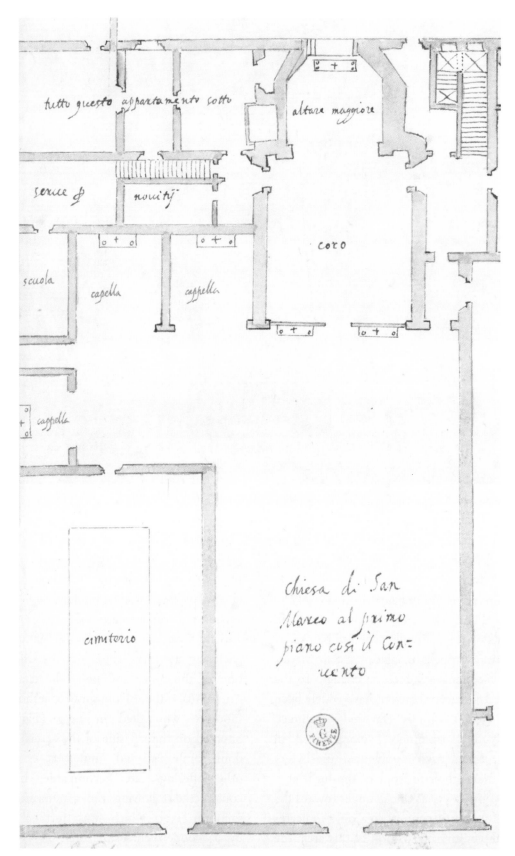

Figure 74 Giorgio Vasari the Younger, *Plan of San Marco*, detail, late 1500s. Gabinetto dei Disegni e delle Stampe degli Uffizi, 4861 A. Photo: © Gabinetto fotografico, Gallerie degli Uffizi, Ministero per i beni e le attività culturali e per il turismo

Bartolomeo's large panel of *St. Mark* dated c. 1514–15 on the left altar of the choir screen, its composition potentially creating the effect of the painted figure turning toward the viewer, with the *St. Sebastian* panel as a pendant on the right.[74] Stating that the choir wall was likely around 5 m in height, Cox-Rearick surmised that the two panels were installed in shallow recesses in the wall, their arched shapes creating visual harmony with the altars on the nave side walls. However, Cornelison has demonstrated that the panels were in fact displayed within the friars' choir, on the side walls above two doorways, with Fra Bartolomeo's *St. Vincent Ferrer* hung above a door to the right of the friars' choir near the nave pulpit.[75] This original arrangement of the panels was rather short-lived: the *St. Sebastian* was sold in 1529 and entered the collection of King of France Francis I before 1532.[76]

In the nave, meanwhile, a tramezzo wall divided two zones intended for use by the laity: laymen in the upper nave, and laywomen in the area closest to the main entrance, providing a clear example of the sort of gender segregation discussed in Chapter 1. The nave tramezzo, the precise location of which is not recorded by early sources, featured two attached chapels.[77] The left chapel was dedicated to the Holy Cross (G on Figure 75), and was patronized by the Compagnia di Santa Croce dei Tessitori, who in the 1490s commissioned an altarpiece for their screen chapel of the *Volto Santo with SS Vincent Ferrer, John the Baptist, Mark, and Antoninus*, attributed to the Master of the Fiesole Epiphany.[78] The right chapel was dedicated to the Dominican St. Thomas Aquinas (H on Figure 75), and was perhaps adorned by Ghirlandaio's *Madonna and Child with SS Dionysius, Dominic, Clement, and Thomas Aquinas*.[79] Cornelison noted that the two more recent Dominican saints in the Tessitori altarpiece (Vincent Ferrer and Antoninus) provided an "iconographical balance" for the two older Dominican saints (Dominic and Thomas

Aquinas) in Ghirlandaio's image.[80] As in other contexts, such as Santa Maria Novella and the Carmine, the tramezzo represented a major site for the public promotion of new mendicant saints.

In the fifteenth and sixteenth centuries, therefore, San Marco was divided into distinct sections intended for use by three social groups: the choir and cappella maggiore for friars, the upper nave for laymen, and the lower nave for laywomen (F on Figure 75). Fra Giuliano Lapaccini's mid-fifteenth-century description of San Marco, preserved in the *Annalia Conventus S. Marci*, describes the upper nave as the "chorus laicorum" and the lower church or "ecclesia inferior" for use by women, which contained altars and seating ("sedilia") for the female confession.[81]

Both the choir screen and nave tramezzo each had a single doorway probably framed by two fluted Corinthian pilasters and entablatures decorated with Medici *palle*, which are still preserved in a room behind the church's apse (Figure 76). These doorframes could have resembled the original high altarpiece frame in a coordinated display similar to those discussed in Chapter 1.[82] According to Theresa Flanigan, this arrangement created a highly controlled "perspectival unity" designed both to restrict the visual distraction of friars and increase the laity's concentration on Fra Angelico's *San Marco Altarpiece* (Figure 77).[83] It is uncertain, however, when precisely the doors would have been opened for the laity to see the altarpiece. If it were only at that sacramental moment of Catholic ritual – the elevation of the Host – the liturgical performance would have at least partially obscured visual appreciation of Fra Angelico's masterpiece. Certainly, lay access to the high altar was temporal in nature: on the Festa de' Magi, a major civic festival that glorified the Medici family, the entire church was open for lay devotion and indulgences were granted to those who prayed before the high altarpiece.[84] However, an anonymous account of an Epiphany

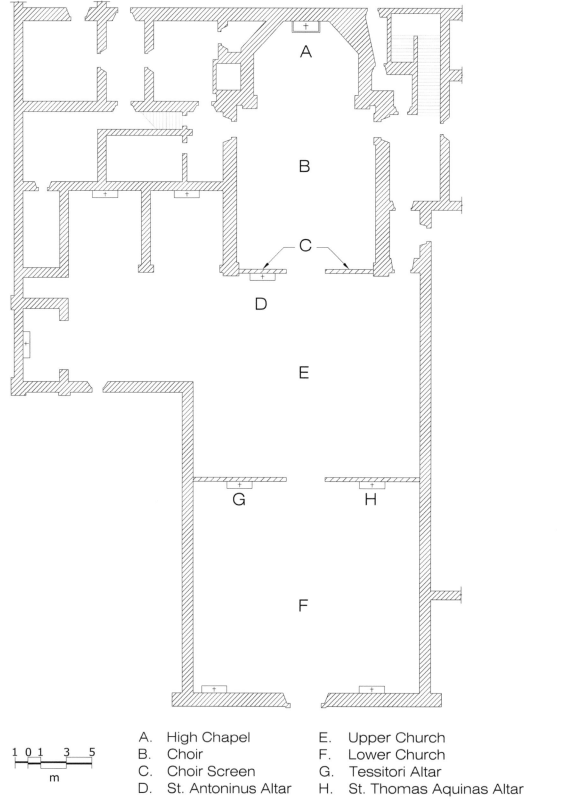

A. High Chapel E. Upper Church
B. Choir F. Lower Church
C. Choir Screen G. Tessitori Altar
D. St. Antoninus Altar H. St. Thomas Aquinas Altar

Figure 75 Plan of San Marco, Florence, in c. 1515, by Sally J. Cornelison. With kind permission of Sally J. Cornelison

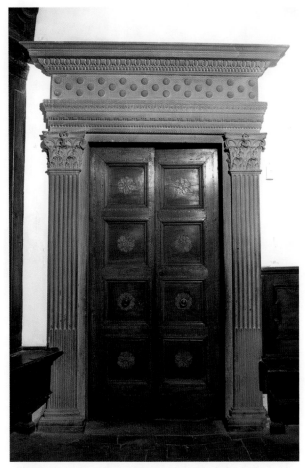

Figure 76 Doorframe conserved behind the apse, San Marco, Florence. Photo: author

procession in 1498 described how the San Marco friars sang sections of Matins and performed religious drama in each of the three zones of the church interior described earlier, perhaps betraying a more rigorous approach to the separation of sacred space.[85]

For the visit of Pope Leo X at Epiphany 1516 the nave tramezzo was, according to the *Annalia*, "destroyed."[86] However, Pacciani concluded that, rather than having been removed completely, the division had likely been perforated or tampered with in some way, to account for the "two openings" noted in Loddi's eighteenth-century account.[87] Indeed, it was only in the early 1560s that the nave of San Marco was radically transformed. The nave tramezzo that separated male and female worshippers was

removed, the two tramezzo altars were transferred to the side walls, the walls were whitewashed, and a new pulpit installed. The screen enclosing the friars' choir remained intact at this point. The *Annalia* mentions the renovation in two sections.[88] The first section dated the work to 1564, and stated that on account of the "decision, effort and diligence" of Prior Santi Cini (presided 1563–66), the church was "brought back to a better shape" with the removal of the nave partition wall, and confirmed that Alessandro Ottaviano de' Medici contributed a new walnut pulpit.[89] In another section listing San Marco's priors and their accomplishments, a passage stated that prior Cini took office in 1563, attributing the spatial changes (here undated) to his actions, possibly on the advice of the community, and also mentioned Alessandro's donation of the pulpit.[90]

While it appears that Duke Cosimo was not a participant in the renovation of San Marco, Alessandro's involvement – at least in contributing the pulpit – shows some direct Medici influence, although Cini and the friars were given full credit in the albeit biased convent chronicle. Only ordained a priest in 1567, Alessandro Ottaviano de' Medici became Archbishop of Florence in 1584, was close friends with Filippo Neri, and later in life was elected Pope Leo XI, an office he held for only twenty-six days before his untimely death.[91] As the son of Francesca Salviati, he was involved in promoting the new Salviati Chapel in San Marco as the internment site for the body of St. Antoninus and was personally involved in recognizing the body of the saint in 1589.[92] Although his views on church architecture are unknown, he laid the first stone of the Oratorian church of the Chiesa Nuova in Rome in 1575, which was characterized by an open nave and uniform side chapels, perhaps suggesting his preference for modern unified church interiors (Figure 8).

Although preceded by Vasari's projects in Arezzo, if the dating of the 1560s renovation was

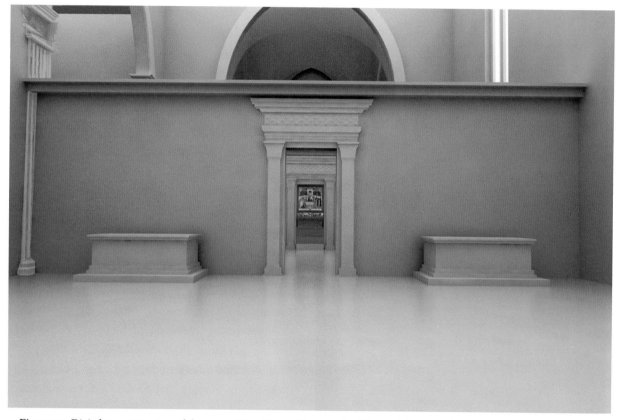

Figure 77 Digital reconstruction of the nave of San Marco, Florence, by Theresa Flanigan; drawing by Ann Cosgrove. With kind permission of Theresa Flanigan

not so uncertain, San Marco, as Monica Bietti Favi acknowledged, could be securely identified as the first church in Florence to undergo a major spatial transformation.[93] Whereas the tramezzo in this case divided the laity into gendered groups, the spatial and visual effect of the renovation would have been broadly similar to other contexts in its opening up of the nave. Later, in around 1580, Giambologna redesigned the church's altar tabernacles in a unified scheme. Indeed, in his description of the translation of St. Antoninus in May 1589, the Dominican theologian Tommaso Buoninsegni stated that "all the altars and the chapels were reduced to the same manner, measure and disposition."[94] As Francesca De Luca has noted, while the altarpiece tabernacles might be consistent, the themes of the paintings themselves do not form part of a broader scheme (Figure 78).[95] Moreover, the friars' choir screen survived until 1678, when the architect Pier Francesco Silvani restructured the whole area,

demolished the choir screen, brought the altar forward, and placed the choir behind.[96]

Ognissanti

Since it housed a group of painted panels dating from c. 1310 to 1320, the Ognissanti tramezzo may represent one of the earliest screens erected in a Florentine church. Originally belonging to the Humiliati order, the single-aisled church of Ognissanti was enlarged following a donation from the Florentine government in 1250 (Figures 2 and 79).[97] Hueck deduced that the Ognissanti tramezzo was a transverse wall crossing the nave in the rough location of the present-day pulpit, hypothesizing that the screen would have been around 4.5 m high, with a single door in the center roughly 1.5 m wide.[98] The structure featured two attached chapels, dedicated to the Angels on the left and the Virgin Mary on the right (C and G on Figure 79).

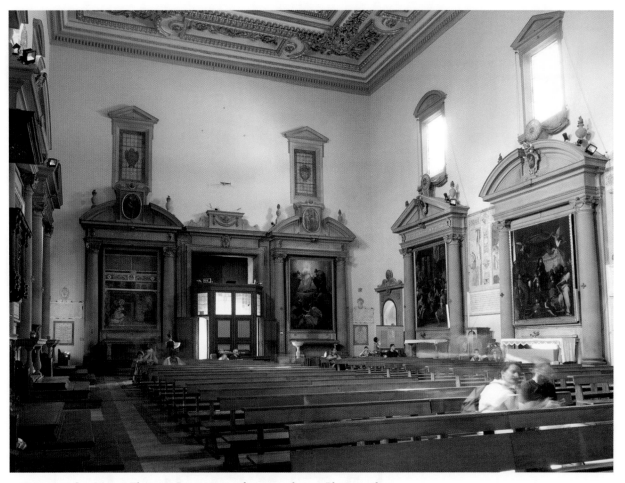

Figure 78 San Marco, Florence. Interior view facing southwest. Photo: author

Giotto and his workshop painted three panels for Ognissanti, all of which have been associated with the tramezzo: the *Crucifix* (still in the church, Figure 80), the *Ognissanti Maestà* (now in the Uffizi, Figure 81) and the *Dormition of the Virgin* (now in the Berlin Gemäldegalerie, Figure 82). In 1418, the Humiliati procurator conceded to Francesco di Benozzo an altar situated to the right of the entrance to the choir that was adorned by a panel of the Virgin Mary by the "famous painter Giotto."[99] Hueck argued that physical and stylistic aspects of the *Maestà* – its great height, well-worked carpentry rear side, and light emanating from the upper right – suggest that it was not intended as an altarpiece for this tramezzo chapel.[100] Instead, her hypothetical reconstruction of the Ognissanti tramezzo placed the *Crucifix* above the central opening (E and M on

Figure 79), the low gabled *Dormition* as right tramezzo altarpiece and the *Maestà* positioned directly above the tramezzo wall, again on the right side.[101] Sonia Chiodo, meanwhile, argued that the *Maestà* might have been on the left of the tramezzo, citing a 1541 document referring to "an antique image of the Blessed Virgin Mary" ("imago antiqua Beate Mariae Virginis") in this location.[102]

Stefan Weppelmann, by contrast, highlighting the Eucharistic iconography and central ideal viewpoint of the *Maestà*, argued that it more likely acted as the medieval high altarpiece, which would have been visible to viewers in the nave when the tramezzo door was open at the elevation of the Host.[103] He further noted that a pulpit was located atop the screen on the right side, later replaced by the extant structure on the right nave wall of

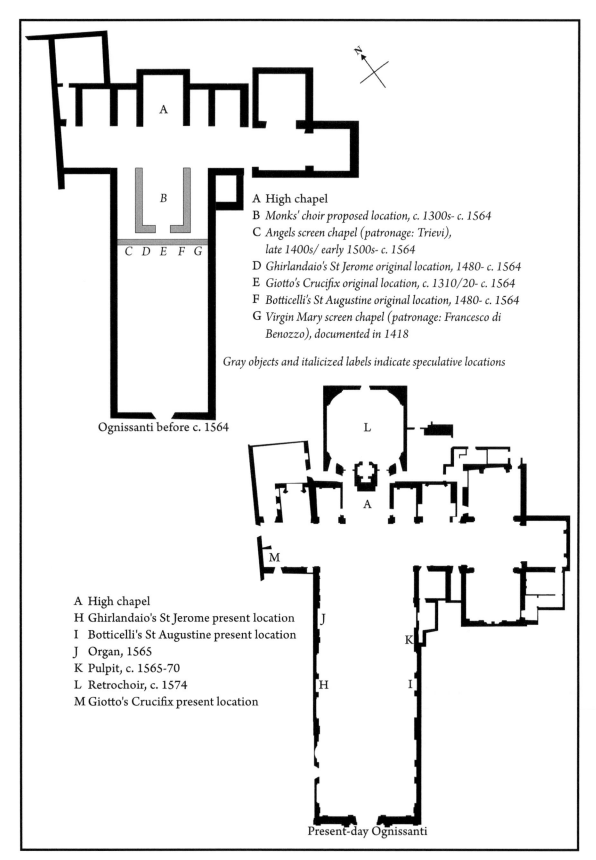

A High chapel
B *Monks' choir proposed location, c. 1300s- c. 1564*
C *Angels screen chapel (patronage: Trievi),*
 late 1400s/ early 1500s- c. 1564
D *Ghirlandaio's St Jerome original location, 1480- c. 1564*
E *Giotto's Crucifix original location, c. 1310/20- c. 1564*
F *Botticelli's St Augustine original location, 1480- c. 1564*
G *Virgin Mary screen chapel (patronage: Francesco di*
 Benozzo), documented in 1418

Gray objects and italicized labels indicate speculative locations

Ognissanti before c. 1564

A High chapel
H Ghirlandaio's St Jerome present location
I Botticelli's St Augustine present location
J Organ, 1565
K Pulpit, c. 1565-70
L Retrochoir, c. 1574
M Giotto's Crucifix present location

Present-day Ognissanti

Figure 79 Ognissanti, Florence. Proposed plans of the church before c. 1564 and after c. 1574. Photo: author

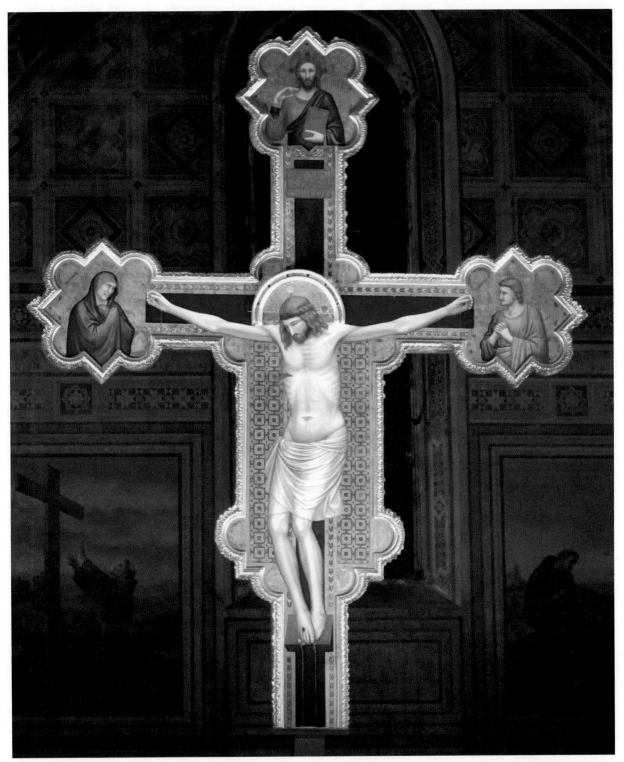

Figure 80 Giotto and workshop, *Crucifix*, c. 1310–20, tempera on panel, 468 × 375 cm. Ognissanti, Florence, northwest transept. Photo: Sailko/ Francesco Bini

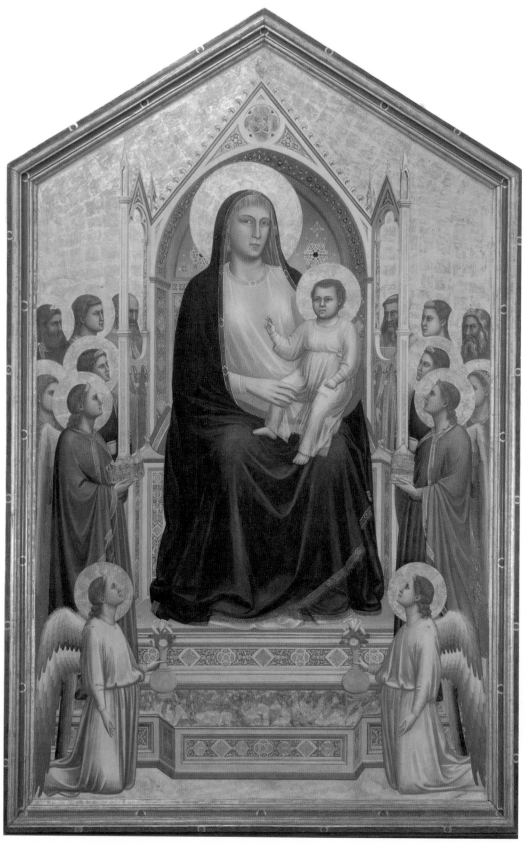

Figure 81 Giotto and workshop, *Virgin and Child Enthroned, Surrounded by Angels and Saints (Ognissanti Maestà)*, c. 1310–20, tempera on wood, 325 × 204 cm. Gallerie degli Uffizi, Florence, Inv. 1890 no. 8344. Photo: © Gabinetto fotografico, Gallerie degli Uffizi, Ministero per i beni e le attività culturali e per il turismo

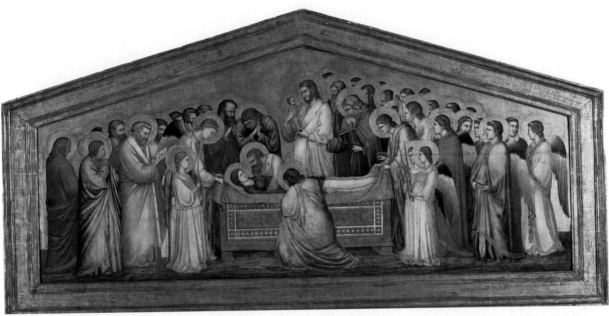

Figure 82 Giotto and workshop, *Dormition of the Virgin*, c. 1310–20, tempera on wood, 75.8 × 179.7 cm. Staatliche Museen, Gemäldegalerie, Berlin, Inv. Nr. 1884. Photo: © Staatliche Museen zu Berlin, Gemäldegalerie/Jörg P. Anders

Ognissanti, precluding the display of the monumental panel in this position.[104] Concurring with Weppelmann, scholars Miller and Taylor-Mitchell concluded that, due to the restrictive height of the nave, Giotto's *Ognissanti Madonna* likely acted as the high altarpiece before Giovanni da Milano's *Coronation of the Virgin* polyptych was installed in the early 1360s.[105] Pairing these various iconographic and physical limitations with a lack of documentary evidence, the original location of the *Ognissanti Madonna* cannot be precisely determined.

As mentioned earlier, the chapel on the left side of the screen was dedicated to the Angels. Madonna Bartolomea di Bernaba Trievi had originally commissioned a panel depicting angels for this altar ("Tavola degl'Angeli"), according to Hueck probably in the late fifteenth or early sixteenth centuries.[106] As in other contexts in Florence, the area to the left of the screen was sometimes associated with female patrons and worshippers, as for example, in San Pier Maggiore and Santo Spirito. At the time of the dismantling of the screen in c. 1565–75, Bartolomea's heirs were assigned a chapel under the organ on the left side in exchange for the Angels Chapel,

because "said place, altar and chapel were removed, in the removal of the choir, which was in the middle of said church."[107] The document further explained that a community of female Third Order Franciscans was utilizing the altar for devotion and burial, which also fits into this wider pattern of female use.[108]

Two frescoes – one depicting St. Jerome by Ghirlandaio (Figure 83, D and H on Figure 79) and another depicting St. Augustine by Botticelli (Figure 84, F and I on Figure 79) – flanked the portal of the nave screen.[109] Dating to 1480, the visually and thematically linked frescoes allude to the medieval legend in which Augustine, writing to Jerome at the very hour of the latter's death, witnessed his presence in a mystical experience. Hueck noted that early sources – the Anonimo Magliabechiano (1542) and the Libro di Antonio Billi, also known as the Codice Petrei, generally dated to 1516–30 – placed these frescoes "in the pilasters of the choir in front" ("nel pilastro del coro dinnanzi"), a phrase that could imply that the prominent fictive pilasters framing each saint were originally related to paired recesses on the screen.[110] Botticelli's *St. Augustine* was commissioned by the

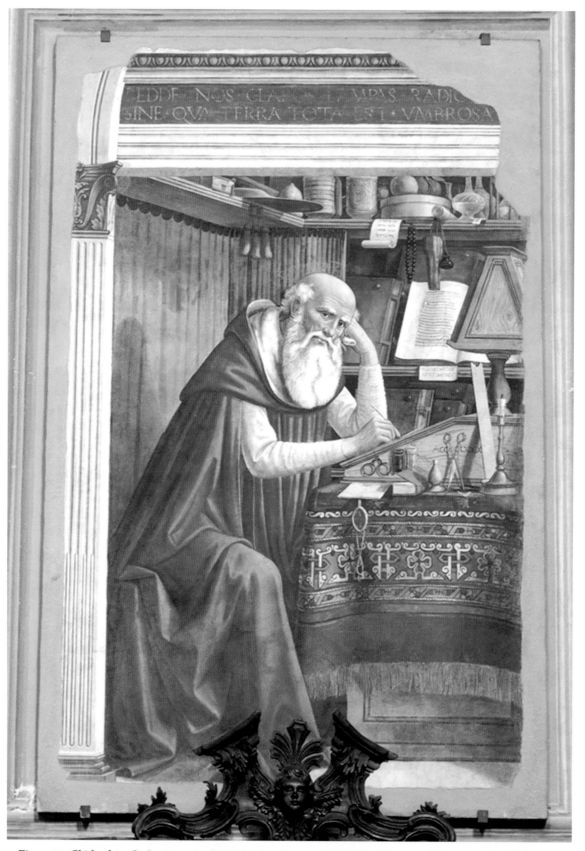

Figure 83 Ghirlandaio, *St. Jerome*, 1480. Fresco, 184 × 119 cm. Ognissanti, Florence, northwest nave wall. Photo: author

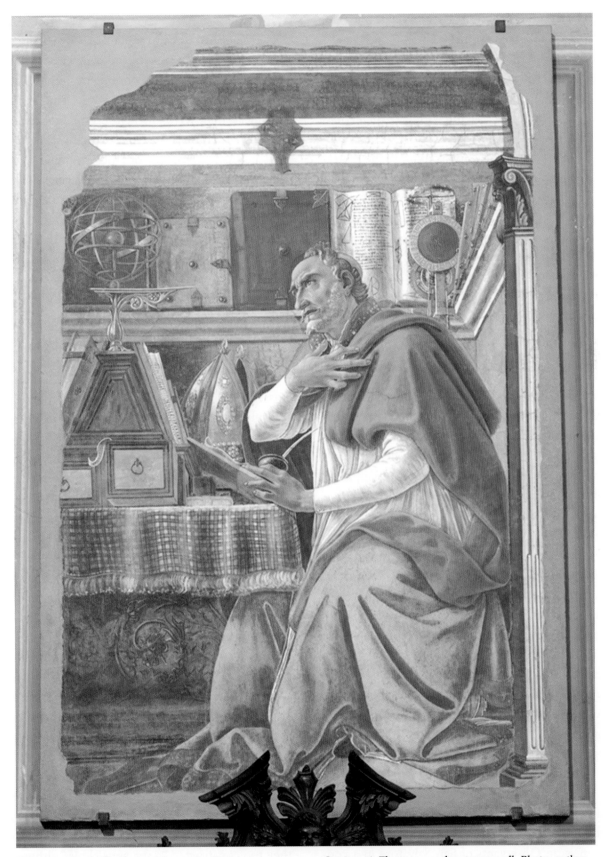

Figure 84 Botticelli, *St. Augustine*, 1480. Fresco, 152 × 112 cm. Ognissanti, Florence, southeast nave wall. Photo: author

Vespucci family, whose coat of arms appear in *fresco a secco* in the cornice above the saint.[111] Ghirlandaio's *St. Jerome*, by contrast, has not been connected with a specific patron, but Irene Mariani identified the profusion of luxury goods in the fresco as evidence that the Vespucci might have commissioned both images.[112] Recent restoration has shown that the classical column to the right of *St. Augustine* was added later, and as it does not follow the same perspectival scheme as the rest of the painting, it was possibly added by Ghirlandaio to homogenize the two scenes.[113]

While the two clerical, scholarly figures accent the transition into the sacred space of the monks' choir, an irreverent detail hints at a more playful viewer engagement. In the open geometrical treatise behind *St. Augustine*, the only legible text in the volume is a short scribbled conversation that begins "Where is fra' Martino?," which alluded to a potential monastic escapade beyond the convent's walls.[114] Although Martin Kemp noted that the small scale and obscure location of the inscription would have made it largely illegible, Gert Jan van der Sman saw the conversational snippet as an example of Florentine "literary wit in the vernacular."[115] In its original placement on the tramezzo wall (perhaps at a height that would have rendered the text more legible), the inscription could be interpreted as a playful mocking of the friars, showing the liminal nature of the screen, which mediated between the lay and religious worlds. Moreover, this witty overtone continued when the frescoes were detached in the sixteenth century: ironic inscriptions alluding to the transfer of the frescoes were added in large lettering above each saint (for example, "St. Augustine was so absorbed in his studies that he didn't notice the move"), at once casting a more lighthearted tone on these spatial changes and ensuring they were not forgotten.[116]

At Ognissanti, the choir arrangement was altered largely because of a change in religious administration from the Humiliati to the Franciscan Observants of San Salvatore in a contestation that took decades to resolve. Between the 1530s and 1560s, a community of Franciscan Observants had already resided at Ognissanti on three separate occasions in the context of various movements of religious communities around the city.[117] Finally, in 1561, Fra Berardo Dragoncini, provincial minister of the Observant Franciscans and ducal confessor to Duke Cosimo, facilitated the permanent move of the community to Ognissanti.[118] In that year, Pius IV officially allowed the Humiliati to transfer to Santa Caterina al Mugnone, a small convent on the northeast outskirts of the city near the Fortezza da Basso, and the Franciscans to reside at Ognissanti.[119] Representative of the overall demise of the Humiliati order (which was suppressed by a papal bull in 1571), this reallocation of the patronage and administration of Ognissanti ultimately led to a shift in the spatial layout of the church.

Indeed, when the Franciscan friars definitively possessed Ognissanti, they removed the tramezzo and placed choir stalls in the cappella maggiore (L on Figure 79), thus creating a seating arrangement they were accustomed to in their previous church of San Salvatore.[120] As we have seen in Chapter 2, that church was equipped with a large cappella maggiore, which contained the friars' choir in a layout that this particular Observant community evidently favored. In fact, the friars' desire to reorder the church interior in Ognissanti is documented much earlier. Antonio Tognocchi di Terrinca, in his 1671 "Descrizione della Chiesa del Convento d'Ognissanti in Firenze," copied a document from when the friars had attempted to negotiate with the Humiliati to take over Ognissanti in 1537. The Franciscans requested "that the church be free for our disposal" and that they should be allowed to "arrange the church to our manner, like the choir and other things."[121] The fact that the friars specifically mentioned the choir could suggest their desire to radically transform its arrangement. Indeed, Tognocchi indicates that during the friars' stay at Santa Caterina they too constructed "a spacious choir," although this is difficult to confirm.[122]

As Hueck has acknowledged, the dating of the removal of the nave choir in Ognissanti is uncertain. Although Vasari stated that the screen frescoes by Botticelli and Ghirlandaio were detached in 1564, elsewhere he stated that this took place around the time of the publication of his second edition (1568).[123] Tognocchi di Terrinca dated the alteration to 1565, stating that it made the church more beautiful, light, and comfortable, while Bocchi stated that this occurred in 1566.[124] According to Fra Dionisio Pulinari, a Franciscan friar from San Salvatore who witnessed these changes firsthand, the Humiliati friars removed the choir "in order to make the church more beautiful," and the Franciscans transferred their wooden choir from San Salvatore al Monte to Ognissanti, which was "beautiful, ample and spacious with a beautiful platform" and installed an altar "on the model of that at Monte."[125] Richa dated the alteration to 1566, commenting without evidence that it was executed on the order of Duke Cosimo.[126] The duke may certainly have had some influence since he was involved with the friars' campaign to exchange convents with the Humiliati, was a protector of the Observant Franciscans, and employed Dragoncini as his personal confessor.[127]

A new polygonal *pietra serena* and gilded marble pulpit, depicting narrative reliefs of the life of St. Francis inspired by the Santa Croce nave pulpit, is attributed to Battista Lorenzi. This structure was added to the right (southeast) nave wall in c. 1565–70, soon after the removal of the screen, which had previously provided a means for delivering public addresses (Figure 85, K on Figure 79).[128] The extant organ also bears an inscription with roughly the same date (1565) as the destruction of the nave screen, perhaps implying that a previous organ had been physically associated with the tramezzo (Figure 86, J on Figure 79). Situated on the left (northwest) nave wall, just before the transept, the new organ was fabricated by Onofrio Zeffirini da Cortona, while the cantoria below is also attributed to Battista Lorenzi. The whole ensemble (including

Figure 85 Battista Lorenzi (attr.), *Pietra serena pulpit with scenes of St Francis*, c. 1565–70. Ognissanti, Florence, southeast nave wall. Photo: author

the Crucifix chapel at ground level) was patronized by Giovanni Maria di Michelangelo, a commercial mediator.[129] Relatively uniform side altars in the nave also date from this period, although the entire interior of Ognissanti experienced substantial baroque interventions.[130] In 1571, the same year as the papal suppression of the Humiliati order, the relic of the habit St. Francis wore when he received the stigmata was translated in a triumphal procession from San Salvatore to Ognissanti.[131] As recorded in an eighteenth-century stone inscription, the construction of the retrochoir extension began in 1574 (Figure 87).[132]

The transformation of Ognissanti, therefore, was linked to the requirements of the newly arrived Observant Franciscans, whose previous church was equipped with a retrochoir. Indeed, Vasari noted that it was "necessary to the *friars* to remove the choir from where it was" (italics mine), neglecting to

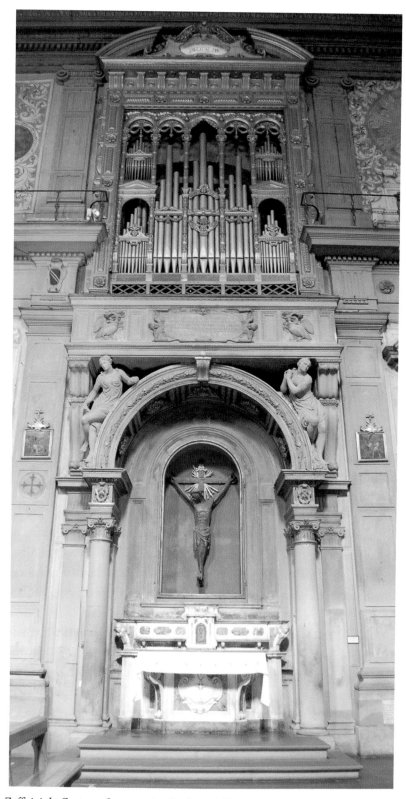

Figure 86 Onofrio Zeffirini da Cortona, *Organ*, 1565. Ognissanti, Florence, northwest nave wall. Photo: author

Figure 87 Ognissanti, Florence. Interior view of retrochoir facing southwest. Photo: author

indicate that any individual patron was responsible.[133] As for chronology, since the Franciscans took possession of the church in 1561 and Vasari attributed the fresco detachments to 1564, the choir alteration in Ognissanti could feasibly predate the better known Vasarian renovations in Santa Maria Novella and Santa Croce.

VASARI'S RENOVATIONS OF SANTA MARIA NOVELLA AND SANTA CROCE

It is probable, therefore, that as early as the 1560s, some church renovations in Florence anticipated Giorgio Vasari's remodeling of the city's largest mendicant churches, although doubts remain regarding their dating. Vasari's letter to Duke Cosimo regarding the Arezzo Pieve renovation (discussed earlier) confirms that the duke was aware of the spatial, acoustical, and liturgical benefits of these new arrangements. Before commissioning the changes to Santa Maria Novella, therefore, the duke would also have been reassured that Vasari had conducted the experiment on a smaller scale in a non-Florentine church of lower hierarchical status. Enjoying the prestige of ducal patronage, the elimination of monumental screens in Santa Maria Novella and Santa Croce would become the most publicly recognizable and widely influential examples of the Florentine church renovations.

Santa Maria Novella

In 1221, the small late eleventh-century parish church of Santa Maria Novella was ceded to the Dominican Order. The incoming friars maintained the old church as their new transept, and in the mid-1240s began work on an ambitiously large church, this time oriented toward the north. Beginning with the high altar area and continuing with the nave in 1279, this structure eventually replaced the older transept. The entirely vaulted church, complete with transept chapels and aisles, was conceived from the start with lay patronage, and particularly lay burials, in mind (Figure 88).[134]

Traversing the nave of Santa Maria Novella, the *ponte* – so-called because its monumental

construction resembled a bridge – was one of the earliest nave screens in existence in Florence (a screen chapel was dedicated in 1298). The Dominican chroniclers Modesto Biliotti, writing in the late sixteenth century, and Vincenzio Borghigiani, who utilized previous sources (including Biliotti's) in the eighteenth, described the *ponte*. In her seminal 1974 article, Hall reconstructed the *ponte* using Borghigiani's description, calculating that it would have been more than 8 m in depth and around 4.5 m high, and was located at an elevation in floor level near the fourth pair of nave piers, extending in either direction into the fourth and fifth bays (6 on Figure 89).[135] Subtle design differences in the fourth and fifth

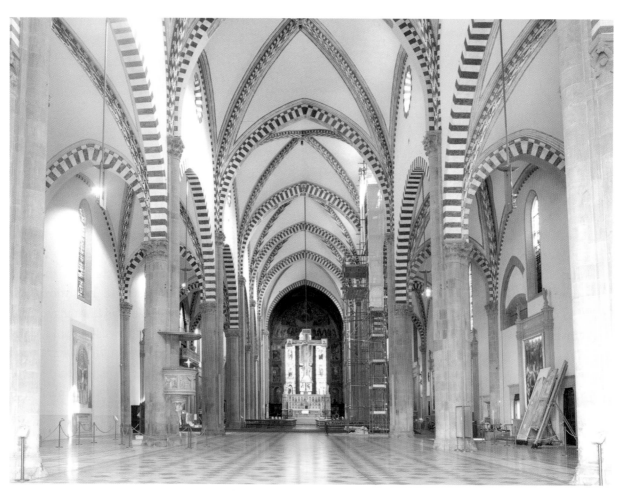

Figure 88 Santa Maria Novella, Florence. Interior view facing north. Photo: author

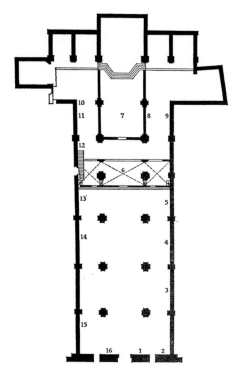

Figure 89 Plan of Santa Maria Novella before 1565, by Marcia B. Hall. With kind permission of Marcia B. Hall

Figure 90 *Tomb of Tommaso Minerbetti* (d. 1499), Santa Maria Novella, Florence, east nave wall. Photo: author

pairs of nave piers show that the choir was planned in this location from the outset of nave construction.[136] Borghigiani described a screen faced with black and white marble and encrusted with family heraldry, pierced by three entrances that corresponded to the nave aisles. Cannon has suggested that the facade-like effect resulted from the initial function of the screen in isolating the lower nave, which was still under construction, while Frithjof Schwartz noted the aesthetic similarities with the marble-encrusted main facade of the church.[137] Hall determined that the chapels on the lower story of the screen were concealed by this wall and faced the crossing under a deep three-bay loggia. However, utilizing a further primary source compiled by Fra Vincenzio Fineschi in 1780–1800, Gaia Ravalli has recently proposed that the screen facade facing the lower nave instead incorporated at least five arches and chapels surrounded by enclosures, and was much lower than previously assumed.[138]

The early sixteenth-century tomb of Tommaso Minerbetti (d. 1499), situated on the right aisle wall just beyond the steps from the nave, may still preserve a remnant of the destroyed tramezzo (Figure 90). The right pilaster of the tomb is incongruous with the rest of the structure; rather, its serpentine marble accents recall Borghigiani's description of the black and white screen.[139] Indeed, Schwartz argued that the materials and modest dimensions of the rogue pilaster, which he dated stylistically to c. 1300–35, imply that it might derive from the right aisle portal of the screen.[140]

Unusually, the screen chapels in Santa Maria Novella were oriented longitudinally (toward west and east), rather than in the same orientation as the high altar (which faces north), and a walkway above supported four more altars that corresponded to those underneath in location

and orientation.[141] On the lower story, the two earliest altars were attached to the nave piers on either side of the central portal, and were dedicated to SS Peter Martyr on the left (patronage Castiglioni, founded 1298), and Mary Magdalene on the right (patronage Cavalcanti, known from 1363). Against the two nave side walls but forming part of the overall screen ensemble were altars dedicated to SS Thomas Aquinas on the left (later St. Mark; patronage Alfani from 1365; then passed to the Compagnia di Santa Caterina da Siena), and Thomas Becket on the right (patronage Minerbetti, from at least 1308). Ravalli has shown that a recently discovered early Trecento fresco of St. Thomas Aquinas in the fourth bay of the left nave aisle confirms the location of this altar in the corner between the screen and the lower nave, rather than enclosed within the screen as suggested by Hall. In this public site easily accessible to the laity, the friars promoted the cult of this newly canonized Dominican saint.[142] On the upper level, reached via a staircase on the left of the screen and enclosed only by a balustrade, the chapels from left to right were dedicated to SS Peter and Paul (patronage unknown); John the Baptist or Louis of Toulouse (patronage Bertaldi); Jerome (in 1339 under Macci family patronage, dedication changed to St. Elizabeth); and Eustace (patronage unknown).[143] Also on the upper story, there was a pulpit for readings and pronouncements, and an organ, while Giotto's painted crucifix (Figure 91) was likely supported by a transverse beam suspended above the *ponte*.[144] The choir complex would have been an immense, decorative, and complicated structure, which had implications for the viewing of frescoes beyond its barrier, especially Ghirlandaio's later frescoes in the Tornabuoni high chapel, where the famous family portraits would have been completely obscured to lay viewers in the nave.[145]

The area between the screen and the friars' choir must have been accessible to the laity, at least to those whose chapels were located there, essentially forming "an additional, privileged lay zone" according to Cannon.[146] The friars' choir, meanwhile, occupied the nave bay nearest the cappella maggiore and part of the crossing bay of the transept. The choir stalls were enclosed by a wall perhaps 2 m high ("higher than a man" – "alto più di un'uomo" according to Borghigiani), inlaid with white and black marble (probably dark green serpentine) and adorned with images and altars.[147] On the exterior of the right wall an Annunciation altar was used for the friars' communal burial and an altar dedicated to Mary Magdalene appeared on the left wall.[148] The intarsiated choir stalls were disposed in two tiers, and there were two lecterns, one for the Mass and Antiphons, the other for lessons.[149]

In a similar debate to that surrounding Giotto's *Ognissanti Madonna* in Ognissanti, the reconstruction of the tramezzo has been complicated by scholarly disagreements over the original location of Duccio's *Rucellai Madonna*. The largest surviving Duecento panel painting, it was commissioned by the Società della Vergine (known as the Compagnia dei Laudesi) in 1285 (Figure 92).[150] Vasari, attributing the panel to Cimabue, saw it hanging on the wall in the transept to the right of the high chapel between the Bardi and Rucellai Chapels. The Rucellai Chapel eventually housed the image from the seventeenth century, lending it its present name.[151] However, some scholars have argued that the panel was originally displayed in a raised position on the tramezzo itself, where it would have acted as the most visually accessible Marian image for a wide lay audience.[152] Others, meanwhile, note that the panel's large scale precludes such a placement, and maintain that it was originally housed in the Laudesi Chapel (in the transept, farthest to the right from the high chapel, later ceded to the Bardi and rededicated to St. Gregory), where it almost perfectly aligned with the chapel's dimensions and fresco decoration.[153] Indeed, given the functionality of the upper platform of the Santa Maria Novella *ponte*, it seems unlikely that the friars would have

Figure 91 Giotto, *Crucifix*, c. 1290, tempera on wood, 578 × 406 cm. Santa Maria Novella, Florence. Interior view facing north. Photo: author

Figure 92 Duccio, *Rucellai Madonna*, 1285, tempera on wood, 450 × 290 cm. Gallerie degli Uffizi, Florence. Photo: © Gabinetto fotografico, Gallerie degli Uffizi, Ministero per i beni e le attività culturali e per il turismo

erected such an imposing image over the tramezzo, due to its potential to interfere with their liturgical activities.

In his autobiography in the 1568 edition of *Le Vite*, Vasari explained that Duke Cosimo, to demonstrate his Catholic piety and in imitation of King Solomon, "lately made me remove the tramezzo in the church of Santa Maria Novella, which deprived it of its beauty," making clear that it was the screen which marred the church's aesthetic appearance.[154] Roberto Lunardi has shown that the first document relating to the project was dated 12 September 1565, in which the prior of Santa Maria Novella reminded Cosimo to organize funds for the church renovation (as we shall see in Chapter 8, this was shortly after a visit to Florence by Carlo Borromeo, who may have encouraged these changes).[155] A letter from the *operai* to the duke on 5 October 1565 confirmed that the project had been instigated by the duke, further explaining that "for the greatest ornament, convenience and beauty and religious observance of your venerable church of Santa Maria Novella the *ponte* and choir be removed from its center."[156] The cathedral canon and diarist Lapini stated that on 22 October the friars began the demolition of the *ponte*, which had "spoiled all the beauty of said church."[157] According to Borghigiani, alongside the 1565 alterations came a "heartrending loss of much antiquity which was lost," but that it pleased Cosimo to modernize the old buildings of the city, especially those churches that gave their names to the *quartieri*.[158]

Moreover, the duke ordered that Vasari install a series of new altars in the side aisles in correspondence with the nave bays, complete with altarpieces and uniform framing tabernacles. Unusually, instead of requesting consent from the patrons of the chapels scheduled for demolition – which included those in the side aisles and on the *ponte* – the majority of the altars were constructed by new patrons with close personal

links to Duke Cosimo.[159] With the guidance of Vincenzo Borghini and Vasari, new altarpieces were completed for the nave interior by Vasari, Bronzino, Naldini, and others, one altar controversially obscuring a masterpiece of the Early Renaissance, Masaccio's *Trinity*.[160] In 1566, the high altar was brought forward and the choir stalls removed from the nave.[161] In January 1567, new stalls designed by Vasari ("a new and very rich choir behind the altar" according to his autobiography), supplemented the existing fifteenth-century stalls in the cappella maggiore (see Chapter 2, Figure 93). Vasari also planned for a passageway behind the transept chapels to connect the cloister with the choir in the high chapel, according to a letter from the friars to the duke, "so that the friars would not be seen," echoing concerns about reciprocal visibility expressed in other contexts, such as in the Cistercian church of Cestello in 1505 (see Chapter 2).[162]

Previously, in 1556, Cosimo had arranged for Observant friars from San Marco to occupy Santa Maria Novella and they eventually replaced the dispersed conventual friars. Borghigiani, writing in the eighteenth century, noted that following this shift, "the church remained for that time completely depopulated; almost all the supporters of the convent withdrew; the donations from benefactors for the most part ceased."[163] This downturn in the fortunes of the Dominican convent casts the Vasarian renovation in a rather political light: Duke Cosimo had already demonstrated his power over the community, and since patrons had already started to leave, new ones had to be found. Indeed, Lunardi argued that the destruction of chapels and imposition of new patrons were driven by the duke's political desire to demonstrate his absolute power by eliminating evidence of past republicanism.[164] This framing also correlates with concerns noted in other contexts in Florence: the depopulation of the monasteries of Santa Trinita and San Pancrazio, the

Figure 93 Santa Maria Novella, Florence. Choir stalls in the high chapel, interior view facing northwest. Photo: author

installation of Observant Franciscan friars in Ognissanti, and the removal of chapels belonging to historically anti-Medicean clans in San Pier Maggiore. The Florentine renovations, including the one undertaken by Vasari at Santa Maria Novella, thus responded to multiple aesthetic, religious, social, and political motivations.

Santa Croce

The construction of the present manifestation of Santa Croce, the largest Franciscan church in Italy, began in 1294, possibly under Arnolfo di Cambio (Figure 94). Although long hailed as the perfect exemplar of the Italian Gothic mendicant church and noted for its extensive lay burials, its medieval interior was not the open and uninterrupted space we see today. In ground-breaking research conducted in the 1970s using records from excavations conducted after the 1966 Arno flood and surviving archival sources, Hall discovered that the church was once divided by a medieval tramezzo (see ground plan on Figure 11).[165] Initially, she deduced that laterally protruding blocks on the fifth nave piers represented vestiges of the screen, which extended to create a wall that supported the fresco of *St. John the Baptist and St. Francis* by Domenico Veneziano (detached and moved by Vasari), situating it in a "corner" just as the Anonimo Magliabechiano (1542) had described.[166] A presentation drawing of the Baroncelli Chapel of St. Martin on the tramezzo (completed 1332–38), which depicts a double-story micro-architectural gabled tabernacle,

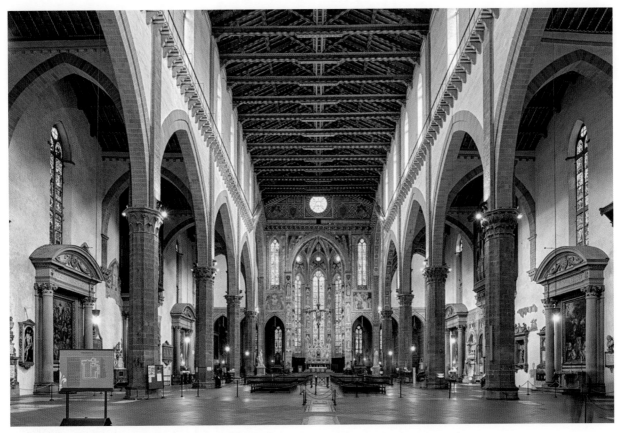

Figure 94 Santa Croce, Florence. Interior view facing southeast. Photo: Michael G. Gromotka

provided the mathematical and aesthetic basis for Hall's more detailed reconstruction of the entire screen (Figure 95). Since the width of the Baroncelli Chapel tabernacle multiplied by nine equaled the width of the nave and corresponded to foundational remains, Hall deduced that the tramezzo was formed of nine uniform modules. In this reconstruction, the tramezzo would have been half a bay deep (6.5 m) and crossed the nave in the center of the fifth bay from the entrance.[167] Each aisle would have had a chapel next to the wall and a grille gate next to the nave pier, while the central section would have had an opening three modules wide, flanked by a chapel on each side.[168]

Analyzing a 1439 inventory of chapels, Hall showed that there were four chapels attached to the front of the screen: in the left aisle the Asini Chapel dedicated to St. Mark; to the left of the central nave opening a chapel dedicated to St.

Peter patronized by Niccolò di Bocchino; to the right of the central door the Baroncelli Chapel of St. Martin; and in the right nave aisle the Foresta Chapel of St. Sebastian.[169] The friars' choir, meanwhile, was a separate structure located further east.[170] A white marble inlay in the pavement of the central nave between the middle of the sixth bay and the end of the seventh bay delineates the original site of the friars' choir (Figure 96).[171] Patronal rights over this area were held by the Alberti family, who funded construction of the wooden choir in 1355–56, and whose coat of arms appears in the later marble floor inlay.[172] When the choir was removed, the Alberti won a court case against the operai of Santa Croce over the appropriation of their rights to the entire choir pavement, which they successfully argued was theirs since their family tombs delineated the space and the operai had previously had to obtain permission from the Alberti

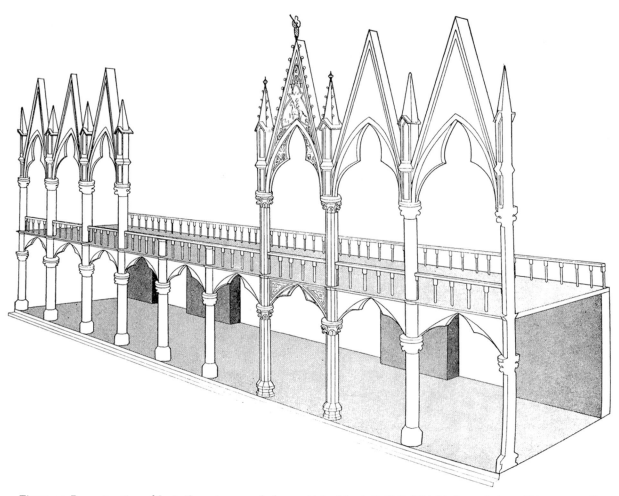

Figure 95 Reconstruction of Santa Croce tramezzo before 1566, by Marcia B. Hall. With kind permission of Marcia B. Hall

for a burial in this area.[173] This lay ownership, although contested, shows that the choir was not seen as an exclusively mendicant space, but could represent a zone of interaction and compromise between lay and religious. The marble inlay represents another example of the role of such features in preserving the memory of significant zones of sacred space. The original wooden choir was replaced possibly in the second decade of the fifteenth century by Manno de' Cori, a Florentine woodworker also responsible for the sacristy of the chapel of San Niccolò in Santa Maria Novella, the surviving choir of San Domenico in Città di Castello (Figure 97), and the monks' choir in Santa Trinita (see Chapter 5).[174] In his late fifteenth-century *Cronica*, Benedetto Dei described its three rows of inlaid and carved seats with one magnificent lectern, the whole precinct

measuring twenty-seven *braccia* wide and thirty-five *braccia* long.[175] A separate preaching pulpit by Benedetto da Maiano (c. 1472–87), meanwhile, was attached to the third nave pier on the south side and was used for the Advent and Lent sermon cycles.[176]

Despite the wide acceptance of Hall's reconstruction of the Santa Croce tramezzo, it has been challenged.[177] By closely examining the measurements in the nave, photographs from the post-1966 flood excavations, and traces of frescoes on the nave walls, De Marchi concluded that the tramezzo was not a continuous body of nine homogenous bays with a continuous upper platform but a more complex construction. Traces of four foundations in the central nave, identified as supports for the vaulted spaces of the Bocchino and Baroncelli Chapels, suggest

Figure 96 Santa Croce, Florence. Nave pavement inlay with coat of arms of Alberti family. Photo: author

that the four tramezzo chapels had square rather than rectangular plans distant from the nave piers. A single gate (rather than Hall's tripartite opening) would have been in the center of the screen, while L-shaped grates would have linked the nave piers with the four autonomous chapels. This varied, intricate articulation, where visible passageways through grates alternated with the obstacles formed by the chapels, contrasts with Hall's regular nine-bay monumental screen. De Marchi acknowledged the exceptional nature of his solution, and indeed, if his reconstruction were accurate, it would be anomalous. None of the contemporary commentators mention the unusual character of the Santa Croce choir precinct: by contrast, they list it alongside Santa Maria Novella and the Carmine, suggesting consistency across the mendicant orders.[178]

However it was originally organized, the interior of Santa Croce was radically altered in July 1566, just a few months after Vasari's previous rearrangement of Santa Maria Novella had begun in October of the previous year.[179] According to a letter written by the operai of Santa Croce to Duke Cosimo on 21 July 1566, at that point they had "removed all the tramezzo and chapels" except the Foresta Chapel along the wall adjoining the cloister.[180] They further explained that they had partially reduced the height of the choir wall according to the duke's suggestion, and that if the high altar were moved

forward, the friars' choir stalls could comfortably fit into the cappella maggiore, rendering the church "much more beautiful and delightful to the eye."[181] Moreover, if they removed the high altarpiece, the windows would be more visible and the friars would be able to view the elevation of the Host: a similar sacramental concern for Eucharistic devotion encouraged by Giberti in Verona and noted by Vasari in Arezzo. The wording of the letter, Hall argued, implies that while the duke was clearly in control of the renovation, specific aspects of the project – such as the removal of the friars' choir – were fluid responses to the practical situation in the church.[182] One week later, Cosimo's secretary responded with a single line: "If the choir can be put in the cappella maggiore, remove it entirely from its present position."[183] At that point, the duke became financially involved with the project, donating marble for the altar table and providing a large new wooden ciborium, which still exists in the church albeit with seventeenth-century additions (Figure 98).[184]

Vasari and Vincenzo Borghini also supervised the whitewashing of the old nave murals and the new program of nave altarpieces – as in Santa Maria Novella, allocated to new lay patrons associated with the duke – depicting the Passion narrative framed by tabernacles characterized by alternating triangular and segmental pediments (Figure 99).[185] Hall has argued that while Vasari should be credited with the overall aesthetic scheme in Santa Croce and praised for his organizational abilities, Francesco da Sangallo designed the classicizing altar tabernacles themselves.[186] By 1589, Michele Poccianti could not only appreciate the altarpiece scheme depicting the life of Christ but could also admire the tomb of Cardinal Alberto Alberti, which was previously hidden from public view within the choir precinct.[187] Zygmunt Waźbiński noted that the Franciscan general chapter, held at Santa Croce on 4 June 1565, could have prompted the church renovation and in particular the Franciscan-inspired iconography of the Passion cycle of side altarpieces.[188] Satkowski linked the renovation of Santa Croce to its status as the site

Figure 97 Manno de' Cori, *Choir of San Domenico, Città di Castello*, engraving in Giovanni Magherini Graziani, *L'arte a Città di Castello* (Città di Castello, 1897), fig. 83. Photo: National Gallery of Art Library, David K. E. Bruce Fund

of Michelangelo's tomb, suggesting that similarities between the altar tabernacles to the interior wall articulation of the Roman Pantheon where Raphael was interred also alluded to the mausoleum theme.[189] Ironically, although Michelangelo requested burial in the Franciscan church, his funeral was staged in the Medici parish church of San Lorenzo in 1564, perhaps partly because the interior of Santa Croce – where the tramezzo was still standing – was deemed unsuitable for this large-scale event.[190]

Following Vasari's projects in the prominent Dominican and Franciscan churches, an intense series of church renovation projects in Florence

in the last years of the 1560s was surely influenced by their new interior aesthetic, which must have seemed appealing and contemporary. Indeed, according to the late sixteenth-century Dominican chronicler Modesto Biliotti, Santa Maria Novella set the precedent for the Florentine renovations and was imitated by the Franciscans, the Carmelites in Oltrarno, and the parish and nuns' churches of San Pier Maggiore and Santa Felicita.[191] The Carmelite church of Santa Maria del Carmine was transformed in late 1568 (see Chapter 4); the nunnery and parish church of San Pier Maggiore in 1569 (see Chapter 6); the civic oratory of Orsanmichele in

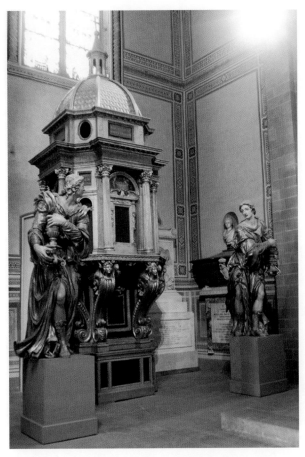

Figure 98 Giorgio Vasari and workshop, high altar ciborium, 1566–69 with seventeenth-century additions. Wood, gilded and painted, 650 × 205 cm. Santa Croce, Florence, northeast transept, Chapel of St. Louis of Toulouse. Photo: author

1569 (see Chapter 7), and the Vallombrosan monks' church of Santa Trinita (see Chapter 5), also in 1569. Evidently, the desire for these alterations transcended differences of function, church architectural type, and religious administration. These cases – which have often escaped scholarly attention – demonstrate the extensive scope of the Florentine church renovations beyond the two largest mendicant churches.

FLORENTINE RENOVATIONS IN THE 1570S AND LATER

The drive to modernize Florence's churches did not perish along with Duke Cosimo (died 21 April 1574) and Vasari (died 27 June

1574). Indeed, at least two further cases albeit under quite unusual circumstances – San Pancrazio in 1573–74 (which will be covered in Chapter 5) and San Giovanni in 1577 – were executed under Cosimo's successor, Grand Duke Francesco I de' Medici.

The medieval interior of the Baptistery of San Giovanni was the locus of Florentine religious and civic identity. Despite its centralized octagonal ground plan, the space was subdivided into areas for the font, choir, and altar, showing that a tripartite arrangement persisted even in a functionally distinctive building.[192] In fact, Vasari recorded the existence of the "priest's choir" in a description of the baptism of the firstborn daughter of Francesco and Giovanna d'Austria, in 1568: "[B]etween this large font which is precisely in the middle and in line with the cupola, and the high altar, is the choir of priests, somewhat raised."[193] An archaeological excavation carried out in 1912–15 discovered a series of marble panels carved with lozenge and circle geometric patterns, likely the remains of the thirteenth-century square font and surrounding octagonal screen.[194] Giuseppe Castellucci, the archaeological administrator in charge, produced a reconstruction of the Baptistery's medieval interior, here interpreted by Franklin Toker, which shows a gate linking the octagonal screen to a rectilinear choir enclosure (Figure 100).

In 1577, this interior was altered to accommodate festivities and decorations made for the baptism on 29 September of Don Filippo, Grand Duke Francesco's firstborn son: a long-awaited male heir destined to die in early childhood.[195] The baptismal *apparato*, masterminded by Vincenzo Borghini, was intended to cement the grand duke's diplomatic ties, especially those with the Spanish King Philip II, after whom Filippo was named.[196] Borghini was a Benedictine Cassinese monk, ducal artistic advisor, historian, philologist, and prior of the Ospedale degli Innocenti. Bernardo Buontalenti, who created the temporary architectural apparatus, produced a ground plan of the Baptistery and annotated the

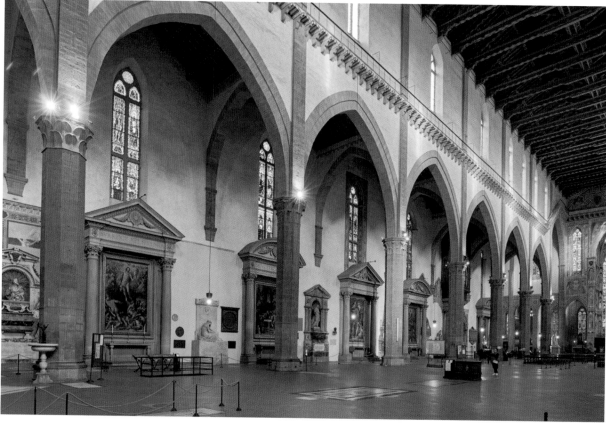

Figure 99 Santa Croce, Florence. Interior of nave facing east. Photo: Michael G. Gromotka

rectilinear choir area thus: "[T]his was the priests' choir which today is ruined – it was marble" ("questo era il coro de pretti che ogie rovinatto – era di marmo").[197] On 14 September 1577, Grand Duke Francesco authorized the destruction of this choir enclosure and the thirteenth-century font, which had found fame in Dante's Divine Comedy.[198] In addition to Buontalenti's scenographic ensemble of double ramped staircases leading to the elaborate font set on a raised platform, Alessandro Allori and Francesco Morandini, known as Il Poppi, provided painted decoration for the building's interior and exterior respectively.[199] Buontalenti's construction is highly reminiscent of the staircase and altar platform he had designed for Santa Trinita a few years earlier in 1574 (see Chapter 5), both of which created dramatic settings for the liturgy in Counter-Reformation Florence.

Although this church renovation may seem like an atypical case set against the other

Florentine projects given the unique status and function of the Baptistery, its centralized ground plan, and the specific temporary circumstances which led to the removal of the priests' choir, Vincenzo Borghini himself viewed it as part of the same city-wide scheme. In a description of the baptismal *apparato* first published only a few days into the celebrations, Borghini explained that the removal of the choir would not only better accommodate the ceremony, but enable the Baptistery to harmonize in its interior parts, and become beautified and enriched "in the manner which has been done in all the other principal ones of this city."[200] Moreover, he added that the medieval furnishings were not useful or decorative; rather they were ramshackled and impeded the "bella vista" of the space, echoing some justifications given for previous church renovations.[201] Although Borghini praised the *apparato* decorations, stating that "one could say

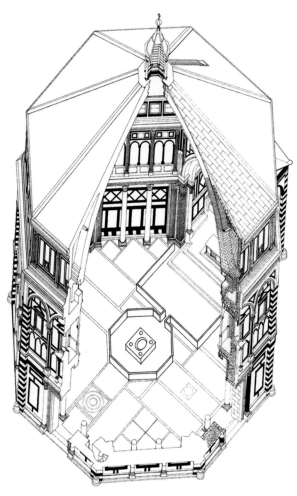

Figure 100 Digital reconstruction of San Giovanni, Florence, by Franklin Toker. With kind permission of Franklin Toker

in the 1620s,[205] and Santo Stefano in 1650.[206] A drastic redevelopment of the Badia Fiorentina from 1627 reoriented the church by ninety degrees, and a deep new choir arm was built in the area of the former right nave aisle to house stalls constructed in 1501–02 by the Del Tasso workshop, previously sited in the center of the nave.[207] Other cases, such as San Michele Visdomini[208] and San Remigio,[209] remain uncertain due to lack of surviving evidence or difficulty in interpreting historical sources.[210]

Conclusion

Across the Italian peninsula in the late sixteenth century, nave screens were demolished, and choir stalls arranged in retrochoir formations. The shift toward an overall more unified, uncluttered aesthetic also comprised the whitewashing of church walls, the erection of high altar tabernacles, and creation of unified side altar schemes. Florence experienced a particularly intensive period of architectural modernization: indeed, no fewer than eleven church buildings were renovated in the 1560s and 1570s.

In the examples covered in detail in this chapter, the most common documented motivation, albeit a common architectural trope, was that the alterations would enhance the overall aesthetic beauty of the church interior and its increased spaciousness: this was noted in Siena Cathedral, the Arezzo Pieve, and in Florence at San Marco, Santa Maria Novella, Santa Croce, and the Baptistery. The convenience of the clergy and their liturgical activities was cited at Siena Cathedral, the Arezzo Pieve, Sant'Ambrogio in Milan, and Santa Maria Novella. Visual access to the Sacrament, and particularly to its elevation during Mass, was noted at Verona Cathedral, Arezzo Cathedral, the Arezzo Pieve, and Santa Croce, showing a strengthening of Eucharistic devotion strongly encouraged by Tridentine policy. More practical and administrative

that everything was most excellent,"[202] others lamented the loss of the Baptistery's historic interior furnishings. An anonymous writer poured scorn on Buontalenti's enterprise, stating that the marble panels "were taken away without reverence for much unction and incense along the walls."[203] This statement reminds us that choir precincts were not simply viewed as instruments of social segregation but were venerated by laypeople as sacred sites for prayer and devotion.

Newly built churches and transformations of existing fabric undertaken in the seventeenth century continued the established tradition of placing the choir behind the high altar. For example, retrochoirs were constructed in Santa Maria Maggiore in 1607,[204] Santi Simone e Giuda

concerns also prompted church alterations: flood damage was influential at San Niccolò Oltrarno; a change in religious administration prompted changes at Ognissanti; and a downturn in lay patronage contributed to the alterations of Santa Maria Novella. In his letter to the bishop of Arezzo, Vasari reminds us of another pragmatic consideration to bear in mind: "the expense would not be great."

This chapter has revealed, however, that it was not only Duke Cosimo and Vasari at the helm of the church renovations. Archival records variously track details of the dating and circumstances of each project, together with references to the actors responsible. From Prior Cini at San Marco to the Observant Franciscan newcomers at Ognissanti, individuals and communities asserted strong influence over the ecclesiastical interiors they themselves utilized. Moreover, on several occasions, choir precincts and screens were physically memorialized on pavement inlays and inscriptions, showing a certain ambivalence toward their elimination. Since church buildings were highly complex arenas for social encounters, it is not surprising that many factors were involved. In the following chapters, individual in-depth case studies will investigate five of these contested sacred spaces in more detail, which will not only demonstrate the diverse typology, settings, and functionality of screens and choir precincts, but the widespread nature of their removal in late sixteenth-century Florence.

NOTES

1 For the pre-1360s liturgical layout of Siena Cathedral, see Martina Schilling, "Zur liturgischen Nutzung des Sieneser Domes 1260–1360," in *Architektur und Liturgie: Akten des Kolloquiums vom 25. bis 27. Juli 2003 in Greifswald*, ed. Michael Alltripp and Claudia Nauerth (Wiesbaden, 2006), pp. 91–104. Choir stalls, first documented in 1362 and enclosed by a screen on a marble base, were constructed in the two bays behind the altar. In 1375 a new high altar was erected further back in the choir, receiving Duccio's *Maestà* in 1382.

Kees van der Ploeg, *Art, Architecture and Liturgy: Siena Cathedral in the Middle Ages* (Groningen, 1993), pp. 117–19. See also Francesca Fumi, "Nuovi documenti per gli angeli dell'altar maggiore del Duomo di Siena," *Prospettiva*, 26 (1981), pp. 9–25. New stalls were added in 1567–70 to the curved niche of the apse constructed earlier in the century according to a design by Peruzzi, and in 1813 the Trecento stalls received intarsiated stall-backs from Fra Giovanni da Verona's Monte Oliveto Maggiore choir. See Enzo Carli, *Il Duomo di Siena* (Genova, 1979), pp. 91–97; Edith Struchholz, *Die Choranlagen und Chorgestühle des Sieneser Domes* (Münster and New York, 1995), pp. 88–102.

2 "ad maiorem ornatum dicte ecclesie et commoditatem cleri pro divinis." Dated 23 June 1506. Struchholz, *Die Choranlagen*, p. 259, doc. 91. See also Gail Schwarz Aronow, "A Documentary History of the Pavement Decoration in Siena Cathedral, 1362 through 1506" (PhD thesis, Columbia University, 1985), pp. 353–54.

3 "ut spatiosior, atque amplior fieret . . . ex medio templi, ubi erat, chorum tolli iussit, quae res non modo clericis, verum et civibus plurimis ingrata fuit." Struchholz, *Die Choranlagen*, p. 268; De Blaauw, "Innovazioni nello spazio di culto," p. 42; Alexander Nagel, *The Controversy of Renaissance Art* (Chicago, 2011), pp. 209–11.

4 Adolfo Venturi, "L'arte dell'intaglio e della tarsia a Ferrara nella fine del Quattrocento," *L'Arte* 19 (1916), p. 56. The choir was reduced to 132 seats in 1715 when the high altar was moved further back. Fiorella Frisoni, "Il coro ligneo della Cattedrale di Ferrara," in *La Cattedrale di Ferrara. Atti del Convegno nazionale di studi storici organizzato dalla Accademia delle scienze di Ferrara sotto l'alto patrocinio della Presidenza del Consiglio dei Ministri, 11–13 maggio 1979* (Ferrara, 1982), p. 547.

5 Bindaccio di Andrea Ricasoli, in a codicil to his will dated 20 March 1522, financed the extension of a retrochoir behind the high altar, probably finished in c. 1538, and rebuilt following almost complete destruction in World War II. Anna Maria Amonaci, *Conventi toscani dell'osservanza francescana* (Milan, 1997), pp. 121, 128.

6 "attendentes hoc non tantum esse expendiens scilicet vero apud omnes laudabile ac honoriggicum ac magnum dicte ecclesie ornamentum futurum esse . . . et etiam laicorum convenientium ad divina, maxime diebus solemnibus." Archivio Notarile di Reggio, Atto Arloti Gianmarco, 14 January 1502, filza n. 180, quoted in *Il Duomo di Reggio Emilia* (Reggio Emilia, 1984), p. 82.

7 Giovanni Pietro Puricelli, *De SS. Martyribus Nazario et Celso, ac Protasio et Gervasio, Mediolani sub Nerone cæsis, deque basilicis in quibus eorum corpora quiescunt: Historica dissertatio, Rerum etiam Urbanarum notitiae perutilis: quam brevitatis gratia Nazarinam nuncupari placeat.* (Milan, 1656), p. 630: "quietiore animo & ad Deum intentiore, quae ad decantanda divina official pertinent, agere possint."

8 One of the executors of Clement VII's will, Cardinal Ridolfi, described in a letter of 1539 his intention to

create a mausoleum retrochoir: "ho pensato levare el coro di mezzo la chiesa della Minerva ove sta al presento et collocarlo drieto alla capella grande in la quale s'hanno a mettere le sepolture." Simonetta Valtieri, "Sistemazioni absidali di chiese in funzione di 'Mausoleo' in progetti di Antonio da Sangallo il Giovane," in *Antonio da Sangallo il Giovane*, ed. Gianfranco Spagnesi (Rome, 1986), p. 111. Hall notes that it is uncertain whether there was a tramezzo or walled choir precinct. Hall, "The Tramezzo in the Italian Renaissance," p. 226.

9 In his testament of 1508, patron Eliseo Raimondi made clear that the friars' choir should be situated in the cappella maggiore, "in dicta capella altaris magni stalla fratrum dicti conventus." Monica Visioli and Paolo Rambaldi, *Palazzo Raimondi: nuove ricerche in occasione dei restauri alla facciata*, Quaderni di storia e tecniche dell'architettura (Viareggio, 2001), p. 34, Doc. II, 2, 2.

10 The cappella maggiore was enlarged at the expense of Beata Elena dall'Oglio in 1517, and the stalls were commissioned to Paolo Sacca and his nephew Giovanni Antonio in 1518. Maria Rita Fabbri, "Il coro intarsiato di San Giovanni in Monte," *Il Carrobbio* 2 (1976), p. 145.

11 Cannon, *Religious Poverty*, p. 246.

12 Giberti's *Constitutiones*, published in 1542, influenced the Council of Trent and Borromeo's *Instructiones*. See Christoph Jobst, "Liturgia e culto dell'eucaristia nel programma spaziale della chiesa: I tabernacoli eucaristici e la trasformazione dei presbiteri negli scritti ecclesiastici dell'epoca intorno al Concilio di Trento," in *Lo spazio e il culto: relazioni tra edificio ecclesiale e uso liturgico dal XV al XVI secolo*, ed. Jörg Stabenow (Venice, 2006), pp. 92–100, 114.

13 "Mandavimus ... tabernaculum ligneum pulcrum ... super Altari magno collocetur." Giovanni Matteo Giberti, *Constitutiones* (Verona, 1542), p. 30.

14 For the *tornacoro*, see Derek Moore, "Sanmicheli's 'Tornacoro' in Verona Cathedral: A New Drawing and Problems of Interpretation," *Journal of the Society of Architectural Historians* 44, no. 3 (1985), pp. 221–32; Paul Davies and David Hemsoll, *Michele Sanmicheli* (Milan, 2004), pp. 101–14; Nagel, *The Controversy*, pp. 239–54.

15 Davies and Hemsoll, *Michele Sanmicheli*, pp. 107, 109. Nagel, *The Controversy*, p. 252.

16 Moore, "Sanmicheli's 'Tornacoro'," p. 231. Quotation from Nagel, *The Controversy*, p. 249. See also Uwe Michael Lang, "Tamquam Cor in Pectore: The Eucharistic Tabernacle Before and After the Council of Trent," *Sacred Architecture Journal* 15, www.sacredarchitecture.org/articles/tamquam_cor_in_pectore_the_eucharistic_tabernacle_before_and_after_the_coun. See a similar *tornacoro* in San Fermo Maggiore in Verona, dating to 1573. Davies and Hemsoll, *Michele Sanmicheli*, p. 113.

17 For example, Christian-Adolf Isermeyer, "Le chiese del Palladio in rapporto al culto," *Bollettino del Centro Internazionale di Studi di Architettura Andrea Palladio* 10 (1968), pp. 43–46; Ackerman, "Observations," pp. 298–302; Hall, *Renovation and Counter-Reformation*, p. 4.

18 "Item et altare statuatur in capite capellae maioris prout est consuetudo congregationis nostrae." Quoted in Gardner von Teuffel, "Perugino's Cassinese Ascension," p. 124.

19 Isermeyer, "Le chiese del Palladio," p. 45.

20 Tracy E. Cooper, "Locus meditandi e orandi: Architecture, Liturgy and Identity at San Giorgio Maggiore," in *Musica, scienza e idee nella Serenissima durante il Seicento*, ed. Francesco Passadore and Franco Rossi (Venice, 1996), p. 85. For the drawing, see Simonetta Valtieri, "U 181A recto," in *The Architectural Drawings of Antonio Da Sangallo the Younger and His Circle*, ed. Nicholas Adams and Christoph Luitpold Frommel (New York, 2000), pp. 116–17.

21 Winkelmes noted the Congregation's "slow response" to these developments. Mary-Ann Winkelmes, "Notes on Cassinese Choirs: Acoustics and Religious Architecture in Northern Italy," in *Coming About: A Festschrift for John Shearman*, ed. Lars R. Jones and Louisa C. Matthew (Cambridge, MA, 2001), p. 308.

22 See Ackerman, "Observations," pp. 298–302.

23 At Santa Giustina in Padua, this was first debated in 1590, but not enacted until 1627–53. Bisson, "Controriforma e spazio liturgico," pp. 480–89.

24 Vasari's renovations of medieval buildings include in 1544 the refacing of the interior of the monastic refectory of Monte Oliveto in Naples. Paola Barocchi, "Il Vasari architetto," *Atti della Accademia Pontaniana* 6, new series (1956–57), p. 118; Vasari et al., *Le vite*, vol. 6, p. 384. For Vasari's 1565 plans for the Benedictine Cassinese church known as the Arezzo Badia, which included a vaulted retrochoir, see Leon Satkowski, *Giorgio Vasari: Architect and Courtier* (Princeton, NJ, 1993), pp. 88–92; Conforti, *Vasari architetto*, pp. 214–19. Vasari also produced a model for the new choir of Pistoia cathedral. The new bishop of Pistoia, Giovanni Battista Ricasoli, wrote to Vasari in January 1565 asking for his assistance "a rassettare questa chiesa assai disordinata." Giuseppina Carla Romby, "Scenografia dello spazio sacro: i rinnovamenti vasariani delle chiese medievali e l'allestimento della cattedrale di Pistoia," in *Giorgio Vasari tra capitale medicea e città del dominio*, ed. Simona Esseni, Nicoletta Lepri, and Maria Camilla Pagnini (Florence, 2012), p. 54.

25 Satkowski, *Giorgio Vasari*, pp. 85–86.

26 Giovanni Freni, "The Aretine Polyptych by Pietro Lorenzetti: Patronage, Iconography and Original Setting," *Journal of the Warburg and Courtauld Institutes* 63 (2000), pp. 95–101. See also Giovanni Freni, "Images and Relics in Fourteenth-Century Arezzo: Pietro Lorenzetti's Pieve Polyptych and the Shrine of St Donatus," in *Images, Relics, and Devotional Practices in Medieval and Renaissance Italy*, ed. Sally J. Cornelison and Scott B. Montgomery, Medieval & Renaissance Texts & Studies (Tempe, AZ, 2006), pp. 27–54.

27 Isermeyer, "Il Vasari," p. 230.

28 Satkowski, *Giorgio Vasari*, pp. 83–84. Sally Cornelison examined this arrangement in her paper entitled

"Portraits and Parenti: Constructing Family Identity on Vasari's Pieve Altar," given at the Renaissance Society of America Annual Meeting in Toronto, 18 March 2019, published as: Sally J. Cornelison, "Art and Religion in Late Renaissance Arezzo: Reconsidering Vasari's Church Renovations," in *Renaissance Religions: Modes and Meanings in History*, ed. Riccardo Saccenti, Nicholas Terpstra, and Peter Howard (Turnhout, 2021, pp. 301–23); Sally J. Cornelison, "Recycling, Renaissance Style: Hybridity and Vasari's Pieve Altarpieces," in *Hybridity in Late Medieval and Early Modern Art*, ed. Ashley Elston and Madeline Rislow (New York and London, forthcoming).

29 Cornelison noted that the whitewashing of the walls is not certain.

30 The letter is dated 18 April 1564: "Ma quello che a fatto meglio che cosa nessuna et a dato spatio alla chiesa et comodita a preti et veduta et gratia a questa opera, e stato laver levato io dinanzi il coro di legname et messolo dreto nella cappella maggiore, nel qual fanno le voci miglior tuono; et posti a sedere i popoli nelle banche fra le colonne, liberano le tre navate, e che si vede senza levarsi da sedere tutta la chiesa et levare il Sagramento: che prima per il tramezzo della chiesa e del coro linpedimento del leggio si aveva a scaramucciare col capo a vedello." Karl Frey, and Herman-Walther Frey, eds., *Der literarische Nachlass Giorgio Vasaris* (Hildesheim and New York, 1982), vol. 2, pp. 71–76. Satkowski translated the text slightly differently. Satkowski, *Giorgio Vasari*, pp. 84–85.

31 For example, Il Redentore in Venice. Howard and Moretti, *Sound and Space*, p. 120.

32 Italo Moretti, *La chiesa di San Niccolò Oltrarno* (Florence, 1973), pp. 9–10; Richa, *Notizie istoriche*, vol. 10, p. 261.

33 From the twelfth century on, the church and parish were part of the possessions of the nearby abbey of San Miniato al Monte, but at some point between 1373 and 1418 San Niccolò was ceded to the Florentine bishop. Paatz and Paatz date the church to 1400/1411. Paatz and Paatz, *Kirchen von Florenz*, vol. 4, pp. 358, 363. Repairs to the roof were financed by Michele Guardini in 1411. Moretti, *La chiesa di San Niccolò Oltrarno*, p. 16.

34 Panels from this dismembered polyptych are in the Uffizi, the National Gallery in London, the National Gallery of Art in Washington, DC, and the Vatican Museums. For Quaratesi patronage, see Grazia Badino, "San Niccolò Oltrarno 1420 circa: note sulla chiesa dei Quaratesi e di Gentile," in *Il "Gentile risorto: Il "Polittico dell'Intercessione" di Gentile da Fabriano*, ed. Marco Ciatti, Cecilia Frosinini, and Roberto Bellucci, Studi e restauro (Florence, 2006); Grazia Badino, "Le disposizioni testamentarie di Bernardo di Castello Quaratesi e le opere di Gentile da Fabriano nella chiesa fiorentina di San Niccolò Oltrarno," in *Gentile da Fabriano "Magister Magistrorum": atti delle giornate di studio, Fabriano 28–30 giugno 2005: XXVI Congresso internazionale di Studi Umanis*, ed. Cecilia Prete (Sassoferrato, 2006), pp. 55–62.

35 Richa, *Notizie istoriche*, vol. 10, p. 264.

36 Giovanna Damiani, "La chiesa quattrocentesca: ipotesi di ricostruzione," in *San Niccolò Oltrarno: la chiesa, una famiglia di antiquari*, ed. Giovanna Damiani and Anna Laghi (Florence, 1982), p. 35.

37 Badino, "San Niccolò Oltrarno," p. 50 and figure 8, p. 49.

38 "In choro dove si canta: 2 cassapanche grandi a mano dextra stanno le casse de' preti; nella cassapancha a mano sinistra, dalla banda del Corpus Domini, sono più paliotti." Alessandro Guidotti, "Appendice Documentaria," in *San Niccolò Oltrarno: la chiesa, una famiglia di antiquari*, ed. Giovanna Damiani and Anna Laghi (Florence, 1982), p. 183.

39 Damiani, "La chiesa quattrocentesca," pp. 36, 45, note 114. "Crocifisso sopra la porta di dentro, de Busini. Era nel tramezzo della chiesa sopra una travaccia tra l'altare di S. Bartolomeo de Pieri, e quello di Santo Antonio de Guardini." Florence, Archivio Parrocchiale di San Niccolo Oltrarno, Leonardo Tanci, *Memoriae della chiesa di San Niccolò Oltrarno in Firenze* (hereafter Tanci, *Memoriae*), fol. 155r. The dedication to St. Anthony was added to the Annunciation Chapel in the sixteenth century. The crucifix mentioned by Tanci is still in the same position against the counter-facade above the entrance door.

40 The testament of Michele Guardini dated 15 July 1417 can be found in ASF, Notarile Antecosimiano, vol. 9042 (Not. Francesco Giacomini), fols. 59v–64v: "Item voluit . . . quod in ecclesie S. Nicholai de Florentia fiat et fieri debeat et construi et edificari una cappella sub titulo Virginis Marie et Incarnationis Domini, que denominetur la Cappella della Nunziata, et fulciatur et ornetur . . ." (fol. 60v). Transcribed in Serena Padovani, "Appunti su alcuni dipinti quattrocenteschi di San Niccolò Oltrarno," in *Studi di Storia dell'Arte in onore di Mina Gregori*, ed. Miklós Boskovits (Cinisello Balsamo, 1994), p. 40. By 1427 the chapel was already being officiated by a chaplain, as mentioned in ASF, Notarile Antecosimiano, vol. 10463 (Not. Guardi Francesco), no. 121. Tanci notes "e stava quella de Guardini intitolata nella Annunciatione, e in Santo Antonio." Tanci, *Memoriae*, fol. 116r.

41 "Questo Michel Guardini fù beccaio, e risede duo volte de Priori nel 1411 e nel 1425, e dovette esser persona facultosa, poi che oltr'all'haver fatto fabbricare la libreria del convento di S. Croce, fece fare ancora questa cappella, et altro in questa chiesa, e morendo senza figli lascio herede l'Arte de Mercatanti con obligo de mantenere queste sue fabriche il tetto di questa chiesa, et il lastrico, che è sopra alle scalee che rigirano di fuori questa chiesa." BNCF, Fondo nazionale, II, I, 125 (Sepoltuario fiorentino di Rosselli, Quartiere S. Croce), fol. 180v. Stefano di Francesco Rosselli (1598–1664) compiled his Sepoltuario of the churches of Florence in 1650–57. It is known in five copies; the one held by the BNCF is in two volumes dating to the eighteenth century. See Michelina Di Stasi, *Stefano di Francesco Rosselli: antiquario fiorentino del XVII sec. e il suo Sepoltuario* (Florence, 2014), p. 52.

42 Tanci confirmed the foundation of the Pieri chapel in 1423 (modern style): "in un altro ricordo afferma che

Bartolomeo nel 1422 a di 21 di Gennaio, rogato Ser Matteo di Giuliano Gozzoli, lasciasse esse … e consoli de legnaioli a dare 12 soldi l'anno per fare offitiare la sua cappella tre volte la settimana …" Tanci, *Memoriae*, fol. 126r, transcribed in Damiani, "La chiesa quattrocentesca," p. 30.

43 "l'altare dela Nuntiata cum due tovalglie et I sciugatoio di sopra et I in fronte cum coperta; l'altare di San Bartolomeo cum due tovalglie e uno sciugatoio largo; tutti cum pietre sacrate." Guidotti, "Appendice Documentaria," p. 175. See also Badino, "San Niccolò Oltrarno," p. 49.

44 Damiani, "La chiesa quattrocentesca," pp. 30, 36.

45 "Nella chiesa ancora di San Niccolò di là d'Arno è nel tramezzo una tavola di mano di Masaccio dipinta a tempera, nella quale, oltra la Nostra Donna che vi è dall'Angelo annunziata, vi è un casamento pieno di colonne tirato in prospettiva, molto bello perché, oltre al disegno delle line che è perfetto, lo fece di maniera con i colori sfuggire che a poco a poco abagliatamente si perde di vista: nel che mostrò assai d'intender la prospettiva." Vasari et al., *Le vite*, vol. 3, part 1, p. 126.

46 Joannides dated the panel to c. 1424. Paul Joannides, *Masaccio and Masolino: A Complete Catalogue* (London and New York, 1993), pp. 432–35, cat. 28. The NGA's online catalogue itemizes the provenance and history of this tempera on panel image, showing that it remained at San Niccolò probably until the end of the eighteenth century. "Masolino da Panicale, The Annunciation," www.nga.gov/content/ngaweb/Collection/art-object-page.18.html.

47 Padovani, "Appunti su alcuni dipinti," p. 43.

48 See for example, Cooper, "Redefining the Altarpiece," pp. 686–713. Joannides, meanwhile, suggested that the painting's low vanishing point might have resulted from restricted sightlines in the chapel. Joannides, *Masaccio and Masolino*, p. 433.

49 "la tavola vecchia [Annunciation of Masolino], in mezzo a due colonne vecchie, che v'erano nel tramezzo." Tanci, *Memoriae*, fol. 116r.

50 For the arch, see Joannides, *Masaccio and Masolino*, p. 433.

51 Padovani, "Appunti su alcuni dipinti," p. 46.

52 Badino, "San Niccolò Oltrarno," p. 49. Damiani also suggested the possibility that this panel, attributed by her to an anonymous Florentine painter, was originally intended for the Pieri altar. Giovanna Damiani and Anna Laghi, eds., *San Niccolò Oltrarno: la chiesa, una famiglia di antiquari* (Florence, 1982), p. 50 (cat. 3). Padovani, however, attributing the panel to Bicci di Lorenzo, interpreted the presence of John the Baptist as evidence it was placed on the Gianni altar dedicated to St. John to the left of the high chapel. Padovani, "Appunti su alcuni dipinti," p. 46.

53 Padovani, "Appunti su alcuni dipinti," p. 46. Damiani suggested it could derive from the Banchi St. Louis Chapel and observed that a damaged inscription on the Madonna's throne ("QUESTA. TAVOLA. EDIACHO/PO.DI … ANCHELLO") could allude to

the Banchi family, who had a chapel in the church dedicated to St. Louis, possibly the bishop saint represented. Damiani and Laghi, *San Niccolò Oltrarno*, p. 62.

54 For example, Baldinucci in *Dalla vita di Bartolommeo Ammannati*: "Alzò in più luoghi nove o dieci braccia … e nelle chiese molto s'alzò." Giuseppe Aiazzi, *Narrazioni istoriche delle più considerevoli inondazioni dell'Arno e notizie scientifiche sul medesimo* (Florence, 1845; Reprinted 1996), p. 19.

55 "le tavole degli altari tutte in moltissime parti rotorno(?) rotte." Tanci, *Memoriae*, fol. 152v, transcribed in Damiani, "La chiesa quattrocentesca," p. 42. note 35. The books had been kept in the prior's house.

56 "Nella facciata di questa Chiesa per di fuori alto dalla strada circa X braccia è una cartella di macigno entrovi i seguenti versi, et una linea fra essi che denota il luogo per apputo dove arrivò l'acqua d'Arno per la piena dell'anno 1557." BNCF, Fondo nazionale, II, I, 125 (Sepoltuario fiorentino di Rosselli, Quartiere S. Croce), fol. 183r.

57 "L'anno 1561 s'alzò la tavola dello altare e appoggiosi al muro … si fece il tabernacolo del Sagramento, con gl'angeli di terra cruda e col nostro Signore in mezzo di terracotta, con duo gradi, secondo il disegno di Giorgio Vasari pittore, ma non interamente … il tabernacolo fu a spese di Bernardo Andrea e Pagol Quaratesi … feci levare del tramezzo della chiesa duoi ordini di sedie, e metterle a fornirle dagli lati della cappella … il pergamo di legno s'è levato perchè si rifaccia uno o duo pergami in mezzo la chiesa più horrevoli." Tanci, *Memoriae*, fol. 97v.

58 Damiani and Laghi, *San Niccolò Oltrarno*, p. 85.

59 Tanci, *Memoriae*, fol. 116r.

60 "l'anno 1567 … per fare anzi per traslatare la cappella delli Scodellari la quale fu di nuovo restaurata con pietre serene in forma come si vede." Tanci, *Memoriae*, fol. 156r-v, transcribed in Anna Laghi, "La chiesa cinquecentesca e il suo arredo: vicende e restauri," in *San Niccolò Oltrarno: la chiesa, una famiglia di antiquari*, ed. Giovanna Damiani and Anna Laghi (Florence, 1982), p. 108, note 46. The present author has not consulted this folio of the manuscript.

61 "24. Passato il pulpito segue l'altare della medesima famiglia de Pieri con arme loro, il quale altare doveva essere anticamente nel tramezzo di questa chiesa come pare che si cavi da una inscrizione che si legge in un tassello di marmo, che è in terra in mezzo della chiesa quasi à dirittura del Pulpito. L'iscrizione è la seguente: 25. Vetustae familiae Petriae Scodellariae vetus hic ara sita fuit, quae pietatis ergo superiorem in locus traducta est ornatiore." BNCF, Fondo nazionale, II, I, 125 (Sepoltuario fiorentino di Rosselli, Quartiere S. Croce), fol. 181v.

62 Laghi, "La chiesa cinquecentesca," pp. 87–135. Richa stated that the church was reconsecrated on 1 August 1585 by Fra Maffeo de' Bardi, bishop of Chiusi. Richa, *Notizie istoriche*, vol. 10, p. 272.

63 The attribution was first identified by Paatz and Paatz, and supported by Jane Immler Lawson in her

1982 catalogue entry. Paatz and Paatz, *Kirchen von Florenz*, vol. 4, p. 366. Damiani and Laghi, *San Niccolò Oltrarno*, p. 127, cat. 15.

64 Michele Poccianti, *Vite de sette beati fiorentini fondatori del sacro ordine de' Servi. Con uno epilogo di tutte le chiese, monasteri, luoghi pii, e compagnie della città di Firenze* (Florence, 1589), p. 175: "e hoggi è una Chiesa molto vaga et ornata d'altari bellissimi fatti da molte nobili famiglie habitanti in detta Prioria."

65 Damiani and Laghi, *San Niccolò Oltrarno*, p. 129, cat. 16.

66 Moretti, *La chiesa di San Niccolò Oltrarno*, p. 19.

67 Laghi, "La chiesa cinquecentesca," p. 102.

68 The papal bull was dated 31 January 1436. Franco Carbonai and Mario Salmi, "La chiesa di S. Marco e il Chiostro di S. Domenico," in *La chiesa e il convento di San Marco a Firenze* (Florence, 1989), p. 262.

69 The attribution originally came from Vasari. See Giuseppe Marchini, "Il San Marco di Michelozzo," *Palladio: rivista di storia dell'architettura e restauro* 6 (1942), p. 103.

70 Giorgio Vasari the Younger, *Plan of San Marco*, ink on paper, Uffizi 4861A, Gabinetto Disegni e Stampe, Uffizi, Florence, published in Cornelison, "Relocating Fra Bartolomeo," p. 320, fig. 5.

71 "Mettendosi anco a lavorare di legno, intagliò Crocifissi grandi quanto il vivo; onde infinito numero per Italia ne fece, e fra gli altri uno a' frati di San Marco in Fiorenza sopra la porta del coro." Vasari et al., *Le vite*, vol. 4, part 1, pp. 292–93. Cornelison, "Relocating Fra Bartolomeo," p. 322.

72 Cornelison, "Relocating Fra Bartolomeo," pp. 314–17.

73 Cornelison, "Accessing the Holy," p. 225.

74 Cox-Rearick, "Fra Bartolomeo's St. Mark Evangelist," pp. 340–43.

75 Cornelison, "Relocating Fra Bartolomeo," pp. 329–30.

76 Cox-Rearick, "Fra Bartolomeo's St. Mark Evangelist," p. 334.

77 Flanigan deduced that the nave tramezzo crossed the nave beyond the second pair of nave lancet windows, in alignment with the south wall of the left transept. Flanigan, "Ocular Chastity," p. 41, figs 2, 4.

78 The painting is now in the Los Angeles County Museum of Art. Sally J. Cornelison, *Art and the Relic Cult of St. Antoninus in Renaissance Florence* (Farnham and Burlington, VT, 2012), pp. 63–65.

79 The painting, dated before 1483, is in the Uffizi. Ibid., p. 65. Hans Teubner, "San Marco in Florenz: Umbauten vor 1500. Ein Beitrag zum Werk des Michelozzo," *Mitteilungen des Kunsthistorischen Institutes in Florenz* 23, no. 3 (1979), pp. 250, 257, note 56, 258, note 57; In San Marco, a chapel dedicated to the Angel Raphael "in medio ecclesiae" (a phrase that often referred to a nave screen) was recorded in the Annalia Conventus S. Marci de Florentia, fol. 76v. However, elsewhere in the same manuscript (fol. 39r), the two altars were recorded as dedicated to the Holy Cross and St. Thomas. See also ibid., p. 258, note 57.

80 Cornelison, *Art and the Relic Cult*, p. 65.

81 "et chorus qui era in medio ecclesiae reductum fuit per ejus transversum id est per longum brachij ecclesiae pro viris laicijs, et reliquum corpus ecclesiae per usu mulierum. Et sic triplex distinctio apparuit. Prima est chorus seu Oratorium fratrum reclausum, tanquam a laicijs separatum. Secunda est chorus laicorum in secunda parte ecclesiae. Tertia est ecclesia inferior, quae dicitur mulierum. Ubi fuerunt erecta altaria, et ubi facta fuerunt sedilia per audientia confitentium mulierum." Hall, "The Tramezzo in the Italian Renaissance," p. 220, note 15, citing Florence, Biblioteca Medicea Laurenziana (BML), Codice San Marco 370, fol. 6r. For Fra Giuliano Lapaccini (1411/12-58), see Raoul Morçay, "La cronaca del convento fiorentino di San Marco: La parte più antica, dettata da Giuliano Lapaccini," *Archivio Storico Italiano* 71, no. 1 (269) (1913), pp. 3–5.

82 Whereas Marchini only attributed one of the portals now in a room behind the apse to the Michelozzo period, Flanigan argued that they can both be dated to the fifteenth century. Marchini was the first to suggest that the portal was associated with the choir screen. Marchini, "Il San Marco di Michelozzo," pp. 105–08; Flanigan, "Ocular Chastity," p. 43, note 9.

83 Ibid pp. 43–46.

84 Michelle O'Malley, "Altarpieces and Agency: The Altarpiece of the Society of Purification and Its 'Invisible Skein of Relations'," *Art History* 28, no. 4 (2005), p. 428. Cornelison, "Accessing the Holy," pp. 237–39.

85 "There they sang Matins and did three stations, one in the lower part of the church, the women's part, one in the choir of the laymen, and the third in the choir of the friars." Trexler, *Public Life*, p. 189. See also Flanigan, "Ocular Chastity," p. 42.

86 Teubner, "San Marco in Florenz," p. 259, note 87 and p. 265, Doc. XIV: "Destructus est usque solum paries eclesiae qui separat viros amulieribus." Teubner stated that this event took place in 1517, but the *Annalia* stated that it was the Epiphany following Leo's *Entrata* of November 1515. For Leo X in Florence, see John Shearman, "The Florentine Entrata of Leo X, 1515," *Journal of the Warburg and Courtauld Institutes* 38 (1975), pp. 136–54.

87 Pacciani, "Liturgia e pianta centrale," p. 100, note 25, citing Serafino Loddi's 1736 *Notizie*: "nella stessa occasione si levarono i muri di divisione che in essa erano tra i religiosi e i secolari, uomini e donne, e vi si fecero dalle parti laterali due aperture, a effetto di dare comodità al popolo."

88 BML, Codice San Marco 370. The library's inventory described the manuscript thus: "Codex scriptus anno 1505. Sed alia addita sunt usque ad annum 1612."

89 BML, Codice San Marco 370, fols. 39r–39v: "Anno 1564. consilio, opera ac diligentia eiusdem Reverendi Patri prioris Fratris Sanctis Cini, ecclesia in meliorem formam redacta est. et primo omnium destructum fuit antemurale, quo mulieres a viris secernebantur. . . . Sublatus est etiam pulpitus ligneus in quem scalis ligneis iuxta

ecclesiae parietem sitis, apendebatur. Et eodem loci alius politissimo artificio de ligneis nuceis constructus est, opera atque expensis Domini Alexandri Octaviani de Medicis, scalis lapideis intra parietem edificatis." See also Teubner, "San Marco in Florenz," p. 267. Doc XVIII. For Alessandro Ottaviano de' Medici, see Cristina Acidini Luchinat, "Il Cardinale Alessandro de' Medici e le arti: qualche considerazione," *Paragone* 529–531–533 (1994), pp. 134–40.

90 "In quo munere officii prioratus de consilio priorum(?), primo Ecclesia tota dealbata est, postea renovata, destructum [enim] fuit ante murale, Chori secularium atque ambone veteri sublato, alius opera et expensis Magnifici et nobilis viri Domini Alexandri Domini Octaviani de Medicis." BML, Codice San Marco 370, fol. 76v. I am grateful to Sandro La Barbera for his help with these passages.

91 For Leo XI, see Bernard Barbiche, "Leo XI," in *The Papacy: An Encyclopedia*, ed. Philippe Levillain (New York and London, 2002), p. 929.

92 Francesca De Luca, "La Cappella Salviati e gli altari laterali nella chiesa di San Marco a Firenze," in *Altari e Committenza: Episodi a Firenze nell'età della Controriforma*, ed. Cristina De Benedictis (Florence, 1996), p. 116.

93 Monica Bietti Favi, "La Pittura nella Chiesa di San Marco," in *La chiesa e il convento di San Marco a Firenze* (Florence, 1989), p. 239.

94 "Tutti gl'altari, e le cappelle furono ridotte a un'istessa maniera, misura e disposizione …" De Luca, "La Cappella Salviati," p. 129, citing Tommaso Buoninsegni, *Descrizione della traslazione del corpo del Santo Antonino Arcivescovo di Firenze. Fatta nella chiesa di San Marco l'anno MDLXXXIX. Composta dal Reverendo P. Teologo, Maestro Tommaso Buoninsegni O.P.* (Florence, 1589), p. 18.

95 De Luca, "La Cappella Salviati," p. 131.

96 Tito Centi, "La chiesa e il convento di S. Marco a Firenze," in *La chiesa e il convento di San Marco a Firenze* (Florence, 1989), p. 40.

97 Richa, *Notizie istoriche*, vol. 4, part 2, p. 253.

98 Hueck, "Le opere di Giotto," pp. 43–44. Stefano Giannetti situated the tramezzo in Ognissanti near the present pulpit, the placement of which, he argued, might have been influenced by the previous screen. Stefano Giannetti, "La chiesa basso-medievale: il tramezzo di Ognissanti," in *Dal Gotico, oltre la Maniera: Gli architetti di Ognissanti a Firenze*, ed. Maria Teresa Bartoli (Florence, 2011), pp. 49–57.

99 "Altare positum in eorum Ecclesia Dive Maria Virginis cum tabula nobili picta per olim famosum Pictorem Magistrum Iottum posita extra [or according to Milanesi *positum iuxta*] portam introitus Chori a latere dextro intrando in Ecclesiam a via." Document dated 21 March 1417 (stil. Flor.), now seemingly lost. Hueck suggested that "extra" was a more likely transcription than "iuxta," given that the space immediately next to the choir door would be occupied by Botticelli's *St. Augustine*. Hueck, "Le opere di Giotto," p. 47.

100 Ibid., pp. 37–39, 47. See also De Marchi, *La pala d'altare*, pp. 47–49.

101 Hueck, "Le opere di Giotto," figures 9, 10 on p. 46.

102 According to Chiodo, a document of 1541 conceded space for a chapel to the Rustici family on the left side of nave opposite the Vespucci Chapel "in loco ubi nunc est situata quadam imago antiqua Beate Mariae Virginis in quadam tabula lignea." The present author has been unable to verify this reference. Chiodo, "Uno sguardo indietro," p. 63.

103 Stefan Weppelmann, "Raum und Memoria. Giottos Berliner Transitus Mariae und einige Überlegungen zur Aufstellung der Maestà in Ognissanti, Florenz," in *Zeremoniell und Raum in der frühen italienischen Malerei*, ed. Stefan Weppelmann (Berlin, 2007), pp. 134–44.

104 Ibid., p. 138.

105 Julia Isabel Miller and Laurie Taylor-Mitchell, *From Giotto to Botticelli: The Artistic Patronage of the Humiliati in Florence* (University Park, PA, 2015), pp. 29–31. See also their previous comments in Julia Isabel Miller and Laurie Taylor-Mitchell, "The Ognissanti Madonna and the Humiliati Order in Florence," in *The Cambridge Companion to Giotto*, ed. Anne Derbes and Mark Sandona (Cambridge, 2004), pp. 157–75.

106 Hueck, "Le opere di Giotto," p. 45.

107 "per essere detto luogo, altare et cappella stata levata, nel levare il Coro, che era in mezo della detta chiesa." ASF, CRS no. 91 (Ognissanti), vol. 14, fol. 268r.

108 "Et perche di presente le donne del terzo ordine di S. Francesco sotto il titolo di Santa Lisabetta stanno celebrare i loro ufizii e altre loro divotioni ad altare et cappella de' Trievi …." ASF, CRS. no. 91 (Ognissanti), vol. 14, fol. 268r.

109 For the Ognissanti frescoes, see Hueck, "Le opere di Giotto," pp. 41–43.

110 Ibid., p. 43. For the Codice Petrei, see Antonio Billi and Fabio Benedettucci, *Il libro di Antonio Billi* (Anzio, 1991), p. 92.

111 Martin Kemp, "The Taking and Use of Evidence; with a Botticellian Case Study," *Art Journal* 44, no. 3 (1984), p. 213; Irene Mariani, "The Vespucci Family and Sandro Botticelli: Friendship and Patronage in the Gonfalone Unicorno," in *Sandro Botticelli (1445–1510): Artist and Entrepreneur in Renaissance Florence: Proceedings of the International Conference Held at the Dutch University Institute for Art History, Florence, 20–21 June 2014*, ed. Irene Mariani and Gert Jan van der Sman (Florence, 2015), p. 208.

112 Cadogan, *Domenico Ghirlandaio*, pp. 216–18; Irene Mariani, "The Vespucci Family in Context: Art Patrons in Late Fifteenth-Century Florence" (PhD thesis, University of Edinburgh, 2015), pp. 157–61.

113 Fabrizio Bandini et al., "Il restauro del Sant'Agostino di Botticelli nella chiesa di Ognissanti e le relative indagini diagnostiche," *OPD Restauro*, 26 (2014), p. 17.

114 "Dove fra martino e scappato/e dove andato e fuori della porta/ al prato," translated by Lightbown as

"'Where is Fra Martino?' 'He has slipped out.' 'Where has he gone?' 'He is outside the Porta al Prato.'" Ronald Lightbown, *Sandro Botticelli: Life and Work* (London, 1978), vol. 1, p. 51; vol. 2, pp. 38–40. Whereas Lightbown interpreted the inscription as a conversational snippet overheard by the artist, Kemp transcribed the text differently, relating it to the convent of San Martino al Mugnone outside the Porta al Prato. Kemp, "The Taking and Use of Evidence," p. 214.

115 Gert Jan van der Sman, "Botticelli's Life and Career in the District of the Unicorn," in *Sandro Botticelli (1445–1510): Artist and Entrepreneur in Renaissance Florence: Proceedings of the International Conference held at the Dutch University Institute for Art History, Florence, 20–21 June 2014*, ed. Irene Mariani and Gert Jan van der Sman (Florence, 2015), p. 192.

116 On the St. Augustine fresco: "SIC AUGUSTINUS SACRIS SE TRADIDIT UT NON MUTATUM SIBI ADHUC SENSERIT ESSE LOCUM" ("St. Augustine was so absorbed in his studies that he didn't notice the move") and on the St. Jerome fresco "NE TIBI QUID PICTO HIERNYME SANCTE DEESSET EST NUPER MIRUM MOTUS AB ARTE DATUS" ("Because you, St. Jerome, who are here painted, do not miss anything, they have recently moved you with ingenuity"). Bandini et al., "Il restauro del Sant'Agostino," p. 34, note 7; Nicoletta Pons, "La pittura del Quattrocento in Ognissanti," in *San Salvatore in Ognissanti: la chiesa e il convento* (Florence, 2018), p. 93.

117 Dionisio Pulinari, a Franciscan friar at San Salvatore, explained that San Salvatore had become so precarious around the siege of Florence that the *Signoria* allowed the friars to lodge initially at San Paolino and then at Ognissanti. The Franciscans returned to Monte in 1531, but on his ascent to power in 1537, Duke Cosimo ordered the friars to return to Ognissanti, although due to the intervention of the Spanish Fra Francesco Pardo, with the support of Duke Cosimo and fellow Spaniard Duchess Eleonora di Toledo, some returned to Monte and others inhabited Santa Caterina. The Franciscans remained at Santa Caterina until 1545, when Cosimo removed the Humiliati friars from Ognissanti and placed them in S. Jacopo tra i Fossi and transferred the Franciscans from Santa Caterina to Ognissanti. This short-lived episode was resolved by the intervention of Paul III. Dionisio Pulinari, *Cronache dei Frati Minori della Provincia di Toscana*, ed. Saturnino Mencherini (Arezzo, 1913), pp. 222–25. For the vicissitudes of the Franciscan move to Ognissanti, see also Fabio Sottili, "Vox super aquas intonuit. L'infinito cantiere di Ognissanti," in *San Salvatore in Ognissanti: la chiesa e il convento*, ed. Riccardo Spinelli (Florence, 2018), p. 35. For the events of 1545, see Antonietta Amati, "Cosimo I e i frati di S. Marco," *Archivio Storico Italiano* 81, no. 307/308 (1923), pp. 248–55.

118 Fra Berardo Dragoncini had already attempted to swap Santa Caterina for Ognissanti in 1553. Pulinari, *Cronache dei Frati Minori*, p. 225.

119 Roberto Razzòli, *La chiesa d'Ognissanti in Firenze* (Florence, 1898), p. 2. For the location of Santa Caterina al Mugnone on the Buonsignori map of 1584, visit: R. Burr Litchfield, "Florentine Renaissance Resources: Online Gazetteer of Sixteenth Century Florence," http://cds.library.brown.edu/projects/florentine_gazetteer/map_page_A.php?p=4&m=1&a1=0

120 Although Pulinari stated that the choir stalls from San Salvatore were brought to Ognissanti, I have not found further confirmation of this, and late fifteenth-century stalls still survive in the retrochoir of San Salvatore (see Chapter 2).

121 "Che la Chiesa sia libera a nostra disposizione . . . Che possiamo acconciare la Chiesa a nostro modo, così il Coro, e le altre cose." Florence, Archivio Storico Provincia San Francesco Stimmatizzato, S. Salvatore Ognissanti, no. 224, *Descrizione della Chiesa del Convento d'Ognissanti in Firenze de' Padri Minori Osservanti divisa in due Part composta dal P. F. Antonio Tognocchi di Terrinca Cronologo dell'Alma Osservante Provincia di Toscana l'Anno 1691 e fedelmente trascritta dall'Originale l'Anno 1760* (hereafter Tognocchi), fol. 66.

122 "Laonde vi fabbricarono più di 30 celle, un Refettorio bello, un Orto, o Giardino grande, un minore, una bella Chiesa, un coro spazioso ." Tognocchi, fol. 69. Indeed, Paatz and Paatz mentioned that the Humiliati, not the Franciscans, might have restored the church architecture at Santa Caterina. Paatz and Paatz, *Kirchen von Florenz*, vol. 1, p. 430.

123 "In Ognisanti dipinse a fresco nel tramezzo, alla porta che va in coro, per i Vespucci un S. Agostino, nel quale cercando egli allora di passare tutti coloro ch'al suo tempo dipinsero – ma particolarmente Domenico Ghirlandaio che aveva fatto dall'altra banda un S. Girolamo –, molto s'affaticò; la qual opera riuscì lodatissima per avere egli dimostrato nella testa di quell Santo quella profonda cogitazione et acutissima sottigliezza che suole essere nelle persone sensate et astratte continuamente nella investigazione di cose altissime e molto difficili. Questa pittura, come si è detto nella Vita di Ghirlandaio, questo anno 1564 è stata mutata dal luogo suo salva et intera." Vasari et al., *Le vite*, vol. 3, part 1, pp. 512–13. "Questa pittura, insieme con quella di Sandro di Botticello, essendo occorso a' frati levare il coro del luogo dove era, è stata allacciata con ferri e trapportata nel mezzo della chiesa senza lesione in questi proprii giorni che queste Vite la seconda volta si stampano." Ibid., vol. 3, part 1, p. 480.

124 "di levare di mezzo il detto Coro per dare la sua vaghezza alla Chiesa, e renderla più luminosa, e adagiata." Tognocchi, fols. 35–36; "[N]el MDLXVI, con ordine del Gran Duca Cosimo (come fu fatto in S. Croce, ed in S. Maria Novella) levato il tramezzo, onde la chiesa fosse più luminosa, più adagiata, e più spedita." Francesco Bocchi and Giovanni Cinelli, *Le bellezze della città di Fiorenza* (Florence, 1677), p. 223; Hueck, "Le opere di Giotto," p. 41.

125 "Levossi il coro, che era avanti l'altare, e quei tramezzi: onde si venne a fare la chiesa più bella . . . e nella cappella ci si è messo il coro, che era al Monte, et è bella, larga e spaziosa, con un bel palco, et un bell'altar maggiore sul modello di quello del Monte." Pulinari, *Cronache dei Frati Minori*, pp. 227–28.

126 "Il Sant'Agostino dipinto a fresco fatto a i Vespucci da Domenico del Grillandaio, per la sua rara bellezza fu trasferito quivi fasciato di ferro, essendo prima nella parete del Coro vecchio, che l'anno 1566, d'ordine del Duca Cosimo I fu levato dal mezzo della Chiesa, ove pure eravi un San Girolamo di Sandro Botticelli traslatato dall'altra banda dirimpetto a Sant'Agostino, ritraendosi in questa pittura molte cose atte allo studio." Richa, *Notizie istoriche*, vol. 4, part 2, p. 266.

127 Sottili, "Vox super aquas intonuit," p. 36.

128 Weppelmann stated that this pulpit replaced one on the tramezzo, while Debby noted that "two balconies used for reciting prayers and conducting religious liturgies" were on the screen. Paatz and Paatz, *Kirchen von Florenz*, vol. 4, p. 420; Ferdinando Batazzi and Annamaria Giusti, *Ognissanti* (Rome, 1992), p. 35; Weppelmann, "Raum und Memoria," p. 138; Nirit Ben-Aryeh Debby, "Preaching, Saints, and Crusade Ideology in the Church of Ognissanti in Florence," in *Mendicant Cultures in the Medieval and Early Modern World: Word, Deed, and Image*, ed. Sally J. Cornelison, Nirit Ben-Aryeh Debby, and Peter Howard (Turnhout, 2016), pp. 300–09.

129 Batazzi and Giusti, *Ognissanti*, pp. 69–72.

130 For the side altars, see Gabriella Di Cagno and Donatella Pegazzano, "San Salvatore in Ognissanti: gli altari del Cinquecento (1561–1582) e il loro arredo nel contesto della Riforma Cattolica," in *Altari e committenza: Episodi a Firenze nell'età della Controriforma* (Florence, 1996), pp. 92–103. Sottili, "Vox super aquas intonuit," p. 37.

131 Arnaldo D'Addario, *Aspetti della Controriforma a Firenze* (Rome, 1972), p. 187.

132 This area was renovated in the eighteenth century when a cupola and new choir stalls were added. Batazzi and Giusti, *Ognissanti*, pp. 48, 58.

133 "essendo occorso a' frati levare il coro del luogo dove era." Vasari et al., *Le vite*, vol. 3, part 1, p. 480.

134 Cannon, *Religious Poverty*, pp. 319–20; Bruzelius, *Preaching, Building, and Burying*.

135 Hall, "The Ponte in S. Maria Novella," pp. 159, 163. See also the reconstruction photograph in Trachtenberg, *Building-in-Time*, p. 228, fig. 167.

136 Schmid, *Et pro remedio animae*, p. 139.

137 Cannon, *Religious Poverty*, p. 322; Frithjof Schwartz, *Il bel cimitero: Santa Maria Novella in Florenz 1279–1348: Grabmäler, Architektur und Gesellschaft* (Berlin and Munich, 2009), p. 192; Schmid, *Et pro remedio animae*, pp. 137–39.

138 Gaia Ravalli, "Attraverso Santa Maria Novella: Spazio, culto, decorazione tra XIII e XVI secolo" (PhD thesis, Scuola Normale Superiore, Pisa, 2019), pp. 30–45. I am extremely grateful to Gaia Ravalli for sharing her unpublished thesis with me in personal communication dated 17 September 2020.

139 Marco Campigli, "Il Cinquecento, fino a Vasari: pittura e scultura," in *Santa Maria Novella: La basilica e il convento*, ed. Andrea De Marchi (Florence, 2015), p. 254.

140 Schwartz, *Il bel cimitero*, pp. 192–93.

141 Ibid., p. 193.

142 The fresco was discovered as part of a restoration campaign in 2018. Ravalli, "Attraverso Santa Maria Novella," pp. 61–76.

143 For the screen altars, see Hall, "The Ponte in S. Maria Novella," pp. 164–65; Ena Giurescu, "Trecento Family Chapels in Santa Maria Novella and Santa Croce: Architecture, Patronage, and Competition" (PhD thesis, New York University, 1997), pp. 186–96; Schwartz, *Il bel cimitero*, pp. 197–200.

144 Schwartz, *Il bel cimitero*, p. 193; De Marchi, *La pala d'altare*, p. 48. Chapels on the screen were perceived as part of the sacred topography of the whole church. This is shown by the representation of ten saints on a portable altarpiece (Andrea di Bonaiuto da Firenze, *The Virgin and Child with Ten Saints*, c. 1365–70, National Gallery, London, NG 5115) seemingly inspired by the order in which chapels dedicated to them appeared in Santa Maria Novella, both on the *ponte* and in the rest of the church. Dillian Gordon, *The Italian Paintings before 1400*, National Gallery Catalogues (London, 2011), pp. 8–16.

145 Schmid concluded that because the Tornabuoni frescoes were only accessible to the friars and male members of the family, they were not intended as visual propaganda for the family. Schmid, *Et pro remedio animae*, p. 160. See also DePrano, *Art Patronage, Family, and Gender*, pp. 126–30.

146 Cannon, *Religious Poverty*, p. 322.

147 Schmid, *Et pro remedio animae*, p. 139.

148 Cannon, *Religious Poverty*, p. 323. One of the images attached to the choir wall was an altarpiece by Bernardo Daddi described in Rosselli's Sepoltuario (1657) as "intorno al coro." Ibid., p. 326.

149 Hall, "The Ponte in S. Maria Novella," p. 162.

150 The contract, dated 15 April 1285, is transcribed in Irene Hueck, "La tavola di Duccio e la Compagnia delle Laudi di Santa Maria Novella," in *La Maestà di Duccio restaurata*, Gli Uffizi Studi e Ricerche (Florence, 1990), p. 44.

151 "Fece poi per la chiesa di Santa Maria Novella la tavola di Nostra Donna, che è posta in alto fra la capella de' Rucellai e quella de' Bardi da Vernia." Vasari et al., *Le vite*, vol. 2, part 1, p. 40.

152 Kempers and Bellosi argued for a position on the tramezzo. Kempers, *Painting, Power and Patronage*, pp. 45–47; Luciano Bellosi, "The Function of the Rucellai Madonna in the Church of Santa Maria Novella," *Studies in the History of Art* 61, Symposium Papers XXXVIII: Italian Panel Painting of the Duecento and Trecento (2002), p. 153.

153 Stubblebine and Boskovits argued that the Rucellai Madonna was initially displayed in or near the St. Gregory chapel. James H. Stubblebine, "Cimabue and Duccio in Santa Maria Novella," *Pantheon* 31 (1973), pp. 15–21; Miklós Boskovits, "Maestà monumentali su tavola tra XIII e XIV secolo: funzione e posizione nello spazio sacro," *Arte cristiana* 99, no. 862 (2011), pp. 13–30, especially p. 16. Hueck argued that the panel had always been in the raised position noted by Vasari. Hueck, "La tavola di Duccio," pp. 41–43. De Marchi stated that the

Rucellai Madonna was originally housed in the St. Gregory chapel, where it almost perfectly aligned with the chapel's dimensions and fresco decoration, but that its eventual location on the tramezzo was probably conceived of from the start. Andrea De Marchi, "Duccio e Giotto, un abbrivo sconvolgente per la decorazione del tempio domenicano ancora *in fieri*," in *Santa Maria Novella: La basilica e il convento*, ed. Andrea De Marchi (Florence, 2015), pp. 125–49, especially p. 146.

154 "ultimamente ha fattomi levare il tramezzo della chiesa di Santa Maria Novella, che gli toglieva tutta la sua bellezza, e fatto un nuovo coro e ricchissimo dietro l'altar maggiore, per levar quello che occupava nel mezzo gran parte di quella chiesa: il che fa parere una nuova chiesa bellissima, come è veramente." Vasari et al., *Le vite*, vol. 6, part 1, p. 406.

155 Roberto Lunardi, "La ristrutturazione vasariana di Santa Maria Novella: i documenti ritrovati," *Memorie domenicane (new series)* 19 (1988), p. 406.

156 "per maggiore ornamento, comodità e bellezza e religiosa osservanza della sua venerabile chiesa di Santa Maria Novella si levi del mezzo di quella il ponte e il coro." Ibid., p. 407.

157 Hall, *Renovation and Counter-Reformation*, pp. 16–17. "A' dí 22 detto li frati di S. Domenico, che stanno nel convento di S. Maria Novella, cominciorno a disfare e mandar giú il ponte che era a traverso alla detta chiesa, nel mezzo, antichissimo; qual ponte guastava tutta la bellezza di detta chiesa. E levato che fu cosí questo, come tutti gli altri che erono per le chiese di Firenze, furno racconce et abbellite tutte le dette chiese, che ce n'erono assai, che chi aveva il ponte e chi il coro a mezzo della chiesa, che paiono tutte riavute, e tutte rimbellite, levati che furono detti ponti e detti cori." Lapini and Corazzini, *Diario Fiorentino*, p. 146.

158 "L'anno 1565 si rivoltò sottosopra tutta la chiesa, con perdita lagrimevole di tante antichità che si sono smarrite … E tutto si fece perché così piacque al Duca Cosimo quale aveva la grandissima idea di rimodernare gli edifizi antichi della città: spezialmente le chiese che erano capi di quartiere." Lunardi, "La ristrutturazione vasariana," p. 414. For other cases of Dominican alterations, which despite being often initiated by the friars themselves were also lamented by later chroniclers, see Haude Morvan, "Ecco disperse tutte le memorie dell'Antichità! La place du choeur dans les travaux des érudits dominicains de l'époque moderne," in *Spaced for Friars and Nuns*, ed. Haude Morvan (forthcoming).

159 Hall, *Renovation and Counter-Reformation*, p. 16; Annamaria Poma Swank, "Iconografia controriformistica negli altar delle chiese fiorentine di Santa Maria Novella e Santa Croce," in *Altari controriformati in Toscana: architettura e arredi*, ed. Carlo Cresti (Florence, 1997), p. 109; Maria Cecilia Fabbri, "Santa Maria Novella e la Controriforma: Genesi e sviluppo del linguaggio controriformato nel ciclo pittorico degli altari," in *Alla riscoperta delle chiese di Firenze. 2. Santa Maria Novella*, ed. Timothy Verdon (Florence, 2003), pp. 131–43.

160 In her will of 1568, Camilla, wife of Recco Capponi, requested the establishment of an altar dedicated to the Virgin of the Rosary, which Vasari decided to place in front of Masaccio's *Trinity*, which was completely covered by the altarpiece and altar. In 1858, the upper part of the fresco was removed to the counter-facade, and the lower part depicting the skeleton was only discovered in 1952. The two were reunited in the original site of the fresco in 2001. Vasari et al., *Le vite*, vol. 3, pp. 126–27; Hall, *Renovation and Counter-Reformation*, pp. 114–17; Rita Maria Comanducci, "'L'altare Nostro de la Trinità': Masaccio's Trinity and the Berti Family," *The Burlington Magazine* 145, no. 1198 (2003), pp. 14–15. See also Louis Alexander Waldman, "'Vadunt ad habitandum hebrei': The Otto di Balìa, Vasari, and the Hiding of Murals in Sixteenth-Century Florence," *Mitteilungen des Kunsthistorischen Institutes in Florenz* 56, no. 3 (2014 (2015)), pp. 352–53.

161 "A' dí 23 d'aprile 1566 si finí di levare il coro vecchio della sopradetta chiesa, dov'era stato molti e molti anni, che guastava tutta la sua bellezza." Lapini and Corazzini, *Diario Fiorentino*, p. 152. Hall, *Renovation and Counter-Reformation*, p. 17.

162 "con far l'ntrata dietro alle cappelle che si possa di dormitorio venire in choro senza che i frati siano visti." Lunardi, "La ristrutturazione vasariana," p. 408. Schmid, *Et pro remedio animae*, p. 157.

163 "la chiesa restò per del tempo come spopolata affatto; quasi tutti i benaffetti al convento si ritirarono; cessarono in maggior parte le limosine de' benefattori." Lunardi, "La ristrutturazione vasariana," p. 413.

164 Ibid., p. 404.

165 Marcia B. Hall, "The 'Tramezzo' in S. Croce, Florence and Domenico Veneziano's Fresco," *The Burlington Magazine* 112, no. 813 (1970), pp. 796–99; Marcia B. Hall, "The Operation of Vasari's Workshop and the Designs for S. Maria Novella and S. Croce," *The Burlington Magazine* 115, no. 841 (1973), pp. 204–09; Hall, "The Tramezzo in Santa Croce," pp. 325–41; Hall, *Renovation and Counter-Reformation*.

166 Hall, "The 'Tramezzo' in S. Croce, Florence and Domenico Veneziano's Fresco," pp. 796–99.

167 See the reconstruction images in Hall, *Renovation and Counter-Reformation*, pp. 197–98, figs 2, 3; Trachtenberg, *Building-in-Time*, p. 229, fig. 168.

168 Hall, "The Tramezzo in Santa Croce," p. 327.

169 Giurescu, "Trecento Family Chapels," pp. 199–203.

170 This is confirmed by the 1566 letter to Duke Cosimo in which the operai explained that the tramezzo had been removed but that the choir wall had simply been lowered. Archivio di Santa Croce, vol. 429, fol. 27r–v. Transcribed in Filippo Moisé, *Santa Croce di Firenze: illustrazione storico-artistica* (Florence, 1845), p. 123, and Hall, *Renovation and Counter-Reformation*, pp. 169–70 (both citing the now incorrect reference vol. 426, fol. 51).

171 Hall, "The 'Tramezzo' in S. Croce, Florence and Domenico Veneziano's Fresco," p. 798.

172 Hall, *Renovation and Counter-Reformation*, p. 22; Thomas J. Loughman, "Commissioning Familial Remembrance in Fourteenth-Century Florence: Signaling Alberti Patronage at the Church of Santa Croce," in *The Patron's Payoff: Conspicuous Commissions in Italian Renaissance Art*, ed. Jonathan K. Nelson and Richard J. Zeckhauser (Princeton, NJ, and Oxford, 2008), pp. 133–48.

173 Hall, *Renovation and Counter-Reformation*, pp. 23–24.

174 Cecchi, "Maestri d'intaglio," p. 219.

175 "27 bracia e' largo un choro a 3 andari e 'ntarsiato e 'ntagliato bellisimo. 35 bracia e' lungho el detto choro con 3 gradi di sedie e Io leggio magnificho." Benedetto Dei, *La Cronica dall'anno 1400 all'anno 1500*, ed. Roberto Barducci (Florence, 1984), p. 107.

176 Nirit Ben-Aryeh Debby, "The Santa Croce Pulpit in Context: Sermons, Art and Space," *Artibus et Historiae* 29, no. 57 (2008), pp. 76, 80.

177 Andrea De Marchi, "Relitti di un naufragio: affreschi di Giotto, Taddeo Gaddi e Maso di Banco nelle navate di Santa Croce," in *Santa Croce: oltre le apparenze*, ed. Andrea De Marchi and Giacomo Piraz (Gli Ori, 2011), pp. 35–38. See also Luca Giorgi and Pietro Matracchi, "La chiesa di Santa Croce e i precedenti insediamenti francescani. Architettura e resti archeologici," in *Santa Croce: oltre le apparenze*, ed. Andrea De Marchi and Giacomo Piraz (Pistoia, 2011), pp. 13–31.

178 For example, Vincenzo Borghini in *Discorsi*: "E generalmente erano in tre parti divise le Chiese antiche, come fino a' tempi nostri abbiamo potuto vedere in Santa Croce, in Santa Maria Novella, nel Carmine ed in alcune altre." Borghini and Manni, *Discorsi*, p. 432.

179 "Il medesimo [Cosimo] ha voluto che si faccia questo gran Duca nella chiesa grandissima di Santa Croce di Firenze; cioè che si lievi il tramezzo, si faccia il coro dietro l'altar maggiore, tirando esso altare alquanto innanzi." Vasari et al., *Le vite*, vol. 6, part 1, p. 407.

180 "habbiamo levato tutto il tramezzo et cappelle, eccetto quelle della Foresta lungo il muro di verso i chiostri." Florence, Archivio di Santa Croce, vol. 429, fol. 27r–v. Transcribed in Moisé, *Santa Croce di Firenze*, p. 122, and Hall, *Renovation and Counter-Reformation*, pp. 169–70 (both citing the now incorrect reference vol. 426, fol. 51).

181 "molto più bello et dilettevole all'occhio." Ibid.

182 Hall, *Renovation and Counter-Reformation*, pp. 18–19.

183 "Se il coro si può mettere nella cappella maggiore, lievisi del tutto il coro dov'è hora." Ibid., p. 170.

184 Ibid., p. 19. For the ciborium, see Elena Capretti, "Vasari, Ammannati e la Controriforma," in *Ammannati e Vasari per la città dei Medici*, ed. Cristina Acidini Luchinat and Giacomo Pirazzoli (Florence, 2011), pp. 127–31.

185 Hall, *Renovation and Counter-Reformation*, pp. 122–51; Poma Swank, "Iconografia controriformistica," pp. 95–131; Sally J. Cornelison, "'Michelangelo's Panel': Content, Context, and Vasari's Buonarroti Altarpiece," *Art History* 42, no. 3 (2019), pp. 416–49.

186 Hall, "The Operation of Vasari's Workshop," pp. 204–09.

187 Cited in Waźbiński, *L'Accademia medicea*, p. 361: "adornato ne' nostri giorni di Cappelle con colonne grandi, et architravi di pietre vive, nel mezzo delle quali si veggano vaghissime tavole, che rappresentano tutta la vita di nostro Signore ... Evvi similmente sepolto ... nel mezzo della Chiesa Alberto degli Alberti Cardinale." Poccianti, *Vite de sette beati*, pp. 149–50.

188 Waźbiński, *L'Accademia medicea*, pp. 364–65.

189 Satkowski, *Giorgio Vasari*, p. 96.

190 For the funeral of Michelangelo, see Edward A. Parsons, "At the Funeral of Michelangelo," *Renaissance News* 4, no. 2 (1951), pp. 17–19; Ben Thomas, "The Paragone Debate and Sixteenth-Century Italian Art" (D. Phil. thesis, University of Oxford, 1997), pp. 96–216.

191 "quo exemplo moti, Franciscani observantes et conventuales, et Carmeliti ultra Arnum, nec non et sancti Petri cognomento Maiori et sanctae Feliciatis presbyteri idem fecerunt, choros de suarum ecclesiarum medio prorsus tollentes." Archivio del Convento di Santa Maria Novella, Biliotti M, Cronica pulcherrimae Aedis S. Mariae Novellae de Florentia, cap. XLIX, fol. 51. Cited in Lunardi, "La ristrutturazione vasariana," p. 407.

192 Isermeyer, "Il Vasari," p. 234; Clearfield, "The Tomb of Cosimo," p. 26.

193 "Fra questa fonte maggiore, che è apunto in mezzo et al diritto della cupola, et l'altare grande è il choro de' preti, alquanto rilevato, et appresso a quello la già detta tribuna et altare." Charles Davis, "Giorgio Vasari: Descrizione dell'apparato fatto nel Tempio di S. Giovanni di Fiorenza per lo battesimo della Signora prima figliuola dell'Illustrissimo, et Eccellentissimo S. Principe di Fiorenza, et Siena Don Francesco Medici, e della Serenissima Reina Giovanna D'Austria (Florenz 1568)," *Fontes: Quellen und Dokumente zur Kunst 1350–1750* 6 (2008), p. 23.

194 Franklin Toker, *Archaeological Campaigns below the Florence Duomo and Baptistery, 1895–1980* (London, 2013), pp. 23–24.

195 Although a note on Buontalenti's drawing stated that the baptism took place in 1576 ("si fece il batesimo l'ano 1576 et il giorno di san michelle"), another inscription on the area of the font states "Batesimo del principe Filipo 1577." Don Filippo was born on 20 May 1577. Gino Benzoni, "Francesco I de' Medici, granduca di Firenze," in *Dizionario biografico degli Italiani*, ed. Mario Caravale (Rome, 1997), vol. 49, p. 800.

196 Eve Borsook, "Art and Politics at the Medici Court II: The Baptism of Filippo de' Medici in 1577," *Mitteilungen des Kunsthistorischen Institutes in Florenz* 13, no. 1/2 (1967), p. 95. Vincenzo Borghini published a description of the event, printed by Giunti as early as 3 October 1577. Vincenzo Borghini and Silvano Razzi, *La descrizione della pompa e dell'apparato fatto in Firenze nel battesimo del serenissimo principe di Toscana* (Florence, 1577).

197 Florence, Gabinetto dei Disegni e delle Stampe delle Gallerie degli Uffizi, Arch. 2483. Enrica Neri Lusanna, "L'antica arredo presbiteriale e il fonte del Battistero: Vestigia e ipotesi," in *The Baptistery of San Giovanni,*

Florence [*Il Battistero di San Giovanni a Firenze*], ed. Antonio Paolucci (Modena, 1994), p. 71, fig. 38.

198 Borsook, "Art and Politics," p. 100. Borsook also mentioned that Duke Cosimo had previously refused to alter the medieval furnishings, but did not provide an archival reference. This font should not be confused with another, smaller font dated to 1370. Bruno Santi, "Il fonte battesimo trecentesco e il monumento all'antipapa Giovanni XXIII nel Battistero di Firenze," in *Il Battistero di San Giovanni a Firenze: atti delle conferenze propedeutiche al convegno internazionale di studi*, ed. Francesco Gurrieri (Florence, 2014), pp. 56–71.

199 Borsook, "Art and Politics," pp. 104, 108. For Buontalenti's interventions in the Baptistery, see also Vera Giovannozzi, "Ricerche su Bernardo Buontalenti," *Rivista d'Arte* 15 (1933), pp. 312–15.

200 "nella maniera, che sono stati fatti tutti dl'altri principali di questa città." Borghini and Razzi, *La descrizione della pompa*, p. 9.

201 "oltre che tutto quello si è levato, non che fusse di commodo, et ornamento, anzi impediva piu presto la sua bella vista: ma era anco in parte guasto, e massimamente la fonte." Ibid., p. 9.

202 "si può dire, che tutte siano eccellentissime." Ibid., p. 28.

203 "e così quei santi marmi e sacri calcinacci, furono portati senza reverentia di tante untioni e di tanti incensi lungo le mura, salvo che molte persone per devozione ne hanno prese e le tengono come cose sante." Mario Tinti, *Il fonte battesimale di Dante* (Florence, 1921), p. 7.

204 Paatz and Paatz, *Kirchen von Florenz*, vol. 3, pp. 615, 631.

205 Richa, *Notizie istoriche*, vol. 1, p. 248; Paatz and Paatz, *Kirchen von Florenz*, vol. 5, pp. 106–07; Renato Stopani, *San Simone*, Le Chiese Minori di Firenze (Florence, 2002), pp. 17–21.

206 In its Gothic manifestation, Santo Stefano featured a walled-in canons' choir in the center of the nave, and the retrochoir was added in 1637–50. Paatz and Paatz, *Kirchen von Florenz*, vol. 5, p. 212, 214; Anthea Brook, Dimitrios Zikos, and Jennifer Montagu, *Ferdinando Tacca's High Altar for Santo Stefano al Ponte and Its Bronze Adornments: A Commission by Anton Maria, Giovanni Battista, and Girolamo Bartolommei* (Florence, 2017); Marisa Forlani Conti, "La ristrutturazione seicentesca nella chiesa di S. Stefano al Ponte," in *La comunità cristiana fiorentina e toscana nella dialettica religiosa del Cinquecento* (Florence, 1980), pp. 279–80; Ferruccio Canali, "La basilica di Santa Trinita (e la chiesa di Santo Stefano al Ponte, 'a pendant') a Firenze: Il 'problema' delle 'aggiunte' ('superfetazioni' e 'superedificazioni') di Bernardo Buontalenti e del barocco durante il ripristino neomedievale (1884–1905)," *Bollettino della Società di studi fiorentini* 23 (2014), p. 195.

207 Leader, *The Badia of Florence*, pp. 36, 285; Paatz and Paatz, *Kirchen von Florenz*, vol. 1, p. 273. Anne Leader has shown that in the medieval and Renaissance periods, the monks' choir was situated in the central bays of the nave, not closer to the entrance narthex as others had supposed. In 1501–02, a new wooden choir was commissioned. Alessandro Guidotti, *The Badia Fiorentina* (Florence, 1982), p. 27. For the contract, see Milanesi, *Sulla storia dell'arte toscana*, pp. 353–54.

208 At an uncertain date, but certainly following the installation of Celestine monks from San Pier Murrone (later San Giovannino dei Cavalieri) in 1552, the monks demolished the old rectory to create space for a "beautiful choir" behind the high altar, and gradually new side altarpieces were completed between 1570 and 1593. The present church is mid-eighteenth century. Paatz and Paatz, *Kirchen von Florenz*, vol. 4, pp. 195, 203, notes 11 and 12; Carlo Celso Calzolai, *San Michele Visdomini* (Florence, 1977), pp. 87–94.

209 Richa stated that in 1568 Archbishop Altoviti granted the church the priory title previously enjoyed by the dissolved San Pier Scheraggio, and Paatz and Paatz note that possibly in connection to this change, in 1568 or 1581, the canons' choir stalls were transferred into the central apsidal chapel. Paatz and Paatz, *Kirchen von Florenz*, vol. 5, pp. 6, 15, note 10; The present author has been unable to consult the recent book on the church: Giampaolo Trotta and Licia Bertani, *San Remigio a Firenze* (Florence, 2020).

210 It has been difficult to ascertain the vicissitudes of choir placement in the churches of Santa Lucia sul Prato, Santa Lucia de' Magnoli, Santa Margherita de' Cerchi, Santi Apostoli, and Santa Maria degli Angeli. It is unclear whether a renovation of Santi Apostoli in 1573–83 was tied to any change in choir location. Giampaolo Trotta, "La chiesa dei Santi Apostoli," in *Gli antichi chiassi tra Ponte Vecchio e Santa Trinita: storia del rione dei Santi Apostoli, dai primi insediamenti romani alle ricostruzioni postbelliche*, ed. Giampaolo Trotta (Florence, 1992), pp. 150–51. In the medieval Camaldolese monks' church of Santa Maria degli Angeli, it seems that the monks' choir was in an annex to the left of the high altar, separated by a wall from an oratory for women known as the *chiesetta*. See George Bent, "Santa Maria degli Angeli and the Arts: Patronage, Production and Practice in a Trecento Florentine Monastery" (PhD thesis, Stanford University, 1993), vol. 1, pp. 100, 103, 157, hand-drawn diagram in vol. 2, p. 820; and vol. 2, p. 647 (Doc. 35); Sally J. Cornelison, "Lorenzo Ghiberti and the Renaissance Reliquary: The *Shrine of the Three Martyrs* from Santa Maria degli Angeli, Florence," in *De Re Metallica: The Uses of Metal in the Middle Ages*, ed. Robert Bork (Aldershot and Burlington, VT, 2005), pp. 173–74, 178 (fig. 10.4); Paatz and Paatz, *Kirchen von Florenz*, vol. 3, p. 122.

Chapter 4

COMMUNITY AND ACCESS
IN THE
MENDICANT CHURCH

Santa Maria del Carmine

I
N MAY 1445, a member of the lay confraternity of Santa Maria delle Laudi
o di Sant'Agnese in Santa Maria del Carmine was delegated the task of
renewing the keyholes and keys of various small doorways located around
the upper reaches of the Carmelite church.[1] These included a doorway
above the pulpit atop the large rood screen in the center of the nave. While
supervising the local locksmith, he asked for *two* keys to be made: one for the
confraternity, the other for the friars' sacristan.

This report reminds us that Italian churches were not just sites for the solemn
recitation of liturgy by the clergy, but fluid spaces that witnessed interaction and
cooperation between social groups. In the Carmine, the cutting of two keys for a
door above the screen immediately suggests an idea of shared ownership of the
church interior and invites a subtle reading of the screen's function. Both laymen
and women were allowed entry to areas beyond the screen, where spaces such as
the Brancacci Chapel and the tomb of the beato, and later saint, Andrea Corsini,
were located. In this chapter, I will show that the Carmine's tramezzo was a
multiuse structure, acting as a site for the display of Carmelite identity, a location
for family chapels and tombs, and a stage set for large-scale *sacre rappresentazioni*.
Lay people and friars alike were challenged to negotiate its practical demands and
invented creative solutions to problems of space and access.

After the Franciscan and Dominican examples, the Carmelite tramezzo is the
most familiar to historians of Florentine religious culture, discussed especially
for its role in sacred drama and for mediating access to the Brancacci Chapel.
Beyond these well-established facts, this chapter will situate the nave choir and
screen within the spatial, artistic, and devotional context of the entire church

interior. Primarily focusing on the kinetic and experiential dimensions of the church, I will propose possible viewing conditions of shrines, images, and furnishings for both friar and lay audiences within the Carmelite sacred topography. Furthermore, this chapter will suggest the importance of the church renovation of the early 1560s. Whereas the tramezzo was not demolished until 1568, certain aspects of the Carmine scheme, including the installation of new altarpiece frames and whitewashing of the nave walls, predate Vasari's interventions in the mendicant churches of Santa Maria Novella and Santa Croce and could potentially have influenced these more prominent alterations. As we have seen in Chapter 3, the second half of the sixteenth century witnessed numerous church renovations both within the city of Florence and beyond. The protracted scheme in the Carmine formed part of this broader shift in architectural aesthetics and spatial dynamics in the Italian church interior.

Santa Maria del Carmine

Although one of the earliest Carmelite communities in Italy, the Carmine was the last of the mendicant orders to be established in Florence (Figures 101 and 102). The friars subsisted in modest accommodations in the years before 1267, but then the permanent foundation of Santa Maria del Carmine, located in the Drago Verde gonfalon in the *quartiere* of Santo Spirito, was founded in 1268 with the financial support of a local laywoman.[2] The medieval church was built over an extended period: the aisleless nave was in use by 1284; the cappella maggiore and flanking chapels, built from 1318 to 1368; and further chapels around the transepts and the sacristy in the years leading up to 1400.[3] The Carmelite convent itself was a multilayered hierarchical community that consisted of educated

Figure 101 Santa Maria del Carmine, Florence. Photo: author

priest-friars from aristocratic families, priests employed to say Mass and office at the many chapels and in the choir, deacons, subdeacons, friars in minor order, professed students, lay brothers, and lay novices.[4] In the fourteenth century, the Carmine numbered within its community a promising candidate for sainthood: Andrea Corsini, a Florentine from a notable family who entered the Carmine convent at an early age. After acting as prior of the Pisan and Florentine houses, he held the post of Bishop of Fiesole from 1349 until his death on 6 January 1374. Following his death, his body was kept in Fiesole until 2 February when a group of friars from the Carmine furtively removed it to their church, where it remained ever since.[5]

The church was formally consecrated by Archbishop Amerigo Corsini in 1422.[6] The roof

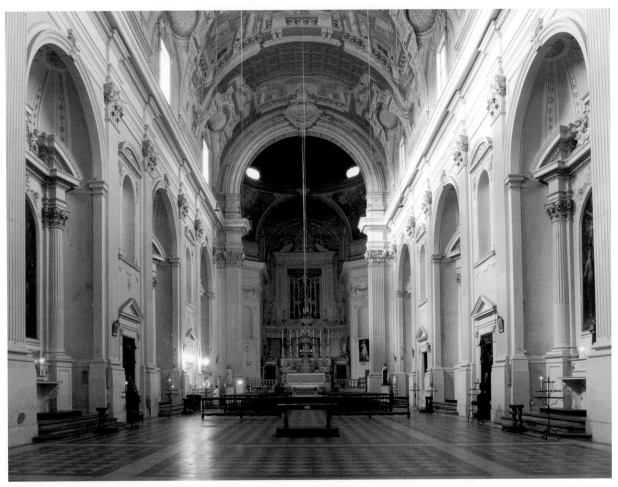

Figure 102 Santa Maria del Carmine, Florence, interior facing south. Photo: author

of the church was not completely finished until 1475, when the proceeds from a salt tax that had been instituted by the Provisione della Repubblica in 1459 for the completion of the building was transferred to neighboring Santo Spirito.[7] In the later fifteenth and early sixteenth centuries, attention shifted to the convent, where the new cloisters, dormitories, infirmary, kitchens, and *studium* were constructed.[8] The church attracted lay patronage from dozens of notable local families, including the Nerli, Serragli, and Soderini (who each acted as patrons of the high chapel in different periods), as well as lay confraternities.[9] Vasari stated that Domenico di Bartolo had produced the high altarpiece around 1436, and Carl Brandon Strehlke has

identified a panel by the artist depicting the *Madonna and Child Enthroned* now in Princeton as the possible central panel of this altarpiece.[10] The late Trecento and Quattrocento saw a flourishing of artistic commissions in the Carmine, most famously the Brancacci Chapel, initially frescoed by Masaccio and Masolino in the mid-1420s (N on Figure 103).[11] The Carmine also featured frescoes by Agnolo Gaddi in the cappella maggiore (A on Figure 103), and still preserves a fresco cycle in the sacristy of the life of St. Cecilia attributed to Lippo d'Andrea (P on Figure 103).[12]

The church experienced a radical restoration from 1568, when the tramezzo was dismantled and new uniform chapels were constructed along

A High chapel (patronage: Nerli; Serragli; Soderini)
B *Friars' choir proposed location, c. 1370s?- 1568*
C *St Andrew and St Anthony Abbot Chapel*
 (patronage: Forte di Piero da Vico), c. 1400-1568)
D *St Albert Chapel (patronage: Dieciaiuti), c. 1420?-1568*
E *St Angelus Chapel (patronage: Carmine), early 1400s?- 1568*
F *Martinelli tomb, 1400s*
G *Magi Chapel (patronage: Manetti), c. 1391-1568*
H *Serragli tomb, c. 1406*
I *St Michael Chapel (patronage: Abadinghi), 1373-1568*
J *Pulpit, on or near screen?*
K Spiral staircase
L St Andrew Corsini shrine, 1385
M Cloister door
N Brancacci Chapel
O Blessed Angelo Mazzinghi tomb, 1438
P Sacristy
Q Chapel of St Agnes (patronage: Compagnia di Sant'Agnese)

Gray objects and italicized labels indicate speculative locations

Figure 103 Santa Maria del Carmine, Florence. Proposed plan of church before 1568. Image: author

the newly whitewashed nave walls. A significant addition to the Carmine was made in 1675–83, when the new Corsini Chapel was constructed by architect Pier Francesco Silvani in the left transept and adorned with frescoes by Luca

Giordano and marble reliefs by Giovanni Battista Foggini.[13] On the night of 28 January 1771, a devastating fire swept through the church and convent, destroying most of the internal furnishings and decoration but miraculously

sparing both the Brancacci and Corsini Chapels.[14] Over the following decade, the church was reconstructed with a new cupola, internal walls, and vaults, substantially restricting our analysis of the medieval fabric.

THE TRAMEZZO

In common with other mendicant churches in Florence, the nave in the Carmine was traversed by a large-scale screen or tramezzo.[15] Dating back to at least 1373, when the St. Michael tramezzo chapel was dedicated, construction of the screen was possibly financed by the wealthy local Serragli family. The screen crossed the aisleless nave roughly halfway between the facade and transept (sometimes described as in the middle of the church: "mezzo della chiesa"[16]), in alignment with a stone staircase within the left nave wall used to access the screen. The Russian Orthodox bishop Abraham of Suzdal, who witnessed the Ascension Day *festa* performed in the church in 1439, estimated that the screen was around 3.6 m high and confirmed that it extended the entire width of the nave, which was 18.2 m.[17] A change in floor level indicated the shift in spatial hierarchy from lower nave to choir, as confirmed by a later archival source, which stated, "[t]here was also a stone step in the middle of the church where the aforesaid vaults [the tramezzo] terminated."[18]

Three archival sources describe the tramezzo extensively: the "Ricordanze dal 1453 al 1647" (contemporary memoranda detailing aspects of the tramezzo before and at the time of its demolition); the 1689 "Libro de Padronati" by Padre Girolamo Castaldi (a compilation focusing on patronage, likely derived from earlier sources); and the "Libro di Provenienze degli'Oblighi di Sagrestia" (a further compendium of sources largely related to patronage compiled by an anonymous eighteenth-century friar of the convent).[19] Dominating the church interior, the

screen was a large vaulted structure densely packed with tombs and chapels. Two of the archival sources describe three arches or vaults, and as the third text mentions six arches, we can assume that three vaults had open arches on both sides of the screen.[20] The central arch, above the tomb of the Serragli family (who also held patronage rights over the high chapel at this time), was likely larger than the two adjacent openings,[21] and was equipped with gates, since a tomb was granted for the space "between the choir and the gates" in 1458.[22] While Garbero Zorzi and Lisi's 1975 reconstruction of the tramezzo indicated a precise elevation and ground plan (Figure 104), the extent of both cannot be determined based on the available evidence, so only its general form is included in the proposed plan in Figure 103.[23]

Figure 104 Cesare Lisi, *Interpretative Scale Model of Santa Maria del Carmine*, 1975, wood, 218 × 187 × 87 cm. Parco mediceo di Pratolino Villa Demidoff Florence. Installation view at Museum of the Bible, Washington, DC. Photo: author

Beyond its bulky architectural form, little is known about the aesthetic characteristics of the tramezzo. Financial records of the Compagnia delle Laudi o di Sant'Agnese, which organized the Ascension Day *festa* in the church, certainly emphasized the architectural nature of the screen through the repeated use of the term "volte." The screen had Gothic pointed arches, and possibly tracery, since a stonecarver was paid for carving "certain stones at the foot of the tracery ('trasforato') of the vaults of *Monte*" (a location on the right side of the screen where mountain scenery was staged for the Ascension Day *sacra rappresentazione*).[24] Writing after the screen's destruction, the eighteenth-century author of the *Libro di Provenienze* described it as "not the most eye-catching and pretty thing in the world" and "made with bricks and with ordinary stone around the arches," although his testimony is not entirely reliable.[25]

The Carmine tramezzo was a concentrated site for tombs in the church. As discussed in Chapter 1, proximity to the crucifix and the efficacious prayers of the religious community made burial on or near a screen desirable for both laity and clergy. Beneath the central arch was the tomb of the Serragli family (H on Figure 103), who, according to the *Libro di Provenienze*, had financed the "rest of" the choir construction, which had not been paid for by the other families.[26] Richa also attributed the majority of the expense of the choir to the Serragli family, except the Martellini tomb, situated toward the left nave wall.[27] With their noble Florentine heritage, immense wealth from the banking, silk, and wool trade, respectable roles in public office and well-connected marriages, the Serragli were the most prominent family in the Drago Verde neighborhood surrounding the Carmine and were patrons of the high chapel.[28] According to the seventeenth-century *Libro de Padronati*, the tomb of Agnolo di Belcaro Serragli (d. 1406), which displayed the family's arms and an inscription,

was in the "center of the church," while "above this tomb there was an arch of the large vaults made by the Serragli where the old choir was."[29] In 1485, Mona Marietta, daughter of Mona Lisa di Serragli, left funds for two offices of the dead, to be said "at the tomb at the middle door of the gates."[30] This family tomb was still being used by the Serragli just one year before the eventual destruction of the tramezzo. In 1567, Antonio di Francesco Serragli transported two sets of remains from the Florentine church in Rome and had them buried in "the middle of the church," evidently indicating the tomb in the center of the tramezzo.[31]

The left-hand arch, which the eighteenth-century source described as "the most magnificent," was sponsored by the Martellini family (F on Figure 103).[32] A marble tomb-slab identified with the family arms and the inscription "Sep. d'Esau d'Agnolo Martellini" must have dated to the first half of the fifteenth century.[33] Further tombs of other families situated around the tramezzo and choir area included those of Filippo di Giusto "in the lower church in front of the chapel of Cione Abadinghi,"[34] Bernardo di Baldassare Bonsi "at the head of the choir toward the high altar,"[35] and Guiliano Ciglioni and Giovanni di Pagolo, both "in a space behind Sant'Alberto," a chapel on the screen.[36] In 1437, Mona Betta Abadinghi was buried in her family chapel of St. Michael, another chapel on the screen, "in her marble tomb with all possible honor."[37]

The arch on the right-hand side of the screen was likely the area of the pulpit (J on Figure 103). In his 1449 testament, Giovanni Manetti requested that the furnishings of his tramezzo chapel be similar to those of the chapel adjacent "on the side of the pulpit," in other words the Abadinghi Chapel of St. Michael.[38] Nirit Ben-Aryeh Debby has shown that during the Renaissance most pulpits were used for preaching but could also have been used for liturgical readings or the exhibition of relics.[39]

Certainly, the Carmine may have been additionally furnished with a moveable wooden pulpit or attached organ balcony in the nave for preaching or an exterior structure for large-scale events in the piazza.[40] Revealingly, a new pulpit was donated just months after the dismantlement of the medieval screen, strongly indicating that a pulpit had been previously integrated into the tramezzo. Only a few months after the choir was removed in November 1568, in January 1569 Bernardo Soderini donated 250 ducats for a new pulpit decorated with mixed marbles "inspired by love of God and for the honoring of the church of Santa Maria del Carmine."[41]

Although large-scale crucifixes were often associated with tramezzi, in the Carmine a painted cross was unlikely to have occupied a position on the screen itself, where it would have interfered with the complex scenery of the regular Ascension performance. In 1436, German illuminator Fra Arrigo d'Arrigo was paid to remake a painted crucifix, which could feasibly have been situated near the tramezzo, either on a beam or suspended from the nave vaults.[42] De Marchi has argued for such separated positions of wooden painted crosses on large transverse beams in other contexts.[43] He has also speculated that the large thirteenth-century panel painting known as the *Madonna del Popolo*, perhaps commissioned by the confraternity later known as the Compagnia di Santa Maria delle Laudi o di Sant'Agnese, could have originally been housed on the tramezzo (Figure 105).[44] However, Christa Gardner von Teuffel cautioned that the early function of this painting is highly uncertain, and Miklós Boskovits argued that the panel might have been displayed on the left side of the church's counter-facade, where a chapel to the Virgin Mary associated with the Compagnia was later recorded.[45]

The friars' wooden choir precinct occupied a large area in the upper nave and was physically distinct from the tramezzo (B on Figure 103).

Figure 105 *Madonna del Popolo*, c. 1260–80, tempera on wood, 262 × 124 cm. Brancacci Chapel, Santa Maria del Carmine, Florence. Photo: Sailko/ Francesco Bini

This is confirmed by the 1426 testament of Orsino Lanfredini, who requested to be buried in his father's tomb, situated "between the choir and the wall which divides the church," revealing the sacral significance of this spatial zone.[46] Little is known about the stalls themselves, although a wooden support for candles "above the choir" was constructed and painted in 1390 and ironwork for the "door of the choir" was purchased in 1445.[47] The friars' choir furnishings were certainly in existence in 1470/1471, when ironwork was bought for the lecterns and a

woodworker was paid to construct a "cathedra" (a Latin term for seat) in the choir.[48]

Chapels at the Tramezzo

The tramezzo was a prominent and desirable location in the church interior for patronage by laity and the Carmelite community. By the mid-fifteenth century, the Carmine screen probably incorporated five chapels attached to both its front and reverse elevations and dedicated respectively to the Magi, St. Michael, St. Albert, St. Angelus and SS Andrew and Anthony Abbot. Archival sources agree that two chapels were situated on the entrance facade of the screen, likely attached to two pilasters on either side of the central archway.[49] Three of the chapels, dedicated to the Magi, St. Michael, and St. Andrew, were specified for demolition at the same time as the tramezzo in 1568, proving that they were integral to the screen. Since the other two, dedicated to St. Albert and St. Angelus, were not mentioned, some doubt remains as to their location; perhaps they had already fallen out of use by that date, or perhaps they were attached to the side walls near the tramezzo, as has recently been discussed for the chapels in Santa Maria Novella.[50]

On the screen facade on the right side, a chapel dedicated to the archangel Michael was founded by Cione di Vanni Abadinghi in 1373 (I on Figure 103).[51] The Abadinghi family had lived in the Drago Verde district since the late twelfth century and Cione had become *priore* in 1372, the year before the construction of his chapel.[52] Seemingly unrelated to any familial names, the St. Michael dedication could have been chosen to invoke the saint's protection or as a response to Carmelite liturgical observance, since the Carmelite General Chapter of Lyon in 1324 added a solemn octave to the feast of St. Michael.[53] Abadinghi's will of 26 May

1373 required the "construction and remaking" of the St. Michael Chapel, implying that it was moved from a previous location.[54] This would suggest that the construction of the tramezzo itself should date to the years around 1373, thus postdating the similarly large structures in Santa Croce and Santa Maria Novella.

An altar dedicated to the Magi was founded on the left pilaster of the screen facade certainly by 1391, when a major sacristy inventory recorded an altarpiece in this location (G on Figure 103).[55] The Magi Chapel was patronized by Giovanni Manetti, a descendant of Bernardo di Giovanozzo Manetti, who in the 1427 Catasto was recorded as the third richest man in Drago and the eighteenth richest in the city.[56] The dedication could have been chosen out of personal preference or reference to broader civic devotion to the Magi, which was publicly manifested in the Festa de' Magi, a public caval-cade through the streets of the city, described by a contemporary observer as early as 1390.[57] In his will of 1449, Manetti requested that within a time frame of two years, his descendants should finish the chapel with "paintings, grille of the arch and tomb just as the chapel adjacent and near to it on the side of the pulpit of the said church," referring to the Abadinghi Chapel of St. Michael, also located on the front side of the tramezzo on the right side.[58] However, it seems that Manetti's wishes were never carried out, since in 1464 his property was requisitioned by Tommaso Soderini for the construction of the refectory and dormitories.[59]

Around 1400, Forte di Piero da Vico founded a chapel dedicated to St. Andrew the Apostle and St. Anthony Abbot,[60] with the additional obligation of a mass on the feast of the Carmelite St. Albert of Trapani.[61] Although the *Libro de Padronati* described the chapel as located against the left wall, documents concerning the destruction of the tramezzo in 1568 refer to "three chapels under the choir of that church under [the titles of] St. Michael, the three Magi,

and St. Andrew," strongly suggesting it was located on the tramezzo itself (C on Figure 103).[62] These later documents also refer to the site with the single dedication of St. Andrew, indicating the saint's primacy over Anthony and Albert.

The figure of St. Andrew the Apostle held distinctive meaning in the Carmine. According to a fifteenth-century *Vita*, Andrea Corsini (the Carmelite candidate for sainthood and Bishop of Fiesole) was born on the feast day of the apostle Andrew and was consequently baptized with his name "in which the future premonition of his contemplation was shown."[63] Corsini's tomb was initially located in the lower nave at the altar of Sant'Orsola, but in 1385 a new marble wall tomb, adorned with the family arms and paintings, and depicting Corsini in pontifical dress, was ready at the juncture of the upper nave and left transept (L on Figure 103).[64] A predella variously dated to the fifteenth or sixteenth century and originally on Corsini's nave altar shows the location of the altar and wall tomb, but erroneously depicts the wooden choir stalls flush with the nave side wall (Figure 106).[65]

After the founding of the St. Andrew screen chapel just a few years later along the same spatial axis, pilgrims passing through the screen would have been reminded of the date of Corsini's birth and of his biblical namesake before encountering his place of burial. The *Vita* of Andrea Corsini confirmed the popularity of this cult, describing the numerous wax images donated to his tomb, thus showing that lay members of the local community could proceed through the tramezzo to access his chapel.[66] Andrea miraculously predicted the Florentine victory of the Battle of Anghiari on the feast day of SS Peter and Paul in 1440, which contributed to a sharp increase in lay devotion and a strong spiritual association with St. Peter, portrayed in the iconography of the nearby Brancacci Chapel.[67] Even before the Anghiari

miracle, the *Vita* claimed that "crowds of people" flocked to Corsini's tomb to offer prayers and supplications.[68] In 1441, the friars commissioned Fra Filippo Lippi to fabricate a now lost and presumably portable reliquary casket, which may have held secondary relics related to Corsini.[69]

In the first half of the fifteenth century, two screen altars were dedicated to the new Carmelite saints, Albert of Trapani and Angelus of Licata. After the Carmelites became an official mendicant order in the mid-thirteenth century, their lack of a founding saint comparable to Francis or Dominic was a sore point.[70] To counter this obvious institutional weakness, fourteenth-century fictive histories of the order, culminating in Felix Ribot's *Ten Books*, promoted an extensive lineage dating back to the Old Testament figures Elijah and Elisha, who were associated with Mount Carmel.[71] Carmelite imagery reinforced this distinguished heritage, as seen in the figures of Elijah and Elisha in Pietro Lorenzetti's high altarpiece for the Siena Carmine.[72] By contrast, the new Carmelite saints lived and died in Italy. St. Angelus was martyred in Licata in 1223 after having left his native Jerusalem to spread Carmelite spirituality to Sicily.[73] His cult flourished in the Quattrocento, with an official *Vita* being written in the 1440s. In 1457, an office was established to be observed by all Carmelite convents and his cult was given papal approval by Pius II in 1459. St. Albert was ordered to preach in Messina and after his death in 1307 his relics were invoked against fever.[74] In 1375, the Carmelite order petitioned the pope to canonize Albert and in 1411 his feast day was added to the liturgical calendar by the General Chapter. The General Chapter of 1420 ordered that every convent have an image of the Blessed Albert and Callixtus III approved his cult in 1457.[75] As Joseph Hammond has shown, the figures of Elijah and Albert represented two sides of a distinctive Carmelite identity, embodying

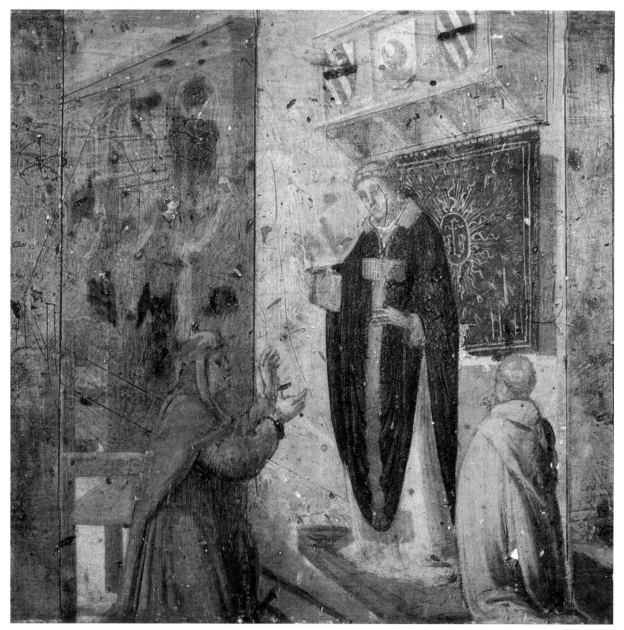

Figure 106 Unknown artist, *Predella of the St. Andrea Corsini Altarpiece* (detail), late fifteenth or early sixteenth century. Sacristy, Santa Maria del Carmine, Florence. Photo: author

both the friars' eremitical origins and their mendicant lifestyle.[76]

Altars dedicated to saints Albert and Angelus, neither of which can be located or dated precisely, were likely established in the spatial zone between the screen and the friars' choir. This side of the screen was variously described as "di sopra," "dietro," or "dentro" (above, behind, or

within). The seventeenth-century *Libro de Padronati* located the St. Albert Chapel "at the foot of the left-hand pilaster," although whether this pilaster was on the screen or the side wall is unclear (D on Figure 103).[77] This source also states that the chapel belonged to Paolo di Lorenzo Dieciaiuti, a local notary who died in 1473 and left three lire a year for two Marian

Figure 107 Ventura di Moro (attr.), formerly attributed to Lippo d' Andrea, *Virgin and Child Enthroned with Saints*, 1420, tempera on wood, framed: 221 × 251.1 × 17.1 cm. Yale University Art Gallery, New Haven, 1871.22a-d. Photo: Yale University Art Gallery, New Haven

masses at his altar.[78] However, it appears likely that this altar was already in existence, and might date back to at least 1420, the date of a polyptych depicting the Virgin and Child with Blessed Albert, and SS Peter, Paul, and Anthony Abbot, now attributed to Ventura di Moro but formerly attributed to Lippo d'Andrea, which certainly originated from the Carmine (Figure 107). According to Gardner von Teuffel, this was displayed on the screen altar before it belonged to

Dieciaiuti, when it may have been dedicated to the Virgin or St. Peter, both of whom appear on the altarpiece.[79] According to Richa, local military leaders in Florence made offerings in honor of Albert in the Carmine in 1445 and 1447, suggesting that the chapel dedication may have changed by this point.[80]

An altar dedicated to St. Angelus and patronized by the convent itself was probably in existence in the early fifteenth century, but similarly

Figure 108 Fra Filippo Lippi, *Madonna and Child with Saints and Angels (The Trivulzio Madonna)*, tempera on wood transported to canvas, 62 × 167.5 cm. Pinacoteca del Castello Sforzesco, Milan. Photo: © Comune di Milano, all rights reserved.

to the St. Albert altar, the seventeenth-century *Libro de Padronati* only gave a vague location of the "right-hand pilaster" of the tramezzo facing the choir, precluding a secure reconstruction (E on Figure 103).[81] Perhaps, in a similar layout to the *ponte* in Santa Maria Novella, these two altars were in fact attached to the side walls rather than the tramezzo proper. The altar was situated behind the Abadinghi screen chapel in a spatial juxtaposition that forged an onomastic association between St. Michael the Archangel and the Carmelite St. Angelus. Moreover, the wordplay between "Angelus" and "angeli" also featured in liturgical hymns sung on the feast day of St. Angelus in the Carmelite tradition.[82] In the mendicant orders, emphasizing connections with established saints was a common strategy to reinforce new saints' legitimacy, as we have already encountered with St. Andrew and Andrea Corsini.[83] It is perhaps no coincidence that the Blessed Angelo Mazzinghi (d. 1438) was also buried along this topographical axis and that his sepulchral inscription

alluded to his angelic characteristics (O on Figure 103).[84]

Fra Filippo Lippi's *Trivulzio Madonna*, dated to the late 1420s or early 1430s,[85] has been consistently associated with the Carmine in Florence, and I argue was probably displayed on the convent's St. Angelus altar.[86] The image depicts the Virgin Mary seated on the ground in a 'Madonna of Humility' pose, holding a chubby Christ child who squirms to escape her loose grasp, and surrounded by blossoming flowers and six child-like angels in white gowns (Figure 108). Three kneeling saints complete the scene: St. Anne on the left, and on the right, Albert, holding a lily, and Angelus, whose head is wounded by a knife.[87]

Several scholars assert that the painting was conceived for the altar in the oratory of the Compagnia di Sant'Alberto, founded in 1419, suggesting that the six young boys without either wings or halos in the panel could be identified as the *fanciulli* members of the confraternity.[88] However, Boskovits proposed that the inclusion

of the Carmelite saints Angelus and Albert suggests a provenance from the St. Angelus altar on the tramezzo, plausibly in existence by the 1420s or 1430s.[89] Indeed, in his description of the demolished nave tramezzo, the anonymous author of the eighteenth-century *Libro di Provenienze* stated: "Then inside [the choir] there is the altar dedicated to St. Albert and to St. Angelus martyr our Carmelites, both painted in the same panel and in the middle of them there is the image of the Virgin Mary immaculately conceived similarly to the images painted above the door to the church."[90] Although not an entirely accurate description of the Lippi panel, two aspects of the painting – a now severely damaged rosebush that lacks thorns and the presence of the Virgin's mother St. Anne – hint at an Immaculist reading of the iconography.[91] Perhaps the low-gable format of the *Trivulzio Madonna* – unique in fifteenth-century Italian painting[92] – could have been specifically chosen to aid its original accommodation on a tramezzo altar, where architectural features may have potentially precluded the display of taller paintings.[93] Indeed, two further panels that have been identified as possible tramezzo altarpieces in Florentine churches display similar dimensions.[94]

An original location on the convent's St. Angelus tramezzo altar may also explain a distinctive aspect of Filippo Lippi's image: the strange sideways glance of the Virgin.[95] Although its precise location cannot be determined, the altar was between the tramezzo and the friar's choir somewhere on the right-hand side when approached from the main door. Therefore, it was near to conventual spaces such as the cloister, which was accessed via a door in the right transept (M on Figure 103).[96] The cloister was an important site for imagery in the church, housing the large *terra verde* fresco of the *Sagra* or consecration of the church painted by Masaccio after 1422,[97] and a fresco by Fra Filippo Lippi known as *Confirmation of the Carmelite Rule* (Figure 109).[98] The cloister door

became an even more important locus of imagery when the venerated panel of the Madonna del Popolo was placed above the door between at least c. 1440–c. 1460.[99] Since the St. Angelus altar was predominantly for the use of the convent, the explicit Carmelite iconography in the *Trivulzio Madonna* would have strongly resonated with the specific audience of the friars themselves, forming part of a concentrated display of Carmelite imagery and fostering a tangible sense of community and identity. Moreover, in this position, Lippi's Madonna seems to turn to face the convent, potentially meeting the gaze of friars approaching the altar from this side of the Carmine complex.

Rather than demonstrating a haphazard arrangement, therefore, the Carmine tramezzo chapels, several of which were decorated with saintly imagery, were integrated within the broader devotional axes of the church. Principal families involved with local politics patronized altars on the main facade of the screen, ensuring maximum visibility and prominence in the predominantly lay area of the church. The saints venerated on this facade side – Michael and the Magi – were considered particularly suitable for lay devotion. On the reverse side of the screen, two chapels dedicated to new Carmelite saints overlooked the friars' choir stalls, where the community performed daily liturgical services. The left side of the screen subtly established a pilgrimage route to the tomb of Andrea Corsini, while the right side made onomastic and liturgical connections between St. Angelus and St. Michael.

THE ASCENSION DAY *FESTA*

In addition to its role in displaying Carmelite identity, the tramezzo also performed an important civic function. As is well known, the Carmine tramezzo acted as an enormous platform for religious drama. Devotion to the Ascension is documented from the 1360s,[100] and from at least the 1390s until 1497 the Carmine regularly hosted

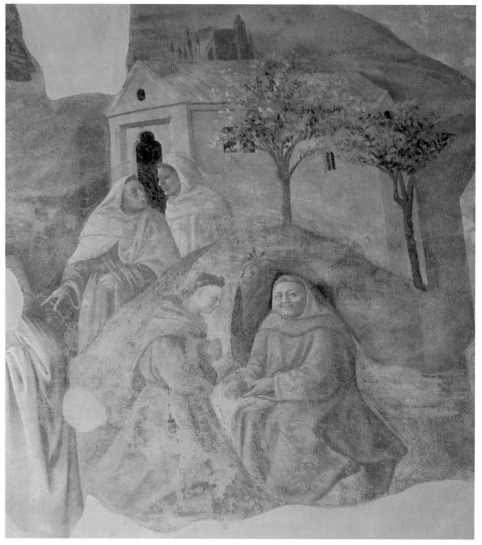

Figure 109 Fra Filippo Lippi, *Confirmation of the Carmelite Rule,* detail, c. 1432, fresco. Cloister, Santa Maria del Carmine, Florence. Photo: author

a dramatic performance or *sacra rappresentazione* on Ascension Day, forty days after Easter, organized by the Compagnia di Santa Maria delle Laudi o di Sant'Agnese.[101] Dating back to at least 1280, this lauds-singing Compagnia became the largest confraternity attached to the Carmine.[102] Cyrilla Barr suggested that the Ascension might have been considered a particularly apt feast for the Carmelite church since it brought to mind the ascension to heaven of Elijah, the mythical founder of the order.[103] The Compagnia's Ascension play was primarily aimed at a general public audience, although it was occasionally performed out of season for visiting dignitaries.[104]

Along with the other two Oltrarno *feste* – the Annunciation in San Felice in Piazza, and Pentecost in Santo Spirito – it formed part of an annual season of such popular events, which culminated in the large-scale civic festival for the patron saint of Florence, John the Baptist.[105]

According to Newbigin, whose extensive scholarship on the Compagnia is invaluable, the Ascension *festa* reached its definitive form by the 1440s.[106] In the 1430s and 1440s the Compagnia received subsidies from the government, constructed new sets, made alterations to the church building, and bought more impressive mechanical devices. The Ascension *festa* survived

attempts by church authorities to limit the activities of confraternities, and in the 1480s the play seems to have been staged sporadically and by the late 1490s ceased to be organized altogether.

An eye-witness account by the Russian bishop Abraham of Suzdal provides the most detailed description of the play.[107] Atop the tramezzo, the set consisted of a castle representing Jerusalem on the left (known as *Castello*) and a mountain representing the Mount of Olives on the right (*Monte*). The play began with the eleven apostles, the Virgin Mary and Mary Magdalene proceeding from the castle or Jerusalem to the mountain. There, Christ gave a parting speech to the apostles, handing Peter the keys of heaven. He then ascended into heaven (*Cielo*) on an illuminated iron frame flanked by two angels, which had been diagonally lowered onto the tramezzo from the niche representing heaven above the high altar.[108] This frame was elevated to fit into a larger apparatus described as the "nugola," which had descended halfway between the Heaven niche and the tramezzo. A blast of light heralded Christ's ascent to heaven, where God the Father appeared in a further frame surrounded by wheels of light representing the planets. Then, two further angels descended from *Paradiso* (situated in a small niche above the *Monte*), greeting the apostles and Maries with the text of the antiphon for Ascension (*Viri galilei*). The whole company then returned to Jerusalem.

The Russian bishop was particularly impressed by the ingenuity of the pulley systems, the different light sources used, including "innumerable lamps," sound effects and "sweet singing."[109] Vasari, who attributed the engineering aspects of the play to Il Cecca, also described the hoists, mechanisms, lamps, and copper lanterns that made the event such a visual feast.[110] The Compagnia had developed several methods to produce spectacular light effects, including the use of oil lamps in clouds of cotton wool, glass receptacles filled with water and pigment, and

lanterns filled with fireworks. Reminding us of the crucial component of sound within the church interior, music was played on bells, lyres, and flutes, while members of the confraternity also provided the singing, which later incorporated polyphony.[111] Brunelleschi was possibly influential in the engineering of the stage machinery, while the artists Masolino and Neri di Bicci were paid for painting sets.[112] On the day of the *festa*, the church was further decorated with wall hangings, bench coverings, and fresh flowers.[113]

The dramatic performance utilized three main areas of the church: the tramezzo, the roof trusses above, and the upper reaches of the high chapel. The tramezzo was temporarily equipped for the performance with a platform (*palcho*) between *Castello* on the left and *Monte* on the right, and an accompanying parapet.[114] In 1430, a small arched niche representing Heaven (*Cielo*) was incised into the vertical wall of the cappella maggiore.[115] By contrast, *Paradiso* was in a separate location: a platform in the roof directly above the right-hand *Monte* section of the tramezzo. In order to access these disparate spaces, a spiral staircase started to be constructed within the left nave wall in 1436 and was probably not completely finished until 1442.[116] These steps, concealed from view from the church interior, gave access to the upper platform of the tramezzo where the castle was located during the drama, and then access further up to the roofline. A wooden bridge or platform (*ponte*) was constructed from the cemetery outside the left nave wall giving direct access to the Castello area of the tramezzo.[117] Members of the Compagnia could have exited the nave via a doorway next to their chapel (the third on the left, Q on Figure 103) straight into the cemetery and via the *ponte* to the screen, from where they could ascend the spiral staircase to the roof, giving access to *Cielo* in the cappella maggiore.[118] Remarkably, part of this staircase still exists. Only accessible from above the nave vaults and

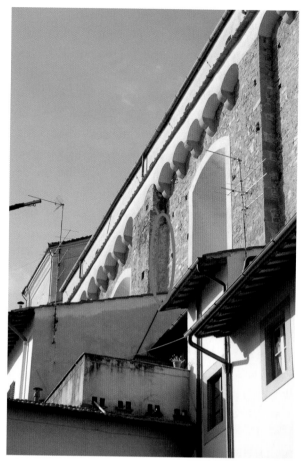

Figure 110 Santa Maria del Carmine, Florence. Exterior of east nave wall with location of staircase indicated. Photo: author

Figure 111 Santa Maria del Carmine, Florence. Staircase in east nave wall. Photo: author

visible from the exterior, the staircase is located between the third and fourth chapels of the present nave (Figures 110 and 111, K on Figure 103).[119] A clear differentiation between the forty-eight lower and fifteen upper steps, which are more roughly cut and have an open tread, implies that the existing staircase was altered at some point in the building's history (Figure 112). The staircase was described in the eighteenth-century *Libro di Provenienze*: "On the left-hand side, there is in the thickness of the masonry a staircase that goes up to the roof . . . it is very steep, I went up it once and my legs hurt for three days after."[120]

The spiral staircase was not the only form of access to the screen. The Compagnia also purchased wooden steps to ascend to the volte, presumably

Figure 112 Santa Maria del Carmine, Florence. Staircase in east nave wall. Photo: author

from inside the church. In 1446 two woodworkers were paid for firwood steps "to go up to the screen for the needs of the *festa*."[121] The artist Neri di Bicci, a Compagnia member who made an inventory of the organization's belongings in 1466/1467,

recorded the existence of a large ladder of twelve steps, which is probably the same one.[122] On the right side of the screen, members of the Compagnia could have used these wooden steps to ascend to the *Monte*, since an exit "that goes up to the volte by Monte" was constructed in 1454.[123]

The Ascension Day *festa* utilized a distinct aspect of the monumental screen.[124] As a large-scale, bulky structure in the church interior, the tramezzo facilitated the construction of substantial sets on its upper ramparts and its height enabled actors to be seen from a distance. The Compagnia workers conceived of the structure from a practical perspective, and with the construction of the spiral staircase, could physically approach it from different access points. The use of the screen for religious drama emphasizes its versatility and multifunctionality as a spatial presence in the church interior. The tramezzo was not only viewed passively from a stationary perspective, but also was experienced kinetically both by the lay faithful proceeding through its three arches and by Compagnia members working above its vaults.

SPACE AND ACCESSIBILITY IN THE CARMINE CHURCH INTERIOR

As Nicholas Eckstein and others have argued, the Carmine was an arena where the ambitions of the Carmelite Order, the Laudesi confraternity, and the local lay community intersected. Modern scholars of the Brancacci Chapel, for example, have identified in its frescoes lay cultural values layered with mendicant institutional objectives. Similarly, the various functions of the Carmine tramezzo indicate that it was not in the exclusive possession of a single sector of society, but acted as a versatile structure that bridged lay and religious culture. Rather than dividing social and gendered groups, the structure seems to have acted as a focal point in the church for a variety of individuals across

Florentine society: friars, local families, and artisan members of the Compagnia.

The screen in the Carmine was certainly permeable by the laity, and in particular by laywomen.[125] Whereas regulations for division of the sexes by screens were defined precisely by the Dominican order, the Carmelite Ordinal did not specify any such gender restrictions. Half of the ten posthumous miracles performed by Andrea Corsini at his tomb involved women, some of whom presented wax votive offerings at his shrine in the upper nave near the friars' choir. After c. 1460, the Brancacci Chapel was used by a female confraternity dedicated to Santa Maria del Popolo, again showing that women were permitted past the tramezzo.[126] Furthermore, laity would probably have been allowed access to the sacristy – again located beyond the tramezzo – to conduct business transactions. As we have seen in Chapter 1, spatial divisions between male and female worshippers were not absolute, although in all likelihood they became stricter during liturgical celebrations. The tramezzo – and the church interior more generally – was used differently according to the time of day and time of year. In the Carmine, ironwork gates at the entrances to the tramezzo facilitated an additional level of spatial control, and it is possible, as in other contexts, that textile barriers could have enforced gender divisions during times of preaching or communion. Moreover, the Compagnia only needed access to certain upper reaches of the Carmine around the feast of the Ascension, as indicated by payments for rat poison to sanitize spaces that had evidently been left unused for some time.[127]

THE REMOVAL OF THE CARMINE TRAMEZZO

By the 1560s, this versatile and fluid functionality of the church interior was becoming

increasingly irrelevant for the emerging post-Tridentine context. In the same years as the last ever *sacre rappresentazioni* were performed in Florence after a long hiatus, numerous tramezzi were demolished, witness to a major shift in the pragmatic and aesthetic experience of the church interior.[128] Instead, large-scale ceremonial events – such as the funeral of Michelangelo in 1564 – were more appropriately staged in buildings with open, unified interiors, such as the Medici parish church of San Lorenzo, rather than Santa Croce, the eventual site of Michelangelo's tomb, where the tramezzo, perhaps considered impractical for such a ceremony, was still standing.[129]

As we have seen in Chapter 3, several renovations, for example in San Marco and Ognissanti, probably anticipated those in the two largest mendicant churches, showing that a shift toward the unified church interior was building in the city. Modernization of the Carmine also unfolded over a protracted period. Already in around 1561 the Botti side chapel in the nave became "the first chapel" to be redesigned with "decoration of *pietra serena*," according to the seventeenth-century *Libro dei Padronati*.[130] In 1563, this chapel received a Crucifixion altarpiece by Giorgio Vasari, who may have been additionally involved in the reworking of this frame design. Whitewashing of the church and consequent elimination of medieval fresco decoration took place in 1564, evidence of a revolution in taste that often accompanied such spatial changes.[131] In 1566, the friars of the Carmine appointed as their new architect Baccino di Maestro Filippo d'Agnolo, perhaps signaling the genesis of the architectural rearrangement.[132] Certain aspects of the Carmine scheme, therefore – the new altarpiece frames and whitewashing – predated the more prominent examples of Santa Maria Novella and Santa Croce, while the removal of the tramezzo itself occurred a few years later. By contrast, although a new Eucharistic tabernacle was installed in Santa

Croce as early as 1569, the Carmine ciborium was only completed much later in 1593.[133]

In 1568, the Carmine tramezzo was dismantled. In an episode that demonstrated the influence of ecclesiastical leaders on the Florentine church interior, Pope Pius V issued a papal bull on 27 September 1568 stating that the prior and convent were released from an excommunication imposed as a result of the arbitrary demolition of the two screen chapels of the Magi and St. Michael without proper consultation. The bull also gave permission to demolish the St. Andrew Chapel, so long as the obligations of all three chapels were transferred elsewhere.[134] These reassignments were confirmed in a subsequent letter from the vicar general of the Archbishop of Florence Antonio Altoviti dated 26 October 1568 in which the St. Michael Chapel was ordered to be incorporated into the Passion Chapel; the Magi into San Giovanni Decollato; and St. Andrew into the Assunta Chapel.[135] The following month, payments are recorded to two porters for "stowing away the wood of the choir," indicating the complete removal of the choir precinct from the nave into the cappella maggiore.[136] The involvement of Archbishop Altoviti in the Carmine following his reentry to the city in 1567 demonstrates his broader interest in changes to church architecture both in the city and the campagna (see Chapter 8 for further discussion). Indeed, he visited the Carmine only months after demolition of the tramezzo began, on 15 March 1569, when he was satisfied with the state of the church building, calling it "very good" ("optime").[137] With regards to ducal influence, the *Libro delle Ricordanze* stated that the friars conducted the Carmine restoration with "the licence" of Duke Cosimo, not that he ordered the alteration himself.[138]

The papal bull stated that the removal of the choir was "for the enlargement of the church," and other archival sources indicate that the change was for the "beauty and ornament of the church" and "to have more space."[139]

According to the contemporary documentation in the *Libro delle Ricordanze*, the expense was covered by "donations given to us by different kind persons"[140] and the results gave "universal satisfaction to the people."[141] Appeals to aesthetic improvement were common motivations recorded for spatial renovations in Florence. Santa Croce, for example, would be "much more beautiful and delightful to the eye" with the nave choir removed, while Santa Trinita would appear "more open and beautiful." According to Richa, the removal of the tramezzo also led to new possibilities for Florentine noble families to patronize chapels in the nave.[142] Moreover, in September 1568, a woodworker was paid for constructing benches for the church likely designed to encourage lay attendance at preaching events, a move inspired by new Tridentine doctrine.[143]

While most historians have based their analysis of the removal of mendicant tramezzi in Florence on the two largest churches of Santa Maria Novella and Santa Croce, which clearly demonstrate both Cosimo's power and Vasari's aesthetic vision, lesser-known examples such as the Carmine reveal an even more complex picture. The case study of the Carmine demonstrates that, both in the early and late Renaissance, Florentine churches were sites of negotiation and compromise between political leaders, local families, and religious communities. Just as the Carmine tramezzo performed multifarious roles when still in use, so too its removal reflected the intricate web of religious and secular patrons who governed the Florentine church interior.

NOTES

1 "Per 1 toppa a stanghetta chon 2 chiavi per l'uscio delle volte sopra al perghamo, diedi 1 chiave a Francescho Giovanni Lorenzi saghrestano." Newbigin, *Feste d'Oltrarno*, p. 418.

2 On 30 April 1267, Avegnente, known as Mona Agnese, the widow of Cione del Vernaccia, donated land for the construction of a new convent in the area of the "populo Sancti Fridiani." The Carmelite house was officially founded by the Florentine bishop Giovanni Mangiadori the following year, on 30 June 1268. Alessandro Guidotti, "Fatti, arredi e corredi carmelitani a Firenze," in *La chiesa di Santa Maria del Carmine a Firenze*, ed. Luciano Berti (Florence, 1992), p. 22. For Agnese Vernaccia, see Patrick McMahon, "Servants of Two Masters: The Carmelites of Florence, 1267–1400" (PhD thesis, New York University, 1994), pp. 91–93. For the church of Santa Maria del Carmine, see Richa, *Notizie istoriche*, vol. 10, part 2, pp. 1–98; Paatz and Paatz, *Kirchen von Florenz*, vol. 3, pp. 188–303; Alberto Busignani and Raffaeollo Bencini, *Le chiese di Firenze*, Quartiere di Santo Spirito (Florence, 1974), vol. 1, pp. 89–122; Priscia Giovannini and Sergio Vitolo, *Il convento del Carmine di Firenze: caratteri e documenti* (Florence, 1981); Nicholas A. Eckstein, *Painted Glories: The Brancacci Chapel in Renaissance Florence* (New Haven, CT, and London, 2014); Alexandra Dodson, "Mount Carmel in the Commune: Promoting the Holy Land in Central Italy in the 13th and 14th Centuries" (PhD thesis, Duke University, 2016), pp. 159–78.

3 Paatz and Paatz, *Kirchen von Florenz*, vol. 3, pp. 188–89.

4 McMahon, "Servants of Two Masters," pp. 201–02. For liturgy at the Florentine Carmine, see James Boyce, *Praising God in Carmel: Studies in Carmelite Liturgy* (Washington, DC, 1999), pp. 115–50.

5 Ludovico Saggi, *Santi del Carmelo* (Rome, 1972), p. 166.

6 Francesco Gurrieri, "L'architettura di Santa Maria del Carmine," in *La chiesa di Santa Maria del Carmine a Firenze*, ed. Luciano Berti (Florence, 1992), pp. 61–62; Eckstein, *Painted Glories*, p. 42.

7 Richa, *Notizie istoriche*, vol. 10, part 2, p. 16; Busignani and Bencini, *Le chiese di Firenze*, vol. 1, p. 91.

8 Giovannini and Vitolo, *Il convento del Carmine*, pp. 86–90.

9 Eckstein, *Painted Glories*, pp. 62–66.

10 Keith Christiansen, Laurence B. Kanter, and Carl Brandon Strehlke, *Painting in Renaissance Siena 1420–1500* (New York, 1989), pp. 250–54. Vasari stated that Domenico had produced works in Florence around 1436 in Santa Trinità "e nella chiesa del Carmine la tavola dell'altar maggiore." Vasari et al., *Le vite*, vol. 2 (Testo), p. 312.

11 For the Brancacci Chapel, see Nicholas A. Eckstein, ed., *The Brancacci Chapel: Form, Function, and Setting: Acts of an International Conference, Florence, Villa I Tatti, June 6, 2003* (Florence, 2007); Eckstein, *Painted Glories*.

12 Angelo Tartuferi, "Le testimonianze superstiti (e le perdite) della decorazione primitiva (secoli XIII–XV)," in *La chiesa di Santa Maria del Carmine a Firenze*, ed. Luciano Berti (Florence, 1992), pp. 146, 168.

13 Paatz and Paatz, *Kirchen von Florenz*, vol. 3, pp. 197, 214.

14 Ugo Procacci, "Incendio della Chiesa del Carmine del 1771," *Rivista d'Arte* 14 (1932), pp. 141–232.

15 For the tramezzo, see ibid., pp. 144–45; Fabbri et al., *Il luogo teatrale*, pp. 59–62; Cécile Maisonneuve, *Florence au XVe siècle: un quartier et ses peintres* (Paris, 2012), pp. 143–53. Eckstein, *Painted Glories*, pp. 26, 59–60.

16 "ponte et volte che erano poste nel mezzo della chiesa." ASF, CRS. no. 113 Santa Maria del Carmine (hereafter Carmine), vol. 19, fol. 75r.

17 Newbigin interpreted the Russian bishop's measurements as equivalent to the English yard (0.91 m). Newbigin, *Feste d'Oltrarno*, p. 63.

18 "Vi era anco uno scalino di pietra in mezzo di chiesa dove terminavano le sudette volte, che fu poi levato nel 1602 in occasione che si riamattonò tutta la chiesa per il che fù necessario per riunire tutto il pavimento." ASF, CRS. no. 113 (Carmine), vol. 13, fol. 8.

19 ASF, CRS. no. 113 (Carmine), vol. 19, "Ricordanze dal 1453 al 1647," fol. 75r-v; ASF, CRS. no. 113 (Carmine), vol. 13, "Libro de Padronati," fols. 7–8; ASF, CRS. no. 113 (Carmine), vol. 7, "Libro di Provenienze," fols. 126–27, 388–89.

20 ASF, CRS. no. 113 (Carmine), vol. 13, fol. 7: "Stava anticamente il choro nel mezzo di chiesa sopra alcuni voltoni che la tramezzavano con tre archi e due gran pilastri." ASF, CRS. no. 113 (Carmine), vol. 19, fol. 75r: "vi erano tre harchi che servivano per tre porte." ASF, CRS. no. 113 (Carmine), vol. 7, fol. 389: "sono 6 archi." "vi erano due porte sotto le volte con due altari verso l'Altar Maggiore con tre altri archi che servivano per posare a dette cappelle." BNCF, Classe XXV, vol. 398, "Memorie della Chiesa del Carmine," fol. 101.

21 Richa stated "entrandovisi per un arco assai grande, che veniva addirimpetto alla porta maggiore della chiesa." Richa, *Notizie istoriche*, vol. 10, part 2, p. 17.

22 A note following the burial concession to Giovanni d'Antonio di Veri (6 June 1458) explained that due to another tomb in the area a different location would have to be selected. ASF, CRS. no. 113 (Carmine), vol. 19, fol. 10r.

23 Elvira Garbero Zorzi, "Chiesa di Santa Maria del Carmine," in *Il luogo teatrale a Firenze: Brunelleschi, Vasari, Buontalenti, Parigi, Firenze, Palazzo Medici Riccardi, Museo Mediceo, 31 maggio–31 ottobre 1975* (Milan, 1975), p. 59, fig. 1.18 (depicting a 1:25 model of the church by Cesare Lisi). See also the present author's review of an exhibition at the Museum of the Bible in Washington, DC, which featured these models: Joanne Allen, "Exhibition Review: 'Sacred Drama: Performing the Bible in Renaissance Florence, Museum of the Bible'," *Renaissance Studies* 33, no. 3 (2018), pp. 502–09.

24 "sono 6 archi ma come usavano in qui tempi ad angolo acuto con pietrami." ASF, CRS. no. 113 (Carmine), vol. 7, fol. 388. 25 April 1442: "A 1 scharpellatore per ischarpellare certe pietre a piè del trasforato delle volte del Monte soldi diciotto." Newbigin, *Feste d'Oltrarno*, p. 388.

25 "non era la più appariscente e vaga cosa del mondo . . . era fatto di mattoni, edi pietre ordinarie agl'archi." ASF, CRS. no. 113 (Carmine), vol. 7, fol. 126.

26 "Tutto il resto di questo coro fù fatto dei Signori Serragli." ASF, CRS. no. 113 (Carmine), vol. 7, fol. 389.

27 "Il Coro soprallodato, che era in mezzo alla Chiesa . . . fu pure altro monumento della pietà de i Serragli;

fuorchè il magnifico arco, che vi aveva di pietra, fatto da i Martellini." Richa, *Notizie istoriche*, vol. 10, part 2, p. 18.

28 On the Serragli, see Roberto Ciabani, Beatrix Elliker, and Enrico Nistri, *Le famiglie di Firenze* (Florence, 1992), vol. 3, pp. 855–56; Nicholas A. Eckstein, *The District of the Green Dragon: Neighbourhood Life and Social Change in Renaissance Florence* (Florence, 1995), p. 157; Lauro Martines, *The Social World of the Florentine Humanists: 1390–1460* (London, 1963), pp. 229–37.

29 "Hanno la sepoltura in mezzo di Chiesa no. 8 lapida, e chiusino quadro di marmo con loro arme, con queste lettere *Erogij et nobilis viri Angeli Ser Belcaris de Serraglis mercat. florent. qui obijt 1406.* Sopra questa sepoltura vi era un arco de voltoni fatto da Serragli ove era il Choro antico come si è detto altrove." ASF, CRS. no. 113 (Carmine), vol. 13, fol. 112.

30 "alla sepultura alla porta di mezo de cancegli." ASF, CRS. no. 113 (Carmine), vol. 9 fol. 4v.

31 "1567 Adì 22 Luglio Antonio di Francesco Serragli fe venire di Roma in una cassa di piombo i due Corpi di Simone e Niccolo Serragli depositati in S. Giovanni de' Fiorentini egli fece mettere in mezzo alla Chiesa nella sua sepoltura." Florence, BNCF, Classe XXV, vol. 398, fol. 76.

32 "Ma quello davanti all'ingresso è più magnifico e fù fatto questo dai Signori Martellini." ASF, CRS. no. 113 (Carmine), vol. 7, fol. 389.

33 "Altrimenti detti d'Esaù nobili fiorentini hanno la sepoltura avanti la loro cappella dell'Orto no. 23 lastrone di marmo con la loro arme, e lettere *Sep. D'Esau d'Agnolo Martellini.* Questa sepolta è antica e fù fatta assai prima della capella sotto un arco de voltoni del Choro antico fatto da questa famiglia." ASF, CRS. no. 113 (Carmine), vol. 13, fol. 178. In the Catasto of 1427, Isau di Agnolo was ranked the fifty-third wealthiest man in Florence but the fourth wealthiest in the *Drago* neighborhood. See www.stg.brown.edu/projects/catasto/newsearch/ M1427w.html and www.stg.brown.edu/projects/cata sto/newsearch/M1427g.html#14.

34 "in chiesa di sotto dinanzi alla capella di cione abadinghi." For the 1455 tomb of Filippo di Giusto, see ASF, CRS. no. 113 (Carmine), vol. 17, fol. 38r.

35 "in chapite chori versus altare maioris." ASF, Notarile Antecosimiano, vol. 6088 (Giovanni Dieciaiuti), fol. 8v.

36 "in loco drito dominus alberto." For the document dated 24 July 1490 mentioning the tombs of Bernardo Bonsi, Guiliano Ciglioni and Giovanni di Pagolo see ASF, Notarile Antecosimiano, vol. 6088 (Giovanni Dieciaiuti), fol. 8v and ASF, CRS. no. 113 (Carmine), vol. 19, fol. 53v.

37 "nella sua sepoltura del marmo facemole quello onore fu possibile." ASF, CRS. no. 113 (Carmine), vol. 16, fol. 129r.

38 "de picturis et graticolia arcuum arca prout est cappella contigua et prope ipsam ex lat[ere] pergami dictae ecclesiae." ASF, Notarile Antecosimiano, vol. 7399 (Filippo di Cristofano), fol. 75r.

39 Debby, *The Renaissance Pulpit*, pp. 55–56.

40 I am grateful to Christa Gardner von Teuffel for her insightful comments on the function of the pulpit.

41 "vi è il pulpito di marmi misti fatto fare dal Signore Bernardo del Signore Nicolò Soderini l'anno 1568 con spesa di ducati dugentocinquanta." ASF, CRS. no. 113 (Carmine), vol. 13, fol. 68. "motus amore dei et pro honorando ecclesiam Sancte Marie del Carmine." ASF, Notarile Antecosimiano, vol. 7520 (Alamanno di Bernardo Filiromoli), fol. 211v (dated 21 January 1569).

42 Megan Holmes, *Fra Filippo Lippi, The Carmelite Painter* (New Haven, CT, and London, 1999), pp. 17–18, 249, note 85. "Item questo dì a Frate Arrigo per lengno della croce fece fare di nuovo s.15"; "Item questo dì a Frate Arrigo per la dipintura del legno della croce s.6." ASF, CRS. no. 113 (Carmine), vol. 85, fol. 243r.

43 For example, Andrea De Marchi, "La diffusione della pittura su tavola nel Duecento e la ricostruzione del tramezzo perduto del Duomo di Pistoia," in *Il museo e la città: vicende artistiche pistoiesi dalla metà del XII secolo alla fine del Duecento*, ed. Fulvio Cervini, Andrea De Marchi, and Guido Tigler (Pistoia, 2011), pp. 64–65.

44 De Marchi, *La pala d'altare*, p. 49; De Marchi, "Cum dictum opus sit magnum," pp. 607–08.

45 Boskovits drew attention to a document of c. 1484 that noted "Cappella di Nostra Donna posta dentro alla porta della chiesa di S. Maria del Carmine a man sinistra," and another eighteenth-century document which confirmed the contraternity chapel "nella ... facciata interna della chiesa, accanto alla porta a mano sinistra entrando." Boskovits, "Maestà monumentali," pp. 18–19. Christa Gardner von Teuffel, "The Significance of the Madonna del Popolo in the Brancacci Chapel: Reframing Assumptions," in *The Brancacci Chapel: Form, Function, and Setting: Acts of an International Conference, Florence, Villa I Tatti, June 6, 2003*, ed. Nicholas A. Eckstein (Florence, 2007), pp. 39–42.

46 Paatz and Paatz, *Kirchen von Florenz*, vol. 3, p. 286, note 222. ASF, Notarile Antecosimiano, vol. 15112 (Niccolò di Diedi), fol. 52r: "inter chorum et murum qui dividit ecclesiam." The following phrase was crossed out: "videlicet prope ^inter^ portam ubi est pergamum et portam medii." The marble floor tomb was described in the Libro de Padronati: "Nobili fiorentini hanno la sepoltura d'avanti il pulpito no. 37 lapida, ò lastrone di marmo dove è la loro arme, con queste lettere *Sep. nobilis viri Lanfredini Orsini de Lanfredinis et filiorum*." ASF, CRS. no. 113 (Carmine), vol. 13, fol. 139.

47 25 February 1390: "Item a Iachopo da Schopeto per legname per fare la via sopra ichoro per porre le chandele in tutte l. cxx. Item al Vecha dipintore per dipingnere la via sopra i choro per sua manifatura in tutto l. lxiiij." ASF, CRS. no. 113 (Carmine), vol. 82, fol. 179r. 24 September 1445: "Item assalvadore ferravecchio per libre quattro eoncie quattro di ferro lavorato e per tre anelli per achonciare luscio del coro in tucto soldi sedici" ASF, CRS. no. 113 (Carmine), vol. 86, fol. 96r.

48 24 December 1470: "Item per due ferri fei fare per legie del coro." 13 January 1470 [stil. Flor.]: "Item adi 13 soldi undici a Iacomo lignaiuole per una cathedra fece nel choro." ASF, CRS. no. 113 (Carmine), vol. 87, fol. 10v. See also Giovannini and Vitolo, *Il convento del Carmine*, p. 87.

49 "A piedi de pilastri de detti archi stavano eretti due altari." ASF, CRS. no. 113 (Carmine), vol. 13, fol. 7.

50 I am grateful to Joanna Cannon for her help in thinking through these possibilities.

51 ASF, Notarile Antecosimiano, vol. 13558 (Biagio Mazzochi), fols. 85r–v.

52 Ciabani et al., *Le famiglie*, vol. 3, p. 826.

53 "Item inseratur ibidem quod octava de Corpore Christi, de omnibus Sanctis et de sancto Michaele per totum ordinem solemniter celebretur." Paschalis Kallenberg, *Fontes Liturgiae Carmelitanae: investigatio in decreta, codices et proprium sanctorum* (Rome, 1962), p. 31. In addition, the feast of the Apparition of St. Michael appeared in the *laudario* belonging to the Compagnia di Sant'Agnese, produced in c. 1340. Christine Sciacca, ed., *Florence at the Dawn of the Renaissance: Painting and Illumination 1300–1350* (Los Angeles, 2012), p. 255, cat. no. 45.11.

54 Maisonneuve, *Florence au XVe siècle*, p. 139.

55 The 1391 inventory listed "una tavola de magi in sull'altare de manetti di sotto." ASF, CRS. no. 113 (Carmine), vol. 33, fol. 30r.

56 For the Manetti, see Ciabani et al., *Le famiglie*, vol. 3, pp. 846–47; Eckstein, *The District of the Green Dragon*, p. 23. Bernardo registered a total wealth of 32,339 florins in 1427. For his Catasto return, see http://cds.library.brown.edu/projects/catasto/newsearch/sqlform.php?referred=yes&drilldown=yes&stg_id=50001885.
In 1427, Giovanni Manetti registered a total wealth of 1,015 florins. See http://cds.library.brown.edu/projects/catasto/newsearch/sqlform.php?referred=yes&drilldown=yes&stg_id=50002793.
For Giovanni Manetti, see McMahon, "Servants of Two Masters," pp. 227–28.

57 Rab Hatfield, "The Compagnia de Magi," *Journal of the Warburg and Courtauld Institutes* 33 (1970), p. 108.

58 "de picturis et graticolia arcuum arca prout est cappella contigua et prope ipsam ex lat[ere] pergami dictae ecclesiae." ASF, Notarile Antecosimiano, vol. 7399 (Filippo di Cristofano), fol. 75r.

59 "Queste Terre nel 1464 furno date à Tomaso di Lorenzo Soderini Camarlingo dell'Opera per la fabbrica del Refettorio, e Dormitorio vecchi." ASF, CRS. no. 113 (Carmine), vol. 13, fol. 38.

60 Forte's testament of 1417 required his descendants to provide the furnishings necessary for a chapel described as already constructed in the church: "una cappella gia per lui ordinata et fatta nella detta chiesa di S. Maria del carmino titolata S. Andrea et S. Antonio di tutte locose per essa cappella necessarie et opportune perlo spaccio et compimento de quella." Testament dated 17 July 1417. ASF, CRS. no. 113 (Carmine), vol. 193, fol. 26r. In 1454, a

disagreement over the endowment was presented at the Mercanzia, the Florentine merchant's court. Eckstein, *Painted Glories*, p. 54.

61 "siamo obligati affare tre feste ogni anno cioe di sancto Antonio: di sancto Alberto ordinis nostri: et di sancto Andrea apostolo." ASF, CRS. no. 113 (Carmine), vol. 9, fol. 4r.

62 "Vi era ancora una cappella sfondata nella muraglia dalla parte della Compagnia di S. Alberto, che anticamente si diceva la Cappella del Forte, eretta e fondata da Forte di Piero da Vico di Val d'Elsa intorno all'anno 1400." ASF, CRS. no. 113 (Carmine), vol. 13, fol. 8. "tres capellas subtus chorum ipsius ecclesie sub sancti Michaelis et trium Regum Magor[um] ac sancti Andree." ASF, Diplomatico, Normali, Firenze, Santa Maria del Carmine, 27 September 1568 (pergamene).

63 "Baptiçatur puer, et sacro fonte baptismatis Andreas nomen imponitur, in quo presagium contemplationis eius futurum demo[n]strabatur." Giovanni Ciappelli, *Un santo alla battaglia di Anghiari: La "vita" e il culto di Andrea Corsini nella Firenze del Rinascimento* (Florence, 2007), p. 112.

64 Ibid., p. 19; Ashley B. Offill, "The Corsini Chapel in Santa Maria del Carmine: Framing the Relic Cult of Saint Andrea Corsini in Baroque Florence" (PhD thesis, University of Kansas, 2020), p. 43.

65 Tartuferi, "Le testimonianze superstiti," p. 145; Offill, "The Corsini Chapel," pp. 58–63.

66 "quod apud sepulturam suam multe erant oblate ymaginem ceree." Ciappelli, *Un santo alla battaglia*, p. 160.

67 Nicholas A. Eckstein, "Saint Peter, the Carmelites, and the Triumph of Anghiari: The Changing Context of the Brancacci Chapel in Mid-Fifteenth-Century Florence," in *Studies on Florence and the Italian Renaissance in Honour of F. W. Kent*, ed. Peter Howard and Cecilia Hewlett (Turnhout, 2016), pp. 317–37, especially p. 324.

68 "et concursus populorum ad visitandum eius reliquias veniebat, vota ipsorum portantes et offerentes." Ciappelli, *Un santo alla battaglia*, p. 146. The *Vita* described ten posthumous miracles that demonstrated the broad influence of Corsini, since they were equally distributed between men and women, and between San Frediano residents and outsiders. Ibid., pp. 152–62; Offill, "The Corsini Chapel," pp. 50–54.

69 Holmes, *Fra Filippo Lippi*, p. 263, note 15; Offill, "The Corsini Chapel," pp. 54–58.

70 Joseph Hammond, "Negotiating Carmelite Identity: The Scuola dei Santi Alberto ed Eliseo at Santa Maria dei Carmini in Venice," in *Art and Identity: Visual Culture, Politics and Religion in the Middle Ages and the Renaissance*, ed. Sandra Cardarelli, Emily Jane Anderson, and John Richards (Newcastle upon Tyne, 2012), pp. 221–23. For the early history of the Carmelites, see Andrew Jotischky, *The Carmelites and Antiquity: Mendicants and Their Pasts in the Middle Ages* (Oxford, 2002), pp. 8–44; Frances Andrews, *The Other Friars: The Carmelite, Augustinian, Sack and Pied Friars in the Middle Ages* (Woodbridge, 2006), pp. 10–14.

71 Jotischky, *The Carmelites and Antiquity*, pp. 136–50; Hammond, "Negotiating Carmelite Identity," p. 222.

72 Joanna Cannon, "Pietro Lorenzetti and the History of the Carmelite Order," *Journal of the Warburg and Courtauld Institutes* 50 (1987), pp. 18–28; Christa Gardner von Teuffel, "The Carmelite Altarpiece (circa 1290–1550): The Self-Identification of an Order," *Mitteilungen des Kunsthistorisches Institut in Florenz* 57, no. 1 (2015), pp. 16–19, 22–23.

73 For St. Angelus, see Jotischky, *The Carmelites and Antiquity*, pp. 191–201; Holmes, *Fra Filippo Lippi*, pp. 38–39.

74 Saggi, *Santi del Carmelo*, pp. 154–55. For St Albert, see Christa Gardner von Teuffel, "Locating Albert: The First Carmelite Saint in the Works of Taddeo di Bartolo, Lippo di Andrea, Masaccio and Others," *Predella: Journal of Visual Arts* 13–14, no. 39–40 (2016), pp. 173–92.

75 Andrews, *The Other Friars*, p. 55; Saggi, *Santi del Carmelo*, p. 155.

76 Hammond, "Negotiating Carmelite Identity," p. 223.

77 "Eravi anco un altare di sopra verso l'altare maggiore à pie del pilastro sinistro dedicato à S. Alberto Carmelitano fatto da Ser Paolo di Lorenzo Dieciaiuti, e vi anco la sua sepoltura." ASF, CRS. no. 113 (Carmine), vol. 13, fol. 7.

78 "Questo S. Paolo mori del 1473 e lasciò lire tre l'anno con obligo di celebrare una *festa* della Natività della Madonna à gl'8 di 7bre à questo Suo Altare." ASF, CRS. no. 113 (Carmine), vol. 13, fol. 182. Eckstein noted the proximity of the St Albert altar to the oratory of the Compagnia di Sant'Alberto, located to the left of the Carmine nave. Eckstein, *Painted Glories*, p. 60.

79 Gardner von Teuffel, "Locating Albert," pp. 177–78. The altarpiece is now in the Yale University Art Gallery in New Haven, 1871.22a-d. Holmes, *Fra Filippo Lippi*, p. 39; Guidotti, "Fatti, arredi e corredi," p. 27.

80 "Notabile è ancora un Osso del Beato Alberto Siciliano. A questo Santo v'era sotto uno de' due Archi, che poneano in mezzo l'Altar Maggiore, e l'antico Coro, allor che era nel mezzo, dedicata una Cappella dalla Famiglia de' Dieciaiuti … S. Alberto dovette mostrarsi protettore de' Fiorentini; poichè il Sig. Can. Giulianelli ha trovato, che adì 7. Agosto 1445. vennero le Capitudini della Città ad offerta con libbre 61. di cera; e nel 1447. fecero lo stesso: adì 7. Ottobre 1445. adì 13. Agosto 1447." Richa, *Notizie istoriche*, vol. 10, part 2, p. 58.

81 "dall'altra parte al pilastro destro vi era un altr'altare dedicato a S. Angelo Carmelitano fatto dal Convento." ASF, CRS. no. 113 (Carmine), vol. 13, fol. 7.

82 A hymn to be sung at Vespers to honor St. Angelus began "Angelorum gaudent chori" in London, British Library, MS Harley 1819, fol. 133b. Kevin Alban, ed., *We Sing a Hymn of Glory to the Lord: Preparing to Celebrate Seven Hundred Years of Sibert de Beka's Ordinal 1312–2012. Proceedings of the Carmelite Liturgical Seminar, Rome, 6–8 July 2009* (Rome, 2010), p. 314.

83 Similarly, the *vita* of St Nicholas of Tolentino described how his parents, unable to conceive until the miraculous

intervention of St Nicholas of Bari, named him in honor of the saint. André Vauchez, *Sainthood in the Later Middle Ages*, trans. Jean Birrell (Cambridge, 1997), pp. 507–08.

84 A wooden casket and painted image of Angelo were installed on the pilaster between the apsidal chapels of St. Lucy and SS Bartholomew and Lawrence. The casket, which is currently located in the sacristy, bears the following inscription, the crude Latin of which alludes to Angelo being worthy of his name: QUID NOS RELIGIO MONEAT QUID VITA PUDICHA ET NORAM ET MULTOS NUNC DOCHUISSE IUVAT CHARMELLI TESTES QUORUM SUM SACRA SECUTUS ANGELUS ET TANTO NOMINE DIGNUS ERAM 1438. Another potential future Carmelite saint, Angelo Mazzinghi had preached at the Carmine in the 1430s to great acclaim. Giuseppe Maria Brocchi, *Vite de' santi e beati fiorentini* (Florence, 2000), Part 2, pp. 229–32. Holmes, *Fra Filippo Lippi*, p. 23.

85 Ruda dated the panel to the mid-late 1420s. Jeffrey Ruda, *Fra Filippo Lippi: Life and Work with a Complete Catalogue* (London, 1993), cat. no. 2, pp. 366–67. The panel is dated 1429–32 in *La Pinacoteca del Castello Sforzesco a Milano* (Milan, 2005), cat. no. 60, p. 96. De Marchi dated the panel to c. 1430-32 in *La Primavera del Rinascimento: la scultura e le arti a Firenze 1400–1460* (Florence, 2013), cat. no. VI.3, p. 382. Holmes dated the painting to c. 1430–34. Holmes, *Fra Filippo Lippi*, p. 65.

86 Now in the Castello Sforzesco (Museo d'Arte Antica: Pinacoteca, inv. 551), the painting originated in Florence, having arrived in Milan via the collection of the Rinuccini family, who owned a chapel in the Carmine and a palazzo in the San Frediano district. Miklós Boskovits, "Fra Filippo Lippi, i Carmelitani e il Rinascimento," *Arte Cristiana* 74, no. 715 (1986), p. 237. Aside from his tenure as sub-prior of the Siena Carmine in 1428–29, the painter was based at the Carmine in Florence from 1422-32. Holmes, *Fra Filippo Lippi*, pp. 14–15.

87 Paolo Caioli, "Un'opera dimenticata di Fra Filippo Lippi," *Il Monte Carmelo* 25, no. 8 (1939), p. 231.

88 Ibid., p. 232. Holmes, *Fra Filippo Lippi*, p. 65. *La Primavera del Rinascimento* cat. no. VI.3, p. 383; Gardner von Teuffel, "Locating Albert," p. 179. For wingless angels, see Andrea De Marchi, "Un raggio di luce su Filippo Lippi a Padova," *Nuovi studi* 1, no. 1 (1996), p. 11.

89 Boskovits, "Fra Filippo Lippi," p. 237.

90 "Dentro poi vi è l'Altare dedicato a S. Alberto, e a S. Angiolo martire nostri carmelitani dipinti ambidue nella medesima tavola et nel mezzo di essi vi è li immagine di Maria Vergine immacolatamente concetta a similitudine delle imagini dipinte sopra la porta della chiesa." ASF, CRS. no. 113 (Carmine), vol. 7, fol. 389. Above the nave portal on the exterior façade, there was a fresco of the Madonna del Carmine with angels and the Carmelite saints Alberto and Angelo by Bernardino

Poccetti dated 1600. Paatz and Paatz, *Kirchen von Florenz*, vol. 3, p. 220.

91 The roses without thorns, a symbol of the Immaculate Conception, were also noted in Maria Pia Mannini and Marco Fagioli, *Filippo Lippi: catalogo completo* (Florence, 1997), cat. no. 2, p. 85. For the identification of St Anne, see Holmes, *Fra Filippo Lippi*, p. 67; Saggi, *Santi del Carmelo*, p. 156; Gardner von Teuffel, "The Carmelite Altarpiece," p. 21; Gardner von Teuffel, "Locating Albert," p. 179. Ruda and Marchini followed Kaftal in his identification of the elderly female saint as Angela of Bohemia. George Kaftal, *Iconography of the Saints in Tuscan Painting* (Florence, 1952), p. 58; Ruda, *Fra Filippo Lippi*, cat. no. 2, p. 366; Giuseppe Marchini, *Filippo Lippi* (Milan, 1975), cat. no. 4, p. 199. For St Anne in Carmelite liturgy, see James Boyce, "The Office of St Anne in the Carmelite Liturgy," *Carmelus* 52 (2005), pp. 165–84.

92 Boskovits argued that the panel was probably the crowning section of a larger altarpiece, but Ruda noted that this iconography would be unprecedented for an apex image. Boskovits, "Fra Filippo Lippi," p. 237. Ruda, *Fra Filippo Lippi*, p. 367. Zambrano instead explored the possibility that the panel was intended as a lunette above a portal. Patrizia Zambrano, "La Madonna Trivulzio," in *Museo d'arte antica del Castello Sforzesco: Pinacoteca* (Milan, 1997), vol. 1, cat. no. 86, p. 169.

93 In a recent restoration, Laura Basso and Carlotta Beccaria discovered that 5 cm thick strips painted with nineteenth-century artificial pigments had been added to each sloping section of the gable, which could have been associated either with an earlier frame or a previous reformatting. Laura Basso and Carlotta Beccaria, "La Madonna dell'Umiltà con sei angeli e i santi Anna, Angelo da Licata e Alberto da Trapani (Madonna Trivulzio)," *Kermes* 5, no. 87 (2012), pp. 53–54. In 1936, Mario Salmi published an image of the panel with the additional upper sections. Mario Salmi, "La giovinezza di Fra Filippo Lippi," *Rivista d'Arte* 18 no. 2 (1936), p. 13, fig. 5.

94 Filippo Lippi's *Trivulzio Madonna* has been given various height measurements, which must be a result of the various restorations: 62 × 167.5 cm in *La Pinacoteca del Castello Sforzesco*, cat. no. 60, p. 96; 89 × 167.5 cm in Maria Teresa Fiorio and Mercedes Precerutti Garberi, *La Pinacoteca del Castello Sforzesco* (Milan, 1987), cat. no. 110, p. 86; 91.7 × 169.9 cm in *La Primavera del Rinascimento*, p. 382. Giotto's *Dormition of the Virgin*, in the Gemaldegalerie, Berlin, which Hueck argued was originally sited on the tramezzo in Ognissanti, measures 75 × 179 cm. The four remaining panels of a polyptych by Pacino di Bonaguida, now in the Cassa di Risparmio in Florence, and perhaps originally sited on the St. Thomas Becket tramezzo altar in Santa Maria Novella, measure between 67.2 cm and 68.2 cm high. Boskovits noted that although the panels seem to be side panels of a polyptych, they could be a low continuous panel since they show horizontal cracks in

alignment. Miklós Boskovits and Klara Steinweg, *A Critical and Historical Corpus of Florentine Painting.* Section 3, vol. 9 (Florence, 1984), p. 254 and plates CII, CIII.

95 Side-facing Madonnas appear in the following works ascribed to Lippi: *Madonna and Child Enthroned with Angels, a Carmelite and Other Saints,* mid-late 1420s, Empoli, Museo della Collegiata; *Madonna and Child Enthroned with Two Angels,* c. 1435–37, New York, Metropolitan Museum of Art; *Madonna del Ceppo,* 1452–53, Prato, Galleria Comunale di Palazzo Pretorio. Ruda, *Fra Filippo Lippi,* pp. 367–68, cat. no. 3; pp. 387–89, cat. no. 17a; pp. 436–37, cat. no. 46.

96 Procacci, "Incendio," p. 208. Procacci stated that the cloister door was originally in the Chapel of the Passion in the right transept, number 5 on his plan.

97 The fresco was destroyed or concealed around 1612, but sixteenth-century descriptions and drawings suggest that it portrayed a public procession outside the church. Holmes, *Fra Filippo Lippi,* pp. 42–47.

98 Ibid., pp. 68–79.

99 Gardner von Teuffel, "Significance of the Madonna del Popolo," p. 41.

100 In 1365 Andrea Corsini gave two florins for the feast of Ascension: "nel 1365 si trova che S. Andrea Corsini Vescovo di Fiesole diede due fiorini per la *festa* dell'Ascensione." ASF, CRS. no. 113 (Carmine), vol. 13, fol. 4. Gloria Fossi, "Grandi casati, uomini illustri e committenti," in *La chiesa di Santa Maria del Carmine a Firenze,* ed. Luciano Berti (Florence, 1992), p. 316.

101 Newbigin, *Feste d'Oltrarno,* p. 45.

102 Ibid., pp. 48–49. See also Giuseppe Bacchi, "La compagnia di Santa Maria delle Laudi e di Sant'Agnese nel Carmine di Firenze," *Rivista storica carmelitana* 2 (1930), pp. 137–51; Giuseppe Bacchi, "La compagnia di Santa Maria delle Laudi e di Sant'Agnese nel Carmine di Firenze," *Rivista storica carmelitana* 2 (1931), pp. 12–39, 97–122.

103 Cyrilla Barr, "Music and Spectacle in Confraternity Drama of Fifteenth-Century Florence: The Reconstruction of a Theatrical Event," in *Christianity and the Renaissance: Image and Religious Imagination in the Quattrocento,* ed. Timothy Verdon and John Henderson (Syracuse, NY, 1990), p. 379.

104 On 26 June 1465, the *festa* was performed to honor the visit of Ippolita Sforza, bride of Alfonso di Calabria. In Lent 1470/1471, the Florentine Signoria requested an extraordinary performance for the visiting duke of Milan, Galeazzo Maria Sforza, who did not actually attend. Newbigin, *Feste d'Oltrarno,* pp. 119, 129–133.

105 Ibid., pp. x–xi. Dale Kent, *Cosimo de' Medici and the Florentine Renaissance: The Patron's Oeuvre* (New Haven, CT, and London, 2000), pp. 59–60.

106 Newbigin, *Feste d'Oltrarno,* p. 66. Newbigin argued that *sacre rappresentazioni* flourished under Cosimo de' Medici il Vecchio and later languished under Lorenzo. Nerida Newbigin, "Piety and Politics in the Feste of Lorenzo's Florence," in *Lorenzo il Magnifico e il suo mondo,* ed. Gian Carlo Garfagnini (Florence, 1994), pp. 17–41.

107 See the translation of Abraham de Suzdal's description in Newbigin, *Feste d'Oltrarno,* pp. 60–63.

108 In her identification of a niche above the high altar, Newbigin corrected Zorzi and Lisi's 1975 reconstruction of the play, which depicted a single upper platform above the *Monte. Il luogo teatrale,* p. 59, fig. 1.18. For the use of tramezzi for *sacre rappresentazioni,* see also Hall, "The Tramezzo in the Italian Renaissance," pp. 222–24.

109 Newbigin, *Feste d'Oltrarno,* p. 62.

110 Ibid., pp. 64–65.

111 Barr, "Music and Spectacle," pp. 387–88.

112 Götz Pochat, "Brunelleschi and the 'Ascension' of 1422," *The Art Bulletin* 60, no. 2 (1978), pp. 232–34. Newbigin, *Feste d'Oltrarno,* pp. 84, 121.

113 Newbigin, *Feste d'Oltrarno,* p. 81.

114 17 April 1473: "per fare el palcho della Sennsione inn sulle volte tra 'l Monte e 'l Chastello." Ibid., p. 632. 2 May 1437: "A 1 legniaiuolo a San Tomaso soldi quindici per legniame per fare el parapetto in su le volte di mezzo da la parte di sopra e per rechatura soldi due, in tutto soldi diciassette a spese di *festa*." Ibid., p. 346.

115 Ibid., pp. 85–86.

116 Ibid., p. 91.

117 May 1441: "A Pagholo legnaiuolo . . . per fare el ponte, soldi otto, nel cimiterio che va nel Chastello." Ibid., pp. 373–74.

118 Although Procacci listed the Sant'Agnese Chapel as the second in the nave, Newbigin argued that Richa was probably correct in citing the third chapel. Ibid., pp. 54–55.

119 Procacci, "Incendio," p. 145n; Eckstein, *Painted Glories,* p. 26.

120 "ella è molto ripida, vi sono salito una volta, mi dolsero le gambe per tre giorni." ASF, CRS. no. 113 (Carmine), vol. 7, fol. 389.

121 "A Bernado e Antonio Antinori a dì 28 di marzo 1446 lire due di picioli, sono per 1 schala s'ebbe da lloro già sono più anni per ire in sulle volte per e bisongni della *festa.* La detta schala è d'abete e chon schaglini piani." Newbigin, *Feste d'Oltrarno,* pp. 421–22.

122 "1 schala grande grossa la quale s'adopera a andare in sulle volte ed è 12 ischaglioni." Ibid., p. 533.

123 1 July 1454: "A spese delle Chonpagnia per fare un [u]scio che va in su le v[o]lte da. Monte a Ventura legna[i]olo lire una soldi 2 danari 6." Ibid., p. 487.

124 Eckstein described the laity's liminal experience of the screen and the *festa* in Eckstein, *Painted Glories,* pp. 12–16.

125 Eckstein noted a comedy published by Giovanni Battista Gelli in 1543 that confirmed the accessibility of the church beyond the tramezzo. Ibid., p. 29.

126 ASF, CRS. no. 113 (Carmine), vol. 19, fol. 15v. Gardner von Teuffel, "Significance of the Madonna del Popolo," p. 41. In addition, many of the Carmine's benefactors were women. McMahon, "Servants of Two Masters,"

pp. 232–34. For the confraternity, see also Eckstein, *Painted Glories*, pp. 151–73.

127 In 1446, two ounces of arsenic were purchased to poison the rats in the roof spaces. Newbigin, *Feste d'Oltrarno*, p. 106.

128 Ibid., pp. 214–18.

129 For the funeral of Michelangelo, see Parsons, "At the Funeral," pp. 17–19; Thomas, "The Paragone Debate," pp. 96–216. See also Maia Wellington Gahtan, *Giorgio Vasari and the Birth of the Museum* (Farnham and Burlington, VT, 2014), pp. 7–8. I am grateful to Laura Overpelt for suggesting this source.

130 "Fù questa la prima cappela che si facessi in tal forma, e ornamento di pietra serena." ASF, CRS. no. 113 (Carmine), vol. 13, fol. 69. Fossi, "Grandi casati," p. 333.

131 "L'anno 1564 del mese di settembre s'imbiancò la nostra chiesa." ASF, CRS. no. 113 (Carmine), vol. 19, fol. 74r.

132 ASF, CRS. no. 113 (Carmine), vol. 23, fol. 209r [new numeration: 199r], dated 1 December 1566. See Hall, *Renovation and Counter-Reformation*, p. 2, note 3. This document was first brought to scholarly attention by Peter Cannon Brookes, "Three Notes on Maso da San Friano," *The Burlington Magazine* 107, no. 745 (1965), p. 196.

133 ASF, CRS. no. 113 (Carmine), vol. 19, fol. 79v.

134 ASF, Diplomatico, Normali, Firenze, Santa Maria del Carmine, 27 September 1568 (pergamene).

135 ASF, Diplomatico, Normali, Firenze, Santa Maria del Carmine, 26 October 1568 (pergamene).

136 18 November 1568: "A dua fachini che assettorno il legname del coro." ASF, CRS. no. 113 (Carmine), vol. 106, fol. 201r.

137 "Ecclesia in edificijs est optime." Florence, Archivio arcivescovile, VP 09.1, fol. 39v.

138 "Havuta la licentia dall' Illustrissimo Signore Duca Cosimo". ASF, CRS, no. 113 (Carmine), vol. 19, fol. 75r.

139 ASF, Diplomatico, Normali, Firenze, Santa Maria del Carmine, 27 September 1568 (pergamene): "pro ampliatione ecclesie"; "per bellezza et ornamento di detta chiesa"; ASF, CRS. no. 113 (Carmine), vol. 7, fol. 126: "per avere più ampio spazio."

140 "La spesa che si pose nella detta rovina et ornamento si fece con limosine donateci da diversi amorevoli persone." ASF, CRS. no. 113 (Carmine), vol. 19, fol. 75v.

141 "con universale satisfattione dei popoli." ASF, CRS. no. 113 (Carmine), vol. 19, fol. 75r.

142 Richa, *Notizie istoriche*, vol. 10, p. 26. See also Cannon Brookes, "Three Notes," p. 196.

143 ASF, CRS. no. 113 (Carmine), vol. 106, fol. 197v: "1568, 13 7bre: A battista legnaiolo lire cinque sono per sua fattura di banchette fatte per la chiesa– l. 5."

Chapter 5

PATRONAGE AND PLACE IN MONASTIC CHURCHES

Santa Trinita and San Pancrazio

O N A MONDAY MORNING in 1479, Vallombrosan monks held their general chapter meeting in the church of San Pancrazio in Florence. As the general public gazed on "with great admiration and expectation," the monks processed into the nave choir precinct two by two in a solemn display of devotion and communal identity.[1] However, one group of monks refused to enter the choir and instead congregated in a corner of the church to elect their own abbot general. Just as the monastic choir precinct was an institutional symbol of community and belonging, the stark rejection of this reserved and elevated space was an equally powerful political statement.

This chapter analyzes two nave choirs in the churches of Santa Trinita and San Pancrazio, both Vallombrosan monastic communities with parish duties. In contrast to the mendicant context explored in Chapter 4, art-historical interest in these two monastic churches has never been strong perhaps due to the unfortunate treatment of the buildings in the modern era. Although the institutional importance of these solemn spaces is clear, both were also profoundly linked with local lay families and neighborhoods. Multiple motivations prompted the late sixteenth-century removal of these nave choirs, which involved both monastic officials and secular leaders, including Duke Cosimo and his son Grand Duke Francesco. Documented reasons included aesthetic improvement, creating quiet and convenient spaces for liturgical office, and the imitation of other churches in the city. In addition, at San Pancrazio, the alteration was conceived as a strategy to eliminate bad behavior in church and mask the dramatic decline of

the monastic population, concerns that reflect broader religious changes associated with Catholic renewal and reform.

THE BENEDICTINE VALLOMBROSANS

The Reformed Benedictine Congregation of Vallombrosa– named for the woodland setting of its first abbey church – was founded by San Giovanni Gualberto in the eleventh century.[2] Bound by tenets of austerity, simplicity, and severity, the monks expanded their territory beyond Tuscany to encompass seventy-nine foundations by 1253. Threatened by the success of the more popular mendicant orders in the fifteenth century, the monks of San Salvi in Florence, encouraged by pope Eugenius IV, initiated a reform movement influenced by similar measures undertaken at the Benedictine monastery of Santa Giustina in Padua.[3] San Pancrazio was numbered among these reformed communities in 1463.[4] As described earlier, the year 1479 saw a partial schism of the congregation into reformed "sansalvini" and conventuals, which was resolved in 1485 by the forcible union of these sects into the "Santa Maria di Vallombrosa" congregation. It maintained some reforming principles such as the ability to transfer monks among different houses, annual elections for abbots, and the abolition of the *commenda* system of patronage.[5] In 1570–73, a further general reform of the congregation was enacted in the wake of the Council of Trent.[6] While sixty-five Vallombrosan abbeys were in existence in 1522, by 1575 the congregation only numbered 234 monks inhabiting nineteen monasteries.[7] The Florentine houses experienced this waning popularity and downturn in population. Indeed, the abbot of San Pancrazio lamented the presence of only three or four monks in choir. Within Florence, the decline in the Vallombrosan monastic populations can be likened to the extinction of the Humiliati in Ognissanti, which was punctuated by the shift from nave choir to retrochoir made by the incoming Franciscan Observants (see Chapter 3). On a broader level, the decline in fortunes of some monastic orders, who perhaps lacked recognizable identity, gave way to the rise of new priestly congregations, such as the Jesuits and Oratorians, who made different demands on sacred space.

Communication, cooperation, and consistency within the Vallombrosan congregations of Florence appear to have been strong. As geographically proximate institutions of the same congregation, Santa Trinita and San Pancrazio were intimate neighbors. The two nave choirs were both constructed in the first half of the fifteenth century, the communities employed some of the same craftsmen, and major changes to their church interiors occurred in the same span of time. Documentary evidence leaves some ambiguity regarding the scale, presence, and liturgical function of each Vallombrosan choir precinct in Florence, but comparable examples at Passignano and Vallombrosa provide vital clues. Furthermore, unwanted choir stalls from both Santa Trinita and San Pancrazio were not completely destroyed but were transported to and reutilized by other Vallombrosan houses.

SANTA TRINITA

The architectural history of Santa Trinita has been distorted by Vasari's contention that the present church was built by Nicola Pisano, and by Richa's mention of an inscription dated 1257 on a marble plaque in the facade.[8] This dating, however, does not accord with the fourteenth-century style of the building nor archival data. Based on excavations conducted in 1957–58, Saalman proposed the consecutive development of four church buildings on the

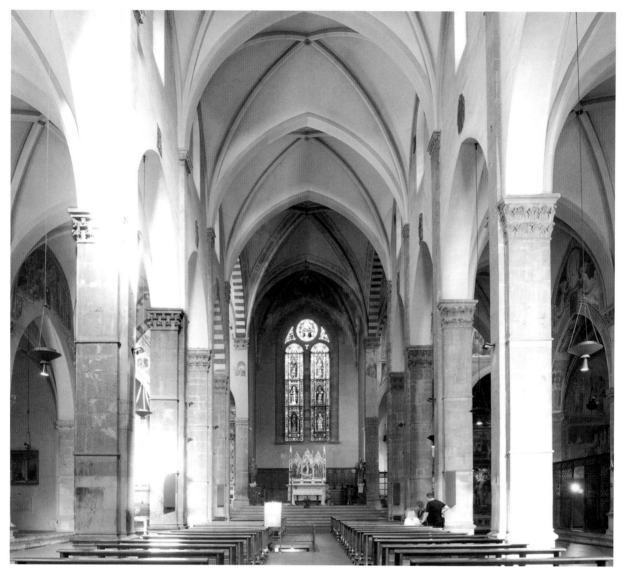

Figure 113 Santa Trinita, Florence. Interior view facing northwest, after nineteenth- and twentieth-century renovations. Photo: author

Santa Trinita site, culminating in the present Gothic edifice (Figures 113 and 114).[9] Vallombrosan monks were documented at Santa Trinita for the first time in 1114 but the present church was almost entirely rebuilt in three main stages, from before the mid-fourteenth century to the period 1383–1407, when the majority of the building was completed.[10]

In the late fourteenth and fifteenth centuries, Santa Trinita benefited from the increased financial prosperity of local families, who transformed the church into a vibrant center for artistic patronage. In addition to older families like the Gianfigliazzi, Compagni, Bartolini, and Sercialli, patronage for the numerous minor chapels in the church came from the new merchant elite, including the Spini, Scali, Davanzati, and Ardinghelli.[11] A sense of competition emerged between patrons: in 1415, for example, Piera degli Scali requested in her will that her chapel dedicated to St. Bartholomew should be equal or superior in beauty to the chapels of St. Lucy and St. Benedict in the same church.[12] From 1464, the *jus patronatus* of the high altar (A on

A	High chapel (patronage from 1464: Gianfigliazzi)	**I**	St Paul Chapel (patronage: Dell'Abbaco, Ficozzi)
B	*Monks' choir proposed location, c. 1411-1569*	**J**	St Francis Chapel (patronage: Sassetti)
C	*Rough location of Carli, Gaetani, Lotti tombs*	**K**	Sacristy (patronage: Strozzi)
D	St Catherine Chapel (patronage: Davanzati)	**L**	Entrance from Via del Parione
E	Assumption Chapel (patronage: Spini)	**M**	Organ, 1571
F	St Giovanni Gualberto relic chapel	**N**	St Nicholas Chapel (patronage: Ardinghelli)
G	St Bartholomew Chapel (patronage: Scali)	**O**	St Luke Chapel (patronage: Sercialli)
H	St Peter Chapel (patronage: Dell'Abbaco, Ficozzi, later Usimbardi)	– – –	*Possible screen?*

Gray objects and italicized labels indicate speculative locations

Figure 114 Santa Trinita, Florence. Proposed plan of the church before 1569. Image: author

Figure 114) was ceded to the Gianfigliazzi family, which was politically and economically powerful in the local community and occasionally came into conflict with the monastery on the same block as their palace.[13] Baldovinetti's cappella maggiore decorations (1460s) included a Trinitarian high altarpiece and Old Testament frescoes on the walls and vaults replete with contemporary Florentine portraits, an artistic strategy later employed by Ghirlandaio in his scenes from the life of St. Francis (1480s) in the nearby Sassetti Chapel (Figure 115).[14]

The present-day neo-Gothic appearance of the Santa Trinita interior largely derives from restorations conducted by Giuseppe Castellazzi and Luigi del Moro between 1881 and 1897.[15] At that time, many of the Mannerist and Baroque furnishings were removed, horizontal stripes were painted around the piers, the pavement level was altered, paintings on the piers were erased, and an upper oculus was inserted into the interior facade wall. Today, visitors to Santa Trinita, upon entering via the sixteenth-century facade (which features remains of the medieval facade on its interior), encounter a rather dark nave flanked by five chapels to either side. A subterranean entrance to the crypt corresponds to the fourth nave pier, and beyond the fifth nave piers the transept extends to either side of the high chapel. On the right, below the organ, a side entrance to the church from Via del Parione (L on Figure 114) lies adjacent to the Strozzi sacristy (K on Figure 114), which unusually contained two chapels, one of which housed Gentile da Fabriano's *Adoration of the Magi*.

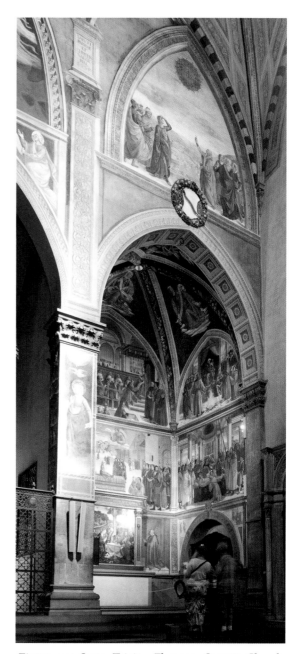

Figure 115 Santa Trinita, Florence, Sassetti Chapel. Photo: author

Location and Construction of the Choir

While the monks appealed to family patrons to complete construction of the Gothic edifice, some of the same patrons sponsored the choir precinct. The monks' wooden choir stalls, situated in the upper nave, were jointly financed by the Spini and Ardinghelli families in the early 1400s. In his surviving original testament dated 1411, Jacopo di Ubaldino Ardinghelli left five hundred gold florins – his largest donation to a nonfamily member – "for the construction and completion of a choir of this church and the time for constructing said choir, for half, namely that

which will be on the side of the Ardinghelli Chapel."[16] The Ardinghelli Chapel, the last on the right nave aisle close to the side entrance from Via del Parione (N on Figure 114), was dedicated to St. Nicholas (Figure 116). In 1393, Michele di Zanobi Ardinghelli left funds in his will for the chapel, which received its vaulting in 1401.[17] The prestigious siting of the chapel reflects the landholding family's elevated social position and wealth in the Unicorno gonfalon.[18] This chapel was adorned by the Ardinghelli polyptych, produced by Giovanni Toscani in 1423–24, a richly decorated and complex construction in painted and sculpted form, panels from which are now distributed among public and private collections in Italy and the United States.[19] The Ardinghelli family also claimed rights over the transept wall between their chapel and the sacristy, and half of the right transept vault. In 1423, Palla Strozzi purchased rights over the half of the transept wall that included the entrance to his sacristy chapel, while the rest of the wall belonged to the Ardinghelli (M on Figure 114).[20] Later, in 1518, a note in a Santa Trinita *Giornale* stated that even though the Ardinghelli had not funded the old organ, it displayed their coat of arms "because they made the facade wall where the said organ is."[21]

The left range of stalls was the responsibility of the Spini family, who owned the last chapel on the left nave aisle (Figure 117; E on Figure 114), directly opposite the Ardinghelli Chapel. Dedicated to the Assumption, the chapel was constructed between 1389 and 1405 and was later frescoed by Neri di Bicci.[22] The Spini family – whose impressive palazzo in Piazza Santa Trinita was the largest in Florence at the end of the Duecento – were a magnate merchant clan who became significant rivals of the Medici as papal creditors.[23] However, the Spini company was bankrupt by 1420, and in the 1427 Catasto they did not number among the wealthiest families in the Unicorno gonfalon or Florence as a whole.[24]

Previously, in 1414, Cristofano Spini made his final testament in which he left sixty florins for the completion of the Spini Chapel, and he was honored in the same year with a state funeral.[25] He was an influential and respected statesman at the highest rank of the Florentine ruling elite in the first decades of the fifteenth century, and heavily participated in the *pratiche* (small special meetings) convened by the *Signoria*.[26] In the same testament, Cristofano left to Santa Trinita half of the amount needed to complete the choir of the church,[27] presumably that half of the stalls adjacent to the Spini Chapel. Although no descriptions of the wooden choir stalls survive, we can speculate that constituent parts of the stalls may have depicted the coats of arms of their respective patrons, a practice observable in contemporary choir furniture albeit for single sponsors.[28] In fact, Manno, the woodworker responsible for the stalls, had previously intarsiated two heraldic motifs on opposing sides of the furnishings in the San Niccolò sacristy at Santa Maria Novella.[29] As we have seen in Chapter 1, in San Lorenzo, payment records for repairs undertaken to the choir stalls itemized heraldry on the *spalliere*, perhaps displaying the enduring legacy of multiple lay patrons.[30]

While it was common for laymen to finance the construction of choir stalls, and sometimes even to claim rights over the ground occupied by the choir (as in Santa Croce, see Chapter 3), splitting the expense was more unusual. In Santa Trinita, by assuming patronage of the adjacent choir precinct, the Ardinghelli and Spini families asserted their political dominance in the church interior. The spatial occupancy of these families spread beyond their private chapels (which themselves feature two open sides) toward the nave choir and, in the case of the Ardinghelli, also toward the wall and vault of the right transept. By contrast, in the late sixteenth century when the choir was removed under Duke

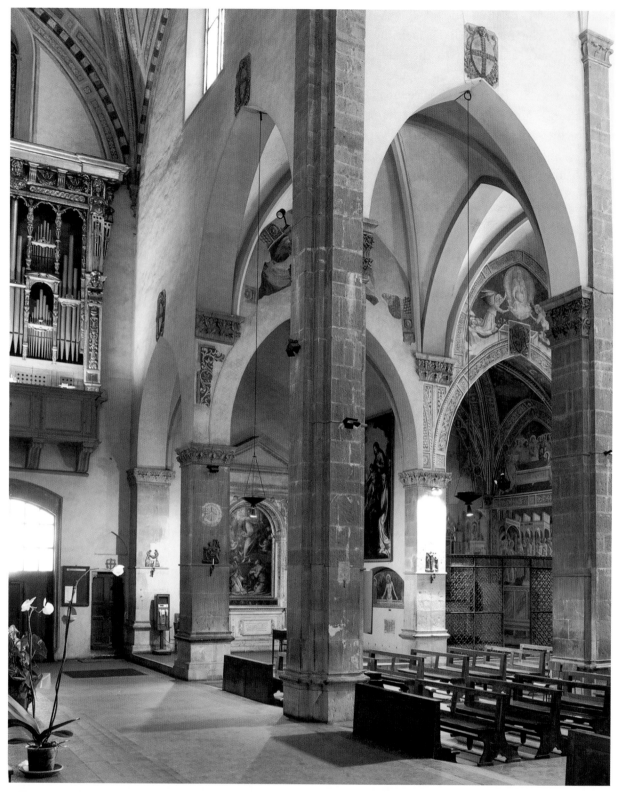

Figure 116 Santa Trinita, Florence. View of the nave, northeast transept, and Ardinghelli Chapel. Photo: author

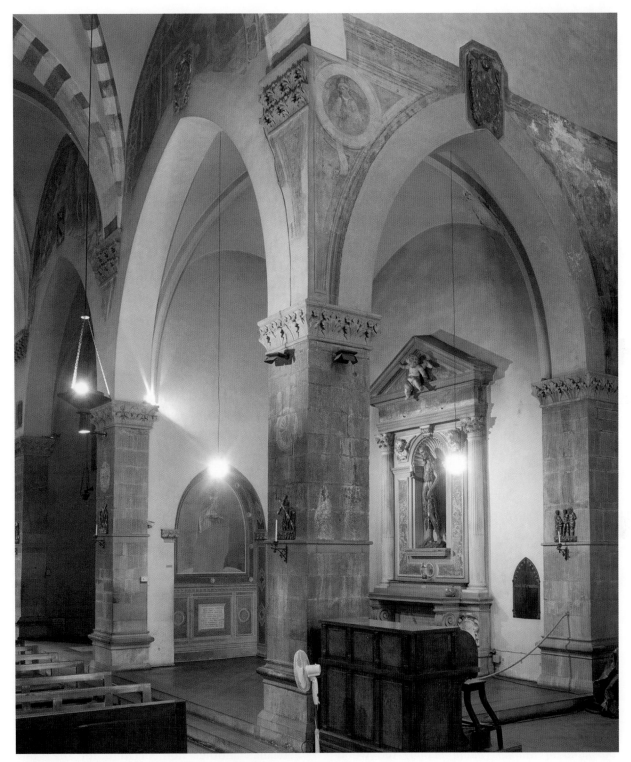

Figure 117 Santa Trinita, Florence, Spini Chapel. Photo: author

Cosimo, the involvement of those families may have held negative connotations. Both the Ardinghelli and Spini had expressed anti-Medicean tendencies. The Ardinghelli had close familial ties via marriage to the Strozzi, and, like the Strozzi, were exiled in 1434.[31] As papal bankers, the Spini had been trumped by the Medici in the 1420s and were subsequently

involved in the anti-Medicean faction of 1433–34.[32]

The choir stalls themselves were fabricated by Manno di Benincasa Mannucci (known as Manno de' Cori) roughly between 1411, the date of Jacopo Ardinghelli's testament, and 1419, the date of a payment for choir lecterns.[33] Manno's commissions elsewhere in Florence include the sacristy of the chapel of San Niccolò in Santa Maria Novella for which a detailed contract survives (1407);[34] possibly the nave choir of Santa Croce (perhaps 1410s); and the choir in the hospital church of Sant'Egidio (1418).[35] As we have seen, his only surviving work is a choir signed and dated "opus manni de florentia 1435," in San Domenico in Città di Castello, which features florid carving and intarsia patterning but lacks architectural canopies (Figure 97).[36] In Santa Trinita, an expense of eleven lire was recorded in 1416 "for a little of the wood had from Manno who makes the choir," indicating its ongoing construction.[37] In 1419, Manno was paid for an intarsiated predella and an intarsiated covering both for the high altar and a walnut lectern "to say the Epistle and prayers in choir."[38] Decorative elements of the choir stalls and high altar, therefore, would have likely demonstrated stylistic unity. This aesthetic coherence might have continued into the Strozzi sacristy, since a somewhat obscure passage in the sacristy choir contract (dated 4 January 1420) might indicate Manno's guiding influence in its design. In this document, the Ferrarese woodworker Arduino da Baiso was commissioned to construct eleven or more walnut choir stalls embellished with intarsia and foliate carving "according to the design *of the hand of Manno (manu manni)* the woodworker" (italics mine), the lower parts of which were to be modeled on furniture in the Baptistery of San Giovanni.[39] As Haines noted, each sacristy stall was likely surmounted by a decorated tabernacle canopy.[40]

Financial and spatial links with the Spini and Ardinghelli Chapels show that the monks' choir occupied at least the last bay of the nave before the transept (B on Figure 114). Leoncini stated that the choir was in the center of the nave in proximity to the transept, while Bertoncini Sabatini claimed that it occupied the space from the crossing zone up to the first two bays of the central nave.[41] Tracking the whereabouts of burials and altars in the church provide further indications regarding the precise location of the nave choir in Santa Trinita. In 1474, Bartolomeo di Giovanni Gaetani was buried "in their tomb under the choir" (a phrase frequently referring to a position beyond the choir in the lower nave), as reported in a volume listing the obligations of the monastery.[42] Stefano Rosselli, in his mid-seventeenth-century Sepoltuario, confirmed the location of the tomb of Pietro di Benedetto Gaetani and his descendants (the 1416 floor slab still exists in the nave though not in its original position, Figure 118). He stated that the Carli tomb was directly in front of the Davanzati Chapel (third on the left), the Conti tomb was in the middle of the church more toward the high altar, and the Gaetani tomb beyond that, again toward the high altar.[43] The Gaetani tomb, therefore, was probably in the third bay of the nave, in the area toward the high altar, giving an indication of the extent of the choir.

A further tomb confirms this location. Although one of the Lotti tombs was situated on the counter-facade,[44] Abbot Niccolini in his mid-seventeenth-century compendium referred to "the other tomb of Lotti at the side of that of Gaetani, toward the chapel of St Luke."[45] Stefano Rosselli also positioned this tomb "toward the Cappella di Ricatto formerly of Sercialli," another nomenclature for the same chapel dedicated to St. Luke (O on Figure 114).[46] A further tomb was described in a fifteenth-century registry as "below ["di sotto"] the choir at the side of Lotti."[47] The Gaetani and Lotti tombs, therefore, verify the location of the

Figure 118 *Tomb of Pietro Gaetani*, 1416, marble. Santa Trinita, Florence, northeast nave aisle. Relaid as part of nineteenth-century renovations. Photo: author

choir in the central nave of Santa Trinita (C on Figure 114). Both tombs were described as "sotto il coro," indicating a site on the lay side of the choir (that is, toward the main entrance).[48] In both cases, more precise descriptions show that both tombs were in the third nave bay, in correspondence with the Davanzati Chapel on the left

(D on Figure 114) and the Sercialli Chapel on the right. The monks' choir seems, therefore, to have extended from the crossing into the first two bays of the upper nave (B on Figure 114).

Most of the archival sources that refer to the nave choir in Santa Trinita use the generic terms "coro" or "choro vecchio," neglecting to indicate the additional presence of a tramezzo or another substantial screen. Since the monastic cloister is located behind the cappella maggiore, the monks would have required access to their choir during liturgical ceremonies away from the lay parishioners, but the presence of the side door from Via del Parione complicates issues of access even further. It is likely, therefore, that the monks' choir stalls would have been, at the very least, enclosed by a simple wall, although no information survives regarding its form or typology.

The historical presence in Santa Trinita of a large gabled panel painting – Cimabue's *Maestà* (Figure 119) – raises the question of whether it was originally positioned atop a tramezzo screen, as has been proposed for Giotto's *Maestà* in Ognissanti (Figure 81). However, as opposed to other contexts, this seems unlikely. Cimabue's *Maestà*, now in the Uffizi, is a late work that displays sophisticated drapery folds and an architectural, frontally positioned throne that indicates a developed approach to perspective. In his 1568 edition of *Le Vite*, Vasari claimed that Cimabue's panel acted as the high altarpiece before being replaced by Baldovinetti's *Trinity* (1470–72), at which point it was moved to a minor chapel in the left nave.[49] Noting the almost complete lack of historical references to the panel before Vasari, Cristina De Benedictis doubted whether the *Maestà* was even commissioned for Santa Trinita, noting that the panel's iconography does not allude either to the Trinity or the Vallombrosan Order.[50] Furthermore, De Marchi, who has advocated for raised panels in other contexts, noted that the huge gabled painting (385 × 223 cm) would be highly

Figure 119 Cimabue, *Virgin and Child Enthroned with Angels and Prophets (Santa Trinita Maestà),* c. 1290–1300, tempera on wood, 384 × 223 cm. Gallerie degli Uffizi, Florence, Inv. 1890 no. 8343. Photo: © Gabinetto fotografico, Gallerie degli Uffizi, Ministero per i beni e le attività culturali e per il turismo

imposing in a church of such modest dimen-
sions.[51] Luciano Bellosi, however, pointed out that
the missing original frame may have alluded to
Trinitarian imagery, which was, moreover, rare in
this early period.[52] Therefore, the lack of docu-
mentary evidence situating the panel in the
church at an early date, together with the dearth
of sources confirming the presence of a tramezzo
in Santa Trinita, makes it unlikely that Cimabue's
Maestà was originally situated atop a screen.

No altars attached to a choir screen are
recorded in Santa Trinita. The lower nave, how-
ever, particularly the counter-facade, was densely
populated with chapels, images, and burials,
revealing its role as a prominent site for lay
patronage. In addition to the Lotti altar, the
counter-facade housed the Cambi Importuni
family's chapel dedicated to the Pietà,[53] and the
Sernigi altar dedicated to St. Sebastian.[54]
A wooden statue of St. Mary Magdalene by
Desiderio da Settignano and completed by
Giovanni d'Andrea, still preserved in the Spini
Chapel, was commissioned for the Cerbini altar
(or "altarino"), situated on the counter-facade,
between the Sernigi Chapel and the right door
(Figure 120).[55] As Gabriele Morolli has noted, the
horizontal stringcourses that appear on the nave
piers were likely guidelines for the application of
intonaco, suggesting the presence of numerous
images of saints.[56]

While the presence of the monks' choir would
have likely restricted visual access to the high
altar, by contrast, it would have *directed* the
attention of lay viewers in the lower nave to
extensive fresco decoration above entrance
arches of the four transept chapels. In Santa
Trinita, all the frescoes postdate the installation
of the monks' choir in the nave (Figures 121 and
122). In 1430, Giovanni dal Ponte received com-
missions for the two chapels founded by Pagolo
dell'Abbaco: the St. Paul Chapel (I on
Figure 114) and St. Peter Chapel (H on
Figure 114), which are located to either side of

Figure 120 Desiderio da Settignano (completed by
Giovanni d'Andrea), *St. Mary Magdalene*, c. 1458/before
1499, willow-wood, pear-wood, cork and gesso, poly-
chromed, 183 cm high. Santa Trinita, Florence, Spini
Chapel. Photo: author

the high altar.[57] Above the entrance arch of the
St. Peter chapel, the fragmented remains of an
image of Christ amid saints, clouds, and angels
may have been an Ascension scene with the
delivery of the keys to St. Peter.[58] The St. Paul
Chapel's arch shows Christ in glory surrounded
by saints. In 1434–35, Giovanni, together with his
assistant Smeraldo di Giovanni, frescoed the Scali
Chapel of St. Bartholomew (G on Figure 114),

Figure 121 Santa Trinita, Florence. Southwest transept, view from center of nave. Photo: author

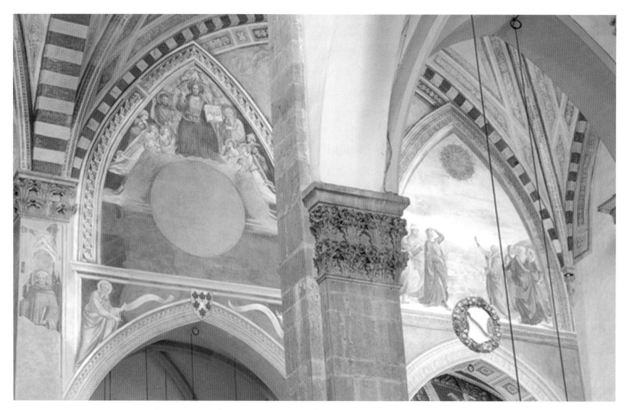

Figure 122 Santa Trinita, Florence. Northeast transept, view from center of nave. Photo: author

whose arch fresco depicts the saint between two genuflecting, music-making angels.[59] In the arch above the later Sassetti St. Francis Chapel (J on Figure 114), Ghirlandaio depicted the *Vision of Augustus with the Tiburtine Sybil*, an event that foreshadowed the advent of Christ, to whose nativity the chapel was partially dedicated.[60] All four frescoes utilized the arched shape to emphasize their ascendant compositions, and all are accompanied by prominent heraldic reliefs.

Although these images are almost impossible to view either from within or near the entrance to the transept chapels – which must have been quite accessible given the side entrance on Via del Parione – the ideal viewpoint is in the center of the nave. In fact, from a central position at the third set of piers – precisely where I argue the nave choir crossed the nave – the last nave piers align with the piers between the transept chapels. This allows an unimpeded view of the frescoes, which herald to lay viewers in the nave both the dedications and family patrons of the transept chapels, again revealing the importance of local patronage in Santa Trinita. In a comparable optical ploy, De Marchi suggested that Giotto's *Stigmatization* above the Bardi Chapel's entrance arch adjacent to the high altar in Santa Croce was designed to be seen in conjunction with the tramezzo.[61] Donal Cooper took this argument even further, arguing that the image "effectively functioned like a tramezzo panel when viewed from the main body of the church."[62] By no means unique to the setting of Santa Trinita, therefore, these cases reveal that nave choirs and tramezzi could create striking visual interplays that connected disparate spaces in the church interior.

Removal of the Choir

In the 1560s, the area surrounding Santa Trinita became an increasingly important civic space for the display of Medici power and patronage in the ducal era. In 1565, a large granite column gifted by Pius IV was erected in Piazza Santa Trinita, both Vasari and Ammannati assisting in its complex transportation (Figure 123). Originally designed to elevate a figure of Duke Cosimo in celebration of a military victory,[63] the column was later surmounted with a porphyry statue depicting a personification of *Justice* intended to form a thematic link with columns dedicated to *Religion* in Piazza San Felice and *Peace* in Piazza San Marco, the latter never being erected.[64] Geographically an important junction along the processional route from Palazzo Pitti or Porta al Prato toward the Duomo, the piazza witnessed the wedding procession of Giovanna d'Austria and Francesco de Medici.[65] Commissioned by Duke Cosimo, who financed the project personally, the new Ponte Santa Trinita was begun by Ammannati in 1567, to replace the bridge destroyed in the 1557 Arno flood (Figure 124).[66] Lia Markey has shown that the bridge project glorified Duke Cosimo as patron, linked ceremonial sites in the city, and represented Medici dominance of urban space.[67]

The Medici family was also interested in the Santa Trinita community itself. In 1566, Francesco de' Medici's consort, Giovanna d'Austria, wrote to Pope Pius V, suggesting that the Jesuits, who were suffering from insufficient quarters at San Giovannino, should transfer to the church and convent of San Pancrazio, whose monks should unite with those at Santa Trinita, "which is very capacious for those few monks which stay at San Pancrazio."[68] As noted at the start of this chapter, this throws light on the general decline of the older monastic orders amid the rise of new priestly congregations. Moreover, she noted that both Cosimo and Francesco had already petitioned the Vallombrosans of San Pancrazio "many times," resulting in her writing to the pope "as a last resort."[69] The monastic community at Santa Trinita was on the decline, but only slightly, from twenty-two monks in c. 1525 to fifteen in 1568.[70]

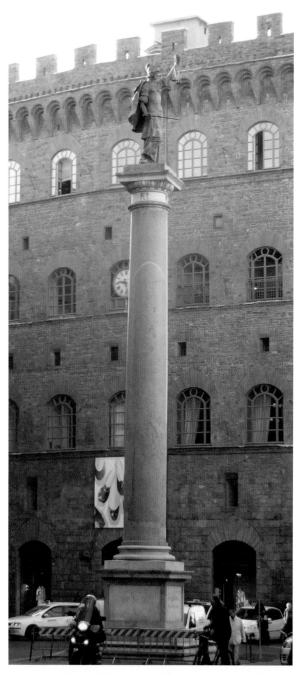

Figure 123 Bartolommeo Ammannati and Francesco Ferrucci del Tadda, *Justice,* 1581, porphyry statue on granite column. Piazza Santa Trinita, Florence, view from north. Photo: Freepenguin

Although Giovanna's plan did not come to fruition, Medici influence continued to affect Santa Trinita. A record in the monastery archive dated 16 April 1569 recalls how on 10 August 1568

(a mere four months after Archbishop Altoviti's Pastoral Visitation), Duke Cosimo had ordered "that as soon as possible the choir in the middle of said church should be removed . . . and must be put behind the high altar."[71] Perhaps prompted by Altoviti, Cosimo would certainly have perceived that he had full jurisdiction in this matter, over and above the abbot or the order's master general: indeed in Florence his ducal edicts were considered law.[72] The abbot, Don Vincentio da Stia went to see the duke's agent, Lionardo Marinozzi, arguing that "removing said choir would displease many gentlemen."[73] However, Lionardo was insistent. Don Vincentio, who wanted to avoid taking full responsibility, told the operai of Santa Trinita that they had ten days to appeal against the judgment; if they did indeed do this, no trace of it appears in the archival record. Considering the monastery's request that the choir stalls be donated, the duke decided that since some were in poor condition ("lavanzo di dicto choro era cattivo") and broken or water damaged ("fradicio"), they should not be given to the monastery at Vallombrosa, but rather to the Vallombrosan nuns of Santo Spirito (now San Giorgio alla Costa), who compensated Santa Trinita thirty scudi. Half of the stalls, however, would remain at Santa Trinita behind the high altar.[74] A subsequent entry in the volume of *Ricordi* dated 1569 appears to be a transcript of a letter sent from the abbot to the duke in which he acquiesced to the duke's request, commenting that with the choir removed "firstly they [the monks] may officiate with more quiet and less difficulty, also the church would remain more open ('spedita') and beautiful."[75] From a broader perspective, concerns for increased space, aesthetic improvement, and quieter liturgical spaces were commonly cited by church communities wishing to remove their choir precincts.

Perhaps, as in San Niccolò Oltrarno (see Chapter 3), the damaged state of the wooden

Figure 124 Designed by Bartolommeo Ammannati, Ponte Santa Trinita, Florence, 1567–78. Reconstructed in 1958 following destruction during World War II. Photo: author

choir in Santa Trinita – so conspicuous in the center of the nave – was an additional motivating factor that led to its elimination. A *ricordo* in the Santa Trinita archive had previously described the devastating flood of the Arno in 1557 and its consequences for the church. The flood affected this area of the city particularly badly, with the Ponte Santa Trinita being completely destroyed. In Santa Trinita itself, the water entered up to the cappella maggiore and "near to ('apresso') our choir, everything was moved from its place," particularly affecting the left side of the church "towards the Spini Chapel," the side closest to the Arno.[76] This description of the 1557 flood-waters entering the choir of Santa Trinita may correlate with Duke Cosimo's complaint that part of the choir was rotten or water damaged ("fradicio").

The relocation of the choir in Santa Trinita sparked an extensive renovation of the high altar area in the years up to 1574, including the creation of two pulpits, a new organ and marble balustrade ensemble. These improvements were completed against the backdrop of a general reform of the Vallombrosan order conducted in

1570–73, overseen by Cardinal Giovanni Ricci acting on behalf of the papacy.[77] Only a few months after the transfer of the choir, in 1570, the monastery purchased a new carpet to embellish the high altar area. The carpet, which measured 9⅔ by 5½ *braccia*, was purchased via the brother of a Vallombrosan monk in Venice, implying that it was of Eastern origin.[78] By this time, Baldovinetti's *Trinity* high altarpiece had been moved into the retrochoir, and there was already a Eucharistic tabernacle on display on the high altar, echoing in the Florentine context Bishop Giberti's commandment that a tabernacle should be on every high altar in the Verona diocese in his *Constitutiones* of 1542 (see Chapter 3).[79] In that very same year, Jacopo Gianfigliazzi had requested permission from the monastery "to make a very beautiful adornment for the Corpus Domini and to locate it in the cappella maggiore of the Gianfigliazzi."[80] An anonymous Florentine chronicler dated the creation of the "ciborium in honor of the most holy sacrament" to 1548, describing it as "all of gold as one sees with a purple veil on top, which allows that gold to shine through."[81]

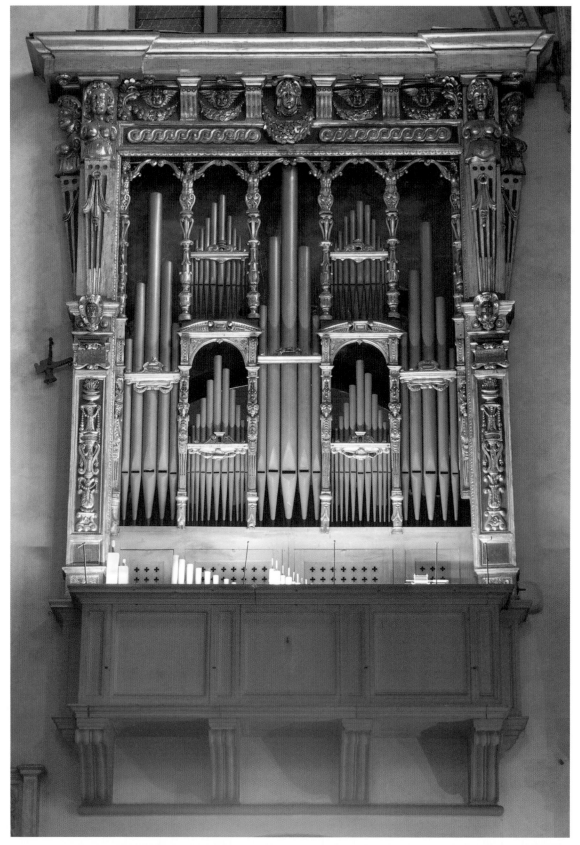

Figure 125 Onofrio Zeffirini da Cortona and Giovanbattista di Gian Pagolo, *Organ*, 1571. Santa Trinita, Florence, northeast transept wall. Photo: author

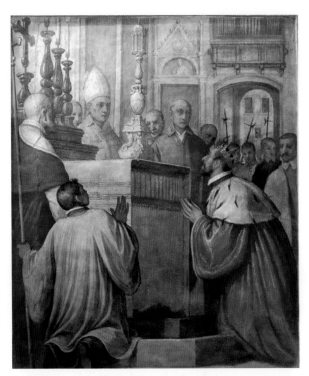

Figure 126 Domenico Cresti called Il Passignano, *Translation of the Relics of San Giovanni Gualberto*, 1593, fresco. Santa Trinita, Florence, Chapel of San Giovanni Gualberto, southwest transept. Photo: Sailko/ Francesco Bini

In 1571, the monks commissioned a new organ as part of a general campaign to improve liturgical performance in the church. Onofrio Zeffirini da Cortona and his assistant Giovanbattista di Gian Pagolo constructed an organ of seven stops with a soft pedal, tremulant (the third register of pipes), with a forty-seven-key console, a bench, and encased bellows, for a price of 550 scudi.[82] Zeffirini had previously restored the fifteenth-century organ in the Duomo in 1567, built a new organ in San Pier Maggiore in 1568, and would later build a new instrument in Santa Croce in 1579.[83] Arnaldo Morelli has argued that the construction of new organs in the wake of choir relocation projects did not necessarily involve any change in location, but instead contributed an aesthetic and functional improvement to the sacred space.[84] Indeed, the organ in Santa Trinita, which still exists in the church, maintained its predecessor's position on the right transept wall,

above the portal leading to the exit on Via del Parione (M on Figure 114; Figure 125). Complete with pipes arranged in a painted and gilded wooden framework, the organ is also equipped with a stone balcony. Domenico Passignano's 1593 fresco of the translation of the relics of San Giovanni Gualberto, located in the reliquary chapel in the left transept of Santa Trinita, depicts the balcony and lower part of the organ, thus verifying that it still maintains its original aspect (F on Figure 114; Figure 126). In 1572, Maestro Baccio di Filippo Baglioni was commissioned, at a price of ninety scudi, to construct two walnut pulpits "on the columns next to the high altar" that had to be "proportionate to our church on the model of those in the Madonna della Pace" and equipped with lecterns, candelabra, steps, and large corbels ("mensoloni") as seen in the design presented to the abbot.[85] The two wooden pulpits, which no longer exist, would have complemented the new location of the choir behind the high altar and perhaps replaced previous pulpits associated with the demolished nave choir.

Improvements to the musical life of the church were also given a more dramatic liturgical setting. In 1574, Abbot Lorenzo da Firenze commissioned Giovanfrancesco di Niccolò Balsinelli, a stonecarver from Passignano, to construct the stone and marble ensemble that had been designed by Bernardo Buontalenti "that goes before the high altar for decoration of the enlarged floor in front." Giovanfrancesco was contracted to use *pietra forte* ("quella di Pitti") for the foundation section from the floor of the church up to the altar, but "fine, white and beautiful" marble for the base, balustrade, and molding.[86] Giovanfrancesco was obliged to deliver the *pietra forte* section by June 1574 and the rest by the following August, and indeed the date 1574 inscribed on the balustrade confirms this timeframe.

The ensemble, which combines two staircases, a stage, and balustrade, has been housed in Santo

Stefano al Ponte Vecchio since its removal from Santa Trinita in 1893–94, yet still preserves some of the decorative elements required by the contract (Figure 127).[87] The difference in materials between the upper and lower sections is quite evident, as is the fine carving of the marble and sandstone. Scholars have noted the scenographic quality of Buontalenti's conception; its fantastical Mannerist forms would have created a dramatic setting for the liturgy.[88] In a tripartite design, the central section, supported by four elegantly serpentine corbels, projects forward slightly at the top, creating a curve in the balustrade to either side. In an organic movement, the side steps transform into sweeping curves that are gathered together into a volute, reminiscent of a shell or the folded leaves of a fan. An inscription in a cartouche supported by two eagles, which appears prominently in the center of the ensemble, asserts Abbot Lorenzo's role in the commission.[89] Two pilasters on the upper level display the shields surmounted by abbot's miters: on the left the shield contains the intertwined letters S and T for Santa Trinita (Figure 128). Buontalenti's seventeenth-century biographer, Filippo Baldinucci, noted that the construction was both useful and majestic, and cleverly accommodated itself to the limitations of the site.[90] To either side of the altar, two marble doorways – also attributed to Buontalenti and held by the Opificio delle Pietre Dure – enabled access between the monks' choir and the high altar.[91]

In many ways, Santa Trinita represents the archetypal church renovation in Counter-Reformation Florence. Promoted by Duke Cosimo in a period that saw his increased interest in the surrounding civic area, the renovation added to the openness and "beauty" of the church, which was administered by a declining monastic population experiencing institutional reform. Subsequent additions including new pulpits, an organ, and a balustrade reinforced the Tridentine emphasis on the Mass, now

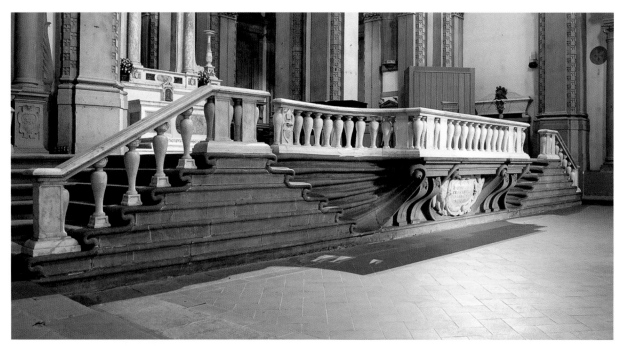

Figure 127 Bernardo Buontalenti and Giovanfrancesco di Niccolò Balsinelli, *Staircases, Stage, and Balustrade*, 1574, marble and *pietra forte*. Transferred from Santa Trinita to Santo Stefano al Ponte Vecchio, Florence, in 1893–94. Photo: author

celebrated in a spectacular *mise en scène* complete with visual, spatial, and aural components. Whereas previously the monks' choir had visually and spatially interacted with surrounding family chapels, its removal under Cosimo symbolized his political dominance over important clans, although it is important to note that these families had lost their once prominent civic roles. Historically, Santa Trinita had been the spiritual home of both pro- and anti-Medicean families – the Gianfigliazzi and Sassetti were notable Medici supporters, while the Strozzi were famously exiled in 1434 – and its monastic leaders had come into conflict with Lorenzo il Magnifico on numerous occasions.[92] As we shall see for Florentine church renovations as a whole,

therefore, the changes enacted in Santa Trinita fulfilled a variety of political, religious, and aesthetic objectives.

SAN PANCRAZIO

In close proximity to Santa Trinita, the church and monastery of San Pancrazio also belonged to the Vallombrosan Order.[93] Today, as home to the Museo Marino Marini, the church has almost completely lost its medieval character (Figures 129 and 130). While the Rucellai Chapel preserves Alberti's micro-architectural replica of the Holy Sepulcher in Jerusalem, of the church itself only the basic structure, crypt, fragments of pilasters and other stonework, and a frescoed cupola survive.

Lending its name to the western gate of the ancient Roman city of Florence, San Pancrazio had a distinguished early history. Cited in documents of the ninth and tenth century, the church was named as one of twelve newly-created "priorie" when the parish of Santa Reparata was partitioned in 1115.[94] Following a period of occupation by Benedictine nuns and then Dominican friars, the convent was ceded to the Vallombrosans in 1235.[95] In the late fourteenth century, the monks began to restructure the conventual complex completely, replacing much older fabric, about which little is known.[96] Under Abbot Lorenzo di Guidotto Martini (1379–1403), the nave and facade were completed, and construction of the apsidal chapels and cappella maggiore were commissioned (A on Figure 131).[97] In the early fifteenth century, members of the Rucellai family – a large, wealthy family with origins in the thirteenth century who lived nearby, manufacturers of dyed-wool products – emerged as major benefactors of San Pancrazio.[98] In addition to the completion of the church building, Abbot Benedetto Toschi (1429–64) oversaw the execution of interior furnishings such as choir stalls, pavements, windows

Figure 128 Bernardo Buontalenti and Giovanfrancesco di Niccolò Balsinelli, *Balustrade (detail)*, 1574, marble and *pietra forte*. Transferred from Santa Trinita to Santo Stefano al Ponte Vecchio, Florence, in 1893–94. Photo: author

Figure 129 Museo Marino Marini (former church of San Pancrazio), Florence. Photo: author

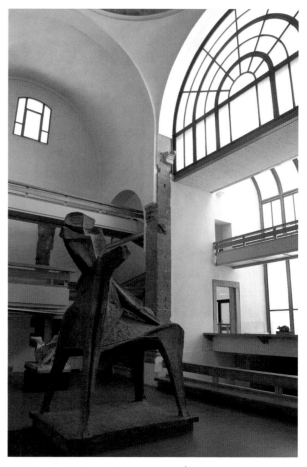

Figure 130 Museo Marino Marini (former church of San Pancrazio), Florence. Interior view toward southeast. Photo: author

and an organ, the campanile, and new conventual buildings comprising a cloister, dormitory, and refectory.[99] Under the church, a large crypt, which, according to Marco Dezzi Bardeschi, is dated to 1449–53, was designated as a site for mass burial.[100] Indeed, in his 1653 Sepoltuario, Stefano Rosselli listed eighty-eight tombs affixed to the walls, vaults, and pilasters, and on the pavement of the space "under the vaults of this church" ("sotto le volte di questa chiesa").[101]

The identification of the high altarpiece of San Pancrazio remains uncertain. A monumental polyptych by Bernardo Daddi, dated to the late 1330s to early 1340s, was previously the high altarpiece of the Duomo until it was sold in 1442 to a member of the Minerbetti family, who likely initially displayed it in their sacristy chapel in San Pancrazio. The 1677 Bocchi-Cinelli guidebook noted its placement on the rear wall

of the apse, but several scholars suggest it was previously displayed on the high altar itself, at least after 1507, the date of an archival source that described the high altar without mention of an altarpiece. Anna Padoa Rizzo, meanwhile, argued that another Bernardo Daddi altarpiece, now in New Orleans, was on the high altar until 1574.[102]

Rucellai patronage of San Pancrazio reached its apogee in the addition of two independent and contiguous spaces off the lower left nave (F and H on Figure 131). Completed by 1467, the Holy Sepulcher reproduction (G on Figure 131) and surrounding chapel commissioned by Giovanni di Paolo Rucellai are universally attributed to Alberti. In a combination of classical and Romanesque motifs similar to those on the facade of Santa

Figure 131 San Pancrazio, Florence. Proposed plan of the church before 1574. Image: author

A High chapel (patronage: Rucellai),
 choir stalls, constructed 1484-99
B *Choir stalls proposed location, c. 1444-1574/77*
C *Crucifix and arch of screen, c. 1497-1574/77*
D *St Mary and St Raphael screen chapel,*
 c. 1490-1574/77 (patronage: Abbot Vincenzo
 Conci/ San Pancrazio)
E *Pulpit proposed location: 1. c. 1489-1600;*
 2. c. 1600-1753
F Holy Sepulcher Chapel (patronage: Rucellai)
G Holy Sepulcher
H St Jerome Chapel (patronage: Rucellai)
I Side entrance
- - *Screen*

Gray objects and italicized labels indicate
speculative locations

Maria Novella (another Rucellai commission), the sepulcher is decorated with marble intarsia panels depicting emblems of both the Rucellai and Medici families, showing their close allegiance in a church once dominated by the Medici's enemies, the Strozzi.[103] The structure is generally interpreted as a spiritual or mimetic, rather than literally architectural, copy of the Holy Sepulcher in Jerusalem (Figure 132).[104] The chapel communicated with the nave via a tripartite opening composed of Corinthian columns and a carved architrave, and a further entrance led directly from the exterior piazza.[105] A second Rucellai Chapel, dedicated to St. Jerome, was founded by Filippo di Vanni (d. 1462) and his sons Uberto and Girolamo, but was not formally consecrated until 1485, around which time the altar was adorned with Filippino Lippi's *Virgin and Child with Saints Jerome and Dominic*, now in the National Gallery in London.[106]

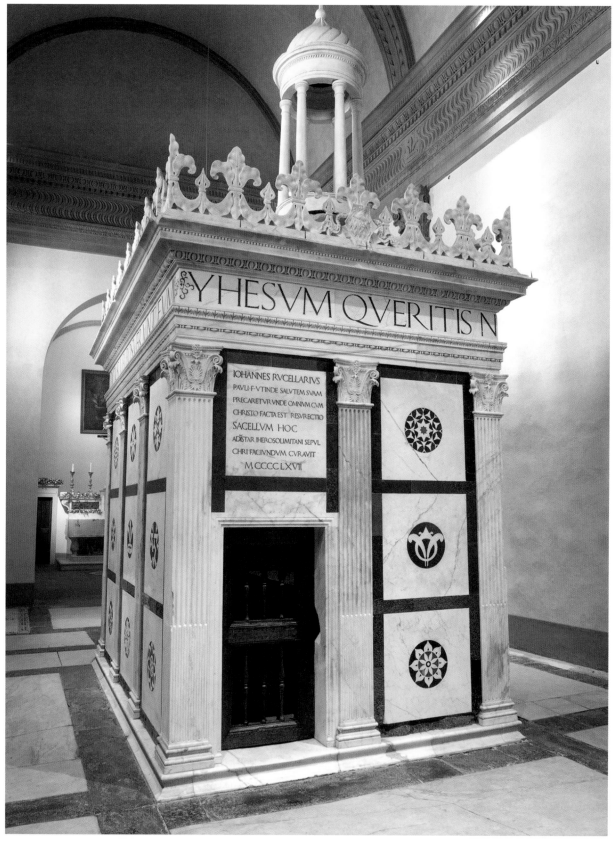

Figure 132 Leon Battista Alberti (attr.), *Rucellai Sepulcher*, completed by 1467. Museo Marino Marini (former church of San Pancrazio), Florence. Photo: author

In modern times, San Pancrazio has experienced radical alterations and multiple changes in function. In 1751–55, architect Giuseppe Ruggieri completely transformed the church with the construction of interior walls and a barrel vault independent of the medieval surrounding structure; an interior transverse wall that reduced the length of the nave by a third; and a domed cupola at the crossing frescoed by Sigismondo Betti in 1752, fragments of which still survive.[107] At the convent's suppression in 1808, the church was reutilized as the seat of the French imperial lottery, with the exclusion of the chapels of the Holy Sepulcher and St. Jerome, which were salvaged as a result of protests from the Rucellai family. At this point, the facade was recomposed with integrative elements from the tripartite colonnade of the Rucellai Holy Sepulcher chapel, and a newly opened thermal window above (Figure 129).[108] In 1883 the space became a tobacco factory, and in 1937 a depository for the military barracks was housed in the adjacent convent. In 1976, restoration work began, and in the 1980s the mistreated building was transformed into the present-day Museo Marini.[109]

The Nave Choir Stalls and Screen

Unusually, the nave choir stalls in San Pancrazio were financed by the gonfalon of Lion Rosso. In the Renaissance period, San Pancrazio was the primary religious institution in the gonfalon of Lion Rosso in the quarter of Santa Maria Novella. Florence's four quarters were each divided into four gonfalons, which were administrative regions originally intended to allow the efficient organization of community militia. These sixteen neighborhoods, created in 1343, each elected council bodies who met to discuss financial matters such as taxation, the distribution of forced loans from the Florentine government, and the organization of secret committees to determine which gonfalon members were eligible to hold public office.[110] Ronald Weissman called the gonfalons both "structures that defined obligation" and "structures of opportunity," which forged strong bonds of identity and community between their members.[111] As D. V. and F. W. Kent have shown, the gonfalon of Lion Rosso took the unusual measure of appointing Abbot Toschi as administrator for life in 1444, perhaps hoping he would succeed in recovering significant debts from Palla Strozzi, whose decade-long exile was renewed in the same year.[112] It is no coincidence that from this date, the gonfalon members became major benefactors of San Pancrazio.

Indeed, in the very meeting that confirmed Toschi's appointment (1 April 1444), the gonfalon decided that the funds that remained after paying the Lion Rosso's creditors should be used "to have made a choir ... bearing the coat of arms of the said district."[113] A further document, dated 21 December 1444, provided further details about the furniture. The gonfalon stipulated that their emblem of the red lion "should be intarsiated ... in those places as will be seen to be proper to said syndics or their successors."[114] In the surviving stalls in Vallombrosa Abbey (where they were transferred in 1574), the lion motif appears twice: on two stall-ends on the lower row on the left range (Figure 133). In the original arrangement of the stalls in two L-shapes in the nave of San Pancrazio (B on Figure 131), these stall-ends would have been visually prominent, probably located at the eastern extreme of both ranges, facing the high altar.[115] Similar corporate sponsorship of monastic furniture took place in San Miniato al Monte, where the arms of the Arte di Calimala, likely financers of the precinct, appear on two seats of larger dimensions in the corners (see Chapter 2, Figure 41). In most meetings of the Lion Rosso gonfalon there were around thirty residents in attendance, who would assemble in San Pancrazio, as it said in their documentation "in the usual place."[116] Since

Figure 133 Francesco di Lucchese da Poggibonsi, *Choir Stalls (detail of stall-end)*, 1444–46. Transferred from San Pancrazio to Vallombrosa Abbey in 1574–77. Photo: author

they had funded its construction and emblazoned their emblem on its wooden furniture, it appears likely that they would have utilized the choir for their regular meetings. Moreover, the surviving choir comprises twenty-four original stalls, although some were lost or damaged over the centuries; this seems a seemingly reasonable number to seat the gonfalon (Figure 134).[117] With their relatively democratic seating plan and air of liturgical solemnity, church choir stalls were ideal for hosting serious gatherings (see Chapter 1). In Santa Trinita, for example, the Strozzi sacristy chapel choir was used for meetings of the Unicorno gonfalon and other meetings involving laymen.[118]

The choir stalls, completed 1444–46, were commissioned from Francesco di Lucchese da Poggibonsi, who inlaid his signature on a surviving

stall (Figure 135).[119] Margaret Haines has shown that Francesco had previously constructed some of the lost inlaid cabinets of the Sagrestia delle Messe in the Duomo in 1435, was enrolled in 1441 in the Pietra e Legname guild (to which woodworkers and stonemasons belonged) and was mentioned in Benedetto Dei's list of notable artisans of Florence.[120] However, another woodworker, Giovanni di Domenico da Gaiuole (see his stalls in San Miniato in Figure 41), also attempted to solicit the commission for himself, in a frustratingly undated document. For a price of fourteen florins per seat, Giovanni claimed that he could make a choir – similar to that by Bartolomeo di Nuto da Empoli and Manno de' Cori in Santa Trinita – within a time frame of sixteen months.[121] Although the wording "nella chiesa di Santa Trinita" suggests the monks' nave choir, it is not clear, however, whether Giovanni intended the monks' nave choir or the sacristy choir, since, as we have seen, both involved Manno de' Cori in their construction. Either way, Giovanni may have referred to Santa Trinita to acknowledge the close institutional links between the two churches. Kent and Kent further suggested that if Giovanni were referring to the Strozzi sacristy choir, it could represent a subtle echo of the funds the Lion Rosso hoped to disburse on San Pancrazio: Palla Strozzi's debts.[122] Haines concluded that either Giovanni relinquished his offer in favor of Francesco or that the two indeed worked together, with Francesco directing the collaboration.[123]

In addition to the choir stalls, the Lion Rosso gonfalon provided funds for other structural and artistic improvements to San Pancrazio. In Toschi's own account book, an entry for 1445–46 notes that "all the expense" for important additions to the church "was provided by funds which came to our monastery through the donation made by the men of the district of Lion Rosso."[124] This included plastering and whitewashing, construction of the cloister, organ, and glass windows.[125] One of the roof bosses still visible in the Museo Marini depicts a lion

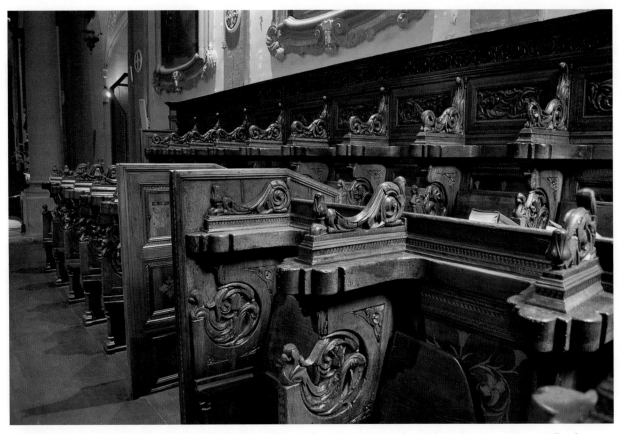

Figure 134 Francesco di Lucchese da Poggibonsi, *Choir Stalls*, 1444–46. Transferred from San Pancrazio to Vallombrosa Abbey in 1574–77. Photo: author

rampant similar in style to the crest on the intarsiated choir stalls, which could reference the gonfalon's financial support (Figure 136).[126]

The nave choir or "choro grande" was equipped with a screen, which later received a wooden entrance arch and crucifix (C on Figure 131). In his reconstruction of San Pancrazio, Pacciani placed the stalls in the nave in alignment with the side door between the Federighi and Rucellai Chapels in the left nave, which seems highly plausible (B on Figure 131).[127] The precise dating of the screen is unclear, as is whether it adjoined the choir stalls themselves. The screen featured at least one attached chapel, according to the chapel's foundation document, "leaning against the large choir ("choro grande") on the right side and dedicated to the Virgin Mary and the Angel Raphael," at which the feasts of the Visitation (2 July)[128] and St. Raphael (probably 31 December)[129] would have been celebrated (D on Figure 131).[130] On 31 March 1490, the

abbey purchased a farm located at Sant'Angelo at Legnaia, one third of the income from which would be directed toward the chapel officially founded by Abbot Vincenzo on the same day.[131] By July 1490, the chapel was in existence since an organist was employed to play throughout the year including on the feast day of the Angel Raphael.[132] The chapel's foundation document also required perpetual offices of the dead for Abbot Vincenzo Conci, who died the following year on 5 May 1491, and was buried below the new pulpit he had commissioned.[133]

The combination of the Virgin and Raphael may seem unusual, but both figures had particular significance to the laity who would have had access to the screen chapel. Marian lay devotion is extensively documented, but the Angel Raphael was also venerated as a protector, healer, and intercessor of the laity and sometimes appeared alongside the Virgin Mary in Italian Renaissance altarpieces.[134] The screen chapel in

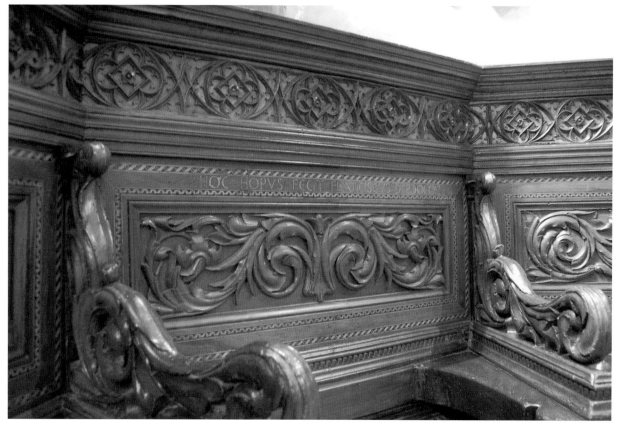

Figure 135 Francesco di Lucchese da Poggibonsi, *Choir Stalls (detail of stall-back)*, 1444–46. Transferred from San Pancrazio to Vallombrosa Abbey in 1574–77. Photo: author

Figure 136 *Roof Boss*, Museo Marino Marini, Florence (former church of San Pancrazio). Photo: author

San Pancrazio featured an altarpiece depicting both saints, since in the Vallombrosa archive recording the transfer of the choir, an additional 300 lire was paid to San Pancrazio for "an altarpiece within which [is] the Madonna and the Angel Raphael with his ornament," which was destined for an exterior chapel.[135] The altarpiece appears to be no longer in existence.

The presence of an angel dedication at the San Pancrazio choir fits into a broader pattern in Florentine churches. Santa Maria del Carmine and Ognissanti featured screen altars dedicated to angels: in the case of the Carmine, to St. Michael. At the Abbey of San Michele Arcangelo in Passignano, the right screen altar was dedicated to the three archangels, Raphael, Michael, and Gabriel, and still bears an altarpiece by Michele di Ridolfo di Ghirlandaio (Michele Tosini) dating to the mid-sixteenth century (Figure 137). Although the archangel theme recalls the dedication of the abbey church (San Michele) and the name of the donor (don Raffaello Nuti), the altar's precise location to the right of the screen door fits into this broader

Figure 137 Screen, mid-sixteenth century, wood. Abbey of San Michele Arcangelo, Passignano. Photo: author

pattern.[136] In another example, a diminutive figure of St. Michael appears at the apex of the tabernacle gable on a presentation drawing for the Baroncelli Chapel of St. Martin situated to the right of the central door of the Santa Croce tramezzo, as revealed by Hall.[137] As musical mediators between divinity and humanity, angels represent ideal protectors of monastic and mendicant choir enclosures. Angelic figures, particularly Raphael, could provide protection and moral guidance to the laity, including boys who participated in a youth confraternity dedicated to Raphael at San Pancrazio, or young men who traveled abroad in the service of family business.[138] Additionally, members of religious orders could see their ideals of communal living, obedience, and strict ecclesiastical hierarchy reflected in the ministry of the heavenly host.[139]

The screen in San Pancrazio likely did not feature a pulpit given that a separate one was recorded

elsewhere. In 1489, Abbot Vincenzo Conci commissioned a new Carrara marble pulpit from the sculptor Bartolomeo di Salvatore Lorenzo, to be placed on the wall adjoining the convent (the right wall of the nave), for a price of forty-eight florins (E on Figure 131).[140] In the contract, the pulpit was requested to be "of the model and form of the pulpit of the church of Santa Maria Maggiore of Florence," – an ancient priory church near to San Pancrazio – "with five faces and a parapet, and columns."[141] The pulpit remained on the right wall of the nave until 1600, when, to make space for the Buonaccorsi Chapel in that location, it was moved to the opposite wall, between the side door (I on Figure 131) and the Rucellai St. Jerome Chapel (H on Figure 131).[142] The marble pulpit previously bore the heraldic arms of Abbot Vincenzo, who was buried nearby in the porch leading to the side door.[143] Piero Morselli discovered that the fifteenth-century pulpit still survives in the parish

church of San Michele a Pianézzoli in Val d'Elsa, where it was transferred in 1753 by Marchese Bernardino Riccardi, who had purchased it from San Pancrazio during its baroque transformation (Figure 138).[144] Evidently inspired by Benedetto da Maiano's Santa Croce pulpit, the five-sided structure, embellished with fluted pilasters and friezes, is supported by carved corbels resting on an ornamental base.[145]

In 1497, the nave choir was given further embellishment with the addition of a new entrance. On 22 January, Abbot Giovanni Gualberto commissioned the woodworkers Chimenti and his son Leonardo del Tasso to "make a door in front of the choir with an arch above, all worked in walnut."[146] Moreover, the woodworkers were instructed to make "above the aforesaid arch a crucifix of wood." For a payment of thirty-one florins – twenty-two for the doorway and arch, and nine for the crucifix – the del Tasso shop was obliged to consign the entire ensemble by 15 April 1497.[147] A later description of the church written in 1507 confirms that while the Lion Rosso paid for the choir stalls, the monastery paid for the "door of the choir with the arch and with the crucifix," which featured the monastery's coat of arms.[148] The combination of an arch and wooden crucifix above was a common construction at the entrance to a choir precinct, particularly in the fifteenth century, a surviving visual example being the Frari in Venice. Unlike in the Frari, however, in San Pancrazio the presumably round arch of the screen would not have echoed the form of the high altarpiece, since both of the proposed Bernardo Daddi polyptychs associated with the church are characterized by Gothic pointed arches. Francesco Traversi has recently suggested that a wooden crucifix, now in the church of San Lorenzo a Fossato in the diocese of Prato, is in fact the del Tasso crucifix from San Pancrazio (Figure 139). In 1813 the Vallombrosan monks donated a crucifix to this church, which Traversi has identified as a work of the fifteenth

century through stylistic comparison with surviving del Tasso sculptures.[149]

Two surviving screens in nearby Vallombrosan churches may have shared visual characteristics with the destroyed structure in San Pancrazio. A *pietra serena* choir screen – still in existence attached to the counter-facade of Vallombrosa Abbey – is dated 1487, just a few years before the screen chapel dedication in San Pancrazio (Figure 140).[150] An inscription running the entire length of the architrave announced that the screen was donated by the Confraternità della Vergine Maria e San Giovanni Gualberto, using funds left in the testament of Filippo Francesco del Milanesi, brother of abbot Don Biagio, to whose family the painted coat of arms on the frieze belong.[151] The screen is composed of four fluted Corinthian pilasters that support an entablature decorated with angel heads below dentil and egg-and-dart moldings. Roberto Paolo Ciardi attributed the carving to the workshop of Francesco di Simone Ferrucci, who would also carve the marble tomb of Pier Minerbetti in San Pancrazio in 1492.[152] According to an early biography, Don Biagio commissioned the high altarpiece from Perugino (which included a portrait of the abbot), "and two others for altars under the choir."[153] When the choir was removed from the nave in 1700, a *ricordo* in the monastery's archives describes how "they also removed the altars that were behind the stalls of the abbot and dean," which were likely the stalls that faced the high altar.[154]

In the Abbey of San Michele Arcangelo, a nave choir with accompanying screen and chapels still occupies the entire width of the modest single-aisled nave (Figure 137).[155] Dating to one of the abbacies of Niccolò Ungaro (1549–51), the choir was financed both by the monastery and Don Raffaello Nuti.[156] The twenty-six walnut choir stalls, disposed in a single upper row in two ranges, were carved by Maestro Bastiano detto Confetto, a woodworker involved in the Medici court who would later assist in the transportation of the San Pancrazio choir to Vallombrosa. The stalls are classical in style, each seat being framed by

Figure 138 Bartolomeo di Salvatore Lorenzo, *Pulpit,* 1489, marble. Transferred from San Pancrazio to San Michele a Pianézzoli in Val d'Elsa in 1753. Photo: author

Figure 139 Chimenti and Leonardo del Tasso (attr.), *Crucifix*, 1497, wood. From San Pancrazio, now in San Lorenzo a Fossato. Photo: Fototeca Ufficio Beni Culturali Diocesi di Prato

pilasters featuring Ionic volutes and female heads and surmounted by a frieze composed of Greek and Hebrew verses from the Psalms (Figure 141).[157] The stalls are divided from the lower nave by a contemporary wooden screen, to which two chapels with altarpieces by Michele di Ridolfo di Ghirlandaio (Michele Tosini) are

affixed. Although the choir at present lacks a crucifix, Lucia Aquino has shown that a depiction of the interior of the choir in c. 1580 – the background of the north transept fresco of the recognition of the relics of San Giovanni Gualberto by Butteri – depicts a crucifix framed by a white cloth (Figure 32).[158]

Figure 140 Screen, 1487, *pietra serena*. Vallombrosa Abbey. Photo: author

Other Choir Spaces in San Pancrazio

The nave choir was not the only choral space in San Pancrazio. In 1490, Chimenti del Tasso constructed intarsiated choir stalls in the Minerbetti sacristy chapel, the location of which is uncertain, that were probably used by the monks for their nocturnal services.[159] Further choir seating was installed in the high chapel. In 1484–85, the high altar was moved forward and Pandolfo Rucellai began to provide funds for a retrochoir in this area, which, however, did not replace the monastic nave choir. A report dated 1508 explained how in 1484, the high altar, which had been located three *braccia* from the wall under the window, was "repositioned forward next to the steps" so that the monks could say Mass and office behind the altar.[160] As we have seen in Chapter 2, lay patronage of retrochoirs and high chapels held a certain high status and were possibly inspired by Cosimo il Vecchio's patronage of the high chapel of San Lorenzo. In terms of cultural capital, therefore, patronage of the high altar choir in San Pancrazio cemented the exclusive reputation of the Rucellai family within the political elite of Florence, and, as Pacciani stated, expanded their power and influence across multiple spaces in the church interior of San Pancrazio.[161] The stalls would have likely been used for specific functions, perhaps including liturgical celebrations in honor of the Rucellai family.

Because Pandolfo Rucellai had first given funds for this project in 1485, Pacciani suggested that the new choir arrangement was implemented to coincide with the church's official consecration, which took place in August of that year.[162] Although substantially postdating the completion of the building fabric, this year was important for the monastery's administrative history, since it witnessed the union of various factions into the congregation of Santa Maria di Vallombrosa, approved by Pope Innocent VIII in January 1485.[163] In the following April, San Pancrazio numbered among the monasteries that had officially joined the new congregation.[164]

Whereas the instigation of the Rucellai choir might have been related to the church consecration, it was not completed until many years later. In a report in the monastery's archive dated

Figure 141 Bastiano detto Confetto, *Choir Stalls*, 1549–51. Abbey of San Michele Arcangelo, Passignano. Photo: Sailko/ Francesco Bini

10 April 1499, Abbot Giovanni Gualberto explained how a few weeks previously two men sent by Pandolfo Rucellai gave him thirty gold florins with instructions to finish "a choir that the aforesaid Pandolfo had started a long time ago behind the high altar and likewise an altarpiece by the painter Bernardo Rosselli."[165] Padoa Rizzo argued that Rosselli's contribution (for which he was compensated a meager nine florins) was merely the updated framing of an earlier high altarpiece, a polyptych by Bernardo Daddi now in New Orleans.[166] The various vicissitudes of the San Pancrazio high altarpiece are, however, highly uncertain. The choir was commissioned from Antonio di Stefano, a woodworker in Piazza Santa Trinita, whom the abbot instructed to add certain intarsia and moldings.[167] This spatial

articulation was maintained for several years, until in 1506, when, to the general satisfaction of the local populace according to the convent's documentation, the high altar was placed in the center of the chapel.[168] A 1507 list of chapels from San Pancrazio described the old altar as badly placed, whereas the new central placement was prominent in all its parts.[169]

Removal of the Nave Choir

The decision to remove the choir from the nave of San Pancrazio and to transfer it to Vallombrosa Abbey can be dated back to 14 June 1573, when the order was concluding its post-Tridentine reforms. In a chapter meeting

convened by the president of the Vallombrosan Congregation, Don Arsenio da Poppi, the relocation of the choir was framed within the context of further improvements to the Vallombrosa Abbey church. After a vote "it passed that they should tile the church namely the roof, and do the ceiling, and bring there the choir of San Pancrazio of Florence."[170] This implies that at least part of the impetus for the project came from Vallombrosa itself, even directly from the president of the congregation.

On the other hand, archival sources provide several justifications for the removal of the nave choir in San Pancrazio. A report in the monastery's archive dated 1574 noted that Abbot Gostanzo Minucci had observed that "in all the churches of Florence, the choirs have been removed from the middle of these churches, and they were changed to officiate behind the high altar."[171] Santa Trinita must have been foremost in his mind, since renovations in San Pancrazio occurred contemporaneously with the construction of Buontalenti's marble balustrade in this neighboring Vallombrosan church.[172] Abbot Minucci further stated that on festal occasions in San Pancrazio only three or four monks would appear in choir, "who were seen by all the people with not much edification to them and with little satisfaction to us."[173] Further, the monks could relocate to the preexisting Rucellai retrochoir, where they would be even more obscured from view. Embarrassment over the low monastic population and a desire to conform to local prevailing taste evidently spurred the abbot to initiate a drastic transformation of the church interior.

Moral rectitude in church was also a factor. Abbot Gostanzo Minucci appealed to Grand Duke Francesco that the monks "could remove the choir which was in church, because it was a great impediment to it [the church], and because behind it [the choir], laypeople were doing many impertinent and disgraceful things."[174] Evidently the phrase "behind" in this case is from the monks' perspective in the choir, thus inferring

the lower nave, which would have been accessible to the laity but less visible to the monks. This euphemistic language is similar to that used in documents surrounding changes to the interior of Orsanmichele, where people were apparently doing "disgusting things" behind the high altar of St. Anne (see Chapter 7). Evidence of such activities shows that, contrary to their perceived functions, one of the unforeseen effects of tramezzi was to create secluded spaces for laity away from the disapproving eyes of the clergy. Especially at times when the monks were engaged in performing the liturgy, screens would have created dark and concealed spaces ideal for clandestine encounters. This desire to counteract lay disobedience or immorality in church accords with post-Tridentine reform objectives, as we shall see in further detail in Chapter 8.

Unlike at Santa Trinita, stalls from the nave choir of San Pancrazio were not transferred to behind the high altar, since the church was already equipped with stalls in the Rucellai retrochoir. Instead, when Grand Duke Francesco gave his permission for the monks to remove the choir, "it was liberally allowed by His Highness that [the choir] be removed and sent to Vallombrosa" at the expense of said monastery.[175] The price specified was 125 scudi and forty-eight barrels of good wine, to be delivered in several installments – the cash over the following two years and the wine over four years.[176] Payments in the Vallombrosa archives chart this unusual transaction.[177] On 18 October 1574, Maestro Bastiano detto Confetto was paid twenty-two lire for "the removal of the choir of San Pancrazio."[178] Another payment was recorded on 14 March 1575. However, it would not be until 28 December 1577 when Bastiano was paid a further 105 lire "for the choir that he dismantled of San Pancrazio to send it to Vallombrosa."[179] As Alessandro Cecchi has shown, this worker was the same Confetto who restored the Vallombrosa choir in 1581–82 and completed the choir stalls in Passignano.[180]

Figure 142 Domenico Atticciati (attr.), *Lectern*, 1592. Vallombrosa Abbey. Photo: author

The stalls from San Pancrazio still exist in Vallombrosa Abbey church, located some 40 km east of Florence. They were initially arranged in front of the high altar enclosed by a *pietra serena* choir screen (which, as we have seen, still exists attached to the counter-facade), but were placed behind the high altar in 1700.[181] The choir lectern, however, remained at San Pancrazio, where it was transferred behind the high altar. The monks at Vallombrosa commissioned their own choir lectern in 1592, the date inscribed on the surviving wooden structure, attributed to Domenico Atticciati (Figure 142).[182]

Further Changes in San Pancrazio

The removal of the nave choir in San Pancrazio was accompanied by further modifications to the church interior.[183] In the monastery's journal, a subheading entitled "Expenses made in bringing the high altar forward" heralds a list of various payments dated March 1574.[184] The monastery paid workers to take away rubble ("calcinacci"), to carry a ladder from Santa Trinita (showing close collaboration within the order), and for raw materials such as lead and charcoal. The old stonework of the steps in front of the high altar was repaired, and pavement bricks ("mezzane") and mortar "needed for the altar" were purchased.[185] New curtains for the choir were also purchased, presumably to obscure the entrances to the choir area on either side of the altar, possibly fulfilling the same function as Buontalenti's choir doors in Santa Trinita. The monks paid for nine *braccia* of fringing, twenty-four curtain rings ("campanelle"[186]) and eight *braccia* of blue ribbon "all of which served for the aforesaid curtains."[187] The monastery employed five porters to transport the choir lectern behind the high altar, in a clear demonstration of its substantial size and weight.[188] In addition, the area underneath the altar and the choir curtains were painted.[189] A few months later, in August 1574, Maestro Jacopo was paid sixty-three lire for "whitewashing all of our church," a measure commonly completed alongside the removal of nave choirs.[190]

Again showing similarities with other contexts, a record in the San Pancrazio archives explains how the "very old and dishonorable" ciborium for the sacrament was replaced in 1574, the same year as the removal of the choir.[191] The new gold ciborium and its stand ("predella") was commissioned from Giovanni Cenni, but eight terracotta figures set in niches were fabricated by the sculptor Domenico Poggini, and small paintings completed by Francesco Brina. The ciborium was donated by Don Marco del Giocondo, a Vallombrosan monk who was also responsible for "bringing the altar forward so that it would be more comfortable to officiate behind it, we having already removed the choir from the center of the church."[192] According to the monastery's archives, on the occasion of Bishop of Camerino Alfonso Binnarini's Pastoral Visitation to San Pancrazio on 16 June 1575, he was reportedly satisfied with everything, especially the very beautiful ciborium on the altar.[193] In the Visitation protocol, which in fact made numerous recommendations, the ciborium, which no longer survives, was described as a large wooden and gilded construction decorated with images of saints in a high position on the altar.[194]

Conclusion

The two Vallombrosan churches of Santa Trinita and San Pancrazio shared similarities in their respective internal spatial articulation, patronage, and later changes to choir precincts. In both churches, nave choirs interacted spatially and visually with images and other furnishings in the church interior. In San Pancrazio, multiple choir areas and changes to the high altar area show that the nave choir was part of a complex layout of liturgical space that continuously evolved in response to changing circumstances. In Santa Trinita, the presence of a screen can be inferred but not confirmed, since no descriptions or archival evidence for screen chapels appears to exist. In San Pancrazio, by contrast, the screen featured a wooden archway, a crucifix, and at least one chapel. In assessing the possible aesthetic qualities of these lost screens, extant tramezzi in the Vallombrosan abbey churches of Vallombrosa and Passignano can provide pertinent comparisons, although it should be remembered that both were for single-aisled churches.

Both Vallombrosan communities sought lay patrons to sponsor their monastic choir precincts. In the case of Santa Trinita, patronage was shared equally between the Spini and Ardinghelli families, while in San Pancrazio, the Lion Rosso gonfalon provided necessary funds for the choir furniture. This diffusion of patronage affected the usage and ownership of space in the church interior. In Santa Trinita, each range of the choir precinct adjoined the site of family chapels, bolstering their spatial presence in the church. In San Pancrazio, the financial support of the gonfalon and hints in their documentary record imply that the stalls were utilized by members for regular meetings, showing the multifunctionality of the seating area. However, in San Pancrazio, Vallombrosa, and Passignano, Vallombrosan monks patronized chapels on the screen, reinforcing institutional ownership of space.

Since the two choirs were patronized by local families and neighborhoods, their removal in the later sixteenth century reinforced the increasingly centralized power of the Medici duchy.[195] Whereas the neighborhood gonfalon had previously represented the base political unit that controlled who was eligible to hold public office, the sixteenth century saw the advent of new systems of bureaucratic nobility, and neighborhood institutions were replaced by parish and citywide confraternities.[196] In a similar vein, both Hall and Lunardi commented that the destruction of private chapels and imposition of new patrons in Santa Maria Novella manifested Duke Cosimo's desire to demonstrate his absolute power in the Tuscan capital, masking any evidence of past republicanism.

The circumstances surrounding the removal of nave choirs in Santa Trinita and San Pancrazio were each quite different. Duke Cosimo ordered the removal of the choir in Santa Trinita in 1569, for liturgical, architectural, and aesthetic reasons. In the context of a post-Tridentine reform of the order, the 1574 renovation in Santa Trinita was completed with Buontalenti's altar balustrade, contemporaneously with major changes occurring at San Pancrazio. There, however, the monks were concerned with imitating other church renovation projects in Florence and preventing bad behavior in the lower nave. Both Florentine churches preferred that their precious carved stalls not be destroyed, but instead benefit another community in the Vallombrosan congregation. On three separate occasions, the Florentine monks transferred stalls to other Vallombrosan sites: choir stalls from Santa Trinita to the nuns of Santo Spirito (now San Giorgio alla Costa) in 1569; choir stalls from San Pancrazio to Vallombrosa Abbey in 1574; and the Strozzi sacristy stalls to a Vallombrosan house in Valle Benedetta, near Livorno, in 1696. In addition to obvious financial benefits, these actions demonstrate close institutional ties within the congregation, whose

communities would often commission works from the same artists.

In the late sixteenth century, both Florentine churches experienced a downturn of fortune, as did the wider Vallombrosan congregation. A slight decline in monastic numbers can be observed at Santa Trinita, while at San Pancrazio the abbot clearly experienced embarrassment over the laity witnessing only three or four monks at liturgical celebrations. In Grand Ducal Florence, it seems that the general populace had no "great admiration and expectation" for the public display of Vallombrosan monastic ceremony and splendor as they had had in the fifteenth century. As in other contexts, the shift in choir location to behind the high altar fulfilled many objectives: it created open and aesthetically pleasing church interiors; it removed the prominent presence of lay patrons; it afforded the monks increased privacy and quiet; and it combated lay bad behavior. Combined with new high altar arrangements and Eucharistic tabernacles, these alterations served to reinforce the sense of the holy within the church interior, which, as we shall see in more detail in Chapter 8, was a major objective of the Council of Trent.

NOTES

1 "El lunedi mattina adunque adi 24 di maggio 1479 ed decano contutti e valombrosani seneva ad San Pancratio acoppia acoppia con grande admiratione et expectatione del popolo." BNCF, Magliabechi, XXXVII, n. 325 (Del Serra, Vita di don Biagio di Francesco Milanese), fol. 14r.

2 For the history of the Vallombrosan congregation, see Charles-Martial de Witte, "Les monastères vallombrosains aux XVe e XVIe siècles: Un 'status quaestionis'," *Benedictina* 17, no. 2 (1970), pp. 234–53; Nicola Vasaturo, "Vallombrosa, Vallombrosane, Vallombrosani," in *Dizionario degli istituti di perfezione*, ed. Guerrino Pelliccia and Giancarlo Rocca (Rome, 1974–2003), coll. 1692–1702; Nicola Vasaturo, *Vallombrosa: L'abbazia e la congregazione. Note storiche*, ed. Giordano Monzio Compagnoni (Vallombrosa, 1994); Francesco

Salvestrini, *Disciplina caritatis: il monachesimo vallombrosano tra Medioevo e prima età moderna* (Rome, 2011).

3 For the various Vallombrosan responses to mendicant ascendancy, see Justine Walden, "Exorcism and Religious Politics in Fifteenth-Century Florence," *Renaissance Quarterly* 71 (2018), pp. 438–45.

4 De Witte, "Les monastères vallombrosains," pp. 235–41; Nicola Vasaturo, "Note storiche," in *Vallombrosa nel IX centenario della morte del fondatore Giovanni Gualberto 12 luglio 1073*, ed. Nicola Vasaturo et al. (Florence, 1973), p. 103.

5 San Pancrazio was a member of this Congregation in 1485, but Santa Trinita joined in 1492. Nicola Vasaturo, "Vallombrosa: ricerche d'archivio sulla costruzione dell'abbazia," in *Vallombrosa nel IX centenario della morte del fondatore Giovanni Gualberto 12 luglio 1073*, ed. Nicola Vasaturo et al. (Florence, 1973), pp. 102–05, 116–19; Justine Walden, "Foaming Mouth and Eyes Aflame: Exorcism and Power in Renaissance Florence" (PhD thesis, Yale University, 2016), pp. 97–115. The *commenda* system allocated to a single patron the benefice income of a monastery. See Denys Hay, *The Church in Italy in the Fifteenth Century* (Cambridge, 1977), pp. 74–75.

6 De Witte, "Les monastères vallombrosains," pp. 247–51; Vasaturo, "Vallombrosa: ricerche d'archivio," pp. 129–31.

7 Vasaturo, "Vallombrosa, Vallombrosane," coll. 1699; Vasaturo, *Vallombrosa: L'abbazia*, p. 162.

8 Vasari et al., *Le vite*, vol. 2, p. 63; Bocchi and Cinelli, *Le bellezze*, p. 184; Richa, *Notizie istoriche*, vol. 3, p. 143. See also Carlo Botto, "Note e documenti sulla chiesa di S. Trinita in Firenze," *Rivista d'Arte* 20, no. 1 (1938), pp. 1–22; Howard Saalman, *The Church of Santa Trinita in Florence* (New York, 1966), pp. 3–4; Gabriele Morolli, "L'Architettura: Gotico e umanesimo," in *La chiesa di Santa Trinita a Firenze*, ed. Giuseppe Marchini and Emma Micheletti (Florence, 1987), pp. 23–48.

9 Saalman's Trinita I, dated between the last quarter of the eighth century and the first half of the ninth, was a small Carolingian church with a trefoil plan at its altarend, identifiable with the heavily restored space of the so-called crypt. In c. 1060, a nave with two aisles was added at a higher floor level (Trinita IIa), and trilobe piers (fragments of which survived), framed descending access to the old apse. Trinita III, dating to the end of the twelfth to the mid-thirteenth century, necessitated a widening of the nave side aisles, possible raising of the altar area, additions to the facade (which would seem to accord with Vasari's commentary) and four independent chapels attached to the left nave aisle. Saalman, *The Church of Santa Trinita*, pp. 7–28.

10 Ibid., pp. 31–40; Paolo Bertoncini Sabatini, "La vicenda architettonica della chiesa di Santa Trinita," in *Alla riscoperta delle chiese di Firenze: 6. Santa Trinita* (Florence, 2009), pp. 47–51.

11 Susan J. May and George T. Noszlopy, "Cosimo Rosselli's Birmingham Altarpiece, the Vallombrosan Abbey of S. Trinita in Florence and Its Gianfigliazzi

Chapel," *Journal of the Warburg and Courtauld Institutes* 78 (2015), p. 112.

12 Nicola Vasaturo, "Appunti d'archivio sulla costruzione e trasformazioni dell'edificio," in *La Chiesa di Santa Trinita a Firenze*, ed. Giuseppe Marchini and Emma Micheletti (Florence, 1987), p. 14; Carl Brandon Strehlke, "Cenni di Francesco, the Gianfigliazzi, and the Church of Santa Trinita in Florence," *The J. Paul Getty Museum Journal* 20 (1992), p. 22.

13 A conflict over property arose between the Gianfigliazzi and Santa Trinita in the 1580s. Brenda Preyer, "Around and in the Gianfigliazzi Palace in Florence: Developments on Lungarno Corsini in the 15th and 16th Centuries," *Mitteilungen des Kunsthistorischen Institutes in Florenz* 48, no. 1/2 (2004), p. 82ff.

14 For Baldovinetti's Gianfigliazzi high chapel, see Vasari et al., *Le vite*, vol. 3, p. 314; Bocchi and Cinelli, *Le bellezze*, pp. 188–89; Ruth Wedgwood Kennedy, *Alesso Baldovinetti: A Critical & Historical Study* (New Haven, CT, and London, 1938), pp. 167–80, 195, 246–47. For the Sassetti Chapel, see Eve Borsook and Johannes Offerhaus, *Francesco Sassetti and Ghirlandaio at Santa Trinita: History and Legend in a Renaissance Chapel* (Doornspijk, 1981); Enrica Cassarino, *La Cappella Sassetti nella Chiesa di Santa Trinita* (Lucca, 1996), E. H. Gombrich, "The Sassetti Chapel Revisited: Santa Trinita and Lorenzo de' Medici," *I Tatti Studies in the Italian Renaissance* 7 (1997), pp. 11–35.

15 For the late nineteenth-century restorations, see Saalman, *The Church of Santa Trinita*, p. 5; Monica Maffioli, "La querelle ottocentesca per il restauro della chiesa: dalle teorie al cantiere," in *La Chiesa di Santa Trinita a Firenze* (Florence, 1987), pp. 61–70; Canali, "La basilica di Santa Trinita," pp. 172–204. Note that the high altar in Santa Trinita faces northwest, so the present author is using the conventions of left and right to describe locations in the church interior.

16 Vasaturo, "Appunti d'archivio," p. 16. "pro construct[is] et confectione unus cori (*sic*) dictae ecclesiae et tempore quo dictus corus construetur pro medietat [is] videlicet que erit exlatere cappelle illorum de ardinghellis." ASF, Diplomatico, Normali, Torrigiani (dono), 1 July 1411.

17 "Michele di Zanobi Ardinghelli l'anno 1393 il di 16 Agosto fece testamento rogato Ser Bartolomeo di Ser Masso Stelli per il quale fece certo legato alla cappella degli Ardinghelli posta nel Chiesa di Santa Trinita." ASF, CRS no. 89 (Santa Trinita), vol. 76, fol. 181r. Ibid., p. 14.

18 As indicated by Gert Jan van der Sman, who suggested that the Ardinghelli altarpiece influenced the young Botticelli. Sman, "Botticelli's Life and Career," p. 186. See also Dale Kent, *The Rise of the Medici: Faction in Florence 1426–1434* (Oxford, 1978), pp. 164–65. In the 1427 Catasto, Piero di Neri Ardinghelli's total capital was valued at 32,432 florins, making him the wealthiest citizen in Unicorno by a substantial amount. For Piero di Neri Ardinghelli, see http://cds.library.brown.edu/projects/catasto/newsearch/sqlform.php?referred=yes&

drilldown=yes&stg_id=50004843. The next wealthiest man in Unicorno was Francesco Benozzo, who recorded a total capital of 23,321 florins. Piero married Palla Strozzi's niece, Caterina.

19 Anna Padoa Rizzo, "Sul polittico della Cappella Ardinghelli in Santa Trinita, di Giovanni Toscani," *Antichità viva* 21, no. 1 (1982), pp. 5–10.

20 "et residuum muri est de Ardinghellis." ASF, Notarile antecosimiano, vol. 380, at date 20 January 1422 (stil. Flor) (unnumbered), transcribed in Massimo Bulgarelli, "La sagrestia di Santa Trinita a Firenze: architettura, memoria, rappresentazione," *Quaderni dell'Istituto di Storia dell'Architettura / Università degli Studi di Roma La Sapienza, Dipartimento di Storia dell'Architettura, Restauro e Conservazione dei Beni Architettonici* 57/59.2011/12 (2013), p. 36; see also p. 29. Strozzi also gained rights over one eighth of the right transept vault, half of which belonged to the Ardinghelli.

21 "cosi si vede che non sono stati li ardinghelli che lo feciano: ma il monasterio e forse seli concesse l'arme perche feciano il muro della facciata dove è detto organo." ASF, CRS no. 89 (Santa Trinita), vol. 52, fol. 95v.

22 Morolli, "L'Architettura," p. 36.

23 They facilitated tithes from Germany, Hungary, Bohemia, and Poland. Marcello Vannucci, *Le grande famiglie di Firenze* (Rome, 1993), pp. 427–29. Spini collaborated with the Mozzi as bankers in England, and were important creditors to Pope Boniface VIII. John M. Najemy, *A History of Florence 1200–1575* (Malden, MA, 2006), pp. 23, 90. Holmes noted that in the early years of Martin V's papacy "[t]he Spini were clearly the main rivals of the Medici." George Holmes, "How the Medici Became the Pope's Bankers," in *Florentine Studies: Politics and Society in Renaissance Florence*, ed. Nicolai Rubinstein (Evanston, IL, 1968), p. 377.

24 In his *Libro Della Famiglia* composed in the 1430s, Alberti noted that: "[m]any noble and honorable families of Florence, like the Cerchi, Peruzzi, Scali, Spini, Ricci, and numerous others, who formerly abounded in vast riches, have been reduced to misery and in some cases to desperate need, owing to the injuries of fortune." English quotation from Martines, *The Social World*, p. 78. It is not known why the Spini bank failed in 1420. Holmes, "How the Medici Became the Pope's Bankers," p. 378. See http://cds.library.brown.edu/projects/catasto/newsearch/M1427a.html for a list of the wealthiest households by last name.

25 Martines, *The Social World*, pp. 240–41. Cristofano Spini's state funeral cost the *Signoria* seventy-three florins, compared to Giovanni di Bicci de'Medici's in 1429, which only cost thirty florins.

26 Gene Brucker, *The Civic World of Early Renaissance Florence* (Princeton, NJ, 1977), pp. 264–65; Claudia Tripodi, *Gli Spini tra XIV e XV secolo: Il declino di un antico casato fiorentino* (Florence, 2013), pp. 38–56.

27 "de bonis suis medietatem quantitatem pecuniensem [sic] et expensarum que occurrent et fieri expedietum

in faciendo et pro [^fieri] faciendo et perficiendo dictum chorum in dicta ecclesia S. Trinitatis." ASF, Notarile Antecosimiano, vol. 14899 (Not. Bartolomeo Nelli), fol. 86r.

28 For example, an empty shield on the stalls in San Domenico in Ferrara, dated 1384, was likely intended for a painted coat of arms. Allen, "Choir Stalls," p. 20.

29 "dal lato di fuori, debba essere uno schudo che nell'un s'ara a mettere il segnio dell'Arte, nell'altro dell'altra testiera l'arme degli Acciaiuoli." Gaetano Milanesi, *Nuovi documenti per la storia dell'arte toscana dal XII al XV secolo* (Soest, 1973), p. 73.

30 Pacciani, "Cori, tramezzi, cortine," p. 326, note 70.

31 Padoa Rizzo, "Sul polittico della Cappella Ardinghelli," p. 9.

32 Kent, *The Rise of the Medici*, pp. 162–64.

33 Vasaturo, "Appunti d'archivio," p. 16.

34 Milanesi, *Nuovi documenti*, pp. 71–73.

35 Cecchi, "Maestri d'intaglio," pp. 217–19. Haines, *Sacrestia delle Messe*, pp. 27–29. For a short biography of Manno, see Milanesi, *Nuovi documenti*, pp. 71n–72n.

36 Cecchi, "Maestri d'intaglio," p. 219. See also Giovanni Magherini Graziani, *L'arte a Città di Castello* (Città di Castello, 1897), pp. 286–87, figure 83; Catia Cecchetti, *Città di Castello: la porta dell'Umbria* (Città di Castello, 2014), p. 112.

37 "e per un pocho de legname avuto da manno che fa il choro l. 11." ASF, CRS no. 89 (Santa Trinita), vol. 46, fol. 3r. Dated 6 July 1416.

38 "Adi viiij di decembre spesi e detti a Manno di Beninchasa maestro di legname … per uno leggio di noce per dire in coro le pistole e lorationi fiorini due." ASF, CRS no. 89 (Santa Trinita), vol. 46, fol. 25r.

39 In a contract dated 4 January 1420, Arduino da Baiso was obliged to make "XI sive plures sedias in choro sacrestie S. Trinitatis de Florentia … secundum formam designi manu manni legnaiuoli." ASF, Diplomatico, Normale, Strozziane Uguccioni (acquisto), 1 January 1419 (stil. Flor). Milanesi transcribed "Manni" as "magistri," and while the text reads as "Manni" it is undoubtedly strange that he would be introduced without the "master" title or suffix. Milanesi, *Nuovi documenti*, pp. 75–77 (doc. no. 92). Haines, Bagatin, and Cecchi accept Manno's involvement in the sacristy choir. Pier Luigi Bagatin, *La tarsia rinascimentale a Ferrara: il coro di Sant'Andrea* (Florence, 1991), pp. 14–17; Haines, *Sacrestia delle Messe*, p. 29; Cecchi, "Maestri d'intaglio," p. 221. In 1696, the Strozzi stalls were transported to a Vallombrosan house in Valle Benedetta, near Livorno; they no longer survive. Vasaturo, "Appunti d'archivio," p. 19.

40 Haines, *Sacrestia delle Messe*, p. 29.

41 Giovanni Leoncini, "Altari in Santa Trinita: la cappella maggiore, la cappella Usimbardi e la cappella delle reliquie di San Giovanni Gualberto," in *Altari e committenza: Episodi a Firenze nell'età della Controriforma*, ed. Cristina De Benedictis (Florence, 1996), p. 106; Giovanni Leoncini, "Il Cinquecento e il Seicento in Santa Trinita," in *Alla riscoperta delle chiese di Firenze: 6. Santa Trinita*, ed. Timothy Verdon (Florence, 2009), p. 139; Bertoncini Sabatini, "La vicenda architettonica," p. 56.

42 "Adi 10 di novembre mori bartholomeo giovanni gaetani sotterrasse nella loro sepultura di sotto al coro." ASF, CRS no. 89 (Santa Trinita), vol. 75, fol. 52r. Another note also suggests the Gaetani tomb was near the choir: "Adi 17 di dicembre 1485 mori agostino gaetani sotterrasse nella loro sepultura apiso del coro." ASF, CRS no. 89 (Santa Trinita), vol. 75, fol. 70v. In this context, the term "apiso" could be interpreted as "appresso."

43 BNCF, Fondo Nazionale, II.I.126 (Sepoltuario fiorentino di Rosselli, Quartiere S. Maria Novella), fols. 189v–190r.

44 Ibid., fol. 188r.

45 "L'altra sepoltura de Lotti o' allato a' quella de Gaetani: verso la cappella di S. Luca." ASF, CRS no. 89 (Santa Trinita), vol. 135, fol. 128v.

46 "Accanto al sopradetto verso la cappella di ricatto gia de Sercialli lastrone e chiusino di marmo della famiglia de Lotti con arme loro." BNCF, Fondo Nazionale, II.I.126 (Sepoltuario fiorentino di Rosselli, Quartiere S. Maria Novella), fol. 190r.

47 "di sotto al coro allate alotti." ASF, CRS no. 89 (Santa Trinita), vol. 75, fol. 90v. Unfortunately, the name on this tomb is indecipherable in the archival record.

48 In the context of church interiors in Florence, the terms "sopra" can mean "after," and "sotto" "before." See De Marchi, "Relitti di un naufragio," p. 57.

49 "la quale tavola finita, fu posta da que' monaci in sull'altare maggiore di detta chiesa; donde essendo poi levata per dar quel luogo alla tavola che v'è oggi di Alesso Baldovinetti, fu posta in una cappella minore della navata sinistra di detta chiesa." Vasari et al., *Le vite*, vol. 2, p. 37. Baldovinetti's *Trinity* is held by the Uffizi, and the current high altarpiece depicting the *Trinity with Saints* is by Mariotto di Nardo (active 1393–1424). Fabrizio Guidi, "La pittura fiorentina del primo quattrocento nel transetto di S. Trinita," in *La Chiesa di Santa Trinita a Firenze*, ed. Giuseppe Marchini and Emma Micheletti (Florence, 1987), p. 118.

50 Cristina De Benedictis, "Riflessioni sulla Maestà fiorentina di Cimabue," in *Scritti di Storia dell'Arte in onore di Roberto Salvini* (Florence, 1984), pp. 131–33.

51 De Marchi, *La pala d'altare*, p. 48.

52 Luciano Bellosi, *Cimabue*, ed. Giovanna Ragionieri (Milan, 1998), p. 255.

53 "Acanto della Porta del mezzo era un Altare intitolato della Pietà, e questo era della famiglia de Cambi Importuni." ASF, CRS no. 89 (Santa Trinita), vol. 135, fol. 93v.

54 "Sepoltura de Ser Nigi all'altare di S. Bastiano fra la porta grande e la piccola verso parione." ASF, CRS no. 89 (Santa Trinita), vol. 52, fol. 48v.

55 Vasaturo, "Appunti d'archivio," p. 16; Strehlke, "Cenni di Francesco," p. 29. BNCF, Fondo Nazionale, II.I.126 (Sepoltuario fiorentino di Rosselli, Quartiere S. Maria Novella), fol. 188r.

56 Morolli, "L'Architettura," pp. 39–40.

57 Michela Becchis, "Giovanni dal Ponte," in *Dizionario biografico degli Italiani* (Rome, 2001), ed. Mario Caravale, vol. 56, p. 185. Vasari et al., *Le vite*, vol. 2, p. 240.

58 Guidi, "La pittura fiorentina," p. 118. Also identified as *Ascension (?), John Evangelist and giving of keys to Peter (?)* in Rudolf Hiller von Gaertringen, "Giovanni da Ponte," in *Allgemeines Künstlerlexikon*, ed. Günter Meißner (Munich and Leipzig, 2007), vol. 55, p. 78.

59 Carlo Gamba, "Giovanni da Ponte," *Rassegna d'Arte* 4, no. 12 (1904), p. 185. Pietro Toesca, "Umili pittori fiorentini del principio del quattrocento," *L'Arte* 7 (1904), pp. 54–56.

60 Borsook and Offerhaus, *Francesco Sassetti*, pp. 30–33.

61 De Marchi, "Relitti di un naufragio," p. 63.

62 Cooper, "Redefining the Altarpiece," p. 704.

63 The battle of Marciano in 1554. Gianluca Belli, "Vasari, Ammannati, Borghini, e l''età dell'oro' cosimiana," in *Ammannati e Vasari per la città dei Medici*, ed. Cristina Acidini Luchinat and Giacomo Pirazzoli (Florence, 2011), p. 120.

64 For the column and sculpture in Piazza Santa Trinita, see Bocchi and Cinelli, *Le bellezze*, pp. 193–94; Richa, *Notizie istoriche*, vol. 3, p. 146; Suzanne B. Butters, *The Triumph of Vulcan: Sculptors' Tools, Porphyry, and the Prince in Ducal Florence* (Florence, 1996), pp. 80, 93–97, 327–32; Belli, "Vasari, Ammanati, Borghini"; Claudio Paolini, "Colonna della Giustizia," www .palazzospinelli.org/architetture/scheda.asp?offset= 2160ID=2086. The statue, carved by porphyry experts Francesco Ferrucci del Tadda and his sons Giovan Battista and Romolo on a model by Ammannati, was only erected in 1581.

65 For the wedding *apparato* and its relation to the Santa Trinita area, see Domenico Mellini, *Descrizione della entrata della serenissima Regina Giovanna d'Austria et dell'apparato, fatto in Firenze nella venuta, & per le felicissime nozze di Sua Altezza et dell'illustrissimo . . . S. Don Francesco de Medici* (Florence, 1566), pp. 37–43.

66 Bocchi praised the design and utility of the new Ponte Santa Trinita. Bocchi and Cinelli, *Le bellezze*, pp. 180–81. Although the bridge was begun in 1567 and not completed until 1578, plaques on the structure itself only bear the date 1569, the year Cosimo was granted the grand ducal title. Lia Markey, "Medici Statecraft and the Building and Use of Ammannati's Ponte Santa Trinita," in *Italian Art, Society and Politics: A Festschrift in Honor of Rab Hatfield Presented by His Students on the Occasion of His Seventieth Birthday*, ed. Barbara Deimling, Jonathan K. Nelson, and Gary M. Radke (Florence, 2007), p. 184.

67 Markey, "Medici Statecraft," pp. 178–193.

68 Alice E. Sanger, *Art, Gender and Religious Devotion in Grand Ducal Tuscany* (Farnham, 2014), p. 23. "il quale è capacissimo di quelli pochi monaci che stanno in S. Pancratio." ASF, Mediceo del Principato, vol. 5927a, Insert 1, fol. 36 (consulted at bia.medici.org, MAP Doc ID# 3705). For Ammannati's rebuilding of the Jesuit San Giovannino (now called San Giovannino degli Scolopi),

see Merlijn Hurz, "Bartolomeo Ammannati and the College of San Giovannino in Florence: Adapting Architecture to Jesuit Needs," *Journal of the Society of Architectural Historians* 68, no. 3 (2009), pp. 338–57.

69 "di che ne son stati pregati più volte da questi Ill.mi Principi [Cosimo I and Francesco I de' Medici], acciò si contentassino di conceder' amorevolmente il prefato convento di S. Pancratio alli Jesuiti, ma non si seno possuto ottenere questo da loro son recorsa ^per ultimo remedio^ alli piedi della Stá V." Sanger, *Art, Gender and Religious Devotion*, p. 23.

70 In c. 1525, "Santa Trinita dentrovi frati venti dua da messa e quattro conversi e un priore e un cherico e un'portinaro, e un' guoco." BNCF, Non acquisti, 987, fol. 4v. The 1568 Pastoral Visitation noted "Monacos quindecim sacerdotus duos clericos secularos et unus convertus." Florence, Archivio arcivescovile, VP 09.1, fol. 22v. San Pancrazio in 1568 was home to only twelve monks. Ibid., fol. 21v (6 April 1568).

71 "che quanto prima facessi levare il Choro del mezzo di dicta chiesa . . . et lo dovessi mettere dietro all'altare maggiore di dicta chiesa." ASF, CRS no. 89 (Santa Trinita), vol. 51, fol. 8r.

72 R. Burr Litchfield, *Emergence of a Bureaucracy: The Florentine Patricians, 1530–1790* (Princeton, NJ, 1986), p. 89.

73 "levando dicto coro si fara dispiacere a molti gentilhuomini." ASF, CRS no. 89 (Santa Trinita), vol. 51, fol. 8r.

74 The present stalls date from 1762. Vasaturo, "Appunti d'archivio," pp. 16–17, 21. In a mid-seventeenth-century account, Abbot Niccolini stated that the stalls were divided between Santa Trinita and Santo Spirito: "Convenne a Padri per ufiziar la chiesa transportare le prospere in detto luogo [behind the high altar in Santa Trinita], ma perche ne avanzorno per non essere il luogo capace, che tutte vi si potessero accomodare, il restante si dette alle nostre R. R. Monache dello Spirito Santo, e loro ne dettero al Convento nostro scudi 30." ASF, CRS no. 89 (Santa Trinita), vol. 135, fol. 183v. The community of Vallombrosan nuns at Santo Spirito was founded in 1520 at the request of Pope Leo X. Vasaturo, *Vallombrosa: L'abbazia*, p. 150.

75 "primieramente con piu quiete, e meno sturbo ufitierebbano poi la chiesa resterebbe piu spedita, e bella." ASF, CRS no. 89 (Santa Trinita), vol. 51, fol. 8v. "[S]pedito . . . privo di ostacoli naturali o di intoppi, aperto (un luogo, la campagna)." Salvatore Battaglia and Giorgio Bàrberi Squarotti, *Grande dizionario della lingua italiana* (Turin, 1961–2002), vol. 19, p. 792.

76 "Apresso il nostro coro tutto si mossa deluogho suo . . . diverso la capella delli spini." ASF, CRS no. 89 (Santa Trinita), vol. 50, fol. 99v.

77 Vasaturo, "Vallombrosa: ricerche d'archivio," pp. 130–31.

78 "essendosi fatto comprare [^in venetia] un tappeto di braccia 9⅔ lungo et largo braccia 5½ per mezzo di Pellegrino brunaccini fratello di D. Rettorio monacho del nostro ordine." ASF, CRS no. 89 (Santa Trinita), vol. 51, fol. 12v. For oriental rugs in Florentine churches,

see Marco Spallanzani, *Oriental Rugs in Renaissance Florence* (Florence, 2007), pp. 38–40. For oriental carpets in Venice, see Walter B. Denny, "Tessuti e tappeti orientali a Venezia," in *Venezia e l'Islam 828–1797*, ed. Stefano Carboni (Venice, 2007), pp. 185–205. The carpet had originally been intended as a kneeler for the duke, but since it was too large, the abbot decided that it should be requisitioned for the high altar, using funds from an existing bequest to purchase it.

79 Leoncini, "Il Cinquecento e il Seicento," p. 143. The miraculous cross of San Giovanni Gualberto was transferred from San Miniato al Monte to Santa Trinita in 1671 and was incorporated into the high altar scheme in architectural changes made by Giovanni Martino Portogalli in 1699.

80 "MDXLI Memoria chome adi primo di marzo Iacobo di M. Bongianni Gianfigliazi ci richiesa di fare uno bellissimo adornamento per il corpus domini e di locarlo nella cappella maggiore del Gianfigliazi." ASF, CRS no. 89 (Santa Trinita), vol. 50, fol. 49r.

81 "in Santa Trinita in su l'altare maggiore un ciborio a honore del santissimo sacramento tutto messo a oro come si vede con un velo pagonazzo di sopra, il quale fa trasparere quell'oro che fa il medesimo." Enrico Coppi, *Cronaca fiorentina, 1537–1555* (Florence, 2000), p. 78. The tabernacle was also recorded in the 1575 Visitation of Bishop of Camerino Alfonso Binnarini: "visitavit sanctum sacramentum in quodam tabernaculo ligneo deaurato supra altare maiori existens." Florence, Archivio arcivescovile, VP 12, fol. 49v.

82 "daccordo con Maestro Hoferini et Giovanbattista di Gian Pagolo da Cortona suo compagno, che ci faccino un' organo perfetto di 7 registri, et piu le sordine et tremolo et il 3° ordine et che il tastanne sia di 47 tasti, con suo pancone di prezzi perfetto, et mantici perfetti con loro cassa." ASF, CRS no. 89 (Santa Trinita), vol. 51, fol. 22v. I am grateful to John Nadas for his help in transcribing and translating this passage.

83 Gabriele Giacomelli, "Organi e simboli del potere a Firenze dalla repubblica al principato," in *Atti del Congresso Internazionale di Musica Sacra: in occasione del centenario di fondazione del Pontificio Istituto di Musica Sacra: Roma, 26 maggio – 1 giugno 2011*, ed. Antonio Addamiano and Francesco Luisi (Vatican City, 2013), p. 1070.

84 Morelli, "Per ornamento e servicio," p. 298.

85 "Ricordo come adi 14 di Gennaio 1571 l'Abate convenire daccordo con Maestro Baccio di Filippo Baglioni di Fare 2 pulpiti nelle colonne accanto l'Altare maggiore di noce … et habbino a essere proportionati alla nostra Chiesa sul modello di quelli della Madonna della pace … ASF, CRS no. 89 (Santa Trinita), vol. 51, fol. 22v.

86 "che vanno innanzi all'Altar grande per ornamento dell'accrescimento del pian dinanzi […] il basamento balustrato e l'or cimasa di marmo fine, bianco e bello." ASF, CRS no. 89 (Santa Trinita), vol. 51, fol. 31r. Contract dated 4 April 1574.

87 For the transfer to Santo Stefano, see Canali, "La basilica di Santa Trinita," pp. 193–95.

88 Bertoncini Sabatini, "La vicenda architettonica," p. 56.

89 The inscription reads D.O.M. ID OPUS ECCLESIAE DE CORI SACRORVMQ. COMMODO D. LAVR. ABB. ADDEN. CVR. MDLXXIIII.

90 Leoncini, "Altari in Santa Trinita," p. 107.

91 Giovannozzi claimed that a small sketch on a sheet related to the Baptistery renovation referred to the altar construction of Santa Trinita, complete with the two doors and pedimented attic above. Giovannozzi, "Ricerche su Bernardo Buontalenti," pp. 305 (fig. 4), 316.

92 See Gombrich, "The Sassetti Chapel Revisited," p. 13.

93 For San Pancrazio, see D. F. Tarani, *La badia di S. Pancrazio in Firenze* (Pescia, 1923); Marco Dezzi Bardeschi, "Il complesso monumentale di S. Pancrazio a Firenze ed il suo restauro," *Quaderni dell'Istituto di Storia dell'Architettura, serie XIII*, no. 73–78 (1966), pp. 1–66; Paatz and Paatz, *Kirchen von Florenz*, vol. 4, pp. 564–90.

94 Dezzi Bardeschi, "Il complesso monumentale," pp. 4–5.

95 Ibid., p. 5.

96 Ibid., p. 6.

97 Ibid., pp. 7–9, and for the building contracts, pp. 50–51.

98 For the Rucellai family, see F. W. Kent, *Household and Lineage in Renaissance Florence: The Family Life of the Capponi, Ginori and Rucellai* (Princeton, NJ, 2015).

99 Dezzi Bardeschi, "Il complesso monumentale," pp. 11–15.

100 Ibid., p. 4.

101 BNCF, Fondo Nazionale, II.I.126 (Sepoltuario fiorentino di Rosselli, Quartiere S. Maria Novella), fols. 198r–200v. Bocchi and Cinelli, *Le bellezze*, p. 206.

102 The 1507 description is in ASF, CRS no. 88 (San Pancrazio), vol. 68, fol. 92r and transcribed in Pacciani, "'Signorili amplitudini …' a Firenze," p. 162, note 76. Vasari erroneously attributed the polyptych to Agnolo Gaddi. The 1677 Bocchi-Cinelli guidebook noted that the polyptych was "posta dietro" the high altar, which Padoa Rizzo argues was also the location where Vasari recorded the altarpiece. She claims that another Bernardo Daddi altarpiece, now in New Orleans, was on the high altar until 1574. Most of the dismembered polyptych originally from the Duomo is in the Uffizi (N. Cat. 00284678), having been dismantled in 1767 and removed from San Pancrazio in 1808 when the church was deconsecrated. Vasari et al., *Le vite*, vol. 2, p. 246; Bocchi and Cinelli, *Le bellezze*, p. 204; Paatz and Paatz, *Kirchen von Florenz*, vol. 4, p. 573; Anna Padoa Rizzo, "Bernardo di Stefano Rosselli, il 'Polittico Ruccellai' e il polittico di San Pancrazio di Bernardo Daddi," *Studi di storia dell'arte* 4 (1993), pp. 213–15, 217 (doc. 4); Gardner, "Giotto in America," p. 166; Stefano G. Casu, "Bernardo Daddi," in *La fortuna dei primitivi: tesori d'arte dalle collezioni italiane fra sette e ottocento*, ed. Angelo Tartuferi and Gianluca Tormen (Florence, 2014), pp. 320–25; Francesco Borghero, "Il Polittico di Santa Reparata di Bernardo Daddi: Fonti notarili inedite sulla committenza e la datazione dell'opera," *Mitteilungen des*

Kunsthistorischen Institutes in Florenz 61, no. 2 (2019), p. 266. I am grateful to Laura Povinelli of the New Orleans Museum of Art for supplying information regarding the Daddi altarpiece in personal communication dated 18 November 2020.

103 John T. Paoletti, "Asserting Presence: Strategies of Medici Patronage in Renaissance Florence," in *Studies on Florence and the Italian Renaissance in Honour of F. W. Kent*, ed. Peter Howard and Cecilia Hewlett (Turnhout, 2016), pp. 90–91.

104 Pacciani, "'Signorili amplitudini . . .' a Firenze," p. 149; Emilia Latini, "La cappella del Santo Sepolcro nel complesso conventuale di San Pancrazio a Firenze," in *I Fiorentini alle crociate: guerre, pellegrinaggi e immaginario 'orientalistico' a Firenze tra medioevo ed età moderna*, ed. Silvia Agnoletti and Luca Mantelli (Florence, 2007), p. 272.

105 Dezzi Bardeschi, "Il complesso monumentale," p. 23.

106 Ibid., pp. 25–26.

107 Giorgio Galletti, "San Pancrazio: la vicenda storica e il suo recupero," in *Marino Marini: Museo San Pancrazio, Firenze*, ed. Carlo Pirovano (Milan, 1988), p. 207.

108 Ibid., p. 209. Paatz and Paatz, *Kirchen von Florenz*, vol. 4, p. 567.

109 Galletti, "San Pancrazio," pp. 209–10.

110 Anthony Molho, *Firenze nel Quattrocento* (Rome, 2006), pp. 58–59; Martines, *The Social World*, pp. 99–100; Kent, *The Rise of the Medici*, pp. 62–64. The Sesti were reorganized in 1343 into sixteen gonfalons. Najemy, *A History of Florence*, p. 121. Ronald F. E. Weissman, *Ritual Brotherhood in Renaissance Florence* (New York, 1982), p. 6.

111 Weissman, *Ritual Brotherhood*, p. 19. For gonfalons, see also Richard T. Lindholm, *Quantitative Studies of the Renaissance Florentine Economy and Society* (London and New York, 2017), pp. 97–126.

112 D. V. Kent and F. W. Kent, *Neighbours and Neighbourhood in Renaissance Florence: The District of the Red Lion in the Fifteenth Century* (Locust Valley, NY, 1982), pp. 141, 145–46.

113 Ibid., p. 155. ASF, CRS no. 88 (San Pancrazio), vol. 53, fol. 39v.

114 "Que arma debeant intarsiari in dicto coro, in illis locis prout videbitur condecens dictis sindicis vel eorum successoribus." Kent and Kent, *Neighbours and Neighbourhood*, pp. 155 and 169, note 86.

115 Carved shields (blank, perhaps painted) surmounted by mitres also appear on extant stall-ends, which were more likely to have been placed next to the hierarchically superior entrance stalls.

116 Kent and Kent, *Neighbours and Neighbourhood*, p. 75.

117 The choir currently has thirty-two stalls, of which eight were remade in 1645 following a fire. When the stalls were moved behind the high altar in Vallombrosa Abbey in 1700, four stalls were removed from each range. Alessandro Cecchi, "Gli arredi e i serramenti lignei e in ferro battuto," in *Vallombrosa: santo e meraviglioso luogo*, ed. Roberto Paolo Ciardi (Florence, 1999), pp. 242–43, note 11.

118 Kent and Kent, *Neighbours and Neighbourhood*, p. 96, note 3. Del Serra's life of Biagio Milanesi, Abbot General of the Vallombrosan congregation, describes laymen meeting in the Strozzi choir in 1488 ("adunati in choro della sagrestia"). Gombrich, "The Sassetti Chapel Revisited," p. 29.

119 Cecchi, "Maestri d'intaglio," pp. 222–23. The inscription reads: HOC HOPUS FECIT FRANCISCUS DE PODIOBONZI. A note in the fabbrica records of San Pancrazio reads: "Choro nuovo: Ricordo chome nell'anno 1445 e parte del 1446 si fece il choro della chiesa diquesto nostro monastero che ne fu il maestro Francesco di Nanni da Pogibonizi." ASF, CRS no. 88 (San Pancrazio), vol. 63, fol. 4v. Haines characterized the extant stalls as rather archaic, with fine carving but minimally impactful intarsia panels.

120 Haines, *Sacrestia delle Messe*, pp. 52–53.

121 ASF, CRS no. 88 (San Pancrazio), vol. 57, fol. 1r. Transcribed in Milanesi, *Nuovi documenti*, pp. 114–15. The document is undated. Giovanni di Domenico da Gaiuole also worked in the Sagrestia delle Messe in the Duomo in 1463 and on the stalls of San Miniato al Monte in 1466. See Haines, *Sacrestia delle Messe*, p. 136.

122 Kent and Kent, *Neighbours and Neighbourhood*, p. 157.

123 Haines, *Sacrestia delle Messe*, p. 53, note 14.

124 Kent and Kent, *Neighbours and Neighbourhood*, p. 157.

125 Dezzi Bardeschi, "Il complesso monumentale," p. 12. One of the windows was the prominent oculus above the main door of the facade, seen in Pinamonti's 1585 drawing of the exterior of the church. Kent and Kent, *Neighbours and Neighbourhood*, p. 158.

126 Rosselli notes another shield bearing a lion rampant perhaps representing a further demonstration of Lion Rosso patronage. "Sopr'alla porta di sagrestia, arme di pietra entrovi leon rampante in campo rosso." BNCF, Fondo Nazionale, II.I.126 (Sepoltuario fiorentino di Rosselli, Quartiere S. Maria Novella), fol. 196v. Tarani stated that the arms show a lion rampant on a blue ground. Tarani, *La badia di S. Pancrazio*, p. 61.

127 Pacciani, "'Signorili amplitudini . . .' a Firenze," p. 146, fig. 1.

128 Pope Urban VI fixed the feast of the Visitation as 2 July in 1389. Stephanie Budwey, *Sing of Mary: Giving Voice to Marian Theology and Devotion* (Collegeville, MN, 2014), p. 80.

129 The boys' confraternity of the Archangel Raphael in Florence celebrated their patron saint on 31 December. Konrad Eisenbichler, *The Boys of the Archangel Raphael: A Youth Confraternity in Florence, 1411–1785* (Toronto, 1998), pp. 150–51.

130 "Ricordo chome oggi questo dì 21 di maggio 1490 Messer Vincenzo . . . Abbate di Santo Pancrazio di Firenze doto l'altare appoggiato al choro grande a man ritta intitolato della Vergine Maria e de l'Agnolo Raphaello . . ." ASF, CRS no. 88 (San Pancrazio), vol. 65, fol. 36r. See also Dezzi Bardeschi, "Il complesso monumentale," p. 45, note 99; Pacciani, "'Signorili amplitudini . . .' a Firenze," p. 145, note 35. Pacciani

suggested that there was a further Rucellai chapel dedicated to St. Bernard on the left side of the screen, described as "next to the gates" ("capella di San Bernardo presso le reggi"). Pacciani speculated that "[s]i tratta forse di un altare accostato alla sinistra dell'entrata del 'coro grande'." Ibid., p. 145, note 35. Marcia Hall has shown that the term "reggi," cited by Vincenzo Borghini in his *Discorsi*, refers to tramezzo doors, which could be left open or closed depending on the liturgical circumstances. Hall, "The Tramezzo in Santa Croce," pp. 325, note 4, 339. Dezzi Bardeschi noted that in 1400 Matteo Rucellai left 200 florins for a chapel of San Bernardo, which was still under construction in 1448. A further donation to the chapel, however, specified its location "under the vaults" ("sotto le volte"), likely indicating the extensive subterranean burial ground beneath San Pancrazio. Dezzi Bardeschi, "Il complesso monumentale," p. 40, notes 32, 49.

131 A note at the end of the document recording the farm purchase reads "E di detto podere ne oblighato el terzo alla chappella della vergine maria e dell'agnolo Raphaello la quale a dotato l'abbate Vincenzio." ASF, CRS no. 88 (San Pancrazio), vol. 65, fol. 35v. See also Tarani, *La badia di S. Pancrazio*, p. 20. Although the angelic connection could have been a reference to the origin of the chapel's funding, the church of Sant'Agnolo at Legnaia is dedicated to Michael not Raphael. www.santangeloalegnaia.it/.

132 The organist Ser Zanobi di Giovanni Lenzi was employed to play the organ on the feast days of those saints honored with chapels in San Pancrazio, listed in calendar order, including "del'agnolo raffaello." ASF, CRS no. 88 (San Pancrazio), vol. 65, fol. 37v.

133 "Mori detto abbate vincentio adi 5 di maggio 1491 et e sotterato nella sepoltura di marmo sotto al perghamo." ASF, CRS no. 88 (San Pancrazio), vol. 65, fol. 36r.

134 For example, Cima da Conegliano's *Adoration of the Shepherds* in Santa Maria dei Carmini in Venice, dated c. 1511. Joseph Hammond, "The Cult and Representation of the Archangel Raphael in Sixteenth-Century Venice," *St. Andrews University Journal of Art History and Museum Studies* 15 (2011), pp. 79–88.

135 "E dicto dare per una ancona detrovi la Madonna e l'Angiolo Raffaello con suo ornamento, andò a Vallombrosa e servi per la cappella di fuora lire trecento al dicto." Dated 1574. ASF, CRS no. 260 (Vallombrosa), vol. 26, fol. 331r.

136 For the altars, see Lucia Aquino and Grazia Badino, "Due legnaioli e un pittore per San Michele Arcangelo a Passignano nel Cinquecento: Bastiano Confetto, Michele Tosini e L'Atticciato," in *Passignano in Val di Pesa: un monastero e la sua storia. 2, Arte nella Chiesa di San Michele Arcangelo (sec. XV–XIX)*, ed. Italo Moretti (Florence, 2014), pp. 128–30.

137 Hall, "The Tramezzo in Santa Croce," p. 326, figure 1. In San Francesco in Pistoia, a chapel dedicated to the Angels was probably attached to the right nave side wall near the tramezzo. Andreini et al., "I cicli costruttivi,"

pp. 60, 63. Screens in the West Country of England also sometimes featured images of archangels: see the examples in Hugh Harrison and Jeffrey West, "West Country Rood Screens: Construction and Practice," in *The Art and Science of the Church Screen in Medieval Europe: Making, Meaning, Preserving*, ed. Spike Bucklow, Richard Marks, and Lucy Wrapson (Woodbridge, 2017), pp. 144, 146.

138 Meredith Gill, *Angels and the Order of Heaven in Medieval and Renaissance Italy* (New York, 2014), especially pp. 178, 186, 191. A youth confraternity performed a Nativity play in San Pancrazio in 1430, which was attended by the Florentine *Signoria* and Pope Eugenius IV, who was so impressed that he granted the boys a permanent home and assigned them the patron saint Raphael. Eisenbichler, *The Boys of the Archangel Raphael*, p. 30.

139 Gill, *Angels*, p. 24.

140 Morselli, following Milanesi, identified the Abbot as Vincenzo Trinci, but Tarani states that the name was Conci. Piero Morselli, "Il pulpito del quattrocento già in San Pancrazio di Firenze," *Antichità viva* 18, no. 5/6 (1979), p. 30; Milanesi, *Nuovi documenti*, p. 153; Tarani, *La badia di S. Pancrazio*, p. 56.

141 "sub modulo et forma perghami ecclesie Sancte Marie Maioris de Florentia, cum quinque faciis et guera et colonnellis." Milanesi, *Nuovi documenti*, p. 153. For the lost pulpit of Santa Maria Maggiore, see Piero Morselli, "Corpus of Tuscan Pulpits 1400–1550" (PhD thesis, University of Pittsburgh, 1979), pp. 157–59.

142 Michela Young made this archival discovery and shared it with me in personal communication dated 25 February 2021, for which I am extremely grateful. Documents dated 1600 that track this relocation can be found in ASF, CRS no. 88 (San Pancrazio), vol. 71, fols. 5r–7r. Rosselli saw the pulpit near the left side door: "Passato il detto sepolcro segue il pulpito di marmo entrovi la medesima arme che è nel sepolcro di D. Vincenzo Abbate." BNCF, Fondo Nazionale, II.I.126 (Sepoltuario fiorentino di Rosselli, Quartiere S. Maria Novella), fol. 196r. Morselli argued that the pulpit was between the two Rucellai chapels and Pacciani placed it on the column of the St. Jerome chapel.

143 BNCF, Fondo Nazionale, II.I.126 (Sepoltuario fiorentino di Rosselli, Quartiere S. Maria Novella), fol. 196r.

144 The heraldry seen today on the front face of the pulpit belongs to Riccardi. Morselli, "Il pulpito del quattrocento," p. 30. I am grateful to the parish priest of San Michele for giving me access to this church.

145 Ibid., pp. 30–31, figs. 1–2.

146 "fare una porta dinanzi al coro con uno arco di sopra, lavorata tutta di noce … di sopra detto arco un Crocifisso di legname." Milanesi, *Sulla storia dell'arte toscana*, p. 353, Document 1, transcribed from ASF, CRS no. 88 (San Pancrazio), vol. 68, fols. 13v–14r. For the Del Tasso family of woodworkers, see Traversi, "Per i Del Tasso," pp. 95–103. Paatz and Paatz mistakenly

dated the woodwork to 1488. Paatz and Paatz, *Kirchen von Florenz*, vol. 4, p. 573.

147 Chimenti del Tasso had previously completed intarsiated choir stalls in the Minerbetti sacristy chapel in San Pancrazio. Milanesi, *Sulla storia dell'arte toscana*, p. 344; Dezzi Bardeschi, "Il complesso monumentale," p. 26; Tarani, *La badia di S. Pancrazio*, p. 18.

148 "La porta del coro con l'arco e con el crocifixo sopra aditto arco fecie fare la badia e pero vi posto l'arme dei dette badia di San Pancrazio." ASF, CRS no. 88 (San Pancrazio), vol. 68, fol. 93r.

149 Traversi, "Per i Del Tasso," pp. 95–103.

150 For another example of a choir screen being moved to the counter-facade, in this case in San Pietro in Perugia, see Gardner von Teuffel, "Perugino's Cassinese Ascension," p. 125.

151 The inscription reads: HOC OPUS FECTI FIERI OMNIS CONFRATERNITAS VIRGINIS MARIE ET SANCTI IOHANNIS GUALBERTI PRIMI ABBATIS VALLE TEMPORE DOMINI D. BLASII GENERALIS DIGNISSIMI ANNO DOMINI MCCCCLXXXVII MENSE OTTOBRIS DEO MAXIMO ET DIVE MARIE MADALENE PHILIPPUS FRANCISCE DE MELANENSIBUS CIVIS FLORENTINUS OB RELIGIONEM MORI POSUIT. Roberto Paolo Ciardi, "I Vallombrosani e le arti figurative. Qualche traccia e varie ipotesi," in *Vallombrosa: santo e meraviglioso luogo*, ed. Roberto Paolo Ciardi (Florence, 1999), p. 60. Gardner von Teuffel noted that this family strongly supported the Vallombrosan Order: Filippo left funds for the confraternity in his testament. Christa Gardner von Teuffel, "The Contract for Perugino's 'Assumption of the Virgin' at Vallombrosa," *The Burlington Magazine* 137, no. 1106 (1995), p. 312, Document 5.

152 Ciardi, "I Vallombrosani," p. 62. For the Minerbetti tomb, see Paatz and Paatz, *Kirchen von Florenz*, vol. 4, p. 572.

153 "Fecesi l'anno 1500 una tavola per l'altare maggiore di Vallombrosa recipienti á quel luogo, e forse in qualunque citta; e due altre per altari sotto il choro da non esser dispregiate in luogo alcuno, in honore di San Gio. Gualberto." BNCF, CS (Conventi soppressi), A. VIII. 1399 (Vita di Don Biagio del Milanese), p. 149. See also Francesca Carrara, *L'Abbazia di Vallombrosa* (Florence, 2015), p. 44. Gardner von Teuffel discovered archival documents which elaborate upon Don Biagio's patronage, concluding that "the persistent intervention of the patron, Don Biagio, becomes palpable." Gardner von Teuffel, "The Contract," p. 311.

154 18 May 1700: "Si levarono pure gli altari che stavano dietro alle prospere dell'abate e padre decano, conservando di detti solo le pitture e le pietre sacrate, del resto non si trovò alcuna cosa degna di memoria, si disfece' il sopradetto tramezzo con molta diligenza per conservare quei pietrami, ben lavorati quali collocarono dalla porta di chiesa per di dentro." ASF, CRS no. 260 (Vallombrosa), vol. 143, fol. 87r. Vasaturo, "Vallombrosa: ricerche d'archivio," p. 9.

155 Leoncini has suggested that the tramezzo and choir survived in Passignano because there was a separate church for the laity, San Biagio. Leoncini, "Altari in Santa Trinita," p. 106.

156 Ungaro was abbot four times, but an archival source published by Lucia Aquino demonstrates that the choir was erected during his third abbacy (from 1549). Aquino and Badino, "Due legnaioli," p. 119.

157 The left (north) range exhibits a Greek inscription corresponding to Psalm 134: 2–3, while the Hebrew inscription on the opposite range is from Psalm 150: 6. Ibid., p. 127.

158 Ibid., p. 117.

159 Milanesi, *Sulla storia dell'arte toscana*, p. 344; Dezzi Bardeschi, "Il complesso monumentale," p. 26; Tarani, *La badia di S. Pancrazio*, p. 18. In October 1489, Madonna Bartolomea left funds "aspendere inornamenti della chapella de'sagresia di detti minerbetti" (ASF, CRS no. 88 (San Pancrazio), vol. 65, fol. 34v), and in April 1490, Chimenti was paid "fare uno choro nelle chappelle e sagrestia di detti minerbetti" (ASF, CRS no. 88 (San Pancrazio), vol. 1, 121v).

160 "Et dipoi l'anno 1484, si rimosse l'altare maggiore che era apresso al muro sotto la finestra braccia tre: & fu posto & ricollocato innanzi presso alla scale: accioche e monachi potessino cantare la messa e l'officio drieto a decto altare." ASF, CRS no. 88 (San Pancrazio), vol. 68, fol. 57v. See also Brown, "The Tribuna," p. 262, note 163. Tarani, *La badia di S. Pancrazio*, p. 43.

161 Pacciani, "'Signorili amplitudini . . .' a Firenze," p. 159.

162 "venerdi adi 10 di gugnio 1485 da Pandolfo di Giovanni Rucellai [. . .] si pagorono per fare el coro altare magiore." ASF, CRS no. 88 (San Pancrazio), vol. 1, fol. 36r. Rosselli gave both the dates 20th and 28th August for the consecration: BNCF, Fondo Nazionale, II.I.126 (Sepoltuario fiorentino di Rosselli, Quartiere S. Maria Novella), fol. 195v. Pacciani, "'Signorili amplitudini . . .' a Firenze," p. 158.

163 Vasaturo, *Vallombrosa: L'abbazia*, pp. 136–37; Walden, "Foaming Mouth and Eyes Aflame," pp. 111–15.

164 Vasaturo, *Vallombrosa: L'abbazia*, p. 137. In 1486, 8 cardinals conceded 100 days of indulgence to whoever attended San Pancrazio on certain feast days. Tarani, *La badia di S. Pancrazio*, p. 28.

165 "un choro che detto Pandolfo aveva chominciato più tempo fa dietro il altare maggiore e così una tavola d'altare che l'aveva Bernando Rosegli dipintore." ASF, CRS no. 88 (San Pancrazio), vol. 2, fol. 65r.

166 Padoa Rizzo, "Bernardo di Stefano Rosselli," pp. 211–22. She argued that the New Orleans altarpiece was on the high altar in San Pancrazio before being transferred to the altar of the Rucellai Holy Sepulcher Chapel during the alterations of 1574, and that during the period of roughly 1507–68 the larger Daddi altarpiece originally from the Duomo was displayed in the retrochoir, under the Gothic window of the apse.

167 "e perché io vi feci agiungniere certe tarsie e cornice." ASF, CRS no. 88 (San Pancrazio), vol. 2, fol. 65r.

168 "Di poi ad contemplatione et contento di alcunj cittadini popolarj et devote persone si rimuto decto altare et collocossi nel mezo di decta capella." ASF, CRS no. 88 (San Pancrazio), vol. 68, fol. 57v. A payment record for this work is dated 1 November 1506. ASF, CRS no. 88 (San Pancrazio), vol. 2, fol. 136v. See also Kent and Kent, *Neighbours and Neighbourhood*, p 134; Pacciani, "'Signorili amplitudini . . .' a Firenze," p. 160.

169 "poiche era mal chollocato e non mostrava eminenzia nella chiesa e in detta chappella pero si translato e posesi nel mezzo dove risiede in tutte le parti eminentemente." Pacciani, "'Signorili amplitudini . . .' a Firenze," p. 162, note 76. From ASF, CRS no. 88 (San Pancrazio), vol. 68, fols. 91r–93v.

170 "passò che si dovesse fare impianellare la chiesa cioè il tetto di quella, e fargli la soffitta, e condurvi il choro di S. Pancrazio d Fiorenza." ASF, CRS no. 260 (Vallombrosa), vol. 145, fol. 2r. For Don Arsenio da Poppi, see Eudosio Locatelli, *Vita del glorioso padre San Giouangualberto fondatore dell'ordine di Vallombrosa* (Florence, 1583), pp. 324–25.

171 "che per tutte le chiese di firenze s'erano levati i chori del mezo di dette chiese, e s'erano ridotti all'uffiziare dietro all'altare maggiore." ASF, CRS no. 88 (San Pancrazio), vol. 70, fol. 121v.

172 Leoncini also noted the close dating of these two similar activities in two churches of close proximity belonging to the same monastic administration. Leoncini, "Altari in Santa Trinita," p. 107.

173 "quali erano visti da tutto il popolo con non molta edificatione loro, e con poca satisfazione nostra." ASF, CRS no. 88 (San Pancrazio), vol. 70, fol. 121v.

174 "poter levare il coro quale era in Chiesa, perche era di grandissimo impedimento a detta, e perche dreto adetto, si facevano da secolari molte cose impertinenti et inhoneste." ASF, CRS no. 88 (San Pancrazio), vol. 70, fol. 123v. Tarani states that the reason the choir was removed was that there was insufficient space for it behind the high altar. Tarani, *La badia di S. Pancrazio*, p. 44.

175 "fu liberamente concesso da Sua Altezza che si levassi, e mandassi a Vallombrosa." ASF, CRS no. 88 (San Pancrazio), vol. 70, fol. 123v.

176 "per parte di ricompensa scudi centoventicinque e barili quarantotto di buon vino." Ibid.

177 See Cecchi, "Gli arredi," p. 242, note 6.

178 "levare il coro di Santo Pancrazio." ASF, CRS no. 260 (Vallombrosa), vol. 191, fol. 138a.

179 "per il coro che disfece di San Pancrazio per mandarlo a Vallombrosa." ASF, CRS no. 260 (Vallombrosa), vol. 182, fol. 47b.

180 Cecchi, "Gli arredi," p. 244.

181 Ibid., p. 242.

182 Ibid., p. 245.

183 According to Tarani, in the same year Domenico Poggini sculpted two life-sized marble statues personifying the old law and the law of grace placed at the sides of triumphal arch, which Paatz and Paatz stated were relocated to the new facade wall of the reduced-scale church after its deconsecration. Tarani, *La badia di S. Pancrazio*, p. 51; Paatz and Paatz, *Kirchen von Florenz*, vol. 4, pp. 573, 576. For Domenico Poggini, see Hildegard Utz, "Sculptures by Domenico Poggini," *Metropolitan Museum Journal* 10 (1975), pp. 63–78.

184 "Spese fatte intirare l'Altare maggiore inanzi." ASF, CRS no. 88 (San Pancrazio), vol. 6, fol. 120r.

185 ASF, CRS no. 88 (San Pancrazio), vol. 6, fol. 120r. Dated 24 March and 2 April 1574.

186 "Campanella . . . anello di metallo . . . per montare tende scorrevoli." Battaglia and Bàrberi Squarotti, *Grande dizionario*, vol. 2, p. 598.

187 "nove braccia di frangia . . . 24 campanelle . . . otto braccia di nastro azzurro . . . tutto servi per le dicte tende." Dated 24 March 1574. ASF, CRS no. 88 (San Pancrazio), vol. 6, fol. 120r.

188 "A cinque facchini che portorno il leggio di coro dreto all'altare maggiore." Dated 24 March 1574. ASF, CRS no. 88 (San Pancrazio), vol. 6, fol. 120r.

189 "A far dipingere sotto l'altare, et le tende del coro." Dated 19 April 1574. ASF, CRS no. 88 (San Pancrazio), vol. 6, fol. 120r.

190 "imbianchare tutta la nostra chiesa." ASF, CRS no. 88 (San Pancrazio), vol. 31, fol. 116v.

191 ASF, CRS no. 88 (San Pancrazio), vol. 70, fol. 124r–v (dated 1574). For the ciborium, see Richa, *Notizie istoriche*, vol. 3, p. 322; Paatz and Paatz, *Kirchen von Florenz*, vol. 4, p. 573.

192 "tirar detto Altare inanzi acciò de piu comodamente si potesse habitar di dieto per star quivi a uffiziare, havendo noi di già levato il choro di mezo la chiesa." ASF, CRS no. 88 (San Pancrazio), vol. 70, fol. 124r. Rosselli noted the Giocondo arms on the altar: "Nell altare di questa cappella maggiore e l'arme scolpita in pietra la quale credo sia della famiglia del Giocondo." BNCF, Fondo Nazionale, II.I.126 (Sepoltuario fiorentino di Rosselli, Quartiere S. Maria Novella), fol. 196r.

193 "soddisfatissimi d'ogni cosa, e massime del bellissimo ciborio che è in sul l'altare e dell'essere tenuto il santissimo sacramento della eucharestia." ASF, CRS no. 88 (San Pancrazio), vol. 70, fol. 126r.

194 Of the eleven altars listed in the Visitation, five were ordered to be improved in some way; seated confessionals were also mandated. Florence, Archivio arcivescovile, VP. 12, fols. 97v–99v.

195 For increased centralization of the Florentine state, see Litchfield, *Emergence of a Bureaucracy*, pp. 84–109; David Rosenthal, *Kings of the Street: Power, Community, and Ritual in Renaissance Florence* (Turnhout, 2015), p. 82; Van Veen, *Cosimo I de' Medici*, pp. 54–67.

196 Weissman, *Ritual Brotherhood*, pp. 195–233.

Chapter 6

GENDER AND CEREMONY IN THE NUNS' CHURCH

San Pier Maggiore

IN 1565, ONE OF THE NUNS of the elite Benedictine convent of San Pier Maggiore in Florence, Suor Colombe, died at the age of thirty-one. Held on the day following her death, her funeral was a magnificent event. Joining the nuns' regular church chaplains were priests from the other high-ranking convents of Sant'Ambrogio and Santa Felicita, and representatives from around a dozen Florentine religious institutions. For this special occasion, the church glittered with candles, and two tabernacle constructions were erected, one "in the choir above and one in the choir below over her body,"[1] indicating that two choir areas reserved for religious women and men respectively were utilized for this lavish ceremony.

Now destroyed, the church of San Pier Maggiore, a female Benedictine convent with parish responsibilities, was divided into distinct spatial zones articulated according to hierarchy and gender (Figures 143 and 144). In this Gothic church, a nuns' choir balcony was located at the eastern end of the south nave aisle, while the "coro degli uomini" – the men's choir precinct – dominated the center of the nave. The upkeep of the nave choir precinct was specifically assigned to the operai, or works committee, showing that laymen held a prominent administrative – and physical – place in the church. One of its attached chapels, dedicated to the pregnant Madonna ("La Gravida") implies that its location, on the left side of the lower nave, was associated with laywomen. In February 1569, Cosimo I de' Medici ordered the removal of the men's choir, which reoriented the carefully composed multifunctionality and spatial dynamics of the church, creating a more open interior focused on the high chapel, where visual emphasis centered on a Eucharistic tabernacle.

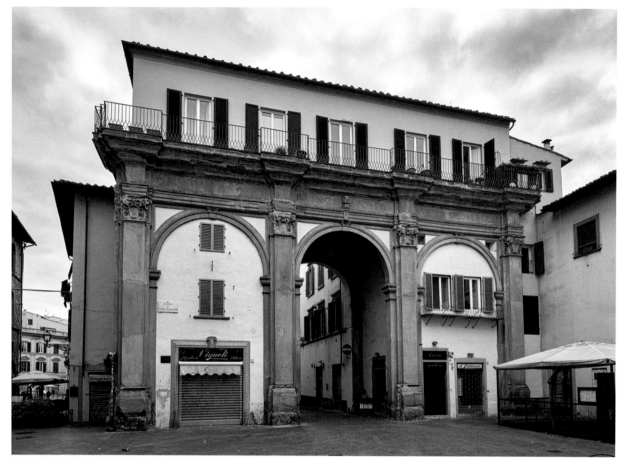

Figure 143 Piazza di San Pier Maggiore, Florence. View toward east showing loggia of destroyed church by Matteo Nigetti (1638). Photo: Michael G. Gromotka

San Pier Maggiore has rarely been included in art-historical investigations of the broader Florentine church renovation schemes of the late sixteenth century, and I present a reconstruction of its interior furnishings here for the first time. Although the church fabric no longer survives, the institution's rich archive is well preserved. Detailed Pastoral Visitation records from 1509 and 1575, now housed in Florence's Archivio Arcivescovile, provide information about the community's population and chapel dedications. Along with Stefano Rosselli's seventeenth-century Sepoltuario, documents from the nuns' convent, registries of chapels, and one volume from the archive of the lay operai, which recounts the removal of the men's choir and associated chapels, aid our understanding of the church's appearance and furnishings prior to its destruction.

THE CIVIC ROLE AND STATUS OF SAN PIER MAGGIORE

As the third convent founded in Florence, probably c. 1000, San Pier Maggiore was first officially recorded in 1067 when Ghisla Firidolfi donated property to the institution and became its first abbess.[2] In the 1427 Catasto tax survey, San Pier Maggiore was listed as the wealthiest female convent in the city, receiving a high income from its large portfolio of

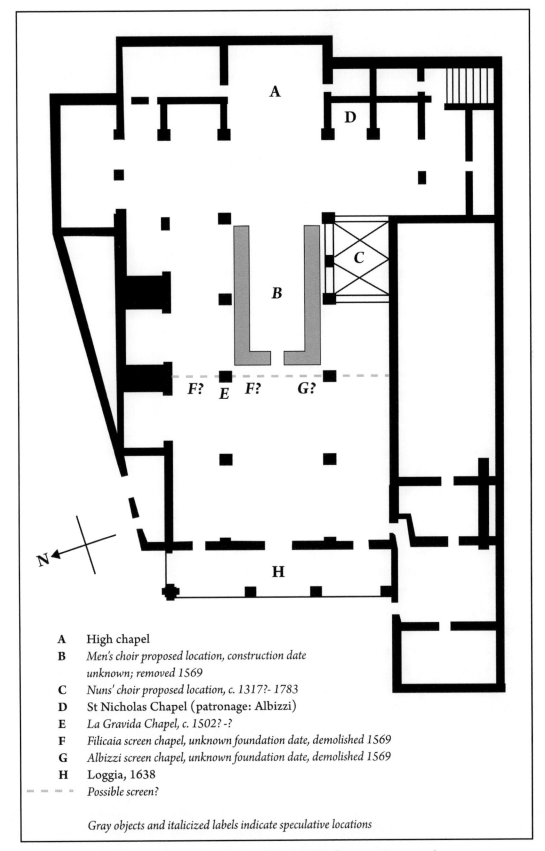

A High chapel
B *Men's choir proposed location, construction date*
 unknown; removed 1569
C *Nuns' choir proposed location, c. 1317?- 1783*
D St Nicholas Chapel (patronage: Albizzi)
E *La Gravida Chapel, c. 1502? -?*
F *Filicaia screen chapel, unknown foundation date, demolished 1569*
G *Albizzi screen chapel, unknown foundation date, demolished 1569*
H Loggia, 1638
- - - *Possible screen?*

Gray objects and italicized labels indicate speculative locations

Figure 144 San Pier Maggiore, Florence, proposed plan of the church before 1569. Image: author

commercial property located within its own parish and the Tuscan countryside.[3] Bringing with them substantial monastic dowries, the convent's nuns came from high-status, wealthy families. The San Pier Maggiore nuns were also the first in Florence to demand exemption from strict enclosure requirements, granted by Bishop Lotterio della Tosa in 1304, although this was challenged by subsequent incumbents.[4]

Officially the number of nuns at San Pier Maggiore was capped at an apostolic twelve, but seventeen were recorded in 1427 and twenty plus the abbess in 1509, together with twenty-four chaplains, a prior, and ten beneficed clerics.[5] In a Florentine census conducted in c. 1525, seventy-nine persons were registered in total: forty-five veiled nuns, five servant nuns, twelve chaplains, fourteen *chierici* (unordained assistants), one prior, one porter, and one master of *chierici*.[6] In comparison to the other Benedictine convents documented in this census, San Pier Maggiore had fewer nuns but the most number of chaplains, who were required to service the numerous private chapels in the church.[7] Indeed, in the fifteenth century, priests administered forty-four mass cycles annually.[8] Demonstrating the high quality of musical and liturgical performance in the church, a combined antiphonary and gradual illustrated with eight large miniatures, dated stylistically to c. 1385 and now in the Walters Art Museum in Baltimore (MS W. 153) is widely believed to have originated from San Pier Maggiore (Figure 145).[9] The Walters manuscript was likely produced for the Albizzi Chapel dedicated to St. Nicholas, situated to the right of the high altar (D on Figure 144).[10] Dale Hoover noted that the musical setting for two alternating groups of male singers ("cantores") was high quality and complex, while the textual content of the Matins service indicates that it was intended to be performed in a public setting.[11]

San Pier Maggiore was an important site in Florence for civic ritual, history, and identity. Its prominent location within the first circle of medieval walls on the present-day Borgo degli Albizzi – a continuation of the ancient east-west Decumanus street of ancient Roman Florentia – reveals its significance within the urban fabric. Florence's first bishop, St. Zenobius, is reputed to have resuscitated the young son of a French pilgrim on Borgo degli Albizzi, linking the church to one of the city patron's most celebrated miracles.[12] Late twelfth- and early-thirteenth-century liturgical manuscripts from Florence's medieval cathedral of Santa Reparata show that the cathedral canons performed four annual processions to San Pier Maggiore.[13] One of these occasions, the 29 June patronal festival of St. Peter, held distinct civic and religious importance, particularly following the Florentine victory over the Milanese at Anghiari in 1440, which occurred on this feast day (see also the impact of this event in the Carmine in Chapter 4).[14] A spectacular procession of the magistrates to the church, together with the poor people they had clothed in honor of the celebration, was followed by a sumptuous banquet in the convent.

The prestigious role of San Pier Maggiore within Florentine civic ritual was forged by the entry rite or *Entrata* of the bishop of Florence, who symbolically "married" the Benedictine abbess in a lavish ceremony.[15] Documented between 1286 and 1583, the entry of a new bishop (or after 1419, archbishop) to the city was, according to Sharon Strocchia, a highly politicized act in which the bishop took possession of his see in imitation of the bridegroom's possession of his bride.[16] Maureen Miller argued that the marriage in effect "domesticated" the bishop, who in the Middle Ages, was often from a non-Florentine background.[17] In its Trecento manifestation, the bishop would first enter the city at one of its southern gates, and accompanied by clerics and laymen, ride on horseback toward the Piazza San Pier Maggiore. There, the bishop would gift the

Figure 145 Cenni di Francesco, *Antiphonary and Gradual*, c. 1385, parchment, folio: 60.5 × 41.8 cm. Walters Art Museum, Baltimore, W.153, fol. 35v. Photo: The Walters Art Museum, Baltimore

horse to the nuns (but not its ceremonial harness, which would be given to another family),[18] and the nuns would later counter-gift a matrimonial bed specially manufactured for the occasion. Within the chapter room, the bishop, seated together with the abbess on a double throne, placed a sapphire ring on her finger. In 1473, Pietro Riario restored the symbolic marriage (which had been suspended by his predecessor Orlando Bonarli), relocating the ring ceremony from the chapter room to the more public cappella maggiore, and introducing a lay sponsor to present the hand of the abbess.[19]

Following the ceremony, the bishop would then enter the conventual spaces, share a sumptuous banquet with the nuns and invited guests, and spend the night in the convent in the nuptial bed as a symbol of marital consummation. The next day he would make his way barefoot toward the archbishop's palace in the Piazza del Duomo, stopping on his way to venerate various holy sites, including the location on Borgo degli Albizzi where St. Zenobius was believed to have healed the young boy.[20]

THE SPATIAL LAYOUT OF THE CHURCH

The antiquarian writers Stefano Rosselli and Giuseppe Richa claimed that a church had existed on the site since the fourth-century miracle of St. Zenobius.[21] While Rosselli argued for three rebuildings of the church, Richa enumerated five occasions when the building was altered or enlarged.[22] In the final Gothic church (1304–52), a three-aisled unvaulted nave of four bays articulated by square piers and shallow pointed arcading led to a transept, the cappella maggiore, and four rectangular, vaulted choir chapels (Figure 146).[23] In the fifteenth century, a sacristy was constructed to the northeast of the church, together with a large chapel ("cappellone") built for the Alessandri family, who were relatives of the Albizzi.[24] Bietti Favi has shown that the early sixteenth century witnessed

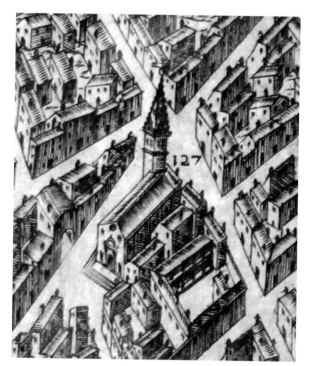

Figure 146 Stefano Buonsignori, *Nova pulcherrimae civitatis Florentiae topographia accuratissime delineata* (detail of San Pier Maggiore), 1594 (first drafted 1584), engraving, overall map: 123 × 138 cm. Photo: Sailko/Francesco Bini

flourishing architectural activity at San Pier Maggiore with the addition of a series of vaulted chapels adjoining the left nave aisle, and to the south of the church, a cloister by Baccio d'Agnolo.[25]

Several high-status families lived in the San Pier Maggiore parish and became patrons of the church, including the Albizzi, Alessandri, Pazzi, Filicaia, and Palmieri.[26] Adorning these family chapels, altarpieces by Botticini, Perugino, Franciabigio, Lorenzo di Credi, Granacci, and others – now dispersed in various European collections – created a vibrant and colorful interior.[27] Following the Medicean renovations to be discussed later in this chapter, in 1612–15, the high chapel was rebuilt in a baroque style designed by architect Gherardo Silvani at the behest of the Ximenes family, who had recently been granted patronage rights over the space (A on Figure 144).[28] In 1638, Luca degli Albizzi financed the classicizing triple-arched entrance loggia by Matteo Nigetti (H on Figure 144).[29] After one of the Gothic piers collapsed during a restoration in 1783, the church was largely demolished.[30] Utilizing geographic information system (GIS) mapping, photogrammetry, and augmented reality, a new three-dimensional virtual reconstruction visualizes the lost church within the fabric of contemporary Florence. In addition to the surviving entrance loggia, this project has discovered fragments of arches, piers, and the spiral campanile staircase that still exist embedded into the surrounding nineteenth-century urban fabric.[31]

Within the church, perhaps the most impressive work of art was its high altarpiece.[32] In the early 1370s, the nuns commissioned one of the largest known polyptychs made in Trecento Florence from Jacopo di Cione and his workshop, the main panels of which are now housed in the National Gallery in London (Figure 147).[33] Depicting the *Coronation of the Virgin* in its central panel, the attendant saints on the side panels held resonance for the city of Florence, the

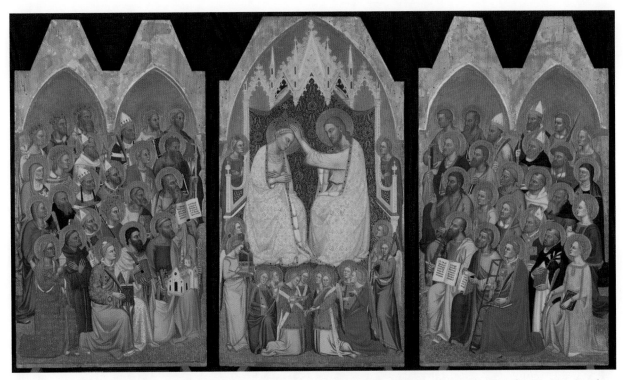

Figure 147 Jacopo di Cione. *The Coronation of the Virgin: Central Main Tier Panel; Adoring Saints: Left Main Tier Panel; Adoring Saints: Right Main Tier Panel.* 1370–71. Tempera on wood, central panel: 206.5 × 113.5 cm; each side panel: 169 × 113 cm. National Gallery, London. Photo: © The National Gallery, London

church, and the nuns themselves.[34] Dillian Gordon concluded that the patrons were "almost certainly" members of the Albizzi family, possibly in consortium.[35] Strehlke argued that the Albizzi may have wanted to demonstrate a connection to their cousin, Bishop of Florence Pietro Corsini (in office 1363–70), given the role the convent played in the archbishop's investiture rite.[36] Gail Solberg emphasized the pro-papal message of the altarpiece's iconography in a church dedicated to St. Peter, and noted that the heavenly pairing of Christ and the Virgin in the Coronation would have echoed the fictive marriage ceremony of the archbishop and abbess.[37]

The Nuns' Choir

In archival sources, the nuns' choir was either termed the "coro delle donne" or the "coro delle monache." A plan and elevation drawing of San

Pier Maggiore, roughly dated to the eighteenth century, shows that the nun's choir – clearly labeled "coro delle monache" – was a raised balcony structure at the eastern extreme of the south nave aisle (on the right when facing the high altar), thus adjacent to the convent (C on Figure 144; Figures 148 and 149).[38] The balcony was sustained by a column and two arches, while the choir itself was enclosed by a latticed grille.[39]

The first reference to the "coro delle donne" appears to date from 1317, a date which, however, has been erroneously interpreted as the earliest one associated with a possible nave tramezzo.[40] In 1323, expenses were recorded for masonry work on the entrance to the nuns' choir, and in the following year, payments were made for wooden beams and columns for the platform, two pieces of elm wood for the choir stalls, and hinges for shutters for the window of the choir.[41] In 1371, the nuns' wooden choir stalls were referenced as an illustrative model for another choir

Figure 148 *Eighteenth-Century Drawing Elevation of San Pier Maggiore, Florence.* National Archives, Prague, Family Archives of the Habsburg-Tuscany, Maps and Plans, Cabreo B.A. 55, fol. 17. Photo: National Archives, Prague

construction. In May of that year, woodworker Piero di Lando da Siena was commissioned to construct a choir in the Duomo di Fiesole, which had to be "like that of the nuns ('donne') of San Pier Maggiore, that is with arm rests in the same form ('in guiso'), with a bench in front to kneel on, and from the arm-rests up should measure around one *braccia* and a half high"; moreover the stalls "should be smooth from the arm-rests down, like that in San Pier Maggiore, of walnut."[42]

Perhaps due to its proximity to the particularly efficacious prayers of the nuns, the area in the vicinity of the nuns' choir on ground level was an important site in the church interior, further confirming the relationship between burial and choir placement discussed in Chapter 1. In a c. 1570 list of chapels in the church, a tomb for priests and chaplains was described as situated "opposite the nuns' choir."[43] The Pesci crucifix

chapel, which featured a life-size wooden crucifix by Baccio da Montelupo, was noted in the c. 1570 registry of chapels as "at the foot of the nuns' choir."[44] Also in close proximity to the nuns' balcony choir, in the south transept near a back entrance door were the Palmieri Chapel of the Assumption, the Albizzi Sacello chapel (dedicated to the Holy Sepulcher), and the Della Rena Annunciation chapel, which housed the Jacopo di Cione polyptych in the early seventeenth century after it had been removed from the high altar.[45]

Although raised from ground level and enclosed with grates, the nuns' choir was in a privileged position in San Pier Maggiore. The space was in the eastern half of the church, which gave the nuns direct visual access to the high altarpiece and important liturgical events such as the archbishop's investiture ceremony.[46] Moreover, the nuns' choir

Figure 149 Still of the digital reconstruction of San Pier Maggiore, Florence, from the "Hidden Florence 3D" app for iOS, 2019. Photo: www .florence4d.org, with kind permission of Donal Cooper

was on the favored right side, as opposed to the left (sinister), which, as we have seen in Chapter 1, was traditionally associated with laywomen. Its position in the nave aisle made the nuns' choir roughly in alignment with the ground-level men's choir, forging a spatial relationship between the male and female authorities in this joint parish and nunnery church.

The other Benedictine nunnery churches in Florence also seem to have featured similar nuns' choir galleries.[47] After San Pier Maggiore, Santa Felicita was the second wealthiest convent in the city (Figure 150).[48] Both convents were extensive landowners and both restricted entry in order to maintain a high social standing.[49] In Santa Felicita, the nuns' choir was a raised balcony situated at the termination of the right nave aisle,

in an analogous location to the nuns' choir in San Pier Maggiore and in correspondence with the conventual buildings.[50] Payment records from the 1360s show that Abbess Gostanza de' Rossi facilitated the construction of the "choro dele donne" that faced the church, paying for building materials such as wood, stone, and mortar, and liturgical items such as lecterns, a lantern, metal grates, a chest, and choir stalls.[51]

The Benedictine convent of Sant'Ambrogio, located close to San Pier Maggiore, held an important status in Florentine society due to its miraculous Corpus Christi relic, regularly displayed to the public but normally kept in a reliquary tabernacle in the Cappella del Miracolo (to the left of the high chapel in Figure 151).[52] Eve Borsook suggested that the

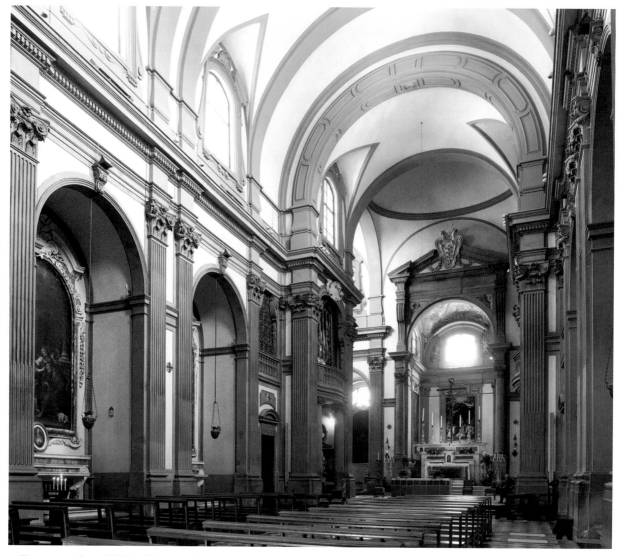

Figure 150 Santa Felicita, Florence. Interior view of the eighteenth-century church facing southeast. Photo: author

nuns may have originally occupied an area for their choir behind the high altar, before this space was given over to priests. She also cited a mid-seventeenth-century account that noted a loggia or gallery for nuns situated above the chapel to the left of the high altar, which might imply that a nuns' choir had previously occupied this space.[53]

In Florence, the majority of extant nuns' choirs date to the sixteenth century, impeding a contextual assessment of the arrangement of the earlier one in San Pier Maggiore.[54] Many vaulted choir balconies located over the main western entrance were constructed in nuns' churches in Florence in the sixteenth century (Figure 152).[55] In response to the strict gender rules within the Dominican Order (as noted for lay women in Chapter 1), Dominican nuns' choirs were generally located in separate enclosed spaces behind the high altar.[56] Originally deriving from medieval practices, these two contrasting nuns' choir types of the western balcony and the enclosed retrochoir – both of which restricted the visibility of religious women and reinforced enclosure – predominated in nuns' churches of all types in the post-Tridentine period.[57]

Figure 151 Sant'Ambrogio, Florence. Interior view facing east. Photo: author

The Men's Choir

The central nave of San Pier Maggiore featured a choir precinct known as the "men's choir" ("coro degli uomini") and described as "in the middle of the church" ("in mezo della chiesa," B on Figure 144).[58] The men's choir was sometimes called the large choir, as shown by the description of Suor Diamante's funeral in 1566, when around thirty priests sang the first nocturne of the night office "in the large choir of the men" ("nel coro grande delli huomini").[59] Archival sources show that a chapel of "La Gravida" – subject to demolition at the same time as the men's choir in 1569 – was situated at the second column of the nave, implying that the entrance to the men's choir was also located at this site, exactly halfway down the four-bay nave. The nave choir in San Pier Maggiore would have significantly affected visual and spatial access to

the church, most notably for the ability to view Jacopo di Cione's high altarpiece.

The ambiguous term "uomini" calls into question who precisely occupied the nave choir.[60] As a parish church, San Pier Maggiore was administered by a prior or procurator together with numerous chaplains who were assigned to various chapels. Certainly, these priests used the men's choir, as noted in the earlier descriptions. But this men's choir was also used by laymen, and indeed, its upkeep was the responsibility of the lay operai, or works committee, of the church. In his 1545 *Reformatio monasteriorum* provision, Duke Cosimo gave church operai in Florence significantly more power.[61] This ruling required that each female convent should have a permanent commission of operai (which, however, already existed at San Pier Maggiore), who would look after discipline, economic life, the fabric of the convent, and liaison with chaplains

Figure 152 San Felice in Piazza, Florence. Interior view facing southeast showing balcony choir. Photo: author

and confessors, ostensibly allowing the nuns to focus on their spiritual lives, but also restricting their agency over their physical property. Membership of the operai of San Pier Maggiore was largely drawn from the major patrons and benefactors, including the Albizzi and Filicaia, whose chapels adorned the lay side of the men's choir.

A report conserved in the operai archive, dated 1563 but describing events of December 1528, explains how the men's choir could be used for civic purposes.[62] A large bell was sounded for around an hour to summon the local populace to the church for the election of the operai. The report described how "around fifty state citizens and many other people were assembled in the choir of the church," who elected five new operai for a term of three years.[63] Following this

description, the powers and responsibilities of the operai were listed, which included the authority to decide on the price and location of new chapels and tombs in the church, the maintenance of the bell-ropes of the campanile, and the prevention of roofing leaks. The final obligation was that "they have to maintain the *choro delli huomini* and all the benches of the church," indicating that the nave choir was in effect a space belonging to the laymen of the local community.[64] The men's choir could have also hosted meetings of the local gonfalon, named *Chiavi* after the keys of St. Peter (Figure 153),[65] since other gonfalons in Florence met in parish churches (see Chapter 5).[66] Laywomen, on the other hand, were provided with special wooden benches for periods of Lenten preaching, which were also the responsibility of the operai.

Figure 153 Piazza San Pier Maggiore, Florence, detail of relief. Photo: author

Further, the men's choir was likely used during the archbishop's investiture ceremony, given the status of that ritual. Although surviving documents do not record precise seating arrangements, they do indicate who attended the event. The bishop's official guardians were representatives from three local magnate families, the Tosinghi, Aliotti, and Visdomini, the latter enjoying the prestigious responsibility of supervising episcopal finances when the bishop's seat was vacant.[67] In the piazza in front of San Pier Maggiore, the harness of the bishop's horse was gifted to a Florentine family in a ritual that Lorenzo Fabbri has shown could spark tension between rival clans.[68] A report of the 1386 *Entrata* ceremony describes how the bishop's guardians – wearing festive garlands and gloves, and carrying batons – processed closely with chaplains of San Pier Maggiore to lead the bishop toward the high altar.[69] Presumably the other attendees who had marched in procession from the city gate, which included cathedral canons and secular officials, would have also entered the church to hear the bishop's oration in anticipation of the marriage ceremony with the abbess.[70] It seems reasonable to hypothesize that these elite male visitors, which would have included members of the Albizzi and Filicaia families, would have occupied the men's choir for this prestigious event.

San Pier Maggiore was not unique among convent churches in its discrete seating arrangements for men and women. In the neighboring Benedictine convent of Sant'Ambrogio, an area, perhaps in the nave or behind the high altar, was designated as the "choro delli uomini," interestingly using the same nomenclature as did San Pier Maggiore.[71] A tantalizing reference in a manuscript composed by the late sixteenth-century Dominican Observant friar, Modesto Biliotti – which cannot be verified by additional sources – also suggests the presence of a nave choir in Santa Felicita, which was removed as part of the wave of Florentine church renovations.[72] Similarly, a nun's chronicle from the Clarissan convent of Santa Lucia in Foligno indicates the presence of two distinct choir spaces: a "choro de sopra" for the nuns and a "choro basso," which could be used by men. When Pope Sixtus IV visited the convent in 1476, the community of nuns entered the lower choir, where the cardinals were also seated, to kiss the pope's foot ceremoniously.[73] In Venice, the Benedictine nuns' church of Santa Croce della Giudecca also featured an upper and lower choir. An early sixteenth-century plan of the convent depicts a choir "de sopra" for the women and a choir in the nave "dabasso," which may have been used by male clergy or, as Victoria Primhak suggested, by visitors to the church.[74]

Documents do not explicitly describe a nave screen in San Pier Maggiore. However, given that three chapels – of the Albizzi and Filicaia and "La Gravida" – were ordered to be removed at the same time as the nave choir in 1569, they were likely attached either to a separate screen or adjoined the choir precinct itself.[75] A large painted crucifix was also associated with the nave choir in San Pier Maggiore. Now displayed in the Museum of Santa Croce, a crucifix by Lippo di Benivieni was commissioned by the Filicaia

family in the 1310s (Figure 154).[76] The intervention of the Filicaia family at this early date suggests a prolonged interest in this area of the church, perhaps even supporting a fourteenth-century foundation of their chapel at the men's choir.[77] In 1325, the nuns bought a piece of ironwork and a ring to hold up the crucifix, which indicates it may have been suspended from the roof trusses or tilted forward from a position atop the choir precinct or a wooden beam.[78]

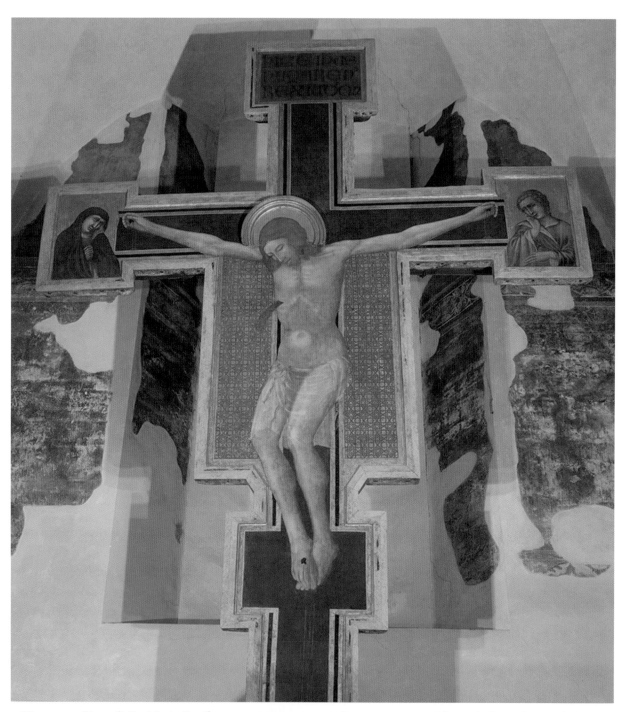

Figure 154 Lippo di Benivieni, *Crucifix*, 1310s, tempera on wood, 426 × 313 cm. Museo di Santa Croce, Florence. Photo: author

La Gravida

The phrase "La Gravida" ("the pregnant Madonna") – used to designate a particular space in the church but also later employed to identify a chapel – reveals the significance of female devotion in San Pier Maggiore (E on Figure 144). The earliest reference to this site appears to be a 1502 notarial act founding a chapel dedicated to the Annunciation by a certain Jacopo di Michelangelo, located "by the second column or pilaster of said church on the left side in the place which is called *in gravida*."[79] This document provides clear evidence for the proposed location of the choir precinct at the second nave pier from the main entrance of the church and accords with the description of the men's choir "in mezo della chiesa." In the registry of chapels datable to c. 1565–66, Agnolo di Carlo was listed as patron of the "cappella della gravida."[80] In the c. 1570 list, the chapel was described as "the chapel of St Mary called la gravida at the side of a column" ("Cappella di Santa Maria detta la gravida al lato a una colonna").[81] Later, the chapel was consistently described as belonging to the Fortunati family, but whether the original Jacopo was a member of this family cannot be determined.[82] In a seventeenth-century list of chapels it was described as "against the second pilaster on the left side [of the church] in the place that is called la gravida patronized by the Fortunati family."[83] In an eighteenth-century source it was listed as the Chapel of the Annunciation, only "colloquially called la gravida."[84]

The "Gravida" area of the church may have been adorned with an image of the pregnant Virgin. In 1754, Richa noted that although an icon of a pregnant Madonna attached to a column on the facade was believed to be a Greek icon fabricated at the time of the Council of Florence (1439), it was of Florentine manufacture.[85] A detached fresco depicting the

Figure 155 Taddeo Gaddi (attr.), *Madonna del Parto*, c. 1320s–50s. Detached fresco, 140 × 85 cm. San Francesco di Paola, Bellosguardo, Florence. Photo: Sailko/Francesco Bini

pregnant Madonna currently displayed in San Francesco di Paola in the Bellosguardo suburb of Florence has been attributed to Taddeo Gaddi since it was uncovered in 1964 (Figure 155).[86] Bietti Favi and Renzo Manetti argue that this work is the Madonna Gravida salvaged from the demolished San Pier Maggiore, and donated to San Francesco di Paola by Giovanni Federighi, who purchased the condemned convent.[87] Certainly, this image could be the 'Florentine' work noticed by Richa, and its survival corresponds to the evident continued devotion to the pregnant Madonna in San Pier Maggiore. Other surviving Tuscan images of the pregnant Madonna on nave columns were often depicted standing, their longitudinal format emphasizing the Madonna's distended womb.[88]

The term "La Gravida" suggests that the area may have functioned as a devotional site for laywomen, attracting prayers for conception, smooth pregnancies, and safe labors.[89] Located on the north or left side of the church and on the public side of the choir precinct, the Gravida zone of San Pier Maggiore could feasibly have been a site where laywomen would congregate. Certainly in other contexts, and as we saw in Chapter 1, this section of the church was reserved for laywomen and sometimes decorated with imagery designed for female viewership.[90] Indeed, Jung has argued that the imagery on the left sides of choir screens in northern European cathedrals could have been particularly targeted toward women.[91] The placement on the left side of a church dedicated to St. Peter was also reminiscent of a papal setting: an altar known as Santa Maria de Pregnantis was situated in the left transept of the Vatican basilica.[92]

Although the chapel of the Annunciation at "La Gravida" was initially founded by a layman, this area also drew female devotees. In 1523, Lorenza, the wife of Zanobi del Zacchera (or Zaccheria) donated forty florins for a mass of the Conception to be said at the altar of La Gravida every Saturday in perpetuity.[93] The convent's records for burials and offices, now conserved in the Archivio Arcivescovile, provide evidence that this memorial mass was performed at least until 1571.[94] In 1627, this obligation was reduced to nine masses per year by Archbishop Alessandro Marzi Medici,[95] and the chapel was still listed in the convent's 1745 registry of chapels.[96] This source further indicates that a second chapel dedicated to the Conception was founded by the Micchieri family at an unknown date.

Archival sources, therefore, show that the Gravida chapel was not in fact destroyed at the behest of Duke Cosimo in 1569. As in other contexts in Florence, this indicates a certain hesitancy toward the removal of these potent sites of lay devotion associated with nave choirs.

Moreover, the establishment of two further endowments related to the Conception, in addition to the original Annunciation chapel, reveals that the Gravida chapel was a locus of significant popular devotion. The nuns, prior, and operai of San Pier Maggiore likely defied the ducal directive to eliminate this chapel specifically to preserve its renown as a site associated with conception, pregnancy, and birth.

The Filicaia and Albizzi Chapels

In the 1569 documentation concerning the destruction of the men's choir, the Filicaia Chapel (F on Figure 144) was described as located "under the pulpit," while the Albizzi Chapel was "opposite the pulpit" (G on Figure 144).[97] Following their demolition, in 1572, the operai paid a carver named Michele "for a frieze of marble made around the Filicaia Chapel, which was done at the request of said Filicaia when the irons were removed which made a grate around their chapel."[98] Simone Peruzzi, who recorded the state of the church in the eighteenth century in an archival manuscript, noted that a square space about seven or eight *braccia* across stretching from the pulpit to the left nave included an inlaid Filicaia coat of arms enclosed by a marble border, feasibly the one created in 1572.[99] We can hypothesize, therefore, that the Filicaia Chapel was on the left side of the nave choir, near the Gravida site, and the Albizzi was on the right.

Both chapels were surrounded by ironwork grates, which were weighed and sold in March 1569 as part of the removal of the men's choir. Ironwork from the Filicaia Chapel weighed 2,089 libre (709.3 kg).[100] Perhaps reflecting the family's high status in the church, ironwork from the Albizzi Chapel weighed more (2,389 libre, 811.2 kg).[101] The "old ironwork" of the Albizzi Chapel was described as having been "in grilles for the

ornament of said chapel."[102] To give some context to these statistics, the extant screen in the chapel in the Palazzo Pubblico in Siena (Figure 156), which extends some 6.94 m in length and 2.5 m in height, was registered as weighing 4,318 libre when it was assessed in 1445, roughly the same as the two ironwork grilles in San Pier Maggiore combined.[103]

Ironwork grilles surrounding private chapels would have been a common sight in Florence. In Santa Trinita, for example, a fifteenth-century openwork screen encloses the Bartolini Salimbeni Chapel of the Annunciation (Figure 165).[104] The mid-fifteenth-century *Tabernacle of the Crucifix* in San Miniato al Monte still preserves wrought iron grilles that contain the diamond ring device of Piero de' Medici, who commissioned the structure in 1447 (Figure 157).[105] Chapter 7 will investigate an ironwork tramezzo that once stood within the

interior of the Orsanmichele oratory, which was also removed and its constituent elements sold in the same months – March–April 1569 – as the sale of ironwork from the two chapels in San Pier Maggiore.

THE REMOVAL OF THE MEN'S CHOIR

A major change in the later sixteenth century transformed the careful divisions of space in the church interior. On 24 February 1569 (1568 stil. Flor), the operai agreed to remove the men's choir ("levare il Coro che è in mezo della chiesa, detto il Coro degli Huomini") together with the two chapels with iron railings ("con li graticole di ferro") of the Albizzi and Filicaia and the one called "La Gravida."[106] No specific reasons for

Figure 156 Jacopo della Quercia, Nicolò di Paolo, Giacomo di Giovanni di Vita, and Giovanni di Giacomo, *Chapel Screen*, 1435–45, iron. Palazzo Pubblico, Siena, Cappella dei Signori. Photo: author

Figure 157 *Tabernacle of the Crucifix,* mid-fifteenth century (commissioned 1447). San Miniato al Monte, Florence. Photo: author

this major change were recorded in the surviving document. However, that document did note that this action had been ordered ("come haveva commesso") by Duke Cosimo I de' Medici, who also required that new benches be made for the church.[107] Two new ranges of wooden benches, purchased on the same day, were referred to as the "choir in front of the high altar," indicating the location of the new seating.[108] This area had previously been used to house a temporary wooden choir on the feast of St. Peter.[109] As

noted earlier, only a few days after the purchase of the new benches, on 2 March 1569, the old ironwork of the two tramezzo chapels was valued, confirming its removal. On 7 July 1569, the operai repaved the church floor, possibly to repair damage due to the removal of the iron railings around the choir chapels.[110] Previously, in July 1568, the priest procurator of San Pier Maggiore had contracted the renowned organ maker Onofrio Zeffirini from Cortona (who also worked in Santa Trinita, the Duomo, and Santa

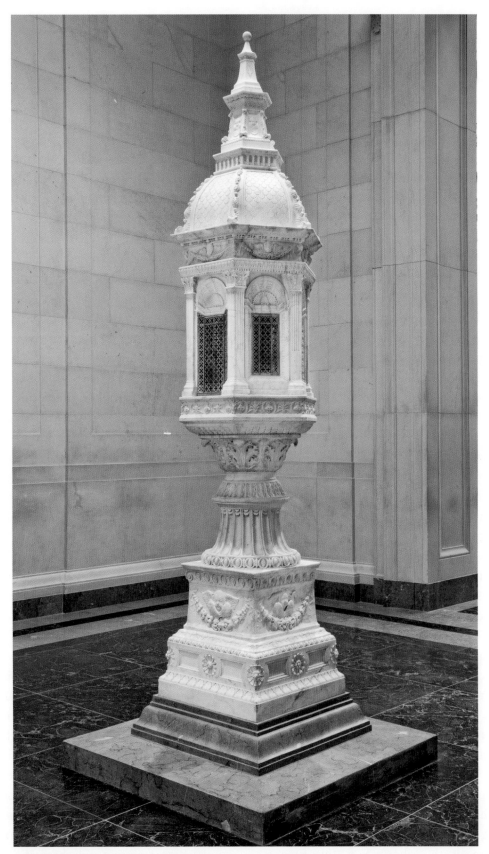

Figure 158 *Ciborium for the Sacrament,* 1460s–c.1470 (stem with integral base); probably 1860s–c. 1870 (dome, enclosure, base beneath enclosure); and 1870s (finial, bottom plinth). Marble, overall: 322.1 × 80.8 × 69.9 cm. National Gallery of Art, Washington, DC, Samuel H. Kress Collection 1952.5.100. Photo: Courtesy National Gallery of Art, Washington, DC.

Croce) to remake a new organ, a project that evidently formed part of this overhaul of liturgical space and furnishings in the church.[111]

The *Entrata* of Archbishop Antonio Altoviti, who had been in exile as a result of a dispute between Duke Cosimo and Antonio's father Bindo, was probably a significant factor prompting this alteration.[112] Perhaps this public spectacle, celebrated in May 1567 (around eighteen months before the renovations) attracted Duke Cosimo's attention. The duke and his retinue would have experienced the packed church interior ("very crowded with a multitude of men and women")[113] and potentially even sat in the men's choir. By May 1567, the alterations in Santa Maria Novella and Santa Croce were well under way, so the traditional layout of San Pier Maggiore might have already felt old-fashioned to the Florentine audience.[114] The alteration also reduced the visible presence – in the form of extensive ironwork – of the wealth of the local elite families of the Filicaia and Albizzi, both of which had fluctuated in their support of the fifteenth-century Medici clan.[115] It could therefore be read as part of the overall drive toward increasingly centralized Medicean power.[116]

Reflecting Tridentine ideals, the interior of San Pier Maggiore was altered to emphasize the high altar as a location for the sacramental power of the Eucharist. There had long been a Eucharistic tabernacle in the church. In the earliest description, Albertini's 1510 guidebook to Florence, the ciborium was the only object in the church selected for further comment: "In the church of San Piero Maggiore are altarpieces by several masters. And the marble tabernacle of the Corpus Domini is by Desiderio da Settignano."[117] Vasari later reiterated this attribution (in both the 1550 and 1568 editions of *Le Vite*), noting that Desiderio produced a ciborium without figures for San Pier Maggiore.[118] While the location of the ciborium at this time is unknown, a letter from 1566 provides a clue about changes to the liturgical furnishings of the high chapel. In this letter, also discussed in Chapter 3, the operai of Santa Croce proposed to Duke Cosimo that the high altarpiece should be replaced by a ciborium or crucifix, as in Santo Spirito, Santissima Annunziata, and San Pier Maggiore.[119] By this date, therefore, the Jacopo di Cione high altarpiece may have been removed to a different location, thus extending the dating of the entire church renovation to before Duke Cosimo's intervention.[120] We have seen in other contexts, such as the Carmine, that alteration schemes could be executed within lengthy time frames. In 1572, the operai paid a woodworker, Lorenzo di Bernardo, for a wooden kneeler to be installed in front of the high altar and a small wooden dome or "cupolino" to be placed above the marble ciborium, located "behind said altar."[121] Conceivably the ciborium rested on a platform behind the altar, presenting the illusion that it rested on the altar itself, since the Santa Croce letter described the marble structure as "above the high altar." By 1575, the marble ciborium was certainly displayed in the cappella maggiore where it was recorded in the Pastoral Visitation of Bishop of Camerino Alfonso Binnarini.[122]

A freestanding Eucharistic ciborium in the National Gallery of Art in Washington, DC, has, until recently, been associated with San Pier Maggiore (Figure 158).[123] The Washington ciborium comprises a square pedestal base, ornamented stem, hexagonal tempietto with cupola, and a lantern. Paul Davies identified this ensemble as the earliest extant freestanding Eucharistic tabernacle, which spawned a series of imitations,[124] and scholars have variously argued for an attribution to Desiderio da Settignano, his circle, or Benedetto da Maiano.[125] Ida Cardellini and Beatrice Paolozzi Strozzi doubted whether the Washington ciborium originated from San Pier Maggiore, noting that in 1591 Francesco Bocchi described an eight-sided construction featuring polychromatic and figural decoration, thus dissimilar in many respects to

the extant object.[126] Doris Carl has recently argued that it is implausible that the tabernacle described by Vasari and others had managed to survive the Silvani redesign of the high chapel. Moreover, the Pastoral Visitation of 1682 noted a baroque ciborium with differently colored marble and *pietre dure*, confirming that Ximenes commissioned a new construction at the time of the new chapel. Through a close technical examination, Carl discerned that the Washington ciborium was produced by nineteenth-century forgers who combined several identifiable motifs from different Quattrocento sources.[127] Alison Luchs, accepting most of Carl's assessment, argued that while the stem is fifteenth century, the tabernacle as a whole ensemble cannot be the one described in San Pier Maggiore.[128]

Leaving aside the authenticity of the Washington ensemble, the existence of a ciborium prominently placed on the high altar of San Pier Maggiore certainly fits into a wider pattern of Counter-Reformation Eucharistic display, which will be explored in more depth in Chapter 8. As in other cases in Florence, the destruction of the men's choir was part of an extended scheme of improvements to the liturgical and practical life of the church, which included the new organ, the repaving of the church floor, and new benches for the cappella maggiore.

Conclusion

Before the 1569 alterations, while the interior of San Pier Maggiore seems strictly divided into segregated spaces that separated men and women, and lay from religious, in practice there was a certain amount of fluidity. The central nave was dominated by the men's choir, which was used by the male community of priests but also by the operai, and other local laymen for neighborhood meetings. Moreover, the position of the nuns' balcony choir was subtly hierarchical, and

the nuns also entered the cappella maggiore on ceremonial occasions. In the nave, meanwhile, the operai seem to have defied the ducal order to also destroy the chapel at "La Gravida," likely to preserve this site of considerable popular devotion.

When the men's choir and two of its attached chapels were removed in 1569, this carefully constructed spatial disposition collapsed. With the nave cleared of visual obstructions, more attention was focused on the high altar, which was embellished with furnishings, including a large marble tabernacle above the altar table itself. While these alterations are difficult to characterize precisely since the chapel was rebuilt in the early seventeenth century and the church was later destroyed, they fit into a general post-Tridentine trend toward greater emphasis on the Eucharistic sacrament, seen in many other contexts in Florence. Political motivations could have also been influential. Since the men's choir was used as a gathering place for neighborhood assemblies, the alteration denied local citizens a solemn meeting space ideally suited to their purposes, thus underlining the increasingly centralized power of the Medici duchy.

Duke Cosimo's original directive appears to be lost, but the operai minutes confirm that he himself issued the order. The *Entrata* of Archbishop Antonio Altoviti in May 1567 might have drawn public attention to the spatial dynamics of the church. Significantly, at a time when, after the investiture in 1583 of archbishop Alessandro Ottaviano de' Medici, the Medici controlled the episcopal see completely, the last ever symbolic marriage ceremony was held in San Pier Maggiore, which thereafter lost its prominent civic role.[129] The subsequent archbishop, Alessandro Marzi Medici (appointed by his predecessor Alessandro Ottaviano, as Pope Leo XI) did not perform the marriage ceremony at all, instead opting to use more familiar religious spaces such as the Duomo and the archbishop's palace. The appointment of

Medici family members as archbishops and the abandonment of the ritual – which had previously "domesticated" incoming archbishops into wider Florentine society – further reflect the consolidation of Medici state power.

Despite its unusual administration by male chaplains, lay operai, and female religious, San Pier Maggiore featured a nave choir more often associated with male mendicant and monastic spaces. The liturgical and practical consequences of its removal may have been different, but the aesthetic effect was the same: nave choir ensembles comprising seating and chapels were exchanged for open and clear sightlines toward the high altar in a shift that fundamentally changed the devotional and pragmatic experiences of those sacred spaces.

NOTES

1 "Fecesi per l'honoranza di chiesa la cappanna nel coro di sopra et quella nel coro di sotto sopra il suo corpo." ASF, San Pier Maggiore, vol. 55, fol. 230r. Dated 27 September 1565. The term "cappanna" was also used in documents related to the funeral of Eleonora di Toledo, where it referred to a wooden construction adorned with candles. See Janet Cox-Rearick, "La Ill. ma Sig.ra Duchessa felice memoria: The Posthumous Eleonora di Toledo," in *The Cultural World of Eleonora di Toledo, Duchess of Florence and Siena*, ed. Konrad Eisenbichler (Aldershot and Burlington, VT, 2004), pp. 229–31.

2 Saundra Weddle, "Identity and Alliance: Urban Presence, Spatial Privilege, and Florentine Renaissance Convents," in *Renaissance Florence: A Social History*, ed. Roger J. Crum and John T. Paoletti (New York, 2006), p. 396; Gail E. Solberg, "Bild und Zeremoniell in San Pier Maggiore, Florenz," in *Zeremoniell und Raum in der frühen italienischen Malerei*, ed. Stefan Weppelmann (Berlin, 2007), p. 200; Maureen C. Miller and Kathryn L. Jasper, "The Foundation of the Monastery of San Pier Maggiore in Florence," *Rivista di storia della chiesa in Italia* 64, no. 2 (2010), pp. 381–96.

3 The financial prestige of the convent is demonstrated by its lack of artisanal production: it was probably the only convent in Florence whose nuns did not manufacture gold thread, books, or other marketable goods. Sharon T. Strocchia, *Nuns and Nunneries in Renaissance Florence* (Baltimore, 2009), pp. 75–76, 79, 149.

4 Ibid., pp. 156, 165.

5 Ibid., p. 20. Florence, Archivio Arcivescovile, VP 03.1 (Cosimo de' Pazzi, 1509–12), unnumbered, at date 4 February 1509.

6 "Monastero di San Piero Maggiore sono monache quarantacinque velate, cinque servigiale, dodici cappellani, quattordici cherici, uno priore, uno portinaio, uno maestro di cherici, che in tucto sono persone 79." BNCF, Non acquisti 987, fol. 103r. I am grateful to Nicholas Eckstein for bringing this manuscript to my attention. For *chierici*, see "Tommaseo Online," www.tommaseobellini.it/#/.

7 Sant'Ambrogio recorded ten "preti da messa" and four *chierici*, while Santa Felicità registered four chaplains, one prior, and one *chierico*. Sant'Ambrogio had eighty nuns and six *servigiale*; Santa Felicita' had sixty nuns and ten *servigiali*. BNCF, Non acquisti 987, fols. 54r, 103r. The mid fifteenth-century *Codice Rustici* stated that San Pier Maggiore was "nobile e bella e bene uficiata da preti. E quel luogo v'e' munistero delle donne sotto il detto governo, il quale sono sotto l'ordine di santo Benedetto." Gurrieri et al., eds., *Codice Rustici*, p. 137.

8 Strocchia, *Nuns and Nunneries*, p. 97.

9 First proposed by Levi d'Ancona, this provenance is suggested by the unusual combination of the feast days of St. Peter and St. Nicholas of Bari, and stylistic features that link it to the work of Don Silvestro de' Gherarducci from the Camaldolese monastery of Santa Maria degli Angeli. Choir books from San Pier Maggiore were sent to Santa Maria degli Angeli for copying in 1385. For the manuscript, see Mirella Levi d'Ancona, *Miniatura e miniatori a Firenze dal XIV al XVI secolo*, Documenti per la storia della miniatura (Florence, 1962), pp. 181–82; Mirella Levi d'Ancona, "Arte e politica: l'Interdetto, gli Albizzi e la miniatura fiorentina del tardo Trecento," in *La Miniatura Italiana in età romanica e gotica, Atti del I Congresso di Storia della Miniatura Italiana, Cortona 26–28 maggio 1978*, ed. Grazia Vailati Schoenburg Waldenburg (Florence, 1979), pp. 461–87; Laurence B. Kanter, ed., *Painting and Illumination in Early Renaissance Florence 1300–1450* (New York, 1994), pp. 178–83; Martina Bagnoli, "Cenni di Francesco, Antifonario-Graduale W.153," in *L'eredità di Giotto: Arte a Firenze 1340–1375*, ed. Angelo Tartuferi (Florence, 2008), p. 232, cat. 55; Dale Hoover, "Affinity between Chant and Image: A Study of a Late Fourteenth-Century Florentine Antiphonary/Gradual (Baltimore: Walters Art Museum: MS W153)" (PhD thesis, University of Ohio, 2004). For an early fourteenth-century gradual from San Pier Maggiore, see Laura Alidori Battaglia and Marco Battaglia, "Il ritrovato Messale di San Pier Maggiore ed una proposta per la datazione dell'intervento del Maestro Daddesco nel Graduale Santorale della Badia a Settimo," *Arte Cristiana* 106, no. 907 (2018), pp. 300–07.

10 "Cappella degli Albizi intitolata in S. Niccolò fu fondata l'anno 1300 la Lando degli Albizi." BNCF, Fondo nazionale, II, I, 125 (Sepoltuario fiorentino di Rosselli, Quartiere S. Croce), vol. 1, fol. 63r. Levi d'Ancona

argued that the liturgy dedicated to St. Nicholas was a reference to Niccolo degli Albizzi, founder of the Alessandri branch of the family. Levi d'Ancona, "Arte e politica," p. 480.

11 Male singers and a priest are specified in the rubric for the third nocturn of Matins for June 29: "Cantores stantes coram altari … deinde dicit sacerdos." Baltimore, Walters Art Museum, MS W.153, fol. 13r. Hoover, "Affinity between Chant and Image," pp. 95, 142.

12 A marble plaque set into the facade of the Altoviti palace marks the spot where this miracle supposedly took place. Sally J. Cornelison, "Art and Devotion in Late Medieval and Renaissance Florence: The Relics and Reliquaries of Saints Zenobius and John the Baptist" (PhD thesis, University of London, 1999), p. 105. Sally J. Cornelison, "Tales of Two Bishop Saints: Zenobius and Antoninus in Florentine Renaissance Art and History," *The Sixteenth Century Journal* 38, no. 3 (2007), p. 636.

13 On the feast days of St. Agnes (21 January) and SS Peter and Paul (29 June), the Monday after Easter, and the Monday before Ascension. Marica S. Tacconi, *Cathedral and Civic Ritual in Late Medieval and Renaissance Florence: The Service Books of Santa Maria del Fiore* (Cambridge, 2005), pp. 99, 102–04, 111.

14 Saundra Weddle, "'Tis Better to Give than to Receive: Client-Patronage Exchange and Its Architectural Implications at Florentine Convents," in *Studies on Florence and the Italian Renaissance in Honour of F.W. Kent*, ed. Peter Howard and Cecilia Hewlett (Turnhout, 2016), p. 307.

15 The following description is taken from Sharon T. Strocchia, "When the Bishop Married the Abbess: Masculinity and Power in Florentine Episcopal Entry Rites, 1300–1600," *Gender & History* 19, no. 2 (2007), pp. 346–68.

16 Ibid., pp. 346–47.

17 Maureen C. Miller, "Why the Bishop of Florence Had to Get Married," *Speculum* 81, no. 4 (2006), p. 1078.

18 Fabbri showed that this honor originally went to the Bellagi family but passed to the Strozzi in 1419. Lorenzo Fabbri, "La sella e il freno del vescovo: privilegi familiari e saccheggio rituale nell'ingresso episcopale a Firenze fra XIII e XVI secolo," in *Uomini paesaggi storie: studi di storia medievale per Giovanni Cherubini*, ed. Duccio Balestracci, Andrea Barlucchi, Franco Franceschi, Paolo Nanni, Gabriella Piccinni, and Andrea Zorzi (Siena, 2012), p. 899.

19 Strocchia, "When the Bishop Married the Abbess," pp. 356–57. Weddle argued that this shift toward a more "neutral" site in the church interior in effect reduced the abbess' authority in the ceremony. Weddle, "'Tis Better to Give than to Receive," p. 306. I am grateful to Saundra Weddle for sharing this text with me prior to publication.

20 The ceremony changed again in 1508, when Archbishop Cosimo de' Pazzi eliminated the overnight fictive consummation and instead required that all the nuns kiss his hand and receive his benediction. Strocchia, "When the Bishop Married the Abbess," p. 357.

21 BNCF, Fondo nazionale, II, I, 125 (Sepoltuario fiorentino di Rosselli, Quartiere S. Croce), fol. 63r; Richa, *Notizie istoriche*, vol. 1, p. 125.

22 The fourth-century church; a new church in c. 1000; alterations when the second circle of city walls were erected in 1078; a restoration of 1352; addition of the loggia, altars, and paintings in the seventeenth century. Ibid., vol. 1, p. 125.

23 Richa noted that the date 1352 appeared on a wooden beam. Ibid., vol. 1, p. 125. Paatz and Paatz, *Kirchen von Florenz*, vol. 4, pp. 629, 631. Osanna Fantozzi Micali and Piero Roselli, *Le Soppressioni dei Conventi a Firenze: riuso e trasformazioni dal sec. XVIII in poi* (Florence, 1980), p. 237.

24 Ibid., p. 640.

25 Monica Bietti Favi, "Dal Savonarola al pontificato di Leone X: artisti e patroni in San Pier Maggiore a Firenze," in *Nello splendore mediceo: Papa Leone X e Firenze*, ed. Nicoletta Baldini and Monica Bietti Favi (Florence, 2013), pp. 129, 131.

26 Weddle has emphasized the importance of the Albizzi as longstanding patrons of the church. Weddle, "'Tis Better to Give than to Receive," p. 310.

27 Bietti Favi, "Dal Savonarola al pontificato di Leone X," pp. 127–37; Catherine King, "The Dowry Farms of Niccolosa Serragli and the Altarpiece of the Assumption in the National Gallery London (1126) Ascribed to Francesco Botticini," *Zeitschrift für Kunstgeschichte* 50, no. 2 (1987), pp. 275–78; Rolf Bagemihl, "Francesco Botticini's Palmieri Altar-Piece," *The Burlington Magazine* 138, no. 1118 (1996), pp. 308–14; Jennifer Sliwka, *Visions of Paradise: Botticini's Palmieri Altarpiece* (London, 2015).

28 The Ximenes family were of Spanish origin. Doris Carl, "Verloren und Wiedererfunden: Desiderio da Settignano, die Ximenes und das Ziborium der National Gallery in Washington," *Mitteilungen des Kunsthistorischen Institutes in Florenz* 56 (2014), pp. 295–99.

29 Paatz and Paatz, *Kirchen von Florenz*, vol. 4, p. 629. Giuseppe Zocchi's 1754 engraving also shows baroque additions to the upper section of the facade. For the drawing inscribed "Veduta della Chiesa, e Piazza di S. Pier Maggiore," see Elaine Evans Dee, *Views of Florence and Tuscany by Giuseppe Zocchi, 1711–1767: Seventy-Seven Drawings from the Collection of the Pierpont Morgan Library, New York* (Meriden, CT, 1968), cat. 19.

30 Paatz and Paatz, *Kirchen von Florenz*, vol. 4, p. 629.

31 Donal Cooper and Jennifer Sliwka, "In Context: San Pier Maggiore," *Apollo* 182, no. 636 (2015), pp. 79–80; Donal Cooper, "Firenze scomparsa: le chiese di Santa Chiara e San Pier Maggiore e la loro ricostruzione digitale presso i musei di Londra," *Archaeologia e Calcolatori* 10 (2018), pp. 72–78. I am grateful to Donal Cooper for sharing with me his observations on the church.

32 For the altarpiece, see Gordon, *The Italian Paintings*, pp. 52–86. De Marchi suggested that an earlier polyptych, possibly by Lippo di Benivieni, appeared on the high altar before Jacopo di Cione's version. De Marchi, "'Cum dictum opus sit magnum'," p. 615.

33 Julian Gardner, "Nuns and Altarpieces: Agendas for Research," *Römisches Jahrbuch der Bibliotheca Hertziana* 30 (1995), pp. 38–39; Carl Brandon Strehlke, *Italian Paintings 1250–1450 in the John G. Johnson Collection and the Philadelphia Museum of Art* (Philadelphia, 2004), pp. 202–12. H. D. Gronau, "The San Pier Maggiore Altarpiece: A Reconstruction," *The Burlington Magazine* 86, no. 507 (June 1945), pp. 139–45; Gordon, *The Italian Paintings*, p. 81; Andrew Ladis, "A High Altarpiece for San Giovanni Fuorcivitas in Pistoia and Hypotheses about Niccolò di Tommaso," *Mitteilungen des Kunsthistorischen Institutes in Florenz* 33 (1989), p. 6. The altarpiece is estimated to have been 550 × 410 cm when reconstructed.

34 Strehlke, *Italian Paintings*, pp. 208–09; Gordon, *The Italian Paintings*, pp. 52–61. For nuns' art patronage in Florence, see Kate Lowe, "Nuns and Choice: Artistic Decision-Making in Medicean Florence," in *With and Without the Medici: Studies in Tuscan Art and Patronage 1434–1530*, ed. Eckart Marchand and Alison Wright (Aldershot, 1998), pp. 129–53.

35 Gordon, *The Italian Paintings*, p. 85.

36 Strehlke, *Italian Paintings*, p. 206.

37 Solberg, "Bild und Zeremoniell," pp. 194–209.

38 Reproductions of the drawings are held by the Kunsthistorisches Insitut in Florence (414666 and 414667). The originals are currently in Prague, National Archives, Family Archives of the Habsburg-Tuscany, Maps and Plans, Cabreo B.A. 55, fol. 17. I am grateful to Grazia Visintainer from the Photo Archive of the Kunsthistorisches Institut in Florence for providing further information on these images in personal correspondence dated 9 September 2014. As Jeffrey Hamburger has shown, such spatial asymmetry was a common feature of convent churches. Jeffrey F. Hamburger, "Art, Enclosure and the Cura Monialium: Prolegomena in the Guise of a Postscript," *Gesta* 31, no. 2 (1992), p. 114. Paatz and Paatz, however, claimed that the nuns' choir was located in the south transept. Paatz and Paatz, *Kirchen von Florenz*, vol. 4, p. 632. I am grateful to Jennifer Sliwka for sharing her observations on the location of the nuns' choir.

39 "la colonna che regge il coro delle monache." BNCF, Fondo nazionale, II, I, 125 (Sepoltuario fiorentino di Rosselli, Quartiere S. Croce), vol. 1, p. 128 (fol. 64v). "la colonna che regge li due archi del Coro delle Monache." ASF, San Pier Maggiore, vol. 42, fol. 7r (unpaginated folios).

40 ASF, San Pier Maggiore, vol. 65 (Libro di Entrata e della Spesa 1315–17), fol. 42v, dated January 1316 (stil. Flor). Bietti Favi states that the 1316 payment referred to

the tramezzo. Monica Bietti Favi, "Indizi documentari su Lippo di Benivieni," *Studi di storia dell'arte* 1 (1990), p. 243.

41 ASF, San Pier Maggiore, vol. 66 (Libro dell'Entrata e della Spesa 1317–27), fols. 110v, 119r–120r (the numeration in this volume is very faint).

42 "Item de'fare il detto Coro come quello delle donne di S. Piero Maggiore, cioè di bracciali in guiso, con una panca dinanzi da inginocchiarsi: e da' bracciali in suso vuole essere un braccio e mezzo intorno intorno alto. . . . e sia regolato da'bracciali in giu', come quello di S. Pier Maggiore, di noce." Milanesi, *Nuovi documenti*, pp. 60–61, doc. no. 79.

43 "Nota che per i sacerdoti s'é deputata quella sepoltura dirimpetto al Coro de Monache." ASF, San Pier Maggiore, vol. 55, fol. 259v.

44 "Cappella del Crocifisso appiè del coro delle monache." ASF, San Pier Maggiore, vol. 55, fol. 258v. Paatz and Paatz also placed this altar at the eastern extreme of the right nave aisle, which would corroborate a location beneath the nuns' choir. Paatz and Paatz, *Kirchen von Florenz*, vol. 4, p. 637. Bietti Favi stated that the crucifix originally belonged to the Compagnia del Sacramento. Bietti Favi, "Dal Savonarola al pontificato di Leone X," p. 133.

45 For the Sacello chapel, see Bietti Favi, "Dal Savonarola al pontificato di Leone X," p. 128. The Palmieri chapel with its altarpiece of the *Assumption of the Virgin* by Botticini (National Gallery, London) was described in the c. 1570 archival registry as "allato alla Porta del Fianco." ASF, San Pier Maggiore, vol. 55, fol. 259r. For the Della Rena chapel, see Paatz and Paatz, *Kirchen von Florenz*, vol. 4, p. 638.

46 Sabine Plakolm-Forsthuber has suggested that the relegation of nuns to the west responded to norms of gender segregation that situated men in the more favored east and thus closer to the high altar. Sabine Plakolm-Forsthuber, *Florentiner Frauenkloster von der Renaissance bis zur Gegenreformation* (Petersberg, 2009), p. 98.

47 Santa Felicita was founded c. 900, Sant'Ambrogio before 1000, and San Pier Maggiore c. 1000. Weddle, "Identity and Alliance," p. 396.

48 In the 1427 Catasto, the gross assets of San Pier Maggiore were recorded as 9658 florins; of Santa Felicita 9423. Strocchia, *Nuns and Nunneries*, p. 76.

49 Ibid., p. 20.

50 Paatz and Paatz, *Kirchen von Florenz*, vol. 2, p. 86, note 30. Francesca Fiorelli Malesci, *La Chiesa di Santa Felicita a Firenze* (Florence, 1986), p. 58.

51 In 1361, after a large part of the roof of the church was damaged, Abbess Gostanza de' Rossi and the nuns applied to the bishop of Florence for permission to sell four *staio* of land to pay for the repairs. A small amount (two florins) was spent on painting the space. Fiorelli Malesci, *La Chiesa di Santa Felicita*, pp. 311–12, Documents 17, 26, 31.

52 Eve Borsook, "Cults and Imagery at Sant'Ambrogio in Florence," *Mitteilungen des Kunsthistorischen Institutes in Florenz* 25, no. 2 (1981), p. 150.

53 Megan Holmes showed that this proposed placement would have greatly impacted the nuns' viewing and interpretation of Filippo Lippi's *Coronation of the Virgin* high altarpiece. Holmes, *Fra Filippo Lippi*, pp. 229, 238, 284, note 119, 286, note 144. Borsook, "Cults and Imagery," p. 167.

54 Paatz and Paatz note that the late fourteenth-century church of the Clarissan nuns, Santi Jacopo e Lorenzo, housed the singular Florentine example of a nuns' choir in the format of a ground-floor monks' choir, which was enclosed by frescoed walls. Within the later church, however, built between 1543 and 1584, the nuns' choir occupied a standard western gallery. Paatz and Paatz, *Kirchen von Florenz*, vol. 2, pp. 428–29, 431, 432, note 13. Richa, *Notizie istoriche*, vol. 2, pp. 215, 217.

55 For San Felice in Piazza see Paatz and Paatz, *Kirchen von Florenz*, vol. 2, p. 46; for Sant'Apollonia see ibid., vol. 1, p. 212; for San Barnabà see ibid., vol. 1, p. 321; for Santa Elisabetta delle Convertite see ibid., vol. 2, p. 32; for San Giovannino dei Cavalieri see ibid., vol. 2, p. 307; for San Girolamo sulla Costa see ibid., vol. 2, p. 345; for San Giorgio alla Costa, see ibid., vol. 2, p. 163; for Santa Maria degli Angiolini see ibid., vol. 3, p. 149; for Santa Monaca see ibid., vol. 4, p. 315; and for Le Murate see Saundra Weddle, "Enclosing Le Murate: The Ideology of Enclosure and the Architecture of a Florentine Convent, 1390–1597" (PhD thesis, Cornell University, 1997), pp. 149–50. See also the relevant entries in Fantozzi Micali and Roselli, *Le Soppressioni dei Conventi*.

56 For Santa Caterina di Siena see Paatz and Paatz, *Kirchen von Florenz*, vol. 1, p. 435; for San Domenico al Maglio see ibid., vol. 2, p. 3; for San Jacopo di Ripoli see ibid., vol. 2, p. 435; and Santa Maria dei Candeli see ibid., vol. 3, p. 179.

57 For medieval nuns' choirs in Italy, see especially Caroline Bruzelius, "Hearing Is Believing: Clarissan Architecture, ca. 1213–1340," *Gesta* 31, no. 2 (1992), pp. 83–91; Helen Hills, "Architecture as Metaphor for the Body: The Case of Female Convents in Early Modern Italy," in *Gender and Architecture*, ed. Louise Durning and Richard Wrigley (Chichester, 2000), pp. 67–112.

58 ASF, San Pier Maggiore, vol. 229, fol. 141a.

59 ASF, San Pier Maggiore, vol. 55, fol. 231v.

60 The term "choro degli uomini" was also used in documents from the parish church of San Lorenzo in Florence. Pacciani noted that in 1440 two beechwood benches were purchased for this choir, which he hypothesized could also have been equipped with a physical barrier. Pacciani, "Cori, tramezzi, cortine," pp. 321, 325, note 35.

61 Victoria Primhak, "Women in Religious Communities: The Benedictine Convents of Venice, 1400–1550" (PhD thesis, University of London, 1991), p. 26; D'Addario, *Aspetti della Controriforma*, pp. 132–44; Silvia Evangelisti, "'We Do Not Have It, and We Do Not Want It': Women, Power, and Convent Reform in Florence,"

The Sixteenth Century Journal 34, no. 3 (2003), pp. 682–84.

62 ASF, San Pier Maggiore, vol. 54, fol. 85r–v.

63 "Ragunoronsi nel choro di chiesa circa 50 cittadini statuali, e molt'altri popolani." ASF, San Pier Maggiore, vol. 54, fol. 85r.

64 "Item hanno amantenere il choro delli huomini et tutte le panche delle chiesa." ASF, San Pier Maggiore, vol. 54, fol. 85v.

65 Kent and Kent noted that in 1455 the Chiavi gonfalon "planned to use local money to repair and beautify the church of San Pier Maggiore, their usual meeting-place." Kent and Kent, *Neighbours and Neighbourhood*, p. 156. They refer to ASF, Notarile Antecosimiano 21155 (Viva Piero). Although these notarial records place the gonfalon meetings in the church of San Pier Maggiore, one document (Inserto 1, 15½ r–v) specifies that they met in the sacristy, although it is not inconceivable that at some point they met in the men's choir.

66 For example, the Lion Rosso in San Pancrazio: see Chapter 5.

67 Miller, "Why the Bishop of Florence," pp. 1064–67; Strocchia, "When the Bishop Married the Abbess," p. 349; Fabbri, "La sella e il freno," p. 895.

68 Fabbri, "La sella e il freno," pp. 895–909.

69 "i Guardiani sopraddetti colle loro Ghirlande di erba in capo, e guanti, e bastoni in mano nulla altra persona tramezzando tra i detti Cappellani, e Guardiani si debba così condurre, e guidare Messer lo Vescovo per la Chiesa insino all'Altare Maggiore di essa Chiesa." Richa, *Notizie istoriche*, vol. 1, p. 129.

70 Strocchia listed this group as "communal officials, judges, knights, men-at-arms, cathedral canons, secular clergy, and monks, along with 'all the populace of Florence.'" Strocchia, "When the Bishop Married the Abbess," pp. 348–49.

71 ASF, CRS no. 79 (Sant'Ambrogio), vol. 121, fol. 4v: "feci rompere el muro della chiesa sotto il choro degli uomini per fare la porta nuova et di poi veduto non essere honesto luogo per la porta lo feci rimurare." Cited in Borsook, "Cults and Imagery," p. 196, note 133. Borsook quoted from Rosselli's Sepoltuario, which stated "Dietro all'altar grande nel Coro de' Preti," ibid., p. 196, note 132.

72 See Chapter 3.

73 Anabel Thomas, *Art and Piety in the Female Religious Communities of Renaissance Italy* (Cambridge, 2003), p. 50. Michele Faloci Pulignani, "Saggi della cronaca di Suor Caterina Guarnieri da Osimo," *Archivio storico per le Marche e per l'Umbria* 1 (1884), p. 301.

74 The plan is in Archivio di Stato di Venezia, Santa Croce della Giudecca, vol. 4, Disegno 14. Primhak, "Women in Religious Communities," p. 79.

75 Following Bietti Favi, De Marchi asserted that San Pier Maggiore had a wooden tramezzo, mentioned in 1381 and demolished in 1569, to which were attached two chapels, hypothesizing that two panels, depicting an enthroned St. Peter and the Virgin and Child between SS Peter and Lucy, could have feasibly been displayed

atop the screen. De Marchi, "'Cum dictum opus sit magnum'," p. 615.

76 Bietti Favi, "Indizi documentari," p. 243.

77 Although the documents from the 1310s that Bietti Favi linked to the tramezzo actually refer to the nuns' choir, the tramezzo could feasibly have existed at this date. Ibid., p. 243.

78 "Item in nun ferro e d'anello per sostenere il crucifisso." ASF, San Pier Maggiore, vol. 66, fol. 119v. When Rosselli compiled his Sepoltuario in the seventeenth century, he described a large old crucifix ("un Crocifisso antico grande") adorned with the Filicaia heraldry ("nella quale è scolpita l'arme de Filicai"). Florence, Biblioteca Nazionale Centrale di Firenze, Fondo nazionale, II, I, 125 (Sepoltuario fiorentino di Rosselli, Quartiere S. Croce), fol. 139 (new numeration 70r). Although lacking any heraldry, the cross is likely that which was transferred to Santa Croce in 1785 after the demolition of San Pier Maggiore. Bietti Favi, "Indizi documentari," p. 243. Santi noted that the cross lacks the triangular base that would have supported its placement on a beam or tramezzo, which however, is present on a similar, smaller cross, also attributed to Lippo in the Villa "La Quiete" in Valcava. Bruno Santi, "Una croce dipinta di Lippo di Benivieni dalla Villa 'La Quiete' in Valcava di Mugello," Studi di storia dell'arte 1 (1990), p. 255.

79 "apud secundum columnum sive pilastrum dicte ecclesie alate sinistro in loco cui dicta Ingravida." ASF, Notarile Antecosimiano, vol. 7898, fol. 222v.

80 ASF, San Pier Maggiore, vol. 55, fol. 231v.

81 Ibid., fol. 258v.

82 The c. 1570 list noted that "il padronato si disputa tra e Fortunati cioè Carlo e Fratelli et il Figliolo d'Angiolo," suggesting that both Carlo and the original Angiolo were members of the Fortunati family. ASF, San Pier Maggiore, vol. 55, fol. 258v.

83 ASF, San Pier Maggiore, vol. 36 (Libro delle Cappelle, sec. XVII), fol. 44r: "Cappella della Santissima Nunziata nuova in nostra chiesa appresso il 2do Pilastro di detta dal lato sinistro, nel luogo il quali si chiamava la gravida patronato della famiglia di Fortunati." Similarly, an undated list of chapels noted "Cappella della Madonna detta la gravida; Padronato de Fortunati." ASF, San Pier Maggiore, vol. 44, loose sheets, no. 35.

84 ASF, San Pier Maggiore, vol. 39, fol. 103.

85 "Questa fu creduta pittura greca fatta in tempo del Concilio Generale, ma io la stima Fiorentina." Richa, Notizie istoriche, vol. 1, p. 141. Paatz and Paatz also commented that this was probably an early Florentine work. Paatz and Paatz, Kirchen von Florenz, vol. 4, p. 650, note 38. Holmes listed this image among other miraculous images in medieval Florence. Megan Holmes, The Miraculous Image in Renaissance Florence (New Haven, CT and London, 2013), pp. 40, 65. I am grateful to Holmes, who confirmed in personal communication, dated 4 November 2019, that she had been unable to verify the source of Richa's assertion.

86 See Andrew Ladis, Taddeo Gaddi: Critical Reappraisal and Catalogue Raisonné (Columbia, MO and London, 1982), pp. 66, 169; Brendan Cassidy, "A Relic, Some Pictures and the Mothers of Florence in the Late Fourteenth Century," Gesta 30, no. 2 (1991), pp. 97–98; Ermes Maria Ronchi, ed., La Madonna nell'attesa del parto: capolavori del patrimonio italiano del '300 e '400 (Milan, 2000), p. 50. The catalogue acknowledged that critics do not agree over the dating of this work, which ranges from the 1320s to 1350s.

87 With reference to ASF, San Pier Maggiore, vol. 351, 22 March 1785 (or 24 January according to Manetti), which has not been consulted by the present author. Manetti states that on 24 January 1785 Mattia Federighi, son of Giovanni, was given permission to remove the image "che esisteva nella demolita chiesa di San Pier Maggiore." Apparently other documents related to this transfer exist in the parish archive of San Francesco di Paola, which again, have not been consulted by the present author. Monica Bietti Favi, "Gaddo Gaddi: un'ipotesi," Arte Cristiana 71, no. 694 (1983), pp. 50, 52, note 26; Renzo Manetti, Le Madonne del Parto: icone templari (Florence, 2005), p. 59; Renzo Manetti, Beatrice e Monnalisa (Florence, 2005), p. 156. See also "Chiesa di San Vito," www.chiesadisanvito.it/page.php?44.

88 Cassidy, "A Relic, Some Pictures," p. 91.

89 Jacqueline Marie Musacchio, The Art and Ritual of Childbirth in Renaissance Italy (New Haven, CT and London, 1999), p. 144. Cassidy suggested that expectant women and their families prayed to images of the pregnant Madonna. Cassidy, "A Relic, Some Pictures," p. 97. See also Irving Lavin, "Santa Maria del Fiore: Image of the Pregnant Madonna: The Christology of Florence Cathedral," in La cattedrale e la città. Saggi sul duomo di Firenze. Atti del convegno internazionale di studi (Firenze, 16–21 giugno 1997), ed. Timothy Verdon and Annalisa Innocenti (Florence, 2001), pp. 683–86.

90 In his later Instructiones, Carlo Borromeo stated that benches for women should be placed on the left, or north, side of the church: "With the exception of churches where, on account of the site, or for some other reason the bishop judges otherwise, the women's side should be on the north." Evelyn Carole Voelker, "Charles Borromeo's Instructiones Fabricae et Supellectilis Ecclesiasticae, 1577. A Translation with Commentary and Analysis" (PhD thesis, Syracuse University, 1977), p. 322.

91 Jung, The Gothic Screen, particularly pp. 126–28.

92 The altar was decorated with an image of the pregnant Madonna. De Blaauw, Cultus et decor, vol. 2, pp. 706, 721, note 211; Carol M. Richardson, Reclaiming Rome: Cardinals in the Fifteenth Century (Leiden and Boston, 2009), pp. 449–50. I am grateful to Julian Gardner for bringing this material to my attention.

93 ASF, San Pier Maggiore, vol. 62, fol. 60v.

94 28 April 1571: "Si disse la messa alla gravida per madonna Lorenza." Florence, Archivo Arcivescovile, Libro de Morti e Ufizi del Monasterio di S. Piero Mag: del 1547 e 1571 segnato B, fol. 189v.

95 ASF, San Pier Maggiore, vol. 38, fol. 18.

96 "Cappella intitolata la Santissima Concezione fondata della Famiglia de Signori Micchieri nella chiesa di S. Pier Maggiore all'altare della Gravida. L'instrumento della fondazione non costare all'Archivio Pubblico, ne altrove. Padronato al presente del venerabile spedale di S. Maria Nuova, e signore Bartolommeo Lasagnini Miccieri." ASF, San Pier Maggiore, vol. 39, p. 28.

97 "cappella di sotto il pergamo che si dice de Filicaia." Payment recorded 1 March 1568 (stil. Flor) ASF, San Pier Maggiore, vol. 229, fol. 36b. "cappella rincontro al pergamo che si dice degli Albizi." ASF, San Pier Maggiore, vol. 229, fol. 39a.

98 "Ancora stanze à Michele scarpellino l. 50 v. per un fregio di Marmi fatte intorno alla Cappella di Filicai, quale si fece à richiesta de dette Filicai quando si levorono i Ferri che facevono grato intorno a detta loro cappella." Dated 13 September 1572. ASF, San Pier Maggiore, vol. 229, fol. 142b.

99 "Accanto a questa sepoltura verso il Corso è una lista di marmo, che ligira, e una circonferenza, che lacchiude uno spazio quadro di braccia sette o otto per lato, che confina colla sopradetta sepoltura e colla nave di verso il coro, e col pilastro, che legge il pulpito, e dè della nobile famiglia da Filicaia. Dentro a questo spazio è un lastrone di marmo della detta famiglia con loro arme senza altra iscrizione, il quale viene adirittura del detto pilastro, e confina colla nave di verso il Corso." ASF, San Pier Maggiore, vol. 42, fol. 16r. The phrase "verso il Corso" refers to the left nave, toward the present-day Borgo degli Albizzi.

100 "Filippo di Marcotto Fabro alla Condotta dare adi ij di Marzo 1568 lire dugento trentacinque s. d. iiij videlicet sono per la valuta di libre dumilia ottanta nove di ferri vechi, quali erano intorno alla cappella sotto il pergamo di nostra chiesa che si dice de filicai." ASF, San Pier Maggiore, vol. 229, fol. 39a. Martini equated one Florentine libbra to 0.339542 kg. Angelo Martini, *Manuale di metrologia, ossia misure, pesi e monete in uso attualmente e anticamente presso tutti i popoli* (Turin, 1883), p. 207. I am grateful to Andy Holtin for his insight into the volumetric weight of sculptural materials.

101 "E de dare ad detta lire dugento sessantotto s. xv. d. iiij videlicet sono per valuta di libre dumilia trecento ottanta nove di ferri vechi . . . era intorno alla cappella rincontro al pergamo che si dice degli albizi." ASF, San Pier Maggiore, vol. 229, fol. 39a.

102 "in graticole per ornamento di detta cappella." ASF, San Pier Maggiore, vol. 229, fol. 40b.

103 For the weight of the Palazzo Pubblico screen, see Paola Elena Boccalatte, *Fabbri e ferri: Italia, XII–XVI secolo,* BAR International Series (Oxford, 2013), p. 125.

104 The screen is attributed to Manfredi di Franco di Pistoia. Nicola Vasaturo, *La chiesa di S. Trinita: Nota storiche e guida artistica* (Florence, 1973), p. 12.

105 For the tabernacle, see Linda A. Koch, "Medici Continuity, Imperial Tradition and Florentine History: Piero de' Medici's Tabernacle of the Crucifix at S. Miniato al Monte," in *A Scarlet Renaissance: Essays in Honor of Sarah Blake McHam,* ed. Arnold Victor Coonin (New York, 2013), pp. 183–212.

106 ASF, San Pier Maggiore, vol. 229, fol. 141a.

107 This directive had been sent to the prior and the purveyor Luca Mini, and was notarized by Ser Piero di Ser Bartolomeo Pontassieve. I have been unable to find this original document.

108 24 February 1569: "ij. Panche con gli appoggiata fatto fare pel coro innanzi alla altare maggiore." ASF, San Pier Maggiore, vol. 229, fol. 141b.

109 ASF, S. Pier Maggiore, vol. 132, fol. 6r; ASF, San Pier Maggiore, vol. 131, fol. 31v.

110 7 July 1569: "per amattonare la chiesa." ASF, San Pier Maggiore, vol. 229, fol. 41a.

111 "sono convenuto con Maestro Nofini di Serafino Zefferini da Cortona organista che il detto rifaccia di nuovo l'organo della nostra chiesa di S. Piero Maggiore." In addition to specific instructions regarding the keyboard, pipes, and bellows, Zeffirini had to "mettendolo nel tuono de l'organo grande della Nutiata." ASF, San Pier Maggiore, vol. 54, fol. 106v. In November 1568, Zeffirini was paid 375 lire for his work on the new organ. ASF, San Pier Maggiore, vol. 95, fol. 190v.

112 Strocchia, "When the Bishop Married the Abbess," p. 361. For Altoviti, see D'Addario, *Aspetti della Controriforma,* pp. 121–23. For Altoviti's *Entrata,* see Domenico Moreni, *De ingressu Antonii Altovitae Archiepiscopi Florentini historica descriptio incerti auctoris* (Florence, 1815).

113 "erat enim Templum multitudine hominum, mulierumque refertissimum." Moreni, *De ingressu Antonii Altovitae,* p. 50.

114 For example, in Santa Croce in January 1567, new stalls designed by Vasari, which supplemented the existing fifteenth-century stalls in the cappella maggiore, were installed behind the high altar. See Chapter 3 for more details.

115 For the Albizzi in terms of the Medici faction of the fifteenth century, see Kent, *The Rise of the Medici,* pp. 140, 355.

116 For the shift toward centralized Medici power, see Isermeyer, "Il Vasari"; Lunardi, "La ristrutturazione vasariana"; Loughman, "Commissioning Familial Remembrance," p. 140; Litchfield, *Emergence of a Bureaucracy,* pp. 84–109; Elizabeth Pilliod, "Cosimo I and the Arts," in *Artistic Centers of the Renaissance: Florence,* ed. Francis Ames-Lewis (Cambridge and New York, 2012), p. 364; Rosenthal, *Kings of the Street,* especially p. 82.

117 Francesco Albertini, *Memorial of Many Statues and Paintings in the Illustrious City of Florence (1510),* trans. Waldemar H. de Boer (Florence, 2010), p. 99.

118 "Fece ancora a San Piero Maggiore il Tabernacolo del Sacramento, di marmo, con la solita diligenza: ed ancorachè in quello non siano figure, e' vi si vede però una bella maniera ed una grazia infinita, come nell'altre cose sue." Beatrice Paolozzi Strozzi, "Desiderio, Matteo Palmieri e un'opera perduta," in *Desiderio da Settignano:*

Atti del convegno, 9–12 maggio 2007, Firenze, Kunsthistorisches Institut, Max-Planck-Institut, Settignano, Villa I Tatti (The Harvard University Center for Italian Renaissance Studies), ed. Joseph Connors, Alessandro Nova, Beatrice Paolozzi Strozzi, and Gerhard Wolf (Venice, 2011), p. 64.

119 "Et quando si levasse la tavola che è molto grande, la cappella appareria maggiore, e con più grazia, et si guadagneria la vista di tutte quelle finestre maggiori che sono molto belle, e li frati potriano veder levare il Sacramento, e in sull'altare si potria metter uno ciborio o un Crocifisso, come hanno Santo Spirito, la Nuntiata et Santo Piero Maggiore, e risparmierebbesi spesa." Dated 21 July 1566. Moisé, *Santa Croce di Firenze*, p. 124.

120 The altarpiece was certainly displayed in the della Rena chapel at least by 1611–15. Strehlke, *Italian Paintings*, p. 202.

121 13 September 1572: "uno inginochiatoio di albero con cornice di noce per tenere innanzi alla altare maggiore insieme con un altro fatto piu tempo fa, e di un cupolini di legniame fatta di lui per tenere sopra il ciborio di marmo che e dreto alla detta altare." ASF, San Pier Maggiore, vol. 229, fol. 142b.

122 "tabernaculo marmoreo non deaurato in altare maiori." Florence, Archivio Arcivescovile, VP 12, fol. 22r.

123 For the following discussion, I am greatly indebted to Alison Luchs of the National Gallery of Art.

124 Paul Davies, "Framing the Miraculous: The Devotional Functions of Perspective in Italian Renaissance Tabernacle Design," *Art History* 36.5 (2013), p. 902.

125 Middeldorf mused that the ciborium may have been designed by Desiderio but completed by members of his wider circle. Ulrich Middeldorf, *Sculptures from the Samuel H. Kress Collection: European Schools, XIV–XIX Century* (London and New York, 1976), pp. 16–18.

126 Ida Cardellini, *Desiderio da Settignano* (Milan, 1962), pp. 252–56; Paolozzi Strozzi, "Desiderio, Matteo Palmieri," pp. 61–78.

127 Carl, "Verloren und Wiedererfunden," pp. 300–18. Carl further argued that since Tito Gagliardi, who sold the piece to the Rothschilds, was demonstrably entangled in the creation of forgeries, he might have feasibly been involved in the creation of this piece.

128 "[W]e can be all but certain that none of its disparate parts come from San Pier Maggiore." Alison Luchs, "The Washington Ciborium Attributed to Desiderio da Settignano: Quattrocento, Ottocento, or Both?," in *Encountering the Renaissance: Celebrating Gary M. Radke and 50 years of the Syracuse University Graduate Program in Renaissance Art*, ed. Molly Bourne and Arnold Victor Coonin (Ramsey, NJ, 2016), p. 200. The National Gallery of Art website attributes and dates the piece thus: "1460s–c. 1470 (stem with integral base); probably 1860s–c. 1870 (dome, enclosure, base beneath enclosure); 1870s (finial, bottom plinth)." www.nga.gov/collection/art-object-page.41715.html.

129 Strocchia, "When the Bishop Married the Abbess," p. 361.

Chapter 7

BEHAVIOR AND REFORM IN THE CIVIC ORATORY

Orsanmichele

THE UNIQUENESS OF ORSANMICHELE as an institution, sacred site, and architectural space is hard to overstate. Originally a communal grain market, Orsanmichele was from the start an exceptional building that combined civic, guild, and devotional functions. The imposing three-story building ("ancient, very tall," according to Albertini[1]) is unlike a traditional church (Figure 159). The Compagnia di Orsanmichele, the wealthy lay confraternity that administered the establishment, was the only one in Florence not explicitly tied to a church.[2] Devotional aspects, such as lauds singing, coexisted with more profane activities, such as a sale of confiscated Medici property that took place in 1495.[3] This intermingling of the sacred and secular continued in the sixteenth century when the upper floors were repurposed to house the city's notarial archives.

The singular status of Orsanmichele within communal and guild life, its predominantly lay administrative system, and the building's divergence from architectural church norms make the presence of an ironwork tramezzo in its interior rather surprising. Specifically designated a "tramezo" in archival documentation, this dividing screen reveals that such structures were not unique to the monastic or mendicant contexts. Although the Orsanmichele tramezzo was typologically and materially distinct from more monumental examples, its removal in 1569 formed part of the broader pattern of Florentine church renovations, crucially indicating that contemporaries viewed it in similar terms. The iron tramezzo has been almost entirely excluded from art-historical scholarship on Orsanmichele, and has never been incorporated within wider examinations of the Florentine church alterations. This chapter will explore the original

Figure 159 Orsanmichele, Florence. Exterior view of northwest corner. Photo: author

function, location, and appearance of the tra-
mezzo and examine the motivations and conse-
quences of its eventual removal.

ORSANMICHELE

In the ninth century, an oratory of St. Michael,
located in a garden in the center of Florence,
was bequeathed to the wealthy Benedictine mon-
astery of San Silvestro at Nonantola with the
requirement that it be converted into a convent.[4]
By 1239, this church had been destroyed, possibly
in relation to disputes between local Guelf and
Ghibelline factions. Despite the monastery's pro-
tests, the Commune transformed the space into
the communal piazza of Orto San Michele.[5] In an
open-air grain market in the center of the piazza,
a frescoed image of the Virgin Mary started

performing miracles, which attracted significant
lay devotion to the site.

Founded in 1291, the Compagnia di
Orsanmichele – whose lay members (known as
Capitani) represented the city's six *sesti* – sang
lauds before the Marian image, facilitated devo-
tional activities within the oratory, received govern-
ment money for distribution to the poor, and
administered numerous individual legacies and
donations.[6] In addition to the Compagnia,
Orsanmichele began its relationship with the
Florentine trade guilds in 1324 when the Wool
Guild began contributing funds.[7] A government
provision of 1336 stipulated that a new "palace"
should be built in Piazza Orsanmichele, supervised
by the Silk Guild, as a site both for Marian devotion
and the preservation of grain.[8] Most likely designed
by Andrea Pisano according to Diane Zervas, the
building's simple rectangular plan is perfectly

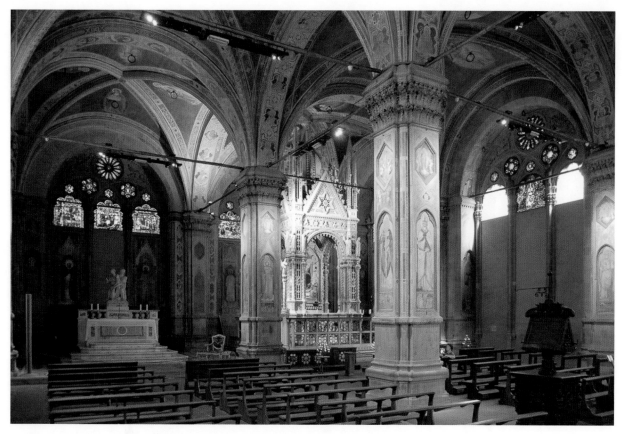

Figure 160 Orsanmichele, Florence. Interior view facing southeast. Photo: author

aligned with the cardinal directions and internally divided into six bays (Figures 160 and 161).[9] The lower floor formed an open loggia while the two upper floors were utilized for the storage of grain and offices of the communal grain magistracy. In 1339, niches on the exterior piers were designated for images of the patron saints of the guilds and the Parte Guelfa in a uniquely public expression of corporate and communal devotion.[10] Niche statues by Ghiberti, Donatello, Verrocchio, and others chart the development of free-standing figure sculpture in early Renaissance Florence.

In a period dominated by the Black Death – which saw donations to Orsanmichele significantly increase – the Capitani undertook a substantial renovation of its devotional apparatus.[11] The third incarnation of the miracle-working image of the enthroned Madonna and Child surrounded by angels was painted by Bernardo

Daddi in 1347, and its new marble tabernacle was constructed by Orcagna in 1352–59 (A on Figure 161).[12] In a compelling design reminiscent of late medieval Roman altar ciboria, Orcagna's tabernacle is a complex three-dimensional marble structure replete with marble reliefs, mosaic, and gilded incrustations (Figure 162).[13] In 1365, the Florentine *Signoria* named the Virgin of Orsanmichele as the city's special protectress, and approved a provision to construct a new grain market to the south-east of the Palazzo della Signoria, heralding the transformation of the oratory into an exclusively sacred space.[14]

THE IRON TRAMEZZO

Although archival sources do not furnish any indications of the precise dating of the iron

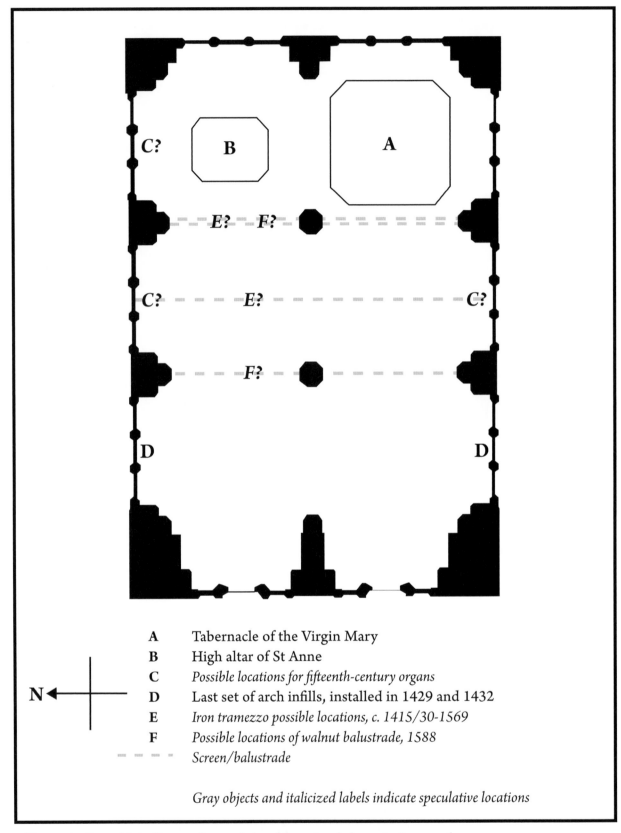

A	Tabernacle of the Virgin Mary
B	High altar of St Anne
C	*Possible locations for fifteenth-century organs*
D	Last set of arch infills, installed in 1429 and 1432
E	*Iron tramezzo possible locations, c. 1415/30-1569*
F	*Possible locations of walnut balustrade, 1588*
– – –	*Screen/balustrade*

Gray objects and italicized labels indicate speculative locations

Figure 161 Orsanmichele, Florence. Proposed plan of the oratory before 1569. Image: author

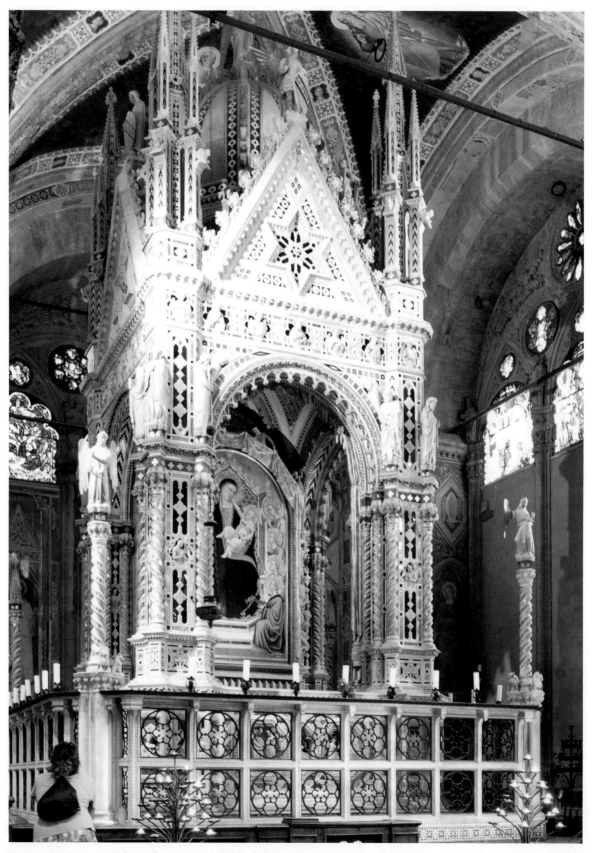

Figure 162 Orcagna, *Tabernacle*, 1352–59, marble, lapis lazuli, gold, and glass inlay; Bernardo Daddi, *Madonna and Child with Angels*, 1347, tempera on wood. Orsanmichele, Florence. Photo: author

tramezzo, circumstantial evidence hints at the probable period of its installation. Zervas proposed that the tramezzo was installed during the ten-year period from July 1419 to March 1429 for which confraternity records do not survive, suggesting that the restricted access to the tabernacle caused by the screen contributed to the vast reduction in income reported by the 1429 Catasto.[15] The conversion of the oratory of Orsanmichele into a collegiate church may have prompted this internal segregation of space. In the absence of original documentation, Richa's eighteenth-century account provides details of this change in administration.[16] Summarizing a now-lost source in the Capitani archives, Richa claimed that the foundation instituted by the Republic in 1415 provided for a college of ten priests, two *chierici* (unordained assistants), and a provost. The priests enjoyed the privilege of wearing purple hoods ("cappuccio pavonazzo"), and could be assisted by musicians at the lauds of the Virgin Mary on feast days and the weekly unveiling of the holy image. Previously, Orsanmichele had been served by a single priest with the title of sacristan.

This change in status was indicative of the modified role of the oratory in this period from a multifunctional, hybrid institution expressive of commercial, civic and charitable values to a more explicitly religious space. Indeed, Marco Rustici's mid-fifteenth-century description noted that Orsanmichele was "well officiated by priests," emphasizing the great quantity of masses celebrated there.[17] By this point, Orsanmichele was also economically weakened compared to its successful status in the fourteenth century, and was no longer the wealthiest source of charitable giving in the city.[18] John Henderson concluded that the administrative change was representative of Orsanmichele's loss of independence, and of the shift in its overriding authority from the state to the bishop.[19] Zervas noted that the government had regularly passed legislation concerning

Orsanmichele, determining that the new status – which placed the oratory on the same ecclesiastical level as the cathedral and San Lorenzo – exemplified its "subordination to the Florentine state."[20]

From an architectural standpoint, the oratory must have been completely enclosed to warrant the division of its interior space, so the construction of the tramezzo certainly postdated the infilling of the open arches on the ground floor. Following the 1365 governmental decision to relocate the grain market elsewhere, in 1366 the Capitani commissioned Simone di Francesco Talenti to execute limestone tracery for the ten external arches of the oratory.[21] The ordering and dating in which the remaining arches received tracery is still in dispute, although scholars agree that the earliest were installed in the bays immediately adjacent to the tabernacle.[22] It also seems clear that the two westernmost bays of the north and south facade were installed last, in 1429 and 1432 respectively (D on Figure 161). According to Gert Kreytenberg, until 1410 the central lights of the windows were left open and essentially functioned as passageways into the building; Zervas clarified that these were intended to be filled with bronze latticework doors.[23] An initial stained-glass campaign was likely executed during the undocumented years 1383–88, while the second campaign, depicting the life of the Virgin devised by Orsanmichele Capitano and poet Francesco Sacchetti and, according to Zervas designed by Ghiberti, was only completely installed in 1432.[24]

The gradual enclosing of the building with traceries and the installation of stained glass visually underscored the separation of its interior sacred space from the exterior civic space. It provides not only a *terminus post quem* but also an ideological context for the decision to further segregate the oratory. As passage into the building as a whole was becoming more prescribed through the creation of walled-up arches and portals, so access to its interior spaces was also

becoming more restricted. Considering the history of both the institution, including its administrative changes and musical enhancements, and of the building, especially the enclosing of the loggia arches, we can therefore conclude that the Orsanmichele tramezzo was likely installed c. 1415–30.[25]

This dating accords with the interior of Orsanmichele becoming better equipped for the more sophisticated liturgical functions associated with its elevated ecclesiastical status. Zervas noted the close involvement of Ghiberti in these years, a period which also witnessed numerous decorative projects including the completion of stained-glass windows and an enameled cross.[26] In 1429, Matteo di Pagolo degli Organi was paid seventy-five florins for a new pair of organs and fifteen florins for subsidiary expenses.[27] These organs were not the first to be installed in the oratory; organs were repaired in 1368, a new pair of instruments were purchased in 1378–81, and further repairs took place in 1410–20.[28] The 1429 organs, however, were a significant visual and spatial addition to the church interior, since they were adorned with shutters painted by Francesco di Antonio del Chierico (b. 1394), the remains of which are now housed in the seat of the Accademia del Disegno adjacent to Orsanmichele (Figure 163).[29] Each shutter door depicts two Evangelists on one side and four singing angels amid intarsiated choir stalls on the other, the latter of which Ludovica Sebregondi related to the lauds-singing practiced by paid musicians.[30] Blake Wilson has emphasized the high quality of musical performance at the oratory, particularly the lauds sung in the space in front of the Virgin tabernacle. From the 1360s on, Orsanmichele employed paid singers and instrumentalists, but by 1416, the confraternity was engaging six singers daily, plus four additional singers for feast days, one organist, and two instrumentalists.[31] In its 1427 tax return, the oratory recorded twelve singers, vielle

Figure 163 Francesco di Antonio del Chierico, *Organ shutter,* 1429, tempera on panel, 206 × 119 cm. Accademia del Disegno, Florence, on loan from Gallerie dell'Accademia. Photo: author

and lute players, and an organist.[32] The oratory employed a series of organists, including Giovanni degli Organi, Piero Mazzuoli and from 1430 Antonio Squarcialupi, who were among the most renowned players and polyphonic composers in the city.[33] The documented presence of a singing master and young boys, which hints at an educational program in polyphonic singing, further indicates the advanced nature of musical performance in Orsanmichele.[34]

Archival sources do not precisely describe the location of the tramezzo in Orsanmichele. However, the March 1569 letter from the

Figure 164 Bernardino Poccetti, *St. Antoninus Kneeling before the Crucifix in Orsanmichele, Florence,* 1602 or 1606, fresco. San Marco, Florence, Cloister of St. Antoninus. Photo: author

Capitani of Orsanmichele to Duke Cosimo regarding the removal of the tramezzo alludes to its placement. Just after describing the benefits of the screen's removal, the Capitani requested that the ugly and dishonorable pulpit, situated underneath the organ, should also be removed because it obscured a painting of *Christ among the Doctors*.[35] In its place, the Capitani were resolved to install a new pulpit attached to one of the central piers toward the altar. Although not explicitly linked, the fact that the tramezzo and pulpit were both subjects for demolition at the same time perhaps implies that they were in spatial relation to one another, as I have argued for Ognissanti and the Carmine (see Chapters 3 and 4).

The location of this pulpit, therefore, is predicated on the location of the organ (C on Figure 161). Analyzing the light sources of the painted organ shutters, Zervas concluded that the organ was likely situated to the north of the St. Anne altar, below the tracery of the east arch of the north facade. A later archival source confirms that one of the organs (if referring to the fifteenth-century instrument) was located in front of a stained-glass window in need of repair.[36] Paatz and Paatz argued that the paired organs were in the middle niches of the north and south walls, suggesting that the south instrument was depicted in Poccetti's *Saint Antoninus Kneeling before the Crucifix in Orsanmichele* in the San Marco cloister, now indiscernible in this damaged fresco (Figure 164).[37] Richa confirmed that the fresco of *Christ among the Doctors* was located beneath one of these organs.[38] While Zervas argued that the tramezzo only enclosed the easternmost bays of the oratory, the possibility remains therefore that it could have divided the whole space into two equal sections (E on Figure 161).[39]

The only known archival sources describing the tramezzo concern its 1569 removal. In the letter requesting ducal permission to demolish the screen, the Capitani claimed that it was an obstacle to viewing the tabernacle and made the oratory too dark. The precise term used, "fosco,"

could indicate either lack of illumination or a dark color.[40] The presumably dull color of the ironwork itself could have detracted from the bright colors of the frescoed piers, vaults and walls, the light Carrara marble of the St. Anne altarpiece, and the Marian tabernacle. Alternatively, perhaps the tramezzo prohibited light from the windows or candles around the tabernacle to be diffused around the church interior. As Orsanmichele was being transformed into an ecclesiastical space via the addition of arch infills and stained-glass windows, a notable side effect was inadequate illumination in the interior. Davies noted that this enhanced the visual effect and symbolic value of the lamps and candles surrounding the Marian tabernacle.[41] Indeed, numerous rings affixed to the cross vaults and arches of the oratory were used for the suspension of lamps, and a large number of wax ex-votos would have pervaded the interior.[42] In the later sixteenth century, candelabra included on the 1587 altar railing design (Figure 171) show that artificial illumination continued to be a valued element of the sacred space.[43]

The decorative ironwork of the Orsanmichele tramezzo formed a distinctive material component of the oratory interior. Income records from the sale of the tramezzo indicate that it was composed of three types of wrought ironwork.[44] "Catenas ferreas" refers to iron beams, presumably horizontal and/or vertical bars that would have framed the tramezzo and perhaps divided it into subsections.[45] The terms "crassas" and "craticulatos" refer to latticework and smaller latticework or grating respectively.[46] Although no specific form of geometric patterning is implied by these terms beyond some sort of interlocking grille, the Orsanmichele tramezzo might have resembled other Tuscan contemporary ironwork. Deriving from Trecento Sienese designs by blacksmiths such as Conte di Lello, numerous extant screens are composed of tie-beams that frame both small and large grated sections.[47]

Two examples close in date to the Orsanmichele tramezzo are extant in the Bartolini Salimbeni Chapel of the Annunciation in Santa Trinita, Florence (possibly c. 1423, Figure 165) and the Cappella dei Signori in the Palazzo Pubblico, Siena (1435–45, Figure 156).[48] Both screens feature large square panels of quatrefoil patterning framed by iron bars, surmounted by smaller rectangular panels of more delicate and densely composed filigree designs. Similarly, the bronze screen enclosing the Chapel of the Sacro Cingolo in Prato Cathedral (1438–68), with its intricate quatrefoil interlacing designs, enclosed an object of lay and civic devotion – the girdle of the Virgin Mary – comparable in status to the Orsanmichele Marian image (Figure 166).[49]

Despite the Capitani's later unreservedly negative appraisal – "made by someone who did not have good visual sense or judgement" ("fatto da chi non hebbe il vedere et giuditio")[50] – the iron tramezzo would have artistically integrated with other elements in the Orsanmichele interior. With its metal latticework, the screen may have echoed decorative forms used in the bronze parapet around the tabernacle, or even in the tracery infills themselves. Identifying stylistic similarities in roundel designs, Zervas has proposed that some of the material from the bronze grilles previously inserted into some arch infills was reemployed for the parapet surrounding the tabernacle.[51] Talenti's traceries were intended to be supplemented by bronze grilles that filled the spaces above the side stone infills and provided a lockable door in the central section. Zervas maintained that these bronze grilles (which were only ever installed on the south bay of the east facade) were removed and reutilized in the protective railing around Orcagna's tabernacle in the late 1380s as part of Sacchetti's decorative scheme (Figure 167). These delicate filigree patterns based on six-lobed rosettes, which may have been supplemented by similar designs on the

Figure 165 Manfredi di Franco di Pistoia (attr.), *Chapel screen,* possibly c. 1423, iron. Santa Trinita, Florence, Bartolini Salimbeni Chapel. Photo: author

tramezzo, provided a stimulating contrast to the building's robust square piers and somewhat heavy architectural forms. By virtue of its medium, design, and setting within a unique civic and sacred space, the Orsanmichele screen contrasted profoundly with tramezzi in other Florentine churches, which were often characterized by solid masonry constructions, painted imagery, and attached chapels.

Although it was a permeable, openwork structure, the tramezzo would have somewhat restricted visual and spatial access to the Marian image. The miracle-working image was never intended to be viewed indiscriminately. Indeed, multiple layers of enclosures enhanced its perceived holiness and dramatized its presence within the oratory interior. Capitani rubrics from 1333 stated that the image should be covered with silk veils and only uncovered on Sundays and feast days when preaching took

place, or when foreigners visited.[52] Megan Holmes has shown that Orcagna's tabernacle featured two sets of carved fictive veils held by angel carvings that created a sense of "intense visual excitement and anticipation," which enhanced the sacred object.[53] The old tabernacle might have featured additional barriers, since the Capitani donated some iron railings "that were in the old pilaster of the oratory" to the hospital of San Piero Novello in 1367.[54] In Orcagna's tabernacle, while physical evidence shows that a type of gate could be inserted 10 cm away to partially obscure the painting, an elaborate system for maneuvering screens (possibly leather curtains) via pulleys and grooves was likely rarely used.[55] Nevertheless, the presence of an iron tramezzo reflected the desire both to visually conceal the image and to physically restrict movement around the interior space of the oratory.

Figure 166 Maso di Bartolomeo, Bruno di Ser Lapo Mazzei, Antonio di Ser Cola, and Pasquino da Montepulciano, *Chapel screen*, 1438–68, bronze. Prato Cathedral, Chapel of Sacro Cingolo. Photo: author

Given the somewhat unusual physical properties of the Orsanmichele tramezzo – its iron material and latticework design – what were the functions of the screen? As discussed in a broader sense in Chapter 1, spatial restrictions imposed by screens in general must have had a temporal dimension. Evidently in Orsanmichele, certain Compagnia members – such as lauds singers, guards, and financial officials – would have had physical access to the tabernacle at specific times. Indeed, payment records for singers' benches and an expensive lectern cloth indicate that lauds-singing took place in front of the Marian tabernacle, at least in the fourteenth century.[56]

Moreover, while the tramezzo restricted some visual access, it did not completely block views of the images in the eastern bays, again showing that strict segregation of space was not necessarily

desired in this civic oratory setting. The St. Anne altar – officially the "high altar" of the oratory – is located in the northeast bay, adjacent to the Marian tabernacle in the southeast bay (B on Figure 161). The popular revolt against Walter VI of Brienne – the despotic ruler of Florence for a short time, known as the "Duke of Athens" – on St. Anne's day (26 July) in 1343, prompted official communal devotion to the mother of Mary centered in the oratory of Orsanmichele.[57] Scholars disagree over whether the Orsanmichele St. Anne high altar was originally adorned with either a polychromed, wooden *Virgin and Child with St. Anne* or a panel painting depicting *St. Anne with the Child Mary*, both of which are currently housed at the Bargello Museum.[58] In 1522, the Capitani commissioned a sculpted altarpiece for the St. Anne altar from

Figure 167 Orsanmichele, Florence, bronze railing around the tabernacle. Photo: author

Francesco da Sangallo (Figure 168). After the design had been approved by archbishop of Florence Cardinal Giulio de' Medici, the classicizing Carrara marble group of the Virgin and Child with St. Anne was completed in 1526.[59] Unusually, Sangallo incorporated Hebrew transliterations of Latin phrases from biblical and liturgical sources on the front of the stone base and around the necklines of St. Anne and the Christ child.[60] Such erudite textual motifs were surely targeted toward a highly intellectual audience, possibly including scholars associated with the Medici court, who must have had, at least occasionally, close visual access to the altar. In addition, an annual St. Anne's Day procession between a convent dedicated to St. Anne outside the city walls and the Orsanmichele high altar shows that the altar was the subject of popular public devotion.[61]

Another cult image was displayed in this privileged zone. A large carved wooden crucifix attributed to Orcagna and dated to c. 1350, now in the adjacent church of San Carlo Borromeo, was originally housed in Orsanmichele (Figure 169).[62] According to early narratives of his life, the young St. Antoninus prayed in the oratory before a carved image of the crucifix ("figuram crucifixi"), to which he pledged to retain his virginity.[63] Del Migliore in 1684 and Richa in 1754 noted that the Orcagna crucifix was attached to the eastern pier between the two altars and that this was the image that had miraculously spoken to St. Antoninus, as depicted in Alessandro Allori's fresco, *St. Antoninus before the Orsanmichele Crucifix*, in the St. Antoninus Chapel in San Marco and Poccetti's fresco, *St Antoninus Kneeling before the Crucifix in Orsanmichele*, for the San Marco cloister (Figure 164).[64] At some point after the saint's death in 1459, the Observant

Figure 168 Francesco da Sangallo, *Virgin and Child with Saint Anne*, 1522–1526, marble. Orsanmichele, Florence, High Altar of St. Anne. Photo: author

Dominicans of San Marco began to venerate this object on annual pilgrimages, and since the fourteenth century, indulgences were granted to those who recited the *Stabat Mater Dolorosa* hymn, which was displayed on the same eastern wall of the oratory.[65] Again, as with the St. Anne altar and Marian tabernacle, it seems that the tramezzo did not entirely restrict access to the eastern area of the oratory.

Whether the tramezzo itself supported any cult images is unclear, but later documents refer to a crucifix (probably not the Orcagna version) on a raised beam in an unknown location. In 1574, the Oratory paid for work on the "foot of the carved cross,"[66] and in February 1582, the Capitani purchased some ironwork to support

"the beam of the crucifix," together with a baluster and a ring,[67] while a walnut cornice for the crucifix beam was purchased in the following month.[68] The 1591 reform statutes required two lamps to be kept alight at the crucifix and one at the Marian tabernacle, but again the location of this unidentified crucifix remains uncertain.[69]

Removal of the Iron Tramezzo

The iron tramezzo was removed from the Orsanmichele interior in the context of a major reform of the oratory and its gradual decline. During the sixteenth century, Orsanmichele gradually lost its central importance in the civic and

Figure 169 Orcagna (attr.), *Crucifix*, c. 1350, wood. San Carlo Borromeo, Florence. Photo: author

religious life of the city and its income was reduced. Economic and societal change lessened the need for strong trade guilds, and in 1534, the minor guilds were reorganized into four universities.[70]

Whereas in other Florentine cases, precise links between reform, ducal interests, and architectural alterations are not always easy to establish, at Orsanmichele, Duke Cosimo ordered a reform of the oratory in spring 1568, which included financial, liturgical, musical, and hygienic improvements.[71] Although a clear statement of reform does not survive, letters from the appointed reformers and Capitani to the duke reveal the nature of the proposed changes.[72] For example, in April 1568, the Capitani requested the replacement of their infirm and weak provost and an increase in their musicians' salaries.[73] In May 1569, they complained that it was difficult to increase the number of chaplains to fourteen because of the low remuneration they were offering, and that the two guards

requested by the reform, whose responsibility it was to keep the oratory and tabernacle clean, also needed to be paid more.[74]

Although Cosimo was clearly engaged in this project, the reform of Orsanmichele could have been prompted by Archbishop Altoviti's Pastoral Visitation. He visited Orsanmichele on 6 April 1568, and ducal secretary Lelio Torelli's reply to the Capitani authorizing the needed reforms was dated 7 April 1568, just one day following the archbishop's visit.[75] It is tempting, therefore, to credit the impetus for reform to Altoviti himself, although the absence of many decade's worth of Capitani documentation precludes an accurate dating.[76] Indeed, the archbishop was central to the world of Catholic reform, in both Rome in the mid-sixteenth century and later at Trent for the Council (see Chapter 8 for further details). However, in common with other entries in his Visitation protocols, Altoviti's record on Orsanmichele is brief and factual, betraying no hint of reforming zeal. He simply noted that a provost and fourteen chaplains perform fourteen daily masses and that lauds are sung before the image of the Virgin Mary.[77]

The following year, on 24 March 1569 (1568 stil. Flor), the Capitani wrote to Duke Cosimo, stating that the reform he had mediated had improved the state of the oratory. They explained that while the oratory had beautiful architecture, its old tramezzo was in need of restoration, but, given that it was artistically poor, instead of using funds to restore it, "the universal judgment of intelligent persons" was to remove it entirely.[78] The Capitani maintained that the tramezzo was an obstacle that deprived the beautiful view of the tabernacle ("ostaculo che ne priva di si bella vista della artificiosa base et dello oggetto del miracoloso tabernacolo della santissima Vergine"). With the tramezzo eliminated, they claimed, the oratory would be transformed from being busy and dark ("occupato et fosco") to being free, spacious, and light ("libero, ampio, et luminoso"). These aesthetic concerns echo

similar documented motivations seen in Santa Croce (where the alteration would render the church "much more beautiful and delightful to the eye") and Santa Trinita (where the church would become "more open and beautiful"). But in Orsanmichele an additional benefit of removing the screen was due to its distinct materiality: the sale of the extensive ironwork on the screen could fund some simple and decent benches ("semplici et honeste panche") to be placed around the walls and piers for the use of the infirm during divine services.[79]

In fact, only a few weeks later, this ironwork was sold. The beams and latticework were valued differently – the beams at 15 lire, 10 soldi per 100 pounds ("quodlibet centinarium"), and the latticework at 13 lire, 6 soldi, and 8 denari in total – indicating that the screen had been already dismantled into its respective sections.[80] Unfortunately, the total weight of the screen was not recorded, precluding an estimate of its overall size, but it seems that the Orsanmichele ironwork cost more relative to the ironwork railings of the screen chapels in San Pier Maggiore.[81] These two cases show that decorative and functional ironwork could form a substantial visual component of the church interior, adding a component of materiality to our understanding of church screens. Moreover, unlike other materials, the disposal of iron screens was tied to their monetary value, and actually generated a profit for church communities, which could be dispersed for other purposes.

Reflecting Tridentine ideals, the Capitani sought to place more attention on the pulpit and the high altar in the oratory. In the same March 1569 letter, the Capitani resolved to remove the ugly and positively dishonorable pulpit ("brutto et dishonorevole positivo pergamo"), in order to erect one on a pier toward the altar where Mass was said ("in un' pilastro verso l'altare"). On 28 April, the Capitani resolved that the woodworker Lorenzo di Bernardo would construct a wooden pulpit on the pier

nearest to the organ, perhaps intended for singers or preachers.[82] On 19 July 1569, "Maestro Lorenzo et Maestro Tomaso et loro garzone" were paid "for putting the pulpit in order."[83]

Again on the orders of Duke Cosimo, the two upper floors of Orsanmichele were reutilized in 1569–70 to house the city's notarial archives.[84] Access to the archive bypassed the ground floor of the oratory altogether. Within the Arte della Lana palazzo on Via Calimala, where a surviving entrance portal displays the Medici arms, a wooden staircase ascended toward Orsanmichele, and continued within a stone bridge between the two buildings to the archive entrance, situated above the southwest portal of the oratory (Figure 170).[85] Financed by the duke, the construction and conversion work was supervised by Francesco Buontalenti, and as Federico Napoli observed, formed part of a broader

Figure 170 View of Via dell'Arte della Lana facing north showing arch connecting Palazzo dell'Arte della Lana with upper story of Orsanmichele. Photo: author

Medici transformation of the city, which included the Uffizi, the so-called Vasari Corridor, and the transfer of the court to Palazzo Pitti.[86] With the installation of the notarial archive, therefore, Orsanmichele reverted to its dual civic and religious functions. This was noted by Michele Poccianti in 1589, who linked the two important civic roles Orsanmichele had played historically, first in storing the grain reserve and then in housing the city archive.[87]

The removal of the iron tramezzo from the Orsanmichele interior formed part of a broader series of reforms that included liturgical and administrative aspects, and an emphasis on the cleanliness and architectural beauty of the oratory. In removing the tramezzo, the Capitani eliminated what they considered to be an unappealing, poorly designed element of liturgical furnishing and an obstruction to viewing the Marian tabernacle, now regularly being cleaned by the oratory guards. Proposed new furnishings, such as a pulpit and benches, show increased attention to preaching and the Eucharist: ideals promoted by the Council of Trent. While the reforms may have been inspired by Archbishop Altoviti, they were sanctioned by Duke Cosimo, and thus represent the subjection of Orsanmichele's independence to ducal power, a shift also demonstrated by the installation of the notarial archive in the building's upper floors. These changes were not inexpensive, despite the sale of the ironwork. In March 1570, the Capitani sought to save the cost of an annual sacristan salary, taking into account "the many expenses made to alter the church to a better form."[88]

ALTERATIONS TO THE ORSANMICHELE INTERIOR IN THE LATE SIXTEENTH CENTURY

Following the removal of the iron tramezzo from Orsanmichele, the Capitani instituted further renovations and additions to the church interior largely to address issues with the behavior of the laity. Although not explicitly linked to the elimination of the screen, these problems might have been an unwanted byproduct of the increased openness and accessibility of the liturgical space. Indecorous behavior had long been a hallmark of Orsanmichele, perhaps due to its overt combination of both sacred and secular functions and its multiple entrances.[89] In 1376, for example, the Capitani decreed that no undesirable women should be permitted to stay or live in the oratory or its environs.[90] One of the roles of the guards, an office instituted in the 1568 reforms, was to "take care that in this church men do not have conversations with women."[91] In the same year the Capitani posted a notice on the doors ordering worshippers – especially women – to leave immediately after services without rendezvousing with others to converse.[92] Orsanmichele was also a place to report illegal behavior, for in the second half of the fifteenth century the building housed boxes whereby the night officers could receive anonymous information concerning homosexual acts.[93]

In 1575, problems were recorded concerning the area around the St. Anne high altar. On 11 August 1575, the Capitani wrote to Grand Duke Francesco de' Medici explaining that an Apostolic Visitor had commanded that the St. Anne altar table be refashioned out of stone instead of wood.[94] Although it seems that the official Visitation records do not survive for Orsanmichele, this dating would correspond to Bishop of Camerino Alfonso Binnarini's Pastoral Visitation to Florence in 1575–76, when he regularly recommended the upgrading of wooden altars to stone versions.[95] As explained later in the letter, the Capitani additionally wanted to push back the St. Anne altar "more towards the wall" with the desired result that a large, unused space behind the altar would be eliminated and more space made available in front of the altar for

those listening to the Mass.[96] The space behind the high altar had evidently been causing problems in the church interior. The Capitani lamented that "as it was a hidden place and not very open, often people do disgusting things not suitable either in profane places or sacred ones like this one."[97] The euphemistic phrase "cose indegne" likely referred to sexual activities, a problem that would recur in the following decade. With their proposal to move Sangallo's sculpture and its base toward the back wall and to construct a low wall at least one *braccia* high around it, the Capitani employed physical means to preserve the sanctity of the high altar area.[98] However, the theft of a precious golden embroidered frieze from the St. Anne altar frontal in 1578 shows that these measures did not entirely succeed.[99]

The 1580s saw many changes to the interior of Orsanmichele, in particular the installation of further subdivisions associated with preaching and the performance of music. In 1581, the Oratory purchased an amount of rope that served "for the preaching curtain," suggesting that during sermons male and female attendees were physically separated, perhaps in a similar fashion to the depictions of preachers noted in Chapter 1.[100] Additionally, wooden benches for use during preaching were repaired in 1590,[101] together with some small platforms or "pachoceti"[102] "to put on the steps of the altar of St. Anne to act as seating for the preaching."[103] Singers and musicians generally stood either at the St. Anne altar or the tabernacle. In 1582, the Oratory restored the walnut woodwork of the "the platform where they sing lauds and the desk where they play music at Mass."[104] In addition, raised flooring was installed "at the side of the high altar where the musicians stand,"[105] also called the "parapet where they sing music."[106] A further marble step ("predella") was situated near the Marian tabernacle "where they sing in front of the Madonna."[107] In January 1584, the Capitani proposed replacing the wooden steps of

the St. Anne altar with stone, and a request for marble was later submitted to the grand duke.[108] In 1586, the stonecarver Jacopo di Zanobi Paccardi was commissioned to make "the steps and decoration of the altar of St. Anne in white Carrara marble," in exchange for 200 scudi.[109] Zervas has concluded that, despite changes to this complex in the eighteenth century, the extant altar steps are indeed Paccardi's work.[110]

In January 1587, the Capitani commissioned a screen ("tramezo che fa coro") from the woodworker Gabriello di Giovanni Cottoli "alla altare di detta chiesa," evidently to screen or enclose the high altar of St. Anne.[111] In a series of payments dated 9 May 1587, Gabriello was reimbursed for four frames ("telai," possibly framed fabric altar frontals)[112] and two wooden pilasters; nails and glue; the disassembly of old benches in the church; and for time lost on making two designs and a wooden model of the tramezzo.[113] Later in the same month, however, the Capitani wrote to the grand duke to complain that their new purveyor had suspended work on the screen, even though it was near completion.[114] In early June, this purveyor wrote to the grand duke independently, stating the reasons behind his decision. He argued that the Capitani had neglected to obtain ducal permission for the project; that it was a costly and unnecessary expense; that with its height of 3¾ *braccia* (roughly 2.19 m[115]) it "takes away the beauty of the oratory" and obscures the newly fashioned marble of the high altar, which had cost 200 scudi; and that if they wanted to make a "division between the people and the priests," it would be better to make a simple balustrade between the pilasters or even just use a curtain "when the priests are in choir."[116] It appears that work on the screen was suspended, as Zervas argues, since in a statement dated 13 October 1587, Gabriello confirmed receipt of the payment solely for the work recorded in May.[117]

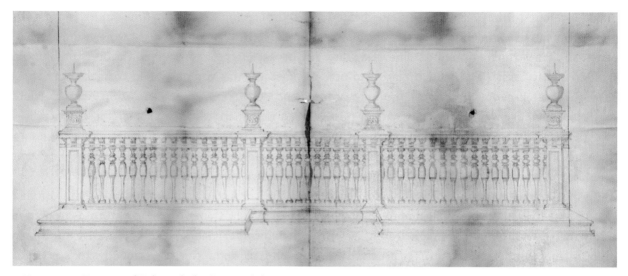

Figure 171 *Drawing of Balustrade for Orsanmichele, 1587.* ASF, Capitani di Orsanmichele, vol. 350, loose sheets. Photo: Courtesy of Ministero per i beni e le attività culturali e per il turismo/Archivio di Stato di Firenze

A drawing inscribed "Designs for the gates for the oratory" ("Disegni per cancelli per l'oratorio") is preserved adjacent to the Capitani's May 1587 letter in which they explained that "the choir of the high chapel was given to said woodworker Gabriello di Giovanni to make" ("fu dato a fare il Coro della Cappella grande di detta Chiesa a Gabriello di Giovanni legnaiolo") (Figure 171).[118] The design shows a balustrade in three sections separated by four pilasters, with a step in front of the screen on either side. Each baluster is elegantly conceived in multiple turned sections, while the taller pilasters display the 'OSM' insignia topped by a vase-shaped candelabra. The proximity of this sheet to the 1587 document strongly suggests that it was associated with the project, perhaps one of the two *disegni* for which Gabriello was paid, but the lack of precise annotations does leave an element of doubt as to its date and purpose.

Following the abandonment of this project in 1587, it was taken up again in 1588, but this time the Capitani made a stronger argument for the installation of a wooden screen possibly in a different location (F on Figure 161). The Capitani noted that although the 1568 reforms required the oratory to remain open during the

day, they proposed closing the building from half an hour after the midday Ave Maria to Vespers and, moreover, installing a walnut balustrade between the pilasters next to the holy water stoup, an object often placed near church entrances.[119] As the Capitani minutes explained, these two measures were designed "to obviate the problems of secret meetings and illicit conversations."[120] In their supplicatory letter to the grand duke, the Capitani further elucidated these problems. Orsanmichele was in a most convenient site, they noted, since it was at the heart of the city, among a confluence of different streets and near to the Officio dell'Onestà, the Florentine Prostitution magistracy. In the sixteenth century, the Officio dell'Onestà was housed in the Butcher's Guild building in Vicolo dell'Onestà, very near to Orsanmichele.[121] This proximity led to the building being often by those who "make illicit negotiations, especially at the hour of lunch."[122] Keeping the church closed during the day, similarly to the Duomo and San Giovanni, would help matters, the Capitani argued, since "at that time, very few come if not to do wrong."[123] But since people could carry on doing these things after Vespers and also because "the church in

itself is dark and has many hiding places," a walnut balustrade should be constructed from one pilaster to another to enclose "two thirds of the church."[124] Whereas the earlier unfinished screen had been intended to enclose the high altar area, it seems likely that the 1588 balustrade was positioned at the first set of piers at the western side of the oratory, although some ambiguity remains. At a height of around 2½ *braccia* (roughly 1.46 m) and cost of around eighty scudi, the screen would have two doors to allow access for officiating priests at Mass.[125] When Mass was over, the gates would be locked "so that whoever had a bad intent would not have a space to execute their bad inclination."[126] Ducal secretary Antonio Serguidi authorized the project ten days later with a hastily written note at the bottom of the letter: "everything is good" ("tutto sta' bene").

The presence of prostitutes among the surroundings of Orsanmichele had been documented since the late fourteenth century.[127] The Officio dell'Onestà (Office of Decency), founded in 1403, viewed prostitution as a necessary evil, insisting on publicly identifying the women it registered under male control.[128] In early fifteenth-century Florence, prostitution was concentrated near the Officio in two main zones (the area between the Duomo and the Mercato Vecchio and the streets around Santa Maria Maggiore), although it had spread throughout the city by the end of the century.[129] Duke Cosimo reduced the number

of official places of prostitution, but in the 1560s the central brothel area at the Mercato Vecchio, near to Orsanmichele, still survived.[130] Notwithstanding the stricter rules on prostitutes' fiscal rights, movement, and dress instituted by the Pratica Segreta in 1577, the practice continued to flourish.[131] The concerns expressed by the Capitani of Orsanmichele about the building's proximity to licentious activities, therefore, would seem to be well founded. Sporadic textual evidence of other instances of banning prostitutes from the churches of Rome and Venice, particularly on important feast days, shows that the situation in Orsanmichele was part of a wider problem.[132] Moreover, Randolph showed that church interiors had long been sites for encounters between men and women, which may have displeased conservative clerics but became a romantic trope in Italian literature.[133]

In their supplicatory letter to the grand duke, the Capitani mentioned a drawing of the new balustrade,[134] which remarkably still exists in the archive, and was first noted by Zervas (Figure 172).[135] An inscription on the back of the drawing reads: "1588 – Design of the choir or rather of the balustrade to be made in Orsanmichele" ("Disegnio del coro anzi del Balaustro da farsi in Santo Michele"). On the drawing itself, an annotation to the right of the balustrade reads "*braccia* 2½ allto," further confirming its relationship to the letter, which specifically mentioned this precise height. The drawing

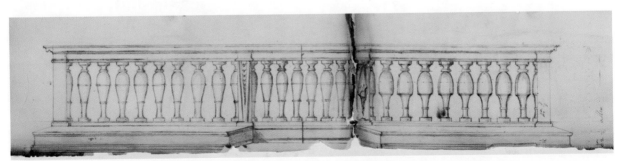

Figure 172 *Drawing of Balustrade for Orsanmichele*, 1588. ASF, Capitani di Orsanmichele, vol. 350, loose sheet dated 1588. Photo: Courtesy of Ministero per i beni e le attività culturali e per il turismo/Archivio di Stato di Firenze

presents two different designs continuously, evidently providing an aesthetic choice for the patrons. On the left side, the balusters are slender and the pilaster displays decoration of overlapping disks; on the right the balusters have a bell-shaped central section and the pilaster is ornamented with drapery. A step half a *braccia* high appears on either side, while in the central section vertical lines on the base and upper handrail indicate a disguised opening. Zervas noted that the balustrade project, together with other wooden items related to the St. Anne altar, was completed by a certain maestro Bastiano, although its precise location remains uncertain.[136]

The Orsanmichele drawings depict balustrades of typical late sixteenth-century form and style. An invention of the early Renaissance, the architectural balustrade – a railing supported by a continuous row of balusters – drew inspiration from classical pedestals, medieval colonnettes, and fictive architectural depictions.[137] Mannerist inversions of dropped balusters (such as those in the 1588 Orsanmichele design) were popular in late sixteenth-century Florence, seen for example in Buontalenti's theatrical combined staircase and altar balustrade originally in Santa Trinita (see Chapter 5, Figure 127).[138] Other contemporary examples include a low balustrade of white marble (displaying similar horizontal banded decoration to the 1588 Orsanmichele drawing) that separates the vestibule and altar area of the Salviati Chapel of St. Antoninus in San Marco, which was designed by Giambologna. Jacopo Piccardi, the *capomaestro* of this project, also worked at Orsanmichele in the 1580s (Figure 173).[139]

In terms of function, the balustrades in Orsanmichele are comparable to late sixteenth-century altar railings and low parapets enclosing

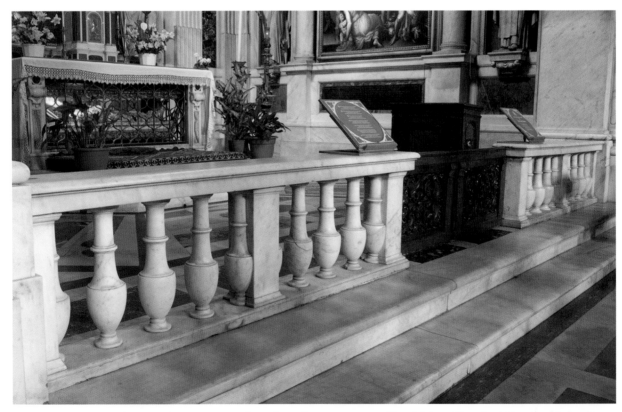

Figure 173 Giambologna and Jacopo Piccardi, *Balustrade*, 1579–91, marble. Salviati Chapel of St. Antoninus, San Marco, Florence. Photo: author

choir areas. Carlo Borromeo instructed that altar railings constructed from iron, stone, marble, or wood should enclose every altar in the church, have a central lockable door, and feature closely inter-weaved grating near to the ground to keep out dogs.[140] Octagonal choir enclosures in centralized architectural spaces, for instance in Santa Maria del Fiore[141] and Santo Spirito in Florence,[142] and Santo Stefano Rotondo in Rome,[143] comprised architectural features such as low parapets, balustrades, and candelabra. With their permeable yet commanding spatial presence, these structures represent a Counter-Reformation compromise between physical separation and visibility in the church interior also sought after in Orsanmichele. Although the permeable and relatively low walnut balustrade would not have obscured visual access to the tabernacle, it would have still acted as a physical barrier restricting free circulation around the church interior. In the years following the removal of the tramezzo, therefore, the Capitani used church furnishings – albeit less obtrusive ones – to restore some of the functions of the lost tramezzo.

Conclusion

The presence of a tramezzo in Orsanmichele radically disrupts our understanding of the functions and contexts for church screens. Administered by a lay confraternity and college of priests and closely associated with civic devotion, Orsanmichele performed a very different religious role than the large mendicant or monastic congregations in the city. Yet the tramezzo – albeit typologically and materially unusual – was still considered a vital component of the liturgical space once the open arches of the loggia had been enclosed. Its relatively late installation, likely in the first half of the fifteenth century, shows that the desire to segregate space persisted in a period characterized by Brunelleschian unified church interiors.

Later, the Capitani's practical motivations for removing the tramezzo in 1569 resonate with other contemporary cases. References to the ugliness of the tramezzo and impediments to viewing the Marian tabernacle tally with concerns documented at other Florentine institutions. Crucially, however, the Orsanmichele renovation was associated with a liturgical and administrative reform ordered by Duke Cosimo, but possibly also involving Archbishop Altoviti. The link between religious reform and architectural change is hard to prove in a general sense, but Orsanmichele represents an important case showing that religious reform could prompt church renovations.

Later alterations to the Orsanmichele interior, however, reveal that these reforms did not necessarily work. Keeping the oratory open during the day led to inappropriate use of the building and the need for architectural solutions to enclose the space once more. By contrast, as we have seen, a similar attempt to preserve the moral integrity of sacred space was achieved in San Pancrazio by removing the nave choir: in both cases, however, church officials tried to eliminate obscure and hidden spaces in the church. The desire for church buildings to be treated with dignity and holiness was given institutional authority through textual pronouncements. As we shall see, a papal bull, various bishops' declarations, and a decree promulgated by the Council of Trent all sought to maintain a pious environment in church. Despite its unique history, status, and architectural style, Orsanmichele was not exempt from this ever-increasing drive to protect and revere sacred space.

NOTES

1 Albertini, *Memorial*, p. 98. A version of this chapter was published in *Space, Image and Reform in Early Modern Art: The Influence of Marcia Hall*, ed. Arthur J. DiFuria and Ian Verstegen (Berlin, 2021).

2 Nancy Rash Fabbri and Nina Rutenburg, "The Tabernacle of Orsanmichele in Context," *The Art Bulletin* 63, no. 3 (1981), p. 385.

3 Jacqueline Marie Musacchio, "The Medici-Tornabuoni Desco da Parto in Context," *Metropolitan Museum Journal*, 33 (1998), p. 146.

4 Diane Finiello Zervas, ed., *Orsanmichele a Firenze* (Modena, 1996), p. 11.

5 Ibid., p. 12.

6 Ibid., pp. 21–29.

7 Ibid., p. 31.

8 Ibid., p. 43.

9 Ibid., p. 50; Maria Teresa Bartoli, "Designing Orsanmichele: The Rediscovered Rule," in *Orsanmichele and the History and Preservation of the Civic Monument*, ed. Carl Brandon Strehlke (New Haven, CT, 2012), p. 37.

10 Zervas, ed., *Orsanmichele a Firenze*, p. 52.

11 While the tabernacle has long been associated with the 1348 plague, Cassidy showed that funding for its construction derived from other sources. Brendan Cassidy, "The Financing of the Tabernacle of Orsanmichele," *Source: Notes in the History of Art* 8, no. 1 (1988), pp. 1–6.

12 The first Marian image was probably destroyed in a fire that damaged the loggia in 1304. A new image was housed within a stone micro-architectural tabernacle. Gert Kreytenberg, "Un tabernacolo di Giovanni di Balduccio per Orsanmichele a Firenze," *Boletin del Museo Arqueológico Nacional (Madrid)* 8 (1990), pp. 37–57; Brendan Cassidy, "Orcagna's Tabernacle in Florence: Design and Function," *Zeitschrift für Kunstgeschichte* 55, no. 2 (1992), p. 197; Francesco Caglioti, "Giovanni di Balduccio at Orsanmichele: The Tabernacle of the Virgin before Andrea Orcagna," in *Orsanmichele and the History and Preservation of the Civic Monument*, ed. Carl Brandon Strehlke (New Haven, CT, 2012), pp. 75–110. On Daddi's panel, see Zervas, ed., *Orsanmichele a Firenze*, pp. 62–63; Holmes, *The Miraculous Image*, pp. 146–51. On the tabernacle, see Fabbri and Rutenburg, "The Tabernacle of Orsanmichele," pp. 385–405; Cassidy, "Orcagna's Tabernacle," pp. 180–211; Holmes, *The Miraculous Image*, pp. 227–39.

13 Cassidy, "Orcagna's Tabernacle," pp. 199–204.

14 For the Marian cult at Orsanmichele, see Giovanni Leoncini, "I luoghi della devozione mariana a Firenze: Or San Michele," in *Atti del VII centenario del Duomo di Firenze*, edited by Timothy Verdon and Annalisa Innocenti (Florence, 2001), pp. 183–94.

15 "Given the ten-year gap in the confraternity records, however, it seems plausible to suggest that the Oratory's rood screen, which stretched from north to south to the west of the St Anne altar and Orcagna's tabernacle, was constructed during this decade." The confraternity claimed only fifteen lire were donated in offertory boxes in the 1429 Catasto. Zervas, ed., *Orsanmichele a Firenze*, p. 191. For the ten-year gap, see Diane Finiello Zervas, *Orsanmichele: Documents 1336–1452* (Modena, 1996), p. 164.

16 Richa, *Notizie istoriche*, vol. 1.1, pp. 24–25.

17 "la detta chiesa è bene uficiata da preti." Gurrieri et al., eds., *Codice Rustici*, p. 135.

18 Zervas, ed., *Orsanmichele a Firenze*, p. 187.

19 John Henderson, *Piety and Charity in Late Medieval Florence* (Oxford and New York, 1994), p. 232.

20 Zervas, ed., *Orsanmichele a Firenze*, p. 187.

21 Diane Finiello Zervas, "New Documents for the Oratory of Orsanmichele in Florence, 1365–1400," *Zeitschrift für Kunstgeschichte* 78, no. 2 (2015), p. 292.

22 In her 1991 articles, Zervas stated that four infills (including those closest to the tabernacle) were completed between 1366 and 1383; three further bays were likely executed before 1400, and then finally the west arches of the north and south facades (i.e. those closest to the portals) were completed in 1429 and 1432 respectively. Diane Finiello Zervas, "Lorenzo Monaco, Lorenzo Ghiberti, and Orsanmichele: Part I," *The Burlington Magazine* 133, no. 1064 (1991), p. 748; Diane Finiello Zervas, "Lorenzo Monaco, Lorenzo Ghiberti and Orsanmichele: Part II," *The Burlington Magazine* 133, no. 1065 (1991), p. 812. Employing close stylistic analysis, Kreytenberg argued that Talenti's traceries of the 1360s were supplemented by several dating 1378–1400, two west facade traceries designed by Ghiberti in 1410 but not fully installed until 1420, one completed in 1429 (western arch of north façade), and another (western arch on south facade) reinstalled in 1432 but carved much earlier. Gert Kreytenberg, "The Limestone Tracery in the Arches of the Original Grain Loggia of Orsanmichele in Florence," in *Orsanmichele and the History and Preservation of the Civic Monument*, ed. Carl Brandon Strehlke (New Haven, CT, 2012), pp. 113–20. Whereas in her 1996 book, Zervas dated the two westernmost arches on the north and south facades to 1429 and 1432, in her 2015 article, she dated the south one to 1381–83. Zervas, ed., *Orsanmichele a Firenze*, p. 192; Zervas, "New Documents," p. 298.

23 Kreytenberg, "The Limestone Tracery," p. 123; Zervas, "New Documents," p. 296.

24 On the stained glass, including the contribution of Ghiberti, see Zervas, "Lorenzo Monaco: Part I," pp. 748–59; Zervas, "Lorenzo Monaco: Part II," pp. 812–19.

25 Even if the tramezzo was installed later, the absence of almost all confraternity records from 1438 to the end of the fifteenth century precludes the existence of any documentary evidence. Zervas, ed., *Orsanmichele a Firenze*, p. 209.

26 Ibid., p. 192.

27 Zervas, *Orsanmichele: Documents*, p. 165; Zervas, ed., *Orsanmichele a Firenze*, p. 192.

28 Zervas, ed., *Orsanmichele a Firenze*, pp. 134, 144, 189.

29 Ibid., p. 637. Francesco was paid eighteen florins for "dipingiatura di due sportelli d'orghani, a suo oro e colori e faticha" on 17 June 1429. Zervas, *Orsanmichele: Documents*, p. 166.

30 The panel depicting SS Mark and Luke is lost. Ludovica Sebregondi, "Francesco d'Antonio, Ante d'organo raffiguranti: Angeli cantori e San Matteo e San Giovanni," in *La Chiesa e la città a Firenze nel 15. secolo: Firenze,*

Sotterranei di San Lorenzo, 6 giugno – 6 settembre 1992, ed. Gianfranco Rolfi, Ludovica Sebregondi, and Paolo Viti (Milan, 1992), p. 96. See also Maria Sframeli, "Francesco d'Antonio, Ante d'organo di Orsanmichele," in *L'età di Masaccio: il primo Quattrocento a Firenze*, ed. Luciano Berti and Antonio Paolucci (Milan, 1990), p. 184.

31 Cassidy, "Orcagna's Tabernacle," pp. 191–92.

32 Blake Wilson, "If Monuments Could Sing: Image, Song, and Civic Devotion Inside Orsanmichele," in *Orsanmichele and the History and Preservation of the Civic Monument*, ed. Carl Brandon Strehlke (New Haven, CT, 2012), p. 144.

33 Ibid., pp. 144–45.

34 References to singing masters are documented in 1412 and 1436. Blake Wilson, *Music and Merchants: The Laudesi Companies of Republican Florence* (Oxford and New York, 1992), pp. 83–85.

35 "Et etiamdio in cambio del brutto et dishonorevole positivo pergamo che è intra di duoi usci della sagrestia sotto l'organo che occupa et toglie la vista della facciata dove è di buon'maestro dipinta l'istoria della disputa che fece Giesu' christo fanciullo con gl'hebrei nel tempio, habbiamo scorto si convegna fare elevato et fermo in un' pilastro verso l'altare." ASF, Capitani di Orsanmichele, vol. 31 bis, fol. 23v. Vasari attributed the fresco to Agnolo Gaddi. Vasari et al., *Le vite*, vol. 2, p. 247.

36 "finestre che son dietro all'organo." ASF, Capitani di Orsanmichele 350, loose sheet dated 1587. See also Zervas, ed., *Orsanmichele a Firenze*, p. 240.

37 Paatz and Paatz state that in Poccetti's fresco, a tabernacle decorated with winged figures could represent the organ shutters. The fresco is now too damaged to permit any firm conclusions. Paatz and Paatz, *Kirchen von Florenz*, vol. 4, pp. 505–06.

38 Richa did not specify where precisely the organ was: "Sotto l'organo Agnolo Gaddi pittore in que' tempi di grido rappresentò alla parete Cristo, che disputa in mezzo a' Dottori." Richa, *Notizie istoriche*, vol. 1.1, p. 27.

39 Zervas, ed., *Orsanmichele a Firenze*, p. 237.

40 "Fosco ... Che è di colore grigio cupo, che tende al nero ... buio, tenebroso." Battaglia and Bàrberi Squarotti, *Grande dizionario*, vol. 6, p. 246.

41 Paul Davies, "The Lighting of Pilgrimage Shrines in Renaissance Italy," *Analecta Romana Instituti Danici. Supplementum* 35 (2004), pp. 62–64, 68–70. For the candelabra surrounding the tabernacle, see Zervas, ed., *Orsanmichele a Firenze*, pp. 165, 173; Wilson, "If Monuments Could Sing," p. 155.

42 I have been unable to find a precise dating for these lamp rings. Wax ex-votos caused a fire in 1304, which destroyed the first Marian devotional image.

43 I am grateful to Alexander Röstel for his insights into altar furnishings, illumination, and balustrades.

44 "catenas ferreas crassas et crati[cu]latos ferreos qui erant in tramezo ecclesiae oratorij." ASF, Capitani di Orsanmichele, vol. 31 bis, fol. 25r.

45 "Catena: Edil. Elemento costruttive resistente a tensione e posto a contrastare spinte prodotte da speciali strutture o da particolari condizioni statiche in cui viene a trovarsi talvolta la parte di un edificio ... in ferro, a forma di sbarra tonda o piatta, che termina alle due estremità con due occhielli in cui vengono infilati altri pezzi di ferro fissati con cunei metallici ribattuti ..." Battaglia and Bàrberi Squarotti, *Grande dizionario*, vol. 2, p. 878.

46 "craticulus, a, um, adj. dim, [cratis], composed of lattice-work, wattled ... cratis ... [Sanscr. Kart, to spin; cf. crassus], wicker-work, a hurdle." Charlton T. Lewis and Charles Short, *A Latin Dictionary Founded on Andrews' Edition of Freund's Latin Dictionary Revised, Enlarged, and in Great Part Rewritten* (Oxford, 1955), p. 478. The word "craticula" was used interchangeably with the word "graticula" in a document concerning the Siena Palazzo Pubblico screen dated 11 February 1434 (stil. Senese): "craticula ferrea ... quod dicta graticula ferrea." Boccalatte, *Fabbri e ferri*, p. 123. I am grateful to Sandro La Barbera for his help in transcribing and translating this passage.

47 For example, Conte di Lello's iron screens in the Cappella Bardi di Vernio o di San Ludovico in Santa Croce, Florence (1335) and the transept screen in the Orvieto Duomo (1337). Boccalatte, *Fabbri e ferri*, pp. 171, 176–77; figs. 12 and 17. See also Sofia Pezzati, *The Art of Wrought Iron: History and Techniques of Workmanship* [*L'arte del ferro battuto: storia e tecniche di lavorazione*] (Florence, 2006), pp. 31–32.

48 Boccalatte notes that while the Santa Trinita chapel is conventionally attributed to Manfredi di Franco and dated c. 1423 (when Lorenzo Monaco completed the fresco decoration), these facts are dubious. Boccalatte, *Fabbri e ferri*, pp. 115–16. For the Palazzo Pubblico chapel, see ibid., pp. 122–25.

49 According to legend, Mary cast down her girdle to St. Thomas the Apostle as she was assumed into heaven. Mayu Fujikawa, "The Medici Judge, a Bitter Lawsuit, and an Embezzlement: The Opera del Sacro Cingolo's Bronze Chapel Screen at Santo Stefano, Prato," *Renaissance Studies* 27, no. 5 (2013), pp. 612–32.

50 ASF, Capitani di Orsanmichele, vol. 31 bis, fol. 23r.

51 Zervas, "New Documents," pp. 299–302.

52 Cassidy, "Orcagna's Tabernacle," p. 189. The bronze gate ("cancello") of the tabernacle, candlesticks and other brass objects were made by metalworkers Piero del Migliore and Benincasa di Lotto in 1366–69: "candelieri e altre cose d'ottone per lo tabernacholo di Nostra Donnaio." Ibid., p. 180, note 10.

53 Holmes, *The Miraculous Image*, p. 230.

54 "graticihole di ferro che furono nel pilastro vecchio dell'oratorio." Cassidy, "Orcagna's Tabernacle," p. 197.

55 Ibid., p. 186; Zervas, ed., *Orsanmichele a Firenze*, pp. 88, 391–98.

56 Zervas, ed., *Orsanmichele a Firenze*, p. 134.

57 The revolt took place on 26 July, but Walter of Brienne was only expelled on August 6. Roger J. Crum and

David G. Wilkins, "In the Defense of Florentine Republicanism: Saint Anne and Florentine Art, 1343–1575," in *Interpreting Cultural Symbols: Saint Anne in Late Medieval Society*, ed. Kathleen M. Ashley and Pamela Sheingorn (Athens, GA and London, 1990), p. 133. A frescoed image of St. Anne in the vault above the St. Anne altar is depicted holding an ideal representation of the city of Florence, emphasizing her role as city protectress. Francesca Nannelli, "Un'inedita veduta di Firenze nella Chiesa di Orsanmichele," *Notizie di cantiere: Soprintendenza per i Beni Ambientali e Architettonici per le Provincie di Firenze e Pistoia* 5 (1993 (1994)), pp. 115–21.

58 Crum and Wilkins doubt that the Bargello group is an Italian sculpture or early enough in date to be identified with the Orsanmichele St. Anne image. Crum and Wilkins, "In the Defense of Florentine Republicanism," p. 135. See also Erin Giffin, "Body and Apparition: Material Presence in Sixteenth-Century Italian Religious Sculpture" (PhD thesis, University of Washington, 2017), pp. 137–39.

59 For Sangallo's St. Anne group, see Crum and Wilkins, "In the Defense of Florentine Republicanism," pp. 133, 157; Joachim Poeschke, *Michelangelo and His World: Sculpture of the Italian Renaissance* (New York, 1996), pp. 180–81; Zervas, ed., *Orsanmichele a Firenze*, pp. 231–34, 604–07; Colin Eisler, Abbey Kornfeld, and Alison Rebecca W. Strauber, "Words on an Image: Francesco da Sangallo's Sant'Anna Metterza for Orsanmichele," in *Orsanmichele and the History and Preservation of the Civic Monument*, ed. Carl Brandon Strehlke (New Haven, CT, 2012), pp. 289–300; Giffin, "Body and Apparition," pp. 134–68.

60 Eisler et al., "Words on an Image," pp. 294–98.

61 Anita Valentini, *Sant'Anna dei Fiorentini: storia, fede, arte, tradizione* (Florence, 2003), pp. 112–13; Zervas, ed., *Orsanmichele a Firenze*, pp. 59–60; Giffin, "Body and Apparition," p. 158. It is unclear whether the procession began at Orsanmichele or the convent (which may have been either Sant'Anna Verzaia or Sant'Anna sul Prato), and the precise period in which this procession was observed.

62 Zervas has clarified the potential confusion between the church of San Michele (from 1616 dedicated to San Carlo Borromeo) and the oratory of Orsanmichele. The church, just across the Via de Calzaiuoli from Orsanmichele, was founded in 1349 under a dedication to St. Anne, and was subsequently enlarged and rededicated to St. Michael before 1380. Diane Finiello Zervas, "Niccolò Gerini's 'Entombment and Resurrection of Christ,' S. Anna/S. Michele/S. Carlo and Orsanmichele in Florence: Clarifications and New Documentation," *Zeitschrift für Kunstgeschichte* 66, no. 1 (2003), pp. 33–38.

63 Cornelison, *Art and the Relic Cult*, pp. 169–73.

64 Paatz and Paatz, *Kirchen von Florenz*, vol. 4, pp. 505–06. The Allori fresco is dated 1583–88, and the Poccetti fresco 1602 or 1606. Richa stated that the San Marco

friars would sometimes make a procession to venerate it, providing a tabernacle for its protection in 1714. Richa, *Notizie istoriche*, vol. 1.1, p. 25; Zervas, ed., *Orsanmichele a Firenze*, p. 611. See also Holmes, *The Miraculous Image*, pp. 49, 71.

65 For the Dominican processions to Orsanmichele, see Cornelison, *Art and the Relic Cult*, p. 173. In 1388 Franco Sacchetti displayed the text of the Stabat Mater behind the St. Anne altar, near a painted Crucifixion on the pilaster between the St. Anne high altar and the Virgin tabernacle. Zervas suggested that either the carved crucifix replaced the frescoed image (she states probably after 1415) after which point it became identified with Antoninus, or that it had been in this location when the saint had prayed in 1405. Zervas, ed., *Orsanmichele a Firenze*, pp. 150–51, 611–12; Zervas, *Orsanmichele: Documents*, pp. 101–02; Giffin, "Body and Apparition," p. 136.

66 "per il piede della croce intagliato." ASF, Capitani di Orsanmichele, vol. 346, loose sheet dated 25 February 1573 (stil. Flor).

67 "per uno fero per regere lase de chrocifiso co uno balaustro e uno anelo danpionbare (?)." ASF, Capitani di Orsanmichele, vol. 346, loose sheet dated 24 February 1581 (stil. Flor).

68 "per lasse dove sta i chocifissi messo una chornice di noce [^itorno]." ASF, Capitani di Orsanmichele, vol. 346, loose sheet dated 10 March 1581 (stil. Flor).

69 "et dipoi ne restino accese sempre dua al crocifisso, et una alla Vergine." ASF, Capitani di Orsanmichele, vol. 79, no. 38, cap. 19.

70 Edgcumbe Staley, *The Guilds of Florence* (New York, 1967), pp. 62–65.

71 Zervas, ed., *Orsanmichele a Firenze*, p. 236. The reform documents insisted that the oratory be cleaned regularly.

72 A document entitled "Avvertimenti fatti al Gran Duca sopra la riforma" and dated 30 January 1569 (stil. Flor) lists financial aspects of the reform such as maintaining a locked box in the sacristy for donations, and liturgical improvements, such as the additional singing of the Lamentations and Benedictus on Wednesdays, Thursdays, and Fridays. ASF, Capitani di Orsanmichele, vol. 32, fols. 19r–23v.

73 ASF, Capitani di Orsanmichele, vol. 78, fol. 164r. Wilson noted that musical documents are lacking for the period 1529–67, but in 1568–93 payments are recorded to the organist, choirmaster, six tenors, four to five ferial sopranos, four festive sopranos, and a singing master. Wilson, *Music and Merchants*, p. 87.

74 "due Guardie che tutto il giorno debbono stare à la cura et guardia della chiesa et fare molte cose che gli comanda la Riforma." ASF, Capitani di Orsanmichele, vol. 78, fol. 187v. no. 13 (20 May 1569). Volume 32 of the Capitani's archive suggests that there were at least fifty-seven chapters in the reform documentation.

75 "Attendasi à riformare le cose che importano . . . – Lelio T. 7 Apr. 68." ASF, Capitani di Orsanmichele, vol. 78, 164v.

76 In the ASF, volume 31 of Capitani minutes covers 1527–28, volume 31 bis covers 1568–1569 and volume 32 covers 1569–70.

77 "In eadem oratorio quotidie celebrantur misse xiiii. Est in eadem oratorio imago virginis marie ubi decantantur laudes." Florence, Archivio Arcivescovile, VP 09.1, fol. 19r (6 April 1568).

78 "universale giuditio di persone intelligenti non fare tale spesa di restauratione, ma levare." ASF, Capitani di Orsanmichele, vol. 31 bis, fol. 23r–v.

79 Zervas notes, however, that the proceeds of the sale of ironwork was in fact allocated for repairs to western portals. Zervas, ed., *Orsanmichele a Firenze*, p. 237.

80 28 April 1569: "Vendita de ferri . . . quodlibet centinarium dictorum catinarum – [lire] 15. 10 – dictorum craticulatorum et aliorum – [lire] 13.6.8" ASF, Capitani di Orsanmichele, vol. 31 bis, fol. 25r.

81 In San Pier Maggiore, the Albizzi chapel railings were sold for 268 lire, 15 soldi, and 4 denari for 2,389 pounds of iron, which roughly corresponds to 9 lire per 100 pounds (see Chapter 6). In Orsanmichele, the ironwork sold for 15 lire, 10 soldi per 100 pounds.

82 "fieri debere in Pilastro vicino organo ecclesie oratorij versus altare maius ipsius ecclesiae unum pergamum ligneum." ASF, Capitani di Orsanmichele, vol. 31 bis, fol. 24v. See also Zervas, ed., *Orsanmichele a Firenze*, p. 237.

83 "per maestro lorenzo et maestro tomaso et loro garzone per mettere in ordine il pergamo." ASF, Capitani di Orsanmichele, vol. 346, loose sheet dated 19 July 1569.

84 On the archive, see Richa, *Notizie istoriche*, vol. 1.1, p. 32; Zervas, ed., *Orsanmichele a Firenze*, pp. 234–36; Federico Napoli, "La scala di Orsanmichele: un manufatto buontalentiano," *Varia: trimestrale di arte letteratura e cultura varia* 13 (1995), pp. 18–19.

85 A photograph in the Soprintendenza Archeologia Belle Arti e Paesaggio per la città metropolitana di Firenze e le province di Pistoia e Prato, Archivio Fotografico, no. 148660, shows the ghost of the staircase within the Arte della Lana palazzo, before the total reconstruction of the section facing via de' Lamberti under Enrico Lusini in 1921. Napoli, "La scala di Orsanmichele," p. 19. I am grateful to the Società Dantesca Italiana for allowing me access to view part of the stone stairs in their office. Zervas, ed., *Orsanmichele a Firenze*, pp. 235–36.

86 ASF, Scrittoio delle Fortezze e Fabbriche, Fabbriche Medicee, vol. 158 (Libro di debitori e creditori della fabrica del nuovo archivio) contains payments for materials, construction and furnishings dated between 29 November 1569 and 31 December 1570. Napoli noted similarities between the portal and Buontalenti's doors of Santa Trinita. Napoli, "La scala di Orsanmichele," p. 19.

87 "già si conservava il frumento del publico, ma poi per maggiore commodità del Serenissimo Gran Cosimo ci fu posto l'Archivio della Città." Poccianti, *Vite de sette beati*, p. 171.

88 "et per le molte spese fatte per ridurre la chiesa a migliore forma." On 20 March 1570 (1569 stil. Flor), the Capitani requested permission from the duke that the Orsanmichele provost could also fulfill the responsibilities of sacristan as had been done in the past, saving them the cost of an annual salary of nine scudi. ASF, Capitani di Orsanmichele, vol. 32, fol. 6r–v.

89 Zervas confirms that the building had multiple entrances. Zervas, ed., *Orsanmichele a Firenze*, p. 239.

90 Zervas, *Orsanmichele: Documents*, p. 75.

91 "et haver' cura che in detta chiesa huomini non faccino parlamenti con donne." ASF, Capitani di Orsanmichele, vol. 78, fol. 298r (letter dated 13 November 1578).

92 ASF, Capitani di Orsanmichele, vol. 31 bis, fol. 11r. Dated 13 November 1568.

93 Michael Rocke, *Forbidden Friendships: Homosexuality and Male Culture in Renaissance Florence* (New York, 1996), p. 49. The other boxes were located at San Pier Scheraggio and the Duomo.

94 Zervas, ed., *Orsanmichele a Firenze*, p. 238. "ci è stato comandato dal Reverendissimo Visitatore Apostolico di fare di pietra l'altare maggiore di Santa Anna in esso tempio quale è di legname." ASF, Capitani di Orsanmichele, vol. 35, fol. 17r. I am grateful to Erin Giffin for bringing these documents to my attention.

95 For example, he ordered that the altar of the Ten Thousand Martyrs in San Pancrazio be upgraded from wood to stone within two months. Florence, Archivio Arcivescovile di Firenze, VP 12, fol. 98v.

96 "più presso al muro." ASF, Capitani di Orsanmichele, vol. 35, fol. 17r.

97 "come in luogo riposto et non aperto bene spesso si fanno cose indegne et non convenevoli ne luoghi profani non che sacri come è questo." ASF, Capitani di Orsanmichele, vol. 35, fol. 17r.

98 The proposal was dated 24 August 1575. The work was to cost eighteen gold florins in total. ASF, Capitani di Orsanmichele, vol. 78, fol. 266r. Zervas, ed., *Orsanmichele a Firenze*, p. 239.

99 "fù spiccato dal paliotto del detto altare un'fregio di ricamo d'oro buono à santi col segno d'O.S.M. con frange rosse foderato di valuta di [scudi] 10 et portato via." ASF, Capitani di Orsanmichele, vol. 78, fol. 298r. The guard's letter is in ASF, Capitani di Orsanmichele, vol. 78, 403r.

100 "libre 3½ di fune . . . servire per la tenda della predica." ASF, Capitani di Orsanmichele, vol. 346, loose sheet dated 22 February 1580 (stil. Flor).

101 "per avere achomoduto le panche dela predicha." ASF, Capitani di Orsanmichele, vol. 350, loose sheet dated 6 March 1589 (stil. Flor).

102 "Pacco . . . Ant. Palco." Battaglia and Bàrberi Squarotti, *Grande dizionario*, vol. 12, p. 317.

103 "per braccia 33 di pachoceti per metere insu lischalioni delatare di santa anna per istare asedere ala predicha." ASF, Capitani di Orsanmichele, vol. 350, loose sheet dated 6 March 1589 (stil. Flor).

104 "il palcho dove si canta le lalde et il descho dove si suona a' messa." ASF, Capitani di Orsanmichele, vol. 346, loose sheet dated 23 October 1582.

105 "per il piano allato allo altare grande dove stanno e musici." ASF, Capitani di Orsanmichele, vol. 346, loose sheet dated 23 October 1582.

106 "e parapetto dove chantano la muscicha." ASF, Capitani di Orsanmichele, vol. 350, loose sheet dated 5 August 1587.

107 "dove si canta dinazi ala madona." ASF, Capitani di Orsanmichele, vol. 350, loose sheet dated 5 June 1590.

108 Zervas, ed., *Orsanmichele a Firenze*, p. 239.

109 ASF, Capitani di Orsanmichele, vol. 350, loose sheet dated 18 March 1585 (stil. Flor).

110 Zervas, ed., *Orsanmichele a Firenze*, pp. 239–40. An inscription on the steps reads AD. MDLXXXVI.

111 Ibid., pp. 240–41. This work was distinct from the improvements to the altar in the church of San Michele (now San Carlo) done in August 1587 and noted by Zervas. Zervas, "Niccolò Gerini's 'Entombment'," p. 42. This archival source refers to the "latare di samichele," whereas the phrase "chiesa dorsanmichele" referred to Gabriello's work in the oratory. ASF, Capitani di Orsanmichele, vol. 350, loose sheet dated 5 August 1587.

112 "Telaio ... qualsiasi armatura, costitua da pezzi per lo più rigidi e indeformabili, uniti fra loro, che svolge una funzione portante rispetto alle atre parti dello stesso sistema." Battaglia and Bàrberi Squarotti, *Grande dizionario*, vol. 20, p. 803. Voelker suggested that the term "telaio" described a horizontal framed altar frontal. Voelker, "Charles Borromeo's *Instructiones*," p. 202, note 9.

113 "e mostrare dua disegni e fare un modellino di legniame." ASF, Capitani di Orsanmichele, vol. 350, loose sheet dated 9 May 1587.

114 "il quale Coro hoggi si ritrova presso alla sua perfetione, et sarebbe in breve finito se il nuovo Proveditore non havere dato ordine al detto legnaiolo che desistesse dall'opera." ASF, Capitani di Orsanmichele, vol. 350, loose sheet dated 17 May 1587. This must refer to the oratory because "detta chiesa" comes after "i Capitani del oratorio della vergine maria d'orsan michele di firenze," with no mention of other church.

115 One *braccio fiorentino* corresponds to 0.583626m. Martini, *Manuale di metrologia*, p. 206.

116 Zervas, ed., *Orsanmichele a Firenze*, pp. 240–41. ASF, Capitani di Orsanmichele, vol. 350, loose sheet dated 2 June 1587.

117 ASF, Capitani di Orsanmichele, vol. 350, loose sheet dated 9 May 1587 on recto and 13 October 1587 on verso. Zervas, ed., *Orsanmichele a Firenze*, pp. 240–41.

118 ASF, Capitani di Orsanmichele, vol. 350, loose sheets.

119 The mention of pilasters confirms that this document is concerned with the oratory rather than the church (which is single-aisled with no piers).

120 "un cancello a balustri di noce da farsi da un pilastro all'altro presso alle pile dell'acqua benedetta, tutto per obviare agl'inconvenienti di conventicole et ragionamenti illecito." ASF, Capitani di Orsanmichele, vol. 41, fol. 11v. Entry dated 21 July 1588.

121 John K. Brackett, "The Florentine Onestà and the Control of Prostitution, 1403–1680," *The Sixteenth Century Journal* 24, no. 2 (1993), p. 274, note 5.

122 "a' far trattati illiciti, et massime in sul'hore del desinare." ASF, Capitani di Orsanmichele, vol. 79, no. 10.

123 "perche in detto tempo pochissimi vi vanno, senon per fare male." ASF, Capitani di Orsanmichele, vol. 79, no. 10. Similarly, in Modena in 1534, authorities tried to counteract bad behavior by keeping churches locked whenever Divine Office was not being performed. Pietro Tacchi Venturi and Mario Scaduto, *Storia della Compagnia di Gesù in Italia* (Rome, 1950), p. 210.

124 "la chiesa in sè è oscura, et ha de' nascondigli assai; ci parrebbe bene fare un'cancello di noce a' balaustri da un pilastro all'altro che chudessi i due terzi della chiesa." ASF, Capitani di Orsanmichele, vol. 79, no. 10.

125 Zervas stated that the cost was 80 lire, but in the document the monetary symbol used was the inverted triangle, which Cappelli confirmed indicated scudi. Adriano Cappelli, *Dizionario di abbreviature latine ed italiane* (Milan, 1949), p. 411. In addition, in her main text Zervas dated the proposal to the grand duke to July 1589, but in the corresponding endnote referring to vol. 79, stated it was 1588. Zervas, ed., *Orsanmichele a Firenze*, pp. 241, 250, note 101.

126 "acciò che havesti mala volùntà, non habbi luogo da exequire il mal animo." ASF, Capitani di Orsanmichele, vol. 79, no. 10.

127 For example, in September 1397, prostitute Bernardina da Padova was fined for being in the area around Orsanmichele without wearing her identifying bell, and other offences. Romano Canosa and Isabella Colonnello, *Storia della prostituzione in Italia: dal Quattrocento alla fine del Settecento* (Rome, 1989), p. 13, note 2.

128 Brackett, "The Florentine Onestà," pp. 274–75.

129 Maria Serena Mazzi, *Prostitute e lenoni nella Firenze del Quattrocento* (Milan, 1991), pp. 251–52, 287–89; Richard C. Trexler, "Florentine Prostitution in the Fifteenth Century: Patrons and Clients," in *Power and Dependence in Renaissance Florence, Volume 2: The Women of Renaissance Florence* (Asheville, NC, 1998), pp. 41–42.

130 Nicholas Terpstra, "Locating the Sex Trade in the Early Modern City: Space, Sense and Regulation in Sixteenth-Century Florence," in *Mapping Space, Sense, and Movement in Florence: Historical GIS and the Early Modern City*, ed. Nicholas Terpstra and Colin Rose (Abingdon and New York, 2016), pp. 112, 122, note 12.

131 Brackett, "The Florentine Onestà," pp. 295–96.

132 Arturo Graf, "Una cortigiana fra mille: Veronica Franco," in *Attraverso il Cinquecento* (Turin, 1888), pp. 201–02, note 53. *Chronica Gestorum in partibus Lombardie et reliquis Italie (Diarium parmense)*, ed. L. A. Muratori, Rerum Italicarum Scriptores (Città di

Castello, 1904), p. 73, lines 32–35. See also Tacchi Venturi and Scaduto, *Storia della Compagnia di Gesù*, pp. 206–07, 209.

133 Randolph, "Regarding Women," pp. 35–38.

134 "come Vostra Altissima potrà vedere per il disegno, che con questa segli manda." ASF, Capitani di Orsanmichele, vol. 79, no. 10.

135 Zervas, ed., *Orsanmichele a Firenze*, p. 241. ASF, Capitani di Orsanmichele, vol. 350, loose sheet dated 1588.

136 Ibid., p. 241. Zervas referred to an unfoliated page in vol. 350, which the present author has been unable to locate.

137 For the development of the Renaissance baluster, see Rudolf Wittkower, "Il balaustro rinascimentale e il Palladio," *Bollettino del Centro internazionale di studi di architettura "Andrea Palladio"* 10 (1968), pp. 332–46; Paul Davies and David Hemsoll, "Renaissance Balusters and the Antique," *Architectural History* 26 (1983), pp. 1–23, 117–22; Silvia Catitti, "Balaustro e balaustrata tra metà Quattrocento e primo Cinquecento," *Quaderni dell'Istituto di Storia dell'Architettura / Università degli Studi di Roma La Sapienza, Dipartimento di Storia dell'Architettura,* *Restauro e Conservazione dei Beni Architettonici* New series 60/62 (2013/2014), pp. 21–32.

138 Davies and Hemsoll, "Renaissance Balusters," pp. 8, 15–16.

139 Ewa Karwacka Codini and Milletta Sbrilli, *Il quaderno della fabbrica della Cappella di Sant'Antonino in San Marco a Firenze: Manoscritto sulla costruzione di un'opera del Giambologna*, Quaderni dell'Archivio Salviati (Pisa, 1996), p. xxvi. The chapel was inaugurated in 1589. I am grateful to Sally Cornelison for bringing this contemporary example to my attention. For the chapel, see Cornelison, *Art and the Relic Cult*, pp. 149–200; Cornelison, "Tales of Two Bishop Saints," pp. 627–56.

140 Voelker, "Charles Borromeo's *Instructiones*," pp. 191–92.

141 Bandinelli's image-laden, monumental marble choir enclosure was completed in 1572 (see Chapter 2).

142 Dated to 1599–1608. Paatz and Paatz, *Kirchen von Florenz*, vol. 5, pp. 140–41; Acidini Luchinat, "L'altar maggiore," p. 337.

143 Dated to the early 1580s. Lief Holm Monssen, "St Stephen's Balustrade in Santo Stefano Rotondo," *Acta ad archaeologiam et artium historiam pertinentia* 3 (1983), pp. 107–81.

Chapter 8

DUKE COSIMO I DE' MEDICI, RELIGIOUS REFORM, AND THE FLORENTINE CHURCH INTERIOR

IN HIS FUNERAL ORATION for Duke Cosimo I de' Medici in 1574, Piero Vettori cited the renovation of Florence's churches as one of the duke's major accomplishments, exclaiming,

> Moreover, are you aware how much beauty and how much splendor he conveyed to the temples and the churches, those things [screens] – that stood in the way and that blocked the light, so that the interiors could not be seen all at once – having been removed from the center parts. After all, through this intervention, the inherent form as well as the greatness has been returned to the holy places. What is more, the piety and majesty have been increased now that a large number of altars and images of saints are placed right before our eyes.[1]

Vettori's praise, however, masks the complexities surrounding the agency, motivation, and influence of these alterations. Who promoted and enacted the Florentine church renovations and what were their motivations? To what extent were they governed by religious reform, aesthetic appeal, or practical benefits? As we have seen, Duke Cosimo, assisted by his court artist and architect Vasari, was certainly involved in these changes, in some cases ordering their execution and providing funds. In other cases, however, the duke merely gave his permission for plans already undertaken by religious communities or does not appear to have been engaged at all. Moreover, this chapter will present new evidence that shows that Cardinal Carlo Borromeo and Archbishop Antonio Altoviti may also have been involved in promoting alterations to Florentine churches.

The gradual shift toward retrochoirs and open church interiors had its origins in the fourteenth and fifteenth centuries, but gained momentum and became more normative in the late sixteenth century. Across Europe in this period, against the backdrop of the unfolding Protestant Reformation, both Catholic and Protestant ecclesiastical spaces were altered to various extents, but the relative influences of religious and political ideology are hard to pin down. Church interiors were sites of negotiation, compromise, and collaboration between the lay and religious who used those spaces. An intricate web of motivations, therefore, drove architectural change, which in itself was piecemeal and scattered. By bringing to light these complex factors, we can gain deeper insights into the interconnections between art, religion, and society in Counter-Reformation Europe.

THE FLORENTINE CHURCH TRANSFORMATIONS: CHRONOLOGY, MOTIVATIONS, AND REACTION

The Florentine alterations represent just one episode in the overall narrative of incremental changes to the church interior in early modern Italy. The forms of choir precincts and screens in Florence differed substantially from one church to another, and, of course, several fifteenth-century churches already featured diverse spatial dispositions. Nave choir precincts were not used for the same purposes in every church building, and different motivations – aesthetic, moral, and practical – guided the decision-making process. One striking aspect of the Florentine alterations, however, is how many took place in such a short time; between around 1561 and 1576, some eleven buildings were affected.

As we have seen, the disastrous Arno flood of 1557 affected at least three churches whose

subsequent renovations may have been prompted in part by the residual effects of high floodwaters: San Niccolò Oltrarno, Santa Croce, and Santa Trinita.[2] In the years 1561–64, when Vasari was involved in the reorganization of the Cathedral and Pieve in Arezzo, it seems likely that church alteration projects in Florence were pursued in San Niccolò, San Marco, and Ognissanti. The pre-Vasarian renovations in Florence, therefore, show that a seemingly independent movement for change was building, in response to diverse factors such as flood damage, administrative change, and the diminishing size of some monastic communities. Alterations completed in the late 1560s were surely influenced by Vasari's projects at Santa Croce and Santa Maria Novella. However, these alterations were also likely related to another ecclesiastical event, the Pastoral Visitation of Florentine archbishop Antonio Altoviti, who arrived in the city in 1567 following a decades-long political exile.

Documented motivations for choir renovations in Florence do not differ greatly from those of other church communities across Italy that conducted similar alterations.[3] The Santa Maria Novella operai explained that the alteration was "for the greatest ornament, convenience and beauty and religious observance." The terms "ornamento" and "comodità" were also used to justify numerous transformations in, for example, San Francesco in Brescia, Siena Cathedral, and San Lorenzo Maggiore in Naples, while an appeal to religious observance also appears in documents relating to Sant'Ambrogio in Milan. Vasari considered that the tramezzo in Santa Maria Novella "deprived [the church] of its beauty," echoing a similar phrase used for San Giovanni in Canale in Piacenza, where the tramezzo was considered "formless and an obstruction to the church." Similarly, the Orsanmichele tramezzo was an obstacle ("ostaculo") that deprived the beautiful view ("bella vista") of the tabernacle. At the Carmine, the removal of the

choir was "for the enlargement ('ampliatione') of the church," and other archival sources indicate that the change was for the "beauty and ornament ('ornamento') of the church" and "to have more space" ("più spazio"), recalling fifteenth-century appeals for additional space, ostensibly for the laity, in San Francesco in Brescia ("amplitudine") and Santa Maria del Carmine in Naples ("ampliandi"). At Santa Trinita, the monks desired to "officiate with more quiet" ("più quiete") and less difficulty, reflecting language used at Sant'Ambrogio in Milan ("quietiore animo"). Meanwhile, transformations of San Pancrazio and the Baptistery of San Giovanni copied other churches (the Baptistery, "in the manner which has been done in all the other principal ones of this city" and San Pancrazio, "in all the churches of Florence the choirs have been removed from the middle of these churches").

Given the primary status afforded to church buildings in Renaissance society as sites of devotion, interaction, and display, the alterations to church interiors in late sixteenth-century Florence were bound to spark heated reactions. The eighteenth-century chronicler Settimanni recorded these divergent opinions, including in his Florentine chronicle a sixteenth-century source that claimed that "all [the churches] became very beautiful for the demolition of said screens [ponti] and choirs; notwithstanding that many old people were displeased, because they divided the church, where many devoted people would withdraw to pray, and they were according to the use of the ancient Christians."[4] Similarly, the prior of Santa Trinita described how Cosimo's order to remove the tramezzo "displeased many gentlemen," echoing documentation from beyond Florence, for example at the cathedrals of Siena and Verona and San Pietro Martire and San Domenico Maggiore in Naples.[5]

Most commentators, however, reacted positively to the changes. Cathedral canon and diarist Agostino Lapini noted that the removal of nave choirs was "universally pleasing to many."[6] According to the Libro delle Ricordanze at the Carmine, the expense was covered by "donations given to us by different kind persons"[7] and the results gave "universal satisfaction to the people." An anonymous letter probably written by a Venetian visitor in 1565 in anticipation of an upcoming Medici wedding described Santa Maria Novella, commenting that "in the middle of which the tramezzo has been removed, which makes it seem larger and much more beautiful."[8]

Vincenzo Borghini, the Benedictine Cassinese monk and ducal artistic advisor, saw tramezzi as useless remnants of a bygone era, whose removal made churches more visually appealing. In his Discorsi (1585), Borghini explained that ancient churches were effectively divided into three zones for use by three social groups: the unbelievers and unbaptized ("gl'Infedeli, e Catecumeni"), who could only proceed up to the tramezzo; the pure Christians ("puri Cristiani"), who could potentially occupy the space between the tramezzo and the altar; and the clergy, whose choir and altar were further enclosed from the laity.[9] Borghini justified the removal of tramezzi because "in our times they do not serve any purpose, there not being, thank God, neither unbelievers or unbaptized, and so the churches today have a much more beautiful and magnificent prospect."[10] Looking beyond the obvious inaccuracy of this statement, Borghini implied a deeper truth: that the usefulness of this old tripartite spatial division was long past and had not served a purpose for some time.[11] Moreover, he added that while these structures had existed for around 150 years, their antiquated style no longer conformed to contemporary taste.[12] By citing both societal change and aesthetic improvement, Borghini provided an explanation of the elimination of tramezzi that closely corresponds with documented motivations.

ENACTING THE FLORENTINE CHURCH TRANSFORMATIONS: VASARI, COSIMO, AND ALTOVITI

Whereas documented motivations do not diverge greatly from standard language used elsewhere, the intense series of Florentine alterations involved high-profile figures seemingly motivated by specific political and religious concerns. While archival sources show that individual decisions regarding the disposition of sacred space variously involved multiple groups such as friars, monks, church congregations, and lay patrons, three figures held significant responsibility: Giorgio Vasari, Duke Cosimo I de' Medici, and Archbishop Antonio Altoviti. What were the roles and motivations of each individual? What led to their involvement in this architectural episode? How should we gauge the level of responsibility of each figure?

Giorgio Vasari

Although Vasari is only officially documented as responsible for alterations in the churches of Santa Maria Novella and Santa Croce (in addition to his projects in Arezzo), he has frequently been given credit for inspiring the whole series of church renovations in Florence. Certainly, in his role as ducal artist and architect, Vasari was the most influential figure in Florentine artistic culture (Figure 174). Together with Vincenzo Borghini, he masterminded paintings for the Palazzo Vecchio (1555–74) and the Duomo's cupola (1568–79) and constructed the Uffizi (1560–80) and the so-called Vasari Corridor (1565). As Elizabeth Pilliod argued, the church renovations can be seen in the context of these various pictorial and architectural schemes, which created new spatial and processional routes through the urban landscape, connecting crucial Medici sites and diffusing ducal power across the entire city.[13]

Vasari's renovations of Santa Maria Novella and Santa Croce radically altered architectural space and responded to stylistic developments in Italian church design. Isermeyer concluded that aesthetics were certainly a significant factor in the church renovations, since they produced open interiors that reflected contemporary architectural practice. Wolfgang Lotz also emphasized that "a new aesthetic conception of space" was a dominant factor in the Florentine episode.[14] As Vettori explained in his funeral oration, the church interior was now unified and light-filled, since previously tramezzi had "blocked the light." The demolition of tramezzi also displaced the screen altarpieces and panels that were sometimes erected atop the screens themselves, and was frequently accompanied by the whitewashing of wall frescoes, reflecting a shift in artistic taste with regards to the appreciation of medieval painting. Hall showed that Vasari's innovative altarpiece schemes in the side aisles of each church established new patterns of patronage and facilitated developments in altarpiece design and iconography.[15]

Vasari's broader motivations included gaining opportunities for fresh commissions – for altarpiece paintings, sculptural altarpiece frameworks, and a Eucharistic tabernacle in Santa Croce – and the opportunity to direct other artists in creating large-scale altarpiece schemes in close collaboration with Vincenzo Borghini. As with his oversight work in Palazzo Vecchio and the Duomo, these managerial positions put Vasari in a position of authority above his fellow artists, a status that would continue with the founding of the Accademia del Disegno in 1563 with the support of Duke Cosimo.[16] Indeed, Vossilla suggested that the modernization of Santa Croce and Santa Maria Novella helped create an artistic system that utilized Accademia-affiliated artists who would promulgate the religious authority of the Medici.[17] Certainly, Vasari's close interactions with the duke on multiple projects brought him public prestige and instilled in him a tangible pride that is

Figure 174 *Plate of Giorgio Vasari*, from Giorgio Vasari, *Le vite de' più eccellenti pittori, scultori, e architettori* (Florence: Giunti, 1568). Photo: Houghton Library, Harvard University, Typ 525 68.864

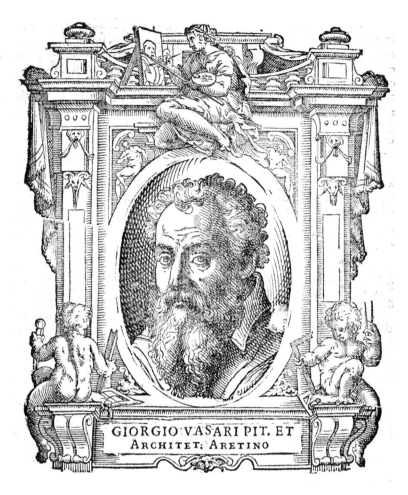

betrayed by the self-satisfied tone of his autobiographical account of the mendicant projects.

Duke Cosimo I de' Medici

As we shall see, numerous scholars have given Duke Cosimo sole credit for personally enacting the Florentine church renovations (Figure 175). Forming part of a longer Italian tradition of lay patrons sponsoring these types of alterations (see Chapters 2 and 3), archival evidence shows that the duke was personally involved in several of the major Florentine church renovations, including Santa Maria Novella, Santa Croce, Santa Trinita, and San Pier Maggiore. From a religious perspective, the alterations can be seen in tandem with the duke's interest in religious reform throughout his reign, his relationships with the reforming figures of Pope Pius IV and Cardinal Carlo Borromeo, and his experiences in Rome. From a political perspective, the renovations and the lavish display of ducal patronage they involved echoed the incremental consolidation of the Duchy's centralized power.

In Florence, although many aspects of the ecclesiastical sphere were autonomous, the Medici dukes nominated bishops, and controlled patronage and jurisdiction for many individual religious sites through the *Auditore della Giurisdizione*, a position that had been founded in 1532 to handle any conflict of interest between the Church and the Florentine state.[18] Before the

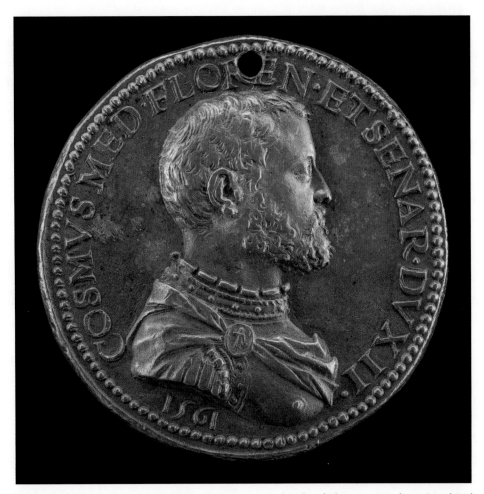

Figure 175 Domenico Poggini, *Cosimo I de' Medici, 1519–1574, 2nd Duke of Florence 1537, later Grand Duke of Tuscany [obverse]*, 1561. Bronze, overall (diameter): 4.12 cm. National Gallery of Art, Washington, DC, Samuel H. Kress Collection 1957.14.934.a. Photo: Courtesy National Gallery of Art, Washington, DC

1560s, Duke Cosimo periodically instigated religious reform: he founded the *Reformatio monasteriorum* in 1545, which increased his power over female communities (see Chapter 6), and, in 1556, showed his preference for the Observant branch of the Dominican order in arranging for Observant friars from San Marco to occupy Santa Maria Novella (see Chapter 3).

Later in his reign, in the years immediately preceding the Florentine architectural projects, Duke Cosimo's links with the papacy became more closely interdependent. The election he helped to secure in 1559 of his distant relative (and Carlo Borromeo's maternal uncle) Giovanni Angelo de' Medici as Pius IV signaled,

according to Roberto Cantagalli, a newly intimate relationship between Cosimo and the Church.[19] The following year, 1560, Pius founded an apostolic nunciature (the equivalent of an embassy to the papal see) in Florence, a privilege normally reserved for royal courts and one of only four created on the Italian peninsula.[20] Whereas Arnaldo d'Addario viewed this development as a prelude to the papal grant to the Medici of a grand ducal title, Claudia Conforti saw it as a partial ceding of Cosimo's ecclesiastical power to Rome.[21] Lorenzo Baldisseri, however, explained that while the nuncio had certain powers, the office was created to revive diplomatic relations between the two powers and thus

promote Cosimo's plan to reach a stable political understanding with the pope for Tuscan authority in Italy.[22]

Cosimo's visit to Rome in late 1560 cemented relations with the newly-elected Pius IV and reinforced diplomatic negotiations for the reopening of the Council of Trent. Waźbiński argued that Cosimo's tour of the early Christian churches of Rome – explicated by his tour guide Onofrio Panvinio – influenced the duke's views on modernizing Florentine church interiors and developing a new sacred iconography.[23] Indeed, Henk van Veen noted that for all their perceived modernity, Vasari's projects emphasized retrospection, reprising both early Christian precedents and Brunelleschi's unified, open interiors.[24] Moreover, Hall remarked that in the late 1530s, Duke Cosimo had directly begun architectural work at Santa Maria sopra Minerva in Rome, which transferred the choir from the nave into the high chapel in order to better exhibit the tombs of the Medici popes, Leo X and Clement VII (the alteration was completed in 1547, see Chapter 3).[25] She noted the early date of this project, suggesting that "this model could have been in Cosimo's mind" when he undertook the Florentine mendicant renovations many years later.

In 1561, the pope approved Cosimo's founding of the military order of St. Stephen (Cavalieri di Santo Stefano), whose church at Pisa Vasari designed.[26] 1562 – Cosimo's *annus horribilis* – saw his wife Eleonora and sons Giovanni and Garzia die of malaria, a tragic event that may have led to greater introspection and attention to religious concerns.[27] Possibly as a result of these crises, in May 1564 Cosimo partially abdicated his power in favor of his eldest son Francesco.[28] In a decretal issued in 1564, he declared himself "a Christian prince and obedient son of the Holy Church," placing himself completely at the disposition of the pope.[29] Under Pius V (1566–72), Cosimo continued his pursuit of the grand ducal crown, supporting papal policy by persecuting suspected heretics, including the reformer and humanist Pietro Carnesecchi, becoming the first secular leader to promulgate the Tridentine decrees within Tuscan territories, supporting the Inquisition, and assisting the crusade against the Turks. On 13 December 1569, in the choir of the Duomo, Archbishop Altoviti recited Pius V's brief that conferred on Cosimo the title of Grand Duke of Tuscany and recorded his merits in implementing Catholic reform. Citing his ardent religiosity, the pope praised his founding of the Order of St. Stephen in support of "the growth and defense of the Catholic faith" and his equipping of "both cathedrals and some of the distinguished and dignified metropolitan churches."[30]

Indeed, Cosimo's piety and interest in church architecture was noted by his contemporaries. Vasari, although not an unbiased observer, denoted him "a Catholic prince" who renovated churches "in imitation of King Solomon."[31] Orations for Cosimo's funeral in 1574 stressed his religious nature, as might be expected from such biased, laudatory speeches. Pietro Angelo da Barga stated that Cosimo frequently attended church services;[32] Benedetto Betti recorded that the duke's great piety aided the maintenance and decoration of religious buildings;[33] and Piero Vettori stated that Cosimo restored the greatness and beauty of the city's churches.[34] Bandinelli's new choir in the Duomo was a particularly prominent example of the duke's patronage of religious art based on Tridentine themes. In an oration delivered to the Accademia Fiorentina in 1574, court physician Baccio Baldini explained that Cosimo's religious zeal manifested itself in many actions including the persecution of heretics.[35] Another early biographer, Aldo Manuzio, writing in 1586, noted that Cosimo was very obedient to the pope, attended many church services, performed spiritual exercises, and supported religious confraternities.[36]

Moreover, Duke Cosimo was certainly acquainted with Cardinal Carlo Borromeo, whose presence in Florence at a crucial juncture in the development of the church renovations was likely a decisive moment in their implementation. Indeed, Conforti argued that Cosimo's friendship with Borromeo and the Florentine papal nuncio Giorgio Cornaro probably inspired his interest in reforming liturgical space.[37] Documentary evidence – albeit circumstantial – in support of this proposition is presented here for the first time. In September 1565, Borromeo traveled from Rome to Milan, where he convened his First Provincial Council the following month. In an anonymous *Diario* compiled by Francesco Settimanni, an entry for 8 September 1565 states that Borromeo "was received by Duke Cosimo with great honor in his palace," where he stayed for three days before leaving with his court for Milan, accompanied by a Medici cavalcade.[38] In a letter dated 9 September, Borromeo wrote to Pius IV that Cosimo had stated that with regards to the repair of churches, no one was more diligent than himself and the Florentine citizens.[39] Intriguingly, Lunardi notes that the first extant document related to the renovation of Santa Maria Novella was dated 12 September 1565, just one day after Borromeo's departure, and just three months after the duke invited exiled Archbishop Altoviti to return to the city.[40] This letter, from that church's prior to one of Cosimo's courtiers, cannot be taken as the earliest evidence for the renovation since it was intended to remind the duke of his previously stated commitment to the church.[41] However, the close dating of Borromeo's visit hints at the possibility of his influence – or at the very least, encouragement – of Cosimo's plans. In November of the same year, Borromeo was again in Florence, where he might have witnessed the dismantling of the Santa Maria Novella *ponte*, which according to Lapini, began on 22 October.[42]

Duke Cosimo also owned Borromeo's published writings. The decrees of Borromeo's first provincial council of Milan (15 October–3 November 1565) were published widely in 1566 and 1567, and a copy was sent to the papal nuncio in Florence, Monsignor Cresengo.[43] In his response to Borromeo, Cresengo mentioned that Duke Cosimo, having also received the text, requested more copies, stating that the decrees could "give a good example to all prelates to do the same in their dioceses."[44] Although officially Borromeo's rules only applied to the Milan archdiocese, their publication decisively impacted the wider Church.[45]

Beyond Duke Cosimo's religious motivations, the church renovations also reflected his consolidation of centralized power and patronage. Throughout his reign, the duke pursued a state-building agenda and the expansion of a centralized governmental bureaucracy.[46] Geographic centralization was manifested in the foundation in 1559 of the *Nove Conservatori della giurisdizione e del Dominio Fiorentino*, which held jurisdiction over the economic and political administration of the provincial towns under Florentine rule.[47] In the city itself, whereas the neighborhood gonfalon had previously represented the base political unit that controlled who was eligible to hold public office, the sixteenth century saw new systems of bureaucratic nobility, and in the religious sphere, new parish and citywide confraternities. Kempers argued that Cosimo's removal of tramezzi, whitewashing of old frescoes, and rescinding of patronal rights was part of a broader drive toward centralized state patronage that cancelled centuries of local lay devotion.[48] According to Lunardi, Cosimo saw the renovations as a demonstration of his absolute power over a changed capital city and as an inspiration for other Catholic nations.[49] Thomas J. Loughman interpreted Cosimo's actions at Santa Croce as part of the duke's "attempt to eradicate all traces of the former republican

oligarchy from the church," in order to establish himself as the most important, and indeed the sole, patron.[50] Most of the new patrons sought for the side altars in the two large mendicant churches had close personal links to the duke.[51] In addition, Hall points out that, at least in Santa Croce, Duke Cosimo controlled the election of operai members (many of whom became these new chapel patrons), thus imposing ducal power on the institutional framework of the church itself.[52]

Both antiquarian and modern scholars have credited Duke Cosimo's interventions, particularly in the two large mendicant churches, to a combination of religious and political motivations. In his 1591 guidebook to the city of Florence, Francesco Bocchi attributed to Duke Cosimo both the impetus and the expense for Santa Croce's transformation, linking the "most beautiful arrangement" of the church to its liturgical use, and the beauty and scale of the new ciborium to increased devotion:

But the undertaking was ordered and paid for by Grand Duke Cosimo, who, having first seen to the removal of the wooden choir and some chapels in the center of the nave, so as to give the entire church a most beautiful arrangement, better suited to the sacred ceremonies, added such splendor with this ciborium, thirteen braccia high, that its great beauty enhances the majesty of the church and seems to enhance devotion as well.[53]

In his 1762 Notizie isoriche, Richa also gave Cosimo credit for instituting the architectural changes, linking them to improved liturgical activities:

Duke Cosimo I, having very strong feelings for the decoration and magnificence of the sacred temples; and wanting there to be in them a larger and more spacious form for the greater

convenience of the ecclesiastical functions: given that he had already taken away the choirs from the churches of Santa Croce, Santa Maria Novella and Ognissanti: so he wanted the same to be done in the Carmine.[54]

The eighteenth-century chronicler of Santa Maria Novella, Vincenzo Borghigiani, noted that Cosimo was particularly interested in modernizing those churches that gave their names to quartieri of the city.[55] The nineteenth-century historian of Santa Croce, Oreste Raggi, explained that Cosimo utilized church patronage to manifest continuity with the fifteenth-century Medici-dominated Republic.[56] Isermeyer stated that clerics were keen for the laity to have visual access to the sacrament in the wake of Trent, and absolutist political leaders like Cosimo valued the removal of republican vestiges in the church interior.[57] Hall analyzed the relative motivations and responsibilities of a complex web of interested parties, suggesting that the alterations publicly demonstrated Cosimo's adherence to the Tridentine spirit, fulfilled Vasari's desire to modernize ecclesiastical space, and represented a new era of altar patronage.[58] Antonio Paolucci held that the symbolic act of displaying a Eucharistic ciborium in Santa Croce, the most popular church of the city, publicly demonstrated Cosimo's dedication to reform.[59] Waźbiński stated that the mendicant modernizations foreshadowed Borromeo's interpretation of Tridentine doctrine in his Instructiones, but were also communicative of Cosimo's insistence on religious reform as part of his pro-papal politics.[60] Lunardi stressed Cosimo's desire to obtain the grand ducal crown via papal intervention,[61] and Vossilla claimed that the renovations displayed "a conscious artistic policy on the part of Cosimo, who anticipated many of the concepts set out by Carlo Borromeo in the Instructiones of 1577."[62] On a more prosaic level, Carlo Cresti noted that the

restorations were a relatively economical, but effective, alternative to constructing grandiose new churches.[63] In a brilliant move, therefore, Cosimo ensured that his contemporaries could accurately state that he had improved the entire city, as indeed his funeral orations attest.[64] Ferretti proposed that with its visual focus on the high altar, rational spatial design and emphasis on pulpits for preaching, San Lorenzo "offered a fine precedent" for Vasari's changes to Santa Maria Novella and Santa Croce, its Medici heritage serving to bolster its exemplary importance for Cosimo.[65] Indeed, several fifteenth-century churches in Florence presented a diversity of spatial options that may have influenced the later sixteenth-century alterations across the city.

Duke Cosimo had numerous political, religious, and personal incentives for pursuing the Florentine church renovations. His political motivations included promoting ducal power and influence across civic and religious institutions, marginalizing other lay patrons, and reviving aspects of fifteenth-century Medici commissions to create an impression of political continuity. Cosimo's perceived interest in religious spaces, perhaps fostered by Borromeo and in anticipation of Altoviti's return, might have been designed to ingratiate him with papal power as part of a campaign to receive the grand ducal crown. However, this having been said, it would be misleading to hold the duke exclusively responsible for these renovation schemes. Church alteration projects had been intensifying both within and beyond the city long before the duke's involvement – even going back to the fifteenth century in some cases. Duke Cosimo's engagement in this evolving process of change, therefore, can be interpreted as an economical move to reap the political and religious benefits of the patronage of these schemes, which, as has been discussed earlier, were advantageous and wide-ranging.

Archbishop Antonio Altoviti

Duke Cosimo and Vasari were not the only influential figures in the Florentine church renovations. An intense series of projects at the end of the 1560s were probably related to another ecclesiastical event, the Pastoral Visitation of the newly present archbishop Antonio Altoviti. The wealthy, scholarly, and politically active Altoviti family had resided in the area surrounding the small medieval church of Santi Apostoli for centuries (Figure 176).[66] As the eldest son of the anti-Medicean papal banker Bindo Altoviti, Antonio pursued an ecclesiastical career under the protection of Cardinal Niccolò Ridolfi, becoming deacon of the Camera Apostolica and secretary to Paul III. However, due to ongoing hostility between Cosimo and Bindo (who was found guilty of rebellion after the Battle of Marciano in 1554) the duke had refused the archbishop entry to the city upon his election to the Florentine see in 1548.[67] Altoviti spent the almost twenty years of his exile residing at Palazzo Altoviti in Rome; in Loreto where he founded a chapel in the basilica; and in Trent, where he undersigned the acts of the final session of the council.[68] In the 1560s, however, when Duke Cosimo cooperated closely with the papacy in order to present himself as the ideal Catholic prince, he granted Altoviti's return to Florence.

Negotiations for Altoviti's return to Florence took place over many years. Already in 1560, Altoviti had petitioned for the repeal of his exile, using Cosimo's son, Cardinal Giovanni de' Medici, as intercessor.[69] Later, ducal ambassador Giovanni Strozzi negotiated with Altoviti in Trent toward the end of the council, writing to Cosimo on 1 February 1563 that the archbishop "had no other desire but to serve you" and to return to the city.[70] Two years later, on 1 June 1565, shortly before his interventions at Santa Maria Novella, Cosimo wrote to Altoviti,

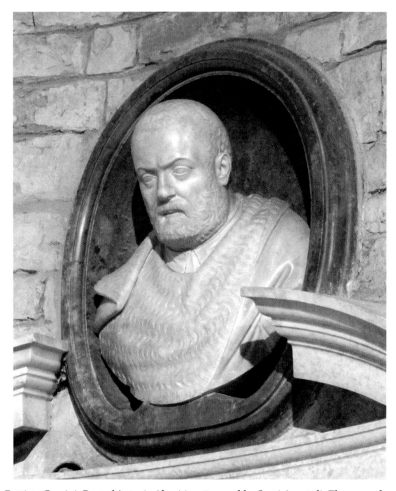

Figure 176 Giovan Battista Caccini, *Bust of Antonio Altoviti*, 1584, marble. Santi Apostoli, Florence, above right door of apse. Photo: Sailko/Francesco Bini

reassuring him that "every error of rebellion" had already been absolved and encouraging him to take care of his Florentine flock.[71] In his *Diario*, cathedral canon Lapini describes the flurry of ecclesiastical activity conducted by Altoviti following his official *Entrata* into the city on 15 May 1567.[72] According to an anonymous description, the revival of the traditional *Entrata*, with its ceremony, music, and spectacle drew large crowds to the church of San Pier Maggiore (see Chapter 6).[73] Initiating liturgical improvements almost immediately, in the same month (29 May), Altoviti ordered that citizens adorn the streets along the route of the Corpus Domini procession.[74] Indeed, Altoviti had been an engaged participant of the Council of Trent, which encouraged bishops to enact

improvements in administration, oversight, and pastoral care on a local level.[75]

On 22 March 1568, the archbishop inaugurated his first Pastoral Visitation of churches in the diocese, beginning with the cathedral, until a mass was held on 6 October 1569 to celebrate his "healthy and safe" return.[76] In this period, Altoviti split his time between completing the Visitation and fulfilling his episcopal responsibilities in the city. From 22 March to at least 8 April 1568, the archbishop visited select city churches, suspending his campaign in April probably to observe the Holy Week and Easter celebrations.[77] From 24 April to 13 December 1568, Altoviti visited churches in the countryside surrounding Florence.[78] He pursued sporadic Visitations the following spring in the city, where

he also presided over Passiontide events.[79] From 10 June to 1 October 1569, the archbishop resumed his Campagna Visitation campaign.[80]

Although Altoviti's concise visitation records for the city churches sometimes praised the state of the buildings, four churches in Florence (the Carmine, Orsanmichele, Santa Trinita, and San Pier Maggiore) started renovations in the same period as the Visitation, either shortly before or after the archbishop's attendance.[81] After witnessing the state of San Pier Maggiore at his ceremonial *Entrata*, the archbishop visited Orsanmichele and Santa Trinita before their restorations and the Carmine only months after demolition of the tramezzo began, on 15 March 1569.[82] Although in three of these cases – San Pier Maggiore, Santa Trinita, and the Carmine – documentation shows that the alterations were ordered by Duke Cosimo himself (or at least by his authority), the archbishop might certainly have asserted additional pressure.

Moreover, the Visitation records prove that on occasion, Altoviti intervened in the arrangement of liturgical space.[83] On 13 June 1569 (in a sample published by d'Addario), Altoviti visited nine parish churches in the Barberino di Mugello area, and ordered three of them to change or remove their screens, which were referred to using the Latin term *intermedium*, again demonstrating that, contrary to general belief, parish churches were regularly equipped with interior screens.[84] The Pieve of San Gavino Adimari was ordered to "demolish within two years the *intermedium* which disfigures the church, together with the two altars standing next to it,"[85] while San Jacopo di Villanova was told that "the two altars next to the *intermedium* of the church be completely demolished within a year and the walls whitewashed."[86] The greater oversight Altoviti gave the rural compared with the urban churches perhaps indicates that in the city either the archbishop's delegates could themselves provide close instruction or the Medici court and other organizations, such as operai or confraternities, demonstrated more influence.

Personal contacts might have influenced Altoviti's views. Perhaps unsurprisingly for the close-knit society of ducal Florence, Altoviti must have known Vasari well. The artist had produced the altarpiece of the *Allegory of the Immaculate Conception* for the Altoviti Chapel in Santi Apostoli in Florence in 1540, and later stayed in Antonio's Roman residence for over two years.[87] Altoviti was also close friends with Filippo Neri: the Chiesa Nuova (Santa Maria in Vallicella), built for Neri's Oratorians from 1575, is an important example of the ideal Counter-Reform church (Figure 8).[88] Indeed, in his oration delivered at Altoviti's funeral in 1574, Matteo Cutini praised the archbishop for repairing old churches using his own funds, perhaps alluding to a concern for reforming religious architecture.[89]

Some scholars have minimized the influence of Altoviti, suggesting that in the archbishop's absence Cosimo essentially acted as a substitute religious reformer. According to Leoncini, the absence of the archbishop from the city – an absence for which the duke himself was responsible – prompted Cosimo to assume control over the Florentine religious sphere, spurring him on to ensure that appropriate Tridentine doctrine, including its architectural implications, was followed in churches.[90] Similarly, Gaston observed that in his personal engagement with church architecture, Duke Cosimo in essence assumed the role of archbishop by asserting centralized authority.[91] Andrea Gáldy, meanwhile, noted that the renovations demonstrated Cosimo's increased power over monastic churches, a contrast with the earlier years of his reign when he had encountered significant resistance at San Marco.[92] Leon Satkowski noted that until the 1560s, religious architecture was of little importance to Cosimo, but that his increasing desire for the grand ducal crown required gaining papal approval, embracing the spirit of Tridentine reform, and preparing Florence in "anticipation of a reforming archbishop."[93] Indeed, Cosimo's interest in Santa Maria

Novella seems to have burgeoned just a few months after inviting Altoviti to return. Paolucci notes that Duke Cosimo's reconciliation with Altoviti was related to the promulgation of the Tridentine decrees, which required the presence of the local bishop to actually enforce.[94] Evidently, the textual evidence that survives relating to the church renovations represents the remnants of undocumented negotiations, which might have involved Cosimo, Altoviti, church leaders, and lay patrons. Indeed, archival sources show that decisions regarding the disposition of sacred space variously involved friars, monks, church congregations, chapel patrons, the pope, the archbishop's vicar general, lay operai, and confraternity Capitani.

Within a broader context, Altoviti was not the only reforming bishop to request the removal of screens. Giberti in Verona was an important precedent (see Chapter 3), and contemporaneously in Milan, Borromeo held decisive control over the articulation of sacred space in the churches under his purview. In other instances, bishops who believed they were executing the practical effects of Tridentine doctrine were challenged by ecclesiastical and civic communities. In 1570, for example, Cardinal Guido Ferrero, bishop of Vercelli, ordered the removal of a twelfth-century iron screen in front of the choir in the cathedral.[95] Aiming to construct a new screen to resemble the Verona *tornacoro*, Ferrero argued that the old iron screen was an impediment that limited the visibility of the holy sacrament, and that it had not prevented some recent thefts.[96] The day after it was disassembled, meanwhile, the cathedral canons reacted against what they perceived as his authority over them, showing that episcopal interference could be greatly resented.

The Cathedral of the Assumption of the Blessed Virgin Mary in Krk, a Venetian-owned island in the north Adriatic sea, featured a screen which had been erected in the 1490s.[97] Bishop Pietro Bembo ordered the removal of the screen in the late 1570s, but the local populace protested so fervently that he was sued by the Venetian Doge, Nicolò da Ponte.[98] In his response to the doge, Bembo stated that he had removed the screen for several reasons: because gentlemen were standing with their backs to the sacrament, facing the women and making immodest gestures toward them; because more than half the church could not see the high altar, its ceremonies, or the elevation of the Host; because the bishop and his retinue could not be seen; because he could not see the laity in the church, especially those who sleep from time to time; because when he gave sermons they were not understood by all; and, finally, because the church as a communal place should be completely open, and in particular, the high altar with the holy sacrament should be visible to all.[99] Bembo's motivations accord with the general tenor of Tridentine reform: an emphasis on preaching, the adoration of the reserved Host, and the promotion of holy behavior in the church interior.[100]

Meanwhile, in Venice, an Apostolic Visitation was conducted in 1581 by papal nuncio Lorenzo Campeggi and bishop of Verona Agostino Valier, the same bishop who confirmed Bembo's reform decrees in Krk.[101] In her magisterial study of Venetian choir precincts during this episode, Modesti concluded that while the Visitors only ordered that two choirs be altered (in San Nicolò dei Mendicoli and Santa Maria della Carità), they systematically ordered the displacement of screen altars and altars beneath raised balcony choirs. Later, in 1584–85, a spokesman for Doge Nicolò da Ponte petitioned for the removal of the *barco* in the Carità to provide space for the doge's personal tomb (an interesting contrast to his actions at Krk Cathedral). This letter provides a tantalizing suggestion that Trent issued directives governing sacred space: the doge, "following that which by the Council of Trent was ordered, removing the place where now the reverend canons reside to sing Divine Office."[102]

In Florence, Altoviti's involvement in the church renovations cannot be proven as definitively as in these examples, which show how closely bishops could promote changes to sacred space. If he did indeed assert pressure on communities to pursue such alterations, Altoviti might have been motivated by the Tridentine order to bishops to ensure care for church buildings. Moreover, on a local level, he would have surely desired to stamp his episcopal authority on both city and country through an extensive Pastoral Visitation after many years of unwarranted political exile.

THE COUNCIL OF TRENT

A major question in the modern interpretation of the Florentine renovations is their relationship to liturgical reform, specifically the Council of Trent. Did broad institutional change exert a strong influence on individual architectural spaces? What specific instructions could have inspired such an interpretation? To what extent did bishops, such as those in Florence, Krk, and Verona, believe they were justly executing Tridentine decrees?

Following failed attempts at Mantua and Vicenza, Paul III officially convened the first session of the council at Trent – a compromise site between northern and southern Europe – in 1545. The majority of the influential business of the council took place in the last session in 1563, when fears for the health of Pius IV (Duke Cosimo's relative and Carlo Borromeo's uncle) forced its expeditious conclusion.[103] Beyond its two main objectives of reaffirming church teaching and establishing pastoral reform, the council had many wider consequences. Crucially, it reaffirmed the sacrality of institutions such as marriage and the priesthood; this renewed emphasis on the holy and sacramental facilitated a shift in the perceived functions of the church interior from the multifunctional to the purely sacred.

The edicts of the Council of Trent were particularly well observed in Florence. Duke Cosimo encouraged bishops to attend the council and even sent his own ambassadors to report on its activities. He accepted the new decrees upon their publication in 1564 and ordered public officials in Florence and Siena to assist bishops in enacting the reforms.[104] In his *Diario*, Lapini reported that in 1565, a synod attended by more than five hundred prelates was held in the Duomo in observance of the Council of Trent.[105] On 28 November 1568 the new Tridentine liturgy, promulgated by Pius V, began to be observed in the city.[106]

As other historians have noted, the council did not legislate on ecclesiastical architecture or furnishings directly or make any direct injunctions concerning the placement of choirs.[107] However, several decrees instigated a shift in the function, atmosphere, and meaning of the church interior.[108] With reference to architecture, the council did proclaim the importance of maintaining an appropriate and safe building environment for the liturgy, with bishops being ordered to ensure that all churches under their control were in suitable condition:

> The Ordinaries of the places shall be bound to visit every year, with apostolic authority, all churches whatsoever, in whatsoever manner exempted; and to provide by suitable legal remedies that whatever needs repairs, be repaired.[109]

The council placed a greater emphasis on the sacraments, particularly the Eucharist.[110] Session 13 reaffirmed the doctrinal truth of transubstantiation and encouraged the laity to attend Mass frequently or at least once a year:

> And finally this holy Synod with true fatherly affection admonishes, exhorts, begs, and beseeches, through the bowels of the mercy of our God, that all and each of those who bear the Christian name . . . would believe and venerate these sacred mysteries of His body and blood with such constancy and firmness of faith, with such devotion of soul, with such

piety and worship as to be able frequently to receive that supersubstantial bread"[111]

If any one denieth, that all and each of Christ's faithful of both sexes are bound, when they have attained to years of discretion, to communicate every year, at least at Easter, in accordance with the precept of holy Mother Church; let him be anathema.[112]

Scholars have shown that this emphasis on the Mass led to the increased manufacture and prominent placement of Eucharistic tabernacles on the high altar and to a shift in altarpiece iconography (Figure 177).[113] Moreover, as Hall

and others have proposed, the council's encouragement of lay visual access to the Eucharist could have influenced the move toward more open naves and uninterrupted sightlines to the high altar without the impeding presence of nave screens. From a devotional perspective, Nicholas Terpstra showed the significance of altars in the rise of stationary practices such as the Forty-Hour devotion, during which confraternity members concentrated extended prayer on a consecrated host displayed in a monstrance on the altar.[114] Indeed, in Florence, Duke Cosimo financed these Forty-Hour practices, as well as sacramental processions, showing that

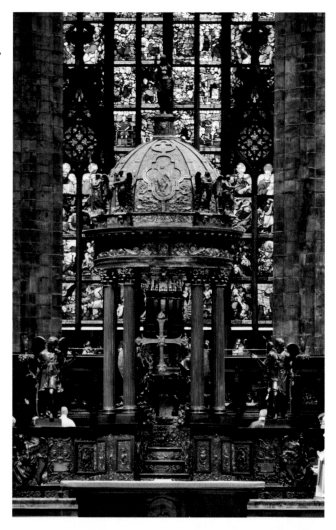

Figure 177 Pellegrino Tibaldi, *Eucharistic tabernacle*, 1580s, bronze. Milan Cathedral. Photo: Zairon

Eucharistic devotion was a state-sanctioned enterprise.[115]

Eucharistic tabernacles pre-dated the Council of Trent, but their display, role, and symbolism shifted dramatically in the light of Counter-Reformation ideals. Doris Carl showed that early Renaissance ciboria could be placed in multiple locations in the church interior before the slow and scattered development of Counter-Reformation standardization and the prescribed conservation of the sacrament on the high altar or another altar by the Roman Ritual, a book of liturgical rites, in 1614.[116] Christoph Jobst argued that because they were bearers of an abstract message charged with controversy, theologians justified the presence of Eucharistic tabernacles by claiming their origins in the early Christian church interior.[117] Even before these reforms, fifteenth-century architectural theorist Francesco di Giorgio Martini envisioned a church space visually focused on a tabernacle on the high altar, as enacted in the cathedrals of Volterra, Prato, Siena, and Verona.[118] In Florence, Eucharistic tabernacles placed on the high altar are documented at Santa Trinita in the 1540s, Santa Croce as early as 1569, San Pancrazio in 1574, San Pier Maggiore by 1575, the Carmine in 1593, and Santo Spirito in 1599–1608.[119]

As part of this shift toward a church interior more focused on the high altar, numerous churches in Florence, including the Carmine and Santa Trinita, were also whitewashed, obscuring centuries of frescoed decoration.[120] The Duomo's walls, which were previously in a deteriorated condition, were whitewashed in 1565, as reported by an anonymous diarist.[121] An emphasis on white walls, with their implied religious symbolism of purity and light, had long been associated with reform movements.[122] Perhaps most influential for the Florentine renovations, Mary-Ann Winkelmes has shown that white, undecorated, illuminated church interiors manifested the reform objectives of the

Reformed Benedictine Cassinese Congregation beginning in the first half of the sixteenth century.[123] The white wall aesthetic also corresponded to contemporary architectural taste based on a revival of classicism, seen for example in Palladio's Venetian churches, which, along with the absence of nave screens, helped to create a unified, focused interior (see Introduction). Whitewashing obscured centuries-old evidence of devotion in patchworked fresco paintings, refocusing the church interior away from the individualized religious fervor more typical of the Middle Ages toward a post-Tridentine congregational attention to Eucharistic devotion focused on the high altar.

In a directive that also required more open space in the church interior, the council compelled clergy to preach regularly to their congregations:

Archpriests, curates, and all those who in any manner soever hold any parochial, or other, churches, which have the cure of souls, shall, at least on the Lord's days, and solemn feasts, either personally, or if they be lawfully hindered, by others who are competent, feed the people committed to them, with wholesome words.[124]

With its emphasis on the education of clergy, the Tridentine Church encouraged the preaching of sermons, particularly in the vernacular.[125] Evelyn Voelker argued that frequent communication and attendance at preaching were the two main liturgical changes that affected church architecture the most, since they required elaborate high altars and open naves.[126] Demonstrating this shift, in some churches in Florence, income from the removal of screens was used to fund the apparatus needed for preaching, such as pulpits and benches (see the chapters on the Carmine, San Pier Maggiore, and Orsanmichele).

Perhaps in response to the historical usage of churches for diverse secular and social functions,

the council also sought to create a more prayerful and religious atmosphere in church. In addition to banning lascivious images and unintelligible polyphonic music,

> [t]hey shall also banish from churches . . . all secular actions; vain and therefore profane conversations, all walking about, noise, and clamor, so that the house of God may be seen to be, and may be called, truly a house of prayer.[127]

In Verona, Giberti had already banned such practices in his *Constitutiones* of 1542,[128] and in 1564, Pius IV banned walking around in churches.[129] In Florence in the same year, the archbishop's vicar, Guido Serguidi, requested permission from Francesco de' Medici (regent at the time) to enact this decree, stating that

> in this your city an abuse of bad example and very great scandal has been happening for a while, of walking through the churches, and particularly around the choir of Santa Maria del Fiore, while Mass and Divine Office is being celebrated, and in front of the holy Sacrament, showing very little religion and contempt for the divine cult.[130]

Ducal secretary Lelio Torelli responded the following day stating that while the regent granted his permission, this tactic had been tried many times in the past and had failed.[131] Based on the Tridentine decree and Gregory X's *Decet domum Domini*, Pius V published the bull *Cum primum* in 1566, which suggests that bad behavior still posed a significant problem. The bull imposed monetary penalties on those who committed irreverent acts in church, which disturbed Divine Office, including having vulgar conversations (especially with women), committing attacks, making noises, disrespectfully sitting or walking around, and turning one's back to the holy Sacrament.[132] Similarly, Carlo Borromeo's

Constitutiones, the decrees of his first provincial council of Milan published in 1566, exhorted against walking around, lingering at the portals, communicating with women or leaning against liturgical furnishings.[133] Later, Archbishop Altoviti's 1573 Provincial Synod reiterated the sentiment of Pius's bull, censuring walking around, shouting aloud, playing tricks, or selling merchandise in church.[134]

In Florence, evidence for secular activities in church largely derives from exhortations against such practices by conservative ecclesiastics. In the fifteenth century, Archbishop Antoninus of Florence cautioned that secular meetings, trials, and theatrical performances should not take place in church, except for religious plays.[135] Similarly, in Siena, San Bernardino castigated the use of churches as locations for dances, business and club meetings, and courtship rituals between young girls and their potential suitors.[136] This latter activity particularly offended Savonarola, who complained that Florentine mothers "put [their daughters] on show and doll them up so they look like nymphs, and first thing they take them to the Cathedral."[137] By subdividing the church interior, tramezzi created spaces hidden from the prying eyes of clergy, in which the laity could potentially misbehave or engage in nonreligious activities. In San Pancrazio in Florence, as we have seen, the monks argued that bad behavior had forced them to remove their nave choir. The clear, open areas revealed when tramezzi were eliminated thus enabled the clergy to oversee the laity's actions within the sacred space.

As well as constituting physical barriers, therefore, tramezzi might have been perceived as ideological barriers to the implementation of some of the most fundamental doctrines promulgated by the Council of Trent. Renewed emphasis on Eucharistic devotion, preaching, and lay engagement in religious rite demanded

a certain openness and potential for communication in the church interior. Moreover, numerous appeals to foster a spirit of holiness in the church fundamentally changed the function of these spaces. Finally, requiring episcopal responsibility for the maintenance of the building fabric brought increased uniformity and focus to developments in church architecture.

CARDINAL CARLO BORROMEO'S *INSTRUCTIONES*

In his roles as cardinal-nephew to Pius IV, administrator of Papal States, head of papal secretaries, and later Archbishop of Milan, Carlo Borromeo was an industrious and zealous promoter of Tridentine policies, and the ideal model of the Counter-Reformation ecclesiastic (Figure 178). Published in 1577, his *Instructiones Fabricae et Supellectilis Ecclesiasticae* was the first treatise to provide practical ways of implementing reform in the church interior.[138] Alexander noted that the fundamental aim of the *Instructiones* was to create "a dignified setting for the Eucharist," thus utilizing the capacity of both furnishings and liturgy to make a visual statement of theological dogma.[139]

Although the *Instructiones* did not explicitly call for the removal of tramezzi and nave choirs, certain instructions indirectly demanded this radical upheaval. Borromeo did not dictate the precise placement of the choir, stating that it could be located in front of or behind the high altar:

> Moreover, as is obvious from ancient buildings and also from church discipline, the location of the choir should be separate from the standing place of the people. [It should be] enclosed by rails, and be situated near the main altar, whether the choir surrounds it in the front (following

ancient tradition) or whether it be in the back owing to either the site of the church, or the position of the altar. If the custom of the country requires it, however, [the choir] ought to extend as widely and as far as the space of the site makes it possible, being in the shape of a semi-circle, or another form, in proportion to the chapel or church, depending upon the judgement of the architect, so that it will correspond accurately in size and proper ornamentation with the importance of the church and the number of its clergy.[140]

As Robert Sénécal observed, Borromeo was notedly ambivalent toward choir layout perhaps because the *Instructiones* were intended mainly for parish rather than monastic churches.[141] Reading beyond the superficial narrative of relative choice, Borromeo's advice to place the choir near the high altar, distinct from people, and perhaps in a semicircular plan implies his preference for retrochoirs, also seen in the architectural renovations he supervised.[142] In addition, Voelker has shown that all the Milanese provincial councils from 1569 to 1582 refer to the arrangement of the choir and the need to clearly delineate the choir area from the nave.[143] Moreover, Borromeo required the clergy to be overtly segregated from secular lay officials and the faithful, ordering the inclusion of steps and balustrades to enclose chapels, including the high chapel, to which the choir was often relocated:

> Iron railings three cubits high should be set into the upper step of every chapel, including the main chapel, on the front or entrance part. It is by no means forbidden to make the railings higher, particularly where the chapels ought to have a safer and more secure enclosure.[144]

Echoing Giberti's decree in Verona (see Chapter 3), Borromeo commanded that a

Figure 178 Francesco Clerici, *San Carlo Borromeo*, in *Calcografia in Iconografia italiana degli uomini e delle donne celebri: dall'epoca del risorgimento delle scienze e delle arti fino ai nostri giorni* (Milan: Locatelli, 1837). Photo: Biblioteca comunale di Trento

Eucharistic tabernacle be placed on the high altar, thus forming the most fundamental focal point in the reformed church interior:

> It is proper that some instruction on the subject of the tabernacle should be given at this point, as a provincial decree has made it obligatory to put the tabernacle of the most Holy Eucharist on the main altar. . . . The size of the tabernacle should be in keeping with the importance, magnitude, and proportion of the church in regard to the main altar on which it is to be placed. The form may be octagonal, hexagonal, square, or round, as will seem more appropriate and religiously suitable, according to the form of the church.[145]

The cardinal also exhorted against variety, disorder, and random placement of chapels and altars:

> All of the minor chapels should have the same length, height and width. They should, as far as possible, be similar in every part and mutually harmonious. . . . In no case should minor chapels or altars be erected under a raised place used for playing the organ, reading the Gospel or Epistle, preaching, or chanting.[146]

Considering that many tramezzi featured attached chapels and altars that were often heterogeneous, this direction indirectly calls for their elimination. In fact, Borromeo's vision of

uniform side chapels immediately conjures up Vasari's interventions in Santa Maria Novella and Santa Croce, or as Sénécal suggested, contemporary designs for Jesuit and Oratorian churches.[147] Moreover, the presence of organs, lecterns, and pulpits on or near screens also implies that with this instruction Borromeo intended to advise the destruction of screen altars – and by extension the screens themselves.

Given the role tramezzi played in dividing the genders in some contexts, it seems surprising that Borromeo upheld this principle in his instruction to install dividing boards:

> Because it is an ancient institution and a custom attested to by blessed Chrysostom and once in use throughout most of this province that in church men should be separate from women, the following is the method and the form of how this division in a church may be brought about.

> In a church, particularly if it is an important one, there should be a partition going in a straight line through the middle of the nave from the main chapel entrance to the main door. It should be built by means of solid wooden columns firmly set in the pavement at a distance of five cubits from each other. And if the boards from which it is made are to be removed on occasion, then the whole [partition] is put together and raised by means of little grooves cut into both sides of each column or arranged in some other way. This partition should be about five cubits high.[148]

Borromeo gave further details on the doors and hinges, which could be used to alter their height during times of preaching or the Mass. Richard Schofield has shown that such wooden partitions were indeed erected in some Milanese churches, adding that Borromeo was unclear whether they should be permanent or temporary.[149]

In a similar spirit to Panvinio's 1570 *Le sette chiese romane*, Borromeo encouraged a revival of the ideals of the early Christian Church. In his letter to Milanese clergy, which formed the preface to the *Instructiones*, Borromeo stated that "we also advise an imitation of that ancient piety . . . which clearly shone forth in the construction of those sacred buildings and in the admirable disposition of their sacred furnishings."[150] In his architectural interventions, however, Borromeo overlooked Roman examples of the medieval *schola cantorum* such as the one at San Clemente, which he erroneously believed represented ancient usage, instead opting to place the choir behind the high altar.[151] Schofield has shown that while Borromeo believed in the early Christian precedents for a clear segregation of clergy and laity, Protestant writers disputed this interpretation of history.[152] The cardinal also requested the removal of private chapels and tombs, believing that ancient churches were clear, uncluttered spaces.[153]

In addition to the *Instructiones*, Borromeo instituted changes to the church buildings over which he had authority, which reveal more minute details about his views on architectural reform. In Rome, Borromeo renovated the two major churches he administered. As archpriest of Santa Maria Maggiore, Borromeo continued a renovation already underway, which included the removal of a colonnaded choir screen and randomly placed altars to focus visual attention on the high altar.[154] At Santa Prassede, where Borromeo was titular cardinal from 1564, he supervised the embellishment of the high altar, which included a new baldachin and wooden choir stalls in the apse, the clearing of disorderly items from the nave and aisles, and the creation of a marble and brass balustrade to make a clearer distinction between nave and presbytery (Figure 179).[155] In his first pastoral visit in 1565, Borromeo required multiple changes to Sant'Ambrogio in Milan, including placing the Eucharistic tabernacle on the high altar, removing all altars positioned haphazardly throughout

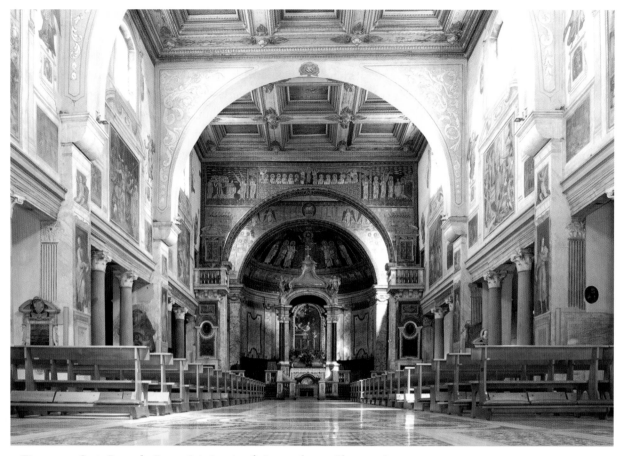

Figure 179 Santa Prassede, Rome. Interior view facing northwest. Photo: author

the church, and ensuring that side altars were placed on platforms of uniform dimensions.[156] The cardinal also ordered modifications to numerous churches in Milan and its environs, including San Lorenzo, San Nazaro, and Monza Cathedral.[157] His personal influence extended outside the city to include the dioceses of Bergamo and Brescia.[158]

In his role as archbishop, Borromeo directed most of his attention to Milan Cathedral (Figure 180). Schofield has analyzed the complex vicissitudes of the Duomo choirs (the upper for clergy, the lower for lay officials), starting from the early sixteenth-century rectangular arrangement in front of the high altar.[159] In 1557, Duomo officials commissioned Vincenzo Seregni to resystematize the choirs and construct a subterranean "scurolo" to house relics beneath. From

1564, Niccolò Ormaneto (Borromeo's vicar and representative in Milan) began to correspond with the cardinal regarding the placement of the Eucharistic tabernacle donated by Pius IV, which was raised above the altar table to avoid obscuring the sightline to the centrally-aligned archbishop's throne.[160] In 1567, after producing several plans and modifications, Seregni was replaced by Pellegrino Tibaldi, Borromeo's favored architect. Extending the *scurolo* further into the nave, Pellegrino designed a choir of four bays: three bays closest to the high altar reserved for ecclesiastics and one bay for the lay officials and governor, separated from the nave via a balustrade raised on three steps, where two large pulpits were established on either side of the nave. Within the upper choir of clergy, the archbishop's seat was further elevated on the left side,

Figure 180 Milan Cathedral. Interior view facing east. Photo: Paolo da Reggio

while in the center the high altar was raised on a dais of five steps.[161]

The broad influence of Borromeo on Italian church architecture, both through his theoretical writings and their practical implementation, cannot be overstated. As we have seen, Borromeo likely encouraged Duke Cosimo to pursue the church renovations when he visited Florence in 1565. Beyond Florence, Borromeo's interpretation of Tridentine thought in the

Instructiones, influence over church buildings in northern and central Italy, and high status and authority, afforded him a unique role in the shaping of sacred space in the context of Catholic reformation and renewal. The 1582 publication of the *Acta ecclesiae mediolanensis*, which included the decrees of Borromeo's six provincial councils, eight diocesan synods, and pastoral letters, plus the text of the *Instructiones*, enjoyed wide readership and influence across Catholic

realms in both Europe and Latin America for centuries to come.[162] Simon Ditchfield noted that while the Council of Trent may have provided the theory behind Catholic reform and renewal, the *Acta* provided the practical manual. Standard furnishings – particularly high altar tabernacles – pervaded Catholic sacred space, focusing the visual attention of the faithful on the sacrament in a form sanctioned by Catholic authority and in direct opposition to Protestant practices.[163] Although, as we have seen, choir layout did not become standardized in Catholic territories in Europe in the sixteenth century (see Introduction), Borromeo's writings and influence promulgated an enticing vision of the holiness of sacred space in the Catholic church up to the eighteenth century and beyond.

Conclusion

Tramezzi and nave choir precincts were constructed at a time when churches were crucial sites in the Italian city, where, for instance, characters such as the young Florentine men and women of Boccaccio's *Decameron* could interact and debate. As one of the only functional interior spaces accessible to all ranks of society, churches were used for neighborhood meetings, religious plays, and social encounters. Subdivisions in the church interior created multiple subsidiary areas in church where, according to contemporary sources, people could commit "many impertinent and disgraceful things"[164] or "withdraw to pray,"[165] according to their differently regulated moral compasses.

The transformation of the Italian church interior proceeded sporadically, with some regional variations such as the early retrochoirs in Umbria, but became more intense in the later sixteenth century. Well before the Council of Trent, changes to sacred space took a variety of forms and were instigated for multiple reasons

(see Chapter 2). Indeed, Borromeo himself acknowledged that various practical factors determined the arrangement of choir space ("the site of the Church, or the position of the altar, or the custom of the country"). Although not explicitly ordered by the Council of Trent and certainly predating its edicts, these types of renovations were sometimes perceived by contemporaries to have proceeded from the spirit of Tridentine reform. Increased Eucharistic devotion and a renewed emphasis on preaching certainly had an impact on church furnishings. In Florence, sacred spaces were sometimes equipped with added accoutrements such as Eucharistic tabernacles, benches, and pulpits to fulfill these objectives. In addition to these specific liturgical practices, the more general directive condemning secular actions, including perambulating church buildings, "so the house of God may be seen to be, and may be called, truly a house of prayer" was also influential. On the surface, the church alterations may seem to run counter to this objective, since screens were originally intended to impede contact with laity for the spiritual benefit of the religious, and since their attached chapels and images fostered communal devotion. However, the removal of choir precincts encouraged greater focus on the high altar and its Eucharistic tabernacle, and created open spaces where the various activities of lay people (such as sleeping, as noted by Bishop Bembo in Krk) were more easily surveilled. This explicit drive to make the church a holier space finds corroborating support in numerous documents relating to the Florentine church renovations.

These changes fulfilled numerous objectives for multiple individuals and groups. For Duke Cosimo, his support of these alteration schemes, which had been developing in the city without his personal involvement, represented an exceedingly economical way to renovate the entire city's churches in a contracted period of time. Conducted with the assistance of his court artist

and architect, Giorgio Vasari, and likely promoted by Carlo Borromeo and Archbishop Altoviti, the renovations conveyed to the public the character and intensity of the duke's religious piety and the extent of his political power, and responded to the contemporary architectural taste for open interiors. Conveniently, the renovated churches also echoed fifteenth-century Medici commissions such as San Lorenzo, and diminished the visibility of other lay patrons.

This localized study of Florence, set within wider chronological and geographical contexts, shows the value of setting individualized situations against the backdrop of broader historical changes. Tracking the city's churches through the fifteenth and sixteenth centuries and investigating a series of in-depth case studies has shown that equating alterations to sacred space with religious reforms such as Trent, or the objectives of single patrons such as Duke Cosimo, is far from straightforward. In addition, the variety of evidence required for this type of study, including archival, antiquarian, and archaeological sources, bears significant challenges of interpretation. It is expected that this interpretative work will be ongoing in the light of new information, as we have seen for the cases of Santa Maria Novella and Santa Croce.

Spatial dynamics in the churches of Renaissance Europe were nuanced, contrasting, and complex. At stake in these inquiries is not just the church's visual appearance but the essential issues of whom the church was for, who gained access to its sacred space, and what and who the church interior represented. These issues – practical, symbolic, and representational – are not easy to resolve. Across Europe, each region and denomination adopted diverse layouts for different ideological reasonings, precluding a categorical definition of the relationship between form, function, and belief. Instead, it is precisely because the church interior was an arena with so many intersecting facets –

encompassing art, religion, society, and politics – that it is so difficult to unravel. In Renaissance Florence, as elsewhere in sixteenth-century Europe, the converging sacred and secular spheres of art, religion, and society both clashed and compromised in the contested arena of the church interior.

NOTES

1 "Quantam autem speciem, splendoremque sacris aedibus ac delubris attulerit, sublatis e medijs illis quae obstabant, luminibusque officiebant, ne tota simul aspicerentur, novistis: ita enim et facies sua, atque amplitudo fanis reddita est, et dignitas etiam religioque aucta, cum simul numerus in gens ararum oculis obijcitur, imaginumque sanctorum virorum." Pietro Vettori, *Oratio P. Victorii habita in funere Cosmi Medicis Magni Ducis Etruriæ, etc* (Florence, 1574), unpaginated. Adapted from translation in van Veen, *Cosimo I de' Medici*, pp. 120–21. I am especially grateful to Tycho Mass for assisting with this translation.

2 For the 1557 flood of the Arno, see Shannon Kelley, "Arno River Floods and the Cinquecento Grotto at the Boboli Garden," *Renaissance Studies* 30, no. 5 (2015), pp. 729–51.

3 See Chapters 2 and 3 for full references for each of these non-Florentine churches.

4 22 October 1565: "tutte divennero molto abbellite per la demolizione di detti ponti, e cori; nonostante ciò dispiacque a molti vecchi, perche dividevano la chiesa, ove molte persone divote si ritiravano ad orare, ed erano secondo l'uso degli antichi cristiani." ASF, Manoscritti 128 (Settimanni, *Diario fiorentino*, vol. III), fol. 334r, quoted in Lapini and Corazzini, *Diario Fiorentino*, p. 147n.

5 For San Domenico Maggiore in Naples, see Morvan, "Ecco disperse," unpaginated.

6 Lapini and Corazzini, *Diario Fiorentino*, p. 152: "fu cosa che piacque molto a l'universale, l'aver levato detti cori." Entry dated 23 April 1566.

7 "La spesa che si pose nella detta rovina et ornamento si fece con limosine donateci da diversi amorevoli persone ... con universale satisfattione dei popoli." ASF, CRS no. 113 (Carmine), vol. 19, fol. 75r.

8 "nel mezzo della quale si è levato quel tramezzo che la fa parer maggiore e più bella assai et si leverà ancora il coro facendolo dopo altar grande." See Waźbiński, *L'Accademia medicea*, pp. 394–95 for a partial transcription. Waźbiński suggested that the letter might have been written by a Venetian because it referred to Verrocchio's equestrian monument to Bartolomeo Colleoni, located in Campo SS Giovanni e Paolo.

9 Borghini and Manni, *Discorsi*, p. 433. Hall, "The Tramezzo in Santa Croce," p. 339.

10 "che ne' tempi nostri a nulla più non servivano, non ci essendo, Diograzia, nè Infedeli, nè Catecumeni: e così restano oggi le Chiese con molto più bella, e magnifica vista." Borghini and Manni, *Discorsi*, p. 433.

11 According to Schmid, Borghini's statement is completely incomprehensible. Schmid, *Et pro remedio animae*, p. 155.

12 "E per questa medesima cagione quelle, che di nuovo si sono da CL. anni in quà murate, lasciarono quell'antica forma non più in uso, nè conforme a' costumi di questi tempi." Borghini and Manni, *Discorsi*, p. 433.

13 Pilliod, "Cosimo I and the Arts," pp. 364, 368.

14 "Secondo la nostra opinione, la causa è piuttosto una nuova concezione estetica dello spazio che non un mutamento nella consuetudine liturgica." Wolfgang Lotz, "Le trasformazioni vasariane e i nuovi edifici sacri del tardo'500," in *Arte e religione nella Firenze de' Medici*, ed. Massimiliano Giuseppe Rosito (Florence, 1980), p. 87.

15 See in particular Hall, *Renovation and Counter-Reformation*. The artist was aware of Brunelleschi's intention to fill each of its homogenous side chapels with large altarpieces, an ambition that was partly fulfilled by Vasari's oversized Martelli altarpiece (*The Martyrdom of St. Sigismund*), completed in 1549 but destroyed by 1711. Gardner von Teuffel, "The Altarpieces of San Lorenzo," pp. 214, 216.

16 For the Accademia del Disegno, see Karen-edis Barzman, *The Florentine Academy and the Early Modern State: The Discipline of Disegno* (Cambridge and New York, 2000).

17 Vossilla, "Baccio Bandinelli," p. 79; Poma Swank, "Iconografia controriformistica," p. 110.

18 Litchfield, *Emergence of a Bureaucracy*, p. 95; Jonathan Davies, *Culture and Power: Tuscany and Its Universities 1537–1609* (Leiden, 2009), pp. 38, 53.

19 Roberto Cantagalli, *Cosimo I de' Medici granduca di Toscana* (Milan, 1985), p. 237.

20 D'Addario, *Aspetti della Controriforma*, pp. 152–54. The document instituting the nunciature is dated 2 August 1560, and transcribed on p. 497 (doc 88).

21 Ibid., p. 154; Conforti, *Vasari architetto*, p. 209.

22 Lorenzo Baldisseri, *La nunziatura in Toscana: le origini, l'organizzazione e l'attività dei primi due nunzi Giovanni Campeggi e Giorgio Cornaro* (Vatican City, 1977), p. 34.

23 Waźbiński, *L'Accademia medicea*, pp. 371–76; Vossilla, "Baccio Bandinelli," p. 71.

24 Van Veen, *Cosimo I de' Medici*, pp. 117–21. See also, Ferretti, "Sacred Space," p. 514; Pilliod, "Cosimo I and the Arts," p. 365. Donal Cooper has questioned whether retrochoir arrangements in general were perceived as modern or retrospective. Cooper, "Revisiting the Umbrian Retro-Choir," unpaginated.

25 Hall, "The Tramezzo in the Italian Renaissance," p. 226. Hall developed this idea in her plenary lecture entitled "What Vasari tore out and what he put in, and why" at the *Vasari @ Santa Croce* conference, sponsored by the Medici Archive Project, Opera di Santa Croce, Syracuse University in Florence, and the Samuel H. Kress Foundation, held at Santa Croce in Florence on 3 March 2016. See also Hall, "Another Look at the Rood Screen."

26 Vasari et al., *Le vite*, vol. 6, p. 403.

27 For example, Booth characterized Cosimo as truly religious. Cecily Booth, *Cosimo I Duke of Florence* (Cambridge, 1921), p. 194.

28 Cantagalli, *Cosimo I*, p. 266.

29 The decretal was issued 28 November 1564. Waźbiński, *L'Accademia medicea*, pp. 368–69.

30 D'Addario, *Aspetti della Controriforma*, p. 154. "ferventioremque Catholicae Religionis cultum … Quod maiora, si usus venerit, ad Catholicae Fidei defensionem et incrementum … Quod quamplures florentissimas Urbes, tam Cathedralium, quam earum nonnullas Metropoliticarum Ecclesiarum dignitate insignes, ac studiorum generalium Universitatibus ornatas." The breve is dated 27 August 1569. Aldo Manuzio (il Giovane), *Vita di Cosimo de' Medici, primo Gran Duca di Toscana, descritta da Aldo Mannucci* (Bologna, 1586), pp. 149–55.

31 Vasari et al., *Le vite*, vol. 6, part 1, p. 406.

32 "et con veneration sia stato solito frequenter le chiese, et quivi intervenire alli divini sacrifitij." Pietro Angèli, *Oratione funerale di m. Pietro Angelio da Barga: fatta nelle essequie del sereniss. Cosimo de Medici gran duca di Toscana, recitata nel Duomo di Pisa il di xiiij. giugno MDLXXIIII / e tradotta in lingua fiorentina* (Florence, 1574), unpaginated. For Duke Cosimo's funeral, see Eve Borsook, "Art and Politics at the Medici Court I: The Funeral of Cosimo I de' Medici," *Mitteilungen des Kunsthistorisches Institut in Florenz* 12, no. 1/2 (1965), pp. 31–54.

33 "Di questo ne sono testimonii i monasterii delle sacre vergini, e gl'altri luoghi, che al culto divino sono dedicati, i quali sono stati fabricate, mantenuti, ornate, restaurati, et aiutati dalla somma pietà di questo Principe." Benedetto Betti, *Orazione funerale di Benedetto Betti: da lui publicamente recitata nelle esequie del sereniss. Cosimo Medici gran duca di Toscana: celebrate il dì 13. de giugnio 1574. nella Compagnia di S. Giouanni Vangelista: con la descrizione dell'apparato messa nel fine* (Florence, 1574), unpaginated.

34 Vettori, *Oratio P. Victorii*, unpaginated.

35 Baccio Baldini, *Orazione fatta nell'Accademia Fiorentina in lode del Sereniss. S. Cosimo Medici Gran Duca di Toscana, Gloriosa Memoria, da M. Baccio Baldini suo protomedico* (Florence, 1578), p. 29.

36 Manuzio (il Giovane), *Vita di Cosimo de' Medici*, p. 167.

37 Conforti, *Vasari architetto*, p. 209.

38 "Addi viii di settembre 1565 sabato. Venne in Firenze un Cardinale, che si chiamava il Cardinal Borromeo; fu ricevuta dal Duca Cosimo con grande onore nel proprio palazzo. Dopo tre giorni fece partenza per Milano accompagnato da tutta la corte, et il Duca mandò 70 cavalleggieri fino a Milan." ASF, Manoscritti 128

(Settimanni, *Diario fiorentino*, vol. III), fol. 327v. This manuscript is composed of individual folios written in a variety of hands and compiled into chronological order.

39 Alexander writes, "While traveling north in 1565, Borromeo visited Duke Cosimo de' Medici who told him that in all sorts of spiritual matters "come de le riparationi degli ornamenti de le chiese ... niuno ne piglia cura se non lui e i cittadini Fiorentini." Letter from Borromeo to Pius IV, dated 9 September 1565 in the Biblioteca Ambrosiana, Milan, F 36bis inf., fol. 434r, quoted in John Alexander, *From Renaissance to Counter-Reformation: The Architectural Patronage of Carlo Borromeo during the Reign of Pius IV* (Milan, 2007), p. 58, note 34. Ferretti also noted Borromeo's visit to Florence, stating that it solidified his friendship with Cosimo. Ferretti, "Sacred Space," p. 514. The visit was also mentioned in Cristina De Benedictis, "Devozione-collezione: sulla committenza fiorentina nell'età della Controriforma," in *Altari e committenza: Episodi a Firenze nell'età della Controriforma*, ed. Cristina De Benedictis (Florence, 1996), p. 8.

40 Lunardi, "La ristrutturazione vasariana," p. 406.

41 "i denari che vanno in assetare il choro et l'altare grande, per potere levare il ponte et il choro del mezzo della chiesa, sì come è stato delibarato (a) da i nostri Illustrissimi et Eccellentissimi Principi." Ibid., p. 406.

42 Borromeo was intimately involved in the wedding of Francesco de Medici and Giovanna d'Austria: he accompanied Giovanna from Trento in November 1565 and was present in Florence as papal representative, before returning to Rome on the pope's death in December. Cantini, *Vita di Cosimo*, pp. 446–47, 451. Lapini and Corazzini, *Diario Fiorentino*, p. 146.

43 Roughly six thousand copies were produced. Enrico Cattaneo, "Il primo concilio provinciale milanese (a. 1565)," in *Il Concilio di Trento e la riforma tridentina. Atti del Convegno storico internazionale, Trento, 2–6 settembre 1963* (Rome, 1965), pp. 249–50.

44 "per dare buono esempio a tutti prelati per fare il simile nelle loro diocesi ..." Letter dated 25 September 1566. Ważbiński, *L'Accademia medicea*, pp. 364–65, note 35.

45 For example, the Venetian ambassador to the papal see, Giacomo Soranzo, wrote that "in tutte le cose [Borromeo] vive con tanta religione, che dà esempio singolare ad ognuno." Eugenio Albèri, *Relazioni degli ambasciatori veneti al Senato; raccolte, annotate, ed edite da Eugenio Albèri, a spese di una società* (Florence, 1839–63), series 2, vol. 4, pp. 133–34; Cattaneo, "Il primo concilio," p. 255.

46 Litchfield noted that "[t]he most rapid growth in permanent staff was in the late sixteenth century, with about a 60 percent increase in number of offices between 1551 and 1604." Litchfield, *Emergence of a Bureaucracy*, pp. 86–87.

47 Ibid., pp. 110–11.

48 Kempers, *Painting, Power and Patronage*, pp. 284–86.

49 "quando ordinò quella ristrutturazine in maniera così tempestiva, la impose come intervento necessario ed esemplare per tutte le nazioni cattoliche." Lunardi, "La ristrutturazione vasariana," p. 415.

50 Loughman, "Commissioning Familial Remembrance," p. 140.

51 Poma Swank, "Iconografia controriformistica," p. 109.

52 Hall, *Renovation and Counter-Reformation*, p. 22.

53 Francesco Bocchi, *The Beauties of the City of Florence: A Guidebook of 1591*, trans. Thomas Frangenberg and Robert Williams (London, 2006), p. 145. See also Giovanni Leoncini, "Santa Croce nel Cinquecento," in *Alla riscoperta delle chiese di Firenze. 3. Santa Croce*, ed. Timothy Verdon (Florence, 2004), pp. 70–71.

54 "Il Duca Cosimo I. essendo assai portato al decoro, e alla magnificenza de' Sacri Templi; e volendo che questi fossero in una più ampla, e spaziosa forma per maggior comodo delle funzioni Ecclesiastiche: siccome avea di già tolto via i Cori vecchi dal mezzo delle Chiese di S. Croce, di S. Maria Novella, e di Ognissanti: così volle, che il medesimo si facesse nel Carmine." Richa, *Notizie istoriche*, vol. 10, p. 26.

55 "perchè così piacque al Duca Cosimo quale aveva la grandissima idea di rimodernare gli edifizi antichi della città: spezialmente le chiese che erano capi di quartiere." Lunardi, "La ristrutturazione vasariana," p. 414.

56 Oreste Raggi, *La chiesa di Santa Croce e la sua facciata* (Florence, 1863), p. 17. See also van Veen, *Cosimo I de' Medici*, p. 121.

57 Isermeyer, "Il Vasari," p. 235.

58 Hall, *Renovation and Counter-Reformation*, p. 8.

59 Antonio Paolucci, "L'arredamento ecclesiale nell'età della riforma," in *Arte e religione nella Firenze de' Medici*, ed. Massimiliano Giuseppe Rosito (Florence, 1980), pp. 99–101.

60 Ważbiński, *L'Accademia medicea*, p. 376.

61 Lunardi, "La ristrutturazione vasariana," p. 404.

62 Vossilla, "Baccio Bandinelli," p. 71.

63 Cresti, "Architettura della Controriforma," p. 15. Ważbiński, by contrast, emphasized the expense of the modernizations, although he focused on the new side chapels, which were largely sponsored by individual lay patrons. Ważbiński, *L'Accademia medicea*, p. 376.

64 For example, Giovanni Battista Adriani, *Oratio Ioannisbaptistae Adrianij habita in funere Cosmi Medicis Magni Etruriae Ducis* (Florence, 1574).

65 Ferretti, "Sacred Space," pp. 514–18. Pilliod also noted Cosimo's revival of Brunelleschi's "open panorama" in San Lorenzo, which Vasari attributed to Cosimo il Vecchio. Pilliod, "Cosimo I and the Arts," p. 365.

66 Donatella Pegazzano, "Il Gran Bindo Huomo Raro et Singhulare: The Life of Bindo Altoviti," in *Raphael, Cellini, and a Renaissance Banker: The Patronage of Bindo Altoviti*, ed. Alan Chong, Donatella Pegazzano, and Dimitrios Zikos (Boston, 2003), p. 3. For Santi Apostoli, see Benedetta Matucci, "Benedetto da Rovezzano and the Altoviti in Florence: Hypotheses and New Interpretations for the Church of Santi Apostoli," in *The Anglo-Florentine Renaissance: Art for the Early Tudors*, ed. Cinzia Maria Sicca and Louis

Alexander Waldman (New Haven, CT, 2012), pp. 149–76.

67 According to Pegazzano, the appointment of Altoviti was "part of the larger strategy of opposition" to Cosimo. Pegazzano, "Il Gran Bindo," p. 9.

68 Giuseppe Alberigo, "Altoviti, Antonio," in *Dizionario biografico degli Italiani*, ed. Mario Caravale (Rome, 1960), vol. 2, p. 572; Luigi Passerini, *Genealogia e storia della famiglia Altoviti* (Florence, 1871), p. 60. A biography of Antonio Altoviti, written by Lorenzo Cantini and read to the Società Colombaria on 18 May 1804, appears to have been lost. I am grateful to Claudia Tombini of the Accademia Toscana di Scienze e Lettere "La Colombaria" for her help in trying to locate the manuscript.

69 D'Addario, *Aspetti della Controriforma*, p. 122.

70 "Finalmente, al presente m'ha scoperto il desiderio suo che è che Ella si degnasse di perdonarli et d'accettarlo nel numero de' Suoi servidori, dicendomi che non desidera altro che servirLa et spedito che sarà il concilio venirsene con Sua buona gratia a Firenze." Ibid., p. 364 (doc. 18).

71 Ibid., p. 505 (doc. 93).

72 Lapini and Corazzini, *Diario Fiorentino*, p. 156. Passerini claimed that Cosimo was so humiliated by the pomp and ceremony surrounding Altoviti's *Entrata* that he banned similar events in the future. Passerini, *Genealogia e storia*, pp. 60–61. In fact, Alessandro de' Medici did have an *Entrata* ceremony, but on a smaller scale.

73 The anonymous author described crowds of both men and women in the church of San Pier Maggiore: "erat enim Templum multitudine hominum, mulierumque refertissimum." Moreni, *De ingressu Antonii Altovitae*, p. 50. For musical aspects of the *Entrata*, see Frank D'Accone, "Reclaiming the Past: Archbishop Antonio Altoviti's Entrance into Florence in 1567," in *Instruments, Ensembles, and Repertory, 1300–1600: Essays in Honour of Keith Polk*, ed. Timothy J. McGee and Stuart Carter (Turnhout, 2013), pp. 237–62.

74 Lapini and Corazzini, *Diario Fiorentino*, p. 157.

75 See, for example, the collected essays in DeSilva, ed., *Episcopal Reform*.

76 Lapini and Corazzini, *Diario Fiorentino*, pp. 158, 164.

77 Florence, Archivio Arcivescovile, VP 09.1, fols. 1r–28r. Easter fell on 18 April in 1568. Adriano Cappelli, *Cronologia, Cronografia e calendario perpetuo* (Milan, 1952), p. 90.

78 The Campagna churches in 1568 are in Archivio Arcivescovile, VP 08.1, fols. 1r–744r.

79 The city churches in 1569 are in Archivio Arcivescovile, VP 09.1, fols. 28r–53v. Easter fell on 10 April in 1569. Cappelli, *Cronologia*, p. 74. On Maundy Thursday that year (7 April 1569), Altoviti broke with Florentine tradition by washing the feet of paupers rather than of the cathedral canons. "Addi vii di Aprile 1569. giovedi santo: M. Antonio Altoviti Arcivescovo di Firenze essendo il giorno del giovedi santo lavò i piedi a xii poveri nel Duomo fiorentino invece di lavargli a xii canonici di detta chiesa." ASF, Manoscritti 128 (Settimanni, Diario fiorentino, vol. III), fol. 447v.

80 The Campagna churches in 1569 are in Archivio Arcivescovile, VP 08.1, fols. 744r–1028v.

81 For example, the Carmine was described thus: "Ecclesia in edificijs est optime." Florence, Archivio Arcivescovile, VP 09.1, fol. 39v.

82 Altoviti visited Orsanmichele (fol. 19r), Santa Trinita (fols. 22v–23r), and San Pancrazio (fol. 22r–v) on the same day, 6 April 1568. The following spring, he visited San Pier Maggiore on 7 March 1569 (fols. 31v–32v), the Carmine on 15 March 1569 (fols. 39v–40v), and San Niccolò Oltrarno on 13 May 1569 (fols. 42r–44r). Florence, Archivio Arcivescovile, VP 09.1.

83 Besides the Pastoral Visitation records, little evidence hints at Altoviti's views on architectural space although his wide-ranging interests in philosophy, alchemy, and music are well documented. For Altoviti's philosophical writings, see Alberigo, "Altoviti, Antonio," p. 572; for musical compositions dedicated to him, see Jane A. Bernstein, "Bindo Altoviti and Music," in *Raphael, Cellini, and a Renaissance Banker: The Patronage of Bindo Altoviti*, ed. Alan Chong, Donatella Pegazzano, and Dimitrios Zikos (Boston, 2003), p. 211.

84 The Latin term "intermedia," meaning screens, appears in the 1249 Dominican General Chapter. Cannon, *Religious Poverty*, pp. 25–26.

85 "Demoliatur infra duos annos intermedium quod deturpat ecclesiam, una cum duobus altaribus iuxta illud consistentibus." D'Addario, *Aspetti della Controriforma*, p. 521.

86 "Duo altaria iuxta intermedium ecclesiae omnino demoliantur infra annum et parietes dealbentur." The third church was Santa Maria Colle Barucci. Ibid., pp. 525–26.

87 Vasari decorated several spaces in Palazzo Altoviti in Rome in 1551–53. Pegazzano, "Vasari's Decorations," pp. 190–99, and Alan Chong, Donatella Pegazzano, and Dimitrios Zikos, eds., *Raphael, Cellini, and a Renaissance Banker: The Patronage of Bindo Altoviti* (Boston, 2003), pp. 435–36.

88 Bernstein, "Bindo Altoviti and Music," p. 211. For the Chiesa Nuova, see Barbieri et al., *Santa Maria in Vallicella*.

89 "Testes erunt mihi Sacerdotes quamplurimi, quorum domus, et templi parietes iam iam vetustate collabentes, reparatione indigebant, aut sacra vestis situ, et squallore absumpta iam iam defecerat, quam liberaliter, et quam pie suis sumptibus reparandas reficiendasque curaverit." Matteo Cutini, *Oratio funebris Matthaei Cutinij in summa aede ludimagistri de laudibus Antonii Altovitae Archiepiscopi Florentini* (Florence, 1574), unpaginated. D'Addario noted that under Altoviti, the work of renovating holy buildings was pursued intensely. D'Addario, *Aspetti della Controriforma*, p. 190.

90 Leoncini, "Santa Croce nel Cinquecento," p. 67.

91 Gaston wrote that Cosimo "in a sense appropriated the archbishop's role as overseer of church maintenance and

beautification." Gaston, "Sacred Place and Liturgical Space," p. 352.

92 Andrea Gáldy, *Cosimo I de' Medici as Collector: Antiquities and Archaeology in Sixteenth-Century Florence* (Newcastle, 2009), p. 161.

93 Satkowski, *Giorgio Vasari*, p. 96.

94 Paolucci, "L'arredamento ecclesiale," p. 100.

95 T. Barton Thurber, "Architecture and Religious Conflict in Late Sixteenth-Century Italy: Pellegrino Tibaldi's Planned Reconstruction of the Vercelli Cathedral" (PhD thesis, Harvard University, 1994), pp. 88–89.

96 Ibid., pp. 93, 94, note 74.

97 I am grateful to Matko Marušić for first bringing this material to my attention at the Misericordia International conference in Rijeka in September 2018, for sharing his archival transcriptions, and for further clarifying certain details in email correspondence dated 16 September 2019. This material will be published in the forthcoming conference proceedings.

98 Bishop Pietro Bembo is a different figure from Pietro Bembo the poet. He became bishop of Veglia in Dalmatia in 1564, although he only visited twice, and instituted reform decrees, which were confirmed by Apostolic Visitor Agostino Valier, Bishop of Verona, in 1579. Giovanni Pillinini, "Bembo, Pietro (Giampietro)," in *Dizionario Biografico degli Italiani*, ed. Mario Caravale (1966), vol. 8, p. 151.

99 BAK (Biskupski arhiv Krk – Diocesan Achives of Krk), Acta P. Bembo I, g. 1581; fols. 391r–392r. I am extremely grateful to Matko Marušić for sharing his archival transcription, which is also partially transcribed in Ivan Žic-Rokov, "Kompleks katedrala – Sv. Kvirin u Krku," *Rad JAZU 6* (1972), pp. 156–57.

100 These documents in the Archivio di Stato di Venezia have not been consulted by the present author.

101 For the Visitation, see Modesti, "I cori nelle chiese veneziane," pp. 39–65.

102 "Havendo il serenissimo Principe posto il suo monumento nella chiesa della Carità, et desiderando magiormente adornarla essequendo ancora quello che'è dal concilio di Trento ordinato, rimuovendo il luoco dove hora resiedono li reverendi canonici a cantar li divini offizi." Ibid., p. 52.

103 Simon Ditchfield, "Catholic Reformation and Renewal," in *The Oxford Illustrated History of the Reformation*, ed. Peter Marshall (Oxford, 2017), p. 169.

104 D'Addario, *Aspetti della Controriforma*, p. 154.

105 Lapini and Corazzini, *Diario Fiorentino*, p. 143.

106 Ibid., p. 162.

107 See Introduction.

108 See Jennifer Mara DeSilva, ed., *The Sacralization of Space and Behavior in the Early Modern World: Studies and Sources* (London and New York, 2016).

109 Session 7, chapter VIII (3 March 1547). Waterworth, *The Canons and Decrees*, p. 62; O'Malley, *Trent: What Happened*, p. 118.

110 For Tridentine Mass liturgy, see Reinold Theisen, *Mass Liturgy and the Council of Trent* (Collegeville, MN, 1965).

111 Session 13, chapter VIII (11 October 1551). Waterworth, *The Canons and Decrees*, pp. 81–82. O'Malley, *Trent: What Happened*, p. 148.

112 Session 13, Canon IX (11 October 1551). Waterworth, *The Canons and Decrees*, p. 83.

113 For example, Stabenow linked two main lines of development in Renaissance church planning: the liberation of the nave from dividing elements, and the placement of the Eucharistic tabernacle on the high altar. Stabenow, "Introduzione," p. 11.

114 Nicholas Terpstra, "Early Modern Catholicism," in *The Oxford Handbook of Early Modern European History, 1350–1750*, ed. Hamish Scott (Oxford, 2015), p. 610.

115 Weissman, *Ritual Brotherhood*, p. 233.

116 Doris Carl, "Il Ciborio di Benedetto da Maiano nella cappella maggiore di S. Domenico a Siena: Un contributo al problema dei cibori quattrocenteschi con un excursus per la storia architettonica della chiesa," *Rivista d'Arte* 42 (4th series, vol. 6) (1990), pp. 12–22. See also: Alison Wright, "Tabernacle and Sacrament in Fifteenth-Century Tuscany," in *Carving, Casts and Collectors: The Art of Renaissance Sculpture*, ed. Peta Motture, Emma Jones, and Dimitrios Zikos (London, 2013), pp. 42–57; Davies, "Framing the Miraculous," especially pp. 908–11.

117 Jobst, "Liturgia e culto dell'eucaristia," pp. 106, 111.

118 For Francesco di Giorgio Martini, see Stabenow, "Introduzione," p. 13. Jobst noted that it is uncertain whether the Eucharistic tabernacle in Orvieto Cathedral was placed on the high altar. Jobst, "Liturgia e culto dell'eucaristia," p. 105. See also Lang, "Tamquam Cor in Pectore."

119 For ciboria in Florentine churches, see Carlo Cresti, "Altari fiorentini controriformati: lineamenti di fortuna e sfortuna critica," in *Altari controriformati in Toscana: architettura e arredi*, ed. Carlo Cresti (Florence, 1997), pp. 15–18, 47.

120 Whitewashing took place at San Marco in the early 1560s, at the Carmine in 1564, at San Pancrazio in 1574, at the Duomo in 1565, at Santa Trinita in 1586.

121 Suzanne B. Butters, "The Duomo Perceived and the Duomo Remembered: Sixteenth-Century Descriptions of Santa Maria del Fiore," in *Atti del VII centenario del Duomo di Firenze*, ed. Timothy Verdon and Annalisa Innocenti (Florence, 2001), p. 495 and Smith, "The Bandinelli Choir," p. 67. According to cathedral canon Lapini, the process lasted two months and cost the Opera 360 scudi in total. Lapini and Corazzini, *Diario Fiorentino*, p. 144.

122 Mary-Ann Winkelmes, "Form and Reform: Illuminated, Cassinese Reform-Style Churches in Renaissance Italy," *Annali di architettura: rivista del Centro internazionale di studi di architettura "Andrea Palladio"* 8 (1996), p. 73.

123 Ibid., pp. 66, 71–73.

124 Session 5, chapter II (17 June 1546). Waterworth, *The Canons and Decrees*, p. 27. O'Malley, *Trent: What Happened*, pp. 99–100.

125 Counter-Reformation churches often had elaborate pulpits, and public seating was in the form of benches or box pews. Yates, *Liturgical Space*, p. 99.

126 Voelker, "Charles Borromeo's *Instructiones*," pp. 28–29.

127 Session 22, chapter IX (17 September, 1562). Waterworth, *The Canons and Decrees*, p. 161. O'Malley, *Trent: What Happened*, p. 192.

128 "De non ambulando per Ecclesias durante divino officio." Giberti, *Constitutiones*, fol. 9r.

129 Ludwig Pastor, *The History of the Popes, from the Close of the Middle Ages* (Wilmington, NC, 1928), vol. 16, p. 83, note 1: "Bando sopra la biastema et del passegiare per le chiese." 8 January 1564. See also Lewine, "The Roman Church Interior," p. 84. Beyond Italy, Aston noted that in 1565, Bishop Thomas Bentham of Coventry and Lichfield in England stated that the faithful should "not walk up and down the church, nor to jangle, babble nor talk." Aston, "Segregation," p. 258.

130 "in questa Sua città è invecchiata un'abusione di mal'esempio et di grandissimo scandolo, di passegiare per le chiese, et particolarmente intorno al coro di Santa Maria del Fiore, mentre si celebra la messa et i divini offitii, et dirimpetto al santissimo Sacramento, segno di pochissima religione et dispregio del culto divino." D'Addario, *Aspetti della Controriforma*, p. 486, doc. 81. Dated 16 December 1564, transcribed from ASF, *Carte Strozziane*, serie prima, vol. 22, fol. 4 (consulted by the present author).

131 "Sua Eccellenza ne vuol lasciare la cura et pensiero a lui, ricordandogli che molt'altre volte s'è voluto fare questo, et non ha havuto luogo; ma che nondimeno essequisca l'edito. Lelio Torelli, 20 di dicembre '64." Ibid.

132 For the text of the bull, see *Bullarum Diplomatum et Privilegiorum Sanctorum Romanorum Pontificum Taurinensis Editio*, ed. Luigi Tomassetti et al. (Turin, 1862), vol. 7, pp. 434–38. The reforming archbishop Cardinal Paleotti promulgated these rules in his diocese of Bologna in a document the following month written in the vernacular, prohibiting a whole host of bad behaviors in church, including buffoonery and fraternizing with "immodest women." Tacchi Venturi and Scaduto, *Storia della Compagnia di Gesù*, pp. 211–12.

133 *Constitutiones et decreta condita in provinciali synodo Mediolanensi* (Venice, 1566), p. 128. See also Wojciech Góralski, *I primi sinodi di San Carlo Borromeo: la riforma tridentina nella provincia ecclesiastica milanese* (Milan, 1989), p. 195.

134 *Decreta Provincialis Synodi Florentinae; praesidente in ea reverendiss. D. Antonio Altoviti Metropolitanae Ecclesiae Florentinae Archiepiscopo* (Florence, 1574), pp. 18–19 (Session 2, rub. 12, Cap. 1).

135 Gaston, "Sacred Place and Liturgical Space," p. 338.

136 Trexler, *Public Life*, p. 54.

137 Alison Brown, *The Renaissance*, 2nd ed. (New York, 1999), p. 115 (Doc. 26).

138 For interpretations of the treatise, see Voelker, "Charles Borromeo's *Instructiones*," pp. 1–20; Aurora Scotti, "Architettura e riforma cattolica nella Milano di Carlo Borromeo," *L'Arte* 18–20 (1972), p. 56; Evelyn Carole Voelker, "Borromeo's Influence on Sacred Art and Architecture," in *San Carlo Borromeo: Catholic Reform and Ecclesiastical Politics in the Second Half of the Sixteenth Century*, ed. John M. Headley and John B. Tomaro (Washington, DC, and London, 1988), pp. 172–87; Stefano Della Torre, "Le architetture monumentali: disciplina normativa e pluralismo delle opere," in *Carlo Borromeo e l'opera della "grande riforma": cultura, religione e arti del governo nella Milano del pieno Cinquecento*, ed. Franco Buzzi and Danilo Zardin (Cinisello Balsamo, 1997), pp. 218–21.

139 Alexander, *From Renaissance to Counter-Reformation*, p. 232.

140 Voelker, "Charles Borromeo's *Instructiones*," p. 153. Chapter XII.

141 Robert Sénécal, "Carlo Borromeo's *Instructiones Fabricae et Supellectilis Ecclesiasticae* and Its Origins in the Rome of His Time," *Papers of the British School at Rome* 68 (2000), p. 257.

142 Federico Borromeo, younger cousin of Carlo and Archbishop of Milan (1595–1631), attributed changes in spatial articulation in Italian churches to architects rather than ecclesiastical or temporal leaders. After describing how the traditional nave choir was appropriately placed in the "most noble and illustrious" center of the church, Federico continued: "I think that architects themselves took the liberty of changing this time-honored layout when they decided to make the primary entrances and facades of a church as imposing as possible; but in the process of doing this they did not realize that they were relegating the Lord of the house (if we may call Him that) and His chief ministers to the more obscure part, while giving the most spacious part of the church to the common people, who are less important." Federico Borromeo, Kenneth S. Rothwell, and Pamela M. Jones, *Sacred Painting; Museum* (Cambridge, MA, 2010), p. 141 (Book 2, chapter 13). See also Repishti and Schofield, *Architettura e controriforma*, p. 182. For Federico Borromeo, see Pamela M. Jones, *Federico Borromeo and the Ambrosiana: Art Patronage and Reform in Seventeenth-Century Milan* (Cambridge; New York; and Victoria, 1993), pp. 19–63.

143 Voelker, "Charles Borromeo's *Instructiones*," p. 157.

144 Ibid., p. 191. Chapter XV, section 5.

145 Ibid., pp. 160–61. Chapter XIII.

146 Ibid., p. 177. Chapter XIV.

147 Sénécal, "Carlo Borromeo's *Instructiones*," p. 263.

148 Voelker, "Charles Borromeo's *Instructiones*," p. 318. Chapter XXIV.

149 Richard Schofield, "Carlo Borromeo and the Dangers of Laywomen in Church," in *The Sensuous in the Counter-Reformation Church*, ed. Marcia B. Hall and Tracy E. Cooper (New York, 2013), pp. 189–90, 200.

150 Voelker, "Charles Borromeo's *Instructiones*," p. 23.

151 Sénécal, "Carlo Borromeo's *Instructiones*," pp. 257–58.

152 In a letter to Cesare Speciani dated 1579, Borromeo listed his arguments with relation to the early Church. Richard Schofield, "Carlo Borromeo in 1578: Separating the Clergy from the Laity," in *La place du choeur: architecture et liturgie du Moyen Âge aux Temps modernes:*

actes du colloque de l'EPHE, Institut national d'histoire de l'art, les 10 et 11 décembre 2007, ed. Sabine Frommel, Laurent Lecomte, and Raphaël Tassin (Paris and Rome, 2012), p. 178.

153 Liliana Grassi, "Prassi, socialità e simbolo dell'architettura delle 'Instructiones' di S. Carlo," *Arte Cristiana* 706 (1985), p. 5; James S. Ackerman, "Pellegrino Tibaldi, San Carlo Borromeo e l'architettura ecclesiastica del loro tempo," in *San Carlo e il suo tempo: atti del Convegno Internazionale nel IV centenario della morte (Milano, 21–26 maggio 1984)* (Rome, 1986), p. 577.

154 Maurizio Caperna, "San Carlo Borromeo, cardinale di S. Prassede, e il rinnovamento della sua chiesa titolare a Roma," *Palladio: rivista di storia dell'architettura e restauro* 12 (1993), p. 50; Alexander, *From Renaissance to Counter-Reformation*, pp. 172–76.

155 Caperna, "San Carlo Borromeo," pp. 43–58. Alexander, *From Renaissance to Counter-Reformation*, pp. 176–79.

156 Scotti, "Architettura e riforma cattolica nella Milano di Carlo Borromeo," pp. 59–61; Voelker, "Charles Borromeo's *Instructiones*," pp. 15–16.

157 Scotti, "Architettura e riforma cattolica nella Milano di Carlo Borromeo," p. 61. For example, Borromeo ordered that choirs be placed behind the high altar in San Francesco in 1571, Santa Maria alla Scala in 1560, San Nazaro in 1578, and San Simpliciano in 1571. Schofield, "Carlo Borromeo and the Dangers of Laywomen," p. 198.

158 For Bergamo, see Giles Knox, "The Unified Church Interior in Baroque Italy: S. Maria Maggiore in Bergamo," *The Art Bulletin* 82, no. 4 (2000), pp. 679–701. A paper given by Michael Gromotka at the Renaissance Society of America Annual Meeting on 27 March 2015 entitled "Was There an Officially Sanctioned Post-Tridentine Church Interior? Borromeo, Bollani, and Brescia's Two Cathedrals," examined Brescia Cathedral in more detail. I am grateful to Michael Gromotka for sharing his unpublished conference text with me.

159 Richard Schofield, "Un'introduzione al presbiterio del Duomo tra Vincenzo Seregni e Carlo Borromeo," *Nuovi annali / Veneranda Fabbrica del Duomo di Milano* 2 (2010/11), p. 43.

160 Voelker, "Charles Borromeo's *Instructiones*," pp. 14–15, 166–67.

161 Richard Schofield, "Pellegrino Tibaldi e tre cori borromaici," in *Domenico e Pellegrino Tibaldi*, ed. Francesco Ceccarelli and Deanna Lenzi (Venice, 2011), pp. 143–44; Schofield, "Carlo Borromeo in 1578," p. 179.

162 The dearth of church councils or synods between Trent and Vatican II shows the comprehensive reach and influence of the Acta. Simon Ditchfield, "Carlo Borromeo in the Construction of Roman Catholicism as a World Religion," *Studia borromaica* 25 (2011), pp. 7–18; Simon Ditchfield, "Tridentine Catholicism," in *The Ashgate Research Companion to the Counter-Reformation*, ed. Alexandra Bamji, Geert H. Janssen, and Mary Laven (Farnham, 2013), p. 21.

163 "Like the Host in the Eucharist, sacred space represented for Catholics the immediate materiality of God's presence. It directly countered the Protestant claim of offering direct and unmediated access to God." Terpstra, "Early Modern Catholicism," p. 611.

164 See San Pancrazio in Chapter 6.

165 See Settimanni in Chapter 1.

GLOSSARY

apse – A space typically at the liturgical eastern end of a church, usually containing the high altar.

arte – A Florentine trade guild.

balcony choir – Choir seating area on raised balcony or gallery, typically above the main entrance to the church.

baldachin – A ceremonial canopy typically placed over an altar.

balustrade – A railing supported by balusters: short columns typically carved into bulbous forms.

barco, pl. barchi – Italian. In churches of the Veneto, a raised choir over the main entrance or across the middle of the nave.

bay – A vertical section of a church building, typically in the nave.

cancello, pl. cancelli – Italian for gate/gates.

canon – A member of a nonmonastic (secular) chapter or body of clerics living according to a certain rule.

Capitano, pl. Capitani – Members of the Compagnia di Orsanmichele, the lay confraternity who administered the oratory.

cappella maggiore – Italian for high or main chapel: the chapel in a church containing the high altar.

catasto – Italian. An inventory of goods for taxation purposes.

chaplain – A clergyman responsible for a particular chapel.

chierico, pl. chierici – Italian. A young, unordained religious assistant, whose responsibilities included serving at the altar, aiding priests, and keeping the church clean.

choir – A set of wooden choir stalls for use by a religious community.

choir stall – A wooden seat in the choir, often grand and decorated.

choir precinct – A clearly defined area in the church occupied by choir stalls.

clergy – Ordained men, as distinguished from the laity.

cloister – Covered walkway in a conventual complex, typically in a rectangular or square layout.

collegiate church – A church maintained by a community of canons.

compagnia – Italian term typically meaning a confraternity.

confraternity – A lay organization devoted to a religious and/or charitable purpose.

convent – A religious community or its buildings (typically but not exclusively used for nunneries).

coro pensile – Italian for suspended choir. A balcony or gallery choir.

Council of Trent – The nineteenth ecumenical council of the Roman Catholic Church, held in three parts from 1545 to 1563.

counter-facade – The interior, reverse side of the church facade.

Counter-Reformation – The period of Catholic reform and renewal prompted by the Protestant Reformation.

donne – Italian for women, sometimes referring to nuns.

Entrata – Italian for entrance. In Florence referring to a ceremonial investiture of a bishop or archbishop.

Eucharist – The ceremony in which bread and wine are blessed in commemoration of the Last Supper, considered a sacrament in both Catholic and Protestant traditions.

Eucharistic tabernacle – A decorative container for the reserved Eucharistic Host.

facade – The front view or elevation of a building.

friars – Members of a mendicant order.

gallery choir – Choir seating area on raised balcony, typically above the main entrance to the church.

gonfalon – In Florence, the base political and administrative unit in a local neighborhood, administered by elected officials.

grille – A screen, usually metal, comprising a pattern of openings that can be looked through.

guild – A group or association, typically of tradespeople, artisans, or merchants.

high altar – The principal altar in a church, typically placed toward the east end in the high chapel, opposite the main entrance.

high chapel – The chapel in a church containing the high altar.

holy water stoup – A vessel containing holy water placed in a church for general access.

Host – The bread element of the Eucharist.

intarsia – Italian. The art of wood inlay or marquetry.

jubé – French. Rood screen.

jus patronatus – Latin. Privilege and duty granted to a lay family patron regarding the altar of a church.

laity (laymen and laywomen) – Persons who are not members of the clergy or a religious order.

lay chapel – A chapel sponsored by a layperson.

lectern – A reading desk with a slanted top that supports a book used in a church service.

liturgy – Prescribed rituals of church worship.

Medicean – Adjective describing something related to the Medici family.

mendicant order – From Latin *mendicare*, to beg. A religious order in which members live in community but do not own property, e.g., Franciscan order.

monastic order – A group of men or women living together under a common religious rule who must remain in one place unless relocated by a superior, e.g., Benedictine order.

nave – The architectural main part of a longitudinal church closest to the main entrance, typically accessible by the laity.

observant – Describes branches of the mendicant or monastic orders especially devoted to strict observance of laws and customs.

operaio, pl. operai – A member of the works committee of the church, typically a layman.

oratory – A place of prayer, especially a private, institutional, or civic chapel.

parish church – A church that acts as the religious center of a parish (a small administrative district).

ponte, pl. ponti – Italian for bridge. In the church context, a large screen typically spanning the width of the nave.

presbytery – Area of a church reserved for the officiating clergy.

pulpit – A raised platform or lectern, often enclosed, used for reading or preaching.

retrochoir – A set of choir stalls behind the high altar, either in the high chapel or in a designated extended space.

rood – A crucifix or cross, typically carved or painted.

rood screen – A screen in the nave associated with a rood.

roodloft – A gallery above a rood screen, normally in the English context.

rotunda – A round architectural space.

sacrament ciborium – A Eucharistic tabernacle.

sacra rappresentazione – Italian for holy representation. A religious play or performance.

sacristy – A room used primarily to store and prepare liturgical items, sometimes equipped with choir stalls used for meetings.

sagra – Italian. Ceremony of church consecration.

schola cantorum – Latin. In the early Christian church, seating disposed in two rows, which formed a rectangular precinct in front of the high altar surrounded by low walls with an entrance toward the nave.

screen – An architectural barrier in a church, normally enclosing the choir precinct.

Signoria – Italian. The government of the medieval and Renaissance Republic of Florence.

spalliera, pl. spalliere – Italian. The back of a chair, stall, bed, etc.

stall-back – The back of a choir stall: the wooden panel that comes into contact with the occupant's back.

tabernacle – A shrine or enclosure, used to house something of religious importance, e.g., an image, relic, etc.

templon – In Byzantine churches, a barrier separating nave and altar.

tramezzo (pl. tramezzi) – Italian. A screen in a church, normally enclosing the choir precinct.

Tridentine – Adjective describing something related to the Council of Trent.

uomini – Italian for men.

upper nave – The bays of the nave closest to the high altar.

ARCHIVAL BIBLIOGRAPHY

ARCHIVO ARCIVESCOVILE DI FIRENZE

Libro de Morti e Ufizi del Monasterio di S. Piero Mag: del 1547 e 1571 segnato B
VP (Visita Pastorale), vol. 03.1
VP (Visita Pastorale), vol. 09.1
VP (Visita Pastorale), vol. 12

ARCHIVIO PARROCCHIALE DI SAN NICCOLÒ OLTRARNO, FLORENCE

Tanci, Leonardo. Memoriae della chiesa di San Niccolò Oltrarno in Firenze

ARCHIVIO DI STATO DI FIRENZE (ASF)

Capitani di Orsanmichele, vol. 31 bis
Capitani di Orsanmichele, vol. 32
Capitani di Orsanmichele, vol. 33
Capitani di Orsanmichele, vol. 35
Capitani di Orsanmichele, vol. 41
Capitani di Orsanmichele, vol. 56
Capitani di Orsanmichele, vol. 78
Capitani di Orsanmichele, vol. 79
Capitani di Orsanmichele, vol. 346
Capitani di Orsanmichele, vol. 350
Carte Strozziane, Serie Prima, vol. 22
Carte Strozziane, Terza Serie, vol. 9 bis
Diplomatico, Normali, Torrigiani (dono), 01 July 1411
Diplomatico, Normali, Firenze, Santa Maria del Carmine, 27 September 1568 (pergamene)
Diplomatico, Normali, Firenze, Santa Maria del Carmine, 26 October 1568 (pergamene)
Manoscritti 128
Mediceo del Principato, vol. 5927a
Notarile Antecosimiano, vol. 6088 (Giovanni Dieciaiuti)
Notarile Antecosimiano, vol. 7399 (Filippo di Cristofano)
Notarile Antecosimiano, vol. 7520 (Alamanno di Bernardo Filiromoli)
Notarile Antecosimiano, vol. 7898 (Francesco di Cristoforo da Valsivignione)
Notarile Antecosimiano, vol. 13558 (Biagio Mazzochi)
Notarile Antecosimiano, vol. 14899 (Bartolomeo Nelli)
Notarile Antecosimiano, vol. 15112 (Niccolò di Diedi)
Notarile Antecosimiano, vol. 21155 (Viva Piero)
San Pier Maggiore, vol. 38
San Pier Maggiore, vol. 39

San Pier Maggiore, vol. 42
San Pier Maggiore, vol. 44
San Pier Maggiore, vol. 54
San Pier Maggiore, vol. 55
San Pier Maggiore, vol. 62
San Pier Maggiore, vol. 65
San Pier Maggiore, vol. 66
San Pier Maggiore, vol. 95
San Pier Maggiore, vol. 131
San Pier Maggiore, vol. 229

No. 113, Santa Maria del Carmine, vol. 87
No. 113, Santa Maria del Carmine, vol. 106
No. 113, Santa Maria del Carmine, vol. 193
No. 260, Vallombrosa, vol. 26
No. 260, Vallombrosa, vol. 143
No. 260, Vallombrosa, vol. 145
No. 260, Vallombrosa, vol. 182
No. 260, Vallombrosa, vol. 191

ASF, CORPORAZIONI RELIGIOSE SOPPRESSE DAL GOVERNO FRANCESE

No. 79, Sant'Ambrogio, vol. 121
No. 88, San Pancrazio, vol. 1
No. 88, San Pancrazio, vol. 2
No. 88, San Pancrazio, vol. 6
No. 88, San Pancrazio, vol. 31
No. 88, San Pancrazio, vol. 53
No. 88, San Pancrazio, vol. 57
No. 88, San Pancrazio, vol. 63
No. 88, San Pancrazio, vol. 65
No. 88, San Pancrazio, vol. 68
No. 88, San Pancrazio, vol. 70
No. 89, Santa Trinita, vol. 46
No. 89, Santa Trinita, vol. 50
No. 89, Santa Trinita, vol. 51
No. 89, Santa Trinita, vol. 52
No. 89, Santa Trinita, vol. 75
No. 89, Santa Trinita, vol. 76
No. 89, Santa Trinita, vol. 135
No. 91, Ognissanti, vol. 14
No. 113, Santa Maria del Carmine, Diplomatico, Normali
No. 113, Santa Maria del Carmine, vol. 7
No. 113, Santa Maria del Carmine, vol. 9
No. 113, Santa Maria del Carmine, vol. 13
No. 113, Santa Maria del Carmine, vol. 16
No. 113, Santa Maria del Carmine, vol. 17
No. 113, Santa Maria del Carmine, vol. 19
No. 113, Santa Maria del Carmine, vol. 23
No. 113, Santa Maria del Carmine, vol. 33
No. 113, Santa Maria del Carmine, vol. 82
No. 113, Santa Maria del Carmine, vol. 85
No. 113, Santa Maria del Carmine, vol. 86

ARCHIVIO STORICO PROVINCIA SAN FRANCESCO STIMMATIZZATO, FLORENCE

S. Salvadore detta d'Ognissanti. Sepoltuario della Chiesa di 1772, Firenze S. Salvatore Ognissanti, vol. 221

BIBLIOTECA MEDICEA LAURENZIANA (BML)

Codice San Marco, vol. 370

BIBLIOTECA NAZIONALE CENTRALE DI FIRENZE (BNCF)

Classe XXV, vol. 398
Conventi soppressi, A. VIII. 1399
Fondo nazionale, II, I, 125
Fondo nazionale, II, I, 126
Magliabechi, XXXVII, n.325
Magliabechiano II. IV. 19
Non acquisti, 987

MISCELLANEOUS

Baltimore, Walters Art Museum, MS W.153
Brescia, Archivio di Stato di Brescia, ASC, vol. 500
Brescia, Archivio di Stato di Brescia, ASC, vol. 495
Florence, Archivio di Santa Croce, vol. 429

BIBLIOGRAPHY

Acidini Luchinat, Cristina. "L'altar maggiore." In *La chiesa e il convento di Santo Spirito a Firenze*, edited by Cristina Acidini Luchinat and Elena Capretti, 337–56. Florence, 1996.

Ackerman, James S. "The Gesù in the Light of Contemporary Church Design." In *Baroque Art: The Jesuit Contribution*, edited by Rudolf Wittkower and Irma B. Jaffe, 15–28. New York, 1972.

"Observations on Renaissance Church Planning in Venice and Florence, 1470–1570." In *Florence and Venice: Comparisons and Relations*, edited by Sergio Bertelli, Nicolai Rubinstein, and Craig Hugh Smyth, 287–307. Florence, 1980.

"Pellegrino Tibaldi, San Carlo Borromeo e l'architettura ecclesiastica del loro tempo." In *San Carlo e il suo tempo: atti del Convegno Internazionale nel IV centenario della morte (Milano, 21–26 maggio 1984)*, 574–86. Rome, 1986.

Adriani, Giovanni Battista. *Oratio Ioannisbaptistae Adrianij habita in funere Cosmi Medicis Magni Etruriae Ducis*. Florence, 1574.

Agnelli, Francesco Antonio. *The Excellences of the Congregation of the Oratory of St Philip Neri*. Translated by Frederick Ignatius Antrobus. London, 1881.

Aiazzi, Giuseppe. *Narrazioni istoriche delle più considerevoli inondazioni dell'Arno e notizie scientifiche sul medesimo*. Florence, 1845. Reprinted 1996.

Alban, Kevin. ed. *We Sing a Hymn of Glory to the Lord: Preparing to Celebrate Seven Hundred Years of Sibert de Beka's Ordinal 1312–2012: Proceedings of the Carmelite Liturgical Seminar, Rome, 6–8 July 2009*. Rome, 2010.

Albèri, Eugenio. *Relazioni degli ambasciatori veneti al Senato; raccolte, annotate, ed edite da Eugenio Albèri, a spese di una società*. Florence, 1839–63.

Alberigo, Giuseppe. "Altoviti, Antonio." In *Dizionario biografico degli Italiani*, edited by Mario Caravale, Vol. 2, 572–73. Rome, 1960.

Alberti, Leon Battista. *Ten Books on Architecture*. Translated by Cosimo Bartoli and James Leoni. Edited by Joseph Rykwert. London, 1955.

Albertini, Francesco. *Memorial of Many Statues and Paintings in the Illustrious City of Florence (1510)*. Translated by Waldemar H. de Boer. Florence, 2010.

Alexander, John. *From Renaissance to Counter-Reformation: The Architectural Patronage of Carlo Borromeo during the Reign of Pius IV*. Milan, 2007.

Alidori Battaglia, Laura, and Marco Battaglia. "Il ritrovato Messale di San Pier Maggiore ed una proposta per la datazione dell'intervento del Maestro Daddesco nel Graduale Santorale della Badia a Settimo." *Arte Cristiana* 106, no. 907 (2018): 300–07.

Allen, Joanne. "Choir Stalls in Venice and Northern Italy: Furniture, Ritual and Space in the Renaissance Church Interior." PhD thesis, University of Warwick, 2010.

"Carthusian Choir Stalls and the Misericord in Italy." *The Antiquaries Journal* 92 (2012): 307–30.

"Giovanni Bellini's *Baptism of Christ* in Its Visual and Devotional Context: Transforming Sacred Space in Santa Corona in Vicenza." *Renaissance Studies* 27, no. 5 (2013): 681–704.

"Innovation or Afterthought? Dating the San Giobbe Retrochoir." In *Art, Architecture and Identity in Venice and Its Territories 1450–1750*, edited by Nebahat Avcıoğlu and Emma Jones, 171–81. Farnham, 2013.

"Nicholas V's Tribuna for Old St. Peter's in Rome as a Model for the New Apsidal Choir at Padua Cathedral." *Journal of the Society of Architectural Historians* 72, no. 2 (2013): 166–89.

"The San Zaccaria Choir in Context." In *La chiesa e il monastero di San Zaccaria, Chiese di Venezia: nuove prospettive di ricerca*, edited by Bernard Aikema, Massimo Mancini, and Paola Modesti, 151–74. Venice, 2016.

"Exhibition Review: 'Sacred Drama: Performing the Bible in Renaissance Florence, Museum of the Bible'." *Renaissance Studies* 33, no. 3 (2018): 502–09.

Alonso, Alicia, Rafael Suárez, and Juan J. Sendra. "The Acoustics of the Choir in Spanish Cathedrals." *Acoustics* 1 (2018): 35–46.

Amati, Antonietta. "Cosimo I e i frati di S. Marco." *Archivio Storico Italiano* 81, no. 307/308 (1923): 227–77.

Amici di San Giacomo di Savona ODV. "Storia del San Giacomo di Savona." http://amicidelsangiacomo .org/ilsangiacomo/storiadelsangiacomo/.

Amonaci, Anna Maria. *Conventi toscani dell'osservanza francescana*. Milan, 1997.

Andreini, Alessandro, Cristina Cerrato, and Giuliano Feola. "I cicli costruttivi della chiesa e del convento di S. Francesco dal XIII al XV secolo: analisi storico-architettonica." In *S. Francesco: la chiesa e il convento in Pistoia*, edited by Lucia Gai and Alessandro Andreini, 47–68. Ospedaletto, 1993.

Andrews, Frances. *The Other Friars: The Carmelite, Augustinian, Sack and Pied Friars in the Middle Ages*. Woodbridge, 2006.

"The Angel of the Annunciation." National Gallery of Art. www.nga.gov/collection/art-object-page.1472 .html#provenance.

Angèli, Pietro. *Oratione funerale di m. Pietro Angelio da Barga: fatta nelle essequie del sereniss. Cosimo de Medici gran duca di Toscana, recitata nel Duomo di Pisa il di xiiij. giugno MDLXXIIII / e tradotta in lingua fiorentina*. Florence, 1574.

Antoninus of Florence, St. *Summa Theologica*. Nuremberg, 1486.

Aquino, Lucia, and Grazia Badino. "Due legnaioli e un pittore per San Michele Arcangelo a Passignano nel Cinquecento: Bastiano Confetto, Michele Tosini e L'Atticciato." In *Passignano in Val di Pesa: un monastero e la sua storia. 2, Arte nella Chiesa di San Michele Arcangelo (sec. XV–XIX)*, edited by Italo Moretti, Vol. 2, 115–35. Florence, 2014.

Armstrong, Lilian. "Benedetto Bordon and the Illumination of Venetian Choirbooks around 1500: Patronage, Production, Competition." In *Wege zum illuminierten Buch: Herstellungsbedingungen für Buchmalerei in Mittelalter und früher Neuzeit*, edited by Christine Beier and Evelyn Theresia Kubina, 221–44. Vienna, 2014.

Aronow, Gail Schwarz. "A Documentary History of the Pavement Decoration in Siena Cathedral, 1362 through 1506." PhD thesis, Columbia University, 1985.

Aston, Elizabeth. "Segregation in Church." In *Women in the Church: Papers Read at the 1989 Summer Meeting and the 1990 Winter Meeting of the Ecclesiastical History Society*, edited by W. J. Sheils and Diana Wood, 237–94. Cambridge, MA, 1990.

"Cross and Crucifix in the English Reformation." In *Macht und Ohnmacht der Bilder: reformatorischer Bildersturm im Kontext der europäischen Geschichte*, edited by Peter Blickle, André Holenstein, Heinrich Richard Schmidt, and Franz-Josef Sladeczek, 253–72. Munich, 2002.

Augusti, Adriana. "Una proposta per Andrea Verrocchio." In *Studi per Pietro Zampetti*, edited by Ranieri Varese, 211–13. Ancona, 1993.

Bacchi, Giuseppe. "La compagnia di Santa Maria delle Laudi e di Sant'Agnese nel Carmine di Firenze." *Rivista storica carmelitana* 2 (1930): 137–51.

"La compagnia di Santa Maria delle Laudi e di Sant'Agnese nel Carmine di Firenze." *Rivista storica carmelitana* 2 (1931): 12–39, 97–122.

Bacci, Michele. *Lo spazio dell'anima: Vita di una chiesa medievale*. Rome, 2005.

Badino, Grazia. "Le disposizioni testamentarie di Bernardo di Castello Quaratesi e le opere di Gentile da Fabriano nella chiesa fiorentina di San Niccolò Oltrarno." In *Gentile da Fabriano "Magister Magistrorum": atti delle giornate di studio, Fabriano 28–30 giugno 2005: XXVI Congresso internazionale di Studi Umanis*, edited by Cecilia Prete, 55–62. Sassoferrato, 2006.

"San Niccolò Oltrarno 1420 circa: note sulla chiesa dei Quaratesi e di Gentile." In *Il Gentile risorto: Il "Polittico dell'Intercessione" di Gentile da Fabriano*, edited by Marco Ciatti, Cecilia Frosinini, and Roberto Bellucci, 45–54. Studi e restauro. Florence, 2006.

Bagatin, Pier Luigi. *La tarsia rinascimentale a Ferrara: il coro di Sant'Andrea*. Florence, 1991.

Bagemihl, Rolf. "Francesco Botticini's Palmieri Altar-Piece." *The Burlington Magazine* 138, no. 1118 (1996): 308–14.

Bagnoli, Martina. "Cenni di Francesco, Antifonario-Graduale W.153." In *L'eredità di Giotto: Arte a Firenze 1340–1375*, edited by Angelo Tartuferi, 232. Florence, 2008.

Baldini, Baccio. *Orazione fatta nell'Accademia Fiorentina in lode del Sereniss. S. Cosimo Medici Gran Duca di Toscana, Gloriosa Memoria, da M. Baccio Baldini suo protomedico.* Florence, 1578.

Baldisseri, Lorenzo. *La nunziatura in Toscana: le origini, l'organizzazione e l'attività dei primi due nunzi Giovanni Campeggi e Giorgio Cornaro.* Vatican City, 1977.

Bandini, Fabrizio, Giancarlo Lanterna, Anna Mazzinghi et al. "Il restauro del Sant'Agostino di Botticelli nella chiesa di Ognissanti e le relative indagini diagnostiche." *OPD Restauro*, 26 (2014): 15–34.

Bandini, Maria. "Vestigia dell'antico tramezzo nella chiesa di San Remigio a Firenze." *Mitteilungen des Kunsthistorischen Institutes in Florenz* 54, no. 2 (2010–12): 211–30.

Bangert, William V. *A History of the Society of Jesus.* 2nd ed. St Louis, MO, 1986.

Bangs, Jeremy Dupertuis. *Church Art and Architecture in the Low Countries before 1566.* Kirksville, MO, 1997.

Barbiche, Bernard. "Leo XI." In *The Papacy: An Encyclopedia*, edited by Philippe Levillain, Vol. 2, 929. New York and London, 2002.

Barbieri, Costanza, Sofia Barchiesi, and Daniele Ferrara. *Santa Maria in Vallicella: Chiesa Nuova.* Rome, 1995.

Barclay Lloyd, Joan. "Medieval Dominican Architecture at Santa Sabina in Rome, c. 1219–c. 1320." *Papers of the British School at Rome* 72 (2004): 231–92.

Barocchi, Paola. "Il Vasari architetto." *Atti della Accademia Pontaniana* 6, new series (1956–57): 113–36.

Barr, Cyrilla. "Music and Spectacle in Confraternity Drama of Fifteenth-Century Florence: The Reconstruction of a Theatrical Event." In *Christianity and the Renaissance: Image and Religious Imagination in the Quattrocento*, edited by Timothy Verdon and John Henderson, 376–404. Syracuse, NY, 1990.

Bartoli, Maria Teresa. "Designing Orsanmichele: The Rediscovered Rule." In *Orsanmichele and the History and Preservation of the Civic Monument*, edited by Carl Brandon Strehlke, 35–52. New Haven, CT, 2012.

Barzman, Karen-edis. *The Florentine Academy and the Early Modern State: The Discipline of Disegno.* Cambridge and New York, 2000.

Baseggio Omiccioli, Eveline. "Andrea Riccio's Reliefs for the Altar of the True Cross in Santa Maria dei Servi, Venice: A Political Statement within the Sacred Walls." *Explorations in Renaissance Culture* 38, no. 1–2 (2012): 101–21.

Basso, Laura, and Carlotta Beccaria. "La Madonna dell'Umiltà con sei angeli e i santi Anna, Angelo da Licata e Alberto da Trapani (Madonna Trivulzio)." *Kermes* 5, no. 87 (2012): 50–56.

Basso, Laura, and Mauro Natale. eds. *La Pinacoteca del Castello Sforzesco a Milano.* Milan, 2005.

Batazzi, Ferdinando, and Annamaria Giusti. *Ognissanti.* Rome, 1992.

Battaglia, Salvatore, and Giorgio Bàrberi Squarotti. *Grande dizionario della lingua italiana.* Turin, 1961–2002.

Becchis, Michela. "Giovanni dal Ponte." In *Dizionario biografico degli Italiani*, edited by Mario Caravale, Vol. 56, 182–85. Rome, 2001.

Belli, Gianluca. "Vasari, Ammannati, Borghini, e l"età dell'oro' cosimiana." In *Ammannati e Vasari per la città dei Medici*, edited by Cristina Acidini Luchinat and Giacomo Pirazzoli, 116–24. Florence, 2011.

Bellosi, Luciano. *Cimabue.* Edited by Giovanna Ragionieri. Milan, 1998.

"The Function of the Rucellai Madonna in the Church of Santa Maria Novella." *Studies in the History of Art* 61, no. Symposium Papers XXXVIII: Italian Panel Painting of the Duecento and Trecento (2002): 146–59.

Benati, Daniele. *La bottega degli Erri e la pittura del Rinascimento a Modena.* Modena, 1988.

Bent, George. "Santa Maria degli Angeli and the Arts: Patronage, Production and Practice in a Trecento Florentine Monastery." PhD thesis, Stanford University, 1993.

Benzoni, Gino. "Francesco I de' Medici, granduca di Firenze." In *Dizionario biografico degli Italiani*, edited by Mario Caravale, Vol. 49, 797–804. Rome, 1997.

Bernardi, Marziano. *Tre abbazie del Piemonte.* Turin, 1962.

Bernstein, Jane A. "Bindo Altoviti and Music." In *Raphael, Cellini, and a Renaissance Banker: The Patronage of Bindo Altoviti*, edited by Alan Chong, Donatella Pegazzano, and Dimitrios Zikos, 207–12. Boston, 2003.

Bertani, Licia. "Dallo spendore 'antiquo' dell'età di Cosimo il Vecchio e di Lorenzo il Magnifico al rigorismo della repubblica piagnona: capolavori artistici per le chiese di San Salvatore tra due stagioni dell'Umanesimo." In *San Salvatore al Monte: "Antiquæ elegantiæ" per un "acropolis" laurenziana*, edited by Giampaolo Trotta, 43–63. Florence, 1997.

Bertoncini Sabatini, Paolo. "La vicenda architettonica della chiesa di Santa Trinita." In *Alla riscoperta delle chiese di Firenze: 6. Santa Trinita*, edited by Timothy Verdon, 39–73. Florence, 2009.

"I primi due secoli: dal 'tabernacolo di via' alla basilica tardo gotica." In *La Basilica della Santissima*

Annunziata: dal duecento al cinquecento, edited by Carlo Sisi, 27–41. Florence, 2013.

Betti, Benedetto. *Orazione funerale di Benedetto Betti: da lui publicamente recitata nelle esequie del sereniss. Cosimo Medici gran duca di Toscana: celebrate il dì 13. de giugno 1574. nella Compagnia di S. Giouanni Vangelista: con la descrizione dell'apparato messa nel fine.* Florence, 1574.

Bietti Favi, Monica. "Gaddo Gaddi: un'ipotesi." *Arte Cristiana* 71, no. 694 (1983): 49–52.

———. "La Pittura nella Chiesa di San Marco." In *La chiesa e il convento di San Marco a Firenze*, Vol. 2, 213–46. Florence, 1989.

———. "Indizi documentari su Lippo di Benivieni." *Studi di storia dell'arte* 1 (1990): 243–52.

———. "Dal Savonarola al pontificato di Leone X: artisti e patroni in San Pier Maggiore a Firenze." In *Nello splendore mediceo: Papa Leone X e Firenze*, edited by Nicoletta Baldini and Monica Bietti Favi, 127–37. Florence, 2013.

Biliotti, Modesto. "Venerabilis Coenobii: Sanctae Mariae Novellae de Florentia: Chronica." *Analecta Sacri Ordinis Fratrum Praedicatorum* 9 (1909): 125–28, 97–200.

Billi, Antonio, and Fabio Benedettucci. *Il libro di Antonio Billi.* Anzio, 1991.

Bireley, Robert. "Redefining Catholicism: Trent and Beyond." In *The Cambridge History of Christianity: Reform and Expansion 1500–1660*, edited by R. Po-Chia Hsia, Vol. 6, 143–61. Cambridge, 2007.

Bisson, Massimo. "Controriforma e spazio liturgico: i cori della Basilica di Santa Giustina di Padova." *Atti dell'Istituto Veneto di Scienze, Lettere ed Arti* 172 (2013–14): 441–518.

———. "San Giorgio Maggiore a Venezia: la chiesa tardo-medievale e il coro del 1550." *AFAT: Arte in Friuli Arte a Trieste* 33 (2014): 11–38.

Blake McHam, Sarah. "Visualizing the Immaculate Conception: Donatello, Francesco delle Rovere, and the High Altar and Choir Screen at the Church of the Santo in Padua." *Renaissance Quarterly* 69, no. 3 (2016): 831–64.

Boccaccio, Giovanni. *Decameron.* Translated by J. G. Nichols. New York, 2009.

Boccalatte, Paola Elena. *Fabbri e ferri: Italia, XII–XVI secolo.* BAR International Series. Oxford, 2013.

Bocchi, Francesco. *The Beauties of the City of Florence: A Guidebook of 1591.* Translated by Thomas Frangenberg and Robert Williams. London, 2006.

Bocchi, Francesco, and Giovanni Cinelli. *Le bellezze della città di Fiorenza.* Florence, 1677.

Bond, Frederick Bligh, and Bede Camm. *Roodscreens and Roodlofts.* London, 1909.

Bonniwell, William R. *A History of the Dominican Liturgy 1215–1945.* 2nd ed. New York, 1945.

Booth, Cecily. *Cosimo I Duke of Florence.* Cambridge, 1921.

Borden, Iain, Barbara Penner, and Jane Rendell. *Gender Space Architecture: An Interdisciplinary Introduction.* London, 1999.

Borghero, Francesco. "Il Polittico di Santa Reparata di Bernardo Daddi: Fonti notarili inedite sulla committenza e la datazione dell'opera." *Mitteilungen des Kunsthistorischen Institutes in Florenz* 61, no. 2 (2019): 265–71.

Borghini, Vincenzo, and Domenico Maria Manni. *Discorsi di monsignore D. Vincenzio Borghini: con annotazioni.* Florence, 1755.

Borghini, Vincenzo, and Silvano Razzi. *La descrizione della pompa e dell'apparato fatto in Firenze nel battesimo del serenissimo principe di Toscana.* Florence, 1577.

Bori, Mario. "'L'Annunziazione' di Piero del Donzello in una cappella Frescobaldi nella chiesa di Santo Spirito." *Rivista d'Arte* 4 (1906): 117–23.

Borromeo, Federico, Kenneth S. Rothwell, and Pamela M. Jones. *Sacred Painting; Museum.* Cambridge, MA, 2010.

Borsook, Eve. "Art and Politics at the Medici Court I: The Funeral of Cosimo I de' Medici." *Mitteilungen des Kunsthistorisches Institut in Florenz* 12, no. 1/2 (1965): 31–54.

———. "Art and Politics at the Medici Court II: The Baptism of Filippo de' Medici in 1577." *Mitteilungen des Kunsthistorischen Institutes in Florenz* 13, no. 1/2 (1967): 95–114.

———. "Cults and Imagery at Sant'Ambrogio in Florence." *Mitteilungen des Kunsthistorischen Institutes in Florenz* 25, no. 2 (1981): 147–202.

Borsook, Eve, and Johannes Offerhaus. *Francesco Sassetti and Ghirlandaio at Santa Trinita: History and Legend in a Renaissance Chapel.* Doornspijk, 1981.

Boskovits, Miklós. "Fra Filippo Lippi, i Carmelitani e il Rinascimento." *Arte Cristiana* 74, no. 715 (1986): 235–52.

———. "Maestà monumentali su tavola tra XIII e XIV secolo: funzione e posizione nello spazio sacro." *Arte cristiana* 99, no. 862 (2011): 13–30.

Boskovits, Miklós, and Klara Steinweg. *A Critical and Historical Corpus of Florentine Painting*, Section 3, Vol. 9. Florence, 1984.

Botto, Carlo. "Note e documenti sulla chiesa di S. Trinita in Firenze." *Rivista d'Arte* 20, no. 1 (1938): 1–22.

Boyce, James. *Praising God in Carmel: Studies in Carmelite Liturgy.* Washington, DC, 1999.

———. "The Office of St Anne in the Carmelite Liturgy." *Carmelus* 52 (2005): 165–84.

Brackett, John K. "The Florentine Onestà and the Control of Prostitution, 1403–1680." *The Sixteenth Century Journal* 24, no. 2 (1993): 273–300.

Brocchi, Giuseppe Maria. *Vite de' santi e beati fiorentini.* Florence, 2000.

Brook, Anthea, Dimitrios Zikos, and Jennifer Montagu. *Ferdinando Tacca's High Altar for Santo Stefano al Ponte and Its Bronze Adornments: A Commission by Anton Maria, Giovanni Battista, and Girolamo Bartolommei.* Florence, 2017.

Brown, Alison. *The Renaissance.* 2nd ed. New York, 1999.

Brown, Beverly Louise. "The Tribuna of SS. Annunziata in Florence." PhD thesis, Northwestern University, 1978.

——. "The Patronage and Building History of the Tribuna of SS. Annunziata in Florence." *Mitteilungen des Kunsthistorischen Institutes in Florenz* 25 (1981): 59–146.

——. "Choir and Altar Placement: A Quattrocento Dilemma." *Machiavelli Studies* 5 (1996): 147–80.

Brown, Patricia Fortini. *Venetian Narrative Painting in the Age of Carpaccio.* New Haven, CT, 1988.

Brucker, Gene. *The Civic World of Early Renaissance Florence.* Princeton, NJ, 1977.

Bruschi, Arnaldo. *Filippo Brunelleschi.* Milan, 2006.

Bruzelius, Caroline. "Hearing Is Believing: Clarissan Architecture, ca. 1213–1340." *Gesta* 31, no. 2 (1992): 83–91.

——. *Preaching, Building, and Burying: Friars and the Medieval City.* New Haven, CT and London, 2014.

——. "The Tramezzo of Sta. Chiara: Hypotheses and Proposals." In *Ingenita Curiositas: studi sull'Italia medievale per Giovanni Vitolo,* edited by Bruno Figliuolo, Rosalba Di Meglio, and Antonella Ambrosio, Vol. 2, 951–64. Battipaglia, 2018.

——. "Introduction." In *Spaces for Friars and Nuns,* edited by Haude Morvan, forthcoming.

Budwey, Stephanie. *Sing of Mary: Giving Voice to Marian Theology and Devotion.* Collegeville, MN, 2014.

Bulgarelli, Massimo. "La sagrestia di Santa Trinita a Firenze: architettura, memoria, rappresentazione." *Quaderni dell'Istituto di Storia dell'Architettura / Università degli Studi di Roma La Sapienza, Dipartimento di Storia dell'Architettura, Restauro e Conservazione dei Beni Architettonici* 57/59, 2011/12 (2013): 25–36.

Bullarum Diplomatum et Privilegiorum Sanctorum Romanorum Pontificum Taurinensis Editio. Edited by Luigi Tomassetti, Charles Cocquelines, Francesco Gaude, and Luigi Bilio, Vol. 7. Turin, 1862.

Buoninsegni, Tommaso. *Descrizione della traslazione del corpo del Santo Antonino Arcivescovo di Firenze. Fatta nella chiesa di San Marco l'anno MDLXXXIX. Composta dal Reverendo P. Teologo, Maestro Tommaso Buoninsegni O.P.* Florence, 1589.

Burke, Jill. *Changing Patrons: Social Identity and the Visual Arts in Renaissance Florence.* University Park, PA, 2004.

Busignani, Alberto, and Raffaeollo Bencini. *Le chiese di Firenze. Quartiere di Santo Spirito.* Florence, 1974.

Butters, Suzanne B. *The Triumph of Vulcan: Sculptors' Tools, Porphyry, and the Prince in Ducal Florence.* Florence, 1996.

——. "The Duomo Perceived and the Duomo Remembered: Sixteenth-Century Descriptions of Santa Maria del Fiore." In *Atti del VII centenario del Duomo di Firenze,* edited by Timothy Verdon and Annalisa Innocenti, Vol. 2.2, 457–502. Florence, 2001.

Cadogan, Jean K. *Domenico Ghirlandaio: Artist and Artisan.* New Haven, CT and London, 2000.

Caglioti, Francesco. "Giovanni di Balduccio at Orsanmichele: The Tabernacle of the Virgin before Andrea Orcagna." In *Orsanmichele and the History and Preservation of the Civic Monument,* edited by Carl Brandon Strehlke, 75–110. New Haven, CT, 2012.

Caioli, Paolo. "Un'opera dimenticata di Fra Filippo Lippi." *Il Monte Carmelo* 25, no. 8 (1939): 230–32.

Calzolai, Carlo Celso. *San Michele Visdomini.* Florence, 1977.

Campigli, Marco. "Il Cinquecento, fino a Vasari: pittura e scultura." In *Santa Maria Novella: La basilica e il convento,* edited by Andrea De Marchi, Vol. 2, 239–61. Florence, 2015.

Canali, Ferruccio. "La basilica di Santa Trinita (e la chiesa di Santo Stefano al Ponte, 'a pendant') a Firenze: Il 'problema' delle 'aggiunte' ('superfetazioni' e 'super-edificazioni') di Bernardo Buontalenti e del barocco durante il ripristino neomedievale (1884–1905)." *Bollettino della Società di studi fiorentini* 23 (2014): 172–204.

Cannon Brookes, Peter. "Three Notes on Maso da San Friano." *The Burlington Magazine* 107, no. 745 (1965): 192–97.

Cannon, Joanna. "Pietro Lorenzetti and the History of the Carmelite Order." *Journal of the Warburg and Courtauld Institutes* 50 (1987): 18–28.

——. "The Era of the Great Painted Crucifix: Giotto, Cimabue, Giunta Pisano, and their Anonymous Contemporaries." *Renaissance Studies* 16, no. 4 (2002): 571–81.

——. "Dominican Shrines and Urban Pilgrimage in Later Medieval Italy." In *Architecture and Pilgrimage, 1000–1500: Southern Europe and Beyond,* edited by Paul Davies, Deborah Howard, and Wendy Pullan, 143–63. Farnham, 2013.

——. *Religious Poverty, Visual Riches: Art in the Dominican Churches of Central Italy in the Thirteenth and Fourteenth Centuries.* New Haven, CT, 2013.

Canosa, Romano, and Isabella Colonnello. *Storia della prostituzione in Italia: dal Quattrocento alla fine del Settecento.* Rome, 1989.

Cantagalli, Roberto. *Cosimo I de' Medici granduca di Toscana.* Milan, 1985.

Cantatore, Flavia. *San Pietro in Montorio: la chiesa dei re cattolici a Roma.* Rome, 2007.

Cantini, Lorenzo. *Vita di Cosimo de' Medici primo, Gran-Duca di Toscana.* Florence, 1805.

Caperna, Maurizio. "San Carlo Borromeo, cardinale di S. Prassede, e il rinnovamento della sua chiesa titolare a Roma." *Palladio: rivista di storia dell'architettura e restauro* 12 (1993): 43–58.

Cappelli, Adriano. *Dizionario di abbreviature latine ed italiane.* Milan, 1949.

——— *Cronologia, cronografia e calendario perpetuo.* Milan, 1952.

Capretti, Elena. "Vasari, Ammannati e la Controriforma." In *Ammannati e Vasari per la città dei Medici,* edited by Cristina Acidini Luchinat and Giacomo Pirazzoli, 125–37. Florence, 2011.

Carbonai, Franco, and Mario Salmi. "La chiesa di S. Marco e il chiostro di S. Domenico." In *La chiesa e il convento di San Marco a Firenze,* 259–302. Florence, 1989.

Cardellini, Ida. *Desiderio da Settignano.* Milan, 1962.

Carl, Doris. "Il Ciborio di Benedetto da Maiano nella cappella maggiore di S. Domenico a Siena: Un contributo al problema dei cibori quattrocenteschi con un excursus per la storia architettonica della chiesa." *Rivista d'Arte* 42 (4th series, Vol. 6) (1990): 3–74.

——— "Verloren und Wiedererfunden: Desiderio da Settignano, die Ximenes und das Ziborium der National Gallery in Washington." *Mitteilungen des Kunsthistorischen Institutes in Florenz* 56 (2014): 285–323.

Carli, Enzo. *Il Duomo di Siena.* Genoa, 1979.

Carrara, Francesca. *L'Abbazia di Vallombrosa.* Florence, 2015.

Casalini, Eugenio M. *Michelozzo di Bartolommeo e l'Annunziata di Firenze.* Florence, 1995.

——— *Registro di entrata e uscita di Santa Maria di Cafaggio (REU), 1286–1290.* Florence, 1998.

Cassarino, Enrica. *La Cappella Sassetti nella Chiesa di Santa Trinita.* Lucca, 1996.

Cassidy, Brendan. "The Financing of the Tabernacle of Orsanmichele." *Source: Notes in the History of Art* 8, no. 1 (1988): 1–6.

——— "A Relic, Some Pictures and the Mothers of Florence in the Late Fourteenth Century." *Gesta* 30, no. 2 (1991): 91–99.

——— "Orcagna's Tabernacle in Florence: Design and Function." *Zeitschrift für Kunstgeschichte* 55, no. 2 (1992): 180–211.

Casu, Stefano G. "Bernardo Daddi." In *La fortuna dei primitivi: tesori d'arte dalle collezioni italiane fra sette e ottocento,* edited by Angelo Tartuferi and Gianluca Tormen, 320–25. Florence, 2014.

Catitti, Silvia. "Balaustro e balaustrata tra metà Quattrocento e primo Cinquecento." *Quaderni dell'Istituto di Storia dell'Architettura / Università degli Studi di Roma La Sapienza, Dipartimento di Storia dell'Architettura, Restauro e Conservazione dei Beni Architettonici.* New series 60/62 (2013/14): 21–32.

Cattaneo, Enrico. "Il primo concilio provinciale milanese (a. 1565)." In *Il Concilio di Trento e la riforma tridentina. Atti del Convegno storico internazionale, Trento, 2–6 settembre 1963,* 215–75. Rome, 1965.

Cattin, Giulio, and Anna Vildera. eds. *Il "Liber Ordinarius" della chiesa padovana* Vol. 27, Fonti e ricerche di storia ecclesiastica padovana. Padua, 2002.

Cecchetti, Catia. *Città di Castello: la porta dell'Umbria.* Città di Castello, 2014.

Cecchi, Alessandro. "Gli arredi e i serramenti lignei e in ferro battuto." In *Vallombrosa: santo e meraviglioso luogo,* edited by Roberto Paolo Ciardi, 239–53. Florence, 1999.

——— "Maestri d'intaglio e tarsia." In *Arti fiorentine. La grande storia dell'Artigianato. Il Quattrocento,* edited by Franco Franceschi and Gloria Fossi, Vol. 2, 215–49. Florence, 1999.

——— "Pontormo e Bronzino nel coro di San Lorenzo." In *San Lorenzo: A Florentine Church,* edited by Robert W. Gaston and Louis Alexander Waldman, 525–32. Florence, 2017.

Centi, Tito. "La chiesa e il convento di S. Marco a Firenze." In *La chiesa e il convento di San Marco a Firenze,* Vol. 1, 13–59. Florence, 1989.

Ceriana, Matteo. "Fra Carnevale and the Practice of Architecture." In *From Filippo Lippi to Piero della Francesca: Fra Carnevale and the Making of a Renaissance Master,* edited by Keith Christiansen, 97–136. New York; Milan; New Haven, CT and London, 2005.

——— "Gli spazi e l'ornamento della chiesa camaldolese di San Michele in Isola." In *San Michele in Isola: Isola della conoscenza: ottocento anni di storia e cultura camaldolesi nella laguna di Venezia. Mostra organizzata in occasione del millenario della fondazione della congregazione camaldolese,* edited by Marcello Brusegan, Paolo Eleuteri, and Gianfranco Fiaccadori, 97–109. Turin, 2012.

Chédozeau, Bernard. *Choeur clos, choeur ouvert: De l'église medievale a l'eglise tridentine (France, XVII–XVIII siècle).* Paris, 1998.

"Chiesa di San Vito." www.chiesadisanvito.it/page.php?44.

Chiodi, Alberto Mario. "Bartolomeo degli Erri e i polittici domenicani." *Commentari* 2 (1951): 17–25.

Chiodo, Sonia. "Uno sguardo indietro sul filo dalla memoria: la chiesa degli Umiliati nel età gotica." In *San Salvatore in Ognissanti: la chiesa e il convento*, edited by Riccardo Spinelli, 51–79. Florence, 2018.

Chong, Alan, Donatella Pegazzano, and Dimitrios Zikos. eds. *Raphael, Cellini, and a Renaissance Banker: The Patronage of Bindo Altoviti*. Boston, 2003.

Christiansen, Keith, Laurence B. Kanter, and Carl Brandon Strehlke. *Painting in Renaissance Siena 1420–1500*. New York, 1989.

Chronica Gestorum in partibus Lombardie et reliquis Italie (Diarium parmense). Rerum Italicarum Scriptores. Edited by L. A. Muratori, Città di Castello, 1904.

Ciabani, Roberto, Beatrix Elliker, and Enrico Nistri. *Le famiglie di Firenze*. Florence, 1992.

Ciappelli, Giovanni. *Un santo alla battaglia di Anghiari: La "vita" e il culto di Andrea Corsini nella Firenze del Rinascimento*. Florence, 2007.

Ciardi, Roberto Paolo. "I Vallombrosani e le arti figurative. Qualche traccia e varie ipotesi." In *Vallombrosa: santo e meraviglioso luogo*, edited by Roberto Paolo Ciardi, 27–117. Florence, 1999.

Cinelli, Carlo, and Francesco Vossilla. "Baccio Bandinelli e Giovanni Bandini per il coro della Cattedrale. Note d'archivio." In *Atti del VII centenario del Duomo di Firenze*, edited by Timothy Verdon and Annalisa Innocenti, Vol. 2.1, 325–34. Florence, 2001.

Clearfield, Janis. "The Tomb of Cosimo de' Medici in San Lorenzo." *Rutgers Art Review* 2 (1981): 13–30.

Cobianchi, Roberto. *Lo temperato uso delle cose: la committenza dell'osservanza francescana nell'Italia del Rinascimento*. Spoleto, 2013.

Comanducci, Rita Maria. "'L'altare Nostro de la Trinità': Masaccio's Trinity and the Berti Family." *The Burlington Magazine* 145, no. 1198 (2003): 14–21.

Commentaria Innocentii quarti pont. maximi super libros quinque decretalium. Frankfurt, 1570.

Conforti, Claudia. *Vasari architetto*. Milan, 1993.

Conigliello, Lucilla. *Le vedute del Sacro Monte della Verna: Jacopo Ligozzi pellegrino nei luoghi di Francesco*. Florence, 1999.

Constitutiones et decreta condita in provinciali synodo Mediolanensi. Venice, 1566.

Cooper, Donal. "In Medio Ecclesiae: Screens, Crucifixes and Shrines in the Franciscan Church Interior in Italy, c. 1230–c. 1400." PhD thesis, University of London, 2000.

———. "Franciscan Choir Enclosures and the Function of Double-Sided Altarpieces in Pre-Tridentine Umbria." *Journal of the Warburg and Courtauld Institutes* 64 (2001): 1–54.

———. "Raphael's Altar-Pieces in S. Francesco al Prato, Perugia: Patronage, Setting and Function." *The Burlington Magazine* 143, no. 1182 (2001): 554–61.

———. "'In loco tutissimo et firmissimo': The Tomb of St. Francis in History, Legend and Art." In *Art of the Franciscan Order in Italy*, edited by William R. Cook, 1–37. Leiden and Boston, 2005.

———. "Projecting Presence: The Monumental Cross in the Italian Church Interior." In *Presence: The Inherence of the Prototype within Images and Other Objects*, edited by Robert Maniura and Rupert Shepherd, 47–69. Aldershot, 2006.

———. "Access All Areas? Spatial Divides in the Mendicant Churches of Late Medieval Tuscany." In *Ritual and Space in the Middle Ages: Proceedings of the 2009 Harlaxton Symposium*, edited by Frances Andrews, 90–107. Donington, 2011.

———. "Redefining the Altarpiece in Early Renaissance Italy: Giotto's Stigmatization of St Francis and Its Pisan Context." *Art History* 36, no. 4 (2013): 686–713.

———. "Recovering the Lost Rood Screens of Medieval and Renaissance Italy." In *The Art and Science of the Church Screen in Medieval Europe: Making, Meaning, Preserving*, edited by Spike Bucklow, Richard Marks, and Lucy Wrapson, 220–45. Woodbridge, 2017.

———. "Firenze scomparsa: le chiese di Santa Chiara e San Pier Maggiore e la loro ricostruzione digitale presso i musei di Londra." *Archaeologia e Calcolatori* 10 (2018): 67–80.

———. "Revisiting the Umbrian Retro-Choir: Plurality and Choice in the Medieval Franciscan Church Interior." In *Spaces for Friars and Nuns*, edited by Haude Morvan, forthcoming.

Cooper, Donal, and James R. Banker. "The Church of San Francesco in Borgo San Sepolcro in the Late Middle Ages and Renaissance." In *Sassetta: The Borgo San Sepolcro Altarpiece*, edited by Machtelt Israëls, 53–105. Florence and Leiden, 2009.

Cooper, Donal, and Janet Robson. *The Making of Assisi: The Pope, the Franciscans, and the Painting of the Basilica*. New Haven, CT, 2013.

Cooper, Donal, and Jennifer Sliwka. "In Context: San Pier Maggiore." *Apollo* 182, no. 636 (2015): 76–81.

Cooper, Tracy E. "Locus meditandi e orandi: Architecture, Liturgy and Identity at San Giorgio Maggiore." In *Musica, scienza e idee nella Serenissima durante il Seicento*, edited by Francesco Passadore and Franco Rossi, 79–105. Venice, 1996.

———. *Palladio's Venice: Architecture and Society in a Renaissance Republic*. New Haven, CT, 2005.

Coppi, Enrico. *Cronaca fiorentina, 1537–1555*. Florence, 2000.

Cornelison, Sally J. "Art and Devotion in Late Medieval and Renaissance Florence: The Relics and Reliquaries

of Saints Zenobius and John the Baptist." PhD thesis, University of London, 1999.

"Lorenzo Ghiberti and the Renaissance Reliquary: The *Shrine of the Three Martyrs* from Santa Maria degli Angeli, Florence." In *De Re Metallica: The Uses of Metal in the Middle Ages*, edited by Robert Bork, 163–79. Aldershot and Burlington, VT, 2005.

"Tales of Two Bishop Saints: Zenobius and Antoninus in Florentine Renaissance Art and History." *The Sixteenth Century Journal* 38, no. 3 (2007): 627–56.

"Relocating Fra Bartolomeo at San Marco." *Renaissance Studies* 23, no. 3 (2009): 311–34.

Art and the Relic Cult of St. Antoninus in Renaissance Florence. Farnham and Burlington, VT, 2012.

"Accessing the Holy: Words, Deeds, and the First Tomb of St. Antoninus in Renaissance Florence." In *Mendicant Cultures in the Medieval and Early Modern World: Word, Deed, and Image*, edited by Sally J. Cornelison, Nirit Ben-Aryeh Debby, and Peter F. Howard, 223–44. Turnhout, 2016.

"'Michelangelo's Panel': Content, Context, and Vasari's Buonarroti Altarpiece." *Art History* 42, no. 3 (2019): 416–49.

"Art and Religion in Late Renaissance Arezzo: Reconsidering Vasari's Church Renovations." In *Renaissance Religions: Modes and Meanings in History*, edited by Riccardo Saccenti, Nicholas Terpstra, and Peter Howard, 301–23. Turnhout, 2021.

"Recycling, Renaissance Style: Hybridity and Vasari's Pieve Altarpieces." In *Hybridity in Late Medieval and Early Modern Art*, edited by Ashley Elston and Madeline Rislow. New York and London, forthcoming.

Corpus juris canonici emendatum et notis illustratum. Gregorii XIII. pont. max. iusslu. editum. Rome, 1582.

Cox-Rearick, Janet. "Fra Bartolomeo's St. Mark Evangelist and St. Sebastian with an Angel." *Mitteilungen des Kunsthistorischen Institutes in Florenz* 18, no. 3 (1974): 329–54.

"La Ill.ma Sig.ra Duchessa felice memoria: The Posthumous Eleonora di Toledo." In *The Cultural World of Eleonora di Toledo, Duchess of Florence and Siena*, edited by Konrad Eisenbichler, 225–66. Aldershot and Burlington, VT, 2004.

Cresti, Carlo. "Architettura della Controriforma a Firenze." In *Architetture di altari e spazio ecclesiale: episodi a Firenze, Prato e Ferrara*, edited by Carlo Cresti, 7–73. Florence, 1995.

"Altari fiorentini controriformati: lineamenti di fortuna e sfortuna critica." In *Altari controriformati in Toscana: architettura e arredi*, edited by Carlo Cresti, 9–73. Florence, 1997.

Crum, Roger J. "Donatello's 'Ascension of St. John the Evangelist' and the Old Sacristy as Sepulchre." *Artibus et Historiae* 16, no. 32 (1995): 141–61.

Crum, Roger J., and David G. Wilkins. "In the Defense of Florentine Republicanism: Saint Anne and Florentine Art, 1343–1575." In *Interpreting Cultural Symbols: Saint Anne in Late Medieval Society*, edited by Kathleen M. Ashley and Pamela Sheingorn, 131–68. Athens, GA and London, 1990.

Cunningham, Dawn. "One Pontile, Two Pontili: The Choir Screens of Modena Cathedral." *Renaissance Studies* 19, no. 5 (2005): 673–85.

"Sacrament and Sculpture: Liturgical Influences on the Choir Screen of Modena Cathedral." *Material Religion* 4, no. 1 (2008): 32–53.

Cutini, Matteo. *Oratio funebris Matthaei Cutinij in summa aede ludimagistri de laudibus Antonii Altovitae Archiepiscopi Florentini*. Florence, 1574.

D'Accone, Frank. "Reclaiming the Past: Archbishop Antonio Altoviti's Entrance into Florence in 1567." In *Instruments, Ensembles, and Repertory, 1300–1600: Essays in Honour of Keith Polk*, edited by Timothy J. McGee and Stuart Carter, 237–62. Turnhout, 2013.

D'Addario, Arnaldo. *Aspetti della Controriforma a Firenze*. Rome, 1972.

D'Ovidio, Stefano. "La trasformazione dello spazio liturgico nelle chiese medievali di Napoli durante il XVI secolo: alcuni casi di studio." In *Re-thinking, Re-making, Re-living Christian Origins*, edited by Serena Romano, Ivan Foletti, Gianandrea Manuela, and Elisabetta Scirocco, 93–119. Rome, 2018.

Damiani, Giovanna. "La chiesa quattrocentesca: ipotesi di ricostruzione." In *San Niccolò Oltrarno: la chiesa, una famiglia di antiquari*, edited by Giovanna Damiani and Anna Laghi, Vol. 1, 25–86. Florence, 1982.

Damiani, Giovanna, and Anna Laghi. eds. *San Niccolò Oltrarno: la chiesa, una famiglia di antiquari*. Florence, 1982.

Davies, Jonathan. *Culture and Power: Tuscany and Its Universities 1537–1609*. Leiden, 2009.

Davies, Paul. "The Lighting of Pilgrimage Shrines in Renaissance Italy." *Analecta Romana Instituti Danici. Supplementum* 35 (2004): 57–80.

"Architettura e culto a Venezia e nelle città di terraferma 1475–1490." In *Pietro Barozzi: un vescovo del Rinascimento*, edited by Andrea Nante, Carlo Cavalli, and Pierantonio Gios, 193–203. Padua, 2012.

"Framing the Miraculous: The Devotional Functions of Perspective in Italian Renaissance Tabernacle Design." *Art History* 36, no. 5 (2013): 898–921.

Davies, Paul, and David Hemsoll. "Renaissance Balusters and the Antique." *Architectural History* 26 (1983): 1–23, 117–22.

Michele Sanmicheli. Milan, 2004.

Davis, Charles. "Giorgio Vasari: Descrizione dell'apparato fatto nel Tempio di S. Giovanni di Fiorenza per lo battesimo della Signora prima figliuola dell'Illustrissimo, et Eccellentissimo S. Principe di Fiorenza, et Siena Don Francesco Medici, e della Serenissima Reina Giovanna D'Austria (Florenz 1568)." *Fontes: Quellen und Dokumente zur Kunst 1350–1750* 6 (2008): 1–110.

De Benedictis, Cristina. "Riflessioni sulla Maestà fiorentina di Cimabue." In *Scritti di Storia dell'Arte in onore di Roberto Salvini*, edited by Cristina De Benedictis, 131–34. Florence, 1984.

——. "Devozione-collezione: sulla committenza fiorentina nell'età della Controriforma." In *Altari e committenza: Episodi a Firenze nell'età della Controriforma*, edited by Cristina De Benedictis, 7–18. Florence, 1996.

De Benedictis, Elaine. "The 'Schola Cantorum' in Rome during the High Middle Ages." PhD thesis, Bryn Mawr College, 1983.

De Blaauw, Sible. *Cultus et decor: liturgia e architettura nella Roma tardoantica e medievale: Basilica Salvatoris, Sanctae Mariae, Sancti Petri*. Vatican City, 1994.

——. "Private Tomb and Public Altar: The Origins of the Mausoleum Choir in Rome." In *Memory & Oblivion: Proceedings of the XXIXth International Congress of the History of Art, Held in Amsterdam, 1–7 September 1996*, edited by Adriaan Wessel Reinink and Jeroen Stumpel, 475–82. Dordrecht, 1999.

——. "Innovazioni nello spazio di culto fra basso Medioevo e Cinquecento: La perdita dell'orientamento liturgico e la liberazione della navata." In *Lo spazio e il culto: relazioni tra edificio ecclesiale e uso liturgico dal XV al XVI secolo*, edited by Jörg Stabenow, 25–51. Venice, 2006.

——. "Origins and Early Development of the Choir." In *La place du choeur: architecture et liturgie du Moyen Âge aux Temps modernes: actes du colloque de l'EPHE, Institut national d'histoire de l'art, les 10 et 11 décembre 2007*, edited by Sabine Frommel, Laurent Lecomte, and Raphaël Tassin, 25–32. Paris and Rome, 2012.

De Canistris, Opicinus. *Liber de laudibus civitatis Ticinensis que dicitur Papia*. Edited by Dino Ambaglio. Pavia, 2004.

de Fabriczy, C. "Memorie sulla chiesa di S. Maria Maddalena de' Pazzi a Firenze e sulla Badia di S. Salvatore a Settimo." *L'Arte* 9 (1906): 255–62.

De Luca, Francesca. "La Cappella Salviati e gli altari laterali nella chiesa di San Marco a Firenze." In *Altari e committenza: Episodi a Firenze nell'età della Controriforma*, edited by Cristina De Benedictis, 115–35. Florence, 1996.

De Marchi, Andrea. "Un raggio di luce su Filippo Lippi a Padova." *Nuovi studi* 1, no. 1 (1996): 5–23.

——. "Due fregi misconosciuti e il problema del tramezzo in San Fermo Maggiore a Verona." In *Arredi liturgici e architettura*, edited by Arturo Carlo Quintavalle, 129–42. Milan, 2007.

——. "Il "podiolus" e il "pergolum" di Santa Caterina a Treviso: cronologia e funzione delle pitture murali in rapporto allo sviluppo della fabbrica architettonica." In *Medioevo: arte e storia*, edited by Arturo Carlo Quintavalle, 385–407. Milan, 2008.

——. "'Cum dictum opus sit magnum'. Il documento pistoiese del 1274 e l'allestimento trionfale dei tramezzi in Umbria e Toscana fra Due e Trecento." In *Medioevo: immagine e memoria*, edited by Arturo Carlo Quintavalle, 603–21. Parma, 2009.

——. *La pala d'altare: dal paliotto al polittico gotico*. Florence, 2009.

——. "La diffusione della pittura su tavola nel Duecento e la ricostruzione del tramezzo perduto del Duomo di Pistoia." In *Il museo e la città: vicende artistiche pistoiesi dalla metà del XII secolo alla fine del Duecento*, edited by Fulvio Cervini, Andrea De Marchi, and Guido Tigler, 61–85. Pistoia, 2011.

——. "Relitti di un naufragio: affreschi di Giotto, Taddeo Gaddi e Maso di Banco nelle navate di Santa Croce." In *Santa Croce: oltre le apparenze*, edited by Andrea De Marchi and Giacomo Piraz, 33–71. Pistoia, 2011.

——. "Duccio e Giotto, un abbrivo sconvolgente per la decorazione del tempio domenicano ancora *in fieri*." In *Santa Maria Novella: La basilica e il convento*, edited by Andrea De Marchi, Vol. 1, 125–55. Florence, 2015.

de Witte, Charles-Martial. "Les monastères vallombrosains aux XVe e XVIe siècles: Un 'status quaestionis'." *Benedictina* 17, no. 2 (1970): 234–53.

Debby, Nirit Ben-Aryeh. *The Renaissance Pulpit: Art and Preaching in Tuscany, 1400–1550*. Turnhout, 2007.

——. "The Santa Croce Pulpit in Context: Sermons, Art and Space." *Artibus et Historiae* 29, no. 57 (2008): 75–93.

——. "Preaching, Saints, and Crusade Ideology in the Church of Ognissanti in Florence." In *Mendicant Cultures in the Medieval and Early Modern World: Word, Deed, and Image*, edited by Sally J. Cornelison, Nirit Ben-Aryeh Debby, and Peter Howard, 297–322. Turnhout, 2016.

Decreta Provincialis Synodi Florentinae; praesidente in ea reverendiss. D. Antonio Altovita Metropolitanae Ecclesiae Florentinae Archiepiscopo. Florence, 1574.

Dee, Elaine Evans. *Views of Florence and Tuscany by Giuseppe Zocchi, 1711–1767: Seventy-Seven Drawings from the Collection of the Pierpont Morgan Library, New York*. Meriden, CT, 1968.

Dei, Benedetto. *La Cronica dall'anno 1400 all'anno 1500*. Edited by Roberto Barducci. Florence, 1984.

Del Migliore, Ferdinando Leopoldo. *Firenze città nobilissima illustrata*. Florence, 1684.

Della Torre, Stefano. "Le architetture monumentali: disciplina normativa e pluralismo delle opere." In *Carlo Borromeo e l'opera della "grande riforma": cultura, religione e arti del governo nella Milano del pieno Cinquecento*, edited by Franco Buzzi and Danilo Zardin, 216–26. Cinisello Balsamo, 1997.

Denny, Walter B. "Tessuti e tappeti orientali a Venezia." In *Venezia e l'Islam 828–1797*, edited by Stefano Carboni, 185–205. Venice, 2007.

DePrano, Maria. *Art Patronage, Family, and Gender in Renaissance Florence: The Tornabuoni*. Cambridge, 2018.

DeSilva, Jennifer Mara. ed. *Episcopal Reform and Politics in Early Modern Europe*. Kirksville, MO, 2012.

——. ed. *The Sacralization of Space and Behavior in the Early Modern World: Studies and Sources*. London and New York, 2016.

Dezzi Bardeschi, Marco. "Il complesso monumentale di S. Pancrazio a Firenze ed il suo restauro." *Quaderni dell'Istituto di Storia dell'Architettura*, serie XIII, no. 73–78 (1966): 1–66.

Di Cagno, Gabriella, and Donatella Pegazzano. "San Salvatore in Ognissanti: gli altari del Cinquecento (1561–1582) e il loro arredo nel contesto della Riforma Cattolica." In *Altari e committenza: Episodi a Firenze nell'età della Controriforma*, edited by Cristina De Benedictis, 92–103. Florence, 1996.

Di Stasi, Michelina. *Stefano di Francesco Rosselli: antiquario fiorentino del XVII sec. e il suo Sepoltuario*. Florence, 2014.

Dionisi, Aurelio. *Il Gesù di Roma: breve storia e illustrazione della prima chiesa eretta dalla Compagnia di Gesù*. Rome, 1982.

Ditchfield, Simon. "Carlo Borromeo in the Construction of Roman Catholicism as a World Religion." *Studia borromaica* 25 (2011): 3–23.

——. "Tridentine Catholicism." In *The Ashgate Research Companion to the Counter-Reformation*, edited by Alexandra Bamji, Geert H. Janssen, and Mary Laven, 15–31. Farnham, 2013.

——. "Catholic Reformation and Renewal." In *The Oxford Illustrated History of the Reformation*, edited by Peter Marshall, 152–85. Oxford, 2017.

Doberer, Erika. "Der Lettner." *Mitteilungen der Gesellschaft für vergleichende Kunstforschung in Wien* 9, no. 2 (1956): 117–22.

Dodson, Alexandra. "Mount Carmel in the Commune: Promoting the Holy Land in Central Italy in the 13th and 14th Centuries." PhD thesis, Duke University, 2016.

Donetti, Dario, Marzia Faietti, and Sabine Frommel. eds. *Giuliano da Sangallo: Disegni degli Uffizi*. Florence, 2017.

Eckstein, Nicholas A. *The District of the Green Dragon: Neighbourhood Life and Social Change in Renaissance Florence*. Florence, 1995.

——. ed. *The Brancacci Chapel: Form, Function, and Setting: Acts of an International Conference, Florence, Villa I Tatti, June 6, 2003*. Florence, 2007.

——. *Painted Glories: The Brancacci Chapel in Renaissance Florence*. New Haven, CT and London, 2014.

——. "Saint Peter, the Carmelites, and the Triumph of Anghiari: The Changing Context of the Brancacci Chapel in Mid-Fifteenth-Century Florence." In *Studies on Florence and the Italian Renaissance in Honour of F. W. Kent*, edited by Peter Howard and Cecilia Hewlett, 317–37. Turnhout, 2016.

Eisenbichler, Konrad. *The Boys of the Archangel Raphael: A Youth Confraternity in Florence, 1411–1785*. Toronto, 1998.

Eisler, Colin, Abbey Kornfeld, and Alison Rebecca W. Strauber. "Words on an Image: Francesco da Sangallo's Sant'Anna Metterza for Orsanmichele." In *Orsanmichele and the History and Preservation of the Civic Monument*, edited by Carl Brandon Strehlke, 289–300. New Haven, CT, 2012.

Ekroll, Øystein. "State Church and Church State: Churches and Their Interiors in Post-Reformation Norway, 1537–1705." In *Lutheran Churches in Early Modern Europe*, edited by Andrew Spicer, 277–310. Farnham, 2012.

Evangelisti, Silvia. "'We Do Not Have It, and We Do Not Want It': Women, Power, and Convent Reform in Florence." *The Sixteenth Century Journal* 34, no. 3 (2003): 677–700.

Fabbri, Lorenzo. "La sella e il freno del vescovo: privilegi familiari e saccheggio rituale nell'ingresso episcopale a Firenze fra XIII e XVI secolo." In *Uomini paesaggi storie: studi di storia medievale per Giovanni Cherubini*, edited by Duccio Balestracci, Andrea Barlucchi, Franco Franceschi, Paolo Nanni, Gabriella Piccinni, and Andrea Zorzi, 895–909. Siena, 2012.

Fabbri, Maria Cecilia. "Santa Maria Novella e la Controriforma: Genesi e sviluppo del linguaggio controriformato nel ciclo pittorico degli altari." In *Alla riscoperta delle chiese di Firenze. 2. Santa Maria Novella*, edited by Timothy Verdon, 131–43. Florence, 2003.

Fabbri, Maria Rita. "Il coro intarsiato di San Giovanni in Monte." *Il Carrobbio* 2 (1976): 143–56.

Fabbri, Mario, Elvira Garbero Zorzi, and Annamaria Petrioli Tofani. eds. *Il luogo teatrale a Firenze: Brunelleschi, Vasari, Buontalenti, Parigi, Firenze, Palazzo Medici Riccardi, Museo Mediceo, 31 maggio–31 ottobre 1975*. Milan, 1975.

Fabbri, Nancy Rash, and Nina Rutenburg. "The Tabernacle of Orsanmichele in Context." *The Art Bulletin* 63, no. 3 (1981): 385–405.

Faloci Pulignani, Michele. "Saggi della cronaca di Suor Caterina Guarnieri da Osimo." *Archivio storico per le Marche e per l'Umbria* 1 (1884): 297–316.

Fantozzi Micali, Osanna, and Piero Roselli. *Le Soppressioni dei Conventi a Firenze: riuso e trasformazioni dal sec. XVIII in poi.* Florence, 1980.

Ferretti, Emanuela. "Sacred Space and Architecture in the Patronage of the First Grand Duke of Tuscany." In *San Lorenzo: A Florentine Church*, edited by Robert W. Gaston and Louis Alexander Waldman, 504–24. Florence, 2017.

Filarete. *Filarete's Treatise on Architecture, Being the Treatise by Antonio di Piero Averlino, known as Filarete.* Translated by John R. Spencer, New Haven, CT, 1965.

Fiorelli Malesci, Francesca. *La Chiesa di Santa Felicita a Firenze.* Florence, 1986.

Fiorio, Maria Teresa, and Mercedes Precerutti Garberi. *La Pinacoteca del Castello Sforzesco.* Milan, 1987.

Flanigan, Theresa. "Ocular Chastity: Optical Theory, Architectural Barriers and the Gaze in the Renaissance Church of San Marco in Florence." In *Beyond the Text: Franciscan Art and the Construction of Religion*, 40–60. St. Bonaventure, NY, 2013.

Fondaras, Antonia. *Augustinian Art and Meditation in Renaissance Florence: The Choir Altarpieces of Santo Spirito 1480–1510.* Leiden, 2020.

Fonseca, Cosimo Damiano. "Vescovi, capitoli cattedrali e canoniche regolari." In *Vescovi e diocesi in Italia dal XIV alla metà del XVI secolo. Atti del VII convegno di storia della chiesa in Italia (Brescia, 21–25 settembre 1987)*, edited by Giuseppina de Sandre Gasparini, 83–138. Rome, 1990.

Forlani Conti, Marisa. "La ristrutturazione seicentesca nella chiesa di S. Stefano al Ponte." In *La comunità cristiana fiorentina e toscana nella dialettica religiosa del Cinquecento*, 277–83. Florence, 1980.

Foscari, Antonio, and Manfredo Tafuri. "Sebastiano da Lugano, i Grimani e Jacopo Sansovino. Artisti e committenti nella chiesa di Sant'Antonio di Castello." *Arte Veneta* 36 (1982): 100–23.

Fossi, Gloria. "Grandi casati, uomini illustri e committenti." In *La chiesa di Santa Maria del Carmine a Firenze*, edited by Luciano Berti. Florence, 1992.

Uffizi: Art, History, Collections. Florence and Hove, 2008.

Franco, Tiziana. "Appunti sulla decorazione dei tramezzi nelle chiese mendicanti. La chiesa dei Domenicani a Bolzano e di Santa Anastasia a Verona." In *Arredi liturgici e architettura*, edited by Arturo Carlo Quintavalle, 115–28. Milan, 2007.

"Sul 'muricciolo' nella chiesa di Sant'Andrea di Sommacampagna 'per il quale restavan divisi gli uomini dalle donne'." *Hortus Artium Medievalium* 14 (2008): 181–92.

"Attorno al 'pontile che traversava la chiesa': spazio liturgico e scultura in Sant'Anastasia." In *La Basilica di Santa Anastasia a Verona: storia e restauro*, edited by Paola Marini, 33–49. Verona, 2011.

"'Item in piscibus pro magistris qui aptaverunt pontem': note sul tramezzo dei Santi Giovanni e Paolo a Venezie." In *Sotto la superficie visibile: Scritti in onore di Franco Bernabei*, edited by Marta Nezzo and Giuliana Tomasella, 163–70. Treviso, 2013.

Freni, Giovanni. "The Aretine Polyptych by Pietro Lorenzetti: Patronage, Iconography and Original Setting." *Journal of the Warburg and Courtauld Institutes* 63 (2000): 59–110.

"Images and Relics in Fourteenth-Century Arezzo: Pietro Lorenzetti's Pieve Polyptych and the Shrine of St Donatus." In *Images, Relics, and Devotional Practices in Medieval and Renaissance Italy*, edited by Sally J. Cornelison and Scott B. Montgomery. Medieval & Renaissance Texts & Studies, 27–54. Tempe, AZ, 2006.

Frey, Karl, and Herman-Walther Frey. eds. *Der literarische Nachlass Giorgio Vasaris.* Hildesheim and New York, 1982.

Frisoni, Fiorella. "Il coro ligneo della Cattedrale di Ferrara." In *La Cattedrale di Ferrara. Atti del Convegno nazionale di studi storici organizzato dalla Accademia delle scienze di Ferrara sotto l'alto patrocinio della Presidenza del Consiglio dei Ministri, 11–13 maggio 1979*, 539–58. Ferrara, 1982.

Frommel, Christoph Luitpold. "La nuova cappella maggiore." In *Santa Maria del Popolo: storia e restauri*, edited by Ilaria Miarelli and Maria Richiello, 383–410. Rome, 2009.

Fujikawa, Mayu. "The Medici Judge, a Bitter Lawsuit, and an Embezzlement: The Opera del Sacro Cingolo's Bronze Chapel Screen at Santo Stefano, Prato." *Renaissance Studies* 27, no. 5 (2013): 612–32.

Fumi, Francesca. "Nuovi documenti per gli angeli dell'altar maggiore del Duomo di Siena." *Prospettiva*, 26 (1981): 9–25.

Gade, John Allyne. *Cathedrals of Spain.* Boston and New York, 1911.

Gahtan, Maia Wellington. *Giorgio Vasari and the Birth of the Museum.* Farnham and Burlington, VT, 2014.

Gaier, Martin. "Il mausoleo nel presbiterio. Patronati laici e liturgie private nelle chiese veneziane." In *Lo spazio e il culto: relazioni tra edificio ecclesiale e uso liturgico dal XV al XVI secolo*, edited by Jörg Stabenow, 153–80. Venice, 2006.

Galbraith, Georgina Rosalie. *The Constitution of the Dominican Order 1216–1360*. Manchester, 1925.

Gáldy, Andrea. *Cosimo I de' Medici as Collector: Antiquities and Archaeology in Sixteenth-Century Florence*. Newcastle, 2009.

Galletti, Giorgio. "San Pancrazio: la vicenda storica e il suo recupero." In *Marino Marini: Museo San Pancrazio, Firenze*, edited by Carlo Pirovano, 202–11. Milan, 1988.

Gamba, Carlo. "Giovanni da Ponte." *Rassegna d'Arte* 4, no. 12 (1904): 177–86.

Garbero Zorzi, Elvira. "Chiesa di Santa Maria del Carmine." In *Il luogo teatrale a Firenze: Brunelleschi, Vasari, Buontalenti, Parigi, Firenze, Palazzo Medici Riccardi, Museo Mediceo, 31 maggio–31 ottobre 1975*, edited by Mario Fabbri, Elvira Garbero Zorzi, and Annamaria Petrioli Tofani, 59–61. Milan, 1975.

Gardner, Julian. "Altars, Altarpieces and Art History: Legislation and Usage." In *Italian Altarpieces 1250–1550: Function and Design*, edited by Eve Borsook and Fiorella Superbi Gioffredi, 5–39. Oxford, 1994.

——— "Nuns and Altarpieces: Agendas for Research." *Römisches Jahrbuch der Bibliotheca Hertziana* 30 (1995): 27–57.

——— "Sant Antonino, Lorenzo Lotto and Dominican Historicism." In *Ars Naturam Adiuvans: Festschrift für Matthias Winner*, edited by Victoria von Flemming and Sebastian Schütze, 139–49. Mainz, 1996.

——— "Giotto in America (and Elsewhere)." In *Italian Panel Paintings of the Duecento and Trecento. Studies in the History of Art, vol. 61. National Gallery of Art, Washington*, edited by Victor M. Schmidt, 161–81. Washington, DC, 2002.

——— "San Zaccaria and Prophet Dedications in Venetian Churches." In *Der Unbestechliche Blick: Festschrift zu Ehren von Wolfgang Wolters*, edited by Martin Gaier, Bernd Nicolai, and Tristan Weddingen, 31–41. Trier, 2005.

——— "A Thirteenth-Century Franciscan Building Contract." In *Medioevo: le officine: atti del Convegno internazionale di studi, Parma, 22–27 settembre 2009*, edited by Arturo Carlo Quintavalle, 457–67. Milan, 2010.

Gardner von Teuffel, Christa. "The Contract for Perugino's 'Assumption of the Virgin' at Vallombrosa." *The Burlington Magazine* 137, no. 1106 (1995): 307–12.

——— "Perugino's Cassinese Ascension for San Pietro at Perugia: The Artistic and Musical Setting of a High Altarpiece in Its Cassa." *Städel-Jahrbuch* 18 (2001): 113–64.

——— "The Significance of the Madonna del Popolo in the Brancacci Chapel: Re-framing Assumptions." In *The Brancacci Chapel: Form, Function, and Setting: Acts of an International Conference, Florence, Villa I Tatti, June 6, 2003*, edited by Nicholas A. Eckstein, 37–51. Florence, 2007.

——— "The Carmelite Altarpiece (circa 1290–1550): The Self-Identification of an Order." *Mitteilungen des Kunsthistorisches Institut in Florenz* 57, no. 1 (2015): 3–41.

——— "Locating Albert: The First Carmelite Saint in the Works of Taddeo di Bartolo, Lippo di Andrea, Masaccio and Others." *Predella: Journal of Visual Arts* 13–14, no. 39–40 (2016): 173–92.

——— "The Altarpieces of San Lorenzo: Memorializing the Martyr or Accommodating the Parishioners?." In *San Lorenzo: A Florentine Church*, edited by Robert W. Gaston and Louis Alexander Waldman, 184–243. Florence, 2017.

Gaston, Robert. "Sacred Place and Liturgical Space: Florence's Renaissance Churches." In *Renaissance Florence: A Social History*, edited by Roger J. Crum and John T. Paoletti, 331–52. Cambridge, 2006.

Gerstel, Sharon E. J. ed. *Thresholds of the Sacred: Architectural, Art Historical, Liturgical, and Theological Perspectives on Religious Screens, East and West*. Washington, DC, 2006.

Giacomelli, Gabriele. "Organi e simboli del potere a Firenze dalla repubblica al principato." In *Atti del Congresso Internazionale di Musica Sacra: in occasione del centenario di fondazione del Pontificio Istituto di Musica Sacra: Roma, 26 maggio – 1 giugno 2011*, edited by Antonio Addamiano and Francesco Luisi, 1061–73. Vatican City, 2013.

Giani, Arcangelo, and Luigi Maria Garbi. *Annalium sacri Ordinis fratrum Servorum B. Mariae Virginis a suae institutionis exordio centuriae quatuor*. Lucca, 1719.

Giannetti, Stefano. "La chiesa basso-medievale: il tramezzo di Ognissanti." In *Dal Gotico, oltre la Maniera: Gli architetti di Ognissanti a Firenze*, edited by Maria Teresa Bartoli, 49–57. Florence, 2011.

Giberti, Giovanni Matteo. *Constitutiones*. Verona, 1542.

Giffin, Erin. "Body and Apparition: Material Presence in Sixteenth-Century Italian Religious Sculpture." PhD thesis, University of Washington, 2017.

Gilchrist, Roberta. *Gender and Material Culture: The Archaeology of Religious Women*. London and New York, 1994.

Giles, Lucas. "Medieval Architecture and Technology: Using GPR to Reconstruct the Choir Screen at Santa Chiara in Naples." *Peregrinations: Journal of Medieval Art and Architecture* 6, no. 4 (2018): 123–60.

Gill, Meredith. *Angels and the Order of Heaven in Medieval and Renaissance Italy*. New York, 2014.

Giorgi, Luca, and Pietro Matracchi. "La chiesa di Santa Croce e i precedenti insediamenti francescani.

Architettura e resti archeologici." In *Santa Croce: oltre le apparenze*, edited by Andrea De Marchi and Giacomo Piraz, 13–31. Pistoia, 2011.

Giovannini, Priscia, and Sergio Vitolo. *Il convento del Carmine di Firenze: caratteri e documenti.* Florence, 1981.

Giovannozzi, Vera. "Ricerche su Bernardo Buontalenti." *Rivista d'Arte* 15 (1933): 299–327.

Giurescu, Ena. "Trecento Family Chapels in Santa Maria Novella and Santa Croce: Architecture, Patronage, and Competition." PhD thesis, New York University, 1997.

Giurescu Heller, Ena. "Access to Salvation: The Place (and Space) of Women Patrons in Fourteenth-Century Florence." In *Women's Space: Patronage, Place and Gender in the Medieval Church*, edited by Virginia Chieffo Raguin and Sarah Stanbury, 161–83. Albany, NY, 2005.

Gombrich, E. H. "The Sassetti Chapel Revisited: Santa Trinita and Lorenzo de' Medici." *I Tatti Studies in the Italian Renaissance* 7 (1997): 11–35.

Góralski, Wojciech. *I primi sinodi di San Carlo Borromeo: la riforma tridentina nella provincia ecclesiastica milanese.* Milan, 1989.

Gordon, Dillian. *The Italian Paintings before 1400.* National Gallery Catalogues. London, 2011.

Götz, Adriani. "Der Mittelalterliche Predigtort und seine Ausgestaltung." PhD thesis, Eberhard-Karls-Universität zu Tübingen, 1966.

Graf, Arturo. "Una cortigiana fra mille: Veronica Franco." In *Attraverso il Cinquecento*, edited by Arturo Graf, 177–298. Turin, 1888.

Grassi, Liliana. "Prassi, socialità e simbolo dell'architettura delle "Instructiones" di S. Carlo." *Arte Cristiana* 706 (1985): 3–16.

Griffith, David. "Texts and Detexting on Late Medieval English Church Screens." In *The Art and Science of the Church Screen in Medieval Europe: Making, Meaning, Preserving*, edited by Spike Bucklow, Richard Marks, and Lucy Wrapson, 71–99. Woodbridge, 2017.

Gromotka, Michael G. "Transformation Campaigns of Church Interiors and Their Impact on the Function and Form of Renaissance Altarpieces: The Example of S. Pietro in Perugia and Pietro Perugino's 'Ascension of Christ'." *Marburger Jahrbuch für Kunstwissenschaft* 42 (2015): 79–125.

———. *Die Geschichte der Kirchenausstattung von S. Pietro in Perugia: Ein Beitrag zur Kircheninnenraumforschung.* 3 vols. Heidelberg, 2021.

———. "Franciscan Choir Location as a Model in Umbrian Context: The Case of San Pietro in Perugia." In *Spaces for Friars and Nuns*, edited by Haude Morvan, forthcoming.

Gronau, H. D. "The San Pier Maggiore Altarpiece: A Reconstruction." *The Burlington Magazine* 86, no. 507 (June 1945): 139–45.

Guerra, Andrea. "Croce della Salvezza. I benedettini e il progetto di Palladio per San Giorgio Maggiore a Venezia." In *Lo spazio e il culto: relazioni tra edificio ecclesiale e uso liturgico dal XV al XVI secolo*, edited by Jörg Stabenow, 353–83. Venice, 2006.

Guidi, Fabrizio. "La pittura fiorentina del primo quattrocento nel transetto di S. Trinita." In *La Chiesa di Santa Trinita a Firenze*, edited by Giuseppe Marchini and Emma Micheletti, 118–22. Florence, 1987.

Guidotti, Alessandro. "Appendice documentaria." In *San Niccolò Oltrarno: la chiesa, una famiglia di antiquari*, edited by Giovanna Damiani and Anna Laghi, Vol. 1, 174–90. Florence, 1982.

———. *The Badia Fiorentina.* Florence, 1982.

———. "Fatti, arredi e corredi carmelitani a Firenze." In *La chiesa di Santa Maria del Carmine a Firenze*, edited by Luciano Berti, 21–56. Florence, 1992.

Gurrieri, Elena, Kathleen Olive, and Nerida Newbigin. eds. *Codice Rustici: dimostrazione dell'andata o viaggio al Santo Sepolcro e al monte Sinai di Marco di Bartolomeo Rustici.* Florence, 2015.

Gurrieri, Francesco. "L'impianto architettonico origini e addizioni." In *La basilica di San Miniato al Monte a Firenze*, edited by Francesco Gurrieri, Luciano Berti, and Claudio Leonardi, 15–78. Florence, 1988.

———. "L'architettura di Santa Maria del Carmine." In *La chiesa di Santa Maria del Carmine a Firenze*, edited by Luciano Berti, 57–88. Florence, 1992.

Gustafson, Erik D. "Tradition and Renewal in the Thirteenth-Century Franciscan Architecture of Tuscany." PhD thesis, Institute of Fine Arts, New York University, 2012.

Haines, Margaret. *The "Sacrestia delle Messe" of the Florentine Cathedral.* Florence, 1983.

Hall, Marcia B. "The 'Tramezzo' in S. Croce, Florence and Domenico Veneziano's Fresco." *The Burlington Magazine* 112, no. 813 (1970): 796–99.

———. "The Operation of Vasari's Workshop and the Designs for S. Maria Novella and S. Croce." *The Burlington Magazine* 115, no. 841 (1973): 204–09.

———. "The Ponte in S. Maria Novella: The Problem of the Rood Screen in Italy." *Journal of the Warburg and Courtauld Institutes* 37 (1974): 157–73.

———. "The Tramezzo in Santa Croce, Florence, Reconstructed." *The Art Bulletin* 56, no. 3 (1974): 325–41.

Renovation and Counter-Reformation: Vasari and Duke Cosimo in Sta Maria Novella and Sta Croce, 1565–1577. Oxford and New York, 1979.

"The Tramezzo in the Italian Renaissance, Revisited." In *Thresholds of the Sacred: Architectural, Art Historical, Liturgical, and Theological Perspectives on Religious Screens, East and West*, edited by Sharon E. J. Gerstel, 214–32. Washington, DC, 2006.

"Another Look at the Rood Screen in the Italian Renaissance." *Sacred Architecture Journal* 27, The Institute for Sacred Architecture (2015). www .sacredarchitecture.org/articles/another_look_at_ the_rood_screen_in_the_italian_renaissance.

Hall, Marcia B., and Tracy E. Cooper. eds. *The Sensuous in the Counter Reformation Church.* New York, 2013.

Hamburger, Jeffrey F. "Art, Enclosure and the Cura Monialium: Prolegomena in the Guise of a Postscript." *Gesta* 31, no. 2 (1992): 108–34.

Hamilton, Sarah, and Andrew Spicer. eds. *Defining the Holy: Sacred Space in Medieval and Early Modern Europe.* London, 2016.

Hammond, Joseph. "The Cult and Representation of the Archangel Raphael in Sixteenth-Century Venice." *St. Andrews University Journal of Art History and Museum Studies* 15 (2011): 79–88.

"Negotiating Carmelite Identity: The Scuola dei Santi Alberto ed Eliseo at Santa Maria dei Carmini in Venice." In *Art and Identity: Visual Culture, Politics and Religion in the Middle Ages and the Renaissance*, edited by Sandra Cardarelli, Emily Jane Anderson and John Richards, 219–42. Newcastle upon Tyne, 2012.

Harrison, Hugh, and Jeffrey West. "West Country Rood Screens: Construction and Practice." In *The Art and Science of the Church Screen in Medieval Europe: Making, Meaning, Preserving*, edited by Spike Bucklow, Richard Marks, and Lucy Wrapson, 123–49. Woodbridge, 2017.

Hatfield, Rab. "The Compagnia de Magi." *Journal of the Warburg and Courtauld Institutes* 33 (1970): 107–61.

Hay, Denys. *The Church in Italy in the Fifteenth Century.* Cambridge, 1977.

Henderson, John. *Piety and Charity in Late Medieval Florence.* Oxford and New York, 1994.

The Renaissance Hospital: Healing the Body and Healing the Soul. New Haven, CT and London, 2006.

Henschen, Godefroid, Daniel Van Papenbroeck, François Baert, and Conrad Ianningus. eds. *Acta Sanctorum Maii, Tomus VII.* Antwerp, 1688.

Herzner, Volker. "Die Kanzeln Donatellos in San Lorenzo." *Münchner Jahrbuch der bildenden Kunst* 23 (1972): 101–64.

Hiller von Gaertringen, Rudolf. "Giovanni da Ponte." In *Allgemeines Künstlerlexikon*, edited by Günter Meißner, Vol. 55, 76–78. Munich and Leipzig, 2007.

Hills, Helen. "Architecture as Metaphor for the Body: The Case of Female Convents in Early Modern Italy." In *Gender and Architecture*, edited by Louise Durning and Richard Wrigley, 67–112. Chichester, 2000.

Holmes, George. "How the Medici Became the Pope's Bankers." In *Florentine Studies: Politics and Society in Renaissance Florence*, edited by Nicolai Rubinstein, 357–80. Evanston, IL, 1968.

Holmes, Megan. *Fra Filippo Lippi, The Carmelite Painter.* New Haven, CT and London, 1999.

The Miraculous Image in Renaissance Florence. New Haven, CT and London, 2013.

Hoover, Dale. "Affinity between Chant and Image: A Study of a Late Fourteenth-Century Florentine Antiphonary/Gradual (Baltimore: Walters Art Museum: MS W153)." PhD thesis, University of Ohio, 2004.

Horn, Walter. "Romanesque Churches in Florence: A Study in Their Chronology and Stylistic Development." *The Art Bulletin* 25, no. 2 (1943): 112–31.

Houston, Kerr. "The Sistine Chapel Chancel Screen as Metaphor." *Source: Notes in the History of Art* 32, no. 3 (2013): 21–27.

Howard, Deborah. *Jacopo Sansovino: Architecture and Patronage in Renaissance Venice.* New Haven, CT and London, 1975.

"Venice between East and West: Marc'Antonio Barbaro and Palladio's Church of the Redentore." *Journal of the Society of Architectural Historians* 62, no. 3 (2003): 306–25.

Howard, Deborah, and Laura Moretti. *Sound and Space in Renaissance Venice: Architecture, Music, Acoustics.* New Haven, CT and London, 2009.

Hueck, Irene. "Der Lettner der Unterkirche von San Francesco in Assisi." *Mitteilungen des Kunsthistorischen Institutes in Florenz* 28, no. 2 (1984): 173–202.

"La tavola di Duccio e la Compagnia delle Laudi di Santa Maria Novella." In *La Maestà di Duccio restaurata. Gli Uffizi Studi e Ricerche*, Vol. 6, 33–46. Florence, 1990.

"Le opere di Giotto per la chiesa di Ognissanti." In *La "Madonna di'Ognissanti" di Giotto restaurata*, 37–49. Florence, 1992.

Huitson, Toby. *Stairway to Heaven: The Functions of Medieval Upper Spaces.* Oxford, 2014.

Humfrey, Peter. "Cima da Conegliano, Sebastiano Mariani, and Alvise Vivarini at the East End of S. Giovanni in Bragora in Venice." *The Art Bulletin* 62, no. 3 (1980): 350–63.

Hurz, Merlijn. "Bartolomeo Ammannati and the College of San Giovannino in Florence: Adapting Architecture to Jesuit Needs." *Journal of the Society of Architectural Historians* 68, no. 3 (2009): 338–57.

Imesch Oehry, Kornelia. *Die Kirchen der Franziskanerobservanten in der Lombardei, im Piemont und im Tessin und ihre "Lettnerwände"*. Essen, 1991.

Ircani Menichini, Paola. *Vita quotidiana e storia della SS. Annunziata di Firenze nella prima metà del Quattrocento*. Florence, 2004.

Isermeyer, Christian-Adolf. "Il Vasari e il restauro delle chiese medievali." In *Studi vasariani: atti del Convegno internazionale per il IV. centenario della prima edizione delle "Vite" del Vasari*, 229–36. Florence, 1952.

——— "Le chiese del Palladio in rapporto al culto." *Bollettino del Centro Internazionale di Studi di Architettura Andrea Palladio* 10 (1968): 42–58.

Israëls, Machtelt. ed. *Sassetta: The Borgo San Sepolcro Altarpiece*. Florence and Leiden, 2009.

Ito, Takuma. "Domenico Ghirlandaio's Santa Maria Novella Altarpiece: A Reconstruction." *Mitteilungen des Kunsthistorischen Institutes in Florenz* 56, no. 2 (2014): 171–92.

Joannides, Paul. *Masaccio and Masolino: A Complete Catalogue*. London and New York, 1993.

Jobst, Christoph. "Liturgia e culto dell'eucaristia nel programma spaziale della chiesa: I tabernacoli eucaristici e la trasformazione dei presbiteri negli scritti ecclesiastici dell'epoca intorno al Concilio di Trento." In *Lo spazio e il culto: relazioni tra edificio ecclesiale e uso liturgico dal XV al XVI secolo*, edited by Jörg Stabenow, 91–126. Venice, 2006.

Johannsen, Birgitte Bøggild, and Hugo Johannsen. "Reforming the Confessional Space: Early Lutheran Churches in Denmark, c. 1536–1660." In *Lutheran Churches in Early Modern Europe*, edited by Andrew Spicer, 241–76. Farnham, 2012.

Jones, Pamela M. *Federico Borromeo and the Ambrosiana: Art Patronage and Reform in Seventeenth-Century Milan*. Cambridge; New York; and Victoria, 1993.

Jotischky, Andrew. *The Carmelites and Antiquity: Mendicants and Their Pasts in the Middle Ages*. Oxford, 2002.

Jung, Jacqueline E. "Beyond the Barrier: The Unifying Role of the Choir Screen in Gothic Churches." *The Art Bulletin* 82, no. 4 (2000): 622–57.

——— "Seeing through Screens: The Gothic Choir Enclosure as Frame." In *Thresholds of the Sacred: Architectural, Art Historical, Liturgical, and Theological Perspectives on Religious Screens, East and West*, edited by Sharon E. J. Gerstel, 185–215. Washington, DC, 2006.

——— *The Gothic Screen: Space, Sculpture, and Community in the Cathedrals of France and Germany, ca. 1200–1400*. New York, 2013.

——— "Moving Pictures on the Gothic Choir Screen." In *The Art and Science of the Church Screen in Medieval Europe: Making, Meaning, Preserving*, edited by Spike Bucklow, Richard Marks, and Lucy Wrapson, 176–94. Woodbridge, 2017.

Jürgensen, Martin. "Between New Ideals and Conservatism: The Early Lutheran Church Interior in Sixteenth-Century Denmark." *Church History* 86, no. 4 (2017): 1041–80.

Kaftal, George. *Iconography of the Saints in Tuscan Painting*. Florence, 1952.

Kallenberg, Paschalis. *Fontes Liturgiae Carmelitanae: investigatio in decreta, codices et proprium sanctorum*. Rome, 1962.

Kanter, Laurence B. ed. *Painting and Illumination in Early Renaissance Florence 1300–1450*. New York, 1994.

Karwacka Codini, Ewa, and Milletta Sbrilli. *Il quaderno della fabbrica della Cappella di Sant'Antonino in San Marco a Firenze: Manoscritto sulla costruzione di un'opera del Giambologna*. Quaderni dell'Archivio Salviati. Pisa, 1996.

Kelley, Shannon. "Arno River Floods and the Cinquecento Grotto at the Boboli Garden." *Renaissance Studies* 30, no. 5 (2015): 729–51.

Kemp, Martin. "The Taking and Use of Evidence; with a Botticellian Case Study." *Art Journal* 44, no. 3 (1984): 207–15.

Kempers, Bram. *Painting, Power and Patronage: The Rise of the Professional Artist in the Italian Renaissance*. Translated by Beverley Jackson. London, 1994.

Kennedy, Ruth Wedgwood. *Alesso Baldovinetti: A Critical & Historical Study*. New Haven, CT and London, 1938.

Kent, D. V., and F. W. Kent. *Neighbours and Neighbourhood in Renaissance Florence: The District of the Red Lion in the Fifteenth Century*. Locust Valley, NY, 1982.

Kent, Dale. *The Rise of the Medici: Faction in Florence 1426–1434*. Oxford, 1978.

——— *Cosimo de' Medici and the Florentine Renaissance: The Patron's Oeuvre*. New Haven, CT and London, 2000.

Kent, F. W. "New Light on Lorenzo de' Medici's Convent at Porta San Gallo." *The Burlington Magazine* 124, no. 950 (1982): 292–94.

——— *Household and Lineage in Renaissance Florence: The Family Life of the Capponi, Ginori and Rucellai*. Princeton, NJ, 2015.

King, Catherine. "The Dowry Farms of Niccolosa Serragli and the Altarpiece of the Assumption in the National Gallery London (1126) Ascribed to Francesco Botticini." *Zeitschrift für Kunstgeschichte* 50, no. 2 (1987): 275–78.

Knox, Giles. "The Unified Church Interior in Baroque Italy: S. Maria Maggiore in Bergamo." *The Art Bulletin* 82, no. 4 (2000): 679–701.

Koch, Linda A. "The Early Christian Revival at S. Miniato al Monte: The Cardinal of Portugal Chapel." *The Art Bulletin* 78, no. 3 (1996): 527–55.

——— "Medici Continuity, Imperial Tradition and Florentine History: Piero de' Medici's Tabernacle of the Crucifix at S. Miniato al Monte." In *A Scarlet Renaissance: Essays in Honor of Sarah Blake McHam*, edited by Arnold Victor Coonin, 183–212. New York, 2013.

Koerner, Joseph Leo. *The Reformation of the Image.* Chicago, 2004.

Kreytenberg, Gert. "Un tabernacolo di Giovanni di Balduccio per Orsanmichele a Firenze." *Boletin del Museo Arqueológico Nacional (Madrid)* 8 (1990): 37–57.

——— "The Limestone Tracery in the Arches of the Original Grain Loggia of Orsanmichele in Florence." In *Orsanmichele and the History and Preservation of the Civic Monument*, edited by Carl Brandon Strehlke, 111–24. New Haven, CT, 2012.

Kroesen, Justin E. A. "Accommodating Calvinism: The Appropriation of Medieval Church Interiors for Protestant Worship in the Netherlands after the Reformation." In *Protestant Church Architecture in Early Modern Europe: Fundamentals and New Research Approaches* [*Protestantischer Kirchenbau der Frühen Neuzeit in Europa: Grundlagen und neue Forschungskonzepte*], edited by Jan Harasimowicz, 81–98. Regensburg, 2015.

——— "The Preserving Power of Calvinism: Pre-reformation Chancel Screens in the Netherlands." In *The Art and Science of the Church Screen in Medieval Europe: Making, Meaning, Preserving*, edited by Spike Bucklow, Richard Marks, and Lucy Wrapson, 195–219. Woodbridge, 2017.

Ladis, Andrew. *Taddeo Gaddi: Critical Reappraisal and Catalogue Raisonné.* Columbia, MO and London, 1982.

——— "A High Altarpiece for San Giovanni Fuorcivitas in Pistoia and Hypotheses about Niccolò di Tommaso." *Mitteilungen des Kunsthistorischen Institutes in Florenz* 33 (1989): 3–16.

Laghi, Anna. "La chiesa cinquecentesca e il suo arredo: vicende e restauri." In *San Niccolò Oltrarno: la chiesa, una famiglia di antiquari*, edited by Giovanna Damiani and Anna Laghi, Vol. 1, 87–135. Florence, 1982.

Laitinen, Riitta. "Church Furnishings and Rituals in a Swedish Provincial Cathedral from 1527 to c. 1660." In *Lutheran Churches in Early Modern Europe*, edited by Andrew Spicer, 311–32. Farnham, 2012.

Lang, Uwe Michael. "Tamquam Cor in Pectore: The Eucharistic Tabernacle Before and After the Council of Trent." *Sacred Architecture Journal* 15, The Institute for Sacred Architecture (2009). www.sacredarchitecture.org/articles/tamquam_cor_in_pectore_the_eucharistic_tabernacle_before_and_after_the_coun.

Lapini, Agostino, and Giuseppe Odoardo Corazzini. *Diario Fiorentino di Agostino Lapini: dal 252 al 1596, ora per la prima volta pubblicato.* Florence, 1900.

Latini, Emilia. "La cappella del Santo Sepolcro nel complesso conventuale di San Pancrazio a Firenze." In *I Fiorentini alle crociate: guerre, pellegrinaggi e immaginario 'orientalistico' a Firenze tra medioevo ed età moderna*, edited by Silvia Agnoletti and Luca Mantelli, 267–81. Florence, 2007.

Lavin, Irving. "Donatello's Bronze Pulpits in San Lorenzo and the Early Christian Revival." In *Past & Present: Essays on Historicism in Art from Donatello to Picasso*, 1–27. Berkeley, CA, 1993.

——— "The Problem of the Choir of Florence Cathedral." In *La cattedrale e la città: saggi sul Duomo di Firenze: atti del convegno internazionale di studi (Firenze, 16 – 21 giugno 1997)*, edited by Timothy Verdon and Annalisa Innocenti, 397–419. Florence, 2001.

——— "Santa Maria del Fiore: Image of the Pregnant Madonna: The Christology of Florence Cathedral." In *La cattedrale e la città. Saggi sul duomo di Firenze. Atti del convegno internazionale di studi (Firenze, 16–21 giugno 1997)*, edited by Timothy Verdon and Annalisa Innocenti, 669–89. Florence, 2001.

Lawless, Catherine. "Representation, Religion, Gender and Space in Medieval Florence." In *Ritual and Space in the Middle Ages: Proceedings of the 2009 Harlaxton Symposium*, edited by Frances Andrews, 232–58. Donington, 2011.

Leader, Anne. *The Badia of Florence: Art and Observance in a Renaissance Monastery.* Bloomington, IN, 2012.

Leclercq, Henri. "Jubé." In *Dictionnaire d'Archéologie Chrétienne et de Liturgie*, edited by Fernand Cabrol and Henri Leclercq, Vol. 7, 2767–69, Paris, 1927.

Lefebvre, Henri. *The Production of Space.* Translated by Donald Nicholson-Smith. Malden, MA and Oxford, 1991.

Leoncini, Giovanni. "Altari in Santa Trinita: la cappella maggiore, la cappella Usimbardi e la cappella delle reliquie di San Giovanni Gualberto." In *Altari e committenza: Episodi a Firenze nell'età della Controriforma*, edited by Cristina De Benedictis, 105–13. Florence, 1996.

——— "I 'cori centrali' di Santa Maria del Fiore e di altre chiese fiorentine: spazi liturgici e architettonici." In *La cattedrale e la città: saggi sul Duomo di Firenze: atti del convegno internazionale di studi (Firenze, 16–21 giugno 1997)*, edited by Timothy Verdon and Annalisa Innocenti, 475–91. Florence, 2001.

——— "I luoghi della devozione mariana a Firenze: Or San Michele." In *Atti del VII centenario del Duomo di*

Firenze, edited by Timothy Verdon and Annalisa Innocenti, Vol. 2, 183–94. Florence, 2001.

"Santa Croce nel Cinquecento." In *Alla riscoperta delle chiese di Firenze. 3. Santa Croce*, edited by Timothy Verdon, 65–91. Florence, 2004.

"Il Cinquecento e il Seicento in Santa Trinita." In *Alla riscoperta delle chiese di Firenze: 6. Santa Trinita*, edited by Timothy Verdon, 135–59. Florence, 2009.

Levi d'Ancona, Mirella. *Miniatura e miniatori a Firenze dal XIV al XVI secolo*. Documenti per la storia della miniatura. Florence, 1962.

"Arte e politica: l'Interdetto, gli Albizzi e la miniatura fiorentina del tardo Trecento." In *La Miniatura Italiana in età romanica e gotica, Atti del I Congresso di Storia della Miniatura Italiana, Cortona 26–28 maggio 1978*, edited by Grazia Vailati Schoenburg Waldenburg, 461–87. Florence, 1979.

Lewine, Milton Joseph. "The Roman Church Interior, 1527–1580." PhD thesis, Columbia University, 1960.

Lewis, Charlton T., and Charles Short. *A Latin Dictionary Founded on Andrews' Edition of Freund's Latin Dictionary Revised, Enlarged, and in Great Part Rewritten*. Oxford, 1955.

Lightbown, Ronald. *Sandro Botticelli: Life and Work*. London, 1978.

Linderbauer, Benno. ed. *S. Benedicti Regula Monasteriorum*. Bonn, 1928.

Lindholm, Richard T. *Quantitative Studies of the Renaissance Florentine Economy and Society*. London and New York, 2017.

Lisner, Margrit. "The Crucifix from Santo Spirito and the Crucifixes of Taddeo Curradi." *The Burlington Magazine* 122, no. 933 (1980): 812–19.

"Andrea Sansovino und die Sakramentskapelle der Corbinelli mit Notizen zum alten Chor von Santo Spirito in Florenz." *Zeitschrift für Kunstgeschichte* 50, no. 2 (1987): 207–74.

Litchfield, R. Burr. *Emergence of a Bureaucracy: The Florentine Patricians, 1530–1790*. Princeton, NJ, 1986.

"Florentine Renaissance Resources: Online Gazetteer of Sixteenth Century Florence" (2006). http://cds .library.brown.edu/projects/florentine_gazetteer/ map_page_A.php?p=4&m=1&a1=0.

Locatelli, Eudosio. *Vita del glorioso padre San Giouangualberto fondatore dell'ordine di Vallombrosa*. Florence, 1583.

Lorenzoni, Giovanni, and Giovanna Valenzano. *Il duomo di Modena e la basilica di San Zeno*. Verona, 2000.

"Pontile, jubé, tramezzo: alcune riflessioni sul tramezzo di Santa Corona a Vicenza." In *Immagine e ideologia: Studi in onore di Arturo Carlo Quintavalle*, edited by Arturo Calzona, Roberto Campari, and Massimo Mussin, 313–17. Milan, 2007.

Lotz, Wolfgang. "Le trasformazioni vasariane e i nuovi edifici sacri del tardo'500." In *Arte e religione nella Firenze de' Medici*, edited by Massimiliano Giuseppe Rosito, 81–89. Florence, 1980.

Loughman, Thomas J. "Commissioning Familial Remembrance in Fourteenth-Century Florence: Signaling Alberti Patronage at the Church of Santa Croce." In *The Patron's Payoff: Conspicuous Commissions in Italian Renaissance Art*, edited by Jonathan K. Nelson and Richard J. Zeckhauser, 133–48. Princeton, NJ and Oxford, 2008.

Lowe, Kate. "Nuns and Choice: Artistic Decision-Making in Medicean Florence." In *With and Without the Medici: Studies in Tuscan Art and Patronage 1434–1530*, edited by Eckart Marchand and Alison Wright, 129–53. Aldershot, 1998.

Luchinat, Cristina Acidini. "Il Cardinale Alessandro de' Medici e le arti: qualche considerazione." *Paragone* 529–531–533 (1994): 134–40.

Luchs, Alison. "Origins of the Widener Annunciation Windows." *Studies in the History of Art* 7 (1975): 81–89.

Cestello. A Cistercian Church of the Florentine Renaissance. PhD thesis, The Johns Hopkins University, 1976.

"The Washington Ciborium Attributed to Desiderio da Settignano: Quattrocento, Ottocento, or Both?." In *Encountering the Renaissance: Celebrating Gary M. Radke and 50 years of the Syracuse University Graduate Program in Renaissance Art*, edited by Molly Bourne and Arnold Victor Coonin, 185–200. Ramsey, NJ, 2016.

Lunardi, Roberto. "La ristrutturazione vasariana di Santa Maria Novella: i documenti ritrovati." *Memorie dominicane (new series)* 19 (1988): 403–19.

Maffioli, Monica. "La querelle ottocentesca per il restauro della chiesa: dalle teorie al cantiere." In *La Chiesa di Santa Trinita a Firenze*, edited by Giuseppe Marchini and Emma Micheletti, 61–70. Florence, 1987.

Magherini Graziani, Giovanni. *L'arte a Città di Castello*. Città di Castello, 1897.

Maginnis, Hayden B. J. "Lay Women and Altars in Trecento Siena." *Source: Notes in the History of Art* 28, no. 1 (2008): 5–7.

Mainardi, Arlotto, and Gianfranco Folena. *Motti e facezie del piovano Arlotto*. Milan and Naples, 1953.

Maisonneuve, Cécile. *Florence au XVe siècle: un quartier et ses peintres*. Paris, 2012.

Manetti, Renzo. *Beatrice e Monnalisa*. Florence, 2005.

Le Madonne del Parto: icone templari. Florence, 2005.

Mannini, Maria Pia, and Marco Fagioli. *Filippo Lippi: catalogo completo*. Florence, 1997.

Manuzio (il Giovane), Aldo. *Vita di Cosimo de' Medici, primo Gran Duca di Toscana, descritta da Aldo Mannucci*. Bologna, 1586.

Marchini, Giuseppe. "Il San Marco di Michelozzo." *Palladio: rivista di storia dell'architettura e restauro* 6 (1942): 102–14.

——. *Filippo Lippi*. Milan, 1975.

Mariani, Irene. "The Vespucci Family and Sandro Botticelli: Friendship and Patronage in the Gonfalone Unicorno." In *Sandro Botticelli (1445–1510): Artist and Entrepreneur in Renaissance Florence: Proceedings of the International Conference Held at the Dutch University Institute for Art History, Florence, 20–21 June 2014*, edited by Irene Mariani and Gert Jan van der Sman, 203–15. Florence, 2015.

——. "The Vespucci Family in Context: Art Patrons in Late Fifteenth-Century Florence." PhD thesis, University of Edinburgh, 2015.

Markey, Lia. "Medici Statecraft and the Building and Use of Ammannati's Ponte Santa Trinita." In *Italian Art, Society and Politics: A Festschrift in Honor of Rab Hatfield Presented by his Students on the Occasion of his Seventieth Birthday*, edited by Barbara Deimling, Jonathan K. Nelson, and Gary M. Radke, 178–93. Florence, 2007.

Markham Schulz, Anne. *The Badoer-Giustiniani Chapel in San Francesco della Vigna, Venice*. Florence, 2003.

Marks, Richard. "'To the Honour and Pleasure of Almighty God, and to the Comfort of the Parishioners': The Rood and Remembrance." In *Image, Memory and Devotion: Liber Amicorum Paul Crossley*, edited by Zoe Opačić and Achim Timmermann, 211–21. Turnhout, 2011.

Markschies, Alexander. *Gebaute Armut: San Salvatore e San Francesco al Monte in Florenz (1418–1504)*. Munich and Berlin, 2001.

Martines, Lauro. *The Social World of the Florentine Humanists: 1390–1460*. London, 1963.

Martini, Angelo. *Manuale di metrologia, ossia misure, pesi e monete in uso attualmente e anticamente presso tutti i popoli*. Turin, 1883.

"Masolino da Panicale, The Annunciation." National Gallery of Art. www.nga.gov/content/ngaweb/Collection/art-object-page.18.html.

Massaccesi, Fabio. "Il 'corridoio' della chiesa agostiniana di San Giacomo Maggiore a Bologna: prime ipotesi ricostruttive." *Zeitschrift für Kunstgeschichte* 77, no. 1 (2014): 1–26.

Massey, Doreen. *Space, Place, and Gender*. Minneapolis, 1994.

Matucci, Benedetta. "Benedetto da Rovezzano and the Altoviti in Florence: Hypotheses and New Interpretations for the Church of Santi Apostoli." In *The Anglo-Florentine Renaissance: Art for the Early Tudors*, edited by Cinzia Maria Sicca and Louis Alexander Waldman, 149–76. New Haven, CT, 2012.

May, Susan J., and George T. Noszlopy. "Cosimo Rosselli's Birmingham Altarpiece, the Vallombrosan Abbey of S. Trinita in Florence and Its Gianfigliazzi Chapel." *Journal of the Warburg and Courtauld Institutes* 78 (2015): 97–133.

Mazzi, Maria Serena. *Prostitute e lenoni nella Firenze del Quattrocento*. Milan, 1991.

McAndrew, John. *Venetian Architecture of the Early Renaissance*. Cambridge, MA and London, 1980.

McMahon, Patrick. "Servants of Two Masters: The Carmelites of Florence, 1267–1400." PhD thesis, New York University, 1994.

McRoberts, David. "Material Destruction Caused by the Scottish Reformation." In *Essays on the Scottish Reformation 1513–1625*, edited by David McRoberts, 415–62. Glasgow, 1962.

Mellini, Domenico. *Descrizione della entrata della serenissima Regina Giovanna d'Austria et dell'apparato, fatto in Firenze nella venuta, & per le felicissime nozze di Sua Altezza et dell'illustrissimo . . . S. Don Francesco de Medici*. Florence, 1566.

Merotto Ghedini, Monica. *La chiesa di Sant'Agostino in Padova*. Padua, 1995.

——. "Il tramezzo nella chiesa dei Santi Giovanni e Paolo a Venezia." In *De lapidibus sententiae. Scritti di storia dell'arte per Giovanni Lorenzoni*, edited by Tiziana Franco and Giovanna Valenzano, 257–62. Padua, 2002.

Middeldorf, Ulrich. *Sculptures from the Samuel H. Kress Collection: European Schools, XIV–XIX Century*. London and New York, 1976.

Milanesi, Gaetano. *Nuovi documenti per la storia dell'arte toscana dal XII al XV secolo*. Soest, 1973.

——. *Sulla storia dell'arte toscana, scritta vari*. Soest, 1973.

Miller, Julia Isabel, and Laurie Taylor-Mitchell. "The Ognissanti Madonna and the Humiliati Order in Florence." In *The Cambridge Companion to Giotto*, edited by Anne Derbes and Mark Sandona, 157–75. Cambridge, 2004.

——. *From Giotto to Botticelli: The Artistic Patronage of the Humiliati in Florence*. University Park, PA, 2015.

Miller, Maureen C. "Why the Bishop of Florence Had to Get Married." *Speculum* 81, no. 4 (2006): 1055–91.

Miller, Maureen C., and Kathryn L. Jasper. "The Foundation of the Monastery of San Pier Maggiore in Florence." *Rivista di storia della chiesa in Italia* 64, no. 2 (2010): 381–96.

Miller, Stephanie R. "Andrea della Robbia and His La Verna Altarpieces: Context and Interpretation." PhD thesis, Indiana University, 2003.

Modesti, Paola. "I cori nelle chiese veneziane e la visita apostolica del 1581. Il 'barco' di Santa Maria della Carità." *Arte Veneta* 59 (2002): 39–65.

"Recinzioni con colonne nelle chiese veneziane. Tradizioni, revival, sopravvivenze." In *Lo spazio e il culto: relazioni tra edificio ecclesiale e uso liturgico dal XV al XVI secolo,* edited by Jörg Stabenow, 181–208. Venice, 2006.

"I cori nelle chiese parrocchiali veneziane fra Rinascimento e riforma tridentina." In *La place du choeur: architecture et liturgie du Moyen Âge aux Temps modernes: actes du colloque de l'EPHE, Institut national d'histoire de l'art, les 10 et 11 décembre 2007,* edited by Sabine Frommel, Laurent Lecomte, and Raphaël Tassin, 141–55. Paris and Rome, 2012.

Moisé, Filippo. *Santa Croce di Firenze: illustrazione storico-artistica.* Florence, 1845.

Molho, Anthony. *Firenze nel Quattrocento.* Rome, 2006.

Monducci, Elio, and Vittorio Nironi. eds. *Il Duomo di Reggio Emilia.* Reggio Emilia, 1984.

Monssen, Lief Holm. "St Stephen's Balustrade in Santo Stefano Rotondo." *Acta ad archaeologiam et artium historiam pertinentia* 3 (1983): 107–81.

Moore, Derek. "Sanmicheli's 'Tornacoro' in Verona Cathedral: A New Drawing and Problems of Interpretation." *Journal of the Society of Architectural Historians* 44, no. 3 (1985): 221–32.

Morçay, Raoul. "La cronaca del convento fiorentino di San Marco: La parte più antica, dettata da Giuliano Lapaccini." *Archivio Storico Italiano* 71, no. 1 (269) (1913): 1–29.

Morelli, Arnaldo. "Per ornamento e servicio: Organi e sistemazioni architettoniche nelle chiese toscane del Rinascimento." *I Tatti Studies in the Italian Renaissance* 7 (1997): 279–303.

"'Sull'organo et in choro': Spazio architettonico e prassi musicale nelle chiese italiane durante il Rinascimento." In *Lo spazio e il culto: relazioni tra edificio ecclesiale e uso liturgico dal XV al XVI secolo,* edited by Jörg Stabenow, 209–26. Venice, 2006.

Moreni, Domenico. *De ingressu Antonii Altovitae Archiepiscopi Florentini historica descriptio incerti auctoris.* Florence, 1815.

Moretti, Italo. *La chiesa di San Niccolò Oltrarno.* Florence, 1973.

Morolli, Gabriele. "L'Architettura: Gotico e umanesimo." In *La chiesa di Santa Trinita a Firenze,* edited by Giuseppe Marchini and Emma Micheletti, 23–48. Florence, 1987.

"Non solo Brunelleschi: San Lorenzo nel Quattrocento." In *Alla riscoperta delle chiese di Firenze. 5. San Lorenzo,* edited by Timothy Verdon, 58–109. Florence, 2007.

Moroni, Lino, Jacopo Ligozzi, Domenico Falcini, and Raffaello Schiaminossi. *Descrizione del Sacro Monte della Vernia.* Florence, 1612.

Morselli, Piero. "Corpus of Tuscan Pulpits 1400–1550." PhD thesis, University of Pittsburgh, 1979.

"Il pulpito del quattrocento già in San Pancrazio di Firenze." *Antichità viva* 18, no. 5/6 (1979): 30–31.

Morvan, Haude. "Ecco disperse tutte le memorie dell'Antichità! La place du choeur dans les travaux des érudits dominicains de l'époque moderne." In *Spaces for Friars and Nuns,* edited by Haude Morvan, forthcoming.

Mulvaney, Beth A. "The Beholder as Witness: The Crib at Greccio from the Upper Church of San Francesco, Assisi and Franciscan Influence on Late Medieval Art in Italy." In *The Art of the Franciscan Order in Italy,* edited by William R. Cook, 169–88. Leiden, 2005.

Murat, Zuleika. "Il podium della pieve di Monselice nella descrizione di Pietro Barozzi." *Musica e Figura* 1 (2011): 87–117.

Musacchio, Jacqueline Marie. "The Medici-Tornabuoni Desco da Parto in Context." *Metropolitan Museum Journal* 33 (1998): 137–51.

The Art and Ritual of Childbirth in Renaissance Italy. New Haven, CT and London, 1999.

Nagel, Alexander. *The Controversy of Renaissance Art.* Chicago, 2011.

Najemy, John M. *A History of Florence 1200–1575.* Malden, MA, 2006.

Nannelli, Francesca. "Un'inedita veduta di Firenze nella Chiesa di Orsanmichele." *Notizie di cantiere: Soprintendenza per i Beni Ambientali e Architettonici per le Provincie di Firenze e Pistoia* 5 (1993 (1994)): 115–21.

Napoli, Federico. "La scala di Orsanmichele: un manufatto buontalentiano." *Varia: trimestrale di arte letteratura e cultura varia* 13 (1995): 18–19.

Neri Lusanna, Enrica. "L'antica arredo presbiteriale e il fonte del Battistero: Vestigia e ipotesi." In *The Baptistery of San Giovanni, Florence* [*Il Battistero di San Giovanni a Firenze*], edited by Antonio Paolucci, 189–204. Modena, 1994.

Newbigin, Nerida. "Piety and Politics in the Feste of Lorenzo's Florence." In *Lorenzo il Magnifico e il suo mondo,* edited by Gian Carlo Garfagnini, 17–41. Florence, 1994.

Feste d'Oltrarno: Plays in Churches in Fifteenth-Century Florence. Istituto nazionale di studi sul Rinascimento Studi e Testi XXXVII. Florence, 1996.

Nickson, Tom. "Reframing the Bible: Genesis and Exodus on Toledo Cathedral's Fourteenth-Century Choir Screen." *Gesta* 50, no. 1 (2011): 71–89.

Nova, Alessandro. "I tramezzi in Lombardia fra XV e XVI secolo: scena della Passione e devozione francescana."

In *Il Francescanesimo in Lombardia: storia e arte*, edited by Arnalda Dallaj, 197–215. Milan, 1983.

O'Brien, Alana. "San Filippo Benizi, 'Honour of the Servi and Florence': His Cycle and Cult at SS. Annunziata, c. 1475–1671." PhD thesis, La Trobe University, 2001.

O'Malley, John W. *The Council of Trent: Myths, Misunderstandings, and Unintended Consequences* [*Il Concilio di Trento: miti, incomprensioni e conseguenze involontarie: 12 marzo 2013*]. Rome, 2013.

Trent: What Happened at the Council. Cambridge, MA and London, 2013.

O'Malley, Michelle. "Altarpieces and Agency: The Altarpiece of the Society of Purification and Its 'Invisible Skein of Relations'." *Art History* 28, no. 4 (2005): 416–41.

The Business of Art: Contracts and the Commissioning Process in Renaissance Italy. New Haven, CT and London, 2005.

Offill, Ashley B. "The Corsini Chapel in Santa Maria del Carmine: Framing the Relic Cult of Saint Andrea Corsini in Baroque Florence." PhD thesis, University of Kansas, 2020.

Paatz, Walter, and Elisabeth Valentiner Paatz. *Die Kirchen von Florenz, ein Kunstgeschichtliches Handbuch.* Frankfurt am Main, 1952.

Pacciani, Riccardo. "Cosimo de' Medici, Lorenzo il Magnifico e la chiesa di San Salvatore al Monte a Firenze." *Prospettiva* 66 (1992): 27–35.

"Testimonianze per l'edificazione della basilica di San Lorenzo a Firenze 1421–1442." *Prospettiva* 75–76 (1994): 85–99.

"Il coro conteso. Rituali civici, movimenti d'osservanza, privatizzazioni nell'area presbiterale di chiese fiorentine del Quattrocento." In *Lo spazio e il culto: relazioni tra edificio ecclesiale e uso liturgico dal XV al XVI secolo*, edited by Jörg Stabenow, 127–52. Venice, 2006.

"'Signorili amplitudini ...' a Firenze. La cappella Rucellai alla Badia di S. Pancrazio e la rotonda della SS. Annunziata: architettura, patronati, rituali." In *Leon Battista Alberti architetture e committenti*, edited by Arturo Calzona, Joseph Connors, Francesco Paolo Fiore, and Cesare Vasoli, 135–77. Florence, 2009.

"Liturgia e pianta centrale a Firenze nel Rinascimento. Percorsi d'incontro fra dissonanze, adeguamenti e innovazioni." In *La place du choeur: architecture et liturgie du Moyen Âge aux Temps modernes: actes du colloque de l'EPHE, Institut national d'histoire de l'art, les 10 et 11 décembre 2007*, edited by Sabine Frommel, Laurent Lecomte, and Raphaël Tassin, 89–100. Paris and Rome, 2012.

"Cori, tramezzi, cortine, vele nello spazio interno di San Lorenzo." In *San Lorenzo: A Florentine Church*, edited

by Robert W. Gaston and Louis Alexander Waldman, 320–29. Florence, 2017.

Padberg, John W. ed. *The Constitutions of the Society of Jesus and Their Complementary Norms: A Complete English Translation of the Official Latin Texts.* St. Louis, MO, 1996.

Padoa Rizzo, Anna. "Sul polittico della Cappella Ardinghelli in Santa Trinita, di Giovanni Toscani." *Antichità viva* 21, no. 1 (1982): 5–10.

"Bernardo di Stefano Rosselli, il 'Polittico Ruccellai' e il polittico di San Pancrazio di Bernardo Daddi." *Studi di storia dell'arte* 4 (1993): 211–22.

Padovani, Serena. "Appunti su alcuni dipinti quattrocenteschi di San Niccolò Oltrarno." In *Studi di Storia dell'Arte in onore di Mina Gregori*, edited by Miklós Boskovits, 39–46. Cinisello Balsamo, 1994.

Paloscia, Tommaso, Fabio Bernacchi, and Piero Bargellini. *Le Robbiane della Verna.* Sacro Monte della Verna, 1986.

Paoletti, John T. "Asserting Presence: Strategies of Medici Patronage in Renaissance Florence." In *Studies on Florence and the Italian Renaissance in Honour of F. W. Kent*, edited by Peter Howard and Cecilia Hewlett, 73–94. Turnhout, 2016.

Paolini, Claudio. "Colonna della Giustizia" (2012). www.palazzospinelli.org/architetture/scheda.asp?offset=2160&ID=2086.

Paolozzi Strozzi, Beatrice. "Desiderio, Matteo Palmieri e un'opera perduta." In *Desiderio da Settignano: Atti del convegno, 9–12 maggio 2007, Firenze, Kunsthistorisches Institut, Max-Planck-Institut, Settignano, Villa I Tatti (The Harvard University Center for Italian Renaissance Studies)*, edited by Joseph Connors, Alessandro Nova, Beatrice Paolozzi Strozzi, and Gerhard Wolf, 61–78. Venice, 2011.

Paolozzi Strozzi, Beatrice, and Marc Bormand. eds. *La Primavera del Rinascimento: la scultura e le arti a Firenze 1400–1460.* Florence, 2013.

Paolucci, Antonio. "L'arredamento ecclesiale nell'età della riforma." In *Arte e religione nella Firenze de' Medici*, edited by Massimiliano Giuseppe Rosito, 95–109. Florence, 1980.

Parker, James. *Did Queen Elizabeth Take "Other Order" in the "Advertisements" of 1566? A Letter to Lord Selborne, in Reply to His Lordship's Criticisms on the "Introduction to the Revisions of the Book of Common Prayer."* Oxford and London, 1879.

Parsons, Edward A. "At the Funeral of Michelangelo." *Renaissance News* 4, no. 2 (1951): 17–19.

Passerini, Luigi. *Genealogia e storia della famiglia Altoviti.* Florence, 1871.

Pastor, Ludwig. *The History of the Popes, from the Close of the Middle Ages.* Wilmington, NC, 1928.

Pegazzano, Donatella. "Il Gran Bindo Huomo Raro et Singhulare: The Life of Bindo Altoviti." In *Raphael, Cellini, and a Renaissance Banker: The Patronage of Bindo Altoviti*, edited by Alan Chong, Donatella Pegazzano, and Dimitrios Zikos, 3–19. Boston, 2003.

——. "Vasari's Decorations for Bindo Altoviti's Palazzo and Villa." In *Raphael, Cellini, and a Renaissance Banker: The Patronage of Bindo Altoviti*, edited by Alan Chong, Donatella Pegazzano, and Dimitrios Zikos, 187–206. Boston, 2003.

Pellecchia Najemy, Linda. "The First Observant Church of San Salvatore al Monte in Florence." *Mitteilungen des Kunsthistorischen Institutes in Florenz* 23, no. 3 (1979): 273–96.

Pezzati, Sofia. *The Art of Wrought Iron: History and Techniques of Workmanship* [L'arte del ferro battuto: storia e tecniche di lavorazione]. Florence, 2006.

Piccinelli, Roberta, Claudia Bonora Previdi, and Stefano Siliberti. eds. *Santa Maria del Gradaro tra storia e arte*. Mantua, 2004.

Pillinini, Giovanni. "Bembo, Pietro (Giampietro)." In *Dizionario Biografico degli Italiani*, edited by Mario Caravale, Vol. 8, 151. Rome, 1966.

Pilliod, Elizabeth. "Cosimo I and the Arts." In *Artistic Centers of the Renaissance: Florence*, edited by Francis Ames-Lewis, 330–73. Cambridge and New York, 2012.

Piva, Paolo. "Dal setto murario allo jubé: il pòzo di Sant'Andrea a Mantova nel contesto di un processo evolutivo." In *Società, Cultura, Economia: Studi per Mario Vaini*, edited by Eugenio Camerlenghi, Giuseppe Gardoni, Isabella Lazzarini, and Viviana Rebonato, 57–78. Mantua, 2013.

——. "La chiesa di San Fiorentino a Nuvolato (Mantova) e il problema dei 'cori murati' dell'XI secolo." In *Architettura del'XI secolo nell'Italia del Nord: Storiografia e nuove ricerche. Pavia 8–9–10 aprile 2010 Convegno Internazionale*, edited by Anna Segagni Malacart and Luigi Carlo Schiavi, 91–97, 379–85. Pisa, 2013.

——. "Lo 'spazio liturgico': architettura, arredo, iconografia (secoli IV–XII)." In *L'Arte medievale nel contesto: 300–1300: funzioni, iconografia, tecniche*, edited by Paolo Piva, 141–80. Milan, 2015.

Plakolm-Forsthuber, Sabine. *Florentiner Frauenkloster von der Renaissance bis zur Gegenreformation*. Petersberg, 2009.

Ploeg, Kees van der. *Art, Architecture and Liturgy: Siena Cathedral in the Middle Ages*. Groningen, 1993.

Poccianti, Michele. *Vite de sette beati fiorentini fondatori del sacro ordine de' Servi. Con uno epilogo di tutte le chiese, monasteri, luoghi pii, e compagnie della città di Firenze*. Florence, 1589.

Pochat, Götz. "Brunelleschi and the 'Ascension' of 1422." *The Art Bulletin* 60, no. 2 (1978): 232–34.

Poeschke, Joachim. *Michelangelo and His World: Sculpture of the Italian Renaissance*. New York, 1996.

Poggi, Giovanni, and Margaret Haines. *Il Duomo di Firenze: documenti sulla decorazione della chiesa e del campanile tratti dall'archivio dell'opera*. Florence, 1988.

Poma Swank, Annamaria. "Iconografia controriformistica negli altar delle chiese fiorentine di Santa Maria Novella e Santa Croce." In *Altari controriformati in Toscana: architettura e arredi*, edited by Carlo Cresti, 95–131. Florence, 1997.

Pomar, Pablo J. "La ubicación del coro en las iglesias de España. San Pío V, Felipe II y el breve *Ad hoc nos Deus unxit*." In *Choir Stalls in Architecture and Architecture in Choir Stalls*, edited by Fernando Villaseñor Sebastián, Maria Dolores Teijeira Pablos, Welleda Muller, and Frédéric Billiet, 87–97. Newcastle upon Tyne, 2015.

Pons, Nicoletta. "La pittura del Quattrocento in Ognissanti." In *San Salvatore in Ognissanti: la chiesa e il convento*, edited by Riccardo Spinelli, 83–105. Florence, 2018.

Powell, Christabel Jane. "The Liturgical Vision of Augustus Welby Northmore Pugin." PhD thesis, University of Durham, 2002.

Preyer, Brenda. "Around and in the Gianfigliazzi Palace in Florence: Developments on Lungarno Corsini in the 15th and 16th Centuries." *Mitteilungen des Kunsthistorischen Institutes in Florenz* 48, no. 1/2 (2004): 55–104.

Primhak, Victoria. "Women in Religious Communities: The Benedictine Convents of Venice, 1400–1550." PhD thesis, University of London, 1991.

Procacci, Ugo. "Incendio della Chiesa del Carmine del 1771." *Rivista d'Arte* 14 (1932): 141–232.

Pugin, Augustus. *A Treatise on Chancel Screens and Rood Lofts, Their Antiquity, Use, and Symbolic Signification*. London, 1851.

Pulinari, Dionisio. *Cronache dei Frati Minori della Provincia di Toscana*. Edited by Saturnino Mencherini. Arezzo, 1913.

Puricelli, Giovanni Pietro. *De SS. Martyribus Nazario et Celso, ac Protasio et Gervasio, Mediolani sub Nerone cæsis, deque basilicis in quibus eorum corpora quiescunt: Historica dissertatio, Rerum etiam Urbanarum notitiae perutilis: quam brevitatis gratia Nazarinam nuncupari placeat*. Milan, 1656.

Quinterio, Francesco. "Un tempio per la Repubblica: la chiesa dei SS. Maria, Matteo e dello Spirito Santo in Firenze. Dal primo nucleo duecentesco al progetto brunelleschiano." *Saggi in Onore di Renato Bonelli, Quaderni dell'Istituto di Storia dell'Architettura* 15/20, no. 1990/92 (1992): 305–16.

Raggi, Oreste. *La chiesa di Santa Croce e la sua facciata*. Florence, 1863.

Randolph, Adrian. "Regarding Women in Sacred Space." In *Picturing Women in Renaissance and Baroque Italy*, edited by Geraldine A. Johnson and Sara F. Matthews Grieco, 17–41. Cambridge, 1997.

Range, Matthias. "The Material Presence of Music in Church: The Hanseatic City of Lübeck." In *Lutheran Churches in Early Modern Europe*, edited by Andrew Spicer, 197–220. Farnham, 2012.

Ravalli, Gaia. "Attraverso Santa Maria Novella: Spazio, culto, decorazione tra XIII e XVI secolo." PhD thesis, Scuola Normale Superiore, Pisa, 2019.

Razzòli, Roberto. *La chiesa d'Ognissanti in Firenze*. Florence, 1898.

Repishti, Francesco, and Richard Schofield. *Architettura e controriforma: i dibattiti per la facciata del Duomo di Milano, 1582–1682*. Milan, 2004.

Richa, Giuseppe. *Notizie istoriche delle chiese fiorentine, divise ne' suoi quartieri*. Florence, 1754–62.

Richardson, Carol M. *Reclaiming Rome: Cardinals in the Fifteenth Century*. Leiden and Boston, 2009.

Ridolfi, Michele. *Scritti d'arte e d'antichità*. Edited by Enrico Ridolfi. Florence, 1879.

Riedl, Peter Anselm, and Max Seidel. eds. *Die Kirchen von Siena*. Munich, 1985–99.

Robson, Janet. "Assisi, Rome and the Miracle of the Crib at Greccio." In *Image, Memory and Devotion: Liber Amicorum Paul Crossley*, edited by Zoe Opačić and Achim Timmermann, 145–55. Turnhout, 2011.

Rocke, Michael. *Forbidden Friendships: Homosexuality and Male Culture in Renaissance Florence*. New York, 1996.

Rodríguez G. de Ceballos, Alfonso. "Liturgia y configuración del espacio en la arquitectura española y portuguesa a raíz del Concilio de Trento." Universidad Autónoma de Madrid, 1991.

Romby, Giuseppina Carla. "Trasformazioni, restauri, 'ornamenti' della chiesa di San Francesco a Pistoia dal'500 alla soppressione del 1808. " In *S. Francesco: la chiesa e il convento in Pistoia*, edited by Lucia Gai and Alessandro Andreini, 173–98. Ospedaletto, 1993.

———. "Scenografia dello spazio sacro: i rinnovamenti vasariani delle chiese medievali e l'allestimento della cattedrale di Pistoia." In *Giorgio Vasari tra capitale medicea e città del dominio*, edited by Simona Esseni, Nicoletta Lepri, and Maria Camilla Pagnini, 53–58. Florence, 2012.

Ronchi, Ermes Maria. ed. *La Madonna nell'attesa del parto: capolavori del patrimonio italiano del'300 e'400*. Milan, 2000.

Rosand, David. "Titian in the Frari." *The Art Bulletin* 53, no. 2 (1971): 196–213.

Rosenthal, David. *Kings of the Street: Power, Community, and Ritual in Renaissance Florence*. Turnhout, 2015.

Rossi, Ferdinando. "Mosaici, intarsi e tarsie." In *La basilica di San Miniato al Monte a Firenze*, edited by Francesco Gurrieri, Luciano Berti, and Claudio Leonardi, 129–55. Florence, 1988.

Röstel, Alexander. "'Una Pieta chon molte figure': Sandro Botticelli's altarpiece for the Florentine church of S. Paolino." *The Burlington Magazine* 157, no. 1349 (2015): 521–29.

Rubin, Miri. *Corpus Christi: The Eucharist in Late Medieval Culture*. Cambridge, 1991.

Ruda, Jeffrey. *Fra Filippo Lippi: Life and Work with a Complete Catalogue*. London, 1993.

Russo, Eugenio. "Lo scomparso jubé della chiesa abbaziale di Pomposa." *Studi vari* 31–32, (2006–07): 7–43.

Saalman, Howard. *The Church of Santa Trinita in Florence*. New York, 1966.

———. *Filippo Brunelleschi: The Buildings*. University Park, PA, 1993.

Saggi, Ludovico. *Santi del Carmelo*. Rome, 1972.

Sale, Giovanni. *Pauperismo architettonico e architettura gesuitica: dalla chiesa ad aula al Gesù di Roma*. Milan, 2001.

Salmi, Mario. "La giovinezza di Fra Filippo Lippi." *Rivista d'Arte* 18, no. 2 (1936): 1–24.

Salvestrini, Francesco. *Disciplina caritatis: il monachesimo vallombrosano tra Medioevo e prima età moderna*. Rome, 2011.

Sandrelli, Caterina. "Sant'Antonio di Castello: una chiesa scomparsa a Venezia." *Arte Documento* 9 (1996): 159–67.

Sanger, Alice E. *Art, Gender and Religious Devotion in Grand Ducal Tuscany*. Farnham, 2014.

Santi, Bruno. "Una croce dipinta di Lippo di Benivieni dalla Villa 'La Quiete' in Valcava di Mugello." *Studi di storia dell'arte* 1 (1990): 253–58.

———. "Il fonte battesimo trecentesco e il monumento all'antipapa Giovanni XXIII nel Battistero di Firenze." In *Il Battistero di San Giovanni a Firenze: atti delle conferenze propedeutiche al convegno internazionale di studi*, edited by Francesco Gurrieri, 56–71. Florence, 2014.

Sanudo, Marino. *I diarii di Marino Sanuto*. Bologna, 1969.

Satkowski, Leon. *Giorgio Vasari: Architect and Courtier*. Princeton, NJ, 1993.

Schelbert, Georg. "SS. Apostoli a Roma: il coro-mausoleo rinascimentale e il triconco rinato." In *La place du choeur: architecture et liturgie du Moyen Âge aux Temps modernes: actes du colloque de l'EPHE, Institut national d'histoire de l'art, les 10 et 11 décembre 2007*, edited by Sabine Frommel, Laurent Lecomte, and Raphaël Tassin, 101–12. Paris and Rome, 2012.

Schilling, Martina. "Zur liturgischen Nutzung des Sieneser Domes 1260–1360." In *Architektur und Liturgie: Akten des Kolloquiums vom 25. bis 27. Juli 2003 in Greifswald*, edited by Michael Alltripp and Claudia Nauerth, 91–104. Wiesbaden, 2006.

Schleif, Corine. "Men on the Right – Women on the Left: (A)symmetrical Spaces and Gendered Places." In *Women's Space: Patronage, Place and Gender in the Medieval Church*, edited by Virginia Chieffo Raguin and Sarah Stanbury, 207–49. Albany, NY, 2005.

Schmid, Josef. *Et pro remedio animae et pro memoria: bürgerliche repraesentatio in der Cappella Tornabuoni in S. Maria Novella.* Munich, 2002.

Schmidt, Victor M. "Filippo Brunelleschi e il problema della tavola d'altare." *Arte Cristiana* 80, no. 753 (1992): 451–61.

Schofield, Richard. "Un'introduzione al presbiterio del Duomo tra Vincenzo Seregni e Carlo Borromeo." *Nuovi annali / Veneranda Fabbrica del Duomo di Milano* 2 (2010/11): 43–66.

———. "Pellegrino Tibaldi e tre cori borromaici." In *Domenico e Pellegrino Tibaldi*, edited by Francesco Ceccarelli and Deanna Lenzi, 143–64, 365–66. Venice, 2011.

———. "Carlo Borromeo in 1578: Separating the Clergy from the Laity." In *La place du choeur: architecture et liturgie du Moyen Âge aux Temps modernes: actes du colloque de l'EPHE, Institut national d'histoire de l'art, les 10 et 11 décembre 2007*, edited by Sabine Frommel, Laurent Lecomte, and Raphaël Tassin, 177–86. Paris and Rome, 2012.

———. "Carlo Borromeo and the Dangers of Laywomen in Church." In *The Sensuous in the Counter-Reformation Church*, edited by Marcia B. Hall, Tracy E. Cooper, 187–205. New York, 2013.

Schwartz, Frithjof. *Il bel cimitero: Santa Maria Novella in Florenz 1279–1348: Grabmäler, Architektur und Gesellschaft.* Berlin and Munich, 2009.

Sciacca, Christine. ed. *Florence at the Dawn of the Renaissance: Painting and Illumination 1300–1350.* Los Angeles, 2012.

Scotti, Aurora. "Architettura e riforma cattolica nella Milano di Carlo Borromeo." *L'Arte* 18–20 (1972): 54–90.

Sebregondi, Ludovica. "Francesco d'Antonio, Ante d'organo raffiguranti: Angeli cantori e San Matteo e San Giovanni." In *La chiesa e la città a Firenze nel 15. secolo: Firenze, Sotterranei di San Lorenzo, 6 giugno–6 settembre 1992*, edited by Gianfranco Rolfi, Ludovica Sebregondi, and Paolo Viti, 96. Milan, 1992.

Sénécal, Robert. "Carlo Borromeo's *Instructiones Fabricae et Supellectilis Ecclesiasticae* and Its Origins in the Rome of His Time." *Papers of the British School at Rome* 68 (2000): 241–67.

Sframeli, Maria. "Francesco d'Antonio, Ante d'organo di Orsanmichele." In *L'età di Masaccio: il primo Quattrocento a Firenze*, edited by Luciano Berti and Antonio Paolucci, 184–85. Milan, 1990.

Shearman, John. "The Florentine Entrata of Leo X, 1515." *Journal of the Warburg and Courtauld Institutes* 38 (1975): 136–54.

Sheppard, Jennifer M. "The Eleventh-Century Choir-Screen at Monte Cassino: A Reconstruction." *Byzantine Studies* 9, no. 2 (1982): 233–42.

Sherman, Allison. "'To God Alone the Honour and Glory': Further Notes on the Patronage of Pietro Lombardo's Choir Screen in the Frari, Venice." *The Burlington Magazine* 156, no. 1340 (2014): 723–28.

Silva, Romano. *La Basilica di San Frediano in Lucca: urbanistica, architettura, arredo.* Lucca, 1985.

Silver, Nathaniel. "'Cum signo T quod potentiam vocant': The Art and Architecture of the Antonite Hospitallers in Trecento Venice." *Mitteilungen des Kunsthistorischen Institutes in Florenz* 58, no. 1 (2016): 26–57.

Simons, Patricia. "Portraiture and Patronage in Quattrocento Florence with Special Reference to the Tornaquinci and Their Chapel in S. Maria Novella." PhD thesis, University of Melbourne, 1985.

Sliwka, Jennifer. *Visions of Paradise: Botticini's Palmieri Altarpiece.* London, 2015.

Sman, Gert Jan van der. "Botticelli's Life and Career in the District of the Unicorn." In *Sandro Botticelli (1445–1510): Artist and Entrepreneur in Renaissance Florence: Proceedings of the International Conference held at the Dutch University Institute for Art History, Florence, 20–21 June 2014*, edited by Irene Mariani and Gert Jan van der Sman, 183–201. Florence, 2015.

Smith, Christine. "The Bandinelli Choir." In *Retrospection: Baccio Bandinelli and the Choir of Florence Cathedral*, edited by Christine Smith, 55–68. Cambridge, MA, 1997.

Solberg, Gail E. "Bild und Zeremoniell in San Pier Maggiore, Florenz." In *Zeremoniell und Raum in der frühen italienischen Malerei* edited by Stefan Weppelmann, 194–209. Berlin, 2007.

Sottili, Fabio. "Vox super aquas intonuit. L'infinito cantiere di Ognissanti." In *San Salvatore in Ognissanti: la chiesa e il convento*, edited by Riccardo Spinelli, 29–49. Florence, 2018.

Spallanzani, Marco. *Oriental Rugs in Renaissance Florence.* Florence, 2007.

Spicer, Andrew. "Sites of the Eucharist." In *A Companion to the Eucharist in the Reformation*, edited by Lee Palmer Wandel, 321–62. Leiden and Boston, 2014.

Stabenow, Jörg. "Introduzione." In *Lo spazio e il culto: relazioni tra edificio ecclesiale e uso liturgico dal XV al XVI secolo*, edited by Jörg Stabenow, 9–23. Venice, 2006.

Staley, Edgcumbe. *The Guilds of Florence.* New York, 1967.

Stopani, Renato. *San Simone.* Le Chiese Minori di Firenze. Florence, 2002.

Strehlke, Carl Brandon. "Cenni di Francesco, the Gianfigliazzi, and the Church of Santa Trinita in

Florence." *The J. Paul Getty Museum Journal* 20 (1992): 11–40.

Italian Paintings 1250–1450 in the John G. Johnson Collection and the Philadelphia Museum of Art. Philadelphia, 2004.

Strocchia, Sharon T. "When the Bishop Married the Abbess: Masculinity and Power in Florentine Episcopal Entry Rites, 1300–1600." *Gender & History* 19, no. 2 (2007): 346–68.

Nuns and Nunneries in Renaissance Florence. Baltimore, 2009.

Struchholz, Edith. *Die Choranlagen und Chorgestühle des Sieneser Domes.* Münster and New York, 1995.

Stubblebine, James H. "Cimabue and Duccio in Santa Maria Novella." *Pantheon* 31 (1973): 15–21.

Summers, David. *Real Spaces: World Art History and the Rise of Western Modernism.* London and New York, 2003.

Tacchi Venturi, Pietro, and Mario Scaduto. *Storia della Compagnia di Gesù in Italia.* Rome, 1950.

Tacconi, Marica S. *Cathedral and Civic Ritual in Late Medieval and Renaissance Florence: The Service Books of Santa Maria del Fiore.* Cambridge, 2005.

Tarani, D. F. *La badia di S. Pancrazio in Firenze.* Pescia, 1923.

Tartuferi, Angelo. "Le testimonianze superstiti (e le perdite) della decorazione primitiva (secoli XIII–XV)." In *La chiesa di Santa Maria del Carmine a Firenze,* edited by Luciano Berti, 143–71. Florence, 1992.

Taucci, Raffaele. "La chiesa e il convento della SS. Annunziata di Firenze e i loro ampliamenti fino alla metà del secolo XV." *Studi storici sull'Ordine dei Servi di Maria* 4 (1942): 99–127.

Teijeira Pablos, María Dolores. "'Aziendo presbiterio mui capaz'. El 'modo español' y el traslado de coros góticos en la España moderna." In *Choir Stalls in Architecture and Architecture in Choir Stalls,* edited by Fernando Villaseñor Sebastián, Maria Dolores Teijeira Pablos, Welleda Muller, and Frédéric Billiet, 1–26. Newcastle upon Tyne, 2015.

Terpstra, Nicholas. "Early Modern Catholicism." In *The Oxford Handbook of Early Modern European History, 1350–1750,* edited by Hamish Scott, Vol. 1, 601–25. Oxford, 2015.

"Locating the Sex Trade in the Early Modern City: Space, Sense and Regulation in Sixteenth-Century Florence." In *Mapping Space, Sense, and Movement in Florence: Historical GIS and the Early Modern City,* edited by Nicholas Terpstra and Colin Rose, 107–24. Abingdon and New York, 2016.

Teubner, Hans. "San Marco in Florenz: Umbauten vor 1500. Ein Beitrag zum Werk des Michelozzo." *Mitteilungen des Kunsthistorischen Institutes in Florenz* 23, no. 3 (1979): 239–72.

Theisen, Reinold. *Mass Liturgy and the Council of Trent.* Collegeville, MN, 1965.

Thibodeau, Timothy M. *The Rationale Divinorum Officiorum of William Durand of Mende: A New Translation of the Prologue and Book One.* New York, 2010.

Thiers, Jean-Baptiste. *Dissertations ecclésiastiques.* Paris, 1688.

Thoenes, Christof. "Renaissance St. Peter's." In *St. Peter's in the Vatican,* edited by William Tronzo, 64–92. Cambridge and New York, 2005.

Thomas, Anabel. *Art and Piety in the Female Religious Communities of Renaissance Italy.* Cambridge, 2003.

Thomas, Ben. "The Paragone Debate and Sixteenth-Century Italian Art." D Phil thesis, University of Oxford, 1997.

Thurber, T. Barton. "Architecture and Religious Conflict in Late Sixteenth-Century Italy: Pellegrino Tibaldi's Planned Reconstruction of the Vercelli Cathedral." PhD thesis, Harvard University, 1994.

Tibbetts Schulenburg, Jane. "Gender, Celibacy, and Proscriptions of Sacred Space: Symbol and Practice." In *Medieval Purity and Piety: Essays on Medieval Clerical Celibacy and Religious Reform,* edited by Michael Frassetto, 353–76. New York and London, 1998.

Tinti, Mario. *Il fonte battesimale di Dante.* Florence, 1921.

Toesca, Pietro. "Umili pittori fiorentini del principio del quattrocento." *L'Arte* 7 (1904): 49–58.

Toker, Franklin. "Excavations below the Cathedral of Florence, 1965–1974." *Gesta* 14, no. 2 (1975): 17–36.

Archaeological Campaigns below the Florence Duomo and Baptistery, 1895–1980. London, 2013.

Tomas, Natalie. "Did Women Have a Space?." In *Renaissance Florence: A Social History,* edited by Roger J. Crum and John T. Paoletti, 311–28. New York, 2006.

Tomasi, Michele. "Memoria dei vescovi e libertas Ecclesiae: il perduto monumento funerario del beato Bartolomeo da Breganze in Santa Corona a Vicenza." In *Medioevo: immagine e memoria. Atti del convegno internazionale di studi, Parma, 23–28 settembre 2008,* edited by Arturo Carlo Quintavalle, 436–42. Milan, 2009.

"Tommaseo Online." Accademia della Crusca (2015). www.tommaseobellini.it/#/.

Tonini, Pellegrino. *Il Santuario della Santissima Annunziata di Firenze.* Florence, 1876.

Totaro, Luigi. ed. *I Commentari.* Milan, 1984.

Trachtenberg, Marvin. *Building-in-Time: From Giotto to Alberti and Modern Oblivion.* New Haven, CT and London, 2010.

"Building and Writing S. Lorenzo in Florence: Architect, Biographer, Patron, and Prior." *The Art Bulletin* 97, no. 2 (2015): 140–72.

Traversi, Francesco. "Per i Del Tasso: il crocifisso di San Pancrazio, da Firenze a Fossato e una nota su Benedetto da Maiano." *Prato storia e arte* 113 (2013): 95–103.

Travi, Carla. "Antichi tramezzi in Lombardia: il caso di Sant'Eustorgio." *Arte Lombarda, Nuova Serie* 158/159, no. 1–2 (2010): 5–16.

Trexler, Richard C. *Public Life in Renaissance Florence.* Ithaca, NY and London, 1980.

——— "Florentine Prostitution in the Fifteenth Century: Patrons and Clients." In *Power and Dependence in Renaissance Florence, Volume 2: The Women of Renaissance Florence,* edited by Richard C. Trexler, 31–65. Asheville, NC, 1998.

Tripodi, Claudia. *Gli Spini tra XIV e XV secolo: Il declino di un antico casato fiorentino.* Florence, 2013.

Trotta, Giampaolo. "La chiesa dei Santi Apostoli." In *Gli antichi chiassi tra Ponte Vecchio e Santa Trinita: storia del rione dei Santi Apostoli, dai primi insediamenti romani alle ricostruzioni postbelliche,* edited by Giampaolo Trotta, 147–58. Florence, 1992.

——— *San Salvatore al Monte: "Antiquæ elegantiæ" per un "acropolis" laurenziana.* Florence, 1997.

Ugonio, Pompeo. *Historia delle stationi di Roma che si celebrano la Quadragesima.* Rome, 1588.

Utz, Hildegard. "Sculptures by Domenico Poggini." *Metropolitan Museum Journal* 10 (1975): 63–78.

Valdameri, Carlo. "Considerazioni sullo scomparso pontile di San Giovanni Evangelista in Rimini e sulla presenza a Rimini di Fra Carnevale." *Romagna Arte e Storia* 31, no. 91 (2011): 5–26.

Valentini, Anita. *Sant'Anna dei Fiorentini: storia, fede, arte, tradizione.* Florence, 2003.

Valenzano, Giovanna. "La suddivisione dello spazio nelle chiese mendicanti: sulle tracce dei tramezzi delle Venezie." In *Arredi liturgici e architettura,* edited by Arturo Carlo Quintavalle, 99–114. Milan, 2007.

Valtieri, Simonetta. "Sistemazioni absidali di chiese in funzione di 'Mausoleo' in progetti di Antonio da Sangallo il Giovane." In *Antonio da Sangallo il Giovane* edited by Gianfranco Spagnesi, 109–18. Rome, 1986.

——— "U 181A Recto." In *The Architectural Drawings of Antonio Da Sangallo the Younger and His Circle,* edited by Nicholas Adams and Christoph Luitpold Frommel, 116–17. New York, 2000.

Van Dijk, Stephen Joseph Peter. *Sources of the Modern Roman Liturgy.* Leiden, 1963.

Van Veen, Henk Th. *Cosimo I de' Medici and His Self-Representation in Florentine Art and Culture.* Translated by Andrew P. McCormick. Cambridge, 2006.

Vannucci, Marcello. *Le grande famiglie di Firenze.* Rome, 1993.

Vasari, Giorgio. *Ricordanze 1527–1573.* Fondazione Memofonte, 2006. www.memofonte.it/autori/gior gio-vasari-1511-1574.html.

Vasari, Giorgio, Rosanna Bettarini, and Paola Barocchi. *Le vite de' più eccellenti pittori scultori e architetti.* 8 vols. Florence, 1966–87.

Vasari, Giorgio, and Karl Frey. *Le vite de' più eccellenti pittori, scultori ed architettori,* Vol. 1. Munich, 1911.

Vasaturo, Nicola. *La chiesa di S. Trinita: Nota storiche e guida artistica.* Florence, 1973.

——— "Note storiche." In *Vallombrosa nel IX centenario della morte del fondatore Giovanni Gualberto 12 luglio 1073,* edited by Nicola Vasaturo, G. Morozzi, G. Marcini, and U. Baldini, 23–159. Florence, 1973.

——— "Vallombrosa: ricerche d'archivio sulla costruzione dell'abbazia." In *Vallombrosa nel IX centenario della morte del fondatore Giovanni Gualberto 12 luglio 1073,* edited by Nicola Vasaturo, Guido Morozzi, Giuseppe Marchini, and Umberto Baldini, 1–22. Florence, 1973.

——— "Vallombrosa, Vallombrosane, Vallombrosani." In *Dizionario degli istituti di perfezione,* edited by Guerrino Pelliccia and Giancarlo Rocca, Vol. 9, 1692–702. Rome, 1974–2003.

——— "Appunti d'archivio sulla costruzione e trasformazioni dell'edificio." In *La Chiesa di Santa Trinita a Firenze,* edited by Giuseppe Marchini and Emma Micheletti, 7–22. Florence, 1987.

——— *Vallombrosa: L'abbazia e la congregazione. Note storiche.* Edited by Giordano Monzio Compagnoni. Vallombrosa, 1994.

Vauchez, André. *Sainthood in the Later Middle Ages.* Translated by Jean Birrell. Cambridge, 1997.

Venturi, Adolfo. "L'arte dell'intaglio e della tarsia a Ferrara nella fine del Quattrocento." *L'Arte* 19 (1916): 55–57.

Vettori, Pietro. *Oratio P. Victorii habita in funere Cosmi Medicis Magni Ducis Etruriæ, etc.* Florence, 1574.

Visioli, Monica, and Paolo Rambaldi. *Palazzo Raimondi: nuove ricerche in occasione dei restauri alla facciata.* Quaderni di storia e tecniche dell'architettura. Viareggio, 2001.

Voelker, Evelyn Carole. "Charles Borromeo's *Instructiones Fabricae et Supellectilis Ecclesiasticae,* 1577. A Translation with Commentary and Analysis." PhD thesis, Syracuse University, 1977.

——— "Borromeo's Influence on Sacred Art and Architecture." In *San Carlo Borromeo: Catholic Reform and Ecclesiastical Politics in the Second Half of the Sixteenth Century,* edited by John M. Headley and John B. Tomaro, 172–87. Washington, DC and London, 1988.

Volta, Valentino, and Rossana Prestini. *La chiesa e il convento di San Francesco d'Assisi in Brescia.* Brescia, 1994.

Vossilla, Francesco. "Baccio Bandinelli and Giovanni Bandini in the Choir of the Cathedral." In *Sotto il*

cielo della cupola: il coro di Santa Maria del Fiore dal Rinascimento al 2000: progetti di Brunelleschi, Bandinelli, Botta, Brenner, Gabetti e Isola, Graves, Hollein, Isozaki, Nouvel, Rossi, edited by Timothy Verdon, 69–99. Milan, 1997.

Walden, Justine. "Foaming Mouth and Eyes Aflame: Exorcism and Power in Renaissance Florence." PhD thesis, Yale University, 2016.

——— "Exorcism and Religious Politics in Fifteenth-Century Florence." Renaissance Quarterly 71 (2018): 437–77.

Waldman, Louis Alexander. "Florence Cathedral in the Early Trecento: The Provisional High Altar and Choir of the Canonica." Mitteilungen des Kunsthistorischen Institutes in Florenz 40, no. 3 (1996): 267–86.

——— "From the Middle Ages to the Counter-Reformation: The Choirs of S. Maria del Fiore." In Sotto il cielo della cupola: il coro di Santa Maria del Fiore dal Rinascimento al 2000: progetti di Brunelleschi, Bandinelli, Botta, Brenner, Gabetti e Isola, Graves, Hollein, Isozaki, Nouvel, Rossi, edited by Timothy Verdon, 37–68. Milan, 1997.

——— "'Vadunt ad habitandum hebrei': The Otto di Balìa, Vasari, and the Hiding of Murals in Sixteenth-Century Florence." Mitteilungen des Kunsthistorischen Institutes in Florenz 56, no. 3 (2014 (2015)): 351–54.

Wallace, William. "Michelangelo's Project for a Reliquary Tribune in San Lorenzo." Architectura 17, no. 1 (1987): 45–57.

Waterworth, James. The Canons and Decrees of the Sacred and Oecumenical Council of Trent. London, 1848.

Waźbiński, Zygmunt. L'Accademia medicea del disegno a Firenze nel Cinquecento: idea e istituzione. Accademia Toscana di Scienze e Lettere "La Colombaria." Florence, 1987.

Weddle, Saundra. "Enclosing Le Murate: The Ideology of Enclosure and the Architecture of a Florentine Convent, 1390–1597." PhD thesis, Cornell University, 1997.

——— "Identity and Alliance: Urban Presence, Spatial Privilege, and Florentine Renaissance Convents." In Renaissance Florence: A Social History, edited by Roger J. Crum and John T. Paoletti, 394–412. New York, 2006.

——— "'Tis Better to Give Than to Receive: Client-Patronage Exchange and Its Architectural Implications at Florentine Convents." In Studies on Florence and the Italian Renaissance in Honour of F.W. Kent, edited by Peter Howard and Cecilia Hewlett, 295–315. Turnhout, 2016.

Weissman, Ronald F. E. Ritual Brotherhood in Renaissance Florence. New York, 1982.

Weitzel Gibbons, Mary. "Cosimo's Cavallo: A Study in Imperial Imagery." In The Cultural Politics of Duke Cosimo I de' Medici, edited by Konrad Eisenbichler, 77–102. Aldershot and Burlington, VT, 2001.

Weppelmann, Stefan. "Raum und Memoria. Giottos Berliner Transitus Mariae und einige Überlegungen zur Aufstellung der Maestà in Ognissanti, Florenz." In Zeremoniell und Raum in der frühen italienischen Malerei, edited by Stefan Weppelmann, 128–59. Berlin, 2007.

Wilmering, Antoine M. The Gubbio Studiolo and Its Conservation. Volume 2: Italian Renaissance Intarsia and the Conservation of the Gubbio Studiolo. New York, 1999.

Wilson, Blake. Music and Merchants: The Laudesi Companies of Republican Florence. Oxford and New York, 1992.

——— "If Monuments Could Sing: Image, Song, and Civic Devotion Inside Orsanmichele." In Orsanmichele and the History and Preservation of the Civic Monument, edited by Carl Brandon Strehlke, 139–68. New Haven, CT, 2012.

Winkelmes, Mary-Ann. "Form and Reform: Illuminated, Cassinese Reform-Style Churches in Renaissance Italy." Annali di architettura: rivista del Centro internazionale di studi di architettura "Andrea Palladio" 8 (1996): 61–84.

——— "Notes on Cassinese Choirs: Acoustics and Religious Architecture in Northern Italy." In Coming About: A Festschrift for John Shearman, edited by Lars R. Jones and Louisa C. Matthew, 307–12. Cambridge, MA, 2001.

Wittkower, Rudolf. "Il balaustro rinascimentale e il Palladio." Bollettino del Centro internazionale di studi di architettura "Andrea Palladio" 10 (1968): 332–46.

Wolters, Wolfgang. La scultura veneziana gotica (1300–1460). Venice, 1976.

——— Architektur und Ornament. Venezianischer Bauschmuck der Renaissance. Munich, 2000.

Wright, Alison. "Tabernacle and Sacrament in Fifteenth-Century Tuscany." In Carving, Casts and Collectors: The Art of Renaissance Sculpture, edited by Peta Motture, Emma Jones, and Dimitrios Zikos, 42–57. London, 2013.

Yates, Nigel. Liturgical Space: Christian Worship and Church Buildings in Western Europe 1500–2000. Aldershot and Burlington, VT, 2008.

Zambrano, Patrizia. "La Madonna Trivulzio." In Museo d'arte antica del Castello Sforzesco: Pinacoteca, Vol. 1, 167–70. Milan, 1997.

Zervas, Diane Finiello. "Lorenzo Monaco, Lorenzo Ghiberti, and Orsanmichele: Part I." *The Burlington Magazine* 133, no. 1064 (1991): 748–59.

"Lorenzo Monaco, Lorenzo Ghiberti and Orsanmichele: Part II." *The Burlington Magazine* 133, no. 1065 (1991): 812–19.

Ed., *Orsanmichele a Firenze*. Modena, 1996.

Orsanmichele: Documents 1336–1452. Modena, 1996.

"Niccolò Gerini's 'Entombment and Resurrection of Christ,' S. Anna/S. Michele/S. Carlo and Orsanmichele in Florence: Clarifications and New Documentation." *Zeitschrift für Kunstgeschichte* 66, no. 1 (2003): 33–64.

"New Documents for the Oratory of Orsanmichele in Florence, 1365–1400." *Zeitschrift für Kunstgeschichte* 78, no. 2 (2015): 292–313.

Žic-Rokov, Ivan. "Kompleks katedrala – Sv. Kvirin u Krku." *Rad JAZU* 6 (1972): 131–57.

Zucchini, Guido. *La chiesa e il chiostro di San Vittore presso Bologna*. Bologna, 1917.

INDEX